SEURAT

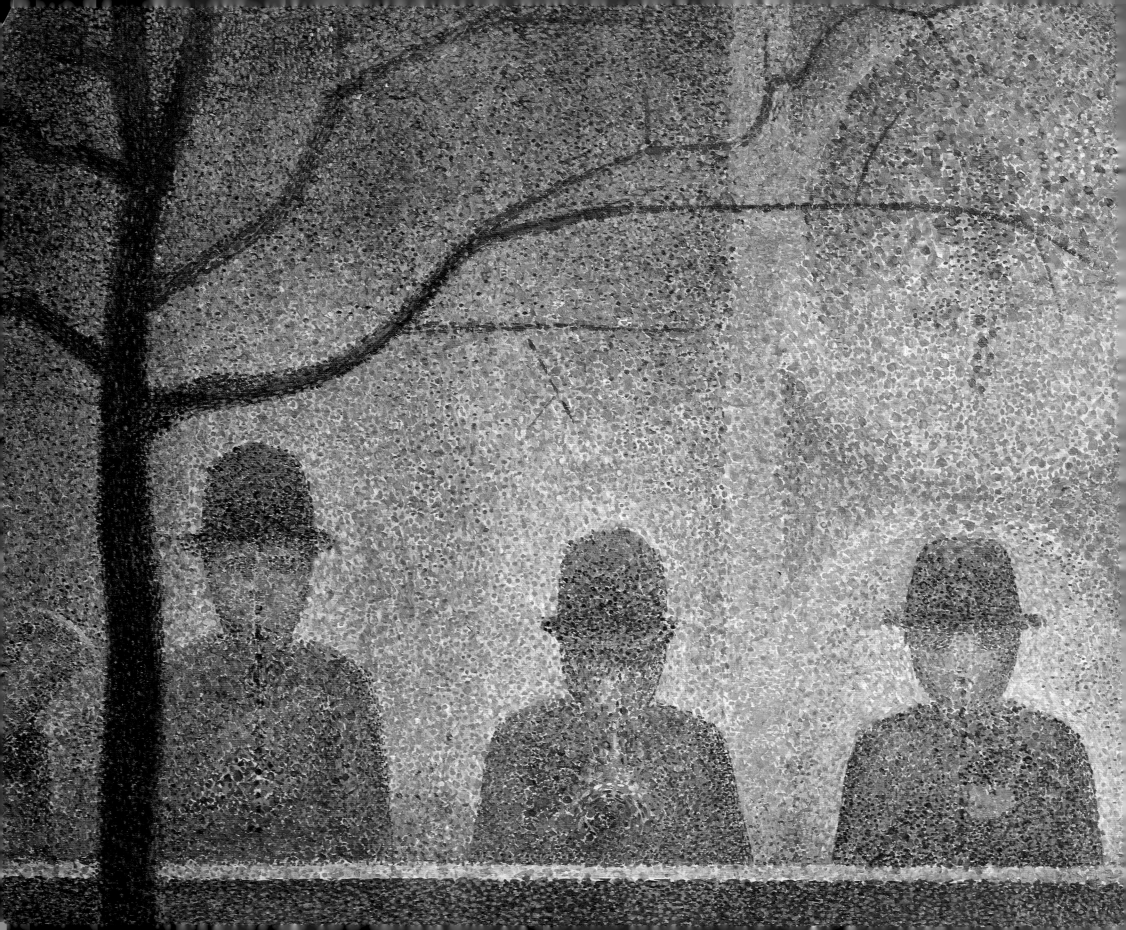

GEORGES SEURAT
1859–1891

ROBERT L. HERBERT

Françoise Cachin, Anne Distel, Susan Alyson Stein, Gary Tinterow

The Metropolitan Museum of Art, New York

Distributed by Harry N. Abrams, Inc., New York

This publication is issued in conjunction with the exhibition *Seurat, 1859–1891,* held at the
Galeries Nationales du Grand Palais, Paris, from April 9 to August 12, 1991, and at
The Metropolitan Museum of Art, New York, from September 24, 1991, to January 12, 1992.

The exhibition is made possible by Fondation Elf,
a non-profit organization established by Elf Aquitaine.

It was organized by The Metropolitan Museum of Art and the Réunion des Musées Nationaux
Musée d'Orsay. It is supported in part by the National Endowment for the Arts and by an
indemnity from the Federal Council on the Arts and the Humanities.

Transportation assistance has been provided by Air France.

Published by The Metropolitan Museum of Art, New York

John P. O'Neill, Editor in Chief
Kathleen Howard, Editor
Bruce Campbell, Designer
Gwen Roginsky, Production Manager
Peter Antony, Production Assistant

Set in Fournier by U.S. Lithograph, typographers, New York
Printed on Gardamatte Brilliante, 135 gsm
Separations made by Arnoldo Mondadori Editore, S.p.A., Verona, Italy
Printed and bound by Arnoldo Mondadori Editore, S.p.A., Verona, Italy

Translations from the French by Ernst van Haagen and Maurice Robine, Bertrand Languages, Inc.
(sections entitled "*Poseuses*" and "*Cirque*"); Richard Miller (Chronology); and Lee Fahnestock
(Foreword and "Seurat in France"). Translations from the French in texts by Robert L. Herbert are
by the author, except where otherwise noted.

Jacket/cover illustration
Seurat, *Poseuses, ensemble* (cat. no. 191). Berggruen Collection on loan to the
National Gallery, London

Frontispiece
Detail from Seurat, *Parade de cirque*, 1887–88 (cat. no. 200). The Metropolitan Museum of Art,
New York, Bequest of Stephen C. Clark, 1960 61.101.17

LIBRARY OF CONGRESS CATALOGING-IN-PUBLICATION DATA

Seurat, Georges, 1859–1891.
 Georges Seurat, 1859–1891 / Robert L. Herbert with Françoise Cachin.
 Anne Distel, Susan Alyson Stein, Gary Tinterow.
 p. cm.
 Catalog of an exhibition.
 Includes bibliographical references and index.
 ISBN 0–87099–618–5. — ISBN 0–87099–619–3 (pbk.). — ISBN 0–8109–6410–4 Abrams)
 1. Seurat, Georges, 1859–1891—Exhibitions. I. Herbert, Robert L., 1929– . II. Metro-
politan Museum of Art (New York, N.Y.)
III. Title.
ND553.S5A4 1991
759.4—dc20 91–17309
 CIP

Contents

CURATORS OF THE EXHIBITION vi

FOREWORD vii

SPONSOR'S STATEMENT viii

LIST OF LENDERS ix

NOTE TO THE READER I

Catalogue ROBERT L. HERBERT

Introduction 3

Early Life and Education 11

Independent Drawings 1881–1884 33

Independent Paintings 1879–1884 103

Une baignade, Asnières 1883–1884 147

Un dimanche à la Grande Jatte 1884–1886 170

1884–1886 220

Seascapes: Grandcamp and Honfleur 1885–1886 233

1886–1888 256

Poseuses 1886–1888 FRANÇOISE CACHIN 273

The Café-Concert 1886–1888 GARY TINTEROW 296

Parade de cirque 1886–1887 GARY TINTEROW 305

Seascapes: Port-en-Bessin 1888 318

1889–1890 328

Chahut 1889–1890 340

Seascapes: Gravelines 1890 349

Cirque 1890–1891 ANNE DISTEL 360

Appendixes

 A. Seurat's Painted Borders and Frames 376

 B. Aman-Jean on Seurat's School Years 377

 C. Seurat's Collection of Prints, Reproductions, and Photographs 378

 D. Seurat's List of Owners of His Works, 1886 380

 E. Seurat's Esthétique 381

 F. Seurat's Letter to Fénéon, June 20, 1890 383

 G. Charles Blanc 384

 H. D. P. G. Humbert de Superville and G. B. Duchenne de Boulogne 386

 I. David Sutter 387

 J. Michel-Eugène Chevreul 388

 K. Ogden Rood 390

 L. Charles Henry 391

 M. Camille Corot 394

 O. Thomas Couture 397

 P. Gauguin's Article (Le papier de Gauguin) 397

CHRONOLOGY ANNE DISTEL 399

LIST OF EXHIBITIONS 413

SEURAT IN FRANCE FRANÇOISE CACHIN 423

BIBLIOGRAPHY 425

CONCORDANCE 433

ACKNOWLEDGMENTS FOR THE AMERICAN EDITION 434

INDEX 436

PROVENANCE ENTRIES BY SUSAN ALYSON STEIN

Curators of the Exhibition

Robert L. Herbert
Professor of Art History, Mount Holyoke College

Françoise Cachin
Directeur

Anne Distel
Conservateur en chef
Musée d'Orsay

Gary Tinterow
Engelhard Associate Curator

Susan Alyson Stein
Special Exhibitions Associate
The Metropolitan Museum of Art

Foreword

To mark the centenary of Georges Seurat's death in 1891, the Réunion des Musées Nationaux/Musée d'Orsay and The Metropolitan Museum of Art have organized a landmark retrospective, which will be seen on both sides of the Atlantic. This exhibition, the first large-scale *hommage* to Seurat by a French museum, opened in Paris, the city where the artist was born, lived, and died. It was assembled by Robert L. Herbert, the Seurat scholar who was the catalogue's principal author, Françoise Cachin and Anne Distel of the Musée d'Orsay, and Gary Tinterow and Susan Alyson Stein of the Metropolitan Museum. To them we owe our sincere thanks.

In this exhibition such masterpieces as *Parade de cirque, Cirque,* and *Jeune femme se poudrant* and an extraordinary group of seascapes testify to Seurat's pictorial ambitions. His splendid drawings in conté crayon place him, with Ingres, among the greatest draughtsmen of the nineteenth century. These sheets and the beautiful series of small paintings on wood—his *croquetons* (little sketches)—give a more intimate view of Seurat. A large number of works are exhibited together for the first time, thanks to the generosity of private collectors, both American and European. We are greatly indebted to them, as well as to the museums that agreed to lend drawings and paintings by this major Neo-Impressionist.

Three of Seurat's principal works—*Une baignade, Asnières* (National Gallery, London), *Un dimanche à la Grande Jatte* (The Art Institute of Chicago), and *Poseuses* (Barnes Foundation, Merion, Pennsylvania)—could not be included in the exhibition because of their fragility or because of the terms of their donation. These are essential paintings, intended by Seurat for public salons: the last exhibition of the Impressionists and the Salon des Indépendants, both in Paris, and the exhibition of Les Vingt in Brussels. It has, however, been possible to assemble numerous studies, some of them large-scale, for these paintings; viewers will thus be able to grasp the place of these works in the artist's oeuvre. In addition this catalogue makes clear Seurat's theoretical and aesthetic importance in the development of modern art, from the Fauves to the Cubists and the pioneers of abstraction.

In France the exhibition benefited from the support of Aerospatiale and IBM and in the United States from the assistance of Fondation Elf; we are very pleased to express our gratitude to them.

The Réunion des Musées Nationaux, the Musée d'Orsay, and the Metropolitan Museum are happy to continue a long series of extraordinary cultural exchanges between France and the United States. Here we have worked together to illuminate the tragically short career of an artist still not enough appreciated even in his native land. Seurat's imagery is closely linked to his period—its Parisian street life, seaside holidays, Sunday pleasures, and evenings in Montmartre—and expresses a late nineteenth-century faith in science and progress; but the innate grandeur of his oeuvre places Seurat solidly in the French tradition. We are certain our visitors and readers will share our immense pleasure in the richly complex works of this great master.

Philippe de Montebello
Director
The Metropolitan Museum of Art

Jacques Sallois
Directeur
Musées de France

Sponsor's Statement

It is with pride that Fondation Elf joins The Metropolitan Museum of Art in presenting this exhibition, which commemorates the centenary of the death of Georges Seurat. Our support of this event is especially appropriate because Seurat, a pioneering French artist, was determined to create masterworks shaped by his research into theories of color and light.

In a similar spirit of innovation, the French industrial group Elf Aquitaine is dedicated to furthering the use of its technical knowledge and to applying its research so as to benefit not only Elf but also an international world.

Fondation Elf sponsors humanitarian, environmental, and cultural programs, encouraging inventive and bold solutions. Here, it plays an important role in bringing the creative wealth of a century ago to a wider audience.

I sincerely hope that this exhibition will be the first of many such undertakings through which Elf demonstrates its willingness to work with and contribute to the American community.

Loïk Le Floch-Prigent
Chairman, President, and Chief Executive Officer
Elf Aquitaine

Lenders to the Exhibition

The numbers cited refer to catalogue entries.

PUBLIC COLLECTIONS

AUSTRALIA
Canberra
Australian National Gallery, 162

BELGIUM
Tournai
Musée des Beaux-Arts de Tournai, 164

BRAZIL
Rio de Janeiro
Museus Raymundo Ottoni de Castro Maya, 182

CZECHOSLOVAKIA
Prague
Národní Galerie v Praze, 170

FRANCE
Bordeaux
Musée des Beaux-Arts, Bordeaux, 81

Nevers
Musée Municipal de Nevers, 59

Paris
Musée du Louvre, Département des Arts Graphiques, Fonds du Musée d'Orsay, 1, 4, 7, 11, 21, 22, 24, 25, 28, 36, 42, 46, 54, 58, 67, 116, 136, 179, 189, 195, 227

Musée d'Orsay, 80, 91, 101, 107, 129, 131, 185, 186, 187, 206, 225, 226

Musée Picasso, 17, 148

Saint-Tropez
Musée de l'Annonciade, 222

Troyes
Musée d'Art Moderne de Troyes, 82, 97

GREAT BRITAIN
Cambridge
Syndics of the Fitzwilliam Museum, 100

Edinburgh
National Galleries of Scotland, 106, 113, 152

Glasgow
Glasgow Art Gallery and Museum, 103

Liverpool
The Trustees of the National Museums and Galleries on Merseyside (Walker Art Gallery), 87

London
Trustees of the British Museum, 138, 140

Courtauld Institute Galleries, 171, 213, 217

The Trustees of the Tate Gallery, 108, 161

Manchester
Whitworth Art Gallery, University of Manchester, 23

Norwich
Robert and Lisa Sainsbury Collection, University of East Anglia, 18

JAPAN
Komaki
Menard Art Museum, 204

Tokyo
Fondation du Musée Nichido, 199

THE NETHERLANDS
Amsterdam
Rijksmuseum Vincent van Gogh, 193

SWEDEN
Stockholm
Nationalmuseum Stockholm, 150

SWITZERLAND
Basel
Oeffentliche Kunstsammlung Basel, 83, 157

UNITED STATES OF AMERICA
Baltimore
The Baltimore Museum of Art, 165

Buffalo
Albright-Knox Art Gallery, 61, 122, 146, 218

Cambridge
Fogg Art Museum, Harvard University, 2, 75, 181

Chicago
The Art Institute of Chicago, 110, 123, 124, 127, 156

Cleveland
The Cleveland Museum of Art, 197

Detroit
The Detroit Institute of Arts, 212

Glens Falls
The Hyde Collection, 99

Indianapolis
Indianapolis Museum of Art, 219

Kansas City
The Nelson-Atkins Museum of Art, 109

Malibu
Collection of the J. Paul Getty Museum, 72

Minneapolis
The Minneapolis Institute of Arts, 209

New Haven
Yale University Art Gallery, 112, 117, 151

New York
The Metropolitan Museum of Art, 3, 30, 32, 50, 53, 57, 63, 76, 78, 79, 94, 95, 119, 125, 135, 141, 169, 184, 190, 200

The Museum of Modern Art, 13, 144, 166, 194, 207, 221

Solomon R. Guggenheim Museum, 65, 69, 93, 98, 145, 149

Northampton
Smith College Museum of Art, 133, 147

Philadelphia
Philadelphia Museum of Art, 47, 142, 202

Providence
Museum of Art, Rhode Island School of Design, 196

Saint Louis
The Saint Louis Art Museum, 208

San Antonio
Marion Koogler McNay Art Museum, 40

San Francisco
The Fine Arts Museums of San Francisco, 210; Achenbach Foundation for Graphic Arts, 16, 29, 178

Washington, D.C.
Dumbarton Oaks Research Library and Collection, 74

National Gallery of Art, 121, 167, 205

The Phillips Collection, 45, 89

PRIVATE COLLECTIONS

Collection of The Honorable and Mrs. Walter H. Annenberg, 173

The John A. and Audrey Jones Beck Collection, on extended loan to The Museum of Fine Arts, Houston, 214

Huguette Berès, Paris, 77, 180

Berggruen Collection on loan to the National Gallery, London, 37, 104, 114, 118, 154, 158, 191, 220

Beyeler Collection, Basel, 115

André Bromberg Collection, 19, 51, 68, 175, 224

Duménil Collection, 84

Feilchenfeldt Collection, Zurich, 134

Fuji Country Co., Ltd., 86

The Armand Hammer Collection at the National Gallery of Art, Washington, D.C., 192

Provost and Fellows of King's College (Keynes Collection), on loan to the Fitzwilliam Museum, Cambridge, U.K., 137

E. W. Kornfeld, Bern, 27, 55, 71

Galerie Jan Krugier, Geneva, 38, 39, 60

Collection of Robert Owen Lehman, 176

Mrs. Alexander Lewyt, 31, 90

Mrs. Jacques Lipchitz, 8

The Phillips Family Collection, 52

Collection of Mrs. Bertram Smith, 70

Mr. and Mrs. Eugene Victor Thaw, 43

Mrs. John Hay Whitney, 139

Woodner Family Collection, New York, 9, 26, 48, 56, 64, 85, 228

ANONYMOUS LENDERS

5, 6, 10, 12, 14, 15, 20, 33, 34, 35, 41, 44, 49, 62, 66, 73, 88, 92, 96, 102, 105, 111, 120, 126, 128, 130, 132, 143, 153, 155, 159, 160, 163, 168, 172, 174, 177, 183, 188, 198, 201, 203, 211, 215, 216, 223, 229, 230, 231

Note to the Reader

DESCRIPTIONS OF DRAWINGS

Because Seurat used the same Ingres paper (nearly always with a Michallet watermark) for most of his drawings, only departures from this norm are described. Slight discoloration of this off-white, slightly creamy paper, a normal effect of aging, are not noted.

DESCRIPTIONS OF OILS

Dimensions given include any border painted on the canvas itself; exterior painted frames are recorded separately.

TITLES

Preference has been given to the titles Seurat used in exhibitions held during his lifetime (for example, *Chahut*, not *Le Chahut*) and to those used in other exhibitions through 1908 (the latter were customarily supplied by the Seurat family and by the artist's close friends). Traditional titles that differ from these are listed secondarily.

DATING

The dates of Seurat's drawings and paintings given in this catalogue are often conjectural but are the result of close comparisons with the nucleus of dated works. Proposed dates that depart significantly from the traditional ones are briefly discussed in the entries. Conflicts with the dates in de Hauke's catalogue raisonné (H) are not separately noted, for he and Félix Fénéon (whose work he incorporated) did not regard dating as important and frequently grouped together works of different years simply because they shared the same subject. The most authoritative dating for drawings is found in Herbert 1962 and in Franz and Growe 1983; disagreements with the latter are rare and minor.

REFERENCES

The short titles used throughout the catalogue refer to the Bibliography and to the List of Exhibitions.

References within a single entry have been kept to a minimum and therefore do not include all the writings on the subject. The introduction to the Bibliography briefly discusses the major critical writings.

ABBREVIATIONS AND TERMS USED IN THIS CATALOGUE

SIGNAC ARCHIVES

Archives of the painter Paul Signac. Private collection, Paris.

DE HAUKE ARCHIVES

Archives of the dealer and author César M. de Hauke, incorporating Félix Fénéon's archives concerning Seurat. Bibliothèque d'Art et d'Archéologie (Fondation Jacques Doucet), Paris.

CP

Camille Pissarro, *Correspondance de Camille Pissarro*. Ed. Janine Bailly-Herzberg. Vol. 1, 1865–85 (1980); vol. 2, 1886–90 (1986); vol. 3, 1891–94 (1988); vol. 4, 1895–98 (1989).

DR

Henri Dorra and John Rewald, *Seurat: L'oeuvre peint, biographie et catalogue critique*, 1959.

H

César M. de Hauke, *Seurat et son oeuvre*, 2 vols., 1961.

When a work by Seurat not in the exhibition is referred to, the de Hauke catalogue number is always given; when a collection is not given, the work's present location is unknown.

MOLINE STAMP

The Parisian dealer Léonce Moline, without intention of deceit, stamped "Seurat" in red on a number of drawings and paintings. In 1895, at the time of his exhibition, he marked twenty oil paintings and at least eleven drawings in this manner (1895 Paris; for documentation, see Herbert 1962, p. 179). Strong circumstantial evidence indicates that all these works came from Madeleine Knoblock, Seurat's common-law wife. In the present exhibition, panels with the Moline stamp are cat. nos. 89, 106, 121, 151, and 168; drawings with the stamp are cat. nos. 35, 60, 61, and 70.

SEURAT ARGUS
Hand-written copies of press reviews and press clippings, preserved in a largely dismembered set of pages and in press service sheets. Many of these lack dates, volume numbers, and sometimes titles but have been referred to when the original publications were not consulted. In the de Hauke archives.

SIGNAC ALBUM
Copies of press reviews pasted in albums by Paul Signac. Some of these lack dates, volume numbers, and occasionally titles but have been referred to when the original publications were not consulted. In the Signac archives.

Introduction

Overheard at an 1894 Neo-Impressionist exhibition:
"It's done mechanically?" "No, Monsieur, by hand."[1]

Mention Seurat's name, and the first thing that comes to mind is his "pointillism," his painted tapestries of divided color. When his large picture *Un dimanche après-midi à l'île de la Grande Jatte* appeared in May 1886, he acquired instant fame; the painting's dotted brushwork and its parade of stately figures were immediately taken as a challenge to Impressionism (the term "Neo-Impressionism" was invented the following September by the critic Félix Fénéon). Yet Seurat was not alone, for three other artists displaying works in the May exhibition used a similar technique: Camille Pissarro, his son Lucien, and Paul Signac. By 1887 they were joined by Charles Angrand, Henri-Edmond Cross, Albert Dubois-Pillet, Léo Gausson, Louis Hayet, and Maximilien Luce.

The younger artists in this group, those born shortly before or shortly after 1860, had known one another since 1884, when they had helped found the Société des Artistes Indépendants, a democratic exhibition society that became the center of Neo-Impressionist activities. The allure of their new technique lay chiefly in its claim to being scientific; only the systematic application of natural laws, they said, could capture the illusion of colored light. Applying paint in regular small strokes, they gave their pictures the look of rational order that openly challenged the instinctive and spontaneous art of the Impressionists. The new movement spread abroad in 1887, when Seurat and Pissarro were invited to show with Les Vingt, an avant-garde society in Brussels; by 1889, Neo-Impressionism had become the dominant new art in Belgium. In Paris other artists who were seeking alternatives to Impressionism—among them Vincent van Gogh, Paul Gauguin, Émile Bernard, and Henri de Toulouse-Lautrec— flirted for a time with the new style.

The present exhibition gives us the opportunity to reexamine Seurat's art and theories and their central role in the short-lived Neo-Impressionist movement. Although artists and critics alike regarded Seurat as the inventor and leading artist of Neo-Impressionism, the ebullient Signac was the more effective propagandist for the movement, and Dubois-Pillet was the group's best organizer within the Indépendants. No doubt Seurat also learned a great deal from Signac, the elder Pissarro, and other comrades. Particularly in need of reappraisal, however, is Seurat's posthumous role as the chief early exponent of "scientific" color and color theory.

The fame of *La Grande Jatte*, Seurat's best-known painting, goes well beyond histories of art. It has been used as an illustration not only in learned discussions of science and technology but also in advertisements for leisure wear and other fashions. It is in fact no contradiction that Seurat's art has lent itself to these seeming opposites. His work is a compound of different elements; these separate realms reveal, it would seem, several different artists. How do we reconcile the artist who was devoted to color science with the one who loved caricatures and poster art? The artist who drew somber twilight scenes in black crayon with the one who constructed sunlit scenes in sparkling colors? The artist who represented unpeopled seaports with the one who pictured boisterous café-concerts? Like most of us, Seurat was several persons wrapped in one; his apparent contradictions are a complicated weave of many strands, resulting in one artistic fabric.

In examining the separate threads of this cloth, the current exhibition questions the broad generalizations that have dominated the literature about Seurat. Most of these generalizations have been based upon six large pictures: *Une baignade, Asnières, Un dimanche à la Grande Jatte, Poseuses, Parade, Chahut,* and *Cirque.* Four of these major works are absent, which necessarily deflects the exhibition toward Seurat's smaller paintings and drawings. The catalogue accounts for this by concentrating upon the subjects and techniques of individual works as well as upon the development of Seurat's craft as both draftsman and painter. Nonetheless, if it is to stand as a reevaluation of the whole artist, the catalogue must also deal with Seurat's major works, especially since about one-third of the paintings and drawings in the exhibition are studies for the larger pictures.

Our ambition here is to stimulate a fresh view of the artist as well as to display his work. A century after Seurat's death, we are now able to correct some of the myths that grew up around him. Because he died at the age of thirty-one, he was long believed to have produced only a few pictures and to have died of consumption or some other frailty (so tenacious is the romantic paradigm of an early death). To the contrary, he was tall for his era (five feet, nine and one-half inches), and his friends always described him as robust—"a solid being, a *grenadier,*" according to Signac. He died in an epidemic of virulent diphtheria.[2] As for his productivity, from his one decade of maturity there survive 6 huge canvases and 60 smaller ones,

Georges Seurat. Date and photographer unknown

in his subjects but in his geometric compositions which presented summary types rather than individual humans. We hope to prove that Seurat's types are not "abstract"—that they are not the residue of a purely formal instinct but are brilliant visual distillations of psychological and social meanings. His early drawings and paintings, for example, grew out of mid-century naturalism and a preference for ordinary mortals instead of heroes, for the quotidian rather than the unusual. Like the *cris de Paris*, the traditional imagery of Parisian types, Seurat's urban and rural figures present a cross section of society and therefore constitute a pattern of interpretation. In his later drawings and paintings of café-concerts and circuses, Seurat plunged into the world of big-city entertainment, adopting and mocking the forms of commercialized pleasure through his puppetlike figures.

This exhibition shows the range of subjects Seurat undertook: drawings or paintings of peasants at work, street vendors, nurses, promenaders, and figures seated by windows; suburban factories, riverbanks, barges, and sailboats; meadows, woodlands, farms; seaports, quays, promontories, ships, and ocean; portraits of father, mother, lover, and friends; bathers, Sunday strollers, nude models, café-concert entertainers and audiences, sidewalk fairs, and circuses. These subjects are explored in the context of the means Seurat used to depict them: his use of conté crayon to create illusions of light and dark, free of individual lines and edges, and his application of brush to panel or canvas so that we see both the separate touches of color and the images of sun-drenched nature they produce. The fact that these works are characterized by highly personal marks of crayon and brush need not draw our attention away from the images or take us to a supposedly "higher" realm of pure form.

Foremost among the myths surrounding Seurat is the belief—promoted by his earliest commentators—that he was virtually a scientist. Using recipes derived from learned treatises, it was said, he reconstructed colored light dot by dot and calculated his compositions with the aid of geometric formulas such as the golden section. So pervasive is this view that some writers who point out that his dotted technique does not actually reconstitute colored light then attack him for his failure to be (successfully) scientific. Artists as well as critics have made him the godparent of the significant modern current embracing science and technology. We cannot study Robert Delaunay, Fernand Léger, or Bridget Riley without thinking of Seurat.

The conception of Seurat as a coldly scientific artist does not readily agree with the caricatural aspect of some of his paintings or with the complexion of most of his drawings, whose swirling lines and strange grays

about 170 wood panels, 230 completed drawings, and 45 studies or fragmentary drawings. Additionally, from his work before the age of twenty-one, we know of 2 canvases, several oil panels, approximately 250 drawings (many of them from disseminated notebooks), and 4 notebooks containing several hundred more drawings.[3]

Harder to overcome than the myth of a frail, unproductive artist is the idea that Seurat's work was all but abstract, that the heart of his art lay not

evoke a shadowy uncertainty. Preferring these drawings, some observers claim that the true Seurat is to be found in them, not in his renowned dotted paintings; the drawings, worthy of Rembrandt or Goya, are considered closer to greatness because they fit a definition of art based on instinct and emotion. The split of Seurat into two different artists is based on the separation of rationality and art that remains characteristic of our culture, despite the work of Piero della Francesca, Juan Gris, or Liubov Popova. Seurat was indeed rational, and he developed a logical method of applying paint (as did Ingres); he theorized acutely and read widely in aesthetics (as did Delacroix); he reacted to what he saw in nature while transforming it into pictorial structure (as did Monet). His paintings are not the result of a methodically applied recipe but are the products of a creative and experimental talent (as are Matisse's); his drawings, limited to black crayon on paper, are inevitably different from his multilayered oil paintings (as are Millet's).

To find the whole artist, both poet and technician, we must redefine Seurat's "science." Younger scholars are helping this revision by pointing out that earlier writers greatly exaggerated his dependence upon theory and mathematical formulas.[4] Careful examination of Seurat's paintings proves that his technique evolved slowly out of the craft of the artist and that his supposed dependence upon scientific theory was far less than previously proclaimed. His texts were a crutch that propped up the evolution of his technique; at the end of his life nearly all his "science" was still based upon his boyhood reading of Charles Blanc. Although the regular brushwork of his mature technique seems to support the idea of a scientific artist, the famous dots are not a screen in front of his images. In fact, they are not even dots—they are instead small touches of paint in various shapes that shift and flow with the images and are interlocked with the underlying paint. Moreover, they do not determine a picture's coloration because, although they contribute to it, they are only the final strokes atop a complex net of brushwork. The many studies for Seurat's major pictures did not form a steady progression toward a preconceived composition but were instead disparate essays, few of them constituting units or fragments of the final pictures. By Seurat's own testimony (Appendix F), it was four years after reading Ogden Rood's treatise before he learned how to abandon earth colors. Meyer Schapiro reminded us many years ago that Michel-Eugène Chevreul described transient color reactions in nature in order to warn artists against them, whereas Seurat exploited them. Who is more "scientific"? The painter's world is flat and depends upon pigments; the scientist's is three-dimensional and depends upon light. The only way to reconcile the two is through the artificial conventions of art.

Many individual entries in this catalogue draw attention to Seurat's brushwork and colors. As we explore his technique, we try to free ourselves from prior assumptions and deduce his evolving techniques from his actual practice; we do not deny his concern for theory, but we do not want it to predetermine what we find in the pictures. The readings that influenced Seurat were mostly from handbooks on aesthetics, not scientific works, and a number of them were written by artists concerned with the craft of painting. All of these are documented in the appendixes. There is some risk that we underplay their significance and therefore separate art from theory; throughout the catalogue, however, Seurat's readings and theories are often mentioned, and the interested reader can use the appendixes to further explore this area.

It would be foolish to deny the importance of Seurat's readings in color science. He wanted to be perceived as a technician of art, and so he borrowed from science some of the signs of its authority, including regularity and clarity of pattern. Nothing in color theory would require the systematic apportionment of small strokes as in Seurat's mature work, which constituted not a scientific act but an expression of his role as inventor. (Even Seurat's painted borders and frames, one of the most idiosyncratic features of his art, were put forward by the artist as responses to natural laws.) Certainly his Svengali-like power over his fellow painters owed much to the fact that his posture of certitude was especially influential in an age that regarded science and technology as essential instruments of progress. In 1887, briefly converted to Neo-Impressionism by Seurat's example, Camille Pissarro called himself one of the "scientific Impressionists" and attacked the "romantic" Claude Monet for the disorder of his brushwork, "which, despite the artist's talent, is no longer in accord with our epoch."[5]

The words "rational" or "disciplined" express what is most often meant when the term "scientific" is employed by or about Seurat. The artist himself revealed this juncture of personal temperament and ambition more than once: at the end of his notes on Delacroix (Appendix N) taken in 1881, for example, Seurat wrote, "It's the strictest application of scientific principles seen through a personality." His readings in Blanc, David Sutter, and others are laced with the morality of discipline, the need for rules and order; this proclivity confirms what we know of his background and temperament. The impulse to organize is a moral and social urge; it is the basis of Seurat's ambition to reform Impressionism. He referred to his major paintings as "toiles *de lutte*" (canvases *of combat*), also as "toiles de recherches et si possible de conquête" (research canvases, conquests if possible).[6] Seurat's "combat" was with incomprehension as well as with the "disordered" Impressionism regnant in the avant-garde; his hope for "conquest" confesses

his wish to establish domain over nature and therefore over others. "But this taking of possession," wrote Blanc, "is the prerogative of stout hearts, of great artists, of those whom we call *masters*, precisely because instead of obeying nature—or rather, having once known how to obey her—they now know how to command her."[7]

In Seurat's generation, as now, "science" bore the connotations of masculine authority; "nature" was feminine. Science was not just an instrument of disinterested knowledge, it gave assurance and control. Blanc taught that color itself was unstable, too much a creature of the moment; it needed a strong hand, manifest in "dessin," that male conception of form based on black and white. Seurat's modernity resides in part in his belief that the assessment of color was not mere instinct, not mere spontaneity, as the Impressionists appeared to profess; it had been brought into the realm of science by men he admired: Chevreul, Blanc, Rood, Charles Henry. Pissarro, voicing these concerns, complained of Guillaumin's paintings that "the harmonies are nil, without logic, not the result of drawing ['dessin'], with outbursts of color but no modeling ['modelé']."[8] Seurat's use of color departed strongly from the Impressionists' precisely because "dessin" and modeling gave control to his imagery. Structured by light and dark as well as in contrasting colors, the forms in his paintings have clearly defined shapes; it is this definiteness of shape, this hieratic set of forms, that made the young Symbolists prefer him to the Impressionists.

If we are to use the word "scientific" to describe Seurat's approach, we must consider how his "science" is entwined with other aspects of his art. For example, his theory of expressive lines holds that upward lines induce a feeling of gaiety, downward lines sadness, horizontal lines calmness. This theory was central to Seurat's 1890 statement of his "esthétique" (Appendix E), and it became more evident in his late paintings. He had thought about the emotional significance of linear direction when, during his school days, he had read about Humbert de Superville's theory in Blanc's *Grammaire*. This concept was reinforced by his acquaintance after 1886 with Henry, who gave the sanction of contemporary science. The linear substructure of the late paintings may therefore seem traceable to Humbert's and Henry's ideas. In fact, it is equally dependent on Seurat's flat, decorative line, which in turn cannot be separated from his penchant for caricature. For Humbert, Henry, and Seurat, these lines provided the underlying support for a composition—they did not regard this emphasis on the linear as a move-ment toward abstraction. On the contrary, Seurat's caricatural line was a response to café and circus performers and thus his views of society. This element—Seurat's witty linear displays—can therefore show his "science," his affinity for the decorative, and his interpretation of Montmartre life.

Like his caricatural line, other features of Seurat's art can be interpreted from different vantage points. The classicism of *Une baignade* and *La Grande Jatte*, for instance, is deeply enmeshed with his "primitivism." The monu-mental figures and the well-regulated order demonstrate that Seurat was heir to the Beaux-Arts tradition whose roots were in classical art. These elements, however, are not copied from antique or Renaissance art but have analogies with Egyptian relief sculpture and painting, early Renaissance art, and popular broadsides. Seurat's contemporaries recognized this, which is one reason why they compared him favorably with the muralist Puvis de Chavannes, whose classicism has a notable streak of primitivism. Seurat's retention of classical idealism indicated a native conservatism, yet his appreciation of both folkloric broadsides and the posters of Jules Chéret was a radical departure from Beaux-Arts teachings, for these popular arts subverted its high-art standards.

After 1886 most of Seurat's friends remarked on his combination of radical and conservative features. They welcomed him as a leading member of progressive art circles, but his reserved demeanor reminded them of his origins in a bourgeois family and of his traditional schooling at the École des Beaux-Arts. Gustave Kahn's succinct account of his character is consis-tent with that given by other friends: "Underneath a reserved demeanor, always dressed in dark blue or black, with an upright and neat appearance that led Degas to nickname him, in a moment of humor, 'the notary,' he had a temperament marked by kindness and enthusiasm. Silent in large groups, in smaller ones and among friends he spoke readily about his art in terms of goals, in terms of technical deliberations."[9]

Not everyone welcomed Seurat's conservatism. "Seurat comes from the École des Beaux-Arts, he's impregnated with it," Pissarro once wrote, when irritated by the young artist.[10] That Seurat could be conservative in some regards and innovative in others is not surprising—these traits were often joined in the ambitious bourgeoisie from which he sprung. His father rose from clerk and bailiff to wealthy real-estate speculator; he and his wife proved their high station by providing the funds for their sons' devotion to the arts—Georges to painting, his brother to the theater. Their daughter married Léon Appert, a successful industrialist-engineer and later the author of texts on stained glass. Seurat's ambition to modernize art with the aid of science fits well with his family's position. He absorbed the values of the progressive middle class, whose old patterns and regulations by necessity gave way to invention and technology. He was, wrote Émile Verhaeren, "technician, risk-taker, inventor."[11]

Seurat's determination to forge a new art appeared early; at sixteen he began to search for an "optical formula" (Appendix F), devoting himself

to color in opposition to his teachers' insistence upon drawing. Labeled Communard by fellow students for his fierce independence and perhaps also for radical political views (Appendix B), he quit the École des Beaux-Arts at age twenty. He did not follow his schoolmates' paths toward official success, nor did he undertake their religious and classical subjects. First apprenticing himself to the naturalist tradition in drawing and painting, he began to assimilate Impressionism by about 1883. That too was only an apprenticeship, for in 1886, with *La Grande Jatte*, he declared Impressionism passé and himself its reformer by virtue of his scientific color and restoration of the classical values of synthesis and essential form.

The year 1886 also marked the sudden emergence of literary Symbolism and Seurat's adoption by many of its young writers. He gave paintings and drawings to several of them (Appendix D), and he thrived on their appreciative reviews of his work. Like Seurat in the visual arts, they were rebelling against the classicizing tradition in literature while retaining some of its qualities, particularly its idealism. They too rejected Impressionism because it consecrated art to the immediate present rather than to permanence and "essence," qualities for which they praised Seurat. Furthermore, among the writers there was a strong interest in modern science, nowhere better seen than in the prominent role given to Henry (Appendix L), who collaborated in their journals and whose writings they published or reviewed. His *Esthétique scientifique* of 1885, portions of which Seurat copied, influenced the theory of Symbolism—Henry's concern for the relatedness of the arts, including music, struck a responsive chord in a movement whose alternative name was "Wagnérisme." Seurat in fact likened his painted frames to Wagner's darkening the theater at Bayreuth, a symptom of his involvement in the vogue for artistic correspondence.[12]

Most of Seurat's admirers in the press were not just literary innovators but political radicals as well, although few adhered to a party. They included Paul Adam, a maverick leftist who supported the reactionary nationalist general, Georges Boulanger; Jean Ajalbert, a radical lawyer and naturalist poet; Paul Alexis, a naturalist friend of Zola's; Félix Fénéon, an anarchist journalist and editor; Georges Lecomte, an admirer of the Commune; and Émile Verhaeren, a Belgian socialist poet. Most of these men were disillusioned with electoral politics and were strongly drawn to the anarchist-communist movement, although it was not until the early 1890s that anarchism pervaded this avant-garde. By then Seurat's fellow Neo-Impressionists Camille and Lucien Pissarro, Maximilien Luce, and Paul Signac were self-declared anarchists, as was the critic Félix Fénéon; Charles Angrand and Henri-Edmond Cross, also Neo-Impressionists, were sympathetic to the cause if not active in it.

In view of these friendships, many have believed that Seurat himself was an anarchist. He may have been. The conclusions of such speculation about Seurat's political beliefs, however, depend on superimposing on the 1880s those ideas from anarchism's years of effervescence, that followed his death. By that time Signac and Fénéon wanted to assimilate Seurat into their beliefs; their eagerness was logical for two reasons. One was that anarchism, as Signac proclaimed, did not require pictures of poverty or of other iniquities of capitalism but instead sponsored individual freedom in the arts. A painting of progressive style, wrote Signac, regardless of its subject, could deliver "a solid blow of the pick to the old social edifice." As an innovator, Seurat could therefore be said to contribute to anarchism's forward thrust. The second reason for Seurat's posthumous adoption by the anarchists was that his drawings and paintings had consistently favored the democratic and the popular, from his early drawings and paintings of peasants, workers, and suburban factories to his late pictures of urban entertainments. These last works, Signac said, embraced a critical view of their era of transition from decadent capitalism to the future workers' society.[13]

Nonetheless, there are some contrary indications to the portrayal of Seurat as an anarchist. Luce was associated with the anarchist-communists by 1888 and Pissarro and Signac no later than 1890, yet they never mentioned Seurat's participation in their activities or, as far as we know, did they attempt to seek it. Their letters imply that they considered him aloof from such engagement. He had opportunities to engage in political activities, but the years from 1888 to 1891 were instead the period of his greatest withdrawal and secretiveness, inspired partly, it seems, from jealousy of his prerogatives as founder of Neo-Impressionism. On balance it appears most likely that Seurat was on the left but probably not an anarchist; the evidence, largely circumstantial, strongly supports the view that the young artist was a left-wing republican. Other vanguard painters, like Manet a generation earlier, also balanced conservative social lives with the oppositional stances that indicated their defiance of established authorities (it is easier, however, to prove a position on the left for Manet than for Seurat).

What cannot be doubted is that Seurat's art grew out of an enlightened middle-class culture whose progressive tendencies he embodied. By basing his technique on scientific method, he proclaimed his faith in the ability of humankind to construct order out of sensory data, to subject even the ephemeral and changing aspects of color-light to close observation and then to artistic pattern. By painting mural-scale canvases he carried out, in more contemporary form, Charles Blanc's republican belief that art should have public and moral purpose; by picturing types rather than unique beings,

Seurat also endorsed the republican view that the social should take precedence over the individual.

Seurat's faith in rational procedures was not unquestioning. He was not an innocent who thought that scientific rules would initiate the millennium. The psychological isolation of his figures, the poignant emptiness of his seaports, and the almost frantic sense of order in his late works—all are marked by foreboding. On the one hand, Seurat isolated himself from society through his temperamental reserve, which indicates a lack of confidence in social cohesion; on the other, he reached out to society through an art that asserted order and control.

We will retain this sense of order as Seurat's leading characteristic, despite his doubts and despite our own fears, in this troubled era, that artistic control is a metaphor for social control. We will grant Seurat the place in history modernism has forged for him because his determination to impose rational order over experience is, after all, one of the central currents of French painting, from Poussin and David to Delaunay and Léger. Sophisticated and naive, classical and primitive, conservative and radical, Seurat looked to the past and the future.

We love in Seurat the crispness of the great, enduring French tradition and also this lucidity, this politeness of really great things, this granulated skin which covers rich tissue underneath. We don't say that we love *only that*; we also love Renoir's [express train]; we also love flowers, trees, flesh. But don't reproach Seurat for being on the line to Athens rather than to Flanders; the Greek train is a good one, are you going to reproach it for not taking you to Amsterdam? One takes it when one needs to, that's all, and one shouldn't go to the wrong station. One uses a Seurat for other trips than a Renoir.[14]

1. Reported by Thadée Natanson, "Expositions," *La revue blanche* 6 (1894): 187.

2. Dr. Jean Sutter (1964) established the exact cause of death. Although John Rewald's pioneering monograph (1948) told the truth of Seurat's physical strength and his death, the romantic view persisted.

3. These figures exceed the number of works catalogued by César de Hauke for two reasons: some works have been discovered since his catalogue was published, and the four early notebooks were unknown to him.

4. Credit should be given first to Meyer Schapiro (1935, 1958, and influential lectures over his lifetime) for pointing out not only that art and "science" are not incompatible but also that Seurat's "science" was a rich compound of artistic and social impulses. The pioneering article debunking the idea that Seurat used dots of the three primaries to form his colors is Webster 1944. My writings (Herbert 1968, 1970) tried to straighten the record but did not go far enough. The most pointed recent discussion of Seurat's color is that by John Gage (1987), who rebuts the curious arguments in Lee 1987. Herz-Fischler 1983 and Neveux 1990 are among those who disprove Seurat's purported use of the golden section and mathematical schemata, although this belief remains strong. Marlais 1989, for example, unwittingly assumes such schemata and then tries to explain away the discrepancies between theory and actual measurements.

5. Letter to Lucien, January 10, 1887, in CP, vol. 2, no. 375.

6. "Toiles de lutte" appears in the draft of a letter to Maurice Beaubourg (de Hauke archives); the other phrase was reported by Émile Verhaeren (Verhaeren, "Georges Seurat," 1891).

7. Blanc 1867, ed. 1880, p. 532.

8. Letter of December 6, 1886, in CP, vol. 2, no. 362.

9. Kahn 1891.

10. To Signac, late summer 1888, cited in Rewald 1948, p. 115.

11. Verhaeren, "Chronique artistique," 1891.

12. See the discussion of frames in Appendix A.

13. Signac's statement comes from Signac 1891, cited in Herbert and Herbert 1960; for a discussion of anarchism, Symbolism, and Neo-Impressionism, see E. Herbert 1961. The most convincing recent discussions of Seurat and anarchism are Hutton 1987 and Zimmermann 1991.

14. Amadée Ozenfant (1926).

SEURAT

Early Life and Education

Georges-Pierre Seurat, born on December 2, 1859, was in many ways the child of a characteristic Parisian family of the second half of the nineteenth century. His mother, Ernestine Faivre (1828–1899), was a member of a Parisian family that had included artisan sculptors and carpenters; her father was a coachman who by middle age had saved enough to set himself up as a jeweler.[1] Seurat's father, Antoine (1815–1891), had come from the Champagne to Paris and had purchased a bailiff's office in 1840 in the rapidly expanding district of La Villette. By 1856 his talent in real estate speculation made him rich enough to retire from his civil post with a substantial income; he continued, however, to acquire rental properties. Georges was the Seurats' third child. The oldest, Émile (1846–1906), thirteen years Georges's senior, first worked in a notary's office and then became a middling playwright; he never had great success and seems to have depended on his parents' largesse. The second, Marie-Berthe (1847–1921), married Léon Appert (1837–1925) when Georges was six. Appert, an engineer and industrialist, owned a successful glass factory. A fourth child, François-Gabriel, was born in 1863 but died five years later. By 1868, when Georges was nine, he was the only child in the Seurat household. His father, then fifty-three, spent much of his time at his suburban villa in Le Raincy. Contemporary accounts and family tradition describe him as an austere and distant parent; his son's drawing of him (cat. no. 33) shows a monumental but self-absorbed and forbidding figure. Seurat's mother, thirteen years younger than her husband, seems to have been a patient, submissive wife, the pillar of the household (cat. no. 32). She is certainly among the many unidentified women whom her son drew sewing, reading, or simply sitting indoors, often by a window. Some of these drawings must also show her sister, Anaïs Faivre Haumonté (1831–1887), whose husband, Paul Haumonté, owned Au Père de Famille, a successful department store on the present-day avenue des Ternes. Anaïs was widowed at an early age, and she and her sister were inseparable until her death in 1887 (cat. no. 179).

Seurat's relationship with his older brother, Émile, was apparently a distant one ("He loves good clothes" is Seurat's only known comment on him),[2] but he was on good terms with his sister and her husband. Seurat gave them a number of paintings and drawings, and he drew members of their family (cat. no. 175). Appert was a specialist in stained glass and the author of two brochures on the subject.[3] Since his work involved color and

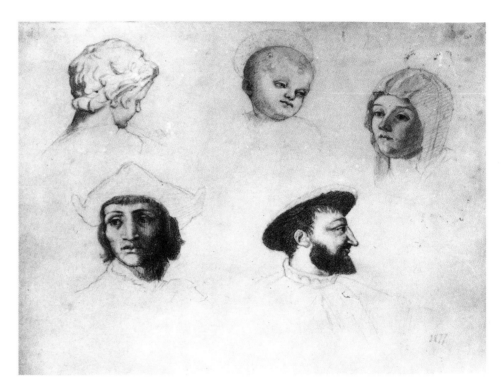

Seurat, *Five Heads, After Old Masters*, 1877. Location unknown (H 263)

its history, it is tempting to think that the young artist's interests were encouraged by his brother-in-law. Appert was a forward-looking industrial entrepreneur, so the artist's matter-of-fact acceptance of industrial architecture, including the Eiffel Tower (cat. no. 210), was a logical outgrowth of his family environment (and Appert was a jury member for the 1889 Universal Exposition). In any case, art and crafts figured in the family history, and Georges's uncle Paul Haumonté was an amateur painter; family tradition says that he took the young boy with him on sketching trips.

When Seurat was three, his parents moved to a fourth-floor apartment at 110 boulevard Magenta in the tenth arrondissement. His mother lived there until her death, and Seurat regularly visited her for supper, even though after 1880 he had his own studio-apartment. The boulevard Ma-

genta was one of the new streets carved out by Baron Haussmann when he was prefect of the Seine (1853–70). The young artist therefore did not grow up in old Paris but within sight of the Gare du Nord in a district that was substantially altered and expanded after 1852.

Seurat began drawing as a boy, and two copies after contemporary artists, signed and dated 1874, show a reasonable competence.[4] He began drawing lessons, probably in 1875, at a municipal school on the rue des Petits-Hôtels near his home. This establishment, run by Justin Lequien *fils,* had been founded by Alexandre Dupuis, a pedagogical reformer and Saint-Simonian, to instruct workers.[5] Dupuis's mentor Eugène Guillaume and other liberal reformers of the Second Empire held that such training was the basis of all the arts, especially the industrial and decorative arts so important to France's economy and national pride. The city government, recognizing the value of educating workers, subsidized schools such as Lequien's, which accepted apprentices in the industrial arts (porcelain, ornamental sculpture, industrial design). Like the young Seurat, however, a number of students later made their careers in the fine arts.

Seurat's drawings after lithographs and other reproductions and after plaster casts indicate the thrust of Lequien's instruction. Drawing in line alone, so prized in earlier generations, was subordinated to the large effects of light and dark. Seurat progressed rapidly and by 1877 was producing skillful copies and drawing competently after the live model. He took the entrance examination for the École des Beaux-Arts in February 1878 and the next month entered the studio of Henri Lehmann (1814–1882).[6] Lehmann's

students were older than Lequien's and were mostly middle-class. Seurat thus moved beyond the society of the rue des Petits-Hôtels and the boulevard Magenta. There was nonetheless a continuity in his education. The curriculum at the École had become imbued with the methods associated with Dupuis and Lequien, and Lehmann, like Lequien, revered the classical tradition and was a disciple of Ingres's. There was no sharp break in Seurat's style when he moved from Lequien to Lehmann, simply a steady progression in expertise.

During Seurat's school years the skills he developed and the range of subjects he drew were not remarkably different from those of his fellow students. In addition to numerous drawings of the live model and after antique sculpture, he made drawings after the same artists admired by others of his generation: thirteen after Ingres, four after Raphael, three after Poussin, and one each after Michelangelo, Bellini, Perugino, Pontormo, and Titian. The last four are on a single sheet dated 1877, based on works in the Louvre; it is the only evidence that he studied there, as his friends later said. Two drawings after Ghiberti confirm the appreciation of early Renaissance art widespread in France since mid-century, and two after Holbein recall Ingres's admiration of this Northern master.[7] Seurat also drew and painted on his own outside the school. His friends later said that he had destroyed his early work, and few paintings survive that can be dated before 1880. Four small notebooks, however, span the years 1877 through 1880 and contain hundreds of drawings from life and a small number of drawings after works of art.[8]

Seurat, page from sketchbook, 1880. Anonymous loan, Yale University Art Gallery, New Haven

Seurat, page from sketchbook, 1880. Anonymous loan, Yale University Art Gallery, New Haven

Until Seurat left school for military service just before his twentieth birthday, he pursued the normal path of a Beaux-Arts student. What made him subsequently give up a conventional career? Some inferences can be drawn from an account of 1923 (Appendix B) by Aman-Jean (Amand-Edmond Jean, 1858–1935), his fellow student and closest friend during this period. They met at Lequien's school, studied together in Lehmann's classes, and shared a studio for several years. Lehmann's instruction must have been more sophisticated than Lequien's; Aman-Jean, however, had nothing good to say about him, and he emphasized Seurat's independence and his "instinct" as the source of his art. Not only was Lehmann an uninspiring teacher, but Seurat's father, Aman-Jean stated, was a philistine, and Charles Blanc's *Grammaire des arts du dessin*, taught at the École, was "foolishly simple and incomplete." In his friend's view, therefore, Seurat rebelled against both family and school. We can also infer that he already displayed the taste for solitude and fierce concentration that Camille Pissarro and others commented upon later, for his antisocial behavior is the likely reason why his fellow students, still according to Aman-Jean, called him a Communard (a radical sympathizer of the Commune of 1871).[9]

Seurat stayed in the École for only about eighteen months; in November 1879 he left for a year's military service and never returned. He therefore withdrew from the traditional route to success: school exams, prizes, fellowships, study in Rome, and government commissions. Upon his release in November 1880, he continued to share the studio that he and Aman-Jean had taken in 1879 at 32 rue de l'Arbalète, off the rue Mouffetard in a working-class district. He also rented a small apartment at 16 rue de Chabrol, just one street away from the rue des Petits-Hôtels (there he eventually painted his first two masterworks, *Une baignade, Asnières* and *Un dimanche à la Grande Jatte*).

How did Seurat, raised in a bourgeois family and educated in a conventional way, become the "revolutionary" who exhibited *La Grande Jatte* in 1886? It is a question that puzzled his friends. The poet and critic Émile Verhaeren, after he and Seurat became acquaintances, drew out the artist on this very question. Seurat, he wrote, "appeared timid and quiet to me. We had to break through a lot of ice before understanding one another. . . . Little by little he told me about his beginnings, his apprenticeship with Lehmann, his school years, the whole story of efforts soured by routine and outmoded practices. Then how he found himself, personally, through studying others, through lessons and rules, the way one discovers unknown stones beneath stratifications of land and soil."[10]

We cannot explain this paradox simply by saying that Seurat made a leap into radical art thanks to some mysterious quality of genius, the

"instinct" that Aman-Jean praised. His rebellion against parents and school was that of an intelligent and ambitious young artist eager to assert himself and, for that reason, willing to defy conventional authority. In fact, "revolutionary" does not seem the right word for this singular young artist. His development was relatively steady from his school days onward and was marked by distinct elements of continuity. His mature drawings of indoor figures repeatedly show middle-class women and men who recall, when they do not represent, his family. They are almost invariably seen singly in quiet poses, the vision of an artist brought up in a quiet household by older parents. Most of his drawings of women and men on the street or working in fields also show solitary figures, suitable images for an artist who retained from his youthful home a reserve that bordered on reclusiveness. His preoccupation with technique was fostered by a milieu that included craftsmen, and his intense study of color theory would not have seemed strange to his brother-in-law, the manufacturer of stained glass.

1. Unless otherwise indicated, all biographical information about Seurat and his family comes from Sutter 1964 and Sutter 1970.
2. See Aman-Jean's account, Appendix B.
3. *Note sur les verres des vitraux anciens* (Paris, 1896, reprinted 1925), and coauthor with J. Henriaux, *La verrerie depuis vingt ans* (Paris, 1894).
4. After Aimé Millet and Alphonse de Neuville: see H 217 and Herbert 1962, fig. 143.
5. Albert Boime (1985) has done the fundamental work on Dupuis, his mentor Eugène Guillaume, their writings and those of Mathias Duval, and on Lequien's school. Although something of the nature of Lequien's teaching had been known, Boime is the first modern writer to have given a thorough account of it and to have studied Seurat's drawings in relation to it.
6. Rey 1931, p. 101: the relevant "feuille de renseignements" that Rey consulted is number 4411 in the École files. There survives one drawing by Seurat after Lehmann (cat. no. 5).
7. For the sheet of heads (H 263; collection unknown) and identifications, see Herbert 1962, fig. 28; the drawings after Ghiberti (from a cast in the École des Beaux-Arts of his bronze doors) are discussed in Herbert 1962, figs. 29, 30.
8. The dating of these is based on internal evidence and comparison with dated works. Annotations in the first of them (anonymous loan, Yale University Art Gallery, New Haven), probably 1877–78, show that it was taken on an otherwise undocumented trip in the Lowlands and along the Rhine (mentioned are Antwerp, Ghent, Charleroi, Cologne, and Aix-la-Chapelle). This is the only trip Seurat is known to have taken outside France. All four notebooks, once in the possession of Aman-Jean, are absent from de Hauke. They are discussed (information provided by R. L. Herbert) in Franz and Growe 1983, pp. 54–56.
9. By then the word had passed into general usage as a derogatory term for someone whose opinions diverged from the norm. It may also have implied leftist views on Seurat's part, and it certainly indicated the young artist's lack of enthusiasm for Lehmann and the École. Lehmann reciprocated, for in March 1879 he placed Seurat forty-seventh out of eighty students (Rey 1931, p. 101).
10. Verhaeren, "Georges Seurat," 1891.

1. *L'Ilissus du Parthénon.* 1875

THE PARTHENON ILISSUS

Charcoal and graphite on pink paper, 14¼ x 21 in. (36.2 x 53.3 cm.)
Signed and dated lower right: G. P. S. 1875 (recto and verso)
Inscribed lower left: L'Ilisus du Parthénon / Antique

Musée du Louvre, Département des Arts Graphiques, Fonds
du Musée d'Orsay, Paris, Gift of John Rewald, 1949 R.F. 29.746

Exhibited in Paris only
H 221

PROVENANCE

The artist until 1891. Posthumous inventory, no. 551 (per inscription
in pencil on reverse, and in red crayon inscribed: Georges Seurat/
'L'Ilissus du Parthénon').* Félix Fénéon, Paris; his gift to
John Rewald, New York, about 1940 until 1949; his gift to the
museum, 1949

*According to Fénéon's description of the posthumous inventory of
the contents of Seurat's studio in 1891 (de Hauke, I, pp. xxix–xxx),
drawings ("croquis rapides" and "dessins") were assigned "dessin"
inventory numbers ranging from 1 to 390; these numbers were
inscribed on the reverse of the drawings and initialed by either Félix
Fénéon (FF), Maximilien Luce (L), or Paul Signac (PS).

However, as was first recorded by Robert Herbert (Herbert
1962), certain of the early drawings by Seurat were inscribed on the
reverse with numbers in the 500s (ranging at least from 534 to 581),
which were initialed by Fénéon and/or Signac. In some cases, the
number appears without initials. Although not "dessin" inventory
numbers (1–390), these "500" numbers are presumably from
another inventory of some kind, perhaps a secondary inventory of
drawings from albums or notebooks.

Since the Renaissance French training in drawing was
based on studies of antique sculpture, stressing the ideal-
ized forms that were at the heart of the humanist tradition.

This drawing dates from 1875, probably Seurat's first year
in Lequien's school. Seurat was fifteen (students enrolled
in such schools at the age when other bourgeois youths
attended lycées). He may have been taking lessons before
then; we know that he was drawing no later than the
previous year (two copies after other artists are dated
1874). Lequien's method, based on drawing after the
antique, emphasized modeling in light and dark, to which
pure line was subordinated.[1] Seurat's Parthenon figure
was probably drawn from a lithograph rather than from a
cast (this is suggested by the line he drew under the
figure). He moved his charcoal delicately within the
uncertain, thin outlines; he obtained broader grays by
stumping (lightly rubbing in powdered charcoal).

1. Boime 1985.

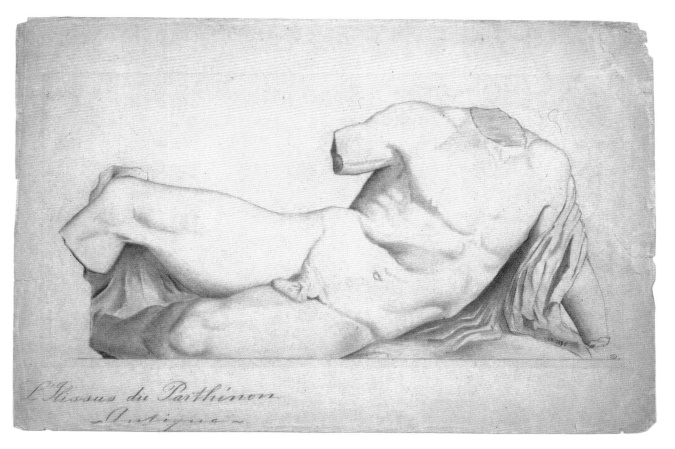

2. *Une sibylle, d'après Raphaël.* 1875–77

A SIBYL, AFTER RAPHAEL

Graphite, 8⅞ x 12⅛ in. (22.5 x 30.7 cm.)

Fogg Art Museum, Harvard University, Cambridge, Massachusetts,
Gift of John Rewald in memory of Félix Fénéon

H 255

PROVENANCE

The artist's brother, Émile Seurat, Paris; sold to Félix Fénéon, Paris;
given to John Rewald, New York, about 1940, until 1945; his gift to
the museum, 1945

EXHIBITIONS

1958 Chicago and New York, no. 8
1963 Hamburg, no. 107

Many of Seurat's early drawings after old masters were
taken from lithographs, engravings, and photographs.

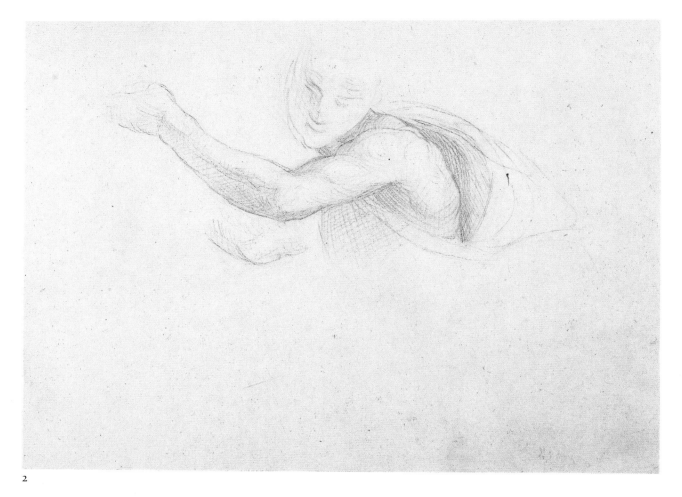

2

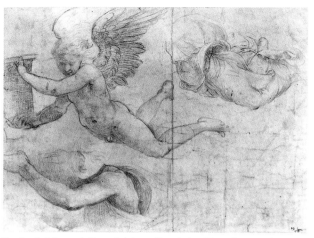

Raphael, *Man with Extended Arms*. Sketch for Chigi Chapel, Santa Maria delle Pace, Rome. Albertina, Vienna

This copy, one of six after Raphael, is after a figure on a sheet in the Albertina, Vienna, for a fresco in Santa Maria delle Pace, Rome. Seurat's source was a plate in *Dessins de Raphaël de la Galerie de Vienne, IIIe série,* an undated album of photographs published by Alinari.[1] His youthful inexperience is evident in the hesitant outline of the arm and back and the rather mechanical hatching. It is not surprising that Seurat copied a study drawing rather than a more finished work—he hoped to learn the methods by which the masters built up their forms. Among the many artists he drew after were Ghiberti, Bellini, Perugino, Michelangelo, Titian, Pontormo, Holbein, and Poussin, but to judge from surviving drawings, he favored Raphael and Ingres.

1. The Alinari firm in Florence has been unable to date this album of tipped-in photographs; it bears no imprint date or colophon, simply a title sheet in French; the plates are unnumbered.

 Seurat made four other drawings after Raphael, only one of them catalogued by de Hauke, *Un pied droit* (H 289), copied after pl. 9 of an undated album of lithographs published by Alphonse Leroy, *Cours de dessin, fac-simile des grands maîtres* ("sous le patronage, surintendance des Beaux-Arts, Comte de Nieuwerkerke"). Of the others, one is after a drawing in the Uffizi of the Daniel in Santa Maria delle Pace (Herbert 1962, no. 145); two others were copied from the Alinari album of drawings in the Albertina: *Nude Leaning Against a Table* (Herbert 1962, no. 27) and *Nude, from "A Study of Three Warriors"* (Indianapolis Museum of Art, W. J. Holliday Collection).

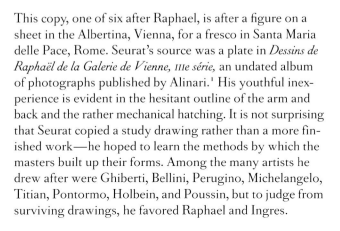

3. *La main de Poussin, d'après Ingres.* 1875–77

THE HAND OF POUSSIN, AFTER INGRES

Graphite, 8⅛ x 5¾ in. (21.2 x 14.6 cm.)
Inscribed lower right margin (most of it illegible): voilà le génie

The Metropolitan Museum of Art, New York, Gift of Mrs. Alfred H. Barr, Jr., 1987 1987.326

Exhibited in New York only
H 285

PROVENANCE
The artist until 1891. Posthumous inventory, no. 575 (per inscription in graphite on reverse of original mount, initialed in blue crayon by Fénéon and in orange crayon by Signac).* Félix Fénéon, Paris, until 1938; his gift to John Rewald, New York, in 1938, until 1944; his gift to Alfred H. Barr, Jr., New York, in May 1944, until his death in 1981; by inheritance to his widow, Mrs. Alfred H. Barr, Jr., from 1981 until 1987; her gift to the Museum, 1987

EXHIBITIONS
1947 New York, no. 27
1958 Chicago and New York, no. 5
1977 New York, no. 2
1983–84 Bielefeld and Baden-Baden, no. 3

*See provenance note, cat. no. 1.

When Seurat began his studies, Ingres had long been the most influential master of drawing in official French schools. Seurat made more drawings after him, thirteen, than after any other artist, most of them after photographs or reproductions (Appendix C).[1] However, he both drew and painted one figure directly from Ingres's *Angélique au rocher* (cat. no. 8 and H 1 [Norton Simon Museum, Pasadena]), then on public view, and he made this copy of Poussin's hand from Ingres's huge *Apothéose d'Homère* in the Louvre. There were reproductions of the latter painting, but Seurat's drawing exhibits the light reflections characteristic of an oil painting. At a ninety-degree angle there is a faint drawing of the figure of the Iliad from the large composition. Two inscriptions in Seurat's hand are too faint to read, but one phrase stands out clearly: *voilà le génie* (there is genius). Ingres took his portrait of Poussin from that artist's self-portrait, also in the Louvre, so this small drawing brings together three of the leading figures in the classicizing French tradition—Poussin, Ingres, and Seurat—each one a *génie*.[2]

1. Six of the drawings he copied are found in a single album: *Collection de 120 dessins, croquis et peintures de M. Ingres, classés et mis en ordre par son ami Édouard Gatteaux*, photographs published by Charles Marville, 1875: album by Armand Guérinet (n.d.), pls. 14 (H 309), 17 (H 239), 21 (H 314), 26 (H 232), 36 (H 311), and 87 (not in H). None of these was identified correctly by de Hauke; two were linked with the Gatteaux album by Homer 1963; the last was identified by L.-A. Prat (personal communication, 1990). The album of reproductions was not Seurat's source for all six, because its pl. 14 cuts off the extended foot of Ingres's figure, whereas Seurat copied the whole figure exactly as it appears in the original (see cat. no. 4).
2. Seurat also made three other drawings related to the *Apothéose d'Homère*. Two are after a reproduction in the Gatteaux album of a drawing by Ingres (Musée de Montauban) of the figure of Alexander: H 311 (Agnes Mongan, Cambridge) and H 312 (de Hauke reversed the two numbers under his illustrations). The third (H 257) is after a drawing for the Molière figure.

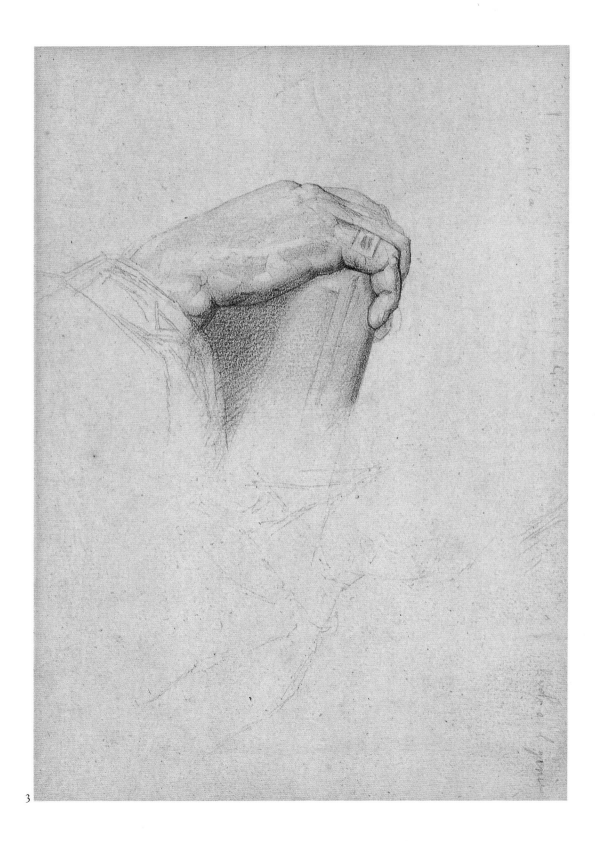

3

4. *Romulus vainqueur d'Acron, d'après Ingres.* 1875–77

ROMULUS, CONQUEROR OF ACRON, AFTER INGRES

Graphite on paper, mounted on another sheet, 8¼ x 5⅞ in. (21 x 15 cm.)

Musée du Louvre, Département des Arts Graphiques, Fonds du Musée d'Orsay, Paris, Gift of John Rewald, 1949 R.F. 29.747

Exhibited in Paris only
H 309

PROVENANCE
The artist until 1891. Posthumous inventory, dessin no. 39 and no. 576 (per inscriptions in pencil "39" and "576" on reverse of original mount initialed in red crayon by Signac).* Félix Fénéon, Paris; his gift to John Rewald, New York, about 1940 until 1949; his gift to the museum, 1949

*See provenance note, cat. no. 1.

This drawing is an exacting copy (probably from a photograph) after a figure on a sheet of studies by Ingres (Musée Bonnat, Bayonne).[1] Seurat emulated Ingres's method of forming a contour from successive short lines, and he retained the two positions that the master gave to the warrior's left arm. Such a copy had a limited value. The physical act of drawing cannot be duplicated, only its visual result, and Seurat followed with painstaking slowness the lines that Ingres had drawn quickly. This exercise would nonetheless show his willingness to accept traditional training. And by doing such copies the young artist could measure the distance between his achievement and that of the master. Eventually Seurat chose not to follow Ingres's conception of a finished figure, but his hundreds of drawings after the live model and after works of art from 1874 through 1881 gave him the knowledge of the human body that underlies his mature drawings, so confident in their continuous contours.

1. Pencil on paper, 9 × 14⅛ in. (22.7 × 35.9 cm.); first correctly identified in Homer 1963.

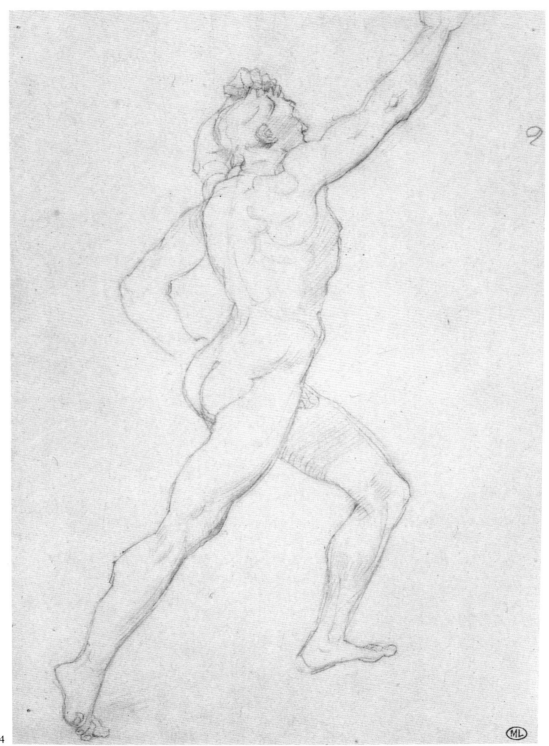

4

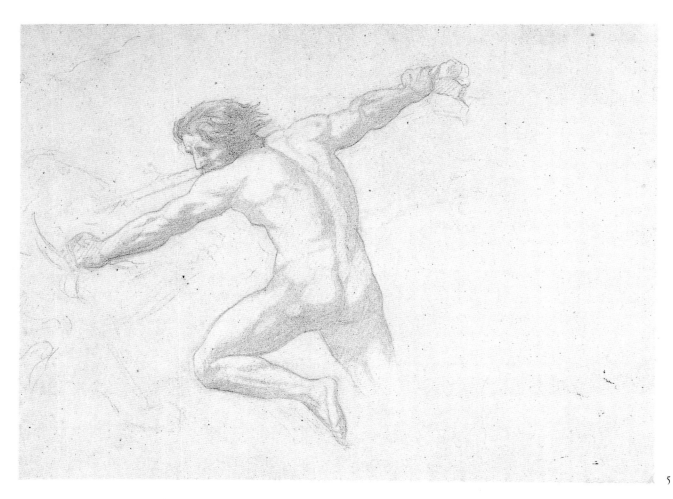

5

Henri Lehmann, *L'homme combat les animaux féroces* (Man fighting with wild beasts). Musée Carnavalet, Paris, inv. no. D 8024(20)

5. *L'homme combat les animaux, d'après Lehmann.* 1876–78

MALE NUDE COMBATTING A LION, AFTER LEHMANN

Graphite, 9 x 12⅛ in. (22.9 x 30.8 cm.)

Private collection, New York

Not in H

PROVENANCE
The artist until 1891. Posthumous inventory, no. 562 (per inscription on reverse, initialed by Fénéon and Signac).* Félix Fénéon, Paris; his gift to present owner about 1940

*See provenance note, cat. no. 1.

Seurat apparently made this drawing after Lehmann's large charcoal and gouache drawing of 1852.[1] Lehmann's work was the principal study for one of the paintings, *La lutte de l'homme contre les éléments* (The Struggle of Man Against the Elements), in his cycle for the old Hôtel de Ville, destroyed by fire in 1871.

Seurat entered Lehmann's class at the École des Beaux-Arts in March 1878, but this copy may well have been done before then because it shows more hesitant modeling than drawings that can be dated 1878–79. Perhaps it was a way for the young student to apprentice himself to the artist he hoped to work with.

Seurat's lion, only faintly drawn, has one paw down, whereas both are raised in the Lehmann composition. He may therefore have drawn his perfunctory lion (giving it a rather Assyrian profile) when Lehmann's drawing was no longer in front of him.

1. Musée Carnavalet, *Henri Lehmann 1814–1882*, 1983, pl. 120, 43¾ × 57⅞ in. (111 × 147 cm.), shaped as a pendentive. I first published Seurat's drawing in 1962 (Herbert 1962, no. 149) and said it was close to Lehmann's style but identified the source only at the time of the 1983–84 exhibition.

6. *Tête d'homme.* 1877

HEAD OF A MAN

Conté crayon and charcoal, 5¼ x 6½ in. (14.6 x 16.5 cm.)
Signed with monogram and dated lower right: G.S. 77
Inscribed in crayon (not in artist's hand) lower left: de Seurat;
and in pen upper right: 97bis
Verso: bust-length drawing of a woman

Private collection

Exhibited in Paris only
H 260

PROVENANCE
The artist until 1891. Posthumous inventory, dessin no. 97 bis (per
inscription in pen at upper right, not recorded by de Hauke). Paul
Signac, Paris, probably in 1891, until his death in 1935; by inheritance
to his daughter, Ginette Signac, Paris; to present owner

EXHIBITION
1926 Paris, Bernheim-Jeune, no. 14

The maturity of this handsome little portrait might sug-
gest that it was borrowed from another work of art, but it
is in fact a life drawing. Its modeling is like the heads of
Seurat's male *académies* (for example, cat. no. 7), and it is
about the same size as the heads of those large figures. Its
more pronounced character results from the use of black
conté crayon instead of charcoal and from the aplomb with
which it is positioned on the sheet. Seurat applied the
crayon in parallel diagonal strokes, as he did charcoal, but
conté produces richer blacks and grays which offer more
contrast with the paper.

Line, as such, hardly exists in this drawing. The head is
in the shape of a lozenge, and the face breaks the paper
plane only slightly, showing the young artist's penchant
for strong surface pattern. By placing the head high on the
page, Seurat lets us feel the support of the shoulders
without seeing them.

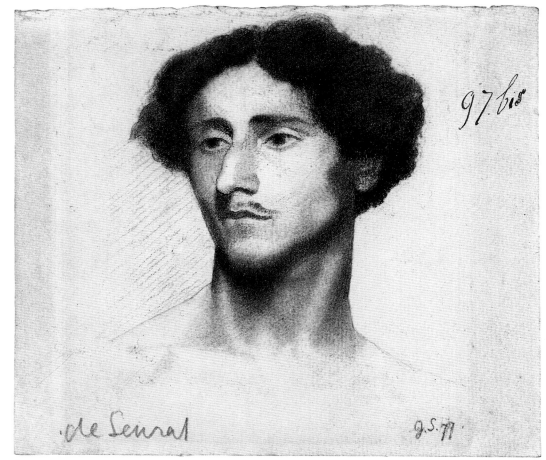

6

7. *Nu de dos, appuyé sur un bâton*. 1877

BACK VIEW OF A MALE NUDE, LEANING ON A
STAFF

Charcoal and graphite, 24⅞ x 19 in. (63.2 x 48.5 cm.)
Signed verso upper left: Seurat
Dated lower right: 27 octobre 1877
Upper right (not in artist's hand): 20 (twice) and disk of gray pigment

Musée du Louvre, Département des Arts Graphiques, Fonds du Musée d'Orsay, Paris, R.F. 38.901

Exhibited in Paris only
H 265

PROVENANCE
The artist's family; by inheritance to Mme Léopold Appert, Paris; private collection; acquired by the Musée d'Orsay, 1981

EXHIBITIONS
1957 Paris, no. 25
1958 Chicago and New York, no. 3
1983 Bielefeld, no. 4
1985 Tokyo and Kyoto, no. 95

Lequien's teaching emphasized modeling in light and dark rather than pure outline drawing, and by 1877 Seurat had mastered this technique. On the margins of the darkest shadows, he used diagonal hatching, making deep blacks by repeated strokes and grays by very light touches and rubbing. The subtle grays and whites across this figure's back give a sense of light reflected by the skin, in contrast to the great mop of hair above. At times the modeling is schematic, as on the left foot and ankle, but at other times it has an arresting, true-to-life quality, as on the exposed hand. The figure's outline is a very thin, crisp line, probably applied over a faint pencil line that acted as a guide. Several small outline drawings survive for studio nudes like this one, and Seurat probably used such drawings to position the figure; he then redrew it on the large sheet and modeled it. The faint initial outline was covered and altered as the modeling progressed; the final outline was then drawn. There are remarkably few erasures in these *académies*.

Although the drawing is based on light and dark, the figure has a sharp-edged silhouette, as though it were a sculpture in a void. Only the strong shadows at the feet give it contact with its environment. The figure is thus an autonomous artistic creation, which can be placed in an independent composition (Beaux-Arts students often confessed their inexperience in awkward groupings of disparate posed models). Seurat's mature paintings combined this autonomy of figure with settings that he developed after he left school, when he turned toward naturalism and Impressionism.

The disk of gray pigment or wax and the number 20 (appearing twice) in the upper right may have been added by Seurat's teacher. According to artists who studied at the turn of the century, teachers marked drawings with sealing wax or a dab of paint. Seurat's large drawings have multiple pinpricks in their corners, showing that they were repeatedly hung. It seems likely that he saved only those that met with approval.

8. *Angélique, d'après Ingres*. 1877–78

ANGELICA, AFTER INGRES

Graphite, 16⅞ x 11 in. (43 x 28 cm.)

Mrs. Jacques Lipchitz

Not in H
Exhibited in New York only
H 315; DR 1a

PROVENANCE
Earliest whereabouts unknown; to present owner by 1947

EXHIBITION
1947 New York, no. 28

The tentative outlines of feet and ankles in this unfinished drawing shows how Seurat began his copy. He established the figure's contours not by using firm lines but by external shading built up with constant delicate movements of his pencil. Only the exposed fingers were rendered in solid outlines. No lines at all were used for modeling hair, breasts, torso, and groin, for he conceived the image in terms of movements of light and dark.

This drawing is after Ingres' figure of Angelica, either from *Roger Rescuing Angelica* (Musée du Louvre, Paris), or from another of the famous artist's many variations on the same nude.[1] Determining Seurat's exact source is made no easier by the fact that his oil painting after the same figure (H 1; Norton Simon Museum, Pasadena) shows several differences in detail. These may result from the impossibility of making exact replicas but may also indicate that the drawing was taken from another variant. (None of these, however, can be authoritatively declared to be Seurat's source.) It is considerably smaller than the painted copy[2] and is not squared up for transfer, so for his painting Seurat is likely to have used one or more other drawings that have not survived. The Louvre's painting, done in 1819, is the most famous treatment by Ingres of this episode from Ariosto's *Orlando furioso*. Widely reproduced, it hung in the Musée du Luxembourg (Paris's museum for works by contemporaneous artists) until 1878, when it was transferred to the Louvre.

1. These include seven versions in oil and many drawings. See Georges Wildenstein, *The Paintings of J. A. D. Ingres* (Londin, n.d.), cat. nos. 124–27, 227, 233, and 287.
2. 31⅞ × 25⅛ in. (81 × 65 cm.).

9. *Satyr et chèvre, d'après l'antique*. 1877–79

ANTIQUE STATUE, SATYR WITH GOAT

Charcoal and black chalk, 24⅛ x 19⅛ in. (63.6 x 48.4 cm.)
Upper right (not in artist's hand): 20 and disk of gray pigment

Woodner Family Collection, New York

H 300

PROVENANCE
The artist's family; by inheritance to Mme Léopold Appert, Paris; Mme Astier, Paris; Alexandre P. Rosenberg, New York, by 1983–84; Marianne Feilchenfeldt, Zurich, until March 1985; sold to present owner, 1985

EXHIBITIONS
1983–84 Bielefeld and Baden-Baden, no. 5
1990 New York, no. 131

Seurat did thirteen known drawings after plaster casts of seven antique sculptures. All these casts were in the collection of the École des Beaux-Arts, where he may have had access to them before he enrolled, or since every art

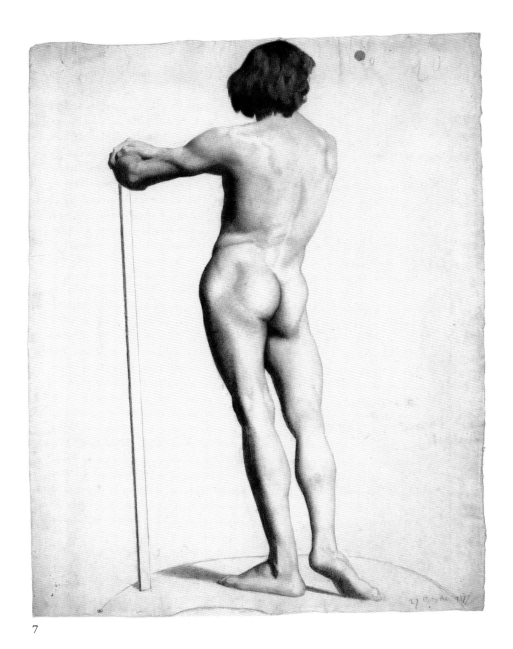

7

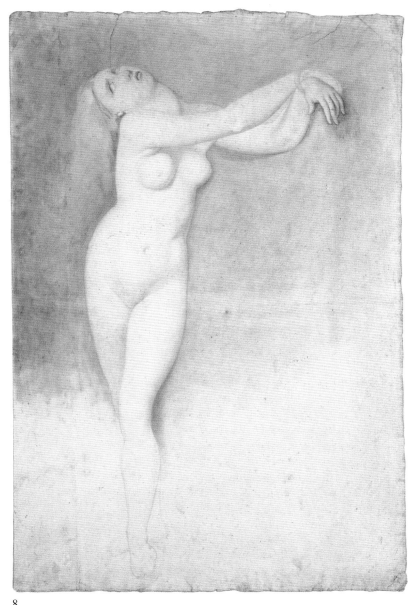

8

school had its own casts, he may have encountered them elsewhere.

This drawing is one of three Seurat made of the Satyr and Goat. (There is a seventeenth-century bronze of this sculpture in the Louvre, after the antique original in Madrid, but he did not work from it.) Another is a

three-quarter view from the back (H 301), and the third is the most familiar view, taken from the front (H 299). For the present drawing Seurat moved slightly to the left, so that the figure's chest and the goat's legs are parallel to surface and the figure's spiral twist is partly suppressed. In the two other drawings the satyr and the goat are fully

modeled, but the support is not drawn. Here Seurat concentrated on the figure and modeled the support and the goat in a schematic way. The incomplete modeling of the goat shows the underpinnings of his technique: parallel hatching in geometric patches which, in finished areas, are blended with softer strokes and delicate rubbing.

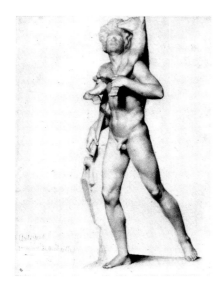

Camille-Félix Bellanger, *Study from antique sculpture* (Satyr and Goat), 1870–75. Sold at Sotheby's, New York, July 12, 1989, no. 312

In the early 1870s Camille-Félix Bellanger (1853–1923), who studied with Adolphe Yvon at the École des Beaux-Arts, did a drawing of the same statue.[1] He produced a softer, smoother surface by minimizing the range of light and dark. He also reduced the prominence of the muscles and bones, and his figure thus has a smoother mass and more uniform surface and is thinner and more supple. Seurat's modeling, with its greater contrasts of light and dark, is more energetic. The differences between the two drawings may indicate why Seurat was not placed higher in his class at the École—he may not have sufficiently idealized his models.

The present drawing is similar in technique to cat. no. 7, which is dated 1877, and it might date from that year or the next (there is no stylistic break in the work Seurat did in his final year with Lequien and his first at the École des Beaux-Arts). Like cat. no. 7, this drawing has a gray disk and the number 20 in the upper right. It is also on excellent quality Michallet paper, as are most of Seurat's large drawings after the antique and the live model.

1. Sold at Sotheby's Arcade Sale 1286, New York, July 12, 1989, no. 312; black chalk, 23¼ × 17 in. (59 × 43 cm.); inscribed recto "Antiques. 2ème concours de médailles," and verso "Bellanger," "Monsieur Yvon," and "El. de M. Yvon."

9

10. *Académie, de profil, tête baissée.* 1877–78

MALE NUDE, PROFILE

Charcoal and black chalk, 25 x 19 in. (63.5 x 48.2 cm.)
Signed verso upper left: Seurat
Inscribed upper right (not in artist's hand): X 15

Private collection

H 278

PROVENANCE
The artist's family from 1891; Mme Léopold Appert, Paris; private
collection; to present owner by 1970

This drawing is the only one of Seurat's school nudes in
strict profile. Thus its silhouette resembles those of his
mature drawings and paintings, although the angled pose,
typical of his early work, did not reappear. More of this
figure is in shadow than the other school nudes; the black
tones are more luminous, fluidly revealing the body's
contours. The sense of control points to a later date than
that of most of the *académies*.

Although the figure is grasped as a single large rhythm,
Seurat brought certain details into sharp focus, suggesting
a specific human model: the prominent vein on the wrist,
the pocket of flesh just below the buttock (also marked on

Seurat, *Nu debout,
hanchant à gauche*
(Standing nude,
weight on left
leg), 1877–79.
J. Nicholson,
Beverly Hills,
California

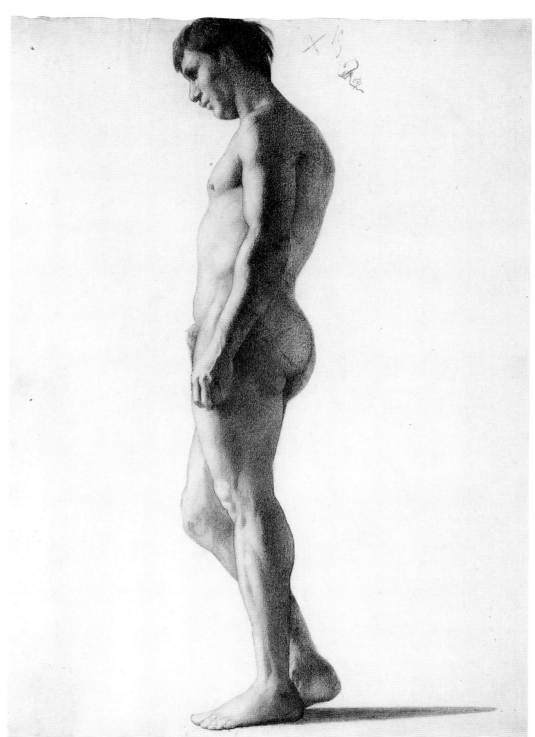

10

the preliminary drawing), and the pensive expression. In the upper right, in addition to a large X and the number 15, there is a reprise of the figure's nose and mouth, echoing the still-visible correction of the lips.

This is one of several male nudes for which a preliminary drawing survives.[1] The study has something of the quality of Seurat's copies after Ingres's linear drawings; as in those, he does not have the master's firm, continuous line but instead forms contours by stitching together separate straight and curved segments.

1. Sold at Sotheby's, New York, November 16, 1989, no. 110; pencil, 12½ × 9 in. (31.5 × 23 cm.).

11. *Le tronc d'arbre.* 1879–81

TREE TRUNK

Conté crayon, 12¼ x 9½ in. (31.3 x 24.2 cm.)

Musée du Louvre, Département des Arts Graphiques, Fonds du Musée d'Orsay, Paris, Gift of Camille Pissarro, 1904 R.F. 29.549

Exhibited in New York only
H 546

PROVENANCE
The artist until 1891. Posthumous inventory, dessin no. 196. Inherited by the artist's brother, Émile Seurat, Paris, in 1891, until 1900; sold to Camille Pissarro, Paris, in 1900, until his death in 1903; his gift, realized by his son Lucien Pissarro, to the Musée du Luxembourg, Paris, April 15, 1904; transferred to the Musée du Louvre, 1947

EXHIBITIONS
1900 Paris, Revue Blanche, *hors cat.*
1908–09 Paris, no. 131
1926 Paris, Bernheim-Jeune, no. 42
1950 Venice, no. 2

This is perhaps the first independent landscape that Seurat drew. Its building has the delicate and somewhat hesitant lines of several tiny landscape fragments in his sketchbooks of 1879–81. The artist seems to have carefully outlined the building before proceeding with the diagonal hatching. Despite these lines, light and dark already form the basis of Seurat's vision of landscape. The building's left side and the forms (perhaps distant roofs) to the left of

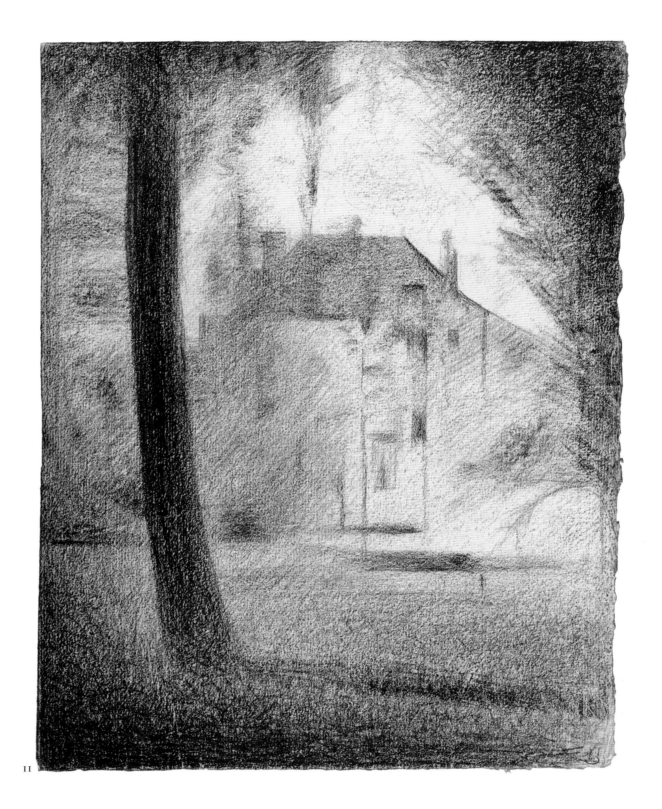

11

the tree trunk have no visible outlines; instead they grow out of the soft gray marks of the crayon. The foliage above and to the right is set down rather schematically and does not have the confident massing evident by 1882. Nonetheless, the placement of the tree trunk and the jagged aperture of the sky are premonitions of his mature style.

Camille Pissarro bequeathed this drawing to the French nation in 1904, having purchased it and several others in 1900 (see cat. no. 28).

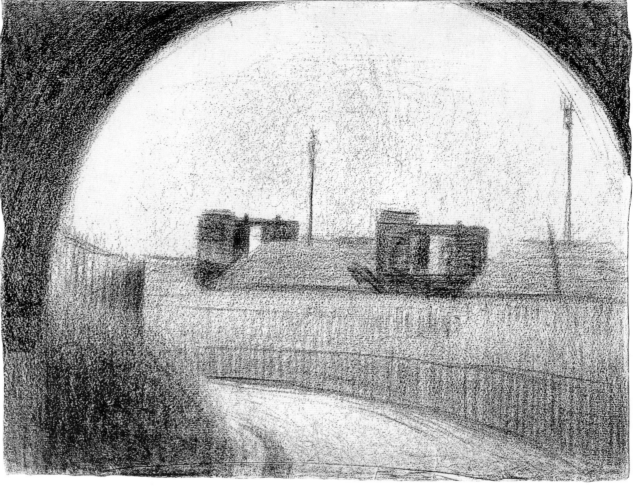

12

12. *Route de la gare.* 1879–81
RAILROAD STATION

Conté crayon, 9⅜ x 11¾ in. (24 x 30 cm.)

Private collection, Switzerland

H 472

PROVENANCE
The artist until 1891. Posthumous inventory, dessin no. 208. Inherited by the artist's brother, Émile Seurat, Paris, in 1891; Bernheim-Jeune, Paris; Gerhardt Hauptmann, Altona, Germany, until his death in 1946; by inheritance to Ivo Hauptmann, Hamburg, from 1946 until about 1975; acquired by Artemis S.A., by 1975; to present owner

EXHIBITIONS
1900 Paris, Revue Blanche, *hors cat.*
1908–09 Paris, no. 99
1963 Hamburg, no. 109
1978 London, no. 5
1983–84 Bielefeld and Baden-Baden, no. 20

From the outset of his career Seurat chose industrial subjects, from both city and suburb, as well as landscapes and images of peasants unmarked by modern change. The absence of people contributes to the haunted quality of the present drawing, as if these forms, although fashioned by humans, could manage without them. Seurat strengthened the composition by repeating the striking black shapes, half-architecture and half-locomotive, and the spindly signal towers, so unlike trees. The embracing arch is off-center, encouraging the viewer's eye to sweep to the

right and forward. Beyond the wall are twin images of dark forms and pale roofs, surmounted by signal towers. The tower to the right is closer to us and helps bring the curving wall forward; the other tower is less distinct and lies farther back in the delicately rendered atmosphere.

Traditionally dated 1881, this drawing may have been done as early as 1879. Its parallel crayon marks have a hesitancy Seurat did not often show after 1881. The second set of vertical strokes in the upper portion of the curving wall gives further evidence of this tentativeness.

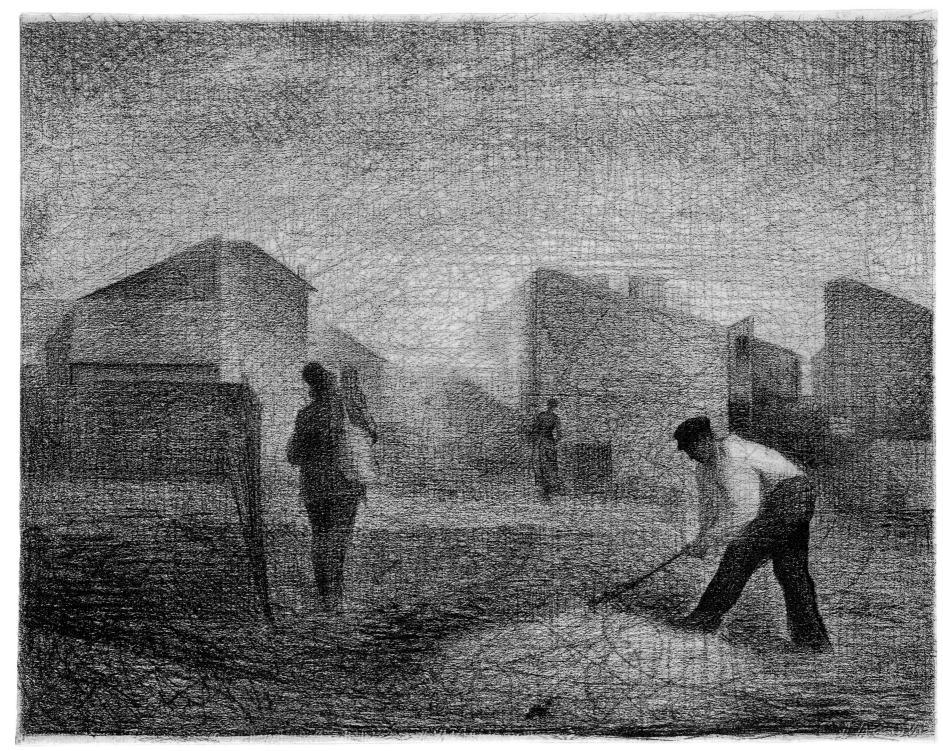

13

13. *Casseur de pierres, Le Raincy.* 1879–81

STONE BREAKER, LE RAINCY

Conté crayon, 12⅛ x 14¾ in. (30.7 x 37.5 cm.)

The Museum of Modern Art, New York, Lillie P. Bliss Collection

H 463

PROVENANCE
The artist's brother, Émile Seurat, Paris, until his death in 1906; by inheritance to his widow, Mme Émile Seurat, Paris and Nice, from 1906 until April 1929 (per inscription, in her hand, on reverse); with Georges Bernheim, Paris, 1929; with Martin Birnbaum, New York, 1929; Lillie P. Bliss, New York, 1929, until her death in 1931; her bequest to the Museum, 1934

EXHIBITIONS
1935 Chicago, no. 21
1947 New York, no. 17
1949 New York, no. 29
1958 Chicago and New York, no. 17
1977 New York, no. 5

Given its large size and deliberate plotting, this drawing may have been a study for a painting that was never undertaken or that has disappeared. Seurat built up his grays with careful hatching, much of it crossing at right angles; this type of pattern underlies many of his finished works, where it is usually covered by heavier surface marks. The swirling lines in the foreground would become familiar in the energetic grays and blacks of his later drawings. Since the drawing is unfinished, it exhibits to our modern eyes, sensitized by abstraction, the structural means that we love to uncover and that we often prefer to verisimilitude (hence the appropriateness of its home in the Museum of Modern Art, New York).

The site is a working-class or lower middle-class district, probably in Le Raincy, a rapidly expanding suburban town east of Paris where Seurat's father had a villa (the drawing bore its present name when it was in the family's possession). The woman in the distance is found also in a separate drawing, and the stone breaker's pose is similar to that seen in several of Seurat's early drawings and paintings. The postman to the left, carrying a child as well as his bag, is the only unfamiliar figure. All three seem to have been borrowed from separate studies and assembled here in an ambitious composition. The three mark out a

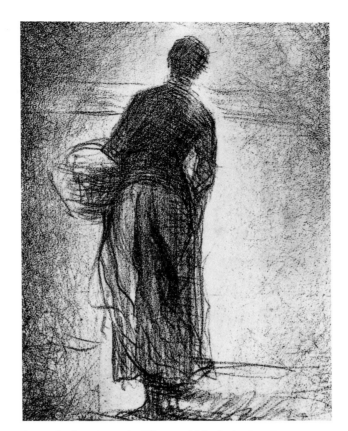

Seurat, *La femme au panier* (Woman with basket), 1879–81. Ex coll. Georges Renand (H 464)

receding space across the scruffy foreground, which is the edge of a city or village whose roads and buildings would use the traprock being broken up by the worker (he wields the long-stemmed hammer appropriate to his task). The somber wedge-shaped buildings—the sort constructed with minimum attention to architectural graces and used as warehouses, garages, and workers' housing—are seen again in *Banlieue* (cat. no. 82). In his numerous drawings and panels of stone breakers, Seurat explored suburban working environments, but he never fashioned a larger painting showing both workers and suburbs. This awaited *Une baignade, Asnières* (H 92; National Gallery, London) which, by representing workers at leisure, marked a shift toward Impressionism.

14. *L'invalide.* 1879–81

MAN LEANING ON A PARAPET

Pastel, 9½ x 6⅛ in. (24 x 15.5 cm.)

Private collection

H 459; DR 9b

PROVENANCE
Paul and Berthe Signac, Paris, by at least 1908; by inheritance to Ginette Signac, Paris; to present owner

EXHIBITIONS
1908–09 Paris, no. 92
1926 Paris, Bernheim-Jeune, no. 2

Like *Le tronc d'arbre* (cat. no. 11), this small page features a dark tree as a repoussoir, all the more necessary because the composition consists only of flat bands. Seurat has positioned us along the Seine, probably opposite the Institut de France. Earlier in the century the composition was called "*L'invalide,*" because the domed building was associated with the Hôtel des Invalides and perhaps because the male figure, in long coat and blue trousers, could be taken for a soldier. However, it has since been recognized that the dome is closer to that of the Institut. A solitary figure leaning over the wall of a quai was a common choice among illustrators who characterized the Seine by the way it attracted contemplative observers. (Later Seurat draw a woman leaning toward the Seine in the same pose [H 462] but in a composition angled along the quay.)

All of Seurat's work in colored chalks was done between about 1879 and 1881. Their chronological anchor is the notebook he used during his military service in Brest, a twelve-month period beginning November 1879. Seurat drew soldiers in color; on pages from the same or another notebook he drew several entertainers, perhaps as late as 1881 (cat. no. 16). By comparison with those colored sheets and with drawings from other youthful sketchbooks, the present drawing would have been done about 1879, although allowance must be made for the possibility of a slightly later date. It is intermediate between a conté crayon drawing (H 460; private collection) and an oil panel (H 9; Mrs. Charles Wrightsman, New York); there is little variation among the three compositions. The spindly

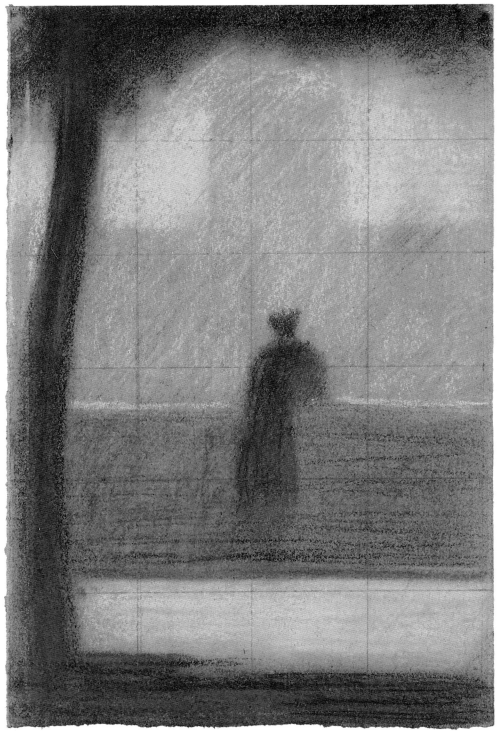

14

tree that rises above the parapet in the drawing is eliminated in the pastel and oil, and the latter has more space to the left of the tree (the panel is proportionately a bit wider). Seurat began with the conté drawing which is exactly the size of the sheets from the Brest notebook. He then squared it up for transfer to the pastel, which in turn he squared up for the oil (the grid is visible on the panel).

Here Seurat applied his chalks in separate parallel strokes, a rather timid but logical application of the principles of broken colors he was learning from his readings and from Delacroix. The sidewalk, for example, is a light greenish gray formed of pinks, creams, earths, gray, pale green, and yellow, and the wall is a darker version of the same mixture, plus blue and dull orange. As opposites of the cool greens and grays, the pinks and oranges enliven the mixtures, but there are no significant contrasts apart from the gold of the dome that opposes the blues of the tree and the figure.

15. *Troupier à l'escrime.* 1880
SOLDIER FENCING, ANOTHER RECLINING

Colored crayons and graphite, 5¼ x 9⅛ in. (14.7 x 23.2 cm.)

Private collection

H 380

PROVENANCE
The artist until 1891; Mme J. D.,* by 1908–09; Camille Platteel, Paris, by 1926, until no later than 1943; to Henri Le Savoureux, Châtenay-Malabry,** by 1943; to present owner at a subsequent date

EXHIBITIONS
1908–09 Paris, no. 89
1926 Paris, Bernheim-Jeune, no. 3

*All that is presently known about "Mme J. D." is that she lent fifteen Seurats to the 1908–09 Seurat retrospective at Bernheim-Jeune, Paris. The fifteen works were subsequently owned by Fénéon's mistress, Camille Platteel (1854–1943). The eleven drawings were lent by Camille Platteel to the 1926 Seurat exhibition at Bernheim-Jeune, and the four other works—an oil painting (H 103) and three panels (H 23, 40, 132)—are recorded by de Hauke as having been in her collection.

It should be noted that with the exception of one loan to the 1908–09 Paris exhibition (no. 75, lent by Émile Seurat) all lenders are indicated simply by their initials. In de Hauke's provenance listings, these lenders are identified by their full names. However, in the case of Mme J. D., neither her initials nor her name was recorded by de Hauke. The omission is uncharacteristic of Fénéon and de Hauke's efforts to catalogue Seurat's oeuvre, but is understandable. No doubt the omission was a matter of discretion, since all of the works were subsequently acquired by Fénéon's mistress. As Bernheim-Jeune is unable to reveal the lender's name, even to the present day, the identity of Mme J. D. remains a mystery. To date, reviews of the 1908–09 exhibition have not proved helpful in this regard.

Quite possibly Mme J. D. was a dealer. There was a Mme Druet Galerie (see Fénéon, BVA, April 15, 1920, in Halperin 1970, I, p. 348), and if she was related to Eugène Druet, who photographed the works exhibited with Bernheim-Jeune in 1908–09, she would be a promising candidate. Another possibility would be the owner of the Galerie Devambez, Paris, where an exhibition was held in October 1922, "Vingt Dessins de Seurat," for which no catalogue survives (listed in DR, p. 282).

**Henri Le Savoureux was the director of a hospice, La Vallée aux Loups, Châtenay-Malabry, near Paris, where Camille Platteel and Félix Fénéon were in residence from 1942 until their respective deaths in 1943 and 1944. This work was presumably acquired from Camille Platteel or from her estate between 1942 and 1943.
See second provenance note, cat. no. 17.

15

This drawing and the next are two of the fifty-six drawings in pencil and colored crayons from the so-called Brest sketchbook, which dates from Seurat's military service in that city (November 1879–November 1880). This sketchbook's sheets usually show several subjects, and most of the drawings are of the artist's own hands, arms, and feet or those of fellow soldiers who are seen seated and standing. Other sheets show civilian figures seated and standing; a few drawings after reproductions of works by Michelangelo, Poussin, and others; men and women with agricultural tools; and some fragmentary landscapes and seascapes. *Troupier à l'escrime* is one of the few that has a soldier in an active pose. The other main figure, at first glance hard to grasp, is radically foreshortened (his feet bend up from the bottom of the page).

The forms here were hastily drawn in pencil, then reworked in colored crayons. Of special interest is the way

Seurat systematically employed color opposites. The fencer's dull red trousers have green along the right side of each leg; the ground or floor is likewise green, while the reclining trooper's blue jacket turns green next to his red trousers. Since about 1876 Seurat had been reading the color theorist M. E. Chevreul (Appendix J), who taught that colors interact dynamically with those of adjacent areas. For progressive painters of the preceding and contemporary generations, furthermore, the color of a given form could not be treated as a flat silhouette divorced from a continuum of atmospheric color and light. As soon as Seurat began to apply color to a human image, he could no longer think of it as an isolated silhouette. Every figure in the Brest notebook that is touched with color also has an atmospheric glow of contrasting colors, a proof that Seurat's pursuit of color-light (Appendix F) helped change his conception of the human form.

16. *Soldat assis* 1880

SEATED SOLDIER, AND OTHER STUDIES

Colored pencils and graphite, $5\frac{7}{8}$ x $9\frac{1}{4}$ in. (14.9 x 23.7 cm.)
Vente Fénéon stamp in black lower right

The Fine Arts Museums of San Francisco, Achenbach Foundation for Graphic Arts, Bequest of Henry S. Williams in memory of his great-uncle H. K. S. Williams

H 366

PROVENANCE
The artist until 1891. Probably posthumous inventory, dessin no. 24 or 26 (per partially illegible inscription, initialed in blue crayon by Fénéon on reverse of original mount; not recorded by de Hauke). Inherited by the artist's brother, Émile Seurat, Paris, in 1891; Félix Fénéon, Paris, until his death in 1944; his estate, 1944–47 (Fénéon sale, Drouot, Paris, July 9, 1947, probably no. 98);* The Matthiesen Gallery, London, by 1958; Henry S. Williams, New York, before 1962, until 1985; his bequest to the museum, 1985

EXHIBITIONS
1936 Paris, no. 59
1958 Chicago and New York, no. 10

*Although the work bears a Vente Fénéon stamp, neither the date of the Fénéon sale nor its lot number was recorded by de Hauke. Lot no. 98 in the fourth Fénéon sale, titled "Soldats et divers croquis," is the most likely candidate for this drawing on the basis of descriptive title and the fact that it had not been assigned otherwise in de Hauke. Of the Seurats included in this sale (nos. 88–110), de Hauke has identified lot numbers 88, 91, 94–97, 99–105, 109.

As in the previous drawing, color opposites are used systematically. Here, however, more colors are involved. The reddish orange trousers are outlined in green and accompanied by green stockings; the pink epaulettes include green streaks and provoke a green reaction on the blue tunic; the purple kepi is surrounded by yellow, and its red pom-pom has a green border; yellow and purple reactions isolate the bench on which the soldier sits. Elsewhere on the sheet, typical of the Brest sketchbook, figures are quickly sketched in pencil without regard to their surroundings.

Fénéon, in describing the sketchbooks which he helped inventory,[1] said that the Brest notebook included views of soldiers and "quelques scènes de rue, de music-hall et de cirque" (a few scenes of streets, music halls, and circuses). This is of capital importance but has been overlooked, partly because de Hauke did not keep all the drawings from Brest together in his catalogue. Among them are five drawings in colored crayons: *Le clown rouge* (H 385); *Banquistes* (H 384; Woodner Family Collection), correctly dated about 1880; *La répétition* (H 676) and *La ballerine au chapeau blanc* (H 677; both in a private collection, U.S.A.); and *Parade de danseuses* (H 678), the last three wrongly dated about 1887. These and a few others in the Brest sketchbook were probably done in Paris just before Seurat began military service in November 1879. They do not have the assurance of the roughly comparable drawings of soldiers, and their color harmonies are not as dependent upon the oppositions that characterize the military figures. Moreover, drawings signed and dated 1881, such as *Le marchand d'oranges* (cat. no. 21) and *Tambour à Montfermeil* (cat. no. 19), have such a maturity that it is hard to imagine that the crayon drawings of performers were done in the same year.

16

1. H, 1, p. xxix. Fénéon lists five other sketchbooks found in the studio. Unbeknownst to him, four others were in the possession of Seurat's friend Aman-Jean. These four remain intact, two on anonymous loan at the Yale University Art Gallery New Haven, and two on the art market in New York. They are described in Franz and Growe 1983, pp. 54–56. One of those at Yale (4⅜ × 7⅝ in. [11 × 19.5 cm.]) overlaps with the year at Brest and includes notes on a trip through Brittany. A number of its pages were apparently done in and near Paris. Its greater sophistication compared with the Brest sketchbook suggests that it was done toward the end of the year in Brittany (and one page bears the date August 4), supporting evidence for dating the disseminated Brest pages to the early months there.

17. *Le couple*. 1880–81

THE COUPLE

Conté crayon, 6⅜ x 4⅛ in. (16.2 x 10.5 cm.)

Musée Picasso, Paris

Exhibited in Paris only
H 438

PROVENANCE
The artist until 1891. Posthumous inventory, dessin no. 72. Inherited by the artist's brother, Émile Seurat, Paris, in 1891, until no later than 1906; Mme J. D.,* by 1908–09; Camille Platteel, Paris, by 1926, until 1942 (sale, Drouot, Paris, November 30, 1942, no. 56 for 42,000 francs);** purchased at this sale by Mme Leiris, on behalf of

Pablo Picasso, in 1942, until his death in 1973; his heirs, from 1973 to 1979; acquired by the Louvre, in lieu of state taxes (by *dation*), in 1979; transferred to the Musée Picasso, 1985

EXHIBITIONS
1900 Paris, Revue Blanche, *hors cat.*
1908–09 Paris, no. 143 (c)
1926 Paris, Bernheim-Jeune, no. 27c

*See first provenance note, cat. no. 15.

**Correspondence and other documents preserved in the Étude Loudmer, Paris, confirm that it was Camille Platteel who sold the ten drawings by Seurat included in this sale (lot nos. 50–59); all had been lent by her to the 1926 Seurat exhibition at Bernheim-Jeune, Paris. The proceeds from the sale of these drawings—per a copy of a check in the amount of 190,282.50 francs—went directly to Henri Le Savoureux, director of the "Maison de Santé," La Vallée aux Loups, where she and Félix Fénéon were confined until their respective deaths in 1943 and 1944. (The previous year Fénéon had sold part of his collection at auction [Fénéon sale, Drouot, December 4, 1941] in order to defray clinic costs.) Henri Le Savoureux, who owned five Seurat drawings that had formerly been in the collection of Camille Platteel, no doubt acquired these works in lieu of payment, either by sale, barter, or from her estate. (See second provenance note, cat. no. 15, and also cat. no. 68.)

The Étude Loudmer archives are revealing on other counts:
• Correspondence shows that Félix Fénéon was actively involved in the arrangements for the sale, from furnishing the auction house with documentation for the catalogue to correcting errata, and that he was also interested in the fate of these drawings—"les noms, prénoms et lieu de nouveaux possesseurs et les chiffres d'adjudication"—for purposes of the "*Catalogue général Seurat* (en préparation)." (The auction house obliged his request of November 25, sending him the relevant information as to owners and prices on December 2, 1942.)
• Moreover, Camille Platteel's correspondence as well as Fénéon's documentation reveal that two groups of four drawings each were exhibited in a single frame in the Seurat exhibitions held at Bernheim-Jeune, Paris, in 1908–09 and again in 1926. In the 1908–09 exhibition, the *Quatre croquis* were listed under no. 105 and no. 106; in 1926, the works were listed as no. 26 a–d and no. 27 a–d. At Camille Platteel's instruction, the frames containing the two groups of four drawings—which had remained intact from at least 1908 until just prior to the sale in 1942—were dismantled; the drawings were reframed ("chacun sous un cadre particulier") and sold as individual lots (nos. 50–57). It should be noted that when Camille Platteel left Paris in 1939, she had entrusted these drawings to her neighbor and good friend, Mme Colette Cahen-Alexandre, who subsequently retired to Varreddes, Seine-et-Marne. The drawings were retrieved from her residence in October 1942.

The reference in de Hauke to a 1927 sale is erroneous; for the *Couple en promenade* included in that sale, see cat. no. 138.

17

This drawing came from a sketch pad small enough to be held in Seurat's hand. It has the character of some of the drawings in an intact early sketchbook, now on loan at the Yale University Art Gallery (see cat. no. 16, n. 1), and it too could have been done in 1880 or 1881. But instead of sharing the page with other minuscule studies, it concentrates on two that take up the whole sheet. Over a simple outline Seurat applied diagonal hatching. By first noting his figures in short discontinuous lines, Seurat avoided giving them an enclosed shape that would separate them from the surrounding space. Hatching flows across the interior lines of the figures, evoking a continuum of light and dark rather than describing portions of clothing or body. He varied the density of his lines to produce darker or lighter areas. To the left the background, rendered in verticals, is probably a wall which leads to the opening on the right (the couple is presumably seated on a terrace or outdoors).

In 1942 Picasso acquired this small drawing, reminiscent of his own youthful sketches of people glimpsed in public places.

18. *Femme sur un banc.* 1880–81

SEATED WOMAN

Graphite, 6½ x 4⅛ in. (16.5 x 10.5 cm.)

Robert and Lisa Sainsbury Collection, University of East Anglia

H 403

PROVENANCE
Maximilien Luce, Paris; Jacques Rodrigues-Henriques, Paris; Kate
Perls, Paris; Adams Bros., London; Sir Hugh Walpole, London, until
his death in 1945; sold from his estate by The Leicester Galleries,
London, to Sir Robert and Lady Sainsbury, London, in 1945, until
1973; their gift to the University, 1973

EXHIBITIONS
1958 Chicago and New York, no. 12
1978 London, no. 3
1983–84 Bielefeld, Baden-Baden, and Zurich, no. 17

Seurat outlined this tiny figure in short lines that change
direction abruptly; he then laid down his hatching in
rapid, neat diagonals. He formed geometric pockets of
light and dark without separately outlining them; he
merely used thicker and darker parallels in the shaded
zones in what Erich Franz has called his "crystalline"
manner.[1] He drew horizontals for some portions of the
bench and ground, but otherwise there too he used
diagonals. Their arbitrariness establishes an atmospheric
light rather than strongly differentiated images. The grays
of this drawing are softer than those of the previous
one because it is done in pencil rather than black crayon
and more of the paper is covered. It seems more "abstract"
than the other, thanks to its denser surface and the
geometry of its pattern. This appeals to the twentieth-
century eye (it seems to predict Jacques Villon's etchings),
but we should be aware of the anachronism of our
reaction. For one thing, Seurat made this small drawing
and others like it in order to develop a drawing technique;
it is not a finished work in its own right. For another, it is
one of a large number of early drawings of figures seen in
parks, streets, and other public places. They are not
"abstractions" in the twentieth-century sense but are, in
the earlier meaning of the term, extractions or distillations
from material objects.

1. Franz and Growe 1983, pp. 56–59.

18

Independent Drawings 1881–1884

On his own by the end of 1880, the twenty-one-year-old Seurat confirmed his break with the École des Beaux-Arts by moving toward naturalism. This word has no absolute definition— naturalism was not a "school" of art—but in Seurat's case it meant a devotion to the people and landscapes of city, suburb, and country. No more copies after the antique, no more subjects drawn from mythology, history, or religion. Here he parted from his closest friends from the École—Aman-Jean, Alphonse Osbert (1857–1939), Alexandre Séon (1855–1917), and Ernest Laurent (1861–1929)—all of whom pursued careers within the Beaux-Arts tradition, painting classicizing subjects and competing for official prizes and commissions throughout the 1880s.

Seurat's naturalism was evident by 1881 when he dated three drawings that show a drummer from a fair (cat. no. 19), a peasant bending over in a field (H 456; private collection), and an orange vendor (cat. no. 21). By 1884, when he exhibited his first mural-scale canvas, *Une baignade, Asnières,* he had made many dozens of drawings of women and men observed on Paris streets and in the suburbs and the countryside. He also drew the industrial edges of the city and painted small landscapes along the Seine and in the country, including many that show peasants at work. His paintings indicate that he was aware of the Impressionists by about 1882, but his drawings reveal little regard for those innovators and instead look toward mid-century naturalism.

Subjects from everyday life were not new to him, for they had filled the notebooks he had used from 1877 onward. Making such drawings, although done outside the classroom, was a standard practice for art students who were encouraged to draw directly from nature in order to give vigor to the classicizing subjects they were to aspire toward. Of course, a student was not supposed to renounce these well-sanctioned subjects, but when Seurat did so, he was not demonstrating unusual independence. He had examples to follow: Millet, Courbet, and other mid-century artists had turned away from academic subjects toward contemporary rural themes.

There were several other indications of Seurat's early interest in naturalism. One was his reading in 1878 of Thomas Couture (Appendix O), who urged drawing from life, including "people who sleep in public places, workers at their jobs, men who tow boats," typical of the subjects that fill Seurat's early notebooks.

Seurat, *Le chiffonier* (The ragpicker), 1882–83. Collection unknown (H 520)

Seurat also had a predilection for the writings of Edmond de Goncourt whom Aman-Jean described as their "divinité" (Appendix B). Since the early 1860s the Goncourt brothers had been at the forefront of literary naturalism. Their novels, whose protagonists often included artists and theatrical performers, featured urban and working-class environments and gave vivid descriptions of the industrial suburbs as well as of the more verdant banks of the Seine, all of which appear in Seurat's paintings and drawings from 1881 to 1884.

In his drawings of 1881–83 Seurat first revealed his astonishing early maturity. His figures are not gods and goddesses or heroic mortals, and his settings are not the Roman *campagna* or the ancient Near East. We find instead subjects from mid-century naturalism: drawbridges, locomotives,

suburban factories, riverbanks, stone breakers, peasants at work, market porters, street vendors, laundresses, nurses with children, middle-class promenaders, and middle-class women who read or sew by a window. The latter remind us that naturalism, although it represented a break with the École, did not necessarily imply political radicalism. Later, after 1884, Seurat formed friendships with leftist artists and writers, allowing us to deduce that he too was on the left, but in his early years his defiance of conservative traditions was well within middle-class boundaries. His matrons are found within their homes, the environment of the artist's own class, and his other figures are situated in public places where a middle-class artist could encounter them without forsaking his own domain.

Seurat's deepest sympathies were with ordinary men and women, not with the unusual or the eminent. In the Beaux-Arts tradition artists painted ideal individuals, not the average citizen, who could not embody a noble pattern to emulate. "To emulate" is the right phrase because art was thought to have a moral purpose, and mere imitations of everyday life did not have the essential uplifting qualities. Contemporary subjects also lacked references to the ancient and modern writings that were the basis of public education, knowledge that marked the cultivated citizen. By choosing unpretentious people for his images, Seurat placed himself among the progressive bourgeoisie, much as did the Goncourt brothers.

Seurat's naturalism was far from "photographic" accuracy. His women and men lack facial features, and his landscapes are bathed in the uncertainty of the shadows that he preferred to the clarity of sunlight. Naturalist writers such as the Goncourts, Zola, and Huysmans often described landscapes similar in quality to those of Seurat; next to the artist's drawings (cat. nos. 65 and 68) we can place lines such as these from the Goncourts: "Wintertime in Paris has days of gloomy, endless, hopeless gray. Gray fills the sky, low and flat, without a gleam, without a patch of blue. A gray sadness floats in the air. What there is of daylight is like a corpse. A cold light, as though filtered through an old tulle curtain, spreads its dirty yellow light over indistinct forms and things. Colors die away like those of bygone shadows and faded veils."[1] In such passages writers exploited the affective value of natural description to evoke the desired mood in their readers, for naturalism was not incompatible with strong feelings.

"Romantic naturalism" is a phrase some have used for a rather Baudelairean fondness for the somber features of the modern landscape. Seurat was sympathetic to this strain of naturalism, and his drawings portray industrial sites that many of his contemporaries would have considered "ugly" and therefore inappropriate subjects for the celebratory realm of art. A drawbridge raises its rather monstrous arms above a grimy canal lock (cat. no. 64); a locomotive, spewing black smoke, rushes by against a fading sunset (cat. no. 55); a group of workers gathers in front of a factory (cat. no. 58). These drawings were immediate responses to things Seurat actually saw. In addition to internal evidence, we have another indication that they were drawn in front of the motifs: the absence of studies for them. Some studies would surely have survived had Seurat regularly used them to make drawings in his studio.

Seurat's subjects can be set against the background of French naturalism, but they are not "literary." On the contrary, they depend little upon the detail a writer's words supply, and much upon the way an artist makes marks on his paper. To form the raised arms of his drawbridge, Seurat pushed his crayon back and forth with so much force that he crushed the paper's fibers into broad, flat streaks.

The foreground of *Le chiffonier* is littered with rapidly scrabbled strokes that characterize a detritus-strewn wasteland. For the sky above a few similar strokes are hidden in a mass of repeated rubbings that creates an unlimited grayness; lifting his crayon with consummate skill, Seurat produced two stars that throb faintly above the ragpicker's angular form.

The naturalism of Huysmans and the Goncourts tended to dwell on the city and its suburbs, which were also the favored sites of drawings and paintings by J. J. Raffaelli (1850–1924), the artist whom Huysmans selected to illustrate his *Croquis parisiens* of 1880. Raffaelli's anecdotal presentation is far removed from Seurat's evocative imprecision. His art grew out of the tradition of journalistic illustration and thrived on the details of facial features, clothes, and setting that Seurat avoided. Seurat also knew this tradition—witness his admiration of Daumier—but his conception of the figure came principally from the nineteenth-century idea of "effet" (effect), in which anecdote and detail gave way to a poetic interpretation that the viewer takes in all at once. Couture (Appendix O) also urged artists to draw and paint at twilight, building up masses and "lignes simples" rather than details in order to achieve "effet" and "style." Seurat's drawings of rural landscape (cat. no. 54) recall Millet, another artist who favored twilight and who also worked in black conté crayon.

Seurat's drawings of the human figure reveal more readily than his landscapes his preferences among artists of the past. He cannot be called a derivative artist—his drawings do not look like any other artist's work—and yet we can tell that he studied the graphic work of Rembrandt, Goya, Daumier, and Millet. The shadowy lighting of his interiors (cat. no. 34), picking out only face, hands, and one or two other elements, recalls Rembrandt's etchings; the rich and varied grays of *Fort de la halle* (cat. no. 39) and *La banquiste* (cat. no. 44) and their haunting strangeness are

reminiscent of Goya's etchings and aquatints; the economical forms of his street figures (cat. no. 21) and their pedestal-shadows bring to mind lithographs by Daumier (who also admired Rembrandt and Goya). The preferred subjects of these earlier artists have echoes in Seurat's images, but he was especially attracted to the techniques of these masters. The constantly moving hand of the printmaker produced grays and blacks from a web of black lines. Seurat could make his greasy conté crayon glide over the paper's surface with a freedom not possible in producing prints; yet it was these graphic artists who provided more lessons for his conception of light and dark than did Ingres, Raphael, and the other artists he was encouraged to emulate in school.

Seurat was not alone in making drawings in a dark manner in the early 1880s. Henri Fantin-Latour (1836–1902) also produced drawings and prints in a velvety sfumato, and both Pissarro and Degas made monotypes in shadowy blacks and grays. Odilon Redon (1840–1916), whom Seurat met in 1884 as a cofounder of the Société des Artistes Indépendants, made both drawings and prints that exploited a similarly rich range of grays and blacks. Redon likewise admired Rembrandt and Goya (in 1885 he entitled one of his albums *Hommage à Goya*), partly because he found support in them for the visionary quality of his creations. Redon and Seurat seem closest when Seurat's naturalism edges over into ambiguity; both artists share a certain somberness, something more than mere seriousness and yet less than pessimism. Seurat never used Redon's fantastic imagery or titles that lured the viewer into a world of dreams, so for all the sympathetic vibrations between them, Seurat remained firmly in the naturalistic tradition.

Although Seurat's drawings can be logically situated within major currents of French art of the 1880s, the particular resonance of his works in black and white, especially his figure compositions, remains unique. What makes these drawings immediately identifiable as his creations, and no one else's, is the way their stately, simple shapes arise from an interlace of light and dark from which they cannot be separated.[2] The continuum of light and dark that forms the surface of a Seurat drawing is not an environment that can be specified in narrative terms. It does not "tell a story"; it does not show trees or buildings because it is an artificial construction used to generate his figures. Sometimes Seurat provides a few peripheral images, but they do not fundamentally alter his conception of solitary forms.

A key element of the effects Seurat sought is the paper that he used, a heavy-textured, high-quality rag paper, milky white when fresh but a creamy off-white after long exposure to light. Michallet was the brand of "Ingres paper" (so named because it was favored by that master) that Seurat used; its watermark is clearly visible in many of his drawings. To

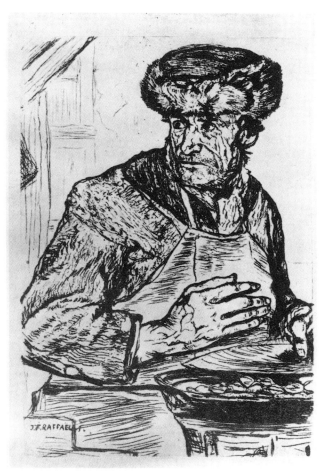

J. J. Raffaelli, *Chestnut Seller,*
etching for J.-K. Huysmans,
Croquis parisiens (Parisian Sketches)

produce Michallet paper (a laid paper), the fluid paste was deposited on a screen which left in the dried product a conspicuous grain of parallel ridges, rather like flattened-out corduroy wales. The ridges consist of tufted and slightly irregular fibers; when Seurat lightly stroked the paper's surface, the tufts caught the crayon here and there, while the valleys between the ridges were untouched. Except for the areas Seurat flattened with hard black strokes, his grays are three-dimensional because the white of the paper shows between the dark touches. Conté crayon is a solid, greasy medium which is easier to handle than charcoal, since it does not crumble or smudge as readily, and the degree of darkness is directly related to the pressure used. It is soft enough to leave its mark no matter how lightly applied, but since it does not turn to dust as charcoal does, it does not color the paper's white valleys. Conté is too hard to be easily stroked broadside like charcoal,

and Seurat used the point, often blunted, to build up his grays in characteristic hatchings and arabesques. His coiling, eccentric movements are given a unified texture by the striations of the paper's grain. Because of the rich collaboration of crayon and paper, light and not line appears to be the basic element.

Seurat's figures stand out clearly from their environment, but they are not silhouettes placed against a neutral ground. Following his principle of contrast, Seurat surrounded their dark portions with glowing light and the light portions with dark. If a figure were "removed" from a drawing, the "background" would have no independent existence—it is formed only in reaction to the figure.

Seurat's halos and penumbrae create a tremulous, shadowy light that indoors seems to capture the character of gaslight, and outdoors, that of twilight or the glow of streetlamps. He deliberately refrained from giving his figures the details that would specify individuality, and he did not create tangible settings. We must therefore give our attention to the shapes that he condensed into archetypes. Although simple at first glance, these shapes represent a distillation of knowledge about body, pose, gesture, and costume gained during his schooltime study of the human body, from both statues and live models. Such study was essential to the humanist tradition that had long shaped French academic art—the belief that through the body one could express human ideals. The human form so dominated his school studies that there are only a handful of landscapes among the hundreds of small drawings with which he filled his early notebooks.

Seurat's figures have a remarkable gravity. They seldom express movement, and their limbs only rarely extend beyond the instantly read masses of their bodies. These masses, moreover, are nearly flat, as though captured by the plane of the paper; this further removes them from an active engagement with their surroundings. The somber isolation of his figures may be rooted in Seurat's own reserved temperament. Because his solemn shapes are obviously the result of an imposed order, some observers might balk at associating them with naturalism. However, Seurat made a blend of artistic convention and "nature," as did all naturalists. For him and his generation there was no incompatibility between naturalism and artistic order. All art requires some kind of pattern, some form of order; Seurat's is simply more obvious to us.

Seurat's early readings in art theory emphasized artistic pattern and nature as the opposed terms of *one* dialogue; the phrase "harmony of contrasts" runs through all of them. In this conception, nature was passive and feminine, merely raw material waiting to be acted upon by masculine creativity, a conception that underlay industrial society's seizure and alteration of natural things and beings. The value of art was similarly located in its transformative powers. On the threshold of his mature art the ambitious young Seurat could have taken great comfort from the words of Charles Blanc: "The highest quality of art, its dignity, is not to be the same thing as nature—it is to distinguish itself from her while imitating her, to use her tongue to speak its own language."[3]

1. *Manette Salomon* (1867), ed. 1894, p. 171.
2. The most sensitive analysis of Seurat's drawing technique has been given by Franz and Growe 1983, although they tend to play down the significance of subject matter.
3. Blanc 1867, ed. 1880, p. 431.

Drawings 1881–1884: Figures

19. *Tambour à Montfermeil*. 1881

DRUMMER AT MONTFERMEIL

Conté crayon, 6⅛ x 4¼ in. (16.8 x 10.8 cm.)

André Bromberg Collection

H 442

PROVENANCE
The artist until 1891. Posthumous inventory, dessin no. 156 (per inscription on reverse of original mount, not recorded by de Hauke). Inherited by the artist's brother-in-law, Léon Appert, Paris, in 1891, until his death in 1925; by inheritance to Mme Léopold Appert; by inheritance to Louise Appert Roussel; by inheritance to François Roussel; private collection, Paris (sale, Ader Picard Tajan [Drouot], November 18, 1989, no. 5); to present owner

EXHIBITIONS
1957 Paris, no. 51
1958 Chicago and New York, no. 16

When this drawing was remounted sometime after 1930, Seurat's descendants recorded two inscriptions on its back: Fénéon's initials and inventory number and "Montfermeil 1881, parades saltimbanques, Place des Marronniers." This work is one of a number of drawings from one sketchbook, most of which show single figures (see cat. nos. 17 and 18). Few have the astonishing aplomb of this drawing. The figure is surrounded by a halo which gives him substance. Even his boot tops have a convincing presence, one that comes from finding an equivalent in light and line for what is actually seen: this is no memory drawing. Because of the close framing and lack of narrative surroundings, however, the drummer exists as a work of art, not as an anecdotal slice of life.

Tambour à Montfermeil demonstrates that Seurat was attracted to public entertainment early in his career. Several colored drawings of clowns and dancers date from about the same time (cat. no. 16), and two or three years later he produced haunting drawings of itinerant entertainers (cat. no. 44).

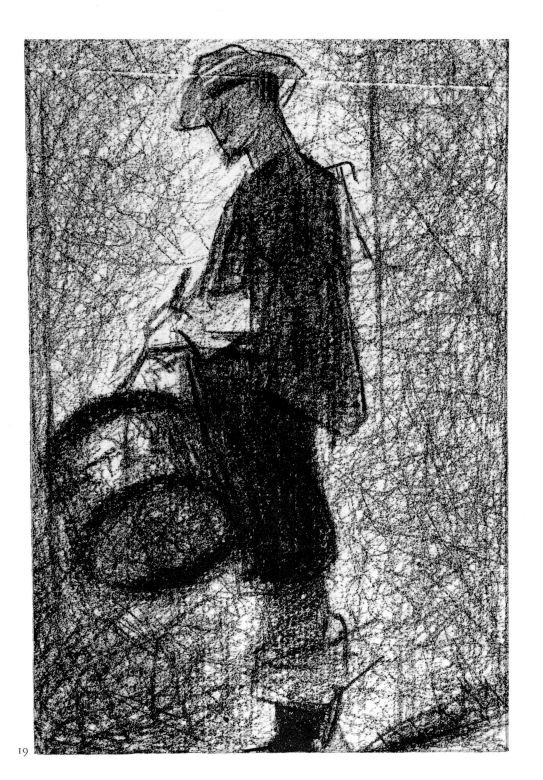

19

20. *Casseur de pierres*. 1881

STONE BREAKER

Conté crayon, 12⅛ x 9½ in. (32 x 24 cm.)

Private collection

H 556

PROVENANCE
Maximilien Luce, Paris, until at least 1926*

EXHIBITIONS
1908–09 Paris, no. 176
1926 Paris, Bernheim-Jeune, no. 130
1983–84 Bielefeld and Baden-Baden, no. 27

*History of subsequent ownership omitted at lender's request.

Although not a study for a painting, this figure is close to several stone breakers in Seurat's early paintings, including the man to the left in *Casseurs de pierres, Le Raincy* (cat. no. 89). In both the light shirt is shown against a dark ground and the dark trousers against a light ground. Here this results in a strong surface pattern, which nonetheless detaches the man from his surroundings. The figure has a sculptural solidity, his archaic immobility in contrast to the spontaneous movement of the previous drawing. Facial features are elided, as are hands, feet, and details of

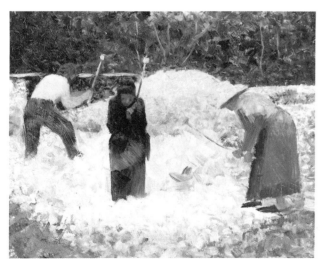

Seurat, *Casseurs de pierres, Le Raincy* (Stone Breakers, Le Raincy), 1881. Norton Simon Art Foundation, Pasadena, California (H 38)

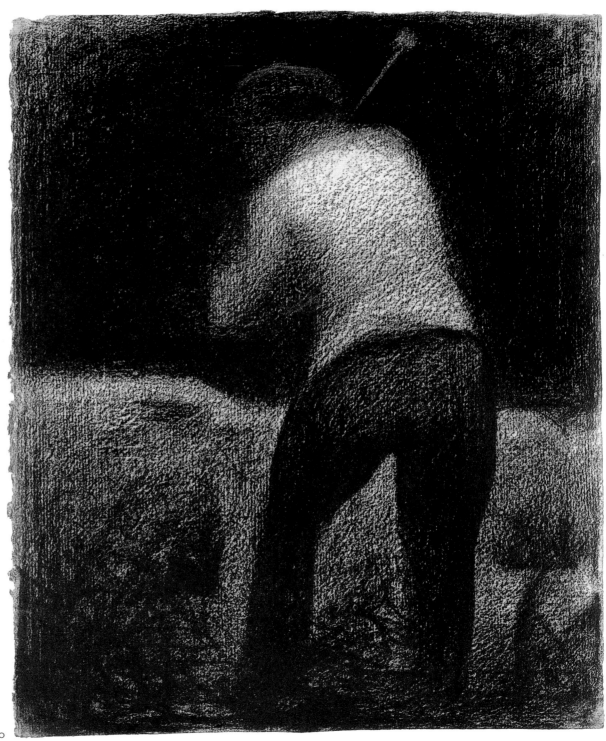

20

clothing. His tilted shoulders, his bent arm, and his hammer express the large movements of the body that are the essence of the composition. This figure recalls Millet's peasants, and Seurat's solemn treatment, like that of the Barbizon master, endows a solitary worker with great nobility.

Seurat's fellow Neo-Impressionist Maximilien Luce (1858–1941) once owned this drawing; whether it was given to him or whether he chose it, it suited his anarchist belief in the dignity of labor.

21. *Le marchand d'oranges.* 1881

ORANGE VENDOR

Conté crayon and white chalk, 12¼ x 9¾ in. (31.1 x 24.8 cm.)
Signed and dated lower left: Seurat 81

Musée du Louvre, Département des Arts Graphiques, Fonds du Musée d'Orsay, Paris, Gift of Baronne Eva Gebhard-Gourgaud, 1965 R.F. 31.027

Exhibited in New York only
H 450

PROVENANCE
Félix Fénéon, Paris; Baron Napoléon Gourgaud, Paris, until his death in 1944; by inheritance to Baronne Eva Gebhard-Gourgaud, in 1944, until her death in 1959; her estate, 1959–65; given to the museum, 1965

EXHIBITIONS
1908–09 Paris, no. 103
1936 Paris, no. 94

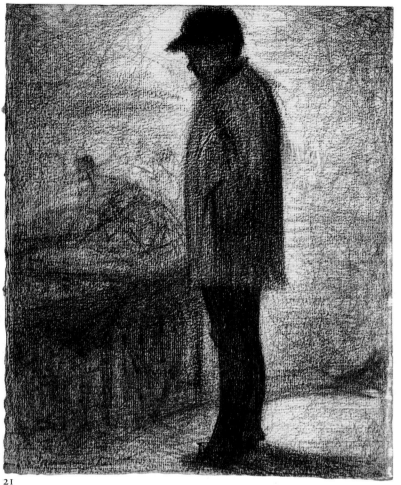

21

Honoré Daumier, *Ce qui explique la vogue des cache-nez* (In explanation of the fashion for mufflers). Lithograph (Delteil 2735), in *Le charivari* (January 11, 1856). The Metropolitan Museum of Art, New York. Gift of E. de T. Betchel, 1952, 52.633.1

Many small drawings of ordinary people standing, sitting, or going about their tasks prepared the way for this drawing by the twenty-year-old Seurat, but its size and skill are still surprising. The much smaller *Tambour à Montfermeil* (cat. no. 19), also dated 1881, shows Seurat's ability to grasp a single figure in characteristic profile and place it in an atmospheric space. Both the vendor and the drummer fill the whole page from top to bottom. Like Seurat's other street figures, the vendor stems from a mid-century tradition of journalistic illustrations and caricatures of Parisian tradespeople, entertainers, vendors, and promenaders, the anonymous population of the city's streets. For Balzac, Baudelaire, Daumier, Gavarni, the Goncourts, Zola, Manet, and Degas, modernity meant the

contemporary urban figure rather than the gods and heroes of past art.

This orange seller recalls Seurat's Beaux-Arts drawings of statues and studio models: the single figure, in profile, stands on a schematic base. But Ingres and Lehmann could not show Seurat how to place modern people in believable if summary urban settings. He thus turned to the graphic arts, particularly Daumier's lithographs, for drawing techniques that suited contemporary subjects. In the present work his conté crayon achieves something of the freely composed grays of Daumier's lithographs, the figure has the same kind of pedestal shadow, and the urban setting is similarly hinted at in a few generalized images. Daumier also offered lessons in typifying city-dwellers in large,

clear shapes, often in profiles that read quickly. We also read Seurat's vendor at a glance, for his stolid, waiting pose *is* virtually the whole story, needing only the shadowy cart to explain his trade.

A light glow partly detaches the young man from the background (small streaks of white gouache correct the gray near his back). The indefinite space around him was created by soft horizontal strokes that blend together, aided by a few thin bending lines. For the wagon Seurat used just enough curving and angular movements to identify the object without giving it sharp focus. In this fashion he integrated all areas; the drawing is further unified by the paper's texture, which is everywhere revealed, even in the dark trousers and hat. This well-

controlled structure, together with the figure's lack of facial features and his quiet pose, removes him from the realm of Daumier's caricature. To some this might seem to deny significance to the subject. Seurat was, however, devoted to these urban figures, a veritable catalogue of city-dwellers elevated to monumental status. Free of anecdote, they have a remarkable dignity and reveal what Growe has called the "pathos of anonymity."[1]

1. Franz and Growe 1983, p. 43.

22. *Nourrice et enfant.* 1881–82
NURSE AND CHILD

Conté crayon, 12⅛ x 9½ in. (31 x 24 cm.)

Musée du Louvre, Département des Arts Graphiques, Fonds du Musée d'Orsay, Paris, Gift of Paul Jamot, 1941 R.F. 29.302

Exhibited in New York only
H 487

PROVENANCE
Eugène Druet, Paris; Bernheim-Jeune, Paris, by 1908–09; Paul Jamot, Paris, from 1909 until 1941; his gift to the museum, 1941

EXHIBITIONS
1908–09 Paris, no. 155
1933–34 Paris, no. 83
1936 Paris, no. 113

One of Seurat's favored subjects is a nurse with a child (see also cat. nos. 26 and 43), another of the familiar figures of Parisian parks and streets through whom he presents a cross section of his society. Although the nurse and her charge lack features, their identities and their relationship are clearly presented. Seated on an outdoor bench, the nurse wears the cap of her profession, a dark cape, and a light skirt. The child, thickly swaddled, reaches its arm out to the nurse's neck, a movement shown not by any edges or contours but by a horizontal area of light that materializes from the gray. Similarly, we judge that the nurse supports the infant with an arm held forward under her cape because lighter tones there indicate the bulge of her arm and hand.

22

Recording observations like *Le couple* and *Femme sur un banc* (cat. nos. 17 and 18) in myriad small notebook pages, Seurat learned how to build figures in patches of light and dark. In this large drawing the same principle is applied but with a much freer handling of the crayon. Oppositions of light and dark determine the overall pattern: the infant and the nurse's cap and skirt are surrounded by darker tones, the nurse's cape and the bench by lighter ones.

Seurat used delicate touches to establish the main areas in soft grays and whites and then moved the point of the greasy conté in swirls and dashes to form the darker regions. He bore down hard on the crayon for the darkest areas at the left and right and finally modulated the whole with light rubbings and eddies, which produce such slight differences in tone as those that locate the infant's raised arm. Such subtleties may reflect constant staring at the

subject, although it is usually assumed that these larger drawings were done in the studio. No studies survive for them, however, and it is hard to believe that all of them would have disappeared had he regularly used them (it is equally hard to believe that he worked only from memory). In any event, the looser treatment of the present drawing is not an "advance" over the less agitated handling of *Le marchand d'oranges* (cat. no. 21), nor is it an earlier phase. In both Seurat preserved the essential structure of light-dark contrasts.

23. *Couseuse.* 1881–82

WOMAN SEWING

Charcoal on gray paper, 9⅛ x 7⅛ in. (23.1 x 18.1 cm.)

Whitworth Art Gallery, University of Manchester

H 446

PROVENANCE
The artist until 1891. Posthumous inventory, dessin no. 296. Inherited by the artist's brother, Émile Seurat, Paris, in 1891; Félix Fénéon, Paris; Percy Moore Turner, London; A. E. Anderson, until 1930; his gift to the museum, 1930

EXHIBITIONS
1900 Paris, Revue Blanche, *hors cat.*
1908–09 Paris, no. 95

This unfinished drawing reveals Seurat's way of working. He outlined the woman's shoulders and arms in thin streaks which would have disappeared under the play of the charcoal had he carried the drawing further. The parallel diagonals on the right would have become a smoother mass of black and gray, and both body and background would then have formed an atmospheric continuity. Equally characteristic of the young artist's method is the way in which the cloth is drawn in chevron-shaped patches, not in lines and edges.

This is one of the few post-1880 drawings that Seurat did entirely in charcoal. Its dark tones are matte gray rather than the waxy black they would be in conté crayon. His preference for conté must have stemmed from the quality of its blacks, deeper than those possible in charcoal.

23

24. *Le laboureur.* 1881–82

MAN HOEING WITH A CULTIVATOR

Conté crayon, 13¼ x 9⅜ in. (33.6 x 26.4 cm.)

Musée du Louvre, Département des Arts Graphiques, Fonds
du Musée d'Orsay, Paris, Gift of Comte Charles de Noailles through
the agency of the Société des Amis du Louvre, 1926 R.F. 6859

Exhibited in Paris only
H 558

PROVENANCE
Paul Signac, Paris; Jacques Rodrigues-Henriques, Paris; Comte
Charles de Noailles, until 1926; his gift to the museum, 1926

Suburban and rural figures appear in Seurat's work in the
early 1880s, alongside urban figures. Van Gogh, different
though he was, also drew and painted peasants and
workers at the same time. Both admired Millet, but—until
van Gogh went to Arles—neither made a rigorous sepa-
ration of village and rural world from the city. Seurat's
plowman might be a suburban or village gardener, for the
slender arms of his implement have the weight of a hand
cultivator. Whether plowman or gardener, he is the rural

Seurat, *Le moissonneur* (The reaper), 1881.
Ex coll. J. Rodriguez-Henriques (H 456)

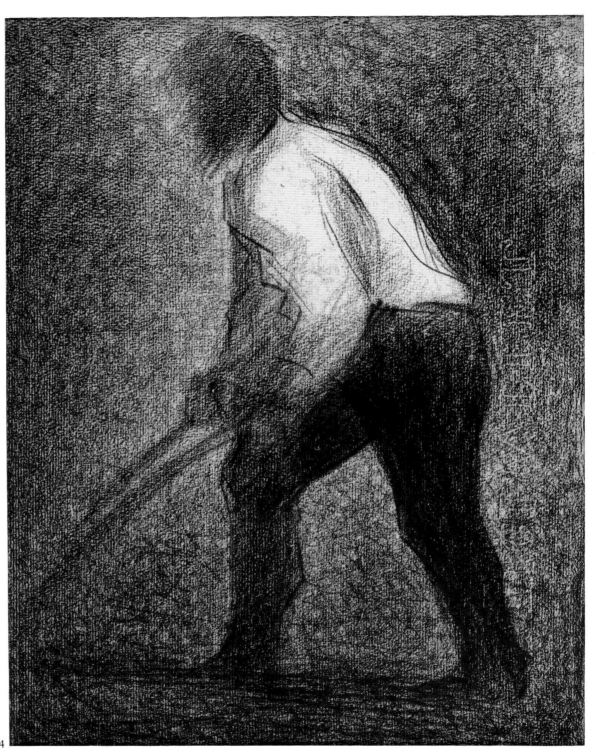

24

counterpart of the Parisian orange sellers, market porters, and nurses, an ordinary citizen going about his task, treated with dignity and in his anonymity transformed into a social type.

Le laboureur can be confidently ascribed to 1881 by comparison with *Le marchand d'oranges* (cat. no. 21) and with another work signed and dated 1881, *Le moissonneur*. Despite superficial differences, in all three the figure is differentiated from its background by contrasts of light and dark and of textures. The shirts of the plowman and the harvester do not have unbroken outlines but are drawn with free lines that run over the surface to form a permeable border between figure and environment. The plowman's head is more summarily indicated than the other two. This is an extreme instance of Seurat's refusal to allow a narcissistic identification with his subject's face by concentrating attention wholly on the figure. Faint pencil lines are visible along the man's forward leg and the plow handles, guidelines that Seurat probably used in other drawings but that he normally covered over.

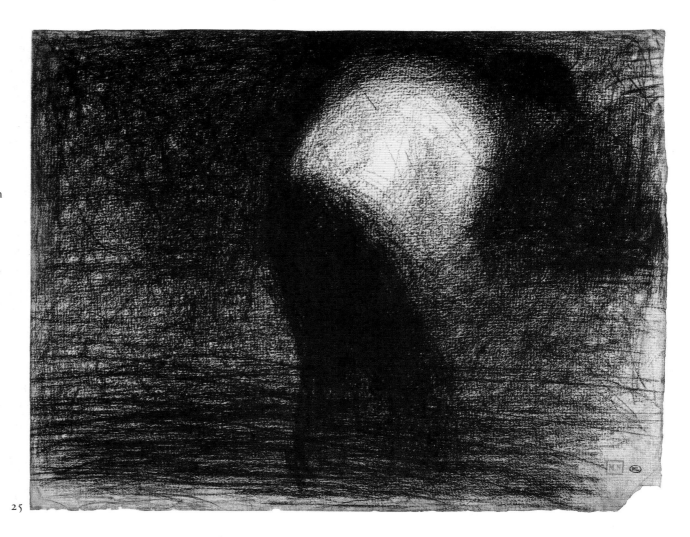

25

25. *Le jardinier*. 1882–83

GARDENER

Conté crayon, 9¾ x 12⅜ in. (24.8 x 31.5 cm.)

Verso: partial figure of a man wearing a cap

Musée du Louvre, Département des Arts Graphiques, Fonds du Musée d'Orsay, Paris, Gift of Camille Pissarro, 1904 R.F. 29.546

Exhibited in New York only
H 562

PROVENANCE
The artist until 1891. Posthumous inventory, dessin no. 139. Inherited by the artist's brother, Émile Seurat, Paris, in 1891, until 1900; sold to Camille Pissarro, Paris, in 1900, until his death in 1903; his gift, realized by his son Lucien Pissarro, to the Musée du Luxembourg, Paris, April 15, 1904; transferred to the Musée du Louvre, 1947

EXHIBITIONS
1900 Paris, Revue Blanche, *hors cat.*
1908–09 Paris, no. 134
1926 Paris, Bernheim-Jeune, no. 45
1958 Chicago and New York, no. 31

When Camille Pissarro bequeathed this drawing (and several others) to the French nation in 1904, it was called *Homme en bras de chemise travaillant la terre* (Man in Shirt

Sleeves Working the Soil), a title that associates it with the closeness to nature and labor central to the anarchist ideals of Pissarro and other Neo-Impressionists, including his son Lucien, Angrand, Luce, and Signac. Its current prosaic title partly detaches it from that meaning because in our delight in pure form and in our distance from hand labor, we have gradually lost the relationship between gesture and work that Seurat's generation still felt. Pissarro's and Seurat's simplified patterns abetted that loss. Here the man's bent back indicates that he is working, but we see no tool or indeed any detail, and his forearms disappear in the gray of the terrain.

Comparison with Seurat's many small paintings of similar figures (cat. nos. 78 and 94) indicates that the man is working in a field against a backdrop of foliage, either hoeing or wielding a stone-breaking hammer. The figure's dark trousers are set against the lighter field and his white shirt is flanked by dark foliage. These darks and lights form a loose checkerboard pattern, which has, however, no rigid separations and is modified by the horizontal shadow at the figure's feet and the light break in the upper right (opposing his dark cap). The veil of atmosphere that suffuses this drawing probably means that it was done after the preceding one; it is certainly at least a year later than the more volumetric *Casseur de pierres* (cat. no. 20), despite the similar light-dark pattern. The drawing of a human figure on the verso, although fragmentary, probably confirms the later date, since it is conceived entirely in terms of light and dark.

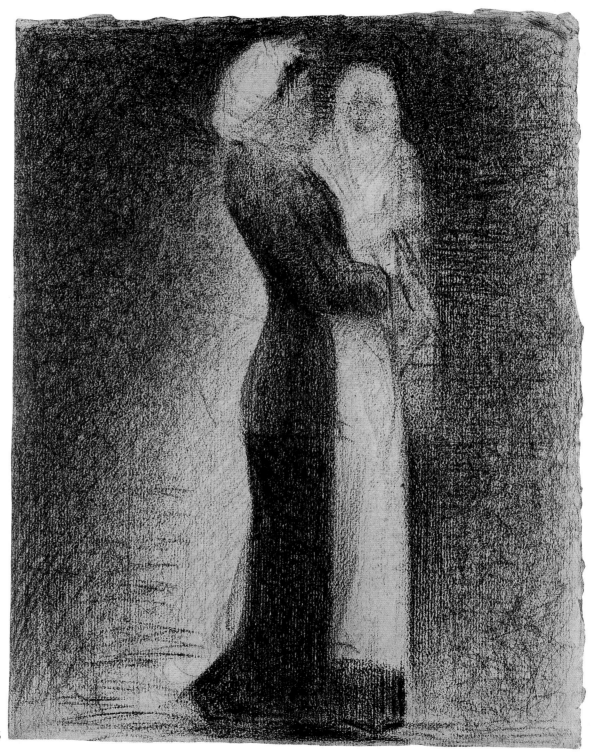

26

26. *La nourrice*. 1882–83

NURSE

Conté crayon, 12⅝ x 9⅝ in. (32 x 24.4 cm.)

Woodner Family Collection, New York

H 488

PROVENANCE
The artist's family; Octave Mirbeau, Paris, until his death in 1917; by inheritance to his widow, Mme Octave Mirbeau, from 1917 until 1919 (Mirbeau sale, Durand-Ruel, Paris, February 24, 1919, no. 52); Dikran Khan Kélékian, Paris and New York, until 1922 (Kélékian sale, American Art Association, New York, January 30–31, 1922, no. 12, for $200); purchased at this sale by Bourgeois Galleries, New York; Alfred Rothbart, New York, by 1924, until his death;* acquired by present owner by 1977

EXHIBITIONS
1900 Paris, Revue Blanche, *hors cat.*
1924 New York, no. 31
1977 New York, no. 8
1990 New York, no. 135

*See Herbert 1962, p. 180, no. 66

Seurat's nurses with children are the urban counterparts of his men laboring in suburban or rural fields. In *Nourrice et enfant* (cat. no. 22) a nurse sits with a child in a park; in *Le bonnet à rubans* (cat. no. 43) another pushes a child in a pram. In the present drawing a nurse holds a child upright, looking past it to the right in the direction she is walking. (At first glance she appears motionless, but her cocked foot pushes her skirt.) Her shoulders are thrust back by the weight of her charge; she also carries a blanket or wrap whose gray folds partly frame the child. Surmounting the vertical of the nurse's apron, the statuelike infant looks out at the viewer, a rare instance of such communication in Seurat's work (another is *Maurice Appert*, cat. no. 175, also a child). It evokes the kind of encounter one has with strangers on the street and gives an immediacy to forms that are otherwise like a statue of a Roman matron or a Madonna with Child.

No document connects Seurat with Goya, but this drawing brings the Spaniard's etchings to mind. Aided by the hint of strangeness that rises from what is, after all, a most ordinary public sight, we find similarities in Goya's etched lines and gray aquatints and in the alternating lights and darks which they form. Seurat's conception is more thoroughly atmospheric, for the few lines that he makes visible are part of the enveloping light and are not descriptive. Nonetheless he wields the crayon almost as Goya does his needle. He forms the darks on either side of the child with firm horizontals and on the left with diagonal and lateral hatching, bringing the strokes close together to build up relatively even tones. His softly swirled and rubbed grays have a counterpart in Goya's speckled aquatint. Although the columnar austerity of Seurat's design is distant from the interlocked complexities of Goya's etching, the two images suggest that the young artist may have found sustenance in traditional printmaking.

Octave Mirbeau, the writer and critic, once owned this drawing, but it is not known if it was a gift or a purchase. A friend of Camille Pissarro's and of Monet's, Mirbeau had only circumspect praise for Seurat. Like J.-K. Huysmans, he much preferred Seurat's drawings to his paintings, perhaps because of their mysterious qualities.

Goya, *Pobrecitas I*. Etching and aquatint from *Caprichos*, pl. 22. The Metropolitan Museum of Art, New York. Gift of M. Knoedler and Co., 1918, 18.64.22

27. *Dame au bouquet, de dos.* 1882–83

WOMAN WITH BOUQUET, SEEN FROM BEHIND

Conté crayon, 12⅛ x 9⅝ in. (31.6 x 24.4 cm.)

E. W. Kornfeld, Bern

H 496

PROVENANCE
The artist until 1891. Posthumous inventory, dessin no. 314. Inherited by the Appert family, Paris, in 1891; by inheritance to the artist's godson and cousin, Paul Levasseur, Paris; to present owner by 1983

EXHIBITIONS
1957 Paris, *hors cat.*
1983–84 Bielefeld and Baden-Baden, no. 30

Like *Le marchand d'oranges* and *La nourrice* (cat. nos. 21 and 26), this drawing presents a person on a street, but because the environment is reduced to a vague sense of light and air, there is no anecdote, no narrative. Impersonal? Yes, but so too are Greek statues. At the heart of Seurat's art lies his ability to invest his figures with an iconic presence. Here he has given a contemporary woman the enduring qualities of the antique sculptures he had drawn in school. This woman's authority comes in large part from her being centered on the page (if she were smaller and off to the side, how different she would be). She herself seems to generate the light glow that surrounds her, as though Seurat had transferred his power to her. She acquires, that is, a special kind of fictional life because her human form alone is the active agent. Like Phidias, Seurat interpreted life by way of the human body.

The woman seems to be walking away from the viewer; both her arms have the forward position of someone who is active, and the dark patches on her skirt suggest movement. She nonetheless has a curious appeal: by holding her bouquet away from her body, she makes a gesture of presentation.

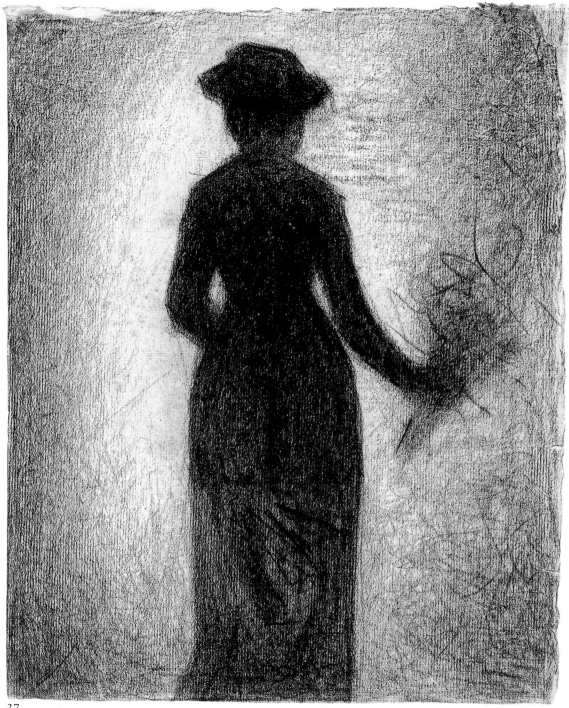

27

28. *Devant le balcon.* 1882–83
ON THE BALCONY

Conté crayon, 12⅜ x 9½ in. (31.4 x 24.5 cm.)

Musée du Louvre, Département des Arts Graphiques, Fonds du Musée d'Orsay, Paris, Gift of Camille Pissarro, 1904 R.F. 29.548

Exhibited in Paris only
H 587

PROVENANCE
The artist until 1891. Posthumous inventory, dessin no. 114. Inherited by the artist's brother, Émile Seurat, Paris, in 1891, until 1900; sold to Camille Pissarro, Paris, in 1900, until his death in 1903; his gift, realized by his son Lucien Pissarro, to the Musée du Luxembourg, Paris, April 15, 1904; transferred to the Musée du Louvre, 1947

EXHIBITIONS
1900 Paris, Revue Blanche, *hors cat.*
1908–09 Paris, no. 130
1926 Paris, Bernheim-Jeune, no. 41
1933–34 Paris, no. 82
1984 Baden-Baden, no. 50

In a large number of drawings Seurat shows a matronly woman seated, sewing or reading by lamplight or by a window. From age nine onward he had been the only child in a household largely dominated by women. Mme Seurat's husband spent much of his time at his Le Raincy villa, and her widowed sister, Anaïs Haumonté, often kept her company. The two sisters are likely to be the subjects of these drawings, which evoke the tranquil middle-class interior at 110 boulevard Magenta. In the present drawing a woman reads by a balcony, whose railing, so characteristic of Haussmannian Paris, appears in *Femme de dos, penchée, Le balcon,* and *Lecture* (cat. nos. 29, 71, and 177). The railing survives today, proving Seurat was faithful to its lines. Here its volutes have a strange prominence, rivaling the woman's profile.

 This drawing is one of seven that Camille Pissarro purchased from the Seurat retrospective of 1900 at the Revue Blanche and bequeathed to the French nation (all are in the present exhibition; see cat. nos. 11, 25, 46, 54, 58, and 136). He may have chosen this one because he knew Seurat's mother and visited her apartment; she commissioned a small landscape from him in the winter of 1886–87.[1]

1. CP, vol. 2, no. 38 (January 14, 1887).

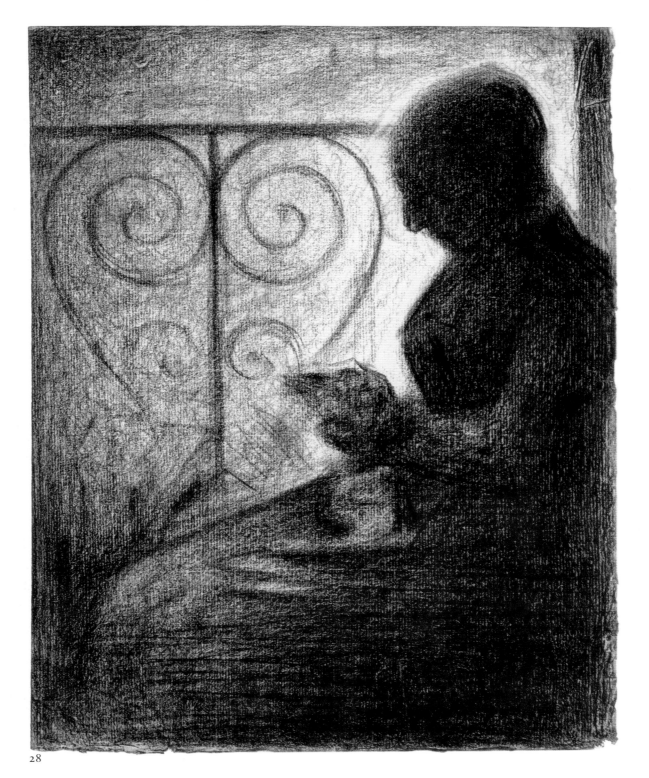

28

29. *Femme de dos, penchée.* 1882–83

WOMAN SEEN FROM THE BACK, BENDING
FORWARD

Conté crayon, 12¼ x 9½ in. (31.1 x 24.2 cm.)

The Fine Arts Museums of San Francisco, Achenbach Foundation for
Graphic Arts, Memorial Gift of Dr. T. Edward and Tullah Hanley,
Bradford, Pennsylvania

H 494

PROVENANCE
Earliest whereabouts unknown; Bourgeois Gallery, New York; sold
to Leonie Knoedler Sterner, New York; Mrs. Marie Sterner, New
York, until 1929 (Sterner sale, American Art Association, Anderson
Gallery, New York, November 26, 1929, no. 220, for $1,300); pur-
chased at this sale by O'Hanart de Cordova; Marie Sterner Galleries,
New York, until 1936 (Sterner Galleries sale, Rains Gallery, New
York, April 23, 1936, no. 74); Henry Sykes, Chicago; Dr. T. Edward
Hanley, Bradford, Pennsylvania, presumably by 1937,* until 1969;
gift, with Tullah Hanley, to the museum, 1969

EXHIBITIONS
1949 New York, no. 46
1958 Chicago and New York, no. 24
1983–84 Bielefeld and Baden-Baden, no. 29

*A Seurat drawing, without title, is included among the works owned
 by T. Edward Hanley in 1937 (collector's file, Frick Art Reference
 Library, New York).

The balcony railing of the previous drawing reappears
here in a much fainter version. Seurat kept it in the middle
distance to indicate that the woman is indeed leaning into
space. The lighter grays along the woman's hips and back,
together with the rounded flare of her coat, give her a
convincing three-dimensionality. The heavy vertical marks
of the crayon prop her up while suggesting folds in her
skirt (in the previous drawing the horizontal streaks of
crayon maintain the profile flatness of the dress). The top
of the woman's polygonal head coincides with the hori-
zontal of the railing, and since she is flanked by its
uprights, her upper body is thus centered in a "frame," a
symmetrical effect that seems to flatten the page. In the
lower right the sawtooth pattern of the woman's garment
is a striking surface element. The adjacent forms, which
suggest potted plants, respond with triangular movements;
their jagged rhythms act as a counterpoint to the woman,
whose matronly bulk speaks of imperturbable strength.

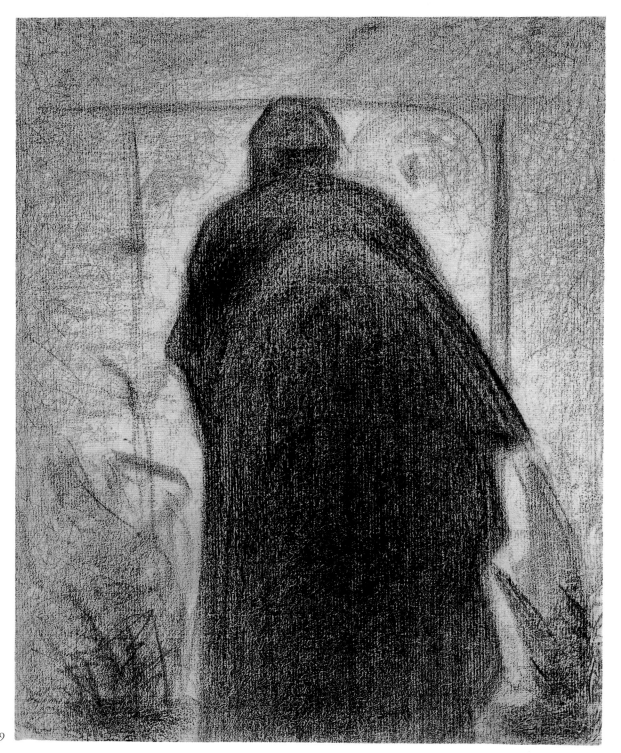

29

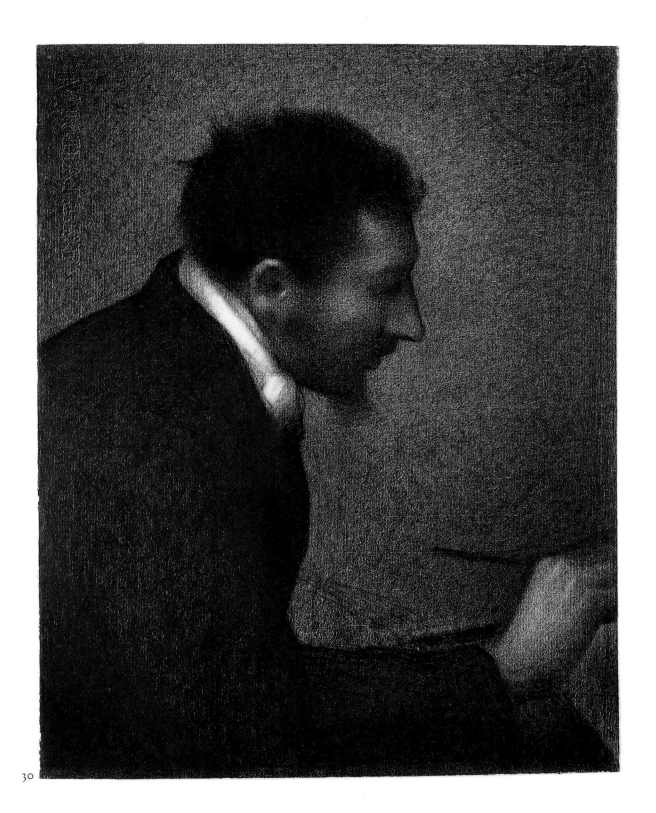

30

30. *Aman-Jean.* 1882–83

Conté crayon, 24½ x 18¾ in. (62.2 x 47.6 cm.)
Signed and dated in conté crayon upper right (but visible only under ultraviolet light): Seurat/1883

The Metropolitan Museum of Art, New York, Bequest of Stephen C. Clark, 1960 61.101.16

Exhibited in New York only
H 588

PROVENANCE
Amand-Edmond Jean (Aman-Jean), Paris and Château-Thierry, from 1883 until June 1930; sold to De Hauke and Co./ Jacques Seligmann and Co., New York, in June 1930, until February 1931 (stock no. 1539);* sold to Stephen C. Clark, in February 1931, until 1960; his bequest to the Museum, 1960

EXHIBITIONS
1883 Paris, no. 3189 (listed erroneously as *Broderie*)
1884–85 Paris, no. 243
1908–09 Paris, no. 151
1947 New York, no. 21A (addendum)
1949 New York, no. 34
1953 New York, no. 25
1958 Chicago and New York, no. 38
1977 New York, no. 23

*De Hauke and Co., New York, was set up to handle modern paintings for the firm of Jacques Seligmann and Co. in 1926; it was renamed Modern Paintings, Inc., in 1930. In 1931 César de Hauke resigned as head of Modern Paintings, Inc., and returned to Paris. In 1934 Modern Paintings, Inc., was dissolved, and its assets were turned over to Jacques Seligmann and Co., and to Tessa, another Seligmann company.

Stock books and gallery correspondence are preserved in the "Jacques Seligmann and Co. gallery records, 1913–1978," Archives of American Art, Smithsonian Institution, Washington, D.C. This material was consulted by Anne M. P. Norton, with the assistance of Judy Throm.

Seurat's study of his friend Aman-Jean is one of the great portrait drawings of the nineteenth century. A remarkably assured work for a young artist, it was accepted by the Salon of 1883 shortly after his twenty-third birthday; it was the first work he exhibited in public and the first to receive notice in the press. Among the mass of works on display it impressed the critic Roger Marx enough to elicit his remark: "an excellent study in light and dark, a meritorious drawing that cannot be the work of a newcomer."[1]

This is a rather conservative work, much larger than his customary drawings, although it is on the same kind of paper. Given the larger sheet, the tiny interstices of exposed paper are proportionately smaller than, say, those of the portrait of his mother (cat. no. 31), so from a slight distance the illusion of three-dimensionality is all the greater. Aman-Jean's head is set off from the background by its luminescent halo. Highlights pick out his ear, temple, and cheekbone. The wide flash of white along his neck isolates his head, adding to the impression that he is concentrating entirely on the picture in front of him. In this manner Seurat tells us that his friend's artistic gifts are marked by refined intelligence. His body and arm, echoing the rectangle of the paper, anchor his figure on the page in a classically calm pose that stems from a long tradition going back to Holbein. Although Seurat had earlier copied two drawings by Holbein (H 283, 284), the pose may not have been specifically derived from that master: countless later portraitists had utilized the same general design. When he embarked on this portrait, Seurat must have had public exhibition in mind, so he chose a composition that would make evident his link with tradition. At one point the portrait would have appeared even more conventional, for there were once brushes in the crook of Aman-Jean's arm; they still show faintly, although Seurat tried to cover them over. The least traditional element of the drawing is the artist's hand. Its blocky form recalls similar features in some of Degas's pictures, and it predicts the simplifications of Seurat's later work.

Aman-Jean later related that his portrait was done in the studio he and Seurat shared on the rue de l'Arbalète (Appendix B).

1. Marx 1883.

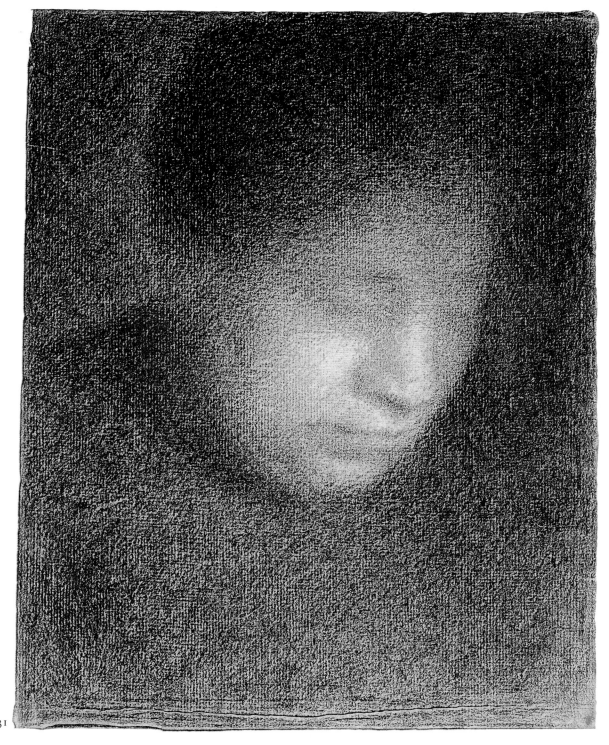

31

31. *Mme Seurat, mère.* 1882–83

THE ARTIST'S MOTHER

Conté crayon, 12 x 9¼ in. (30.5 x 23.3 cm.)

Mrs. Alexander Lewyt

H 583

PROVENANCE
The artist's mother, Mme Ernestine Seurat, Paris, until 1891; her
gift to Lucien Pissarro, Paris, in 1891, until his death in 1944; by
inheritance to his widow, Mme Esther Pissarro, Paris, from 1944
until 1949; her gift to John Rewald, New York, November 1949,
until at least 1951; acquired by present owner by 1953

EXHIBITIONS
1950 Venice, no. 5
1950 Rome, no. 11
1953 New York, no. 28
1958 Chicago and New York, no. 61
1977 New York, no. 22
1983–84 Bielefeld and Baden-Baden, no. 55

This portrait, one of many Seurat made of his mother, is
an exercise in modeling without lines. No edges can be
found, only contours that arise tremulously from the
enveloping light and dark. The pale light to the left
discloses Mme Seurat's head and shoulder, but to the right
her hair and shoulder merge with the black veil that
sweeps down, turning lighter as it descends. Her head
casts a dark shadow on her shoulder. The lighter gray at
the bottom of the page lets us sense rather than see her
body; otherwise there is only her face.

With lowered eyes she might be sewing or reading, as
Seurat represents her in other drawings, but it is equally
possible that her eyes are closed. In either case, although
all signs of sentiment have been excluded, the artist treats
her with the dignity one would give to a sculpted head
from antiquity. No other head in his oeuvre fills so much
of the page.

Seurat's mother gave this drawing to Lucien Pissarro,[1]
who had exhibited with Seurat from 1886 onward.

1. CP, vol. 3, no. 660 (May 9, 1891). She also gave him a study for *La
Grande Jatte* (cat. no. 119). In his entries for both works, de Hauke
listed the owners out of sequence, so Lucien Pissarro does not
appear as the first owner.

32. *Broderie; La mère de l'artiste.* 1882–83

EMBROIDERY; THE ARTIST'S MOTHER

Conté crayon, 12¼ x 9½ in. (31.2 x 24 cm.)

The Metropolitan Museum of Art, New York, Purchase, Joseph
Pulitzer Bequest, 1951; acquired from The Museum of Modern Art,
Lillie P. Bliss Collection 55.21.1

Exhibited in New York only
H 582

PROVENANCE
The artist's mother, Mme Ernestine Seurat, Paris, until at least 1892
and probably until her death in 1899; by inheritance to the artist's
brother, Émile Seurat, Paris, until his death in 1906; by inheritance
to his widow, Mme Émile Seurat, Paris, from 1906; Félix Fénéon,
Paris, by 1926, until 1929; sold to De Hauke and Co., New York, in
January 1929, until October 1929 (stock no. 1329);* sold to
Lillie P. Bliss, New York, in October 1929, until her death in 1931; her
bequest to The Museum of Modern Art, New York, 1931, until 1951;
purchased by the Metropolitan Museum, 1951

EXHIBITIONS
1892 Paris, Indépendants, no. 1118
1900 Paris, Revue Blanche, no. 40
1920 Paris, no. 62
1922 Paris, no. 14
1926 Paris, Grand Palais, no. 3221
1926 Paris, Bernheim-Jeune, no. 79
1929 New York, no. 71
1935 Chicago, no. 10
1936 Paris, no. 96bis
1947 New York, no. 22
1948 New York, no. 56
1949 New York, no. 35
1953 New York, no. 26
1958 Chicago and New York, no. 52
1977 New York, no. 21

* See provenance note, cat. no. 30.

This drawing was refused by the same Salon jury that
accepted Seurat's portrait of Aman-Jean. It is hard to
believe that it would have been considered unskilled or
radical in 1883. The larger drawing, however, was more
impressive and more "public," and it therefore may have
been easier to admit by a jury always anxious to limit the
number of works in exhibitions so huge they had become
unwieldy.

The drawing is embedded in the art of the past, recall-
ing Vermeer's *Lacemaker* in the pose, the conception of the
head as a solid ovoid, and the dependence upon atmo-
spheric light. Even the angle of the light (and hence the
principal highlights) is the same. After two centuries of
oblivion Vermeer had been rediscovered by the previous
generation, and his *Lacemaker* hung in the Louvre for
Seurat to see.

Vermeer's oil paint is distant from Seurat's crayon, but
since the young artist eliminated lines in favor of a
continuity of light and dark, he could admire an art
similarly conceived, though in another medium. More-
over, Vermeer and other Dutch artists presented bourgeois
women in domestic interiors, and these depictions consti-
tuted the reservoir of secular images upon which Seurat
drew, consciously or not. In this drawing of his mother
and in *Le noeud noir* (cat. no. 36), *Femme lisant*, and many
others, his figures recall the women in Dutch painting
who with a similar dignified solemnity sit at a table
occupied in everyday tasks or stand reading a letter.

In *Broderie* Seurat's mother is more fully revealed than in
the previous drawing. There only her pensive head is
seen, but it has a greater intimacy than the present image,
from which we are kept at a distance. Here the same
velvety technique suggests a whole, if limited environ-
ment: a chair, wall, the corner of a table, and her sewing,
the attribute of the domestic matron. We are also distanced
by admiration of the drawing's immaculate structure,
including the way the part in her hair continues the
vertical of her nose and then forms a right angle with her
hair. She can as readily be associated with Brancusi as with
Vermeer, and it seems fitting that this drawing was once in
the Museum of Modern Art, New York.

Despite its abstract beauty and lack of sentimentality,
which so appealed to modernists, this image confirms all
that is known about Seurat's mother. She was the center of
his parental home, the epitome of the reliable matron who
admired and supported her son. Franz expressed well the
relationship between the forms of this drawing and the
image they create when he wrote that "something of the
atmosphere evoked by these graphic means—a tranquil-
ity, gentleness and order; the all-pervading twilight and
self-containment of the plane—seems to transmit itself to
the figure and thus takes on meaning in terms of content."[1]

1. Franz and Growe 1983, p. 64.

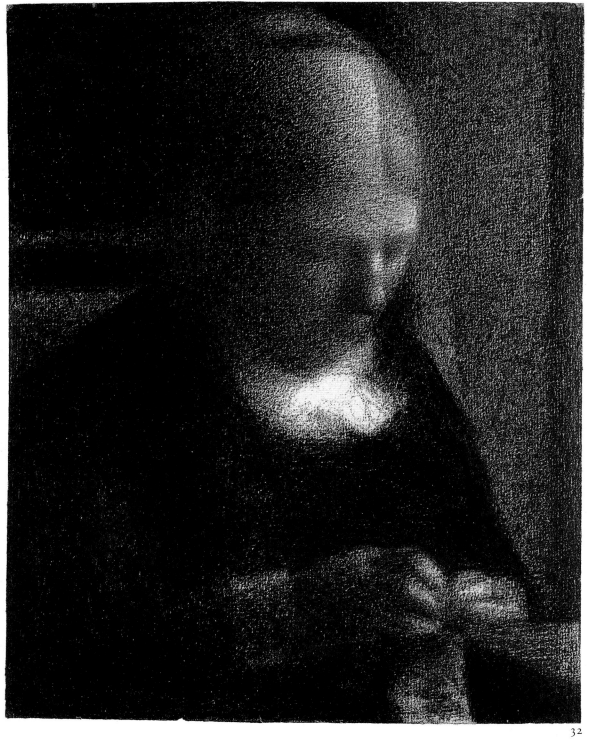

32

Vermeer, *The Lacemaker.* Musée du Louvre, Paris

33. *Le dîneur.* 1883–84

MAN DINING; THE ARTIST'S FATHER

Conté crayon, 12⅛ x 8⅝ in. (31 x 22 cm.)
Signed lower right: Seurat

Private collection

Exhibited in Paris only
H 600

PROVENANCE
The artist's mother, Mme Ernestine Seurat, Paris, by 1891, until
at least 1893 and probably until her death in 1899; to the artist's
brother, Émile Seurat, Paris, from 1899 until 1900; sold to Paul
Signac, Paris, in 1900, until his death in 1935; by inheritance to
Berthe Signac, Paris; by inheritance to Ginette Signac, Paris; to
present owner

EXHIBITIONS
1888 Paris, Indépendants, no. 619
1892 Brussels, no. 20
1892 Paris, Indépendants, no. 1121
1892–93 Paris, no. 54
1900 Paris, Revue Blanche, no. 49
1905 Paris, no. 27
1908–09 Paris, no. 174
1926 Paris, Bernheim-Jeune, no. 61
1957 Paris, no. 57
1958 Chicago and New York, no. 59

We are so much the children of Freud that we wonder
about Seurat's relationship with his parents when we place
this drawing of his father alongside that of his mother (cat.
no. 32). The constant movement of his crayon gives his
father a tentative reality, as though he were made of black
yarn, in contrast to the impression of solid matter that the
artist created in the drawing of his mother. Neither is a
portrait in the usual sense, for each was destined for
exhibition; they were titled *Broderie* and *Le dîneur*, and so
the public need never have known who the models were.
Even so, we are bound to reflect on the deep differences
between these two works. Seurat presents his mother as a
model for a woman engaged in productive domestic work
(this suits what is known of her as a selfless woman
around whom family life centered). He depicts his father
as a man intent only on food (Antoine Seurat lived largely
apart from his wife, returning periodically from his subur-
ban villa to dine at the apartment on the boulevard

33

Magenta). In contrast to the mother's pyramidal solidity, the father's head hangs over the void of his napkin, threatening to fall forward but propped up by the wine bottle. Mme Seurat is a proper middle-class matron, whereas he appears as a lower-class man whose attributes are the wine bottle and the napkin tucked into his collar in petit-bourgeois fashion. He was regarded as a worker by Théo van Gogh who, according to Gauguin, said in 1888 that he had seen Seurat "who has made some good studies showing a good workman relishing a bite to eat."[1]

Paul Signac, who acquired the drawing from the exhibition of 1900 at the Revue Blanche, identified the subject as Seurat's father, whom he had known.[2] He later remarked that Antoine Seurat had an artificial arm, and this knowledge impinges on our reading of the drawing. We cannot help but think that M. Seurat's left arm is weakly off to the side, especially when compared to the powerful dark lever of his active arm.

Seurat's enveloping light suppresses detail and makes the man's head loom skull-like from a skein of lines, creating a brooding image of almost tragic impact. Paul Adam, a critic friendly to Seurat, recognized the poetic force of his light in typically Symbolist terms: "A man . . . meditates facing a bottle, letting his cranium grow heavy above the whiteness of a napkin where the light from a lamp spreads out, irradiates, expands, attenuates, and dies near the convexities of his forehead and cranium."[3]

1. Gauguin to Émile Bernard from Arles, about November 9–12, 1888, in *Correspondance de Paul Gauguin* (1873–88), ed. Victor Merlnès, no. 178.
2. To his friend Lucie Cousturier (Cousturier 1914) and subsequently in Coquiot 1924, p. 30.
3. Adam 1888.

34. *La lampe*. 1882–83

THE LAMP

Conté crayon, 11¾ x 9¾ in. (29.9 x 24.8 cm.)

Private collection

H 578

PROVENANCE
Félix Fénéon, Paris, until 1941 (Fénéon sale, Drouot, Paris, December 4, 1941, no. 20, for 52,000 francs); Henry and Irena Moore, Much Hadham, England, by 1961, until his death in 1986; to present owner

EXHIBITIONS
1908–09 Paris, no. 110
1920 Paris, no. 50
1924 New York, no. 25
1926 Paris, Bernheim-Jeune, no. 93
1936 Paris, no. 83
1983–84 Bielefeld and Baden-Baden, no. 53

This drawing shares with *Le dîneur* (cat. no. 33) a moody strangeness quite different from Seurat's maternal images. We can observe *Broderie* (cat. no. 32) with detachment because the figure does not solicit our interest. In *La lampe* the face is disembodied (there is no indication of neck or shoulders), and the eyes look at us and yet are not visible. The domestic environment is reduced to a lamp, rendered odd by its placement. The lamp sheds either a very feeble light or none at all (both face and lamp may be lit by a window or another light), a bizarre effect that denies the lamp's function as an unambiguous source of light. Rembrandt and Millet are among the artists who taught Seurat that uncanny moods could be created with ostensibly natural effects of light and dark. Seurat's naturalism becomes apparent when he is compared with Odilon Redon, his older contemporary and cofounder in 1884 of the Société des Artistes Indépendants. Redon's *Le prisonnier* more willfully projects us into a world of symbolic reverie, both through its title (which would be alien to Seurat) and through the appeal of its embrasured image.

Seurat, *Femme lisant* (Woman reading), 1882–84. Location unknown (H 584)

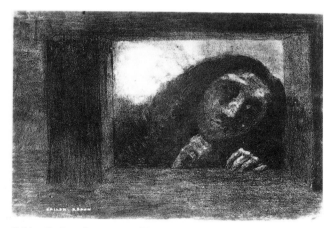

Odilon Redon, *Le prisonnier* (The prisoner), 1882–90. Private collection

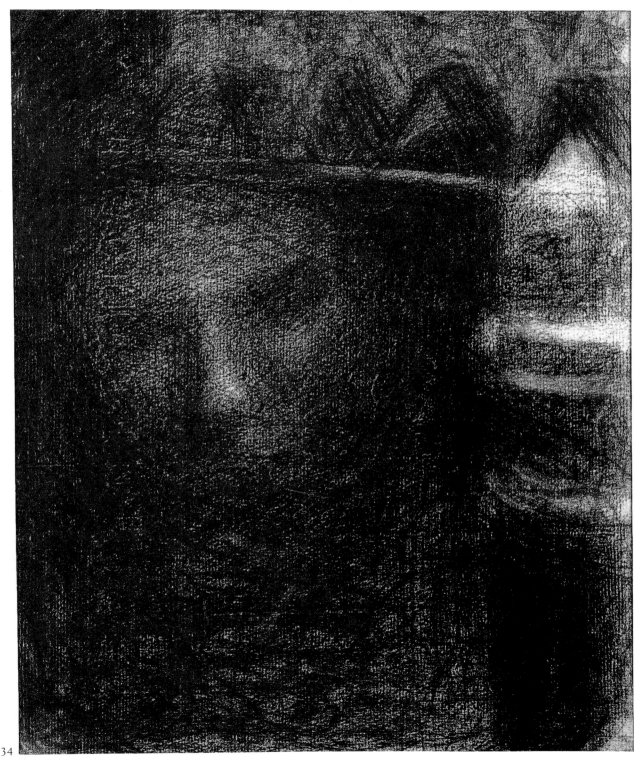

34

35. *Femme au chien.* 1882–83

WOMAN WITH A DOG

Conté crayon, 12⅜ x 9½ in. (31.4 x 24.1 cm.)
"Moline" stamp in red lower right: Seurat

Private collection

H 649

PROVENANCE
Probably Madeleine Knoblock, Paris, from 1891; Jos Hessel, Paris,
by 1926; with C. W. Kraushaar Art Galleries, New York, by 1927,
until 1928; sold to the family of present owner, 1928

EXHIBITIONS
1895 Paris
1926 Paris, Bernheim-Jeune, no. 125
1929 New York, no. 66
1977 New York, no. 34

A walker on a city's streets usually lowers his or her eyes
to avoid engaging a stranger's gaze ("civil indifference" in
Erving Goffman's helpful phrase). Thus this woman's
stare, although a fiction, causes unease in the viewer
(Seurat rarely has us confront his outdoor personages in
this manner). The woman's dog also looks at us, and
although this is a charming, unthreatening incident, it adds
to the directness of the encounter. Another factor of slight
tension is the woman's cape. Its dark horizontal and
radiating lines give it a weblike appearance, different from
its neighboring textures.

The figure's immediacy is counteracted by the general-
ized setting which does not describe a specific place or
moment. The rectilinear background says "building" only
in a generic sense, and the thin horizontals are the merest
reminder of sidewalk or pavement. Set against this mini-
mal environment, the woman's iconic shape, centered on
the page, coalesces into a slightly malevolent silhouette.

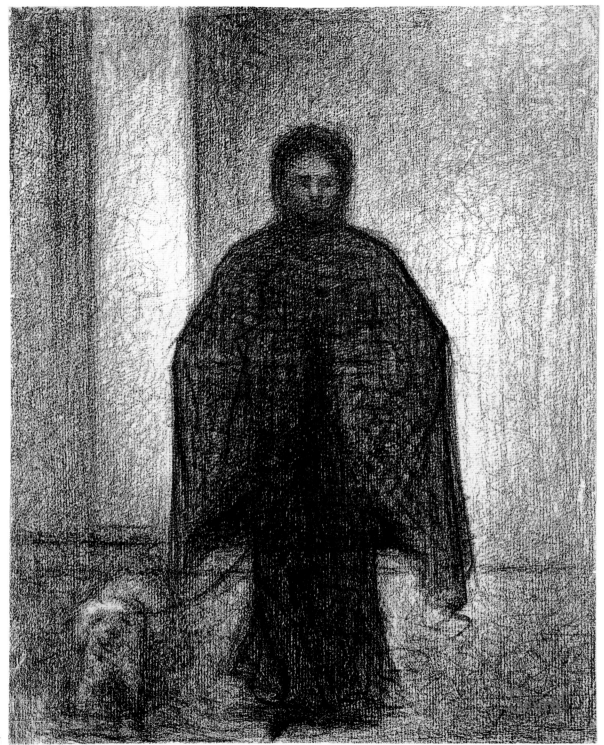

35

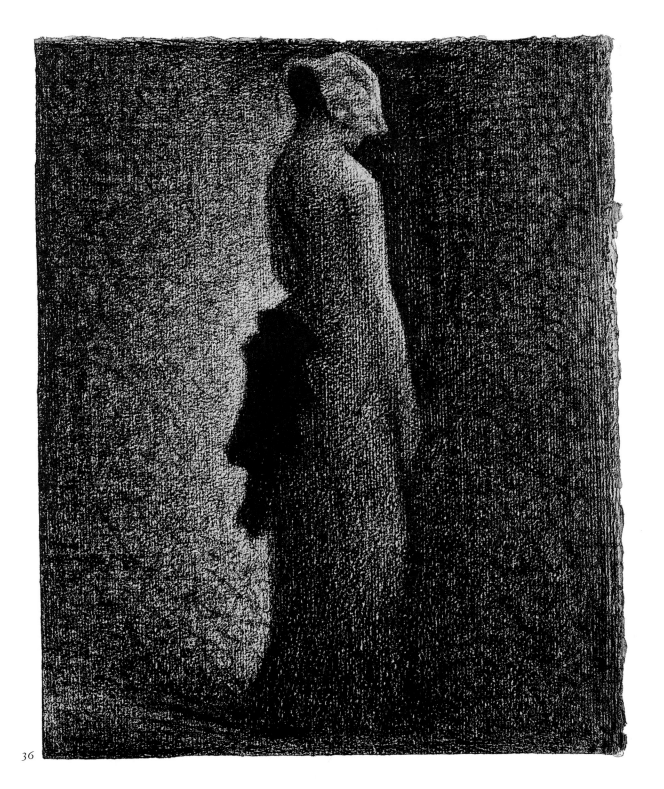

36

36. *Le noeud noir.* 1882–83

THE BLACK BOW

Conté crayon, 12⅜ x 9⅝ in. (31.5 x 24.5 cm.)

Musée du Louvre, Département des Arts Graphiques, Fonds du Musée d'Orsay, Paris R.F. 41.903

Exhibited in Paris only
H 511

PROVENANCE
The artist's brother-in-law, Léon Appert, Paris, until his death in 1925; by inheritance to his son, Léopold Appert, Paris; by inheritance to his widow, Mme Léopold Appert; private collection, Paris; acquired by the Musée d'Orsay, 1989

EXHIBITIONS
1908–09 Paris, no. 157
1957 Paris, no. 64

Like a Greek *kore* reborn in the costume of the 1880s, this young middle-class woman has an arresting presence. Compared, say, with the woman of *Dame au bouquet, de dos* (cat. no. 27), who is a distillation of the ordinary, she has a self-effacing elegance. Her head is bent as if in shyness, and her hat's graceful lines complement those of her body. She is pensive, absorbed in herself. Were it not for her bow, in fact, she might seem overly refined. The drawing centers around that bow whose notched shape is so different from the rest of the costume. It stands out sharply against its halo, a striking element whose blotchy abruptness prevents us from treating the woman as a doll. A flagrant piece of fashion that suggests sexual display, the bow calls attention to the woman's attractions which her demure posture might otherwise deny.

Like Phidias, Seurat made memorable forms out of his contemporaries and their costumes without imitating them in great detail and without specifying their environment. The upright bodies that he drew in school reappear in drawings like *Le noeud noir*. There is little in this drawing that seems "real." Nowhere are Seurat's artificial devices, his mental structures, more apparent than here. The young woman looms out of the shadows because the dark side of her body is set against light and the light side, against dark. At the bottom of the page she is integrated with her space; her skirt loses its right edge in the penumbra of dark grays, and to the left her shadow indicates a ground

plane, giving her form a necessary if minimum foundation. She is not, therefore, like a sculpture in front of a continuous background, because this "background" does not exist independently but only as a reaction to her (remove her and the environing space would be peculiarly divided).

37. *La dame en noir.* 1882–84

THE HIGH COLLAR; LADY IN BLACK

Conté crayon, 12⅛ x 9⅛ in. (30.7 x 23 cm.)

Berggruen Collection on loan to the National Gallery, London

H 508

PROVENANCE
Théo van Rysselberghe, Brussels, by at least 1908; Charles Vignier, Paris; Charles Gillet, Lyons; César de Hauke, Paris, until his death in 1965; his estate, with Brame et Lorenceau, Paris, from 1965 until 1967; sold to present owner, 1967

EXHIBITIONS
1908–09 Paris, no. 179
1983–84 Bielefeld and Baden-Baden, no. 37
1988 Geneva, no. 14

"Elegance" is not an absolute term, so it can be applied both to the young woman of the previous drawing and to this woman, different though they are. Here the woman in black has a haughty elegance. Her erect head, her high collar, and her folded arms speak of self-assurance. Her pose has a touch of the aristocratic, perhaps even a hint of arrogance; she is a Baudelairean passerby whose self-possession astonishes. The woman who wears a bow faces the dark and might well be standing still. This woman, however, glides along the axis of her shadow and is illuminated on both sides; she is mistress of her environment. Like the other, she is centered on the sheet of paper and closely framed by it, top and bottom. This arbitrariness contributes to the impression that she is a type, not an individual, a creation of Seurat's that merges his conscious art-making and his observations of people on the Paris streets. It is this intersection of artistic thought and real life that Charles Blanc called simply "style."

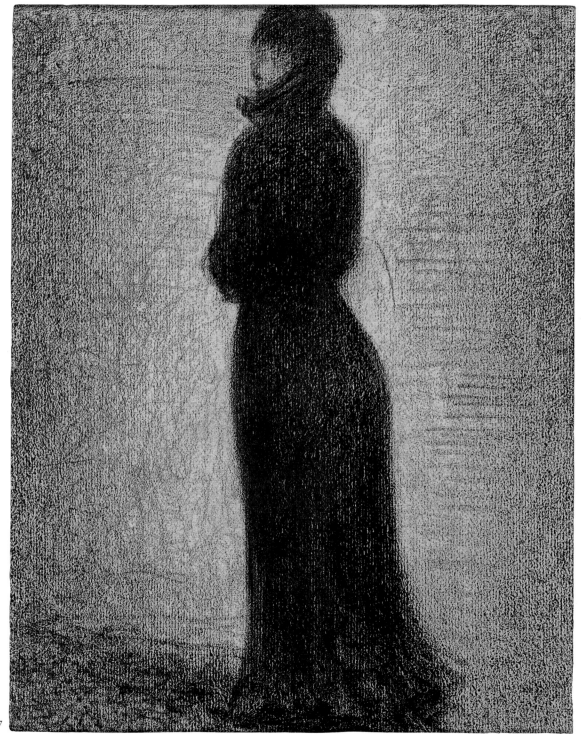

37

38. *La concierge*. 1882–84

CONCIERGE

Conté crayon, 12⅞ x 9¼ in. (32.7 x 24.8 cm.)

Galerie Jan Krugier, Geneva

H 603

PROVENANCE
Paul Signac, Paris, by at least 1905, until his death in 1935; by
inheritance to Berthe Signac, Paris; by inheritance to Ginette Signac,
Paris, until at least 1958; Sam Salz, Inc., New York; Paul Mellon,
Upperville, Virginia, until 1983 (Mellon sale, Christie's, New York,
November 15, 1983, no. 23); to present owner

EXHIBITIONS
1905 Paris, no. 33
1908–09 Paris, no. 168
1926 Paris, Bernheim-Jeune, no. 55
1957 Paris, no. 60
1984 Zurich, *hors cat.*

Unlike *Le noeud noir, La dame en noir* (cat. nos. 36 and 37),
and other drawings of middle-class women, this woman is
given an environment, albeit a schematic one. When
Seurat drew middle-class women and men outdoors, he
treated them as autonomous creatures whose surround-
ings are limited to atmospheric light. This figure, although

Honoré Daumier,
La nourrice (The
nursemaid). Litho-
graph (Delteil 836),
in *Le charivari*
(December 26,
1841)

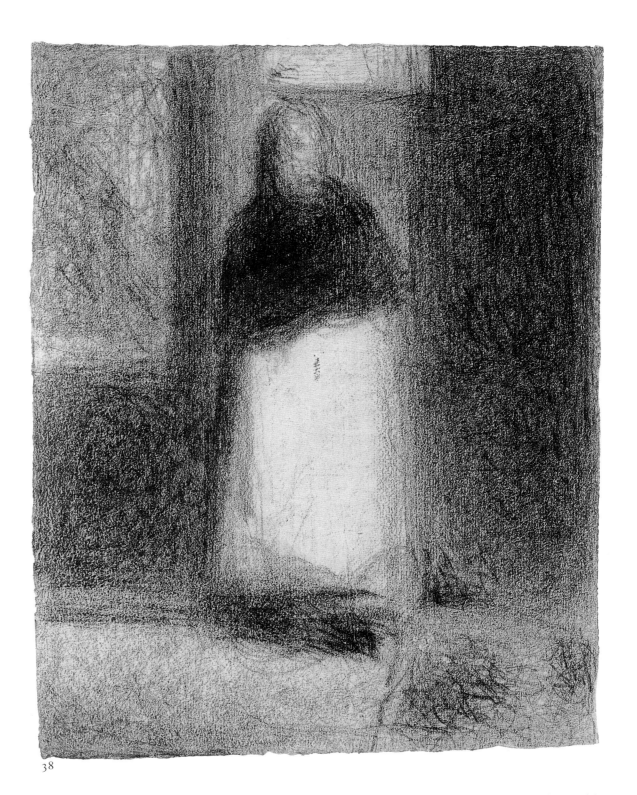

38

inactive, is a working-class woman, and like his nurses, laundresses, and vendors, she is given enough of a pictorial context to show that she is not just a promenader. She is characterized by her surroundings because she is determined by them—that is, Seurat discloses her social class by showing that she does not have the bourgeois woman's independence. She is probably a concierge but may be a nurse, cook, or maid standing in a doorway.

The concierge and the nurse were familiar urban types, depicted in numerous illustrations and caricatures in the middle third of the century when artists like Daumier and Gavarni catalogued the people who frequented Paris. Like Daumier's *Nourrice*, these working women were shown in doorways as they observed the street from the vantage point of their places of employment. Seurat's woman has the traditional waiting pose and prominent light apron of mid-century concierges and nurses. She is, however, not a caricature but a drawing, a piece of autonomous art. Caricature should no longer be regarded as an "inferior" art, so this is not a judgment of quality but a statement of Seurat's ambition. His figure does not have the wizened face or the details of costume and body of Daumier's lithograph, around which viewers could construct a story (one that would not be flattering to the old nurse).

Seurat's pattern of light and dark loosely echoes that of Daumier, whom he admired, but the architecture it suggests is as removed from specificity as is the figure itself. This woman may be standing in her own doorway or may be walking from a shop (the light aperture to the left looks like a store window) or from an entrance alongside a shop. The dark spot at her feet is a shadow, but what are the scumbled patches to the right? Are they also shadows or perhaps litter? This area and indeed all that surrounds the figure can be read only in generic terms: pavement, doorway, wall, building, light, and dark, just as the woman consists only of apron, shawl, body, and head. Nonetheless from near or from far this drawing instantly evokes a working-class woman on a city street, and therein lies its particular eloquence.

39. *Fort de la halle*. 1882–84

MARKET PORTER

Conté crayon, 12⅛ x 9⅞ in. (31.5 x 25 cm.)

Galerie Jan Krugier, Geneva

H 484

PROVENANCE
The artist until 1891. Posthumous inventory, dessin no. 118. Inherited by the artist's brother, Émile Seurat, Paris, in 1891; Paul Signac, Paris, by 1908, until his death in 1935; private collection, Paris; to present owner

EXHIBITIONS
1900 Paris, Revue Blanche, *hors cat.*
1908–09 Paris, no. 171
1926 Paris, Bernheim-Jeune, no. 58
1984 Baden-Baden, *hors cat.*

The *forts* (strong men) were members of the porters' guild in the Halles, Paris's produce market. Known for their size and strength, they carried heavy loads of food, protected by the distinctive wide-brimmed hat and jacket seen in Seurat's drawing. They were the originators of "argot," the Parisian slang whose pungent phrases were borrowed by songwriters and others who could thus claim some of the *forts'* streetwise knowledge.

Seurat had made two other drawings of a market porter somewhat earlier, probably in 1882,[1] so he was already practiced when he added this one to his galaxy of Parisian types. Here a chair, a carrying rack, and a box or low table are reflected in the moist pavement. They tell of the work and of the sidewalk conferences that typified social life around Paris's central market pavilions. A simple horizontal marks the edge of the sidewalk or street, but it does not continue behind the porter's dark form, constructed from oppositions of light and dark. Seurat's rubbings, dashes, and scumbles of black crayon create a thickened atmosphere that is incompatible with specific locations of depth and space. The market furniture and the pavement suffice to establish the porter's domain. His powerful and self-assured form, set off by his huge hat, dominates the space. Like the two women in Goya's *Bellos consejos*, he is pictured in an ordinary public place that has been transformed into a brooding enigma.

1. H 842, Paul Nitze, Washington, D.C., and H 483, British Museum.

Goya, *Bellos consejos* (Good advice). Etching and aquatint from *Caprichos*, pl. 15. The Metropolitan Museum of Art, New York. Gift of Walter E. Sachs, 1916, 16.4.10

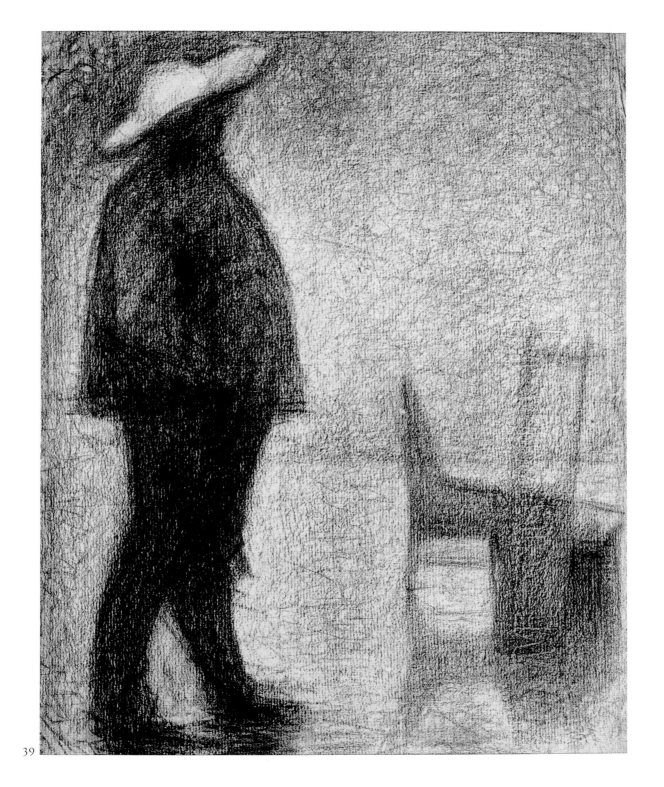

39

40. *Silhouette de femme; La dame joufflue.* 1882–84

YOUNG GIRL

Conté crayon, 12⅛ x 8¼ in. (30.6 x 22.2 cm.)

Bequest of Marion Koogler McNay, Marion Koogler McNay Art Museum, San Antonio, Texas

H 501

PROVENANCE
The artist's family until 1926; Étienne Bignou, Paris, from 1926 until July 1929; sold to M. Knoedler and Co., New York, July 1929, until November 1933 (stock no. WCA 303); sold to Chester H. Johnson, Chicago, November 1933; Marion Koogler McNay, San Antonio, until her death in 1950; her bequest to the Museum, 1950

EXHIBITIONS
1926 London, no. 15
1926 Paris, Bernheim-Jeune, no. 134

Like most of Seurat's promenaders, this woman is caught between eternal stillness and the possibility of movement. There is no anecdotal environment, so we are inclined to place her in a timeless realm. And yet, angled into depth, she can also seem to walk along with confidence (her flaring skirt suggesting motion). She does not have the assertiveness of a market porter, but her erect head indicates that she is mistress of her actions.

Seurat's complicated technique shows unusually well in this drawing because its several stages are all evident. The grays consist not only of soft, directionless rubbing but also of parallel horizontals, which are still visible, and short dashes and arabesques made with the crayon's point. In the lower right the heavy black marks, where he first touched the paper, trail off to lighter lines as he completed the flick of his wrist. Along the left edge are some partial erasures, short white diagonals made by a dull point to lighten the grays; subsequently he moved his crayon up and down so that it formed black edges as it skipped over these tiny valleys. The free lines around the figure's edges are found in many of his drawings, but they are seldom so conspicuous. In *Fort de la halle* (cat. no. 39), for example, they are worked into the mass of the figure and into the adjacent grays. Here they stand out against the lighter ground, but they are also visible where they indicate the backward flare of her skirt. Above these lines are short

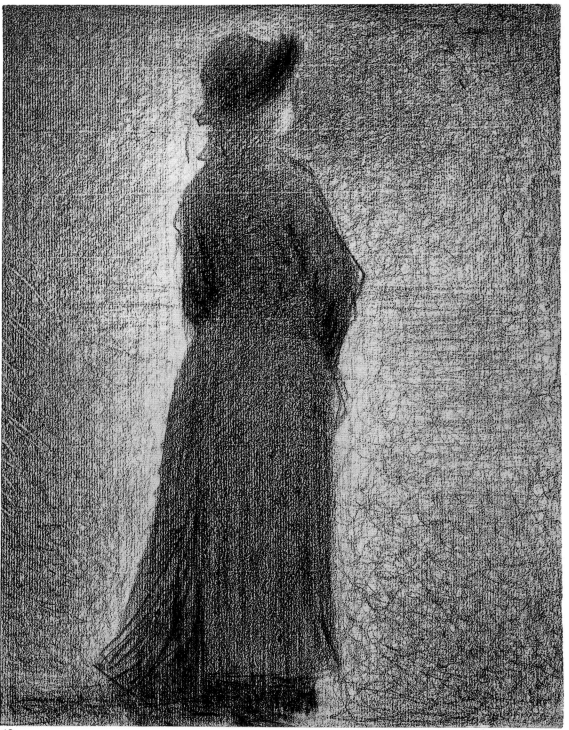

40

curving diagonals along the coat's left edge. Seurat raised his crayon at this edge, but working quickly, he carried his strokes slightly beyond it. At the base of the dress, heavy black horizontals have largely merged with stubby verticals to form a nearly solid black.

41. *Petite fille au chapeau niniche*. 1882–84

GIRL IN A SLOUCH HAT

Conté crayon, 12½ x 9½ in. (31.8 x 24.1 cm.)

Private collection, New York

H 573

PROVENANCE
The artist until 1891. Posthumous inventory, dessin no. 131 (per inscription on reverse in red crayon; not recorded by de Hauke);* Jacques Blot, Paris; Jacques Rodrigues-Henriques, Paris, until 1928; sold to De Hauke and Co./Jacques Seligmann and Co., New York, in April 1928, until at least 1943 (stock nos. 1239 and 1590);** transferred to private collection of Mr. and Mrs. Germain Seligman, New York, by 1947, until his death in 1978; his estate, with Artemis S.A., 1978; to present owner

EXHIBITIONS
1947 New York, no. 8
1949 New York, no. 44
1950 Venice, no. 12
1950 Rome, no. 5
1953 New York, no. 31
1958 Chicago and New York, no. 49
1977 New York, no. 19
1978 London, no. 10
1983–84 Bielefeld and Baden-Baden, no. 58

*The number 539 bis also appears on the reverse, in another hand. See provenance note, cat. no. 1.

**The stock number for this work was 1239, from the date of purchase in 1928, until the date of a presumed sale, to Mrs. Charles Netcher, Paris, which was "cancelled" in May 1933; after that date, the stock number became 1590. "Jacques Seligmann Co. gallery records, 1913–1978," Archives of American Art, Smithsonian Institution, Washington, D.C. (See also provenance note, cat. no. 30.)

Seurat's austerity is so much his stamp that we are relieved (and perhaps surprised) to find that he can also invest his drawings with humor and affection. Like the *fort* (cat. no. 39), this little girl wears a prominent light hat, but where his bulky upper body and forked legs indicate great

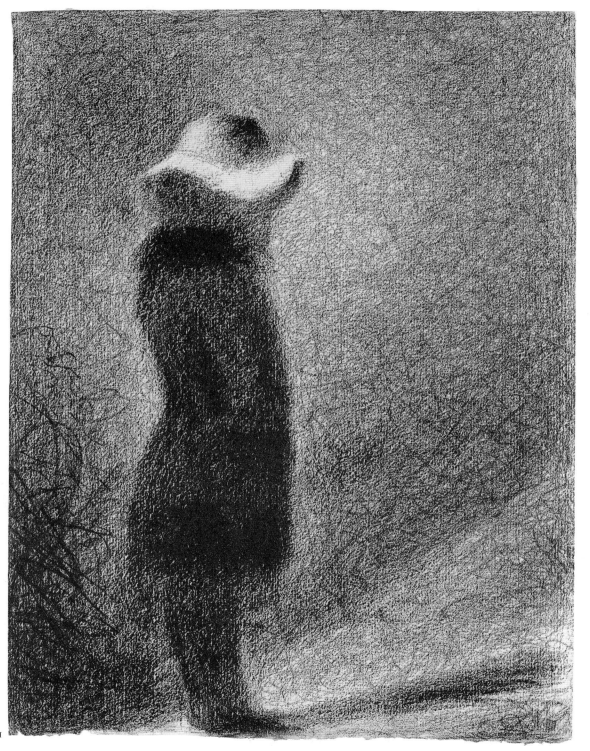

41

strength, her stubby body has a childish grace and awkwardness. She stands with hands in pockets, looking along the diagonal, which is the only indicator of environment except for her pedestal shadow. Her coat, like those worn by many of Renoir's children, has a fur collar and edging, marking her as a middle-class child. The young woman of *Le noeud noir* (cat. no. 36) wears a similar hat with remarkably different effect. The child is defined with canny simplicity, principally by the harmonic S-curves of her hat and her body, the one light and horizontal, the other dark and vertical. Seurat later enunciated such an analogy of opposites as the essence of his art.

The crayon marks reveal two aspects of Seurat's way of working. The grays are made in his usual manner, soft strokes that form a rather uniform light gray, then myriad lines made by moving the crayon's point in every direction. The lines in the lower left show how quickly he rotated his wrist to make the heavy darks. In apparent contrast to this rapid procedure, he built up the girl's form slowly and even made a change: her coat once extended about one-eighth of an inch below its present edge.

42. *La voilette*. 1882–84

THE VEIL

Conté crayon, 12⅜ x 9½ in. (31.4 x 24.1 cm.)
Verso: silhouette of a horse in profile

Musée du Louvre, Département des Arts Graphiques,
Fonds du Musée d'Orsay, Paris R.F. 38.977

Exhibited in New York only
H 568

PROVENANCE
The artist until 1891. Posthumous inventory, dessin no. 113 (per inscription on reverse initialed by Signac; not recorded by de Hauke). Mme J. D., by 1908–09;* Camille Platteel, Paris, by 1926; Suzanne Léo Verger; sale, Palais des Beaux-Arts, Brussels, February 15–17, 1955, no. 465, for 125,000 Belgian francs; Jacques Dubourg, Paris; private collection; acquired, in lieu of state taxes (by *dation*), by the Musée d'Orsay, 1982

EXHIBITIONS
1908–09 Paris, no. 149
1926 Paris, Bernheim-Jeune, no. 71
1957 Paris, no. 54

*See provenance notes, cat. no. 15.

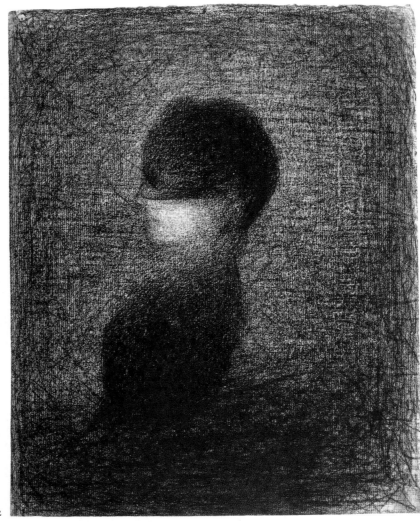

42

Here again a woman rendered in the simplest terms has the compelling quality so characteristic of Seurat's figures. Were she accompanied by a few other forms and provided with a suggestive title, she might be a lithograph or drawing by Odilon Redon. She is, however, not a dreamworld or literary personage, simply a woman taken by Seurat from the parade of figures he studied as they moved along public thoroughfares. Her slight backward tilt indicates that she is riding in an open carriage, whose top has been folded back, surrounding her with its dark mass. Her veil suggests hidden identity and perhaps also mourning. Its masklike quality adds to the secrets the woman guards.

This drawing not only depicts but also precipitates a psychological event: a chance encounter with a stranger—a daily occurrence in a city—that becomes rich in possibilities.

La voilette is one of several drawings by Seurat that have entered the French national collections since the founding of the Musée d'Orsay. *Le noeud noir* and *Anaïs Haumonté sur son lit de mort* (cat. nos. 36 and 179) and the present drawing form singular additions to an already remarkable body of work by this gifted draftsman. Not previously recorded is the silhouette on the verso of a horse in right profile, in conté crayon, and Signac's initials with the studio inventory number 113.

43. *Le bonnet à rubans.* 1883–84
NURSE WITH CARRIAGE

Conté crayon, 12⅛ x 9⅞ in. (31 x 25 cm.)
Verso: woman standing, arms extended

Mr. and Mrs. Eugene V. Thaw

H 485

PROVENANCE
The artist until 1891. Posthumous inventory, dessin no. 317 (per inscription in red chalk on reverse; not recorded by de Hauke). Félix Fénéon, Paris; Edmond Cousturier, Paris, by 1908, until at least 1926; François Cousturier, Paris, by 1937; A. and R. Ball, New York; Mr. and Mrs. Samuel Sair, Winnipeg, until 1959 (Sair sale, Parke Bernet, New York, December 9, 1959, no. 24, for $7,000); purchased at this sale by A. and R. Ball, New York; sold to present owner, about 1960

EXHIBITIONS
1908–09 Paris, no. 121
1926 Paris, Bernheim-Jeune, no. 127 (not shown)
1936 Paris, no. 87
1937 London, no. 48
1977 New York, no. 7
1978 London, no. 12
1983–84 Bielefeld and Baden-Baden, no. 34

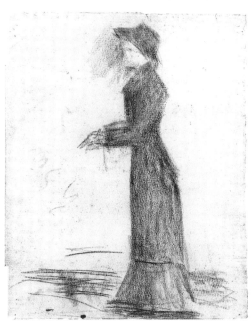

Seurat, *Femme debout* (Woman standing), verso of
cat. no. 43 (H 485)

43

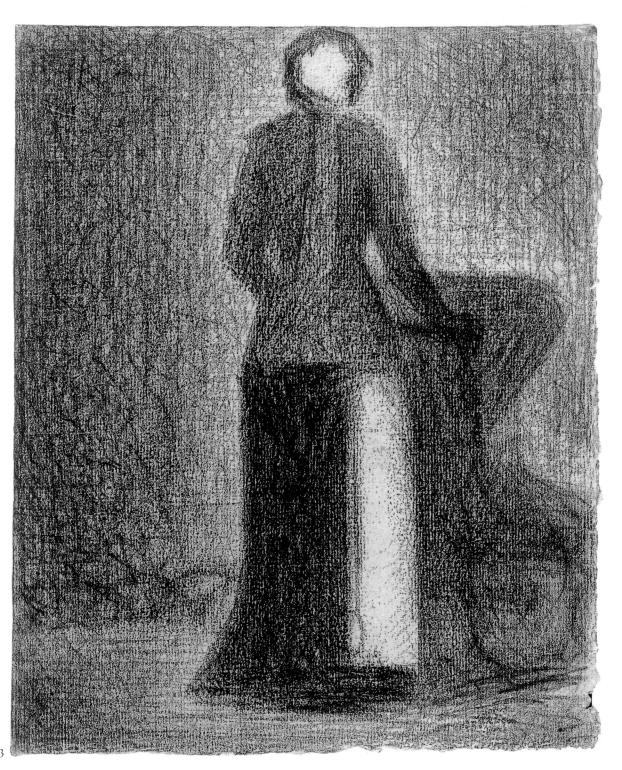

Seurat made four drawings of nurses with children, including cat. nos. 22 and 26.¹ Often dated 1882, the present drawing was more probably done in 1884 because its geometric regularity resembles that of the studies for *La Grande Jatte*.

Here the child is unseen inside its stroller. Since the nurse does not actually hold her charge, she is performing a mechanical task. Her nurse's cap and ribbons and her apron identify her instantly; she is the distillation of a working-class woman, known by her external attributes.

The center of the nurse's cap, encased in a seven-sided polygon, sets up a dialogue with the rectangle of her apron, an effect that contributes to the flattening of the figure. The crisscross swirls of the background are more regular than in earlier drawings, and in the lower left they change to the regular rhythms of overlapping half-circles that represent the low fences of withies (or their imitations in iron) that border the pathways of Parisian parks.

The drawing on the reverse side, probably of a woman pushing a pram, is one of the rather rare unfinished drawings that survive from Seurat's maturity. It suggests the speed with which he worked and the way in which he conceived form in light and dark, not line, from the very outset.

1. The fourth, collection unknown, is H 486.

44. *La banquiste*. 1883–84

ACROBAT BY THE TICKET BOOTH

Conté crayon, 12⅜ x 9½ in. (31.5 x 24 cm.)
Signed lower left: Seurat

Private collection

Exhibited in Paris only
H 671

PROVENANCE
Robert Caze, Paris, until his death in 1886; by inheritance to his widow, Mme Robert Caze, Paris, from 1886 until her death in 1887; Paul Signac, Paris, until his death in 1935; by inheritance to Berthe Signac, Paris, from 1935; by inheritance to Ginette Signac, Paris; to present owner

EXHIBITIONS
1886 Paris, rue Laffitte, no. 183
1905 Paris, no. 31
1908–09 Paris, no. 202
1926 Paris, Bernheim-Jeune, no. 119
1957 Paris, no. 59
1958 Chicago and New York, no. 132
1963 Hamburg, no. 117

Seurat drew circus performers in his sketchbooks of 1879–81, and subsequently they fitted readily into his company of street figures. Here an acrobat leans against a wall next to a ticket window, a common enough scene in the period's imagery. However, if the intention of an illustrator (Faverol, for example) was to provide information in an amusing way, Seurat wanted to extract from this realm a drawing meager in information but rich in evocation. His acrobat and ticket seller are side by side, yet there is no dialogue between them and none of the charm or amusement that might lure a passerby into the show. They are reminiscent of Daumier's images of sad clowns which intimate that behind the masks of entertainment lie private lives and thoughts, that joyful illusions are the result of hard work. Seurat's cashier is a disembodied bust and head placed in its own compartment. In contrast to the woman, he does not need legs. Her bare (or stockinged) legs display the profession of one whose livelihood depends upon her limbs. Her robe, loosely thrown over her costume, acts as a commentary on her profession, both hiding and disclosing it. Its horizontal, diagonal, and vertical slashes flow down her right leg, spilling on the platform like a skein of unwinding yarn.

It has not been recognized that this drawing was shown in the last Impressionist exhibition in 1886 as no. 183, *La banquiste*, or that it first belonged to the writer Robert Caze. Seurat's handwritten list of the works that belonged to his friends (Appendix D) identifies it as "banquiste, femme de cirque, dessin. Mme. Caze. No 183 du catalogue 8e exp. rue laffitte 1886." Seurat must have given Caze the drawing sometime after he and Signac had begun attending the writer's literary evenings in the autumn of 1885. These gatherings included many of the young writers who subsequently championed Seurat (Paul Adam, Jean Ajalbert, Paul Alexis, Rodolphe Darzens, Félix Fénéon, and others) and most of the painters soon to be baptized Neo-Impressionists. Caze died as a consequence of a duel with a fellow writer, Charles Vignier, on March 23, 1886, and Seurat's drawing passed to his widow. When she died in 1887, it was sold with Caze's other artworks, and it must have been then that Signac acquired it.¹

Seurat had had more than one reason to sympathize with the writer. Caze, a former Communard amnestied in 1880, was a prolific editor and writer, who admired the Goncourts and whose preferred subjects paralleled those of Seurat. *Paris vivant* (1885), his collection of short pieces, includes naturalistic vignettes of clerks, storekeepers, artists' models, well-dressed promenaders, a government official, and a street vendor. Caze also loved itinerant fairs and circuses, so *La banquiste* is an appropriate intersection of the two men's interests.

1. In an undated manuscript in the Signac archives, Signac lists by title the works Seurat exhibited in his lifetime; one entry reads: "La Banquiste —Caze—Signac." The circle around Caze (1853–1886) is documented in Ajalbert 1938, pp. 111ff., in P. V. Stock, *Memorandum d'un éditeur* (1935), vol. 3, pp. 106f., and in numerous columns by Alexis in *Le cri du peuple*. Alexis also gives accounts of the duel, the funeral, and the sale of Caze's art. Adam and Dubois-Pillet were Caze's seconds in the fatal duel; they, Seurat, and Signac were among the mourners at his funeral.

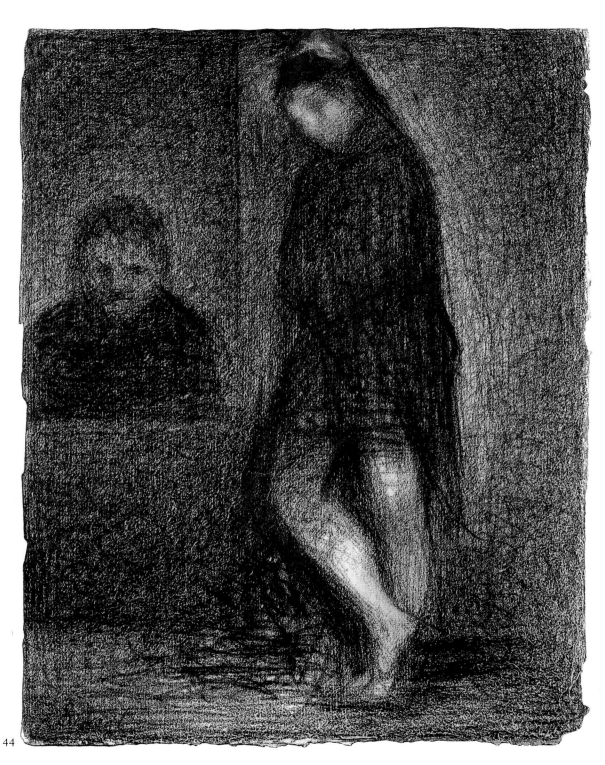

44

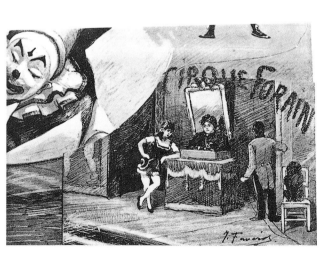

J. Faverol, *Traveling Circus*. Detail of engraving in *Le courrier français*, November 18, 1886, p. 5

45. *Une parade; Clowns et poney.* 1883–84

SIDEWALK SHOW

Conté crayon, 12⅛ x 9⅛ in. (33.9 x 24.4 cm.)

The Phillips Collection, Washington, D.C.

Exhibited in New York only
H 668

PROVENANCE
Possibly Joris-Karl Huysmans, Paris, in 1886; with Hodebert, Paris,*
until May 1928; sold to De Hauke and Co./Jacques Seligmann and
Co., New York, in May 1928, until June 1939 (stock no. 1269); sold
to the Collection, June 1939

EXHIBITIONS
1886 Paris, rue Laffitte, no. 181(?)
1947 New York, no. 12
1949 New York, no. 33
1958 Chicago and New York, no. 134

* Hodebart was a branch of the Galerie Barbazanges at 109 faubourg
Saint-Honoré, Paris; with the close of the parent gallery in 1928,
Hodebert succeeded Barbazanges at 174 faubourg Saint-Honoré.
Gallery stationery from 1927–28 reads: Galerie Barbazanges/
Hodebert Succr. In June 1928 letters are stamped with Hodebert's
new address and affiliation: Hodebert, anciennement Galerie
Barbazanges. ("Jacques Seligmann Co., gallery records, 1913–1978,"
Box 366, Archives of American Art, Smithsonian Institution,
Washington, D.C.)
 See also provenance note, cat. no. 30.

Itinerant fairs, housed in temporary structures, made
seasonal appearances along the boulevards and streets of
Paris and its suburbs. Seurat's interest in these fairs
culminated in several studies for *Parade de cirque* (cat. no.
200) exhibited in 1888, but before that major effort he
made several drawings, including *Une parade, foire au pain
d'épices* (cat. no. 178). In the present drawing, as in those
other works, performers stand as living advertisements on
their narrow platform. Below and in front are the heads of
a crowd listening to the patter of the clown in horizontal
stripes. Between him and the other clown is a pony, one of
the most common animals in these fairs, and behind, on
either side of the wood posts, are other entertainers. The
one on the right can be identified as a female acrobat or
equestrienne. Unlike *La banquiste* (cat. no. 44), whose pose
she roughly approximates, she and the others are seen in
their public roles; we are not invited to ponder their
private selves.

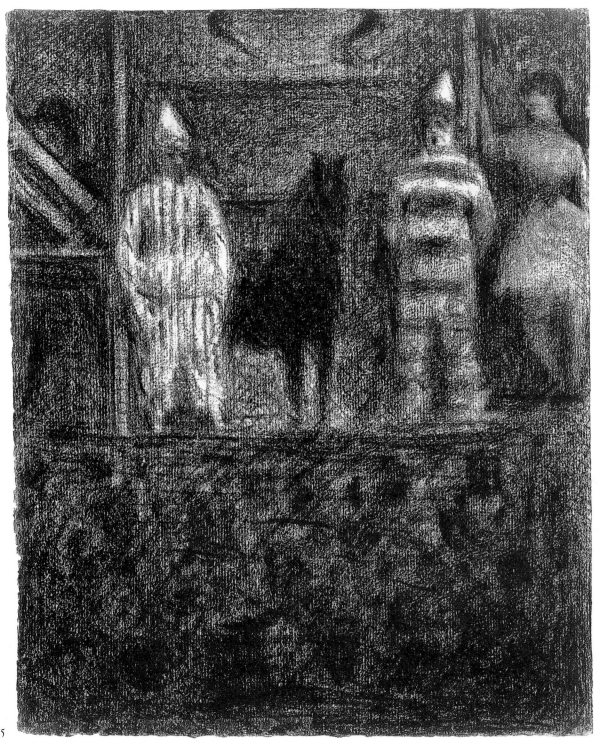

45

46. *Le badigeonneur.* 1883–84

HOUSEPAINTER

Conté crayon, 12½ x 9¼ in. (31.8 x 24.9 cm.)

Musée du Louvre, Département des Arts Graphiques, Fonds
du Musée d'Orsay, Paris, Gift of Camille Pissarro R.F. 29.545

Exhibited in New York only
H 565

PROVENANCE
The artist until 1891. Posthumous inventory, no. 292. Inherited
by the artist's brother, Émile Seurat, Paris, in 1891, until 1900;
sold to Camille Pissarro, Paris, in 1900, until his death in 1903; his
gift, realized by his son Lucien Pissarro, to the Musée du Luxem-
bourg, Paris, April 15, 1904; transferred to the Musée du Louvre,
1947

EXHIBITIONS
1900 Paris, Revue Blanche, *hors cat.*
1908–09 Paris, no. 133
1926 Paris, Grand Palais, no. 3227
1926 Paris, Bernheim-Jeune, no. 44
1933–34 Paris, no. 81

It was a nineteenth-century commonplace that Paris was
one of Europe's great theaters and its streets a veritable
stage. For the illustrator, painter, and writer, Parisians
were lifted from their own lives and became performers.
Seurat's worker makes a wide swath of white on the wall
above a door, whose dark aperture contrasts with his
white garb. The dynamic element here is the prominent
diagonal of the ladder. Since its top and bottom are not
seen, it floats, drawing attention to the aplomb with which
the housepainter uses a precarious perch.

Seurat's spirited use of the crayon echoes the man's
large strokes. The white zigzags on the left are erasures,
among the few instances of Seurat's lightening an area in
this way. Another unusual element is the forty-five-degree
hatching that partly fills three corners. These hasty marks
show Seurat's consciousness of the rectangle he was
working on while simply building up gray areas.

Le badigeonneur is one of several drawings that Camille
Pissarro purchased from the Revue Blanche exhibition of
1900 and bequeathed to the French nation in 1904 (see cat.
no. 28). Most of the group show peasants or workers,
choices that reflect Pissarro's social consciousness.

46

47

47. *Le peintre au travail.* 1883–84

ARTIST AT WORK

Conté crayon, 12¼ x 9⅛ in. (31.1 x 23.2 cm.)
Verso in pencil: three profile faces

Philadelphia Museum of Art: A. E. Gallatin Collection

H 602

PROVENANCE
The artist until 1891. Posthumous inventory, dessin no. 149 (per inscription on reverse in red chalk, not recorded by de Hauke); Théo van Rysselberghe, Brussels, until at least 1909; Charles Vignier, Paris, by 1926; Baron Eduard von der Heydt, Elberfeld; Alfred Flechtheim, Berlin; Max Silberberg, Breslau, by at least 1931, until 1932 (Silberberg sale, Georges Petit, Paris, June 9, 1932, no. 10, for 17,500 francs); purchased at this sale by Jacques Seligmann and Co., New York, 1932, until 1938 (stock no. 5266); sold to A. E. Gallatin, New York, in January 1938, until his death in 1952; his bequest to the museum, 1952

EXHIBITIONS
1908–09 Paris, no. 180
1926 Paris, Bernheim-Jeune, no. 48
1953 New York, no. 29
1958 Chicago and New York, no. 62

This drawing and the portrait of Aman-Jean (cat. no. 30) are Seurat's only known images of an artist. By showing a painter at work here, he associates him with peasants and urban workers whereas his middle-class males are usually promenading or resting. This painter nonetheless forms an instructive contrast with *Le badigeonneur* (cat. no. 46). The whitewasher has the solidity of a bucket of paint, while the artist perches on his short ladder in a graceful hipshot pose. He cradles his palette on his left arm while reaching out with the right to the large canvas, which leans against the wall. We are assured by his elegance that he is making a delicate and purposive touch on the picture. To the left is the edge of a large stretcher or a pole, adding its tilt to those of stepladder and canvas. The play of these slanted lines against the figure's rightward gesture gives the drawing its vitality.

It has sometimes been said that this is a self-portrait, but the top edges of Seurat's *Baignade* and *Grande Jatte* were only a few inches above his head and he had no reason to use such a ladder. It may embody his ambitions by showing an artist working in mural scale rather than in

front of an easel. Several of his friends from the École des Beaux-Arts painted such large works, so he was familiar with this setting. He has drawn, furthermore, the image of a studio artist, not that of an Impressionist in front of the motif. Its first recorded owner was, appropriately enough, a painter, Seurat's friend the Belgian Neo-Impressionist Théo van Rysselberghe.

48. *Le haut de forme.* 1883–84

MAN IN A TOP HAT

Conté crayon, 12⅛ x 9 in. (31 x 23 cm.)

Woodner Family Collection, New York

H 571

PROVENANCE
The artist's brother-in-law, Léon Appert, Paris; Mme Léon Roussel, Paris; private collection, Paris (sale, Ader Picard Tajan, Paris [George V], June 22, 1988, no. 4); purchased at that sale by present owner

EXHIBITIONS
1908–09 Paris, no. 159
1957 Paris, no. 46
1990 New York, no. 132

Some of the popular broadsides Seurat collected (Appendix C) bordered on caricature, and a number of them were devoted to national and regional types, differentiated by costume. The attire of this stocky figure has none of the detail of those prints, but like them this drawing articulates a type with a touch of caricature. The man's profile—one of the few outlined faces in Seurat's oeuvre—is drawn with a cartoonist's economy. The wispy features lack substance, as though the man's reality was found in his clothing. His top hat seems overly large, although he wears it with pride. This portly gentleman is regarded with humor, a gentle humor as always in Seurat. The figure resembles some of those for *La Grande Jatte* in its smooth modeling, its strong silhouette against a light ground, and its puppetlike aspect.

48

49. *Sous la voûte; Le clochard.* 1883–84

UNDER THE BRIDGE; THE TRAMP

Conté crayon, 9¼ x 12⅞ in. (24.8 x 31.7 cm.)

Private collection

H 645

PROVENANCE
Paul and Berthe Signac, Paris, by at least 1905; by inheritance to Ginette Signac, Paris; to present owner

EXHIBITIONS
1905 Paris, no. 34
1908–09 Paris, no. 164
1926 Paris, Bernheim-Jeune, no. 52

This man dozing under the arch of a bridge on the Seine (the two heavy rings on the wall were used for mooring ships) might be a sailor or a worker. Before Seurat's time, however, such a pose had become an accepted image of the clochard, a homeless urbanite. Clochards were reputed to be proud men and women, philosophers of the street who preferred their independence to the bondage of employment. These qualities are not evident in Seurat's drawing, but he has avoided condescension and has given the figure a certain dignity. The man's leisure is not that of a bourgeois promenader who, if he dozed, might do so on a park bench. His back is firmly against the wall, and his raised knee and body suggest a strong frame. He is silhouetted against light reflected from the water, which forms a shadow behind his back. The light recedes to grayness, and this together with the dark curve overhead hollows out the paper. Apparently Seurat once thought of bringing the arch down across the upper left corner but changed his mind (leaving the partly formed curve), presumably to let that portion of the imaginary space recede even farther. The figure loses his flatness as our eyes sink into this riverside cavern.

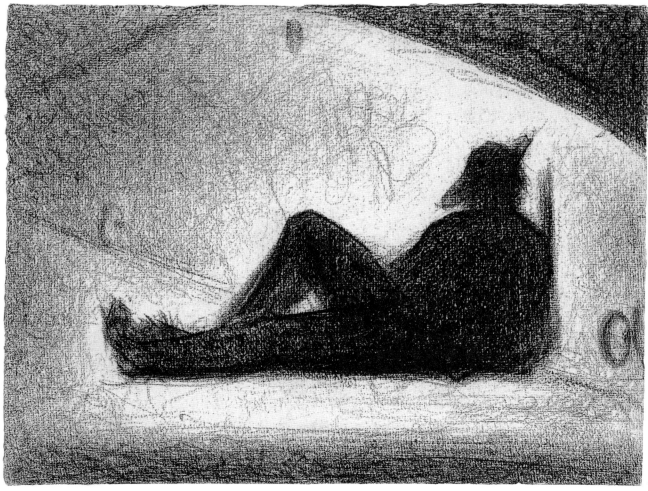

49

Drawings 1881–1884: Landscapes

50. *Maisons*. 1881–82
LANDSCAPE WITH HOUSES

Conté crayon, 9¼ x 12½ in. (24.7 x 31.7 cm.)

The Metropolitan Museum of Art, New York, Bequest of
Walter C. Baker, 1971 1972.118.234

Exhibited in Paris only
H 455

PROVENANCE
The artist until 1891. Posthumous inventory, dessin no. 273. Possibly
given by the artist's family to Émile Verhaeren, Brussels (per
inscription on reverse) in 1891; Léo Gausson, Paris, probably until
his death in 1944; by inheritance to his daughter and son-in-law,
M. and Mme Georges Tardif, Paris; Walter C. Baker, New York,
by 1960, until his death in 1971; his bequest to the Museum, 1971

EXHIBITIONS
1958 Chicago and New York, *hors cat.*
1977 New York, no. 4

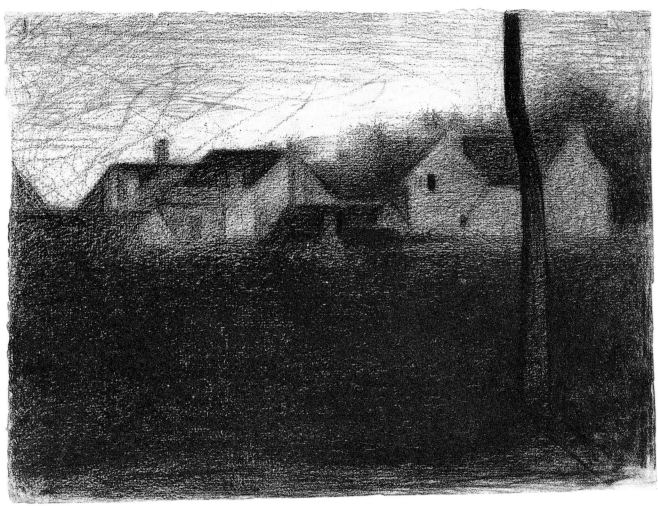

50

Millet, Théodore Rousseau, and Daubigny frequently
pictured village buildings from a field or copse of trees, a
practice continued by Pissarro and Cézanne in the next
generation. In Seurat's drawing, as in their compositions,
the spatial distance between the vantage point and the
village also gives a temporal distance. The viewer is not in
or of the village but an outsider, coming from an urban
society and looking back on a premodern setting. Nostal-
gia for such a place is an intimate part of appreciating it.
This does not deny the image's modernity, for the rise to
prominence of landscape and rural subjects in France was
a direct consequence of the urban-industrial revolution.
The countryside was the counterimage of the transformed
city, its physical other, site of the peace of ancient days
untainted by the anxious present.

Maisons has a more closely integrated surface than the
earlier *Le tronc d'arbre* (cat. no. 11). No hatching is visible,
and the foliage stays behind the houses, where its irregular
mass sets off the light walls. Both drawings make use of a
stark tree trunk, a repoussoir which positions the viewer
by establishing an intermediate location (Cézanne often

used the same device). Here it makes a striking curve
against which the geometric massing of the village is
measured. Beyond the trunk, across the indeterminate
dark field, there are houses whose light gray walls and
dark roofs assume a comforting pattern of repeated trian-
gles, parallelograms, and rectangles.

The verso of this drawing bears a studio inventory
number initialed by Maximilien Luce and a pencil inscrip-
tion "Verhaeren." Émile Verhaeren, the Belgian writer,
was a friend and defender of Seurat and one of his first
patrons (he was the original purchaser of *L'hospice et le
phare de Honfleur*, cat. no. 167). If the inscription signals his
ownership, he might have been given the drawing by Mme
Seurat *mère*, who distributed a number of works among
Seurat's friends (only part of the list survives). This
drawing was not shown in public until 1958.

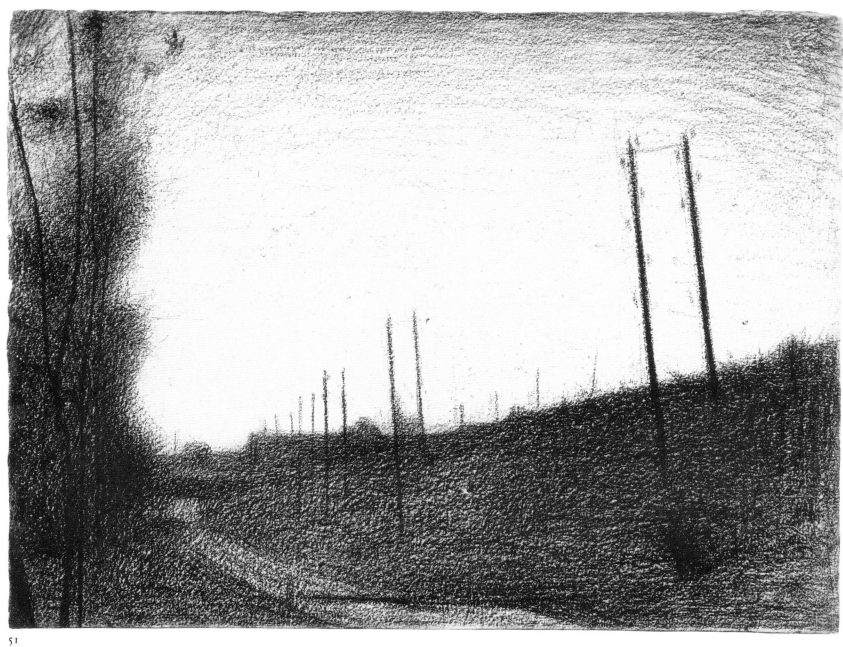

51

51. *La voie ferrée*. 1881–82

RAILWAY TRACKS

Conté crayon, 9⅝ x 12½ in. (24.5 x 31.6 cm.)

André Bromberg Collection

H 471

PROVENANCE
Mme J. D.,* by 1908–09; Camille Platteel, Paris, by 1926, until no later than 1943; to Henri Le Savoureux, Châtenay-Malabry,** by 1943; to present owner at a subsequent date

EXHIBITIONS
1908–09 Paris, no. 150
1926 Paris, Bernheim-Jeune, no. 72

 * See first provenance note, cat. no. 15.
 ** See second provenance note, cat. no. 15.

This drawing displays the miraculous combination of sparse detail and evocative fullness that makes Seurat one of the great masters of black and white. A mere list of its images gives scant idea of its poetic richness: trees on the left; a roadway on the edge of a talus, atop which the railroad's path is sensed; paired arms of electric poles; other poles on the far side of the tracks; and the small, lumpish shapes of distant buildings.

Probably no more than a few months had passed since Seurat drew *Route de la gare* (cat. no. 12), and yet that drawing, for all its attraction, seems more purely descriptive. In this slightly later work he exploits the velvety potential of conté crayon to create uncertain surfaces against which the easily identified features take their positions. The spindly tree trunks on the left, detached from the foliage beyond, have an organic, swaying rhythm that contrasts with the rigid poles bearing electrical insulators instead of leaves. Only the nearest pair delicately reveals the insulators, but by analogy we assume the others are likewise studded; we know wires are there although we see none of them. The first pair of poles leans to the left, while the others progressively straighten up, a rhythm that lends life to their recession. Below, a thin horizontal across the roadway forms an ambiguous barrier; it looks like a fallen pole but is more probably a shadow. The sky glows so strongly that it obliterates all detail in the foreground. At the top, curving grays provide closure and suggest the limitless vault so like, and yet

unlike, the more tangible one of *Route de la gare*. In neither case are tracks or locomotive seen. The earlier drawing depicts man-made shapes; here nature has been thoroughly reshaped by humans, demonstrating how an industrial society stamps its impress upon both land and space.

Several years later the naturalist writer Jean Ajalbert, who admired Seurat's work, published a poem (here translated literally) whose mood is remarkably similar to that of this drawing:

La brume du soir a tissé The evening's mist has woven
La mousseline violette A violet-colored muslin
Sur ce paysage effacé Over this landscape, effaced
Comme derrière une voilette. As though behind a veil.

Je n'ai, pour bercer mon exil, To soothe my exile, I only have,
Dans cette campagne où l'on broute, In this pasturing landscape,
Que la chanson vibrant au fil The vibrating song of the
Du télégraphe sur la route.¹ Telegraph wire along the route.[1]

1. Stanzas, each printed twice, from an untitled poem in *Le symboliste* 1, 3 (October 22–29, 1886).

52. *Arbre et route*. 1881–82

TREE BY A ROAD

Conté crayon, 9⅜ x 12¼ in. (23.9 x 31.1 cm.)

The Phillips Family Collection

H 539

PROVENANCE
The artist until 1891. Posthumous inventory, dessin no. 224.* César M. de Hauke and Hector Brame, Paris; Lazarus Phillips, Westmount, Quebec, Canada, by 1975; to present owner

* Per de Hauke, II, Addenda, p. 303.

Seurat drew this landscape the way he often drew the human figure: the constant movement of his crayon created areas of light and dark without pronounced edges. There are no autonomous lines to interrupt atmospheric continuity. He treated trees in their mass, thinning them toward their outer edges by using lighter grays and irregular profiles. The trees have no leaves or individual branches, just as his figures have no facial features or detailed costumes. He moved his crayon back and forth repeatedly, suppressing most individual strokes. He did not, however, press out the wrinkles in the upper left and right but allowed his crayon to reveal their paths. He thus recognized the reality of the medium on which he worked; this same acknowledgment is seen elsewhere in his use of the delicate weave of the paper.

The landscape is pinned in place by a wonderful tree. Not quite symmetrical—it is weighted to the left—its outline dominates the sky, and its base marks the transition from the hill to level terrain. It forms with the other tree a horizontal plane that incorporates the rising slope on the left and a fence. From the foreground a road sweeps back in a curve; parallel to it at the right is a footpath, then a bordering field that seems to rise upward slightly. This type of composition is found also in such paintings as *Abords du village* (cat. no. 90) where color permits a more complicated mosaic of incident.

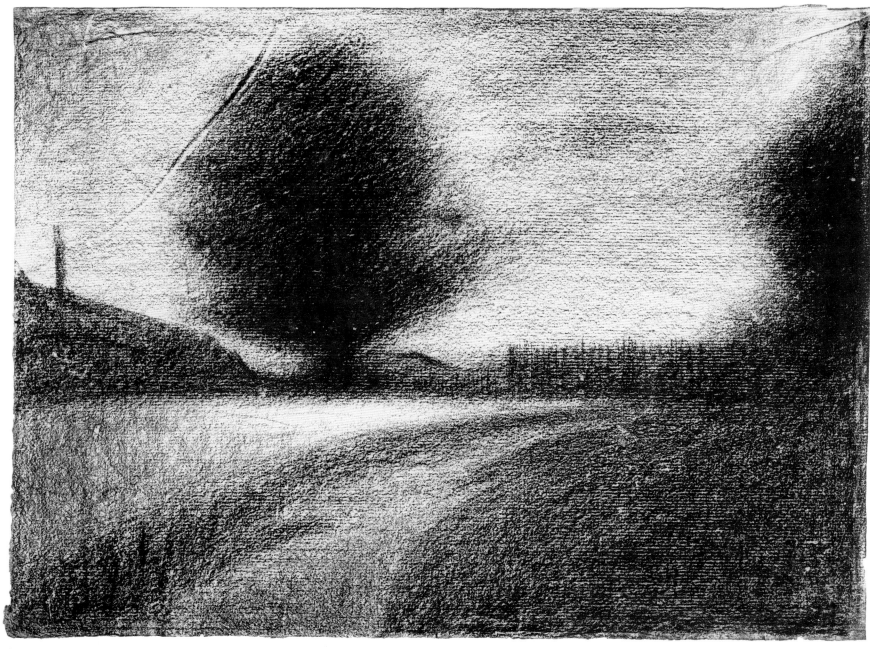

52

53. *La cité.* 1881–82

HOUSE AT DUSK

Conté crayon, 12 x 9⅛ in. (30.6 x 23.7 cm.)
Watermark: E. D. & Cie

The Metropolitan Museum of Art, New York, Purchase, Joseph
Pulitzer Bequest, 1951; acquired from The Museum of Modern Art,
Lillie P. Bliss Collection 55.21.5

Exhibited in New York only
H 545

PROVENANCE
The artist until 1891. Posthumous inventory, dessin no. 222 (per
inscription on reverse; not recorded by de Hauke). Inherited by the
artist's brother, Émile Seurat, Paris, in 1891, until his death in 1906;
by inheritance to his widow, Mme Émile Seurat, from 1906 until
1929; with Georges Bernheim, Paris, in 1929; with Martin Birnbaum,
New York, in 1929; Lillie P. Bliss, New York, from 1929 until her
death in 1931; her bequest to The Museum of Modern Art, New York,
in 1931, until 1951; purchased by the Metropolitan Museum, 1951

EXHIBITIONS
1936 New York, no. 257
1947 New York, no. 20
1949 New York, no. 30
1958 Chicago and New York, no. 67
1977 New York, no. 16

Like other landscapes by Seurat, this one combines geo-
metric and amorphous shapes, certitude and incertitude.
The triangle with curved sides might be a tent, a sail, a net
or cloth hung up to dry, the top of a building, or none of
these. Its location is uncertain; it could be in front,
alongside, or—most likely— behind the building. The
dark irregular area in the foreground may be a shadow
cast by overhead foliage that extends up the building's
wall, or it may be two separate forms, perhaps foliage.
Although the tree in the upper left reads clearly, the
rectangular vertical in the lower right could refer to
any one of a number of objects. Once again, in this
beautiful assortment of shapes, Seurat invites contempla-
tion of the poetics of black, gray, and white, which
conceals as much as it reveals.

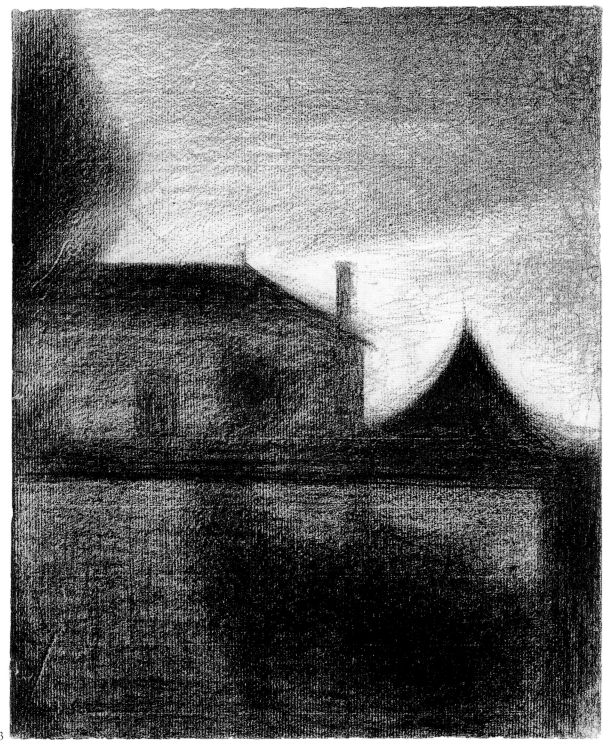

53

54. *Le labourage*. 1882–83

PLOWING

Conté crayon, 9¾ x 12½ in. (24.8 x 31.9 cm.)

Musée du Louvre, Département des Arts Graphiques, Fonds
du Musée d'Orsay, Paris, Gift of Camille Pissarro, 1904 R.F. 29.523

Exhibited in New York only
H 525

PROVENANCE
The artist until 1891. Posthumous inventory, dessin no. 116. Inherited
by the artist's brother, Émile Seurat, Paris, in 1891, until 1900; sold to
Camille Pissarro, Paris, in 1900, until his death in 1903; his gift,
realized by his son Lucien Pissarro, to the Musée du Luxembourg,
Paris, April 15, 1904; transferred to the Musée du Louvre, 1947

EXHIBITIONS
1900 Paris, Revue Blanche, *hors cat.*
1908–09 Paris, no. 129
1926 Paris, Grand Palais, no. 3226
1926 Paris, Bernheim-Jeune, no. 40
1957 Paris, no. 33
1958 Chicago and New York, no. 26
1965 Paris, no. 197

Seurat drew this foreground in lines that sweep broadly across the paper, not just following but creating the topography. Beyond, the plain is stretched out in smooth grays. The sky consists of horizontal gray streaks that blend together, dark zigzags and swirls and light spirals and crosses, all leading to the far-off patch of light, untouched paper that stands for the setting sun. This drawing brings Millet to mind. In his *Twilight* the Barbizon artist did not draw his figures with separate linear strokes but formed them through the constant movement of the same kind of black crayon Seurat later used. Millet's grays and blacks have an almost tangible atmospheric presence that shapes objects, space, and light; we admire both the arbitrary means and the result they achieve.

Seurat's array of grays, blacks, and whites recalls the mid-century artists, as does the plowman, but city-dwellers would be alien in Millet's peasant scenes. They would be a disturbing reminder of the present Millet sought to suppress. Seurat was of another generation, conscious of the intersections of city, suburb, and country. Camille Pissarro had already placed townfolk in the midst of rural scenes, and here Seurat's two observers, dressed like many of his urban personages, are a bourgeois couple. The setting may well be in the suburbs, not the countryside, but the drawing turns upon the contrast of two urban figures with the peasant. They stand in for us, making us self-consciously aware of the encroachment of modern sensibilities on the landscape.

J. F. Millet, *Crépuscule* (Twilight), about 1858. Museum of Fine Arts, Boston. Gift of Quincy Adams Shaw through Quincy A. Shaw, Jr. and Mrs. Marian Shaw Haughton

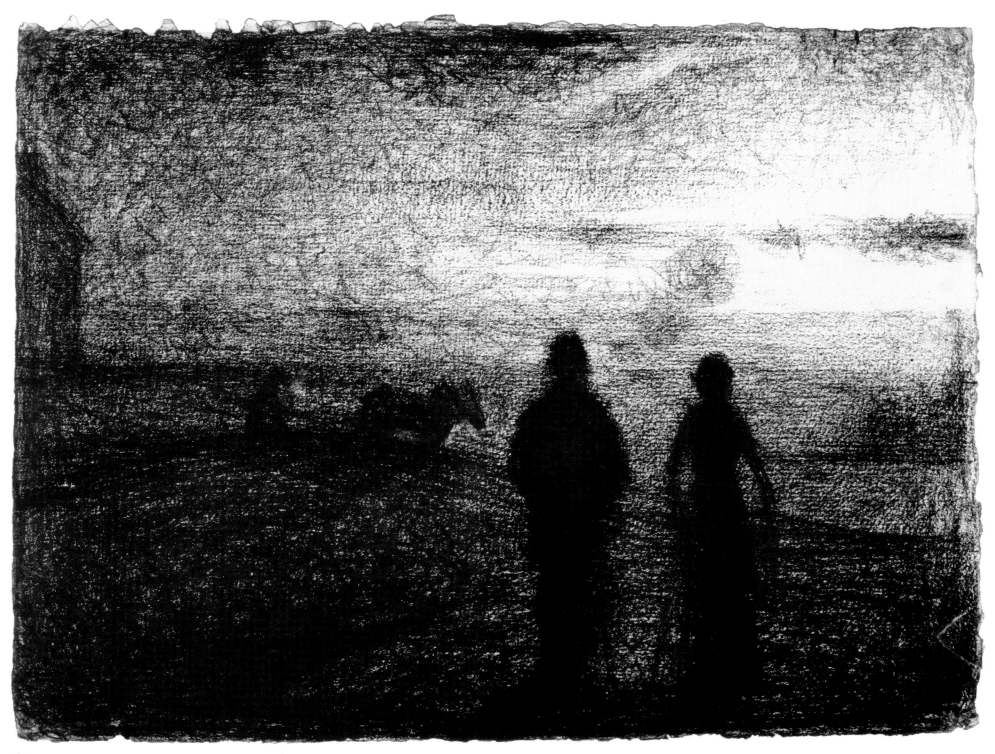

54

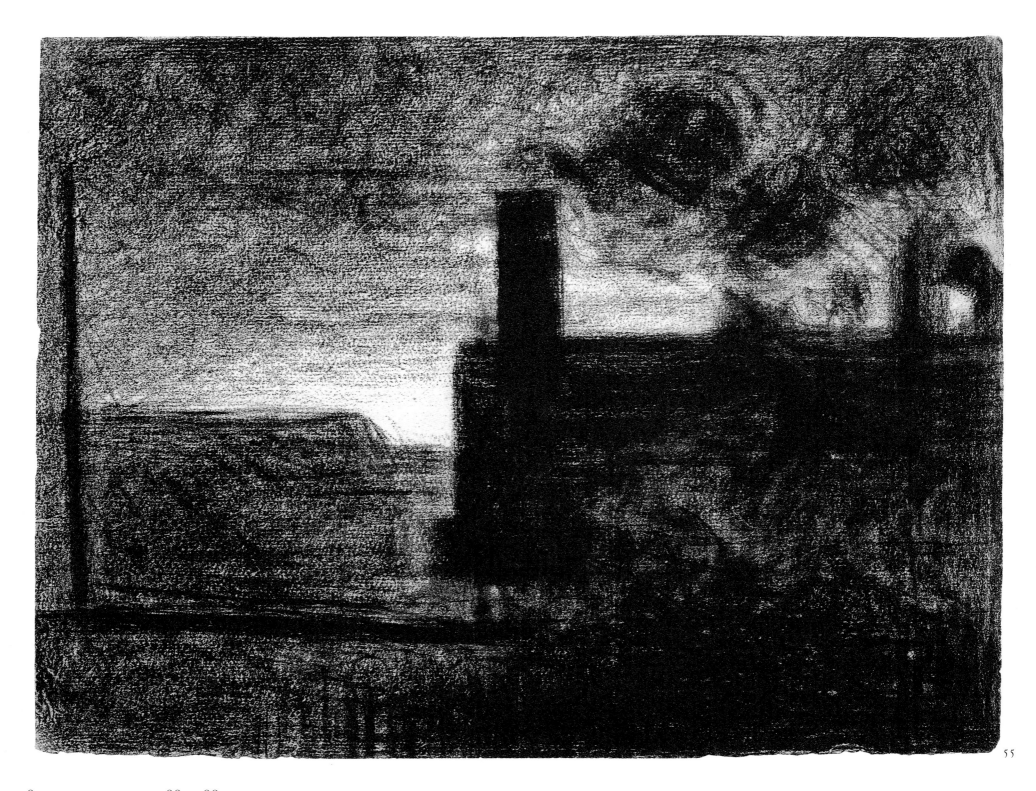

55

55. *Locomotive.* 1883–84

Conté crayon, 9⅝ x 12½ in. (24.5 x 31.8 cm.)

E. W. Kornfeld, Bern

H 478

PROVENANCE
The artist's family; Thadée Natanson, Paris; Charles Gillet, Lyons, before 1961; to present owner by 1983

EXHIBITIONS
1900 Paris, Revue Blanche, *hors cat.*
1983–84 Bielefeld and Baden-Baden, no. 39

Steam locomotives, one of the most ubiquitous symbols of the industrial revolution, were commonly found in journalistic illustrations and popular broadsides but less frequently in the fine arts in France. We cannot imagine Corot, Courbet, or Millet painting railroad engines, which made their first prominent appearance in Monet's paintings of the 1870s. Seurat did not paint a train—the modernity of his work in oil lies elsewhere—but in this drawing he gave memorable shape to a locomotive rushing across the land. It is one of several drawings of industrial subjects (*Le pont-levis*, cat. no. 64, is another), images of city and suburb that express looming power. The landscape of *Locomotive* is generalized; only a pole, the horizontal track, and a distant hill defer to the silhouette of the engine. Just as his human figures usually lack facial features and feet, the engine has no wheels; instead there are grays and blacks that give an impression of steam and dust. The distant sunlight is weak but casts an opaque shadow beneath the engine. Black crayon is singularly appropriate in this vision of an industrial form that is more suggestive of dark powers than of progress. This somber effect springs not only from the image but also from Seurat's expressive language, which has evolved considerably since *Route de la gare* (cat. no. 12).

56. *Les meules.* 1882–83

HAYSTACKS

Conté crayon, 9½ x 12¼ in. (24 x 31 cm.)

Woodner Family Collection, New York

H 540

PROVENANCE
The artist until 1891. Posthumous inventory, dessin no. 178. Inherited by the artist's brother, Émile Seurat, Paris, in 1891. Félix Fénéon, Paris, until 1941 (Fénéon sale, Drouot, Paris, December 4, 1941, no. 13, for 50,000 francs); purchased at this sale by Galerie Georges Petit, Paris; Sir Kenneth Clark, Saltwood Castle, England, by at least 1949, until his death in 1983; by inheritance to his sons, the Honorable Alan and Colin Clark, Saltwood Castle, England, from 1983 until 1986; sold to present owner, 1986

EXHIBITIONS
1900 Paris, Revue Blanche, *hors cat.*
1908–09 Paris, no. 107
1920 Paris, no. 55
1926 Paris, Bernheim-Jeune, no. 36
1936 Paris, no. 98
1983–84 Bielefeld and Baden-Baden, no. 44
1990 New York, no. 136

Here the clear profile of a wheat stack on the right allows the viewer to discern the peak of another in the distance against the sky, which helps establish a deeply receding plain. In other drawings with equally indistinct forms, we are often unsure of the time of day and worry that we might unjustly read twilight or stormy darkness into the textures Seurat wove with the black fibers of his crayon. But here the moon rising near the wheat stack indicates that this is indeed a twilight scene and that the glow on the horizon is the setting sun. The uncertain shapes on the plain are ordinary objects metamorphosed into phantoms by twilight: "From the waning sky fell imperceptibly this gray veil which, in the still surviving day, brings uncertainty to the appearance of things, makes them doubtful and vague, and drowns the forms and contours of nature, who slowly goes to sleep in the effacement of twilight: this sad and gentle and barely perceptible agony of the life of daylight."[1]

Seurat has filled his page with different textures that we can decipher just sufficiently to sense the main elements of the landscape. In the immediate foreground horizontal crayon strokes and black patches suggest the furrows of plowed ground. Just beyond, slanting parallels form a path or roadway that cuts across a field made of short streaks and zigzags; close to the path is a dark mound, perhaps a pile of rakings. Beyond this field is a darker one, suggesting another kind of soil condition or planting. Along the left edge rises a stream of verticals culminating in an energetic swirl, perhaps the foliage of a bush or tree; less conspicuous swirls move among the horizontals of the darkening sky. Against the horizon rise great tangles that might be partial stacks or great heaps of hay or dried stalks, but they are so undefined that they might be taken as creatures of the artist's technique in the service of what Milton called "sable-vested Night, eldest of things."

1. Edmond de Goncourt, *Les frères Zemganno* (1879), p. 9.

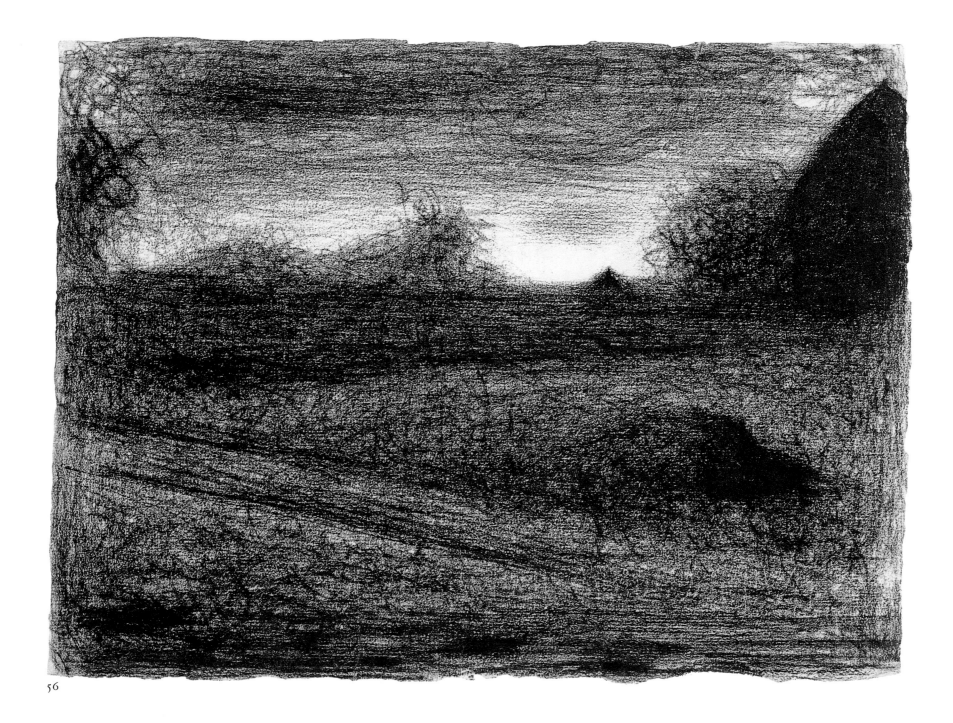

56

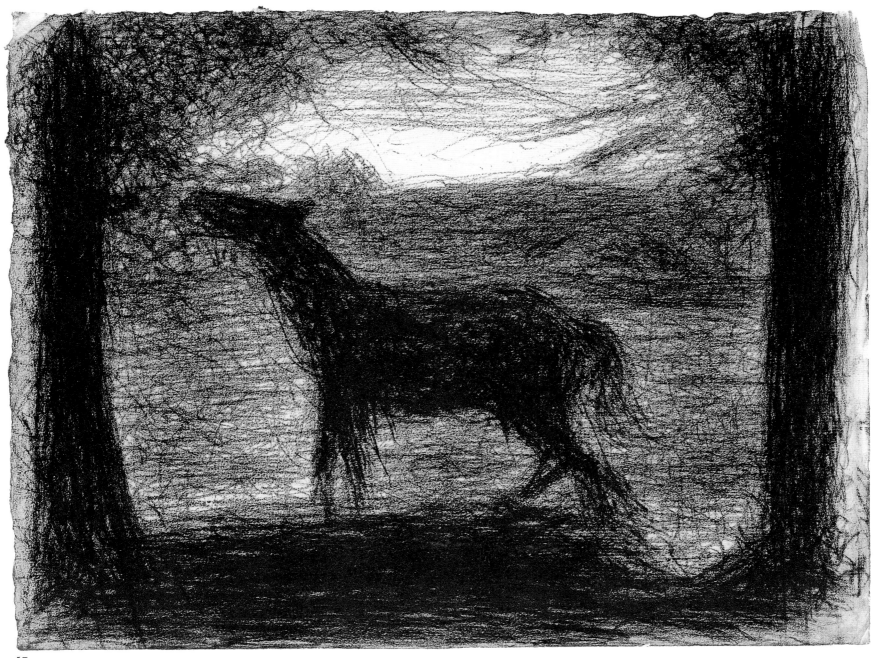

57

57. *Le poulain.* 1882–83

FOAL

Conté crayon, 9 x 12 in. (22.9 x 30.5 cm.)

The Metropolitan Museum of Art, New York, Robert Lehman
Collection, 1975 1975.1.706

Exhibited in New York only
H 527

PROVENANCE
The artist until 1891. Posthumous inventory, dessin no. 186 (per
inscription on reverse in red crayon; not recorded by de Hauke).
Probably given by the artist's family to Henri Edmond Cross, Paris,
in 1891, until his death in 1910; by inheritance to his widow, Mme
Henri Edmond Cross, Paris; Félix Fénéon, Paris, by at least 1937 and
probably shortly after 1910,* until 1941 (Fénéon sale, Drouot, Paris,
December 4, 1941, no. 17, for 45,000 francs); Gustave Goubaud;
Robert Lehman, New York, by 1949, until his death in 1969; his
bequest to the Museum, 1975

EXHIBITIONS
1922 Paris, no. 9
1926 Paris, Bernheim-Jeune, no. 88
1936 Paris, no. 103
1937 London, no. 68
1949 New York, no. 60
1953 New York, no. 22
1958 Chicago and New York no. 37
1977 New York, no. 12

* Fénéon purchased the contents of Cross's studio after his death.
 See J. Rewald, "Félix Fénéon," *Gazette des beaux-arts* 6, 33 (1948),
 p. 120.

Profiled against a sunlit field and a distant hill, a young
horse stretches its neck to nibble tree leaves. Centered
between two trees, it might have had the stiffness of a
Sumerian heraldic animal, were it not for the vitality of
Seurat's hand. He constantly moved the point of his
crayon, searching for forms. Everything is in a state of
becoming, of acquiring pictorial life. There are no well-
focused images, but the viewer can instantly read "horse,"
"tree trunks," and "foliage." Narrow channels of light on
the far side of each tree trunk set them back somewhat
from the edges of the sheet, and the interior light of this
drawing creates a palpable atmosphere and space that defy
the armorial configuration. Once again Seurat has set up a
dialogue between a strong surface pattern and a believable
space.

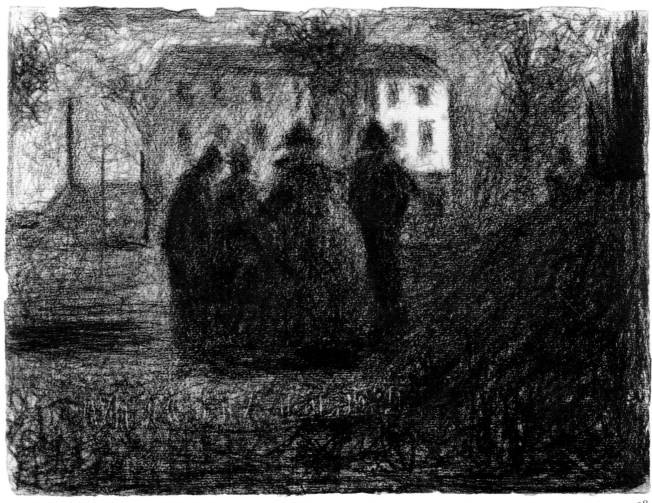

58

58. *Groupe de gens.* 1882–83

MEN IN FRONT OF A FACTORY

Conté crayon, 9⅝ x 12¼ in. (24.4 x 31.1 cm.)

Musée du Louvre, Département des Arts Graphiques, Fonds
du Musée d'Orsay, Paris, Gift of Camille Pissarro, 1904 R.F. 29.544

Exhibited in Paris only
H 550

PROVENANCE
The artist until 1891. Posthumous inventory, dessin no. 164. Léonce
Moline, Paris; La Revue Blanche, Paris, probably until 1900; Camille
Pissarro, Paris, probably in 1900, until his death in 1903; his gift,
realized by his son Lucien Pissarro, to the Musée du Luxembourg,
Paris, April 15, 1904; transferred to the Musée du Louvre, 1947

EXHIBITIONS
1900 Paris, Revue Blanche, *hors cat.*
1908–09 Paris, no. 132
1926 Paris, Bernheim-Jeune, no. 43

Five figures stand together in front of a suburban factory.
To the left, in the distance, a tall chimney protrudes from a
lower building. Together the chimney and the factory

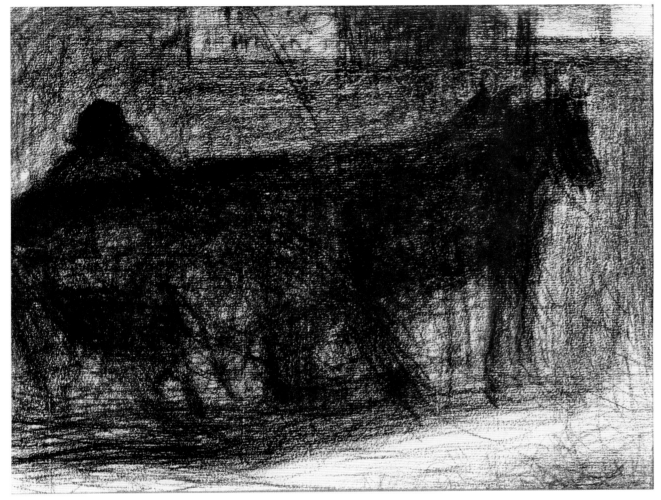

59

59. *Attelage à deux chevaux.* 1882–83

HORSECART

Conté crayon, 9 x 11¾ in. (23 x 30 cm.)
Signed lower right: Seurat

Musée Municipal de Nevers

H 646

PROVENANCE
Collection H. D. until 1908 (?);* Frédéric Paulhan, Paris, until his
death in 1931; by inheritance to his widow, Mme Frédéric Paulhan,
1931, until 1934 (Paulhan sale, Drouot, Paris, February 26, 1934, no.
54, for 2,100 francs); Victor and Marguerite Bossuat, Paris, until May
1935; their gift to the museum, 1935

EXHIBITION
1983–84 Bielefeld, Baden-Baden, and Zurich, no. 45

* According to the Paulhan sale catalogue, this work had been
 included in an earlier sale: Vente H. D., salle 11, du 10 avril 1908.
 De Hauke lists the sale as follows: Tableaux, Hôtel Drouot, Paris,
 10 avril 1908, no. 268 (3 Fr.). Neither citation has been confirmed
 by the Paris sale catalogues consulted for April 10, 1908.

In Seurat's early sketchbooks there are numerous draw-
ings of horses, coachmen, and horse-drawn wagons. Horses
were the chief carriers of goods and people, and their
number increased considerably in Paris and the suburbs as
the urban-industrial revolution took hold. In this drawing
a two-horse shay waits in the shadow of a wall. The
horses' front legs are still, and the coachman or rider sits in
the back of the carriage, away from the unused whip
which is angled upward at the front.

Constantly moving his wrist in short jabs, Seurat quickly
roughed out the mass of the figures, going back and forth
until he approximated their final shapes. He used lighter
touches for the background, then worked all over the
sheet, darkening where needed with short movements of
his crayon. He did not use linear outlines but groped for
his shapes; this practice allowed him to construct perme-
able contours (his figures are not separated from their
surroundings) and to adjust the shapes without regard to
any preestablished outlines. He did not usually make
erasures, and here he went back over the horses' front legs
with a point, probably a pencil, to make the blacks lighter.

resemble those to the right rear in *Le pont* (cat. no. 95) and
may represent the same part of Clichy (or Courbevoie), an
area Seurat explored in many drawings and paintings. To
the right the ground rises steeply to meet the blackened
mass of a fence or barrier. Across the background are
several patches of scumbled lines which could be smoke or
foliage; two of them becloud the lines of the building. The
light-struck end of the building cuts through the indefinite
grays, and placed next to the darkest of the figures, it
establishes a clear distance from the group. In the center
four men form a semicircle; completing the circle are

indistinct forms, including a broad, shorter figure in a cape
or coat, seen from behind. Perhaps the workers are
gathered around a vendor or are simply talking together;
Seurat gives them the solidarity of an enclosed cluster. An
anxious employer might worry about conspiratorial to-
getherness, but a fellow worker would think it normal that
they seek one another's company amid the starkness of the
factory and its surroundings. In any event it is not leisure
that is confronted in this drawing but a quiet scene that
questions the relationship between workers and factory
grounds.

60. *À deux chevaux.* 1882–83

WINE TUMBRIL

Conté crayon, 8⅝ x 12 in. (22 x 30.5 cm.)

"Moline" stamp in red lower right: Seurat

Galerie Jan Krugier, Geneva

H 526

PROVENANCE
Probably Madeleine Knoblock, Paris, from 1891; Mme J.D.,* by
1908–09; Camille Platteel, Paris, by 1926; Mlle Alix Guillain; Francis
Ponge; sale, Palais Galliéra, Paris, November 30, 1961, no. 74; with
Galerie Motte, Geneva, until 1972; sold to private collection,
Switzerland, in 1972, until 1988 (sale, Sotheby's, London, November
30, 1988, no. 410); to present owner

EXHIBITIONS
1895 Paris
1900 Paris, Revue Blanche, *hors cat.*
1908–09 Paris, no. 147
1926 Paris, Bernheim-Jeune, no. 69

* See first provenance note, cat. no. 15.

This drawing has a deeper and more active space than that
of the previous one, but once again it is achieved by
deceptively simple means. A tumbril pulled by two horses
moves along a street flanked on the near side by two
inclined trunks and on the other by two saplings. The
nearby trunks divide the sheet into slanted apertures that
help us feel the wagon's motion as our eye sweeps to the
right. Light gray streaks reflect water in the gutters,
defining the road's ground plane and its direction. Unlike
the wheels of the preceding drawing, those of the tumbril
are massive. There the shay's wheels are summarily
indicated because Seurat was interested in the horizontal
mass of the stationary figures, but here their substantial
roundness is needed to support a huge barrel and to
suggest lumbering movement. The driver's head does not
show, but his whip projects from his hunched body, and
reins stretch forward to the paired horses.

This drawing's somber mood is compatible with the
tradition of naturalist literature, which abounds in vi-
gnettes of the horse-drawn wagons that were a ubiquitous
feature of Parisian life. Zola, for example, described wag-
ons rumbling toward the city's central markets in the
opening paragraph of *Le ventre de Paris* (1879): "In the

middle of the great silence, and in the desert of the avenue,
the carts of the market gardeners pulled toward Paris, with
the jolting rhythms of their wheels, whose echoes beat
against the facades of the buildings asleep on both sides,
behind the obscured lines of the elm trees."

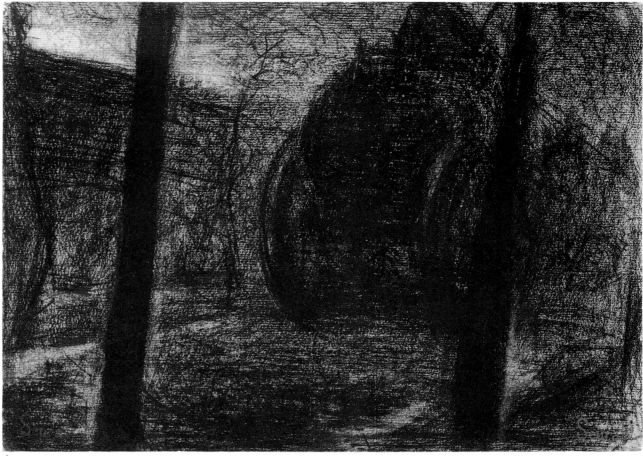

60

61. *Le bateau à vapeur.* 1882–83

STEAMBOAT

Conté crayon, 9⅜ x 12⅛ in. (23.7 x 30.7 cm.)
"Moline" stamp in red lower right: Seurat

Albright-Knox Art Gallery, Buffalo, New York, Gift of A. Conger
Goodyear, 1955

H 654

PROVENANCE
Probably Madeleine Knoblock, Paris, from 1891; with Bernheim-
Jeune, Paris; Albert Vuaflart, Paris, until 1917 (his sale, "Collection
d'un amateur,"* Drouot, Paris, December 28–29, 1917, no. 321, for
351 francs); purchased at this sale by Léon Marseille; Marius de
Zayas, New York, by 1919,** until 1923 (de Zayas sale, Anderson

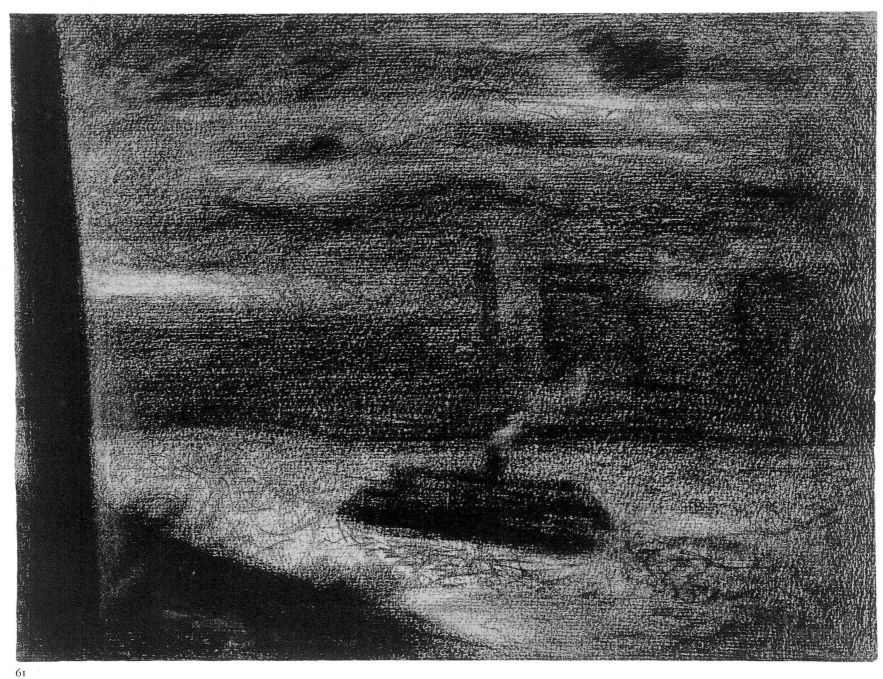

61

Galleries, New York, March 23–24, 1923, no. 72, for $250); purchased at this sale by John Quinn, New York; Quinn estate, 1924–26; purchased from the estate by A. Conger Goodyear, New York and Buffalo, probably between February and April 1926, until 1955; his gift to the Gallery, 1955

EXHIBITIONS
1895 Paris
1947 New York, no. 24
1949 New York, no. 42
1958 Chicago and New York, no. 116
1983–84 Bielefeld and Baden-Baden, no. 46

* This sale catalogue was incorrectly recorded by Lugt (no. 77427) as the collection of Jacques Doucet; the procès-verbal (Archives de Paris) corrects this misnomer.
** In 1919 the drawing was included in M. de Zayas (gallery), New York: "Exhibition of Drawings, Watercolors, Etchings and Lithographs" (December 15–31, 1919, no. 37) and also at an exhibition he organized for the Arden Gallery, New York, "The Evolution of French Art," April 29–May 24, 1919, no. 132.

One of Seurat's most unusual skies rises here above the Seine on the outskirts of Paris. Many of his skies, like that of *Le labourage* (cat. no. 54), are an active mixture of clouds and clear air, but none has the dramatic corrugation of this one. The view is from a rise across a river to an industrial district. In the left foreground is another of Seurat's repoussoir tree trunks. On the opposite shore the lowest elongated streak of light is intersected by factory buildings and a chimney, which share the thick air with the clouds. The sky breaks into great troughs and gashes that make the water below seem calmer by comparison. From a distance the light and dark alone create this dramatic sky, but at close range Seurat's textures are recognized as vital instruments of his effects. Smooth rubbing of the crayon made the relatively even grays which hang back as the sky's matrix. With continued rubbing Seurat made the darker streaks and patches; he then used a variety of short and long hatchings, wavelike squiggles, and other marks to activate the surface. The water below constitutes a single plane, across which the crayon's smooth grays and choppy marks render the reflections of land and sky and suggest the boat's wake. Any ship would have given an image of movement, but this is a commercial craft whose steam has a symbolic role. It brings to mind the work of Turner and other romantic artists who linked dramatic skies and steam, juxtaposing nature and the industrial revolution.

62. *Clochetons*. 1882–83

TURRETS

Conté crayon, 9½ x 12⅜ in. (24 x 31.5 cm.)
Verso: fragmentary drawing of a woman bending over

Private collection, Switzerland

H 473

PROVENANCE
The artist until 1891. Posthumous inventory, dessin no. 201. Félix Fénéon, Paris, until his death in 1944; his estate, 1944–47 (Fénéon sale, Drouot, Paris, May 30, 1947, no. 35, for 75,500 francs); purchased at this sale by Mme Vergé, Paris; with Marlborough Fine Art Ltd., London, in 1957; Alphonse Bellier, Paris, by 1960; sale, Sotheby's, London, April 16, 1970, no. 50; purchased at this sale by Davies; to the present owner

EXHIBITIONS
1908–09 Paris, no. 100
1926 Paris, Berheim-Jeune, no. 91
1936 Paris, no. 74
1983–84 Bielefeld and Baden-Baden, no. 40

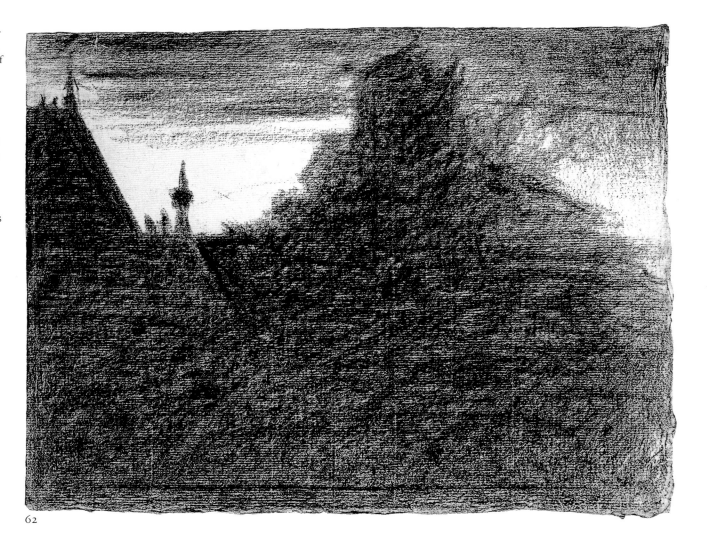

62

Chimney pots and pinnacles are characteristic of the Parisian skyline. Here their contrast with the trapezoid of untouched paper suggests twilight or perhaps dawn. The diagonal that slants downward from the larger pinnacle helps define the mass of the building on the left. The form at the right center looms out of a scumble of crayon, without ready clues to its origins. Its left profile is made of short straight edges, which hint at a building; its right side consists of black coagulations and gray rubbings, which perhaps suggest foliage. One guesses, without assurance, that it is a building on a rising wooded slope. In the gloaming of the foreground is an occasional calligraphic movement, but most of Seurat's marks are horizontals and diagonal slashes worked on top of more even grays. Above, in the pyramidal mass, the black strokes have a more undefined wriggle, as though they were about to float free and rise upward.

63. *La lune à Courbevoie: Usines sous la lune.* 1882–83

COURBEVOIE. FACTORIES BY MOONLIGHT

Conté crayon, 9¼ x 12⅛ in (23.4 x 30.7 cm.)
The Metropolitan Museum of Art, New York, Gift of Alexander and Grégoire Tarnopol, 1976 1976.243

Exhibited in Paris only
H 536

PROVENANCE
The artist until 1891. Posthumous inventory, dessin no. 180 (per inscription on reverse in orange crayon, not recorded by de Hauke). Probably given by the artist's family to the Belgian artist Georges Lemmen in 1891, until at least 1892 and possibly until his death in 1916; Alfred Vallotton; Félix Fénéon, Paris, until his death in 1944; his estate, 1944–47 (Fénéon sale, Drouot, Paris, May 30, 1947, no. 41, for 103,000 francs); purchased at this sale by Michoux; Grégoire Tarnopol, New York, by 1948, until 1976; gift of Alexander and Grégoire Tarnopol to the Museum, 1976

EXHIBITIONS
1886 Paris, Indépendants, *hors cat.*
1892 Brussels, no. 29
1926 Paris, Bernheim-Jeune, no. 96
1936 Paris, no. 78
1948 New York, no. 54
1977 New York, no. 14

This drawing must be "La lune à Courbevoie," which Paul Signac, in an undated note in the Signac archives, listed with the works shown at the Indépendants in 1886 (if so, it was *hors catalogue*). The other entries on Signac's list are verifiable, so there seems little reason to doubt his inclusion of this work. (Signac shared Seurat's preoccupation with the industrial suburbs and his own display included two paintings of gas tanks at Clichy.[1])

Here the moon surely shines down on a factory setting. The prominent vertical with a rounded top is a chimney. With no space above or below, it sits on the paper's surface and forms a foreground plane with the low horizontal, which appears to be a fence. In the distance is another chimney or a pole that helps give depth to the drawing, but it is chiefly the dialogue between chimney and moon (contrasts both of shape and of tone) that allows the viewer's eye to sink into the distance. The blacks and grays have greater depth and resonance than those of the earlier *Route de la gare* (cat. no. 12). The large shapes on the left, surmounted by a smaller one in the upper corner, must be buildings, but they read like landscape masses as though nighttime permitted a merger of man-made forms with nature.

1. *Les gazomètres, Clichy* (National Gallery of Victoria, Melbourne) and *Passage du Puits Bertin, Clichy* (collection unknown).

64. *Le pont-levis.* 1882–83

DRAWBRIDGE

Conté crayon, 9⅝ x 12 in. (24.3 x 30.5 cm.)

Woodner Family Collection, New York

H 608

PROVENANCE
The artist until 1891. Posthumous inventory, dessin no. 228. Possibly given by the artist's family to Octave Maus, Brussels, in 1891 (per inscription in old script in graphite on the reverse which reads: Mouss [?]); Mr. and Mrs. Samuel A. Lewisohn, New York, by at least 1943, until 1954; by inheritance to their daughter and son-in-law, Mr. and Mrs. Sidney Simon, New York, from 1954 until 1972; sold, through Stanley Moss, New York, to present owner, 1972

EXHIBITIONS
1908–09 Paris, no. 113
1949 New York, no. 58
1958 Chicago and New York, no. 45
1968 New York, no. 66
1977 New York, no. 26
1990 New York, no. 133

Most of Seurat's drawings of industrial sites show no activity, but this drawing, like *Locomotive* (cat. no. 55), conveys movement. The drawbridge's angular forms, terminating in the twin parallels of its "arms," have an anthropomorphic aspect that gives them emotional force. (Some modern observers may think of the black shapes of Franz Kline's paintings, suggestive of urban-industrial sites.) The bridge, which has the overpowering scale of romantic images of industry from earlier in the century, seems to have a somewhat monstrous life of its own. The subject is probably one of the iron bridges over the Canal Saint-Martin or the Canal de l'Ourcq in the northeast quadrant of Paris. Beyond the bridge are large buildings, some of them presumably warehouses.

The freedom with which Seurat draws is readily observed here. The lines of the bridge's cables pass beyond their terminal points or fly out loosely from the girders; the multiple strokes that compose the girders do not lie neatly within sharp boundaries. This gestural freedom embodies both Seurat's spontaneous way of working and his deeply felt emotional reactions.

65. *Place de la Concorde, hiver.* 1882–83

PLACE DE LA CONCORDE, WINTER

Conté crayon and charcoal, 9⅛ x 12⅛ in. (23.2 x 30.8 cm.)

Solomon R. Guggenheim Museum, New York, Gift, Solomon R. Guggenheim, 1941

H 564

PROVENANCE
Félix Fénéon, Paris, until 1938; sold to Solomon R. Guggenheim, New York, August 1938, until 1941; his gift to the Museum, November 1941

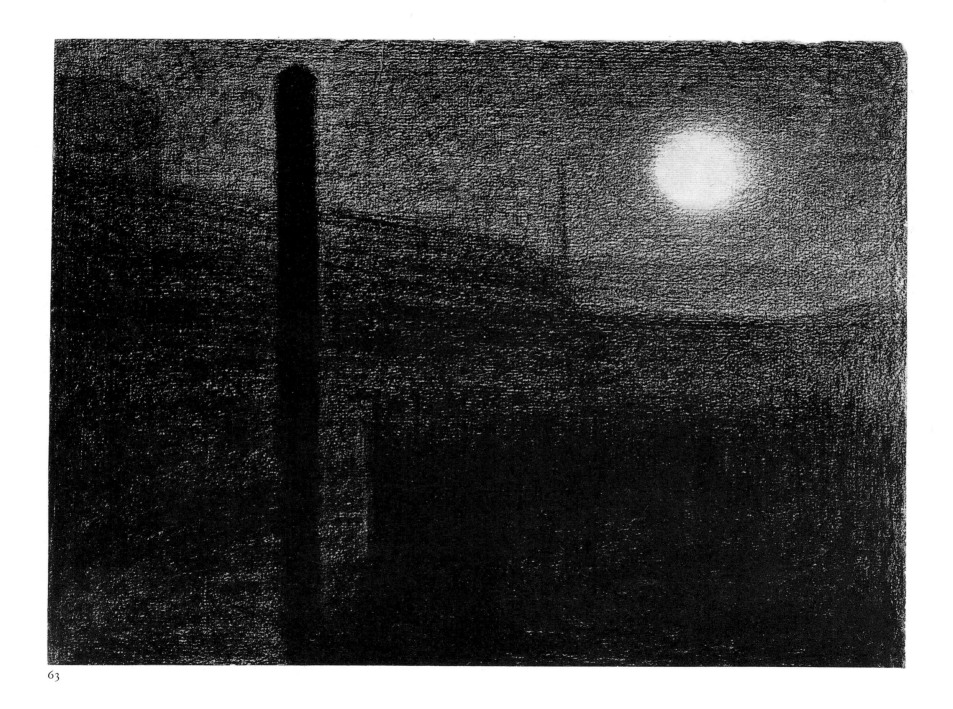

63

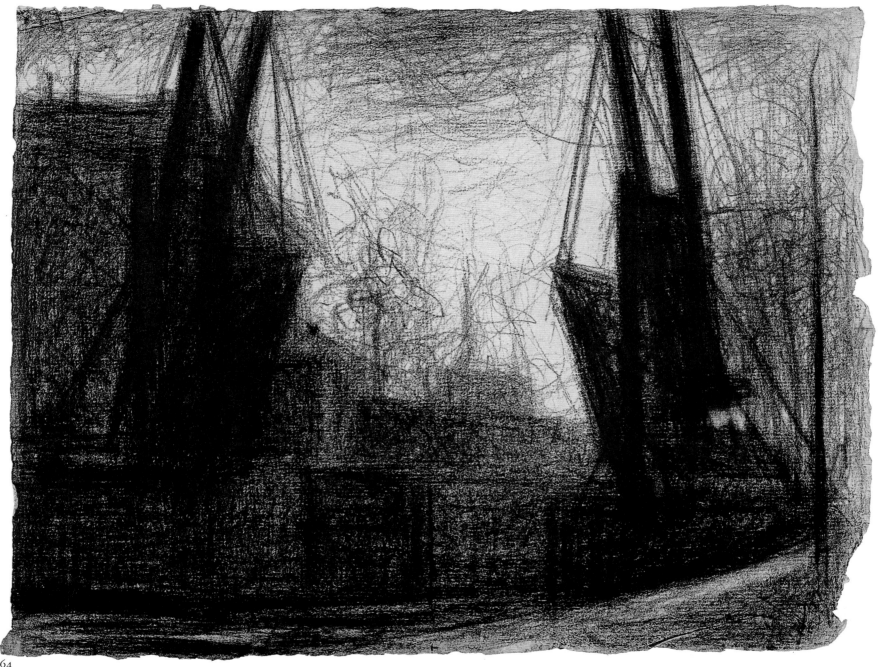

64

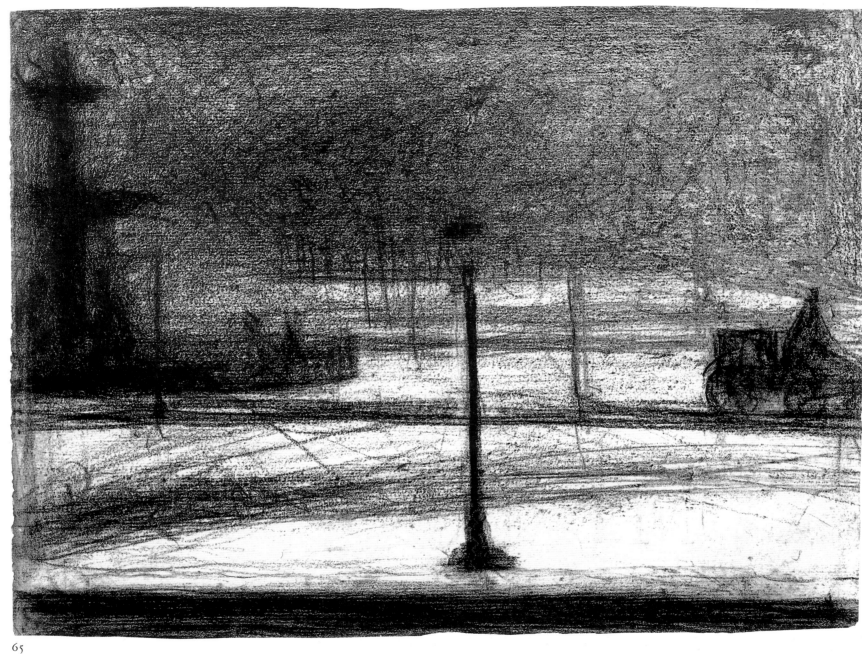

65

EXHIBITIONS
1908–09 Paris, no. 115
1920 Paris, no. 58
1926 Paris, Bernheim-Jeune, no. 87
1936 Paris, no. 86
1937 London, no. 64
1958 Chicago and New York, no. 44
1963 Hamburg, no. 111
1968 New York, no. 67
1977 New York, no. 18

Seurat used the white of his paper to represent a light snow on the largest and most famous of Paris's *places*. The identification of his means with his subject is exact, for his dark lines trace the tracks of carriages across the square. The gaslights, which might have shed a warming glow, have not yet been lit; only their stems show clearly, the potential sources of light swallowed up by the leaden obscurity of winter. The space is unusually deep for Seurat. The ground plane tips back, held down by the fountain and the carriage, while the lamps march convincingly into the distance. The vantage point is above street level and is probably from the raised terrace of the Orangerie and the Jeu de Paume. Across the way the dark mass left of center, with its many vertical stems, is likely to be the trees at the beginning of the Champs-Élysées. (His other drawing of the place de la Concorde [H 563], which also places the viewer above ground level, must be from the terrace because there is a tree in the left foreground.)

The medium is unusual, since Seurat seems to have used a form of black chalk as well as his customary conté crayon. Under and among the surface strokes of the conté are gray lines and zones that have a nearly liquid quality, and there are tiny granular lumps scattered across the middle ground. The central lamp and two that recede to the right show signs of redrawing, but the "changes" may have resulted from the artist's habit of using multiple lines to avoid definitive edges.

66. *La pluie.* 1882–83

RAIN

Conté crayon, 9⅜ x 11⅞ in. (23.7 x 30.2 cm.)

Private collection

Exhibited in New York only
H 519

PROVENANCE
Marius de Zayas, New York, by 1919, until 1923 (de Zayas sale, Anderson Galleries, New York, March 23–24, 1923, no. 73, for $210); purchased at this sale by John Quinn, New York, 1923, until his death in 1924; his estate, 1924–27 (Quinn estate sale, American Art Galleries, New York, February 9–11, 1927, no. 9, for $300); purchased at this sale by Veraccho Gallery; Arthur B. Davies, New York, by 1928; his estate, 1928–29 (Davies estate sale, American Art Galleries, New York, April 16–17, 1929, no. 363, for $900); purchased at this sale by C. W. Kraushaar Art Galleries, New York, 1929, until 1946; sold to M. Knoedler and Co., New York, in April 1946, until November 1950 (stock no. WCA 941); sold to present owner, 1950

EXHIBITIONS
1908–09 Paris, no. 120
1947 New York, no. 16
1949 New York, no. 28
1958 Chicago and New York, no. 41
1977 New York, no. 10

Two forms anchor our perception in this chaotic swirl and slash of grays and blacks: the silhouette of the woman and the torn opening of the sky. The woman walks away from us, her left arm holding a purse or bag, her right bent to hold her umbrella. The diagonal from the woman to the sky gives a sense of depth, although little else in the drawing specifies image. The ragged edges of the black forms above must indicate foliage, but there are no tree trunks or branches. The trapezoid against the sky is probably a rooftop, but it does not help in deciphering the intermediate space. Is the broad central area a receding lawn, a roadway, or a rising wall? All these uncertainties are borne along on the angular and crisscross lines of the rain, the kind of rain that would be lugubrious were it not for the sky's light.

67. *Le cheval au tombereau.* 1882–83

TIPCART

Conté crayon, 9¼ x 12⅞ in. (23.5 x 31 cm.)

Musée du Louvre, Département des Arts Graphiques, Fonds du Musée d'Orsay, Paris, Gift of Mme Thadée Natanson, 1953
R.F. 30.257

Exhibited in New York only
H 531

PROVENANCE
The artist's brother, Émile Seurat, Paris; Germaine Teisset; Mme Henry Roberts (née Marie Gueydan); Félix Fénéon, Paris; Thadée Natanson, Paris, until his death in 1951; by inheritance to his widow, Mme Thadée Natanson, 1951, until 1953; her gift to the museum, 1953

EXHIBITIONS
1900 Paris, Revue Blanche, *hors cat.*
1920 Paris, no. 52
1926 Paris, Bernheim-Jeune, no. 37
1936 Paris, no. 100

A sense of waiting permeates this rendering of a two-wheeled tipcart, one of the mainstays of suburban and country folk. There is no driver, and the horse looks about while standing idle. The cart's distinctive shape and tilt permit the unloading of bulky produce (its back panel can be removed to release its contents). Centered on the page, the stubby wagon is the portrait of a premodern vehicle, one that speaks of the heavy labor of working the land. Nothing distracts from it, except perhaps the thick swirls which energize the gray area on the lower left. The field that surrounds the cart is a rudimentary plain. The sky has little incident since the dark and light zones around the horse's head are not clouds but Seurat's habitual reactions of contrast. Huge wheels support the weight of the heavy wood sides. The shadow under the cart is wedded to its bulk, so that one large shape is seen, with only the horse's head protruding from its mass.

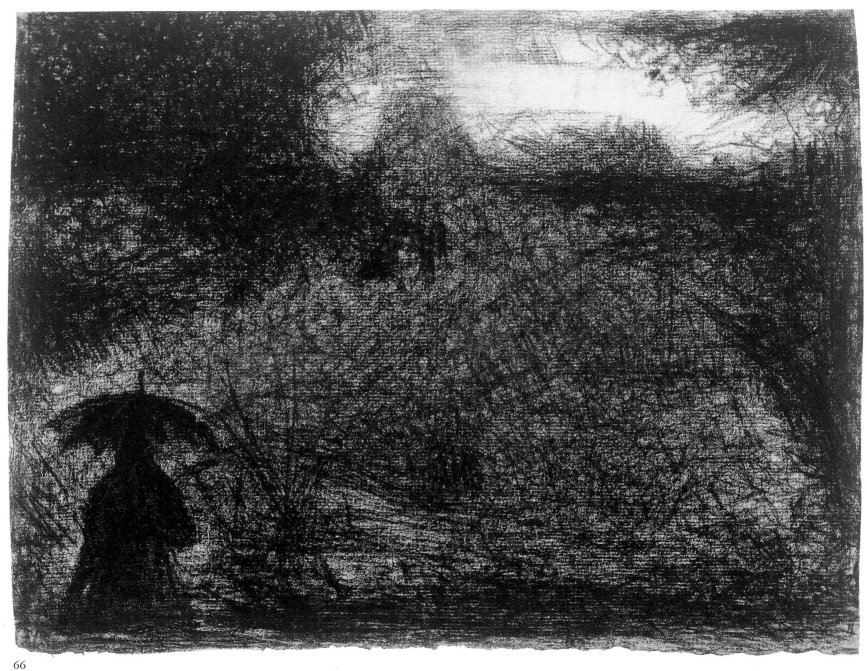

66

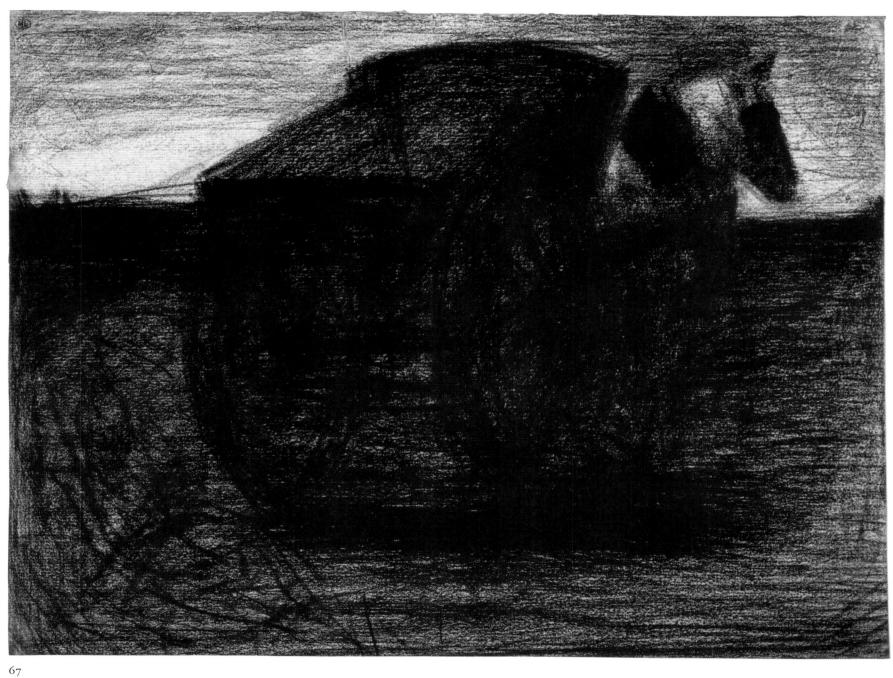

67

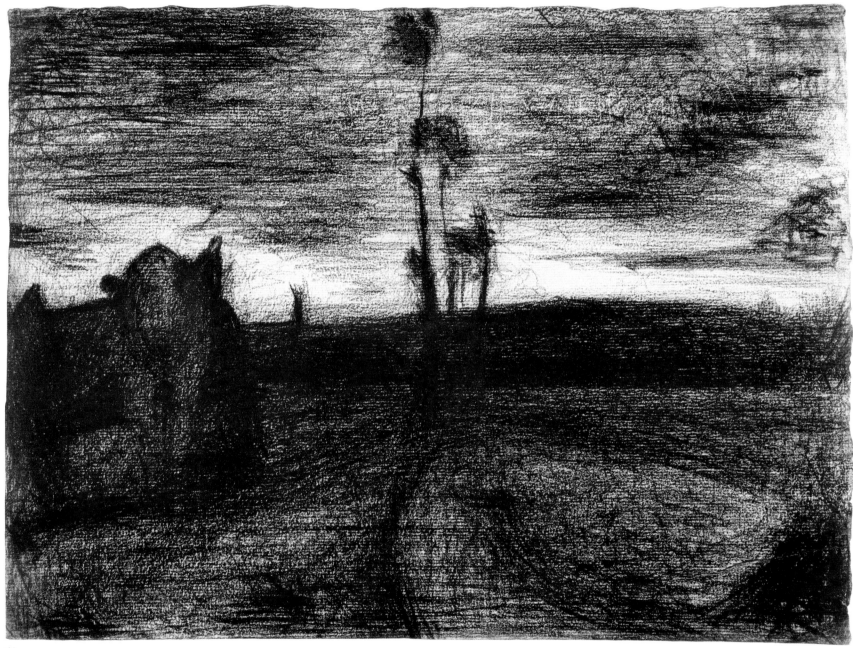

68

68. *Arbres grêles*. 1882–83

TREES AGAINST THE SKY

Conté crayon, 9½ x 12⅜ in. (24 x 31.5 cm.)

André Bromberg Collection

H 530

PROVENANCE
Mme J. D.,* by 1908–09; Camille Platteel, Paris, by 1926, until no later than 1943; to Henri Le Savoureux,** by 1943; with Galerie Bellier, Paris, by 1988; to present owner

EXHIBITIONS
1908–09 Paris, no. 141
1926 Paris, Bernheim-Jeune, no. 76

* See first provenance note, cat. no. 15.
** See second provenance note, cat. no. 15.

Seurat's frequent choice of a sunset sky hovering over an uncertain foreground let him indulge his penchant for the poetry of indecision. From romantic depictions of sunset he borrowed the drama of light and dark as day is defeated by night. His sky here is comparable to those of *Le labourage* and *Les meules* (cat. nos. 54 and 56); in all three the movements of his crayon activate the patches and streaks of gray that determine the sky's character. This rendering is not neutral or descriptive but is charged with gestural and emotional meaning. Against the strong glow rise spindly trees, rachitic forms that gain poignancy from their prominent central position. Their shadows reach forward across the field, helping to flatten it into a broad plain. On the left looms a lumpy phantasmal form that lends itself to conflicting interpretations. It can be made out, however, by comparison with other drawings of horses and carts. A horse, radically foreshortened, faces forward, its front legs stiffly together. To the right is the vertical mass of the cart's huge wheel, and slanting slightly downward on the left is the horizontal of the wagon and its other wheel. As so often in Seurat, the absence of a human figure lends an air of expectancy to the scene, as though the horse were waiting for us.

69. *La grille*. 1882–84

GATEWAY

Conté crayon, 9¾ x 12¾ in. (24.8 x 32.4 cm.)

Solomon R. Guggenheim Museum, New York, Gift, Solomon R. Guggenheim, 1937

H 651

PROVENANCE
Possibly given by the artist to Henry van der Velde, who sold it to Félix Fénéon, Paris,* probably by 1908, until 1930; sold to Solomon R. Guggenheim, in 1930,** until 1937; his gift to the museum, June 1937

EXHIBITIONS
1908–09 Paris, no. 112
1926 Paris, Bernheim-Jeune, no. 84
1958 Chicago and New York, no. 126
1977 New York, no. 35

* The name "Van der Velde" is inscribed on the reverse in Fénéon's hand, as is "de Seurat"; as no inventory number appears on the reverse, presumably Fénéon recorded the name of its former owner after he acquired the drawing.
** Date of purchase based on registrar's shipment invoice, dated November 12, 1930.

At first glance the clear geometry of this drawing seems to place it worlds apart from the preceding drawing and others of country and suburbs. The wall and gateway are easily read as a single shape, rather like a monkey wrench laid on its side. Its striking shapes appeal to the modern predilection for abstract compositions (one can imagine with what admiration twentieth-century artists viewed it in the Museum of Non-Objective Art, the predecessor name of the Guggenheim Museum in New York). It, however, shares with Seurat's other drawings the nocturnal light and dark that produce as much mystery as clarity. There is indeed a subject here, and to disregard it in favor of "abstraction" is to deny Seurat's power to construct forms that interpret what he saw. The geometry admirably suits an urban setting. There may be nothing of "nature" here except the light, unless the vertical to the right is a tree trunk and not a lamp standard (its slight slant suggests a tree). A gray patch seeps over one vertical of the gateway, and once we note this, we see the neighboring gray as foliage. The gateway is stone, each side surmounted by a gabled coping. Beyond is a building, whose window, wall, roof, and chimney can be distinguished. In mid-distance light streaks in from the left, where a low vertical indicates a wall, surmounted by a slanting mass that may be foliage or simply the absence of light. The light reveals variations in the pavement and walls which are not, after all, flat. In the foreground a thinner streak must come from an overhead source. It helps articulate the street on which we stand, looking across its intersection with another street toward the gateway. This drawing is a play of clear geometry with uncertain shadows; light clarifies only enough to reveal a walled entrance keeping a nighttime vigil.[1]

1. In my *Seurat's Drawings* (1962) I said the site was "almost certainly" the gateway of the École des Beaux-Arts, but this now seems wrong. It does resemble old photographs of the entrance but not so closely as to confirm the identification.

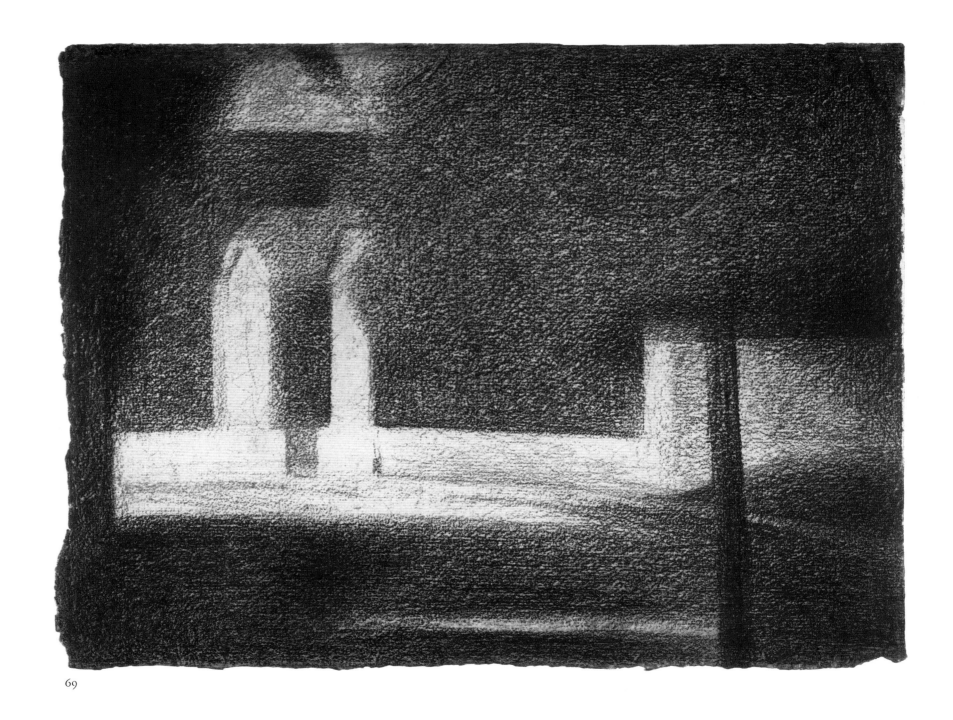

69

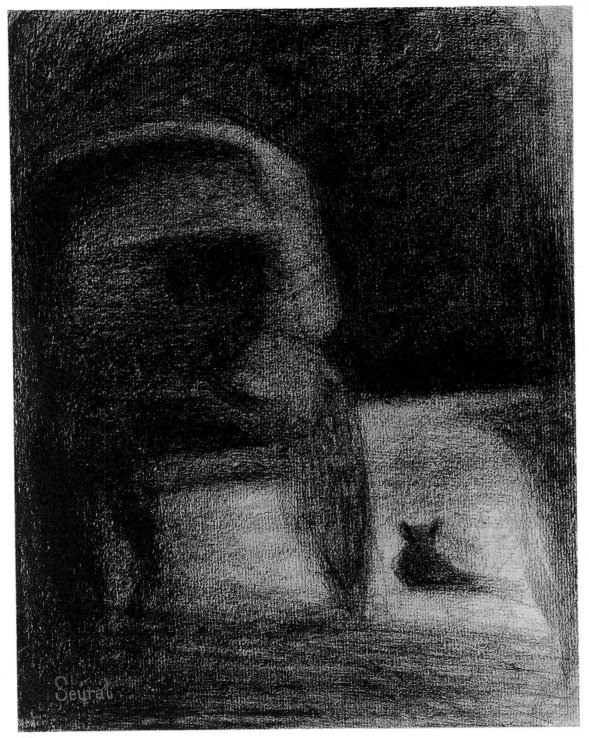

70

70. *La carriole et le chien.* 1882–84

CARRIAGE AND DOG

Conté crayon, 12 x 9 in. (30.5 x 22.9 cm.)
"Moline" stamp in red lower left: Seurat

Collection of Mrs. Bertram Smith

Exhibited in New York only
H 543

PROVENANCE
Probably Madeleine Knoblock, Paris, from 1891; Léonce Moline, Paris; Mme J. D.,* by 1908–09; Camille Platteel, Paris, by 1926; Mlle Alix Guillain; Princess Marguerite Caetani de Bassiano, Rome, by 1950, until at least 1958; with Mr. del Corso in 1966; to present owner by 1977

EXHIBITIONS
1895 Paris
1908–09 Paris, no. 145
1926 Paris, Bernheim-Jeune, no. 67
1950 Rome, no. 9
1958 Chicago and New York, no. 48
1977 New York, no. 15

* See first provenance note, cat. no. 15.

Here again Seurat creates a bizarre effect from the most ordinary circumstances. A dog rests in a roadway near a carriage whose left wheels are in the gutter, causing it to tilt. This plain statement, however, says little about the drawing, whose character lies in its nondescriptive qualities. It is another of Seurat's drawings that Redon might have signed.

The left edge of the carriage disappears into the shadows, which render it insubstantial. Its wheels do not have quite the expected shape, and its interior cannot be wholly deciphered, although its overhead canopy is clear and its projecting footplate can be made out below. There is no one in the carriage and no horse; these absences suggest abandonment, not merely waiting. In other hands the dog might have introduced a note of domesticity, but Seurat makes it look like a shadowy manifestation of the occult.

In the lower left is an unusually clear example of the red stamp invented by the dealer Léonce Moline in 1895 to legitimate drawings and paintings he had acquired from Seurat's lover Madeleine Knoblock. (For an account of Moline's stamp and an enumeration of the works to which it was applied, see cat. no. 89.)

71. *Le balcon.* 1883–84

BALCONY

Conté crayon, 12¼ x 9¾ in. (32.4 x 24.7 cm.)

E. W. Kornfeld, Bern

H 586

PROVENANCE
Félix Fénéon, Paris; Ker-Xavier Roussel, La Montgane, France; with
Galerie Renoue et Poyet, Paris, until 1954; sold to Marianne
Feilchenfeldt, Zurich, in 1954, until 1965; sold to Dr. Zdenko Bruck,
Bern and Buenos Aires, in 1965, presumably until his death; to
present owner by 1983

EXHIBITIONS
1958 Chicago and New York, no. 47
1963 Hamburg, no. 112
1983–84 Bielefeld and Baden-Baden, no. 51

The iron railing at the Seurat family apartment, at 110
boulevard Magenta, is still intact, giving evidence that the
artist was faithful to the pattern of its fronds. The same
balcony railing appears in other drawings, including *Devant
le balcon* and *Femme de dos, penchée* (cat. nos. 28 and 29).
The apartment is a large one on the fourth floor of a

Window in Seurat family apartment on
boulevard Magenta (as it now appears).
Photo: Paul Smith, Bristol, England

71

Haussmannian building, and several of its rooms face the boulevard. This quietly lyrical drawing is a nighttime view through the parted curtains of a tall French window whose horizontal sash appears below the top of the foliate railing. Windows of the building opposite are illuminated, while above is a distant tower. In his boyhood, windows like this would have been Seurat's apertures on the world. This view, together with his many drawings of a middle-aged woman sewing or reading, depicts the sober, sheltered environment of his youth, which he regularly visited after he left home. Although steeped in these rooms and their views, he succeeded in distancing himself sufficiently to transform them into memorable works of art.

72. *Les peupliers*. 1883–84
POPLARS

Conté crayon, 9½ x 12 in. (24.1 x 30.5 cm.)
"Moline" stamp in red lower right: Seurat

Collection of the J. Paul Getty Museum, Malibu, California

Exhibited in New York only
H 554

PROVENANCE
Probably Madeleine Knoblock, Paris, from 1891; Léonce Moline, Paris; Gustave Geffroy, Paris, until no later than 1926; André Barbier, Paris, until no later than 1970; Marianne Feilchenfeldt, Zurich, from 1981 until 1982; sold to Franz Armin Morat, Freiburg im Breisgau, in 1982; to the Morat Institut für Kunst und Kunstgeschichte, Freiburg im Breisgau, by 1983–84; to Mrs. Charlotte Morat, until 1988 (sale, Christie's, London, June 28, 1988, no. 308); purchased at this sale by the museum

EXHIBITION
1983–84 Bielefeld and Baden-Baden, no. 48

If Seurat had painted this site, his colors would have identified its elements: field, poplars, distant foliage, a clearing to the left, and sky. In the grays and blacks of his conté crayon these can finally be located, but the drawing's attraction lies in the struggle to do so. The tall poplars stand against the sky, their bases rooted in the meadow. Given this area of certainty, the broad horizontal of the field takes shape, aided by the horizon of darkened growth in mid-distance. The scale of the gray foliage in the distance is grasped only when the viewer realizes that the rectangular patch of light on the left is a clearing seen through a break in the wall of brush. The illuminated spot of the nearby field in the lower left corner lines up with it to form a deeply receding space. Lastly the viewer notices more poplars—the fainter verticals on both sides of the two prominent ones. Their shadows are seen in the rhythmic alternation of dark spots along the base of the sheet below the angled watermark.

72

73. *Bords de rivière*. 1883–84
TREES BY THE RIVERSIDE

Conté crayon, 8⅞ x 11⅞ in. (22.4 x 30.2 cm.)
Watermark: E. D. & Cie

Private collection

Exhibited in Paris only
H 553

PROVENANCE
Mme Billard; Jacques Rodrigues-Henriques, Paris, until 1935; sold to Frau Hedy Hahnloser-Bühler, Winterthur, from 1935 until her death in 1952; by inheritance to Lisa Jaeggli-Hahnloser, Winterthur, from 1952; to present owner

EXHIBITION
1983–84 Bielefeld, Baden-Baden, and Zurich, no. 47

73

Hovering between regularity and irregularity, this drawing reverses usual expectations: the reflections are more prominent than the real trees. Both the trunks of the poplars and their reflections were made with the same vertical sweeps of the crayon, and they move flatly up and down the page. The far edge of the river cannot be located, and therefore the water does not appear to recede. However, after we look for a moment, the stubby trunks above assume an immovable fixity, while their reflections acquire vitality as they sway across the water's surface. Paradoxically plunging downward to reach the sky, they exist in a realm closer to that of Redon than of Monet, whose later paintings of poplars and their reflections have a more extroverted poetry.

Independent Paintings 1879–1884

The solitary urban figures and dusky streets of Seurat's early drawings do not appear in his oils of the same period. Seurat, like many artists, treated painting and drawing as separate worlds. The distinction between them was deeply rooted in European culture and particularly in the tradition in which Seurat studied. Lequien and Lehmann, like most professors of art, taught students to master drawing before turning to painting. Drawing was rational, scientific, teachable, the very basis of illusionistic form, of composition, even of one's grasp of the visible world. Color was ephemeral (did it not change with angle of sun or time of day?), emotional, sensual, not readily subjected to rules. Drawing was masculine and Western; color was feminine and Oriental. "Drawing is art's masculine gender; color is its feminine gender," wrote Charles Blanc. In painting, he said, "Color is essential, even though it is placed second. The union of drawing and color is necessary in order to beget painting, just as the union of man and woman begets humanity; but drawing must preserve its preponderance over color."[1]

Throughout his short life Seurat placed black and white before color. He therefore exercised control over shapes and their positioning, so that color could be treated as a garment: a glorious garment, woven with miraculous sensitivity and bookish knowledge, but a garment nonetheless. Most of the writings on art and science that he studied before 1881, although devoted to color, claimed that the controlling phenomenon was light and dark. Both his drawings and paintings, dissimilar in some respects, posit a continuum of light and dark and are therefore subject to this principle. Seurat was not the draftsman that Ingres and Degas, those brilliant wielders of line were—he was a painter's draftsman. Signac later said of his drawings that they were "so studied in contrast and gradation that one could paint after them without seeing the model."[2]

Seurat's school lessons had been largely limited to drawing, but he had painted on his own outside the classroom. The few oils that survive from his school years show scant signs of his eventual independence: a portrait head (cat. no. 74), a still life (cat. no. 75), a copy after Ingres, a nude, and a classical subject.[3] These last three speak well for the youthful artist trying to escape school lessons but not yet capable of doing so. The subjects are those of the Beaux-Arts tradition, but the palette and brushwork are closer to Delacroix. Delacroix loomed large in Seurat's early years when, according to his own later testimony (Appendix F), his chief concern was the "purity of the spectral element." The romantic master was the leading colorist of the preceding era, and Seurat found in his art and writings a release from the strict attention to drawing that his own schooling required. Delacroix was at the center of several of his early readings. He read an article on him by Charles Blanc, and in the same author's *Grammaire*, the text that most influenced the young artist, Delacroix is put forward as the leading practitioner of divided color. Seurat also read a book about Delacroix, and above all he closely studied his paintings. In them he found, in his own words, "the strictest application of scientific principles seen through a personality." (For Seurat's readings and notes, see Appendix N.)

According to his friends, Seurat repeatedly visited the chapel in Saint-Sulpice where there were two large murals by Delacroix. The notes that he took on Delacroix in 1881 were based on visits to several dealers, to exhibitions, and to the Musée du Luxembourg. He paid special attention to two of Delacroix's practices: surrounding a color with its opposite and breaking or dividing colors into several tints. He noticed that Delacroix enlivened his grayish areas by fine streaks of the opposites orange and blue and that he broke up single colors by brushing in several variations of the same hue in separate strokes, a feature of Delacroix's technique that Blanc repeatedly emphasized. For example, by laying in small strokes of orange-red, brick red, and purplish red over a maroon, Delacroix formed a resonant, richer red. This technique, which Seurat imitated from the beginning, was the "analogy of similarities" he incorporated in his later statement on his "esthétique" (Appendix E). In discussing these arrangements of color, Blanc invoked the theories of the famous chemist M.-E. Chevreul, yet another writer whom Seurat read and annotated, and the same broken tints were recommended by Thomas Couture and David Sutter, whom he had read in 1880.

After his return from military service in late 1880, Seurat gave up Beaux-Arts figure subjects and turned instead to genre painting and landscape, following the dominant current among progressive artists. When he entered this realm, he put Delacroix behind him except as a moral hero and a master of broken color. From 1881 through 1884, not counting studies for his major oils, he produced about twenty canvases and seventy small panels mostly devoted to landscapes and peasants. Only five pictures

represent the city, and only about twenty (including *Baignade* and its studies) show suburban industry or work. This is not surprising for two reasons. First, as noted above, the city and industrial suburbs were featured in his drawings, whereas color was associated with "nature," with the open spaces of suburb and country. And second, he had apprenticed himself to those mid-century artists who preferred meadows, forests, villages, peasants, seashore, fisherfolk, and suburban riverbanks to the city. Théodore Rousseau, Diaz, Bonheur, Millet, Corot, Courbet, Daubigny, Boudin, and Jongkind had largely forsaken history painting and romantic themes in favor of these subjects, and for that reason they were among the principal mentors of the next two generations.

Seurat's predilection for landscapes and peasants in his first postschool years was therefore typical of his time. He left the Beaux-Arts determined to find his own way, and for him this meant color, which had been slighted by his teachers. In 1881 he adopted the Barbizon artists' imagery of rural life and landscape and learned how their palette transcribed effects of outdoor light and color. In *Paysage au piquet* (cat. no. 83), for example, both subject and palette go back to the work of Corot, Rousseau, and Diaz, which Seurat interpreted with his own variation upon Delacroix's technique. He broke up color areas with large strokes of adjacent hues: for the sunny grass, broad touches of pale yellow, orange-yellow, yellow-green, and green; for the shaded grass and foliage, green, green-blue, blue, dark blue, wine-red, and a scattering of pink. In the small panel *Casseur de pierres à la brouette, Le Raincy* (cat. no. 89), reminiscent of Millet, the brownish color of the wheelbarrow is formed by the exposed wood of the panel plus green, orange-brown, blue, and wine-red.

After 1882 Seurat's paintings in a modified Barbizon manner overlap with pictures of suburban riverbanks that increasingly move into the orbit of Impressionism. According to his friend Ernest Laurent, Seurat, Aman-Jean, and he visited the fourth Impressionist exhibition in spring 1879 and were much struck by it.[4] Seurat slowly absorbed lessons from Impressionist pictures over the next several years, and by the end of 1884 he had left Barbizon far behind. This shift coincided with his pondering another of the treatises on color that were to become so important to him: Ogden Rood's *Modern Chromatics*, which, together with Impressionism, contributed to his unfolding maturity.

Rood's treatise (Appendix K), which Seurat began reading in early 1881, confirmed Chevreul's emphasis upon contrasts of colors but gave them a more solid scientific base. Rood pointed out that Chevreul had confused colored lights and colored pigments, and he summarized the most recent scientific findings in lay language. Since Seurat could not paint with light, he could not reconcile Rood's lessons with his craft. Rood's chief virtue for Seurat was to put him in touch with current science, which explained why there was no such thing as "local color" (that is, color as inherent to objects). Green grass, for example, is really a mixture of several colors that produce a green effect. This much Seurat had observed in Delacroix's pictures, so Rood allowed him to proceed with "scientific" assurance in the use of intermixed and contrasting hues. By 1883 he was experimenting with some of Rood's complementaries (purples against greens instead of the traditional red-green opposition and oranges against greenish blues instead of purer blues).

Just as Rood supplanted Chevreul and Blanc, so the Impressionists succeeded Delacroix in Seurat's development after 1881. In 1890 he told Fénéon (Appendix F) that he had been "struck by the intuition of Monet and Pissarro" (to other friends he also mentioned Renoir), a condescending phrase by which he meant that although they had not gone far enough toward "scientific Impressionism," they had broken sufficiently with the past to help him on his way. They had already learned from Delacroix, in particular from his broken colors (Renoir was especially beholden to the romantic master). Moreover, scientific conceptions of color had been attributed to the Impressionists, for some reviewers had defended the new art by evoking optical mixtures and theories of contrasting hues.[5] Seurat's knowledge of Impressionism was not fully revealed in his art until 1883, nor can it be readily disentangled from what he was learning from Barbizon art, Delacroix, and Rood, but it certainly influenced his development between 1881 and 1884.

In *Paysage au piquet* (cat. no. 83), for example, color contrasts are very muted. The complementaries are all present (reds and greens, blues and oranges, yellows and purples), but they seldom touch and are only in subdued tints. A picture painted a year or more later, *Paysannes au travail* (cat. no. 93), shows a much bolder juxtaposition and intermixing of contrasts and more saturated colors. Seurat could feel he was faithful to Rood because, for example, the green foliage to the rear displayed reflected sunlight (orange-yellows), partly absorbed sunlight (yellow-greens, blue-greens), and indirect light (blues and purples). His contrasts were closer to Rood than to Chevreul: oranges and cyan blues, greens and purples. The brushwork is very bold, rather like chopped straw (Seurat called it "balayé" [broom-swept]). The colors had to be separated, so this was a rational, analytical way of going about it. Imitative appearances were sacrificed because this was more a sketch than a "finished" picture. (In the *Baignade*, exhibited in 1884, the "chopped straw" was more refined and lent itself to a more acceptable illusion of nature.)

In traditional painting, which Seurat's Beaux-Arts training was intended to serve, artists first modeled their forms in light and dark and then followed with translucent glazes to provide color. In other words, coloration was built up in successive layers from the canvas to the surface. Delacroix and the Barbizon painters retained some of these procedures but also laid colors side by side on the surface. The Impressionists were influenced by these precedents but shed even more of the traditional layering, relying upon opaque pigments which they applied in frankly revealed strokes. In doing so they greatly reduced the role of modeling in light and dark and put correspondingly greater emphasis upon color. Since they also began adopting the bright new industrial hues and gradually gave up most earth tones, their brushwork became all the more prominent. It seemed to result from their spontaneous reactions to what was actually in front of them, as distinct from artificial studio work.[6] Strokes are large and separate, but they usually suit the imagined angles and textures of the images they help create. Compared with Seurat's *balayé* surfaces, theirs are more adapted to the illusion of natural forms. Only for foliage did they use crisscross strokes that resemble Seurat's.

The arbitrary brushwork of Seurat's pictures has appealed to the twentieth century and so has the geometric patterning of his pictures, thanks to the modern penchant for nonimitative arts. His peremptory shapes and brushwork are not really "abstract" because they are responses to color and light, and the images they construct have consistent meanings. However, in *Paysage au piquet* and *Paysannes*, meadows and foliage are laid out in surprisingly rudimentary swatches. In neither painting is there much concession to atmospheric modeling, for the individual areas do not bend back, they rise up flatly. Stake, tree trunk, and figures act as signposts of depth, but only to a minimum degree, and their shapes partake of the overall clarity of pattern. Some of this simplicity can be put down to the fact that these canvases are sketches and need not have the subtler modeling of finished oils, but that is not a sufficient explanation. Their geometric formulations were characteristic both of his contemporary drawings and of his major finished oils. They are remarkable inventions that stamp Seurat's early art with a distinctive creative mark. On the walls of museums they have a surprisingly "modern" appeal.

Equally singular are Seurat's tiny wood panels, which greatly exceed in number his early canvases. Since the turn of the century they have been universally admired, even by those who are cool to his major paintings. Some of their appeal is explained by their comfortable, unpretentious size (6¼ x 9⅞ in. [16 x 25 cm.]). They were not ambitious paintings but studies whose character is naturally intimate. Seurat called them "croquetons"

(sketchettes), a word he may have invented.[7] He always exhibited them alongside his large finished pictures whereas he never showed canvas sketches like the *Paysage au piquet*.

The panels were easily transported, readily held in the hand while working, and durable. They could be used with no more preparation than the wood had already received from the framemaker. Seurat coated a few of his panels with white, perhaps inspired by the Impressionists and by Rood, who recommended white grounds,[8] but in most cases he painted directly on the wood which had usually been varnished. He let the wood show through between his strokes and incorporated it as an orange color. Looked at very closely, it is a warm brown, but from a slight distance, affected by the pigments which surround each little patch, it usually has an orangish glint. Painters had used panels for many generations and had often exploited the wood's color, so Seurat's practice was more that of a conservative craftsman than a venturesome technician. Impressionist painting, as well as Barbizon art, offered a precedent here, for although the Impressionists eventually shifted to very light grounds, they had used toned grounds in their early work.[9] In other words, later Barbizon and early Impressionist practice overlapped and supplied Seurat with many examples to observe.

Seurat's panels demonstrate the same evolution found in his early canvases. His *Paysage au tas de bois* (cat. no. 76), probably of 1879, is essentially a tonal picture with no strong contrasts. *Le faucheur* (cat. no. 78), done after his release from military service, also has no significant use of contrasts, but it takes a step toward Barbizon art in both subject and palette. The warm brown of the varnished panel enters into the broken colors of each of the three horizontal precincts that are spanned by the harvester. The foreground strip, for example, is dominated by a yellowish tan, which results from the panel's orange, plus a range of yellows, tans, and earth tones. In the later *Jardinier* (cat. no. 94), the comparable sunny areas actually have fewer colors but they seem brighter. This results from the clash of the orange and green that compose them, abetted by the contrasting blue-purples of the shaded strips. Elsewhere color opposites are prominent. The dull orange patch above the man's lower back is surrounded by blue, and yellowish tans enclose his purple trousers. The trousers, incidentally, embody Seurat's heritage from Delacroix. They are a *ton rompu*: several tints of blue, wine-red, and touches of pink and greenish blue over a base consisting of thin strokes of wine red modified by the brown wood color that shows through feebly. Another sign of Seurat's rapid development is the complicated pattern he has woven with such simple means, one that produces subtle tensions that activate the composition.

Despite its brighter palette *Le jardinier*, like the earlier panel, recalls

Millet, but during 1883 Impressionism began to crowd out Barbizon art and, with it, rural subjects. Paintings of suburban riverbanks and boating became increasingly common, and more saturated colors supplanted earth tones. *Bords de rivière* (cat. no. 99), for example, was probably painted within a year of *Le jardinier* but seems to signal a wholehearted adoption of Impressionism. Between 1881 and 1884 the young artist recapitulated the styles of previous decades, moving through Barbizon art to Impressionism. In 1884, when he exhibited *Une baignade, Asnières* and began work on *Un dimanche à la Grande Jatte,* he left behind the world of the peasants, never to return.

1. Blanc 1867, ed. 1880, pp. 21, 22. Blanc reinforced the idea of male dominance by continuing: "If it is otherwise, painting is on the road to ruin; it will be lost by color as humanity was lost by Eve."
2. Diary entry of February 22, 1895, in *Signac Journal,* ed. J. Rewald, p. 117. The continuum of light and dark in Seurat's drawings is the special subject of Bernd Growe in Franz and Growe 1984.
3. After Ingres's *Angélique au rocher* (H 1; Norton Simon Foundation, Pasadena, California); *Truth Emerging from the Well* (H 4; location unknown), whose subject was first correctly identified in Thomson 1985, fig. 11; *Jupiter et Thétis* (H 5; art market, Japan).
4. Laurent, cited in Rosenthal 1911, p. 65.
5. For example, the famous pamphlet by Edmond Duranty, *La nouvelle peinture* (1876) or J.-K. Huysmans's "L'exposition des Indépendants en 1880," in his *L'art moderne* (1883),

p. 119. Huysmans wrote of Degas: "Not since Delacroix such a new application of optical mixture ['mélange optique'], that is, of a tone missing from the palette, and obtained on the canvas by the bringing together of two others. Here, in the portrait of Duranty [Burrell Collection, Glasgow], patches of nearly vivid rose on the forehead, green on the beard, blue on the velvet of the suit's collar; the fingers are done with yellow edged by bishop's violet."
6. They did, in fact, work a lot in their studios and developed a whole set of artfully disguised conventions. See R. L. Herbert, "Method and Meaning in Monet," *Art in America* 67 (September 1979): 90–108.
7. Several reviewers of Seurat's first major showing, at the Indépendants in 1884, refer to his nine "croquetons," but they derived this term from the catalogue entry, which he must have given himself. Years later Signac said that Seurat had found the word in the writings of the Goncourts, but it has not yet been located there. The small panels were also called "boîtes à pouce" and "boîtes à cigare." The varnished mahogany of some of the panels Seurat used suggests that he actually used cigar-box tops, but presumably he purchased most of his panels from art shops. Many of the panels are a reddish brown mahogany, some of lighter brown poplar. He probably used a prepared oil-sketching box, fitted with grooves to hold two or more panels, such as can be seen in J. A. M. Whistler's paraphernalia in the Hunterian Art Gallery, University of Glasgow.
8. At least three were so coated: *Paysage d'eau* (cat. no. 86), *Paysannes à Montfermeil* (H 34; Mr. and Mrs. Paul Mellon), both of 1881–82, and *Homme peignant son bateau* (H 66; Courtauld Institute Galleries, London), of 1883–84.
9. For example, Sisley's *Neige à Louveciennes* of 1874 (Phillips Collection, Washington, D.C.) has a light brown priming that shows through between the surface strokes; in places the brushwork has a nearly *balayé* look, although not as regular as Seurat's.

74. *Tête de jeune fille.* 1877–79

HEAD OF A YOUNG WOMAN

Oil on canvas, 12 x 9⅞ in. (30.5 x 25.1 cm.)

Dumbarton Oaks Research Library and Collection, Washington, D.C.

H 2; DR 2

PROVENANCE
The artist's brother-in-law, Léon Appert, Paris, until at least 1908–09 and probably until his death in 1925; to his son, Léopold Appert, from 1925; sold to Étienne Bignou, Paris, by 1929; owned jointly by Étienne Bignou, Paris, and M. Knoedler and Co., New York (stock no. A 906), from July 1929 until 1935; sold to Mr. and Mrs. Robert Woods Bliss, Dumbarton Oaks, in November 1935, until 1940; their gift to the collection, 1940

EXHIBITIONS
1908–09 Paris, no. 1
1949 New York, no. 2
1958 Chicago and New York, no. 9

This small study was still in the artist's family when Fénéon borrowed it for the exhibition at Bernheim-Jeune in 1908, and family tradition said it was a portrait of "Mademoiselle B.," a cousin. The subject has not otherwise been identified, and there is so little evidence of Seurat's paintings before 1881 that we can only be sure that it was painted sometime in the late 1870s. He modeled the head with parallel strokes of his brush, visible both in the hair and the back of the neck, a method similar to that of his conté crayon drawings. Also consistent with his early drawings is the blocky rectangle formed by the head and its diagonal tilt. The simple color scheme rotates around the warm flesh color with light tan highlights, brick red touches on the ear, and brown in the hair. Pale blue streaks in the hair are the strongest marks of opposed color. The tiny earring assumes importance because its tangible substance contrasts with the translucent skin and hair. The lost profile, commonly found in Seurat's school drawings of nudes, the tilt of the head, and the lowered eyes invest the figure with a distinct modesty.

74

75. *Bouquet dans un vase*. 1878–79

BOUQUET

Oil on canvas, 18¼ x 15¼ in. (46.4 x 38.5 cm.)

Fogg Art Museum, Harvard University, Cambridge, Massachusetts, Collection of Maurice Wertheim, Class of 1906

Exhibited in Paris only
H 3; DR 7

PROVENANCE
The artist's brother-in-law, Léon Appert, Paris, until his death in 1925; by inheritance to his daughter, Mme Léon Roussel, Paris, until at least 1934; by inheritance to her son, François Roussel, until 1939; sold to Bignou Gallery, Paris and New York, in June 1939, until March 1940; sold to Maurice Wertheim, New York, in March 1940, until his death in 1950; his bequest to the Museum, 1951, with his widow retaining life interest until her death in 1974

EXHIBITIONS
1933–34 Paris, no. 153 suppl.
1948 New York, no. 46

Despite its relatively dull colors, this early canvas contains in germ much of Seurat's future color practice. It is based on the contrasts of hue and the broken rather than uniform colors that were at the center of his readings about Delacroix and color theory. He began with wide crisscross strokes of dark tones which he allowed to dry, so that subsequent layers, picking up just the ridges of these strokes, left the valleys partly exposed. This assured both a binding matrix and a shimmer of light and dark that activated the surface. For the background, vaguely resembling cloth, he then applied several colors in short vertical strokes: wine red, blue, brick red, dull orange, brown. The backdrop turns dark or light to contrast with the opposite tonality of the vase and flowers; it also accumulates more green and blue to oppose nearby reds and oranges. For the darker base of the bouquet, greens become prominent in opposition to the mixture of reds and yellows of the blossoms; those greens (medium green, yellow-green) are partly mixed with pink, cream, and dark blue. The vase has a grayish cream local color with a pale green floral pattern, but these are largely obliterated by the strong direct light and, on the extreme right, by a narrow zone of orange tints that represents light reflected from the illuminated tablecloth. In reaction to that orange zone the vase has a parallel band of "gray," consisting of blue and green

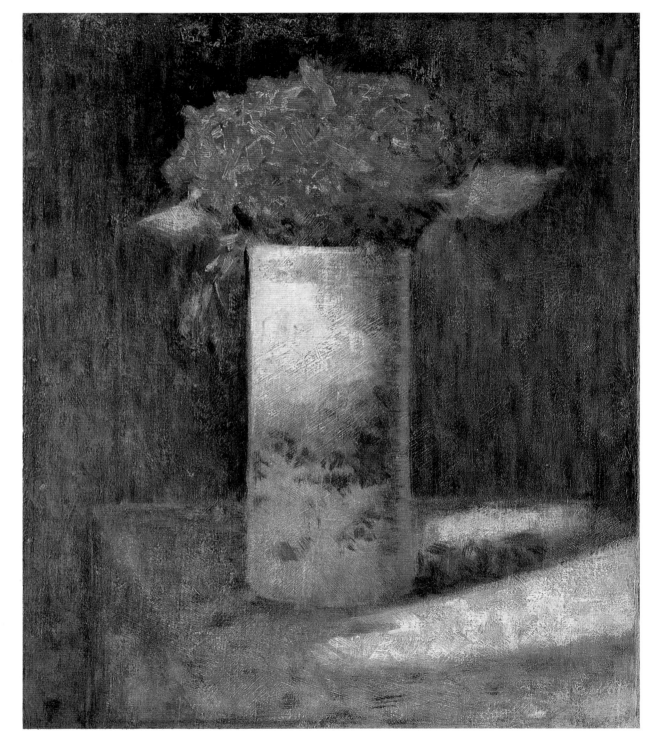

75

tints mixed with orange. These bands and zones follow the principle of shifting contrasts that would, at the end of Seurat's career, be manifested in his painted borders and frames as well as in his compositions.

Bouquet dans un vase is Seurat's only painted still life, and not counting studies for his large paintings, he drew only one still life (H 572, *Roses dans un vase*, 1882–83). Since still lifes are an ideal way to study color-light under controlled conditions, their scarcity seems strange but may be explained by Seurat's ambition. He aspired to the highest categories of art as measured by his generation: figure painting (the successor of history painting), genre, and landscape. Portraiture and still life were lower on the scale of prestige and less likely to win a place for a young artist.

boyhood friend Aman-Jean identified the site of the landscape. In a letter to Benedict Nicolson of 1938 or 1939, Félix Fénéon wrote that "Aman-Jean spontaneously recalled having seen Seurat paint this panel at Saint-Ouen, as he wrote on the back of the photographs I showed him [in 1935] along with the panel."[1]

This work was painted in 1878 or 1879 and is Seurat's earliest surviving landscape. Its pigments, mostly earth tones, which he began to abandon in 1881, are applied in rather flat and partly blended strokes. Throughout the panel the golden color of the wood is exposed between the strokes and used as an essential hue. It is a key element of the pile of wood and elsewhere acts as a warm tint that relieves the dull, mixed greens.

1. Copied in a personal communication from Mr. Nicolson, December 29, 1954.

This landscape with its free copy after Puvis de Chavannes was painted on the reverse of cat. no. 76. Since Puvis's famous picture was exhibited in the Salon in the spring of 1881, we can confidently assign Seurat's little copy to that season. The landscape was done first, and the copy was then painted atop it. Far from exact, it is undoubtedly a rough copy from memory. Because Seurat misspelled the artist's name ("Puvisse de Chavannes"), it is likely that he intended to mock his famous elder, despite the fact that several of his closest friends sat at Puvis's feet.

The landscape on which the copy is painted is not easily deciphered, but on the left there is a house whose wall, roof, and chimney can be seen. (The gray border on the left may be unrelated to the composition or may be the edge of a wall.) The sky above is in several blended tints of pale blue, green, and lavender. In front of the house is a fruit tree in bloom, which would confirm a spring date for this side of the panel. Foliage fills the left foreground, in large strokes of gray-green, earth tones, and pinkish gray. On the far right the gray scumble suggests that the landscape was never finished.

76. *Paysage au tas de bois.* 1879

LANDSCAPE AT SAINT-OUEN

Oil on wood, 6⅞ x 10⅜ in. (17.5 x 26.4 cm.)
Originally part of a double-sided panel that was separated after 1950 into two separate panels; the other side is cat. no. 77

The Metropolitan Museum of Art, New York, Gift of Mrs. Bernice Richard, 1980 1980.342

Exhibited in New York only
H 7; DR 3

PROVENANCE
Félix Fénéon, Paris, by at least 1935, until his death in 1944; his estate, 1944–47 (Fénéon sale, Drouot, Paris, May 30, 1947, no. 99 [recto and verso, with cat. no. 77], for 191,000 francs); purchased at this sale by Courcelle; sale, Drouot, Paris, May 10, 1950, no. 122 (recto and verso, with cat. no. 77), for 450,000 francs; with Berès, Paris; with Jacques Dubourg, Paris; Anna Maria Biondi, Beverly Hills, California, until 1951 (Biondi sale, Kende Galleries, New York, November 15, 1951, no. 90, for $1,200); George N. Richard, New York, by 1954, until his death in 1973; by inheritance to his widow, Bernice Richard, 1973, until 1980; her gift to the Museum, 1980

This and the following picture were two sides of a single panel that was sawed in two in the early 1950s. They are reunited in this exhibition for the first time. Seurat's

77. *Paysage avec "Le pauvre pêcheur."* 1881

LANDSCAPE WITH COPY AFTER "LE PAUVRE PÊCHEUR"

Oil on wood, 6¼ x 9⅞ in. (16 x 25 cm.)
Originally part of a double-sided panel that was separated after 1950 into two separate panels; the other side is cat. no. 76

Huguette Berès, Paris

H 6; DR 4

PROVENANCE
Félix Fénéon, Paris, by at least 1935, until his death in 1944; his estate, 1944–47 (Fénéon sale, Drouot, Paris, May 30, 1947, no. 99 [recto and verso, with cat. no. 76], for 191,000 francs); purchased at this sale by Courcelle; sale, Drouot, Paris, May 10, 1950, no. 122 (recto and verso, with cat. no. 76), for 450,000 francs; with Berès, Paris with Jacques Dubourg, Paris; Anna Maria Biondi, Beverly Hills, California, until 1951 (Biondi sale, Kende Galleries, New York, November 15, 1951, no. 91); sale, "Collections de divers amateurs," Galerie Charpentier, Paris, November 30, 1954, no. 63; to present owner

EXHIBITIONS
1936 Paris, no. 2
1957 Paris, no. 5

Pierre Puvis de Chavannes, *Le pauvre pêcheur* (The poor fisherman), 1881. Musée d'Orsay, Paris

76

77

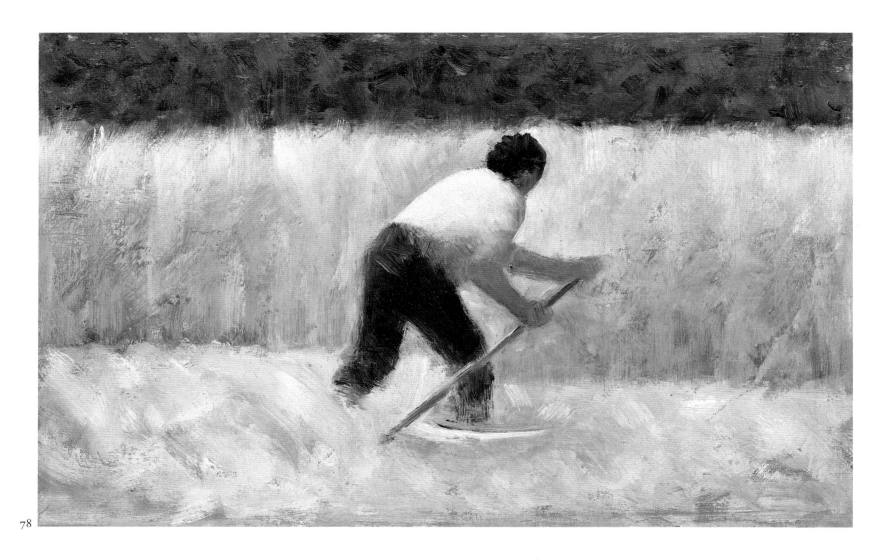

78

78. *Le faucheur.* 1881–82

THE MOWER

Oil on wood, 6½ x 9¼ in. (16.5 x 25 cm.)

The Metropolitan Museum of Art, New York, Robert Lehman
Collection, 1975 1975.1.206

Exhibited in New York only
H 58; DR 39

PROVENANCE
The artist until 1891. Posthumous inventory, panneau no. 39. Inher-
ited by the artist's brother, Émile Seurat, Paris, in 1891, probably
until his death in 1906; by inheritance to his wife's daughter, Mme

Mouton, Paris; Félix Fénéon, Paris; Josef Stransky, New York, by
1929, until his death in 1936; his estate, with Wildenstein and Co.,
New York, from 1936 until 1949; sold to M. Knoedler and Co., New
York, in September 1949 (stock no. CA3322); sold to Mr. Robert
Lehman, New York, in September 1949, until his death in 1969; his
bequest to the Museum, 1975

EXHIBITIONS
1929 New York, no. 63
1937 London, no. 42
1949 New York, no. 1
1958 Chicago and New York, no. 50
1977 New York, no. 46

The earth tones and lack of contrasts mark this as one of
Seurat's early peasant pictures, probably painted in mid-
summer 1881. In its simple structure as well as its subject,
it recalls Millet's work, particularly drawings and prints
like the famous *Travaux des champs*. Pissarro and van Gogh
also admired Millet, for peasants and rural life retained a
strong attraction through the 1880s despite the Impres-
sionists' preference for suburban leisure. In contrast to van
Gogh's interest in Millet's expressive powers, Seurat val-
ued the Barbizon master's ability to construct sculptural
forms that stressed synthesis over detail and type over

individual. Seurat's anonymous mower is an elemental
form whose convincingness lies in the overall control of
his action: feet firmly planted, upper body bent to swivel
from the hips, arms outstretched to swing the scythe,
whose handle parallels his back. Centered on the panel, he
is part of the simple geometric surface characteristic of
both Seurat's paintings and drawings. Modeling is at a
minimum, largely limited to the man's upper body, which
turns blue on the shaded side. Color is rather rudimentary
but sufficient to present a simple image. The foreground is
in a straw color (yellow, white, tan, and earth tones, mixed
with some pink and blue, plus exposed panel color). To
the left sweeping strokes of lighter yellow give an idea of
the mown hay. The standing hay or grain is nearly the
same color but darker toward the ground, where a good
deal of exposed wood acts as an orange, adding its effects
to the grayish blues, greens, and purples. At the top the
distant foliage is a dull blue-green, consisting of both
those colors plus wine red and purple.

J. F. Millet, *Le faucheur* (The reaper),
engraved by Adrien Lavieille after Millet.
Illustration, February 5, 1852, p. 92.

79. *Sous-bois à Pontaubert*. 1881–82

THE FOREST AT PONTAUBERT

Oil on canvas, 31⅛ x 24⅝ in. (79.1 x 62.6 cm.)

The Metropolitan Museum of Art, New York, Purchase, Gift of
Raymonde Paul, in memory of her brother, C. Michael Paul, by
exchange, 1985 1985.237

H 14; DR 8

PROVENANCE
The artist's brother, Émile Seurat, until about 1900; Alexandre
Natanson, Paris, from about 1900 until at least 1909; with Bernheim-
Jeune, Paris; Otto von Waetjen, Paris, Barcelona, and Düsseldorf, by
1914, until about 1919; with Alfred Flectheim, Berlin and Düsseldorf;
Julio Kocherthaler, Madrid, by 1935; Sir Kenneth Clark, London, by
1937, until his death in 1983; his estate, 1983–85; purchased from his
estate through E. V. Thaw and Co., New York, 1985

EXHIBITIONS
1900 Paris, Revue Blanche, *hors cat.*
1908–09 Paris, no. 6
1936 Paris, no. 3
1937 London, no. 35
1968 New York, no. 64

With his friend Aman-Jean, Seurat spent the late summer
of 1881 in Burgundy, at Pontaubert, between Avallon and
Vézelay, a region earlier favored by Corot and by Daubigny.¹
From this trip came *Sous-bois à Pontaubert*, the largest and
most ambitious of his canvases until the *Baignade*. He
presumably worked on it after his return to Paris, and the
winter of 1881–82 is its likely date.

In both subject and technique this work recalls the
forest clearings painted by Corot, Théodore Rousseau,
and Diaz, rather than the work of Delacroix. The romantic
master was Seurat's guide in the use of broken colors, but
he conceived his rural landscapes and figures in a Barbizon
manner. Rousseau used a dense interweave of multicol-
ored strokes that offers analogies with Seurat's picture.
Diaz often placed flecks of paint side by side over broader
and more liquid strokes to produce a shimmer that is
looser than Seurat's but that has somewhat the same effect
from a distance. Corot, whose advice Seurat had copied
out (Appendix M), frequently used small dabs to capture
the sparkle of light over dense foliage.

Sous-bois is a canvas of remarkable maturity for such a
young artist. Its clearly ordered rhythm moves with
elegant grace from left to right, where the gently swaying

birches give place to the stately trunk. Small touches of
golden yellows and oranges shimmer in front of a network
of greens and browns, forming a continuity of colored
atmosphere that is the counterpart of the grays and blacks
of his contemporaneous drawings. The color was applied
over a brown ground which shows through everywhere
and enters into the composition of the surface colors. This
was the practice of Delacroix and the mid-century painters
but not of the Impressionists, who employed light-colored
grounds.

Because of the small dabs that Seurat used on this
canvas, many observers have dated it much later, but there
are two reasons to retain an early date. First, his pigments
are in earth tones or mixtures, and they do not involve
contrasts of hue except for a few pinks and oranges against
the greens. Second, the small touches of color (except for a
few on the tree trunks) are not at all the *pointillé* of his later
years. In the left foreground, for example, the brown
undercoating shows through here and there. Over it
Seurat stroked some green, using a dilute mixture that had
little physical substance. He then added other greens,
mixed in different proportions on the palette with yellow
and white. Next he introduced a few sparse dabs of blue

79

and pink and many more of orange-tan and yellow-tan. Finally, over this still thin surface he dragged a brush heavily loaded with thick yellow-tan: the weave of the canvas picked up tiny bits of color which appear as separate flecks of paint but in reality resulted from broad brush movements. Neither the pigments nor their harmonies are like his later work; the effects here result from his immersion in Barbizon painting.

Sous-bois is Seurat's only major essay in a mid-century manner of painting. In a few small canvases and in numerous tiny panels he continued to build rural scenes on Barbizon precedents, but his exposure to Impressionism must have made them seem inconclusive. By 1882 the signs of Impressionism show in his small paintings, in both palette and subject, and with his *Baignade* of 1883 he left mid-century art largely behind. This early canvas is nonetheless an impressive work that holds its own with his contemporaries' landscapes. It shows that by age twenty-one or twenty-two, Seurat had found his distinctive vision, one that combined glimmering, pervasive light with a tightly controlled composition.

1. The stay in Pontaubert is mentioned in letters of Seurat's aunt Anaïs Haumonté to her daughter dated September 19 and October 8, 1881, the relevant passages copied by Jean Sutter from family records (Sutter archives, Beinecke Library, Yale University, New Haven). In one of two unpublished early notebooks (art market, New York), Seurat recorded train schedules to Avallon and Pontaubert. This notebook bears evidence that it was used both before and after Seurat's military service (November 1879–November 1880); several of its drawings of animals and peasants are consistent with a date of 1881.

80. *Le petit paysan en bleu.* 1881–82
YOUNG PEASANT IN BLUE

Oil on canvas, 18⅛ x 15 in. (46 x 38 cm.)

Musée d'Orsay, Paris, Gift of Robert Schmit, 1982 R.F. 1982–54

H 16; DR 44

PROVENANCE
The artist's brother-in-law, Léon Appert, Paris; Félix Fénéon, Paris, until 1941 (Fénéon sale, Drouot, Paris, December 4, 1941, no. 72, for 385,000 francs); Paul Pétridès, Paris, from 1941; Robert Schmit, Paris, until 1982; his gift to the museum, 1982

EXHIBITIONS
1900 Paris, Revue Blanche, no. 4
1908–09 Paris, no. 9
1920 Paris, no. 2
1924 New York, no. 2
1936 Paris, no. 12
1957 Paris, no. 2

Fénéon, who derived his information from frequent interviews with Seurat's heirs, said this young Burgundian was painted at Pontaubert.[1] Like *Sous-bois* (cat. no. 79), this canvas may have been initiated in Burgundy in the fall of 1881 but was probably worked on in Paris over the next several months. Its palette is a pre-Impressionist one, and its modeling is based on the traditional light and dark, not on color contrasts. Greens do not bring about touches of red, and blues do not provoke oranges. Light comes from the left, illuminating that side while leaving the right in

Seurat, *Petit paysan assis dans un pré* (Young peasant sitting in a meadow), 1881–82. Glasgow Art Gallery and Museum (H 15)

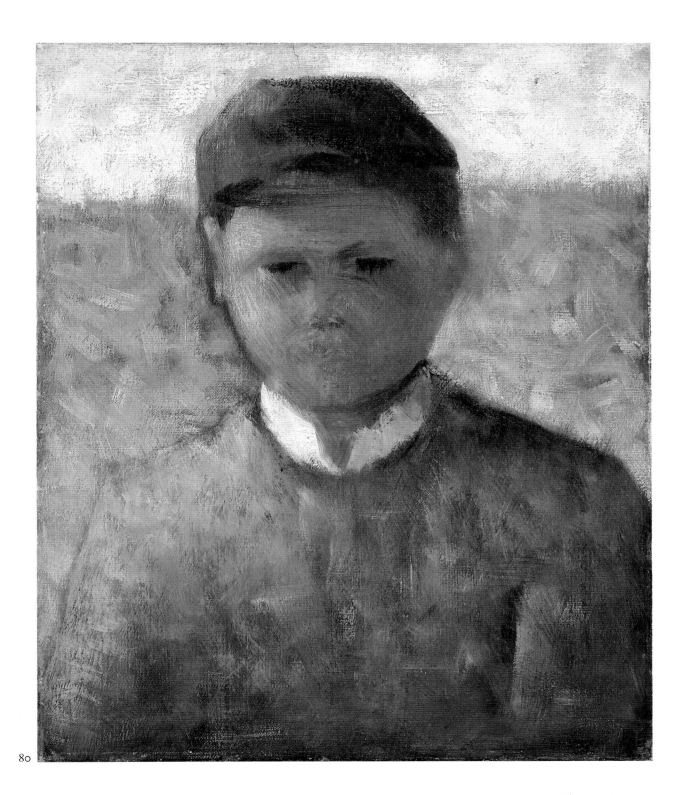

80

shadow (the sky and foliage next to the head are reversed, as in his drawings, dark on the left, light on the right). The sky is rather smoothly painted, but the greenery and the boy's jacket consist of energetic, large strokes, and the streaks of Seurat's brush remain obvious in the head. Equally "modern" is the composition which is all on the surface because its flat zones cater to the vigorous marks of the brush and the lack of detail. The polygonal head has already become a signature element of Seurat's style.

The painting's free brushwork and elemental composition mean that Seurat must have considered it a sketch, a way of learning his craft, and not a portrait (that is, not an interpretation of the model's character). We might say that what his painting *lacks* is what makes it eligible for our admiration, that is, it fits neatly into the modernists' pattern of development toward abstraction that we have superimposed over nineteenth-century art. The boy's frontal gaze and his closeness to us suggest that we will sense his character, his individuality, but his facial features are indistinct, and the composition's geometry transfers our inquiry from the fictional boy to the artist's pictorial means. In that way we ultimately recover a feeling for an individual—but it is Seurat we find, not the boy from Pontaubert.

1. In his notes accompanying this picture in the de Hauke archives. Fénéon either deduced or was told that the same model posed for *Petit paysan assis dans un pré* (see illustration). A boy in a similar cap and short jacket appears in a drawing detached from a sketchbook (H 435; private collection, Paris), but we cannot be sure that it represents the same model.

81. *Paysage dans l'Île de France.* 1881–82

LANDSCAPE OF THE ÎLE DE FRANCE

Oil on canvas, 12¼ x 16 in. (32.5 x 40.5 cm.)
"Moline" stamp in red lower right: Seurat

Musée des Beaux-Arts, Bordeaux

H 18; DR 27

PROVENANCE
Probably Madeleine Knoblock, Paris, from 1891; Georges Lecomte, Paris, by 1900; Eugène Blot, Paris; Alexandre Natanson, Paris, by 1908–09; Albert Marquet, Bordeaux and Paris, until his death in 1947; his bequest to the museum, 1948, with his widow retaining life interest; deposited at the museum after 1961

EXHIBITIONS
1895 Paris
1900 Paris, Revue Blanche, no. 5
1908–09 Paris, no. 5
1936 Paris, no. 37
1957 Paris, no. 20
1958 Chicago and New York, no. 36

Like Seurat's other early canvases, this picture is less than half the height of *Sous-bois à Pontaubert* (cat. no. 79) and could easily have been carried about the countryside. Although it was probably worked on in the studio and has a strong geometric order that smacks of arbitrary invention, it also has the character of a sketch taken from nature. Within its limited palette, for example, the narrow yellow band in front of the pale blue wall captures the look of a field of ripe hay or grain, foreshortened by the low vantage point. Similarly, the walls of the building are delicately varied, convincing us that Seurat stared fixedly at them. The gable end is a pinkish cream, turning to greenish blue at the peak; the windowed wall is bluish gray, tinted differently from the low wall that runs along the front.

Seurat followed Delacroix's principle of broken color in most areas. At the base of the canvas several warm tones are mixed with the greens, and farther back, pinks, oranges, and wine reds are scattered among the greens and blue-greens. The dull pink path that slants across the field contrasts with the greens. The roof is a broken color, an unresolved mixture of blue and ruddy brown; the distant foliage is wine red and blue at the bottom, changing to green as it nears the sky which has contrasting pink mixed with pale cream. These oppositions are relatively subdued compared with his work of just a year or so later; such heightened contrasts are evident in *Ville d'Avray, maisons blanches* (cat. no. 87) which might represent the same site from a slightly different angle.

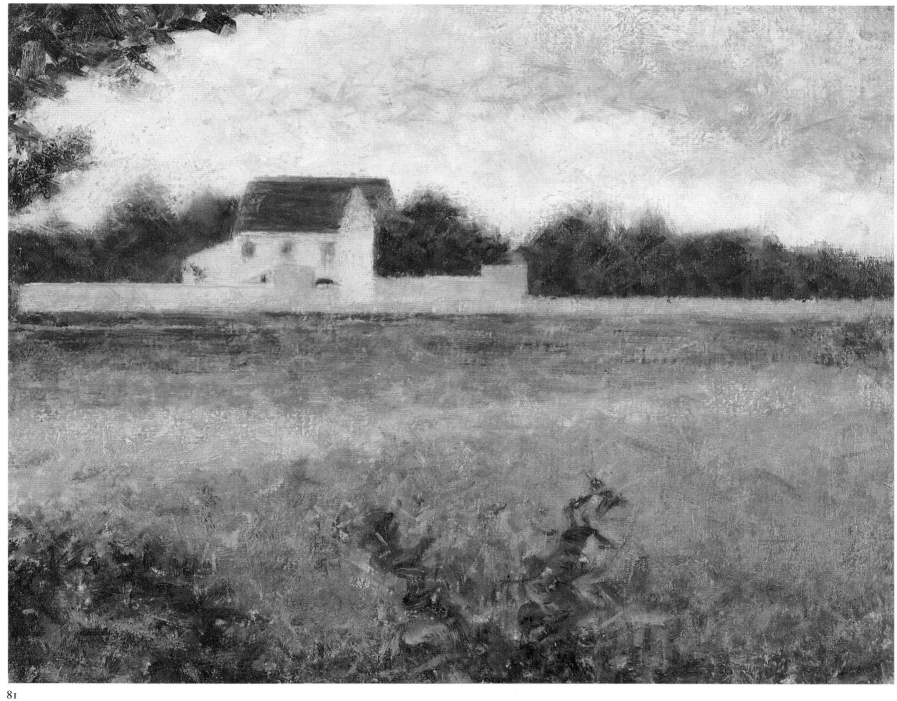

81

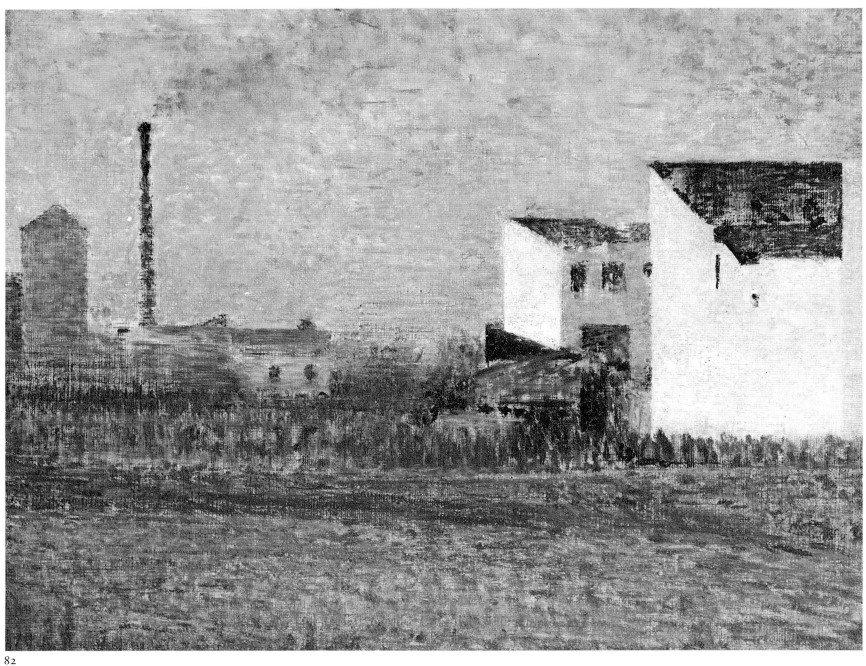

82

82. *Banlieue*. 1881–82
SUBURB

Oil on canvas, 12⅛ x 16 in. (32 x 40.5 cm.)

Musée d'Art Moderne de Troyes, Gift of Pierre and Denise Lévy

H 75; DR 13

PROVENANCE
Félix Fénéon, Paris, until his death in 1944; his estate, 1944–47 (Fénéon sale, Drouot, Paris, May 30, 1947, no. 101, for 1,300,000 francs); purchased at this sale by Pierre Lévy, Troyes, 1947, until 1982; gift of Pierre and Denise Lévy to the museum, 1982

EXHIBITIONS
1908–09 Paris, no. 7
1920 Paris, no. 4
1924 New York, no. 3
1936 Paris, no. 14
1957 Paris, no. 23
1958 Chicago and New York, no. 29

Seurat did not content himself with rural landscapes and people but painted also in the suburbs. There are many more drawings than paintings of suburban landscapes, but his oils show his determination to be a modern artist. This painting bears comparison with *Casseur de pierres, Le Raincy* (cat. no. 13), in which we find the same kind of wedge-shaped edifices, low outbuildings, fences, and a *terrain vague* in the foreground.

Except for the pinkish white pigment of the stuccoed buildings, Seurat's paints were very thinly brushed in, leaving the off-white canvas as a prominent element of the facture. His contrasts are timid compared with those he will use a year or so later (this is probably an unfinished canvas, and he might have fortified the oppositions had he worked on it more). Dull greens flank the equally dull purplish brown pathway in the foreground, and bluish green in the sky contrasts with the adjacent red roofs. The sky is the principal area of Delacrucian broken colors, although these are applied with a discretion that has none of the romantic master's verve: gray-blues, blues, brown, lavender, pink, and dull orange. Our modern appreciation of the picture hinges on the striking geometry of the nearby buildings. The vertical strip on the right edge defies explanation, unless it is the portion of a building whose height accidentally matches that of the white building it touches.

83. *Paysage au piquet*. 1881–82
THE CLEARING; LANDSCAPE WITH A STAKE

Oil on canvas, 15 x 18¼ in. (38 x 46.5 cm.)

Oeffentliche Kunstsammlung Basel, Kunstmuseum, Dr. h.c. Émile Dreyfus-Stiftung

H 28; DR 26

PROVENANCE
Maximilien Luce, Paris; Edmond Cousturier, Paris; Jean Metthey; Georges Bernheim, Paris; with Reid and Lefevre, Glasgow and London, by 1928; Étienne Bignou, Paris; Galerie Pierre, Paris; Émile Dreyfus, Basel, from 1950 until 1970; his gift to the museum, 1970

The stake in the foreground, Seurat's unique imprint, is the inanimate protagonist of this small canvas. Were it not for this piece of wood, the picture would seem like a clearing sketchily painted by Corot or Daubigny. The patently man-made form of the stake contrasts with the tree trunk to its right. Its colors stand apart from the others in the picture and model it in three dimensions: dull blue with touches of wine red blending to purple in the shade, pale pink and off-white in the sun, and a brilliant streak of orange-red at the top. Its slant, echoed on the left by two switches, gives it a conspicuous presence. Like so many elements of Seurat's early drawings, the stake is interlocked with other forms to produce a striking surface pattern: its upper portion hides the juncture of dark foliage and light field growth, and the slant of its top is continued by the adjacent downward angle of light yellow-green. To the left of the stake a gap in the foliage recedes quite convincingly; its off-white color probably marks a building. The color harmonies here do not yet have the contrasts that loom larger a year or so later. The sunlit meadow consists largely of whitish yellows and attenuated oranges mixed with light greens; shaded grass and foliage are in a range of greens and blues, with some wine red and touches of pink.

84. *Casseur de pierres*. 1881–82
STONE BREAKER

Oil on canvas, 13 x 16 in. (33 x 41 cm.)

Duménil Collection

H 36; DR 28

PROVENANCE
Eugène Blot, Paris; Bernheim-Jeune, Paris, until 1913; sold to Gerhardt Hauptmann, Altona, Germany, in January 1913, until his death in 1946; by inheritance to Ivo Hauptmann, Hamburg, from 1946 until 1971 (sale, Sotheby's, London, April 21, 1971, no. 25); purchased at this sale by Edwards; E. V. Thaw and Co., New York, by 1975, until 1987; with Acquavella Galleries, New York, from 1987 until 1990 (sale, Ader Picard Tajan [Drouot], Paris, March 20, 1990, no. 50); to present owner

EXHIBITIONS
1978 London, no. 8
1985 Tokyo and Kyoto, no. 16

In the previous landscape the stake was an inert sign of work, while here a man hammers at a pile of stones in a clearing. The pictures were probably done within a few weeks or months of each other, and they have essentially the same palette and pattern of brushwork. Where the stake suggests the measuring and laying out of land, stone breaking means a more substantial shaping of nature to human needs. Because Seurat's man is hammering the stones and protecting himself from the sun with a huge hat, we empathize with his labor and cannot treat this landscape as though it were, like the other, a quiet pastoral corner. Farmers had reason to break up outcroppings of limestone, but in his many drawings and paintings of stone breakers, one of his favorite subjects, Seurat seems to evoke the encroachment of villages and cities on once-rural land. He himself identified one painting of stone breakers with Le Raincy (cat. no. 89), and family tradition gives that location to a drawing (cat. no. 13). Visits to his father in this rapidly expanding suburb may well have put him into contact with such labor.

In any event, this figure is hard at work. Seurat painted twenty-three panels and canvases depicting women or men in rural settings; of these, twenty show them actively at work, harvesting, raking, hoeing, or breaking stones. Even Millet gave more attention to peasants at repose, and Pissarro's peasants and villagers are resting more often

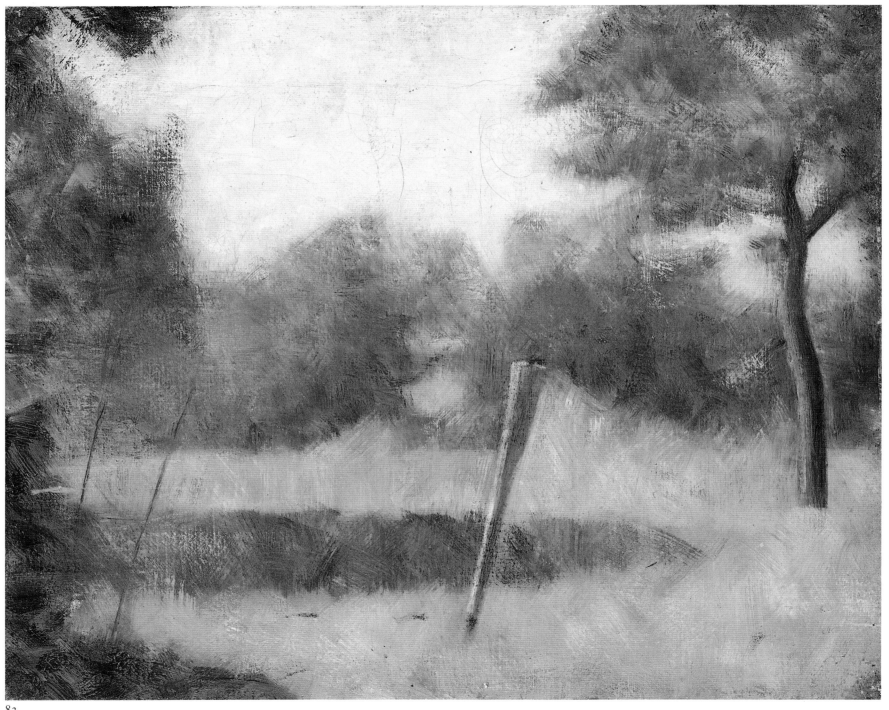

83

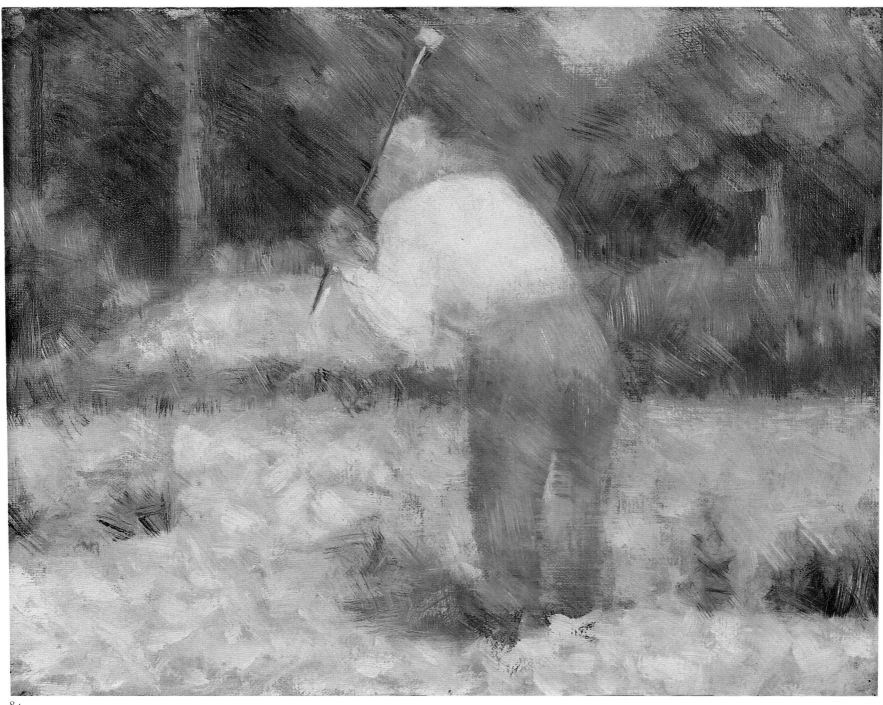

84

85

than not. Seurat gave his figures the dignity of their labor, even if he did not individualize them.

Here the straw hat and blue trousers are the picture's dominant contrast. The hat is another example of Delacrucian broken color, a medley of yellows, pale tans, pinks, and oranges, with touches of light blue. Faithful to his principle of contrast, Seurat surrounded it with purplish tints mixed with the greens and blues of the tree foliage. In the foreground the stones are represented by creamy off-whites blended with wan pink and light yellow over an undercoating of greenish brown, a blend that captures the ubiquitous limestone of northern France.

85. *Effet de neige; Hiver en banlieu.*
1882–83

WINTRY SUBURB

Oil on wood, 6¼ x 9⅞ in. (16 x 25 cm.)

Woodner Family Collection, New York

H 71; DR 61

PROVENANCE
The artist until 1891. Posthumous inventory, panneau no. 57. Inherited by the artist's brother, Émile Seurat, Paris, in 1891; Adam Natanson, Paris; Alexandre Natanson, Paris, until 1929 (Natanson sale, Drouot, Paris, May 16, 1929, no. 104, for 20,000 francs); Félix Fénéon, Paris, until his death in 1944; his estate, 1944–47 (Fénéon sale, Drouot, Paris, May 30, 1947, no. 97, for 206,000 francs); purchased at this sale by Frey; Comtesse de Ganay, Paris; Antoine Salomon, Paris; Mme Huguette Berès, Paris, until January 1989; sold to present owner, 1989

EXHIBITIONS
1900 Paris, Revue Blanche, *hors cat.*
1936 Paris, no. 57
1957 Paris, no. 8

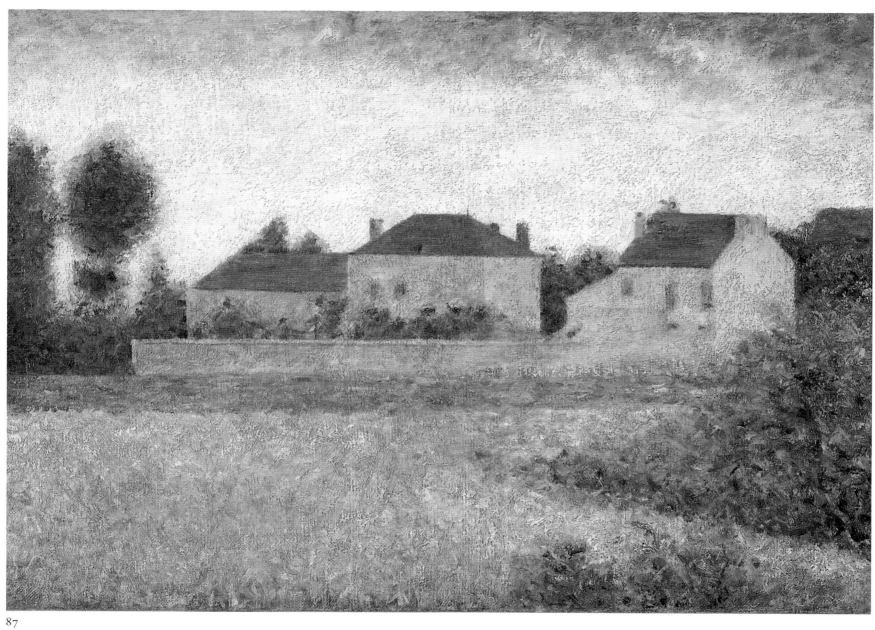

87

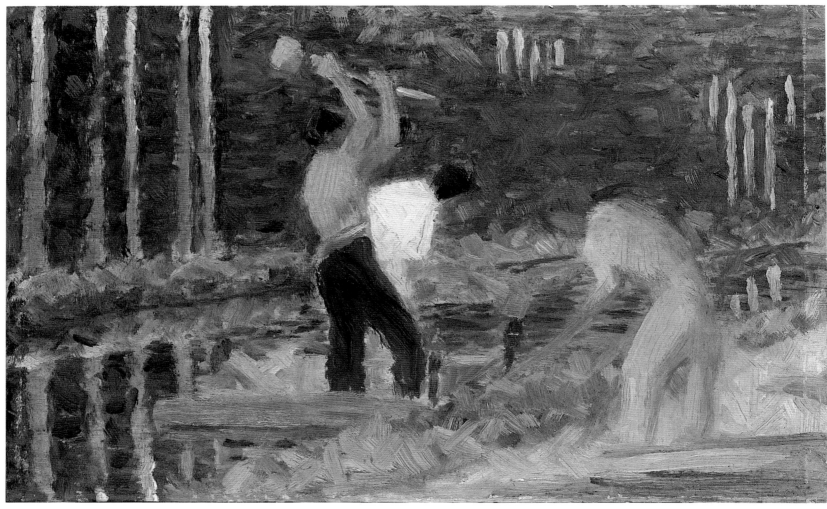

88

88. *Hommes enfonçant des pieux; Bûcherons.* 1882–83

MEN LAYING STAKES

Oil on wood, 6⅜ x 9⅞ in. (16.2 x 25.1 cm.)

Private collection

H 39; DR 51

PROVENANCE
Possibly given by the artist to Arsène Alexandre, Paris; Count Harry Graf Kessler, Weimar; Alfred Flechtheim, Berlin; Marie Harriman Gallery, New York, by 1935, until at least 1940; to the Honorable and Mrs. W. Averell Harriman, Albany, New York; to present owner

EXHIBITION
1935 Chicago, no. 6

In only three panels did Seurat represent more than a pair of workers: this one, *Les terrassiers* (H 18; Mr. and Mrs. Paul Mellon), and *Paysans enfonçant des pieux* (H 38; private collection, Japan). Here three men pound stakes at the edge of a narrow stream. To indicate their rhythmic labor, Seurat painted one with his wood mallet raised—a dramatic gesture for the artist—just as the other two have completed their strokes. Their work is framed and echoed by three clumps of tree trunks. The men are painted in wide strokes whose directions virtually create their movements. The upright man is guaranteed prominence over

his plainer companions by his red sash, wine-brown trousers, and the blues of the shaded portions of his tan shirt. Tan binds together the foreground, but richer hues and contrasts are found in the water and background. The tree trunks on the left show the panel's golden brown, overlaid with red, rising to a cream tone at the top. They resonate against the dark greens, blues, and wine reds of the dense foliage. The low growth flanking the stream is a crisscross of light greens and yellowish greens.

The first owner of this panel was the writer Arsène Alexandre, a friend and defender of Seurat's in the press; the artist may have given it to him. Alexandre also owned *Le pont de Courbevoie* (cat. no. 171).

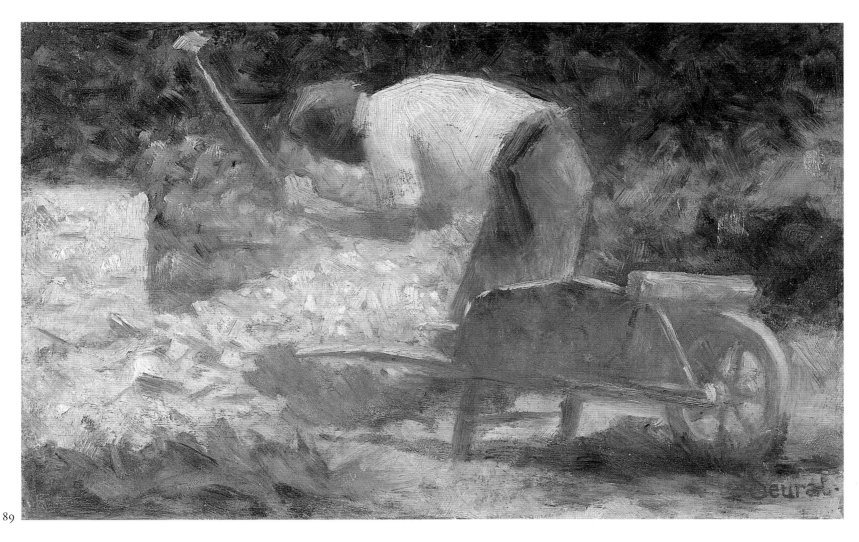

89

89. *Casseur de pierres à la brouette, Le Raincy.* 1882–83

STONE BREAKER AND WHEELBARROW,
LE RAINCY

Oil on wood, 6¾ x 10¼ in. (17.1 x 26 cm.)
"Moline" stamp in red lower right: Seurat

The Phillips Collection, Washington, D.C.

H 100; DR 49

PROVENANCE
Probably Madeleine Knoblock, Paris, from 1891; Félix Fénéon, Paris;
Georges Lévy, Paris; Gérard Frères, Paris, until 1926; sold to Reid

and Lefevre, London, in 1926; sold to Leonard Gow, Scotland, in
1926, until 1927; sold to Reid and Lefevre, London, in 1927; sold to
D. W. T. Cargill, Lanark, in 1927, until 1940; with Bignou Gallery,
New York (in partnership with Reid and Lefevre, London), in 1940;
sold to the Collection, 1940

EXHIBITIONS
(?)1886 New York, no. 133 (no. 8 in a frame of "12 studies")*
1892 Paris, Indépendants, no. 1109
1895 Paris
1900 Paris, Revue Blanche, no. 9
1958 Chicago and New York, no. 22

* This work has been identified as one of the twelve panels in a
 single frame shown in the following exhibitions: 1886 New York,

no. 133; 1887 Paris, no. 447; 1892 Brussels, no. 1 (see H, I, p. xxx,
and p. 305, Addenda and Errata). However, this hypothesis is
unlikely. Either Fénéon and de Hauke's identification of the group
of twelve panels exhibited in New York in 1886 is faulty or their
assumption that the 1886 group of twelve was reexhibited in 1887
and 1892 is wrong.

If one presumes, as Fénéon and de Hauke did, that the same
group of twelve panels was exhibited in a single frame in the 1886,
1887, and 1892 exhibitions, the following early provenance may be
constructed. The group of twelve panels remained in the artist's
possession until his death in 1891. They were included in the
posthumous inventory of 1891, but not numbered (see Fénéon's
notes in H, I, p. xxx [under Panneaux, b]: "12, alors groupés en un
seul cadre, qui furent pas numérotés isolément [12 grouped in one

frame, which were not separately numbered]"; and Madeleine Knoblock's handwritten list, p. XXXVIII, as "les panneaux encadrée" [the framed panels]). They were inherited from the estate by Madeleine Knoblock in 1891 and lent by her to the February 1892 Les Vingt exhibition in Brussels. During the run of the show, the works were purchased by the Belgian landscape painter Jean de Greef (1852–1894) (see "Clôture du Salon des XX," *L'art moderne*, March 13, 1892, in the section titled "Oeuvres acquises pendant l'Exposition," where there appears: G. Seurat. *Douze études* [M. J. de Greef] and *Le printemps à la Grande-Jatte* [Mlle A. Boch]); also cited in Jane Block, *Les XX and Belgian Avant-Gardism, 1868–1894* [1981 diss.], Ann Arbor, 1984, pp. 68 and 102, note 73).

This scenario presumes that the original group of twelve panels remained intact in its frame from 1886 until 1892. The frame was subsequently dismantled and the individual panels dispersed. Most of the panels that have been ascribed to this group betray—as might be expected—a very meager early history of ownership and exhibition; most are not reexhibited until after 1920. However, this work was lent to the 1892 Paris Indépendants exhibition (March 19–April 27) as no. 1109. It seems improbable that, within a couple of weeks after the purchase of the group of twelve panels by Jean de Greef in Brussels, a single panel would have been removed from the frame and exhibited independently in Paris. The presence of the Moline stamp, which suggests the direct transfer of the panel from Madeleine Knoblock to Léonce Moline, seems as well to contradict the possibility of its earlier sale to Jean de Greef in 1892, and thus implies that this panel was not one of the twelve in the single frame.

Of course, these works were not identified with great certainty by Fénéon and de Hauke when they annotated Seurat's handwritten list of titles for the 1886 New York exhibition (H, I, p. xxx; see also Appendix D). A number of errors were made in cataloguing these works and in annotating the exhibition catalogues reprinted; see H, I, Errata, p. 305, and provenance note, cat. no. 126 below (H 122).

However, depending on the construction of the frame, there is always the possibility that different panels may have been substituted for those originally exhibited in 1886; that is, a different group of twelve panels was later exhibited in a single frame in 1887 and 1892. One piece of evidence for this argument is the fact that H 119, the only other panel stamped by Moline, seems to have been earmarked for Pissarro (next to the title of the work on Seurat's handwritten list, he had noted in the margins "à Pis.ᵗᵒ" [see Appendix D]). It should also be noted that the only signed panel in the group, H 153, could not possibly have been exhibited *ensemble* after 1886; it was already in the collection of Paul Alexis (1847–1901) before the 1887 Paris exhibition (see Appendix D).

Paintings and drawings of men at work inevitably remind us of Millet. Here, as in *Le faucheur* (cat. no. 78), we find one of the Barbizon artist's favored subjects: a man with a wheelbarrow. Millet made clear the rural surroundings of his figures, but Seurat's worker might well be imagined in a suburb, and he could equally be a laborer or a small landholder breaking up rocks for his own purposes. Seurat's palette is still that of the mid-century; it resembles Millet's and Daumier's more than that of the Impressionists. The brown panel forms the basic color of the wheelbarrow and the man's trousers. Over it, for the wheelbarrow, Seurat scumbled dull greens, orange-browns, purplish blues, and wine red and, for the trousers, reddish and purplish browns. Despite the shallow space there is a convincing sense of three-dimensionality because the wheelbarrow is highlighted on its upward-facing edges and has a pronounced shadow. The man's work draws our attention because his ruddy forearm, framed in green, is the hottest color on the panel. This beautifully integrated little composition closely links, both symbolically and formally, the man and his barrow. The barrow's arms parallel the man's, its legs substitute for his, and its profile repeats the man's angular outline (and at the back of his knees it shares a tripartite intersection with him).

The title comes from Seurat himself, who listed this panel as the eighth among twelve he exhibited in one frame in 1886,[1] but his name on the lower right is not a signature. In 1895 the dealer Léonce Moline stamped twenty panels and eleven drawings in red to certify that they had come from Seurat's heirs (most, if not all, had been owned by Madeleine Knoblock).[2]

1. On an unpublished manuscript note in the de Hauke archives. The list is excerpted from this note (without giving the source) by de Hauke (H, I, p. xxx).
2. For the Moline stamp, see Note to the Reader.

90. *Abords du village*. 1882–83

VILLAGE ROAD

Oil on wood, 6 x 9⅝ in. (15.2 x 24.4 cm.)
Signed lower left: Seurat

Mrs. Alexander Lewyt

H 53; DR 68

PROVENANCE
Possibly with Ambroise Vollard, Paris, and acquired, by exchange, by Paul Signac, Paris, in December 1898; Signac's collection, certainly by 1908, until his death in 1935; by inheritance to Berthe Signac, Paris, from 1935; by inheritance to Ginette Signac, Paris; to present owner by 1949

EXHIBITIONS
1908–09 Paris, no. 19
1953 New York, no. 2
1977 New York, no. 45

The dark shadow along the bottom of the picture is a formula that Seurat used, most famously in *La Grande Jatte* and its studies. At first it can be ignored, but after a moment its saturated blues draw our attention. When we link it with the foliage in the upper right, we realize that the painter has situated us under a tree. This is a marginal retention of a device used by Théodore Rousseau and other Barbizon painters, who often framed a vista in foliage and shadow. By using this schema, but greatly diminishing its extent, Seurat emphasized its structural function more than its representational raison d'être. Furthermore, his preoccupation with color-light meant that he gave his shadow a nearly autonomous existence. Where it crosses the dirt road, it is blue and orangish brown, but atop the grass it is blue, dark green, and purple. The brown, as usual largely formed of the warm color of the wood, is conspicuous in the lower third of the panel. It constitutes the basic tone of the distant buildings and also of the rectangular plantings on the other side of the road.

John Rewald has conjectured that Paul Signac acquired this panel as one of several works he exchanged with Vollard in 1898 for a still life by Cézanne.[1]

1. *Signac Journal*, ed. J. Rewald, p. 37.

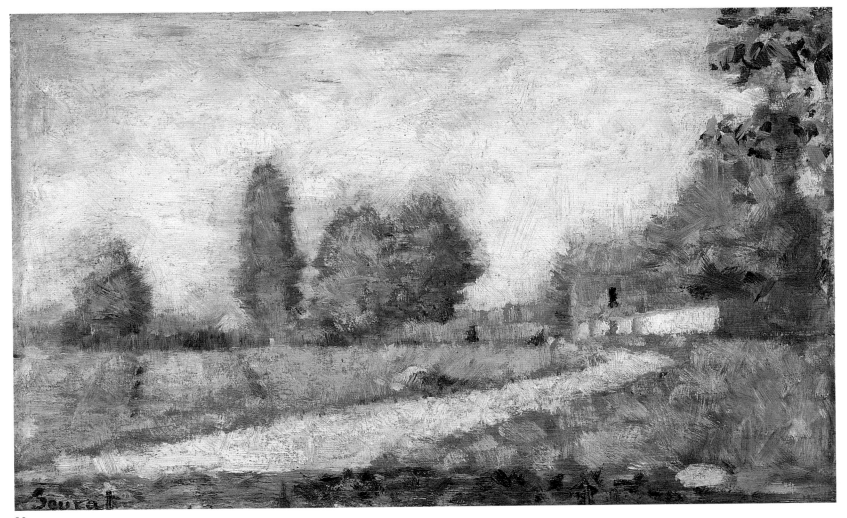

90

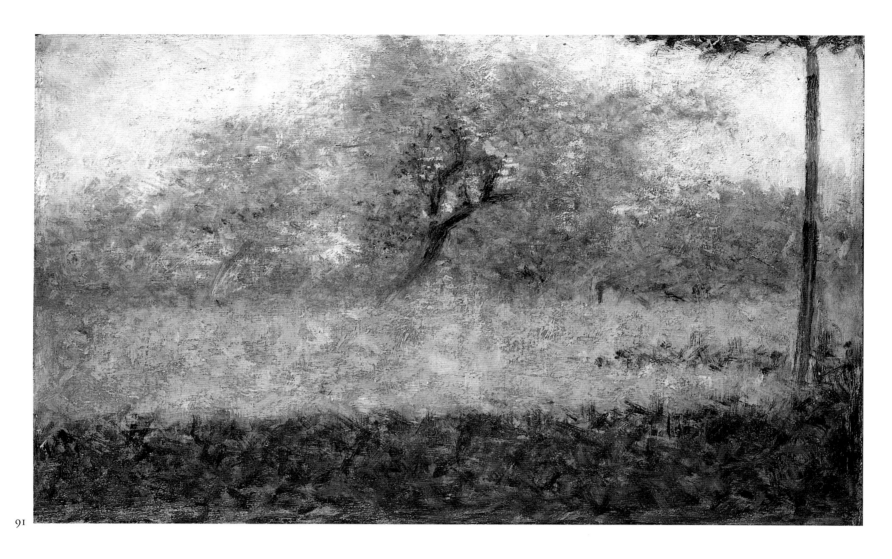

91

91. *Lisière du bois au printemps.* 1882–83

EDGE OF THE WOOD, SPRINGTIME

Oil on wood, 6½ x 10¼ in. (16.5 x 26 cm.)

Musée d'Orsay, Paris, Gift of Max and Rosy Kaganovitch, 1973
R.F. 1973–23

Exhibited in Paris only
H 51; DR 54

PROVENANCE
The artist until 1891. Posthumous inventory, panneau no. 65. Given by the artist's family to the Belgian Les XX artist Robert Picard,

Brussels, in 1891;* Mme Pangallos; Félix Fénéon, Paris, by at least 1937, until his death in 1944; his estate, 1944–47 (Fénéon sale, Drouot, Paris, May 30, 1947, no. 98, for 505,000 francs); purchased at this sale by Poussard; Max and Rosy Kaganovitch, Paris, by at least 1950 (and on deposit at the Kunsthaus Zurich from 1968) until 1973; their gift to the Jeu de Paume, 1973; transferred to the Musée d'Orsay, 1986

EXHIBITIONS
1936 Paris, no. 9
1937 London, no. 56

* Robert Picard's name appears on a list, found among the papers of Théo van Rysselberghe, of Belgians who were to receive works from the family. He is listed as "M. Picard, Rob.," [the son of Edmond Picard] with a indication that he was to receive "1 panneau," inventory number 65. This list is transcribed in DR, p. LXXVI.

In its neat organization this landscape speaks for the well-tended meadows bordering the woods that typified the countryside near Paris. The horizontal banding so

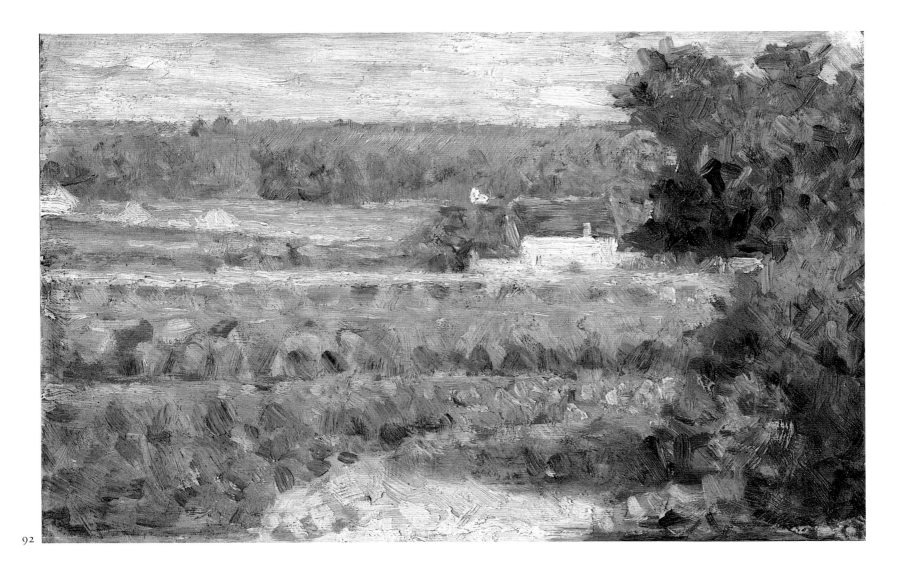

92

characteristic of Seurat's pictures is partly relieved by the tree on the right and its shadow. To give a sense of mottled light on the tree trunk, Seurat alternated bands of light and dark (for the dark bands he mixed purple with orange and blue) while retaining an overall purplish tone that contrasts with the picture's yellows. Despite the lack of diagonals, he created an illusion of receding space by making his brushstrokes progressively smaller with distance and by using strong shifts in color. The foliage on the far side of the field sits well back because of its duller

oranges and yellows; patches of unlit foliage have blue and some purple. The foreground, shaded by overhead foliage, is quite dark; it is dominated by dark greens, blues, and wine reds. The straw-colored central strip has several tints of yellow and orange, mixed with pale green; the panel color, showing through as a dull brown, subdues the sunlit effect.

92. *La maison au toit rouge.* 1882–83

HOUSE WITH THE RED ROOF

Oil on wood, 6¼ x 9⅞ in. (16 x 25 cm.)

Private collection

H 55; DR 73

PROVENANCE
Zborowski collection; Bernheim-Jeune, Paris; with Percy Moore Turner, London, in 1925; Lord Ivor Spencer Churchill, London, until 1929 (his sale, "Collection d'un amateur anglais," Drouot, Paris, May 29, 1929, no. 56); Georges Lévy, Paris, until 1932 (his sale,

"Collection de Monsieur G. L.," Drouot [salle no. 6], Paris, November 16, 1932, no. 105, for 9,900 francs);* purchased at this sale by Victor Bossuat, Paris, 1932, until his death; to present owner

EXHIBITIONS
1933–34 Paris, no. 78
1936 Paris, no. 21
1937 London, no. 51
1968 New York, no. 68

* The *procès-verbal* for this sale (preserved in the Étude Loudmer, Paris) clearly indicates that the collection sold was that of M. Georges Lévy, of 43 boulevard de Clichy, Paris; this corrects the misidentification—in Dorra and Rewald and de Hauke—of the sale as that of Gaston Lévy, another collector. The three Seurats sold in this sale (lot nos. 104–06) were purchased by Victor Bossuat; see also cat. nos. 101 and 102.

The shallow space and simple horizontals of the previous picture give way here to a vista of a broad cultivated plain, the kind of pastoral landscape that Daubigny and Pissarro had favored. Seurat's palette remains essentially that of mid-century: the brown of the panel still takes an important place (especially in the foreground), and the broken colors continue to exemplify the principles he had found in Delacroix and Chevreul. The dark foliage in the foreground includes blues and purples, the opposites of the oranges and yellows of the sunlit fields and foliage. The contrast of lighter purples and yellow-greens helps regulate the alternate bands of the open landscape; they line up prominently because Seurat deployed his contrasts of light and dark at their junctures, the lights becoming lighter and the darks, darker. These elements show a young artist absorbed in theory, but the picture is equally the result of vision. It has more than a hint of Impressionism in the freshness of its brushwork and in the impact of its color-light. No mid-century artist would have so frankly colored the shadow across the road in the foreground, and for all the regularity of the lateral planes, the brushwork embodies the spontaneity associated with Impressionism. The tiny picture's chromatic harmonies revolve around the red roof. We measure the greens by opposition to it and the purples by the degree to which they share its hue.

93. *Paysannes au travail.* 1882–83
FARM WOMEN AT WORK

Oil on canvas, 15⅛ x 18¼ in. (38.5 x 46.2 cm.)

Solomon R. Guggenheim Museum, New York, Gift, Solomon R. Guggenheim, 1941

H 60; DR 41

PROVENANCE
The artist's brother, Émile Seurat, Paris, until his death in 1906; by inheritance to his widow, Mme Émile Seurat, Paris, from 1906; Félix Fénéon, Paris, by 1930, until 1938; sold to Solomon R. Guggenheim, New York, in 1938, until 1941; his gift to the Museum, 1941

EXHIBITIONS
1900 Paris, Revue Blanche, *hors cat.*
1924 New York, no. 5
1936 Paris, no. 13
1958 Chicago and New York, no. 21

Although the larger size of this canvas makes it seem quite different from the three preceding panels, it is also a country view, and it pursues the same logic of color and composition. Like other early canvases with such large brushstrokes, it was done as a sketch or color study, not a finished picture. It probably dates well into 1883, a year or more later than *Ville d'Avray, maisons blanches* (cat. no. 87). Women and men bending their backs at work are Seurat's favorite representations of rural or suburban labor; they appear in eighteen paintings and eleven drawings. Here the evocation of Millet's *Gleaners* (Musée d'Orsay, Paris) confirms his enduring interest in the Barbizon master, an interest that characterized Pissarro's work as well as van Gogh's in the same years. Unlike van Gogh's empathic depictions of peasant life, Seurat's treatment of this subject was marked by modernity of another kind, rooted in secular naturalism. Outdoor color and light are as much the subject here as the working women, whom Seurat presents not as burdened laborers but as imbricated elements of his pastoral scene. Paired like figures in a bas-relief, they mediate between the parallel rhythms of sun and shadow across the foreground and the curves of the distant foliage.

In canvases like this, Seurat's large and rather regular brushstrokes make few concessions to illusion-building and are dedicated instead to laying out reactions of color-light. For this eager reader of Ogden Rood, foliage and field growth (slightly different in tint and tone) have oranges, yellows, and tans to indicate reflected and partly absorbed sunlight, several greens for the local color, and blues for indirect light in shaded portions. The blues and the oranges cohabit as color opposites: Delacroix's broken colors seen now in large strokes, not in fine hatchings. Touches of lavender in the light areas express the opposite of yellow-green, and wine reds and purples in the dark zones are the complements of blues, blue-greens, and yellow. Although laid down mostly in separate strokes, pigments of adjacent tint are balanced with one another. There is little pure green or yellow, for example, but tints of orange-yellow, tannish yellow, yellow-green, and blue-green.

The composition's obvious geometry might seem to embody arbitrary studio invention, but despite the parti pris for flat lateral planes, the picture shows Seurat's concern for an actual site in brilliant sunshine. In the immediate foreground the lighter yellow strip, lacking the greens of those farther back, indicates a roadway. Shade from an overhead tree darkens the lower left corner, so the roadway there turns to a brownish tint. Another example of close observation: the woman on the left is angled slightly more toward the front, so her straw hat acquires a blue shadow, absent in the other's hat because it is turned more fully to the sun. We see the exposed arm of the near figure, who seems to be reaching down with one hand, whereas the other has both arms plunged into the field. Their shirts are the lightest parts of the canvas, and they share its coloristic and psychological center. The harmony of their labor is the key to this picture of "nature" made over to humankind's needs.

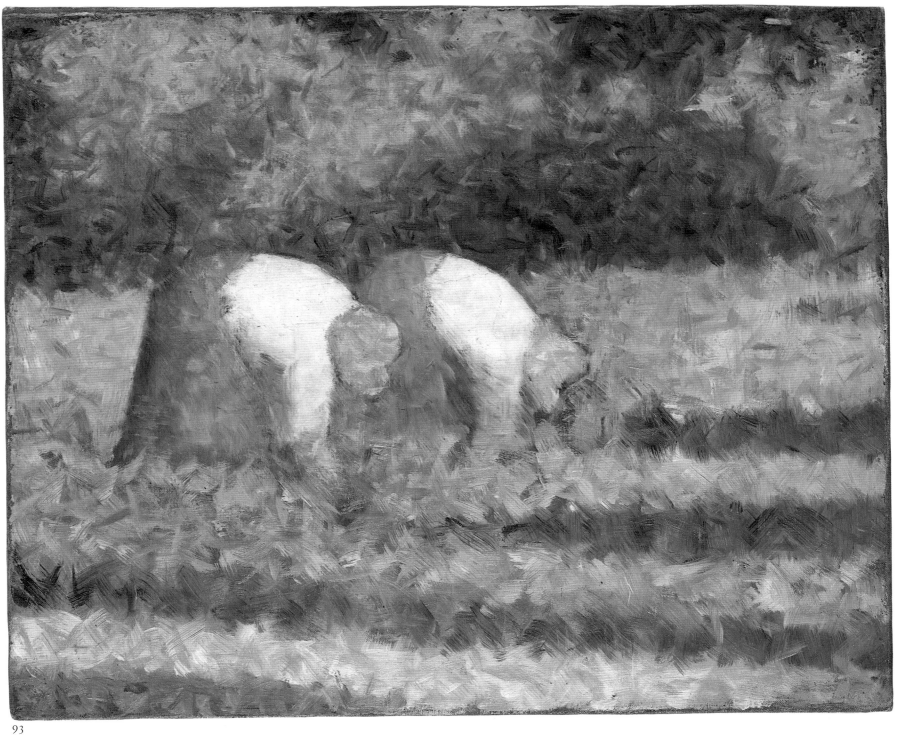

93

94. *Le jardinier.* 1882–83

THE GARDENER

Oil on wood, 6¼ x 9¼ in. (15.9 x 24.8 cm.)

The Metropolitan Museum of Art, New York, Bequest of Miss Adelaide Milton de Groot (1876–1967), 1967 67.187.102

Exhibited in New York only
H 101; DR 48

PROVENANCE
Private collection, Paris; Louis Vauxcelles, Paris; Jacques Rodrigues-Henriques, Paris, from 1928 until 1929; Adelaide Milton de Groot, by 1936, until 1967; her bequest to the Museum, 1967

EXHIBITIONS
1958 Chicago and New York, no. 33
1977 New York, no. 47

Like the previous picture, this small panel probably dates from the end of the 1882–83 period, and its palette is essentially the same. Seurat was aware of the Impressionists' pigments, and their saturated colors worked well with his determination, aided by Rood, to replace earth colors with those that he believed more fully captured color-light. There is only one color here that might be a brown earth tone. All the others derive from mixtures of white and four or five pigments: green, blue, yellow, wine red, and orangish red (although the latter may be a mixture of the previous two). He retained a leading feature of his earlier technique because the man's trousers were first brushed in broadly in wine red before the surface colors were added (blue, wine red, pink, some rare green mixed with blue). The warm panel color, rather than the Impressionists' light ground, is still important, but color contrasts are now heightened. Yellows respond to the purples of the tree trunks, and the blues of the man's clothing are opposed by the oranges of the meadow. Seurat continued to observe contrasts of light and dark, so light cream-colored strokes are dragged along the man's trousers.

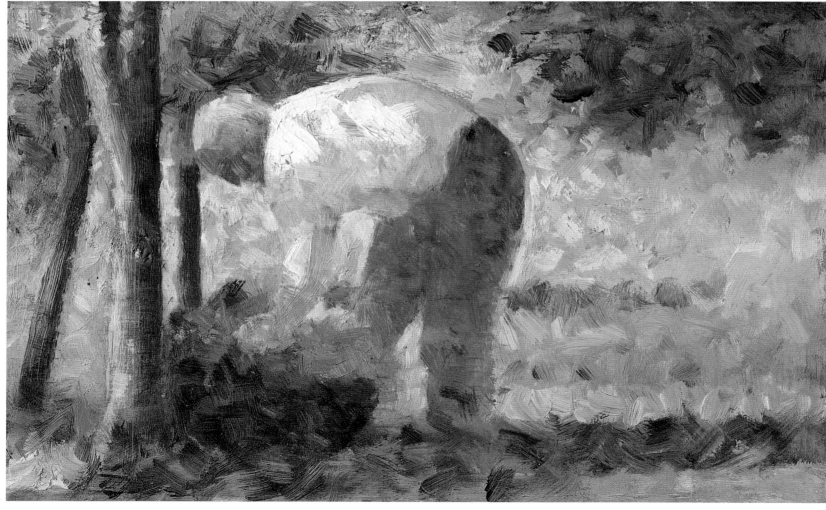

94

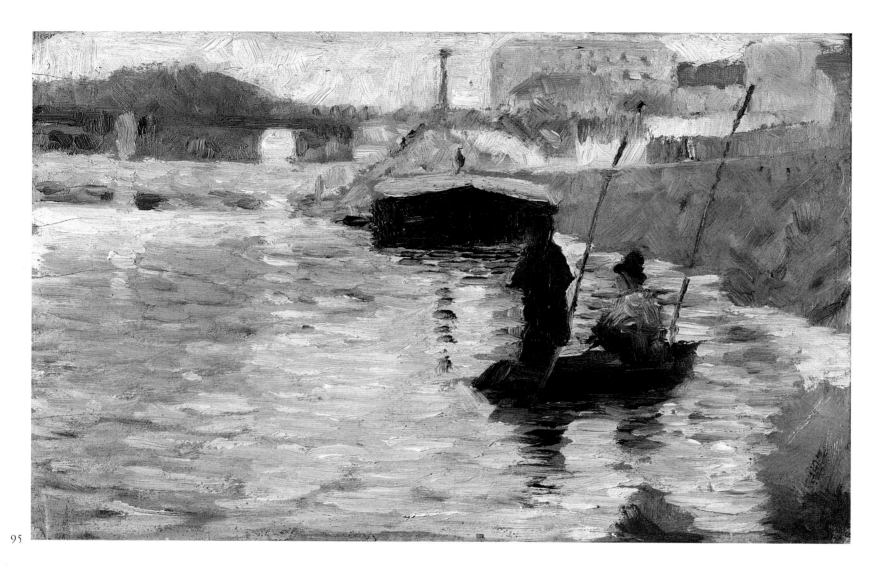

95

Like the stone breaker of cat. no. 89, this worker is squeezed within his rectangle. If we imagine him upright, we realize that he would burst the bonds of the frame. Like a misericord sculpture from a medieval choir stall, he gains energy from the pressure of the frame that surrounds him. His head abuts the tree trunks, and this establishes a subtle relationship between the trees and his legs and arms, another of the metaphors that enrich this little composition. The three shaded strips that stretch in the opposite direction are effective counterweights, more dynamic than the static horizontals of earlier panels like *Le faucheur* (cat. no. 78).

95. *Le pont.* 1882–83

THE BRIDGE; VIEW OF THE SEINE

Oil on wood, 6½ x 10 in. (16.5 x 25.4 cm.)

The Metropolitan Museum of Art, New York, Bequest of Mabel Choate in memory of her father, Joseph Hodges Choate, 1959
59.16.5

Exhibited in New York only
H 77; DR 78

PROVENANCE
Henry van der Velde, from 1891 until 1929; Félix Fénéon, Paris;

Bernheim-Jeune, Paris; possibly with Valentine Gallery, New York and Paris; Mabel Choate, New York, until 1959; her bequest to the Museum, 1959

EXHIBITION
1908–09 Paris, no. 25

The Seine on the outskirts of Paris had long been a place where city and country intermingled, but this became more apparent when industrial buildings became more numerous and when open land was gradually taken over by commerce and housing. Here men are fishing near a bridge in an industrial setting. A commercial barge is

moored at the shore, and there are factories in the background. (The largest building and the adjacent chimney may be the same as those in the drawing *Groupe de gens*, cat. no. 58.) As in the large canvas *Une baignade, Asnières*, men's leisure cohabits with industry, and the tiny boat is given pride of place in front of the barge. Two features of Seurat's technique show clearly here: his use of exposed wood as the equivalent of orange and his rough mixtures of two colors on the palette before applying them to the panel. The light green in the lower right corner shows streaks of the yellow which he had mixed with darker green; farther back, the same dark green was mixed with wine red to produce a brownish green and with blue to form a bluish tint. By so mixing his colors Seurat avoided the stronger contrasts that he would use a year later, when, for example, yellows and blues were frankly applied to foliage in separate strokes, together with greens. Despite the free brushwork the panel was worked up rather slowly, for close inspection reveals many colors that resulted from the wish to capture different objects. The bridge to the rear, not at all conspicuous, consists of a dark purple streak against a saturated green; its left pier is gray, apparently because it projected forward while the other pier, in pinkish cream, remained in the plane of the bridge.

The Belgian painter, designer, and architect Henry van de Velde was the first owner of this panel. By 1889 he was a prominent member of the Belgian Neo-Impressionist group and subsequently wrote important articles on Seurat. Later, quite fittingly, he was the architect of the museum in Otterlo established by his friend Mme Kröller-Müller, who had acquired five canvases by Seurat. The record of his ownership is confusing, but letters of 1934 and 1935 between Fénéon and van de Velde (de Hauke archives; van de Velde archives, Brussels) prove that this indeed belonged to him from 1891 to 1929 and had been shown in the 1908–09 exhibition organized by Fénéon for Bernheim-Jeune as *Le pont*, no. 25, grouped with studies for the *Baignade*. Later, because a photograph of the painting in the Bernheim-Jeune files was numbered "49 bis" and because it is not a study for the *Baignade*, Dorra and Rewald (DR 78) excluded van de Velde's ownership and the 1908 exhibition.[1] What happened is that Fénéon marked a Vizzavona-Druet photograph "49 bis" when planning the exhibition but changed it to no. 25 in the catalogue. There is no mystery in the picture's appearance among the *Baignade* studies in 1908–09, for it was common practice to

regard panels and drawings that were only roughly similar to the large pictures as studies for them.

1. Charles Sterling and Margaretta M. Salinger, in their catalogue of French paintings in the Metropolitan Museum of Art (*French Paintings*, vol. 3, 1967, p. 194), followed the Dorra-Rewald entry rather than de Hauke's, but the latter's provenance should now be restored to the picture.

96. *Allée en forêt, Barbizon*. 1883

FOREST PATH, BARBIZON

Oil on wood, 6¼ x 10 in. (16 x 25.5 cm.)

Private collection, Paris

Exhibited in Paris only
Not in H

PROVENANCE
The artist until 1891. Posthumous inventory, panneau no. 68 (per inscription in blue crayon on reverse, initialed by Maximilien Luce; also inscribed in crayon, in an unknown hand: 'Barbizon'). Inherited by the artist's paternal aunt, Mme Gustave Chevalot, in 1891; by inheritance to her daughter, Mme Clémentine Masson; by inheritance to her daughter, Mme Jeanne Gerbier; by inheritance to her daughter, Mme Marguerite Richard; by inheritance to her son, M. Richard; private collection (sale, Ader Picard Tajan [Drouot], November 24, 1988, no. 37bis); to present owner

Seurat was so much the painter of clearings and meadows that this densely wooded landscape has only one parallel in his work, the earlier canvas *Sous-bois à Pontaubert* (cat. no. 79). Perhaps its unusual look should be explained as a deliberate essay in the Barbizon tradition, for it was probably painted when he and Aman-Jean spent five days in that village in October 1883.[1] Certain works by Diaz are recalled in this picture, but it is more dependent upon pure chroma; despite his use of separate splotches of paint, Diaz underpinned his paintings with a framework of drawing and modeled them in light and dark. In this panel, about two years later than the Pontaubert canvas, Seurat used more saturated colors to construct an exceptionally complicated pattern. Reading from bottom to top, we cross at least six horizontal zones of color. To the right of the path, for example, the shaded grass has blues, greens,

purple, lavender-pink, the orangish brown panel color, and a brown (wine red and green mixed); next is a patch of yellowish green and pale pink with touches of violet and again the warm panel color; beyond this is a small zone of dark green, purple, greenish yellow, and panel orange; just below the center is an orangish section made chiefly of the wood color, orange, and violet; above this are more zones in the distance, each a composite of several tones of lower intensity. The pathway is distinguished from the grass on either side by its own sequence of colors, so that there is also a horizontal banding in the bottom half.

1. According to the ledger of the Auberge Ganne, they were there from October 6 to 10: M. T. Lemoyne de Forges, *Barbizon, lieu dit* (1962), p. 74.

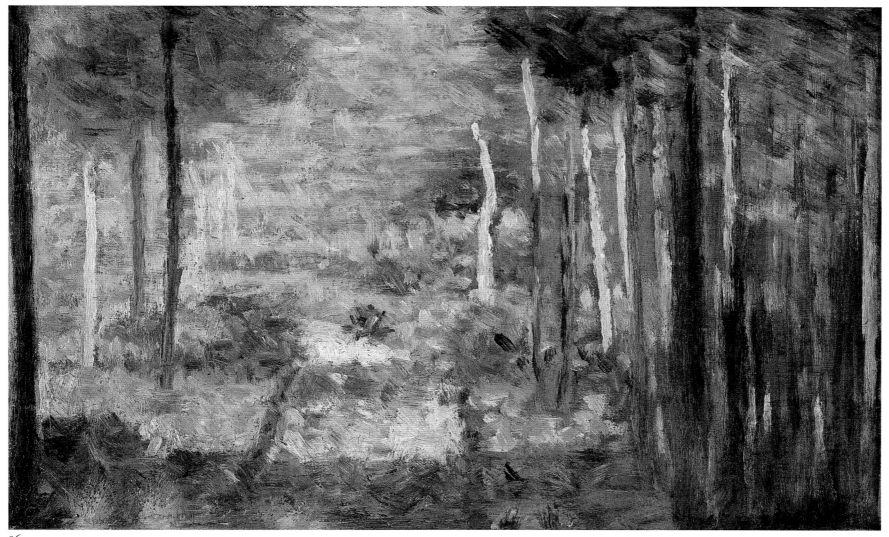

96

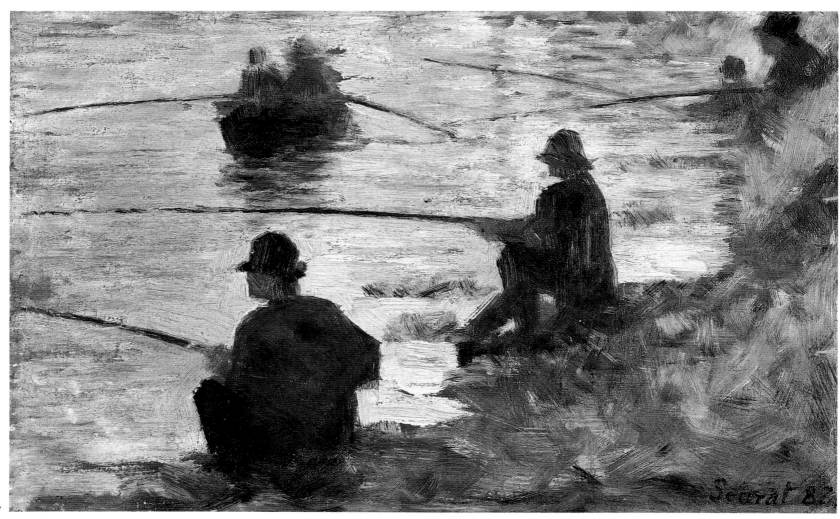

97

97. *Les pêcheurs à la ligne.* 1883

FISHERMEN

Oil on wood, 6¼ x 9⅞ in. (16 x 25 cm.)
Signed and dated lower right: Seurat 83

Musée d'Art Moderne de Troyes, Gift of Pierre and Denise Lévy

H 78; DR 80

PROVENANCE
The artist's brother-in-law, Léon Appert, Paris, by 1886, presumably until his death in 1925; by inheritance to his son, Maurice Appert, Paris, from 1925 until at least 1937; Pierre Lévy, Bréviandes and Troyes, by 1949, until 1982; gift of Pierre and Denise Lévy to the museum, 1982

EXHIBITIONS
1886 Paris, rue Laffitte, no. 180
1892 Paris, Indépendants, no. 1108
1900 Paris, Revue Blanche, no. 11
1908–09 Paris, no. 49
1933–34 Paris, no. 161
1937 London, no. 74
1942–43 Paris, no. 2
1957 Paris, no. 24
1958 Chicago and New York, no. 51

When this little picture was shown with the Impressionists in 1886, an anonymous reviewer, who did not like the *Grande Jatte*, called it "the gem of the exhibition," remarking that "it seems impossible, with such primitive means, to produce at some distance a more just and surprising effect."[1] Other writers then and subsequently singled it out with equally laudatory phrases. Two qualities give it distinction: the believable freshness of the riverside setting and the pattern of flat, nearly abstract shapes. These qualities, too often regarded as being in conflict, come together in the *contre-jour* study. The light bounces off the water into our eyes, which gives the impression of something truthfully seen. It comes from behind the fishermen,

reducing them to blocky, rather awkward silhouettes which are convincing in their simplicity. The glare reduces the water's complexity to a dominant cream color, although streaked with blues, tans, greens, and other tints that mark reedy growth and reflections. The panel is contemporaneous with *Le pont* (cat. no. 95), with which it shares the prominent use of the exposed wood color (here even more extensive along the bank) and the greens of the embankment growth.

Monet's *Fishermen on the Seine at Poissy* of 1882 (Österreichische Galerie, Vienna), exhibited by Durand-Ruel in the spring of 1883, may have inspired this work. It was, in any event, a challenge to Impressionism in the bosom of the group's last exhibition (from which Monet abstained). Among the very few pictures both signed and dated by the Seurat, it was lent to that show by his brother-in-law, Léon Appert.

1. "L'exposition des impressionnistes," *La république française*, May 17, 1886 (Signac album).

98. *Paysanne assise dans l'herbe*. 1883

WOMAN SEATED IN THE GRASS

Oil on canvas, 15 x 18 in. (38.1 x 46.2 cm.)

Solomon R. Guggenheim Museum, New York, Gift, Solomon R. Guggenheim, 1937

H 59; DR 29

PROVENANCE
The artist until 1891. Posthumous inventory, toile no. 7. Probably given by the artist's family to Léo Gausson, Paris, in 1891; Félix Fénéon, Paris, by 1912, until 1932; sold to Solomon R. Guggenheim, New York, in 1932, until 1937; his gift to the museum, 1937

EXHIBITIONS
1908–09 Paris, no. 8
1920 Paris, no. 3
1924 New York, no. 4
1949 New York, no. 4
1958 Chicago and New York, no. 18
1968 New York, no. 70

Compared with earlier canvases this picture represents a large step toward the palette, the technique, and the monumentality of Seurat's first mural-scale composition, *Une baignade, Asnières* (see cat. nos. 103–17). Because we cannot see what the woman might be doing with her hands, she appears pensive and withdrawn. This absence of facial expression contributes to a remote, sculptural quality like that of the young men in the *Baignade*. Her statuesque form recalls Millet's seated peasants and, even more, Pissarro's contemporaneous work. For several years Pissarro had been picturing peasant women sitting or reclining in meadows or clearings, often with a high horizon line that excluded the sky.[1] Because of his Impressionist color and his exposed brushwork, he seems much closer to Seurat than Millet does. Pissarro offered more than one lesson in modernizing mid-century subjects. His seated women, although they have more active poses than Seurat's figure, are at repose and usually pensive, so the woman here fits into an established tradition: the peasant as artist's model, as "motif," as a creature of pastoral rest. Of course, she would never be confused with Pissarro's peasants because Seurat gave her a pose whose enclosed profile echoes classical bas-reliefs, and he set her against a unified background whose crisscross brushwork evokes a

generic kind of growth instead of the more tangible terrains of the older painter. This mixture of the classical and the "primitive" has some analogies with Puvis de Chavannes, but Seurat's color and his rough tapestry of paint place him in the naturalist tradition. The same can be said of panels like *Le jardinier* (cat. no. 94), but there the composition's elemental forms could be attributed to the "study" aspect of the small format. The larger size of this canvas proves that Seurat's severe style was indeed at the heart of his aesthetic theory.

Paysanne assise was preceded by a roughly similar picture, *Petit paysan assis dans un pré* (p. 115), painted several months earlier.[2] There the boy's diagonal position, the cow grazing in the distance, and the angled line of the dark foliage give the illusion of more space. The present drawing was a deliberate shift to a flatter composition, a less awkward but perhaps a more "primitive" one. The broken colors of this picture are close to those of the *Baignade* and include more heightened contrasts than those of the seated boy. Streaks of orange mark the dark green shadow and the dark blues of her dress, and the oranges throughout the meadow are more intense than those of the earlier picture. These oranges and the associated yellows are the painter's device for giving the effects of direct sunlight, but they are not illusionistic and in fact have the arbitrariness of his later dotted strokes. However, since they recall the brushwork of Delacroix and of the Impressionists and are varied with the imagery (smoother for the figure), they do not seem unduly conspicuous.

This is another of the works first owned by a friend of Seurat's, the Neo-Impressionist painter Léo Gausson. He was perhaps given it by Seurat's mother, since Fénéon, who bought the picture from Gausson, credited him with its possession by 1891.

1. Among the best known of these is the *Paysanne assise* (Musée d'Orsay, Paris), exhibited with the Impressionists in 1882.
2. Angelica Rudenstine (*The Guggenheim Museum Collection, Paintings 1880–1945* [New York 1976], vol. 2, p. 646) points to this picture's proximity to Pissarro's *Père Melon en repos* (1879; Pissarro and Venturi, no. 498), but this would be a parallel, not a source, since it was not exhibited and Seurat did not meet the older artist until 1885.

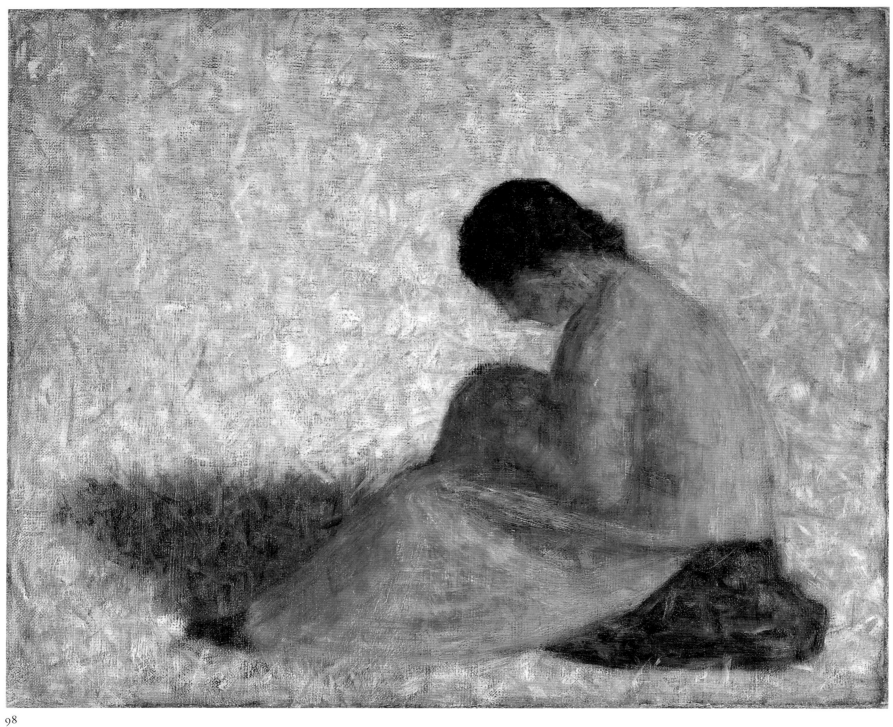

98

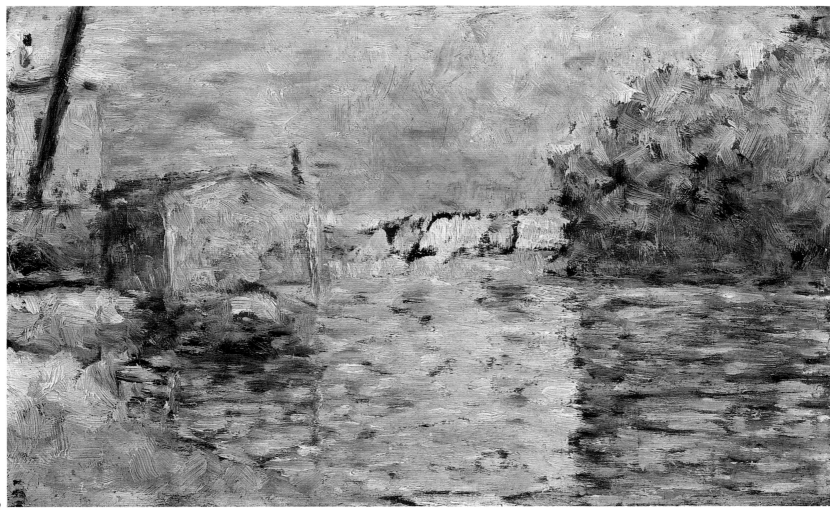

99

99. *Bords de rivière*. 1883–84

RIVER'S EDGE

Oil on wood, 6½ x 9¾ in. (16.5 x 24.8 cm.)

The Hyde Collection, Glens Falls, New York

H 67

PROVENANCE
The artist until 1891. Posthumous inventory, panneau no. 103;[*]
Jacques Dubourg, Paris, about 1939; M. Bruneau; with Watson Art
Galleries, Montreal, in 1947; with Mortimer Brandt Gallery, New
York, in 1947; sold to Mrs. Charlotte Hyde, Glens Falls, New York,
1947

[*] Presumably this work was included in the posthumous inventory
as panneau no. 103. De Hauke, who erroneously catalogued the
work as oil on canvas, also placed it among the oils in the
posthumous inventory, as "toile no. 103." As the panel is cradled,
it is impossible to consult the reverse for an inventory number.

Comparisons with studies for the *Baignade* suggest that
this panel depicts the shore of the Seine at Asnières, with
the tip of the island of La Grande Jatte to the right. A
commercial boathouse, its prow facing us, is moored to
the bank. Its superstructure is framed in yellow and red

roughly mixed to form carmine, a strong note of color that
is repeated, somewhat subdued, among the reflections in
the water. Distant buildings on the shore at Clichy form
vertical reflections in the water, sharply differentiated from
the adjacent reflections of the trees. The lower half of the
mass of foliage is mostly blue-green and panel color, but
over the upper half Seurat brushed orange, yellow, and
cream tones atop greens and some of the dark blue-green.
In the extreme upper left is a curious note of red, white,
and blue, possibly a flag surmounting the building that
rises behind the slanted tree trunk.

100. *La rue Saint-Vincent.* 1883–84

Oil on wood, 9¾ x 6⅛ in. (24.8 x 15.4 cm.)

Lent by the Syndics of the Fitzwilliam Museum, Cambridge

Exhibited in Paris only
H 104; DR 104

PROVENANCE
The artist until 1891. Posthumous inventory, panneau no. 71; Félix
Fénéon, Paris, from 1891 until 1926; sold to Reid and Lefevre,
London, 1926; sold to Captain S. W. Sykes, 1926, until 1948; his gift
to the Museum, 1948

EXHIBITIONS
1892 Paris, Indépendants, no. 1111
1908–09, Paris, no. 27
1920 Paris, no. 12
1926 London, no. 6
1985 Tokyo and Kyoto, no. 18

Long favored by painters, the rue Saint-Vincent was (and
is) a picturesque street in the heart of Montmartre, run-
ning east-west from an ancient cemetery to the rue du
Mont Cenis. One of its best-known renderings is by Corot
(*La rue Saint-Vincent*, Musée des Beaux-Arts, Lyons). Still
having the character of a village street far from Paris, it is
flanked on the south side by the garden of Montmartre
where Renoir had his studio and where *montmartrais* still
raise grapes. Seurat painted another view of the street, *La
rue Saint-Vincent, hiver* (H 70; private collection), that looks
even more like a village lane. By choosing a premodern
view of the city, Seurat was faithful to his early love of
mid-century effects. Although he drew city folk and
painted the suburbs and their factories, he never painted
the city's bustling streets and boulevards in oil, so his
modernity was a complex blend of old and new. The view
in this panel is westward through a tunnel of luxuriant
foliage as the street slants down from the top of the slope.
It is midday in summer because the sunlight is from the
south at a steep angle. Shadows of the large trees of the
garden on the left cross the road and climb up the wall,
staining it purple and blue. Their progressive diminution,
an effect Corot often used for country lanes and wooded
paths, spells out the extension of the street in the distance.
The bright yellow-greens and oranges of the foliage above
are opposed by the blues, lavenders, and purples below.
Blues and the warm panel color appear top and bottom,
unifying a composition split by its hollow center.

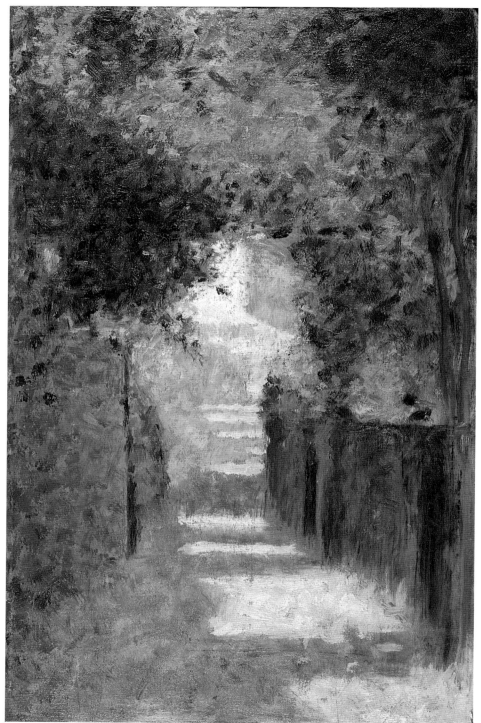

100

101. *Paysage rose.* 1882–83

PINK LANDSCAPE

Oil on wood, 6⅛ x 9⅝ in. (15.5 x 24.5 cm.)
Inscribed at the time of the studio inventory by Maximilien Luce, in blue lower left: G. Seurat; lower right: 86
Originally part of a double-sided panel that was separated after 1929 into two panels; the other side is H 96 (cat. no. 102)

Musée d'Orsay, Paris R.F. 1965-18

Exhibited in Paris only
H 98; DR 43

PROVENANCE
The artist until 1891. Posthumous inventory, panneau 86a. Inherited by the artist's brother, Émile Seurat, Paris, in 1891, until at least 1892; Alexandre Natanson, Paris, until 1929 (Natanson sale, Drouot, Paris, May 16, 1929, no. 105 [recto and verso], for 40,000 francs); acquired at this sale by Georges Lévy, Paris, until 1932 (his sale, "Collection de Monsieur G. L.," Drouot [salle no. 6], Paris, November 17, 1932, no. 104, for 3,700 francs);* purchased at this sale by Victor Bossuat, Paris, until at least 1934; Paul Augier; Jean-Claude Bellier, Paris, until 1965; acquired by the Jeu de Paume, 1965; transferred to the Musée d'Orsay, 1986

EXHIBITIONS
1900 Paris, Revue Blanche, *hors cat.*
1933–34 Paris, no. 73
1936 Paris, no. 23

* See provenance note, cat. no. 92.

Until 1932, when they were sawed apart, this landscape study was the back surface of the next picture (cat. no. 102). Evidently Seurat thought it was unimportant and used the other side a year or more later. Almost undecipherable at first glance, this work comes into partial focus as a brisk sketch of an unpaved road in brilliant sun, flanked by foliage on both sides. The opposition of yellowish greens with rose determines the panel's harmony. Light blues mark a shadow that falls on the road from the right, and dark blues help form the shaded areas of the foliage. The picture is probably an autonomous sketch, abandoned before it was developed into a more complete rendering. The small canvas *La clairière* (H 21) of 1882–83 is a more finished variation on the same theme.

102. *Courbevoie, paysage à la tourelle.* 1883–84

COURBEVOIE, LANDSCAPE WITH TURRET

Oil on wood, 6⅛ x 9⅝ in. (15.5 x 24.5 cm.)
Inscribed at the time of the studio inventory by Maximilien Luce: G. Seurat; 86
Originally part of a double-sided panel that was separated after 1929 into two panels; the other side is H 98 (cat. no. 101)

Private collection

H 96; DR 106

PROVENANCE
The artist until 1891. Posthumous inventory, panneau 86b. Inherited by the artist's brother, Émile Seurat, Paris, in 1891, until at least 1892; Alexandre Natanson, Paris, until 1929 (Natanson sale, Drouot, Paris, May 16, 1929, no. 105 [recto and verso], for 40,000 francs); acquired at this sale by Georges Lévy, Paris, 1929, until 1932 (his sale, "Collection de Monsieur G. L.," Drouot [salle no. 6], Paris, November 17, 1932, no. 106, for 8,000 francs);* purchased at this sale by Victor Bossuat, Paris, 1932, until his death; to present owner

EXHIBITIONS
1892 Paris, Indépendants, no. 1113
1900 Paris, Revue Blanche, *hors cat.*
1933–34 Paris, no. 74
1936 Paris, no. 22
1937 London, no. 52
1968 New York, no. 73

* See provenance note, cat. no. 92.

This panel is hardly more finished than the study that was once its other side (cat. no. 101). The wood is everywhere exposed, but the composition reads clearly because we can identify most of its parts. The river is readily separated from the multicolored embankment. Strong hazy light bounces off the water (we are looking southwest from the island of La Grande Jatte),[1] hence the glaring off-white that reflects the sky. On the left a few strokes of blue give the beginnings of a boat whose lone passenger is reflected in the water. Elsewhere, despite the sketchiness, the colors are more developed and tell a surprising amount about the site. A purple angle on the far left marks the bridge's ironwork; it springs from its yellow abutment, and together with its reflection it frames a green arc of distant foliage. If we examine just the two inches occupied by the bridge and its immediate surroundings, we will appreciate the numerous decisions that entered into such an appar-

ently elemental study. The top edge of the huge building is made of horizontal strokes of grayish blue, but its walls are vertical streaks, mostly blended, of purplish blue and yellowish green. Crossing through the brightly colored wedge to the right, the horizontal stitching of light yellow above center and along the top of the embankment picks out walls or roadways. The color of the wood forms a binding matrix of intermediate brown, but Seurat moves closer to Impressionism in pictures such as this, which are conceived almost entirely as juxtaposed spots of color-light.

1. The identification of Courbevoie was provided by the artist's family when this work was lent to the retrospective organized by the Indépendants in 1892.

101

102

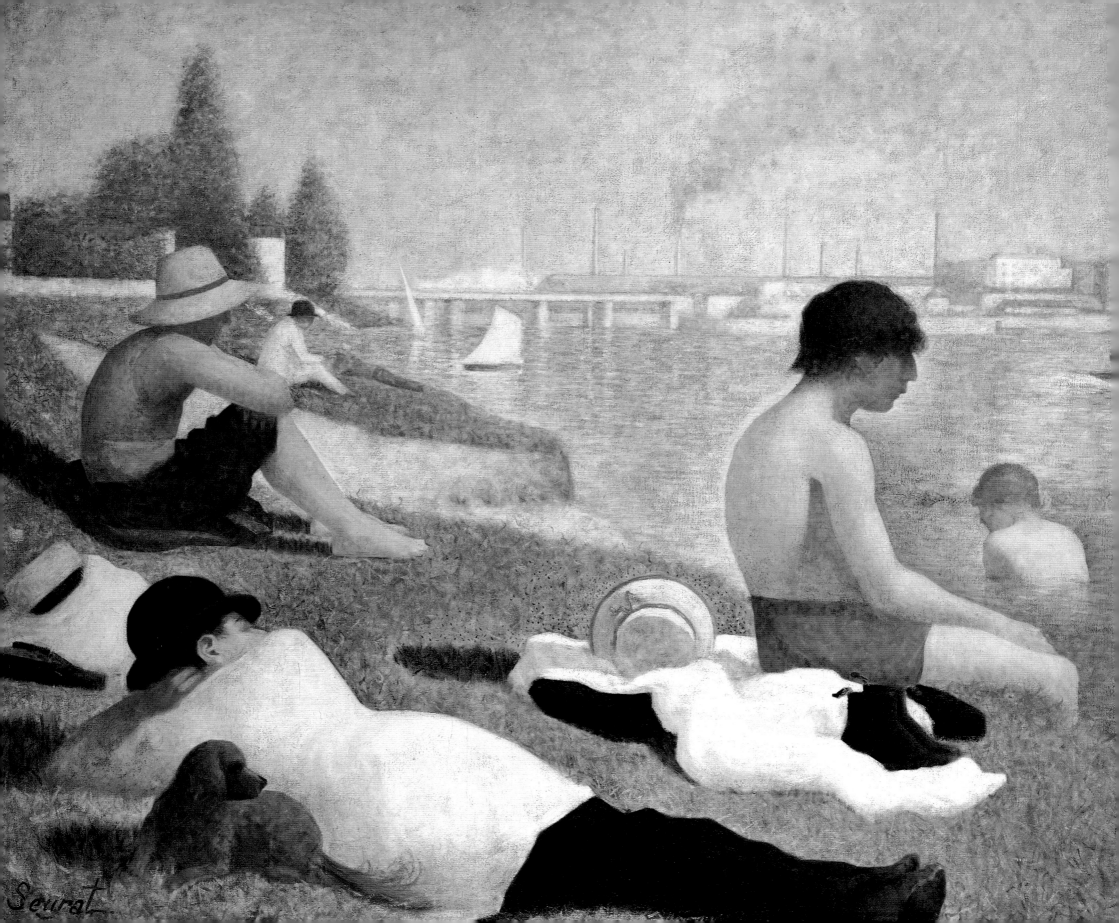

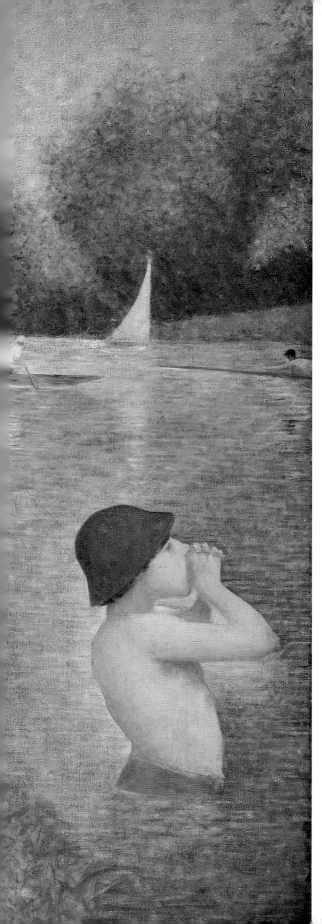

Une baignade, Asnières 1883–1884

When Seurat began *Une baignade, Asnières* in 1883, he was conforming to a time-honored practice: he was preparing an ambitious picture that would make his mark in the major showcase of Parisian art. He submitted his painting to the official Salon in early spring 1884, following the example of his Beaux-Arts friends (Aman-Jean and Laurent regularly participated in the Salon). He had shown his large drawing of Aman-Jean (cat. no. 30) there the previous year, although another drawing (cat. no. 32) had been refused by the jury. The *Baignade* was rejected—we can only guess at the reasons—and Seurat showed it instead in an exhibition of the newly formed Groupe des Artistes Indépendants that opened on May 15. The Groupe was open to all on payment of a small fee, therefore achieving the aim of the many artists who had protested the Salon juries for decades. Displaying this painting with the Indépendants marked a key point in Seurat's career, not only because it was his first exhibition of a major work but also because it was there that he met the nucleus of the future Neo-Impressionist group, Charles Angrand, Henri-Edmond Cross, Albert Dubois-Pillet, and Paul Signac. Dissatisfied with the poor organization of the Indépendants, these artists joined Odilon Redon and others in December 1884 to form the better-managed and equally jury-free Société des Artistes Indépendants, an organization that is still in existence.[1] Until his death Seurat was faithful to its exhibitions, committees, and periodic suppers and to his newly found friends. They drew him away from his old milieu—after 1884 he maintained only perfunctory contact with Aman-Jean, Laurent, Osbert, and Séon—and plunged him into the world of vanguard art and journalism.

The *Baignade* was shown in the temporary exhibition quarters of the Indépendants. It was noticed favorably by a few critics who published in progressive reviews and was given a backhanded compliment by Zola's disciple Paul Alexis, who soon afterward became a friend and staunch supporter of Seurat and his allies. Alexis called it a "faux Puvis de Chavannes" because it had features associated with Puvis and the classicizing tradition: seminude figures that recalled ancient reliefs; the scale of a mural; a composition based on readily grasped geometries; and a solemnity that eschewed frivolity. (Another reviewer likened the picture to Renaissance frescoes.[2]) The *Baignade* was also called an Impressionist picture by

Seurat, *Une baignade, Asnières*, 1883–1884. Oil on canvas, 79 × 118 in. (201 × 300 cm.). National Gallery, London (H 62)

contemporary reviewers, and for good reason: it is a scene of leisure on a sunny riverbank and has a light palette with broken brushwork in the landscape. In fact, the picture was formed by three currents: the Beaux-Arts tradition, naturalism, and Impressionism.

Seurat's origins in the Beaux-Arts are most evident in his conception of the figures of the *Baignade*: they were posed in his studio and have the clarified outlines of classical sculpture. In many ways this canvas is the culmination of his schoolboy training. Although the Impressionists had painted nude and seminude bathers, their figures have irregular surfaces and edges that register effects of mottled sunlight and reflections (Seurat would not have known that in 1883 Renoir was entering his "Ingres period," devoted to classicizing nudes). Seurat's men are painted with waxy smoothness and uninterrupted outlines that give them a sculptural autonomy. Their elemental poses recall stock figures from the repertoire of great painting, and they conform to the dictum of Charles Blanc, spokesman of the Beaux-Arts tradition: "Indeed, the right way of idealizing is to efface the purely individual accents furnished by nature, in order to choose those which belong to a species, those that characterize generic life. [In Greek sculpture] each figure having the dignity of a type, one might think that feeling was weakened by the process of generalizing: the contrary is true. The type condenses and epitomizes all joys, all sorrows; it is not one, it is all."[3]

The artist develops types that encapsulate the essence of life; his ideas enter into partnership with natural forms, an unequal partnership for it is the ideas that count. Nature herself (of course, nature is feminine for Blanc) is passive, waiting to be acted upon by human thought. Such ideas let Seurat measure his own ambition against tradition. He could make himself into a latter-day Phidias by distilling from his own era a set of forms that would have enduring value. Paul Alexis was right to liken the *Baignade* to Puvis de Chavannes, for although the great muralist avoided modern subjects, he attracted younger artists because he made creative variations upon the classical tradition. He was a mentor to several of Seurat's Beaux-Arts comrades and a few years later was a major figure in the evolution of Symbolist painting (Gauguin was among his admirers).

Puvis's *Doux pays*, exhibited in the 1882 Salon, anticipated some aspects of Seurat's picture.[4] Puvis, the master of vast surfaces, avoided breaking the integrity of the architectural wall by using broad, flat areas and by deploying his figures in lateral planes. Having vindicated the "mural aesthetic" that Charles Blanc made so much of in his *Grammaire*, Puvis was a worthy exemplar for the young Seurat. Writing as a disciplined republican, Blanc held that murals were superior to easel paintings: as the repositories of society's morals, murals were vehicles of public enlighten-

Pierre Puvis de Chavannes, *Doux pays* (Gentle landscape), 1882. Musée Bonnat, Bayonne

Louis-Alexandre Dubourg, *Les bains de mer à Honfleur* (Seaside, Honfleur), 1869. Musée Eugène Boudin, Honfleur

ment; small pictures, however, typified individualism and were merely commodities of the moneyed classes.[5]

The figures of Puvis's large decorations contribute to the elevated public character of his compositions. His nude and partly draped figures transport the viewer into a vaguely Hellenistic past, long associated with public buildings and national culture, rather than into the multiple worlds of privately owned, naturalistic easel painting. Except for one figure who may be talking, the adults in *Doux pays* are absorbed in statuesque reverie; they lack the social interplay of most Beaux-Arts painting, including that of

Seurat's teacher, Lehmann. In Lehmann's work individual figures may evoke classical prototypes, but they twist and bend in active poses and one overlaps another. Puvis's classicism is "primitive" by comparison; like the rebellious "Barbus" among David's pupils at the beginning of the century, he associated an archaic simplicity with a strongly moral outlook. This simplicity struck Seurat's school friends as a sign of reform, and they had apprenticed themselves to Puvis by the time the *Baignade* had become the young painter's chief preoccupation. Modern historians have connected the *Baignade* and *Doux pays* to prove Seurat's direct debt to Puvis. Both canvases are roughly divided along the diagonal from upper left to lower right, with land to the left and water to the right. In both, land and water form large triangles, and most of the figures face to the right. This structure is, however, common in Western landscape; it underlies the composition of Dubourg's *Les bains de mer à Honfleur* and of Renoir's *Canotiers à Chatou*, and it need not point to Puvis's picture as Seurat's source.

Juxtaposing Puvis and Seurat allows us to explore Seurat's links with tradition, yet we must not make the younger artist out to be a follower of the older. Seurat admired the muralist less than his friends did (his free copy after Puvis's *Pauvre pêcheur* [cat. no. 77] is probably a sly criticism of the master); it was with even greater interest that he looked toward naturalism and Impressionism. Although Seurat's contemporary subjects are his most obvious departures from Puvis, his conception of human form is also quite different (even if the two share a statuesque solemnity). Puvis modeled his figures so that breasts, shoulder blades, and folds of flesh have visible weight, aided by poses partly angled into depth. Seurat's figures are depicted in rigorous profile which suppresses depth, and there is little interior modeling. Moreover, the muralist conceived of drawing as linear outline to be filled in with modeling, whereas Seurat drew in masses of light and dark: there are edges but no lines.

The composition of the *Baignade* has been linked with Puvis and with the Beaux-Arts tradition; so too has the way Seurat worked up his picture in thirteen sketches and ten drawings.[6] Historians have frequently cited these as proof of his distance from the spontaneity of Impressionism and of his proximity to the calculation of Renaissance and later masters. While there is no doubt that this is generally true, there has been a tendency to exaggerate the degree to which the studies led implacably to the final picture. Like so many other artists, Seurat used studies to try out and then reject certain features, such as the horses that appear in four panels for the *Baignade*. In fact, he may even have painted one or two panels before he thought of a large picture at all and only afterward saw the possibility of using them. Most of the drawings, however, probably did intervene toward

the end of the process, although one or two had perhaps already been made simply as studio drawings and were utilized after he decided on the bathing picture. It was proper Beaux-Arts procedure to develop a satisfactory pose and then seek an appropriate subject. When we stop evaluating the preparatory studies solely by looking backward from the final composition, a rich variety is revealed, particularly among the panels. Several of them have an extraordinary freedom and a luminous glow that reflect the excitement of fresh outdoor discoveries; for these Impressionism was his guide.

The proof that Seurat had been looking closely at Impressionist pictures by 1883 can be found in the palette and brushwork of several studies for the *Baignade*. *Le cheval blanc* (H 87; Mr. and Mrs. Paul Mellon) has flat tones and black-and-white contrasts that stem from Manet. The factories in *Chevaux dans l'eau* (cat. no. 105) have a coral red and lavender-blue Renoir frequently used in combination; the water has contrasting oranges and blues also favored by Renoir, whose *Canotiers à Chatou* has more than one parallel with Seurat's panels. Generally the brushwork (with due allowance for the small size of the panels) is far closer to Monet, Pissarro, and Renoir than was true of his earlier oils and so is the heightened palette. Both Renoir and Pissarro had been using small strokes of different colors that partly blend in the eye—they too were admirers of Delacroix—so Seurat could find optical mixture in their work. Furthermore, the sunny river at Asnières (Monet and Sisley had often painted there) is far closer to the Impressionists in both subject and palette than were the peasants and country landscapes that dominated Seurat's paintings

Vincent van Gogh and Émile Bernard (facing camera) at Asnières, 1886

of the previous two years. The Impressionists were the obvious guides for a young artist who was gradually turning away from Barbizon art as he explored suburban leisure.

Seurat's alertness to Impressionism, however, did not mean a wholesale adoption of the new style. In the panels for the *Baignade* he kept the warm brown of the wood as the ground for his hues, a Barbizon trait. Moreover, the little oils betray some of the calculation of the final composition. In *Chevaux dans l'eau* and in the final study, the horses and boys are surrounded by contrasting light and dark zones which are incorporated into the finished picture (most conspicuously around the three boys over the water). As in his earlier drawing, these halos and umbras are rooted more in light and dark than in color, and they contribute to the sculptural silhouettes of the figures, which alone would distinguish Seurat from the Impressionists. The colors of the canvas, compared to those of his panels and of Impressionism, are quite subdued, even though the landscape does have the broken brushwork and some of the opposed colors of the new movement.

Seurat's choice of subject, as well as his rendering, distinguishes him sharply from both the Impressionists and Puvis; these features of his work also partly explain why Alexis, Jean Ajalbert, Robert Caze, and other naturalist and leftist writers befriended him after 1884. The *Baignade* represents an ordinary embankment of the Seine at Asnières, with working-class or lower middle-class men in the foreground; to the rear are the railroad bridge (largely hiding the parallel highway bridge) and the factories of Clichy. The exposed sand in the middle ground resulted not only from dragging boats in and out of the water but also from the activity of horses that were bathed here. *Baignade* refers less to the middle-class idea of enjoying the water than to the working-class use of the site (on old maps the word *baignade* marked places along the Seine where horses and dogs were bathed). When Seurat studied the site, he would have seen an unpretentious river road, studded with run-down villas, boatyards, and lower-class cafés and restaurants. We know this view from guidebook descriptions and from a photograph of the artists Émile Bernard and Vincent van Gogh against a backdrop of the same factories. Asnières had once been a small suburban village, and in mid-century it was a favorite boating spot in the Paris region. It grew with astonishing speed, however, as did Clichy and its industry on the opposite bank, so by the 1870s boaters favored Argenteuil and other less built-up sites.

The Asnières embankment and bridges were painted by Paul Signac as early as 1883 and by Bernard and van Gogh in 1887. The plainness of this industrialized site attracted artists who preferred its contemporary "ugli-

ness," honestly revealed, to the more idyllic resorts embraced by the Impressionists. Young naturalist writers like Alexis and Huysmans also favored the suburbs (Alexis lived in Asnières); in their novels the Goncourts had featured the industrialized banks of the Seine, doubtless one of the reasons why both Seurat and van Gogh admired their works. For example, in the opening scene of their 1864 novel *Renée Mauperin*, the protagonist and her admirer are holding the hawser of an industrial barge near Saint-Denis, taking a pause in their swim. Renée Mauperin, a liberated woman and a very modern artist, tells her companion that contemporary beauty is found in the nearby mixture of greenery with factories, boatyards, and stained soil, not in untouched nature.

The naturalist setting of the *Baignade* would have been evident to Seurat's contemporaries, but we are aware of the extent to which he has in fact idealized it. We see young working-class men against the backdrop of smoking factories, yet they are entirely at leisure, and the embankment, which was a scruffy, well-used place, seems almost like a park. We do not see the cafés and wineshops on the adjacent roadway, and although we see the gash in the bank made by the sandy gully, no horses are being bathed. Four of the *croquetons* associated with the *Baignade* show horses; their elimination was part of the process by which Seurat idealized his subject. In removing those features that Charles Blanc would have labeled temporary and individual, Seurat attempted to raise the painting to the plane of the permanent and universal. Comparison of the final picture with other panels

Ivry-sur-Seine, Parisian suburb, 1900–20

reveals that Seurat also regularized the bank's geometry and arranged the figures along neat lines into depth, changes that identify the process of picture-making with that of idealization. One exception is the central boy who seems to be a well-groomed youth in the final panel (cat. no. 110) but who in the large canvas acquires an unself-conscious slump and a mop of hair that indicate his lower-class origins.

Seurat's idealization of his subject does not deny its social significance, for he sought to make an enduring monument from the plebeian clay of this suburban shoreline; he did not eliminate social content in favor of "form" but instead elevated it to the standing of high form. The *Baignade* is an allegory of summertime in the guise of the leisure of working-class males. No women are present; this is masculine leisure whose counterpart is the workplace. It is summertime, but neither that of the eighteenth-century *fête champêtre* nor that of Renoir's *Canotiers à Chatou* (p. 154), where pleasure boating and courtship take place uncontaminated by work or the city. It is leisure against a backdrop of factories, but not that of Manet's *Argenteuil* (1874, Musée des Beaux-Arts de Tournai), a saucy picture in which a boater casually courts a young woman. It is contemporary youth, but not the young men relaxing together far from the city in Bazille's *Scène d'été* (1869, Fogg Art Museum, Cambridge, Massachusetts).

The gravity of the *Baignade*, its entire lack of Manet's irony and Renoir's sociability, separates the picture from Impressionism and leaves us without a label for it. It is neither a Beaux-Arts picture nor a Puvis-like idyll, although we can easily detect its ties with tradition. Nor is it a naturalist picture like those of the preceding generation, although we see in its sober figures the heritage of Millet. Seurat's youths are part of working-class Asnières or Clichy. There is no feeling that they came there together as friends, even though they share the embankment.[7] Are they condemned, as it were, to share leisure and yet not to form a community? They are not at all like those photographs of men and boys bathing or washing animals along the Seine that by the turn of the century became a staple of commercial photo suppliers. In those photos the swimmers cavort in the water and lounge on the shore, sparring playfully or talking; they provided middle-class magazine readers with a comforting idea of leisure entirely divorced from work. Seurat, however, isolated his youths from one another and removed most signs of playful activity; he gave them the grave monumentality that idealizes them in Blanc's meaning of the term, that makes them into social types, not individuals. In so doing he expunged the celebratory sense of leisure and thereby questioned their relationship to work and to society.

Five of them gaze in the direction of Paris, toward the island of La Grande Jatte whose verdure shows in the upper right. The sailboats are not for them, nor the single shell a *canotier* is rowing off the right edge. They look over to the island but do not join the middle-class couple being ferried there (the boatman is the only person actively working in the picture) —the ferry is strung along the diagonal that leads back to the right, forcing us to compare the boys with them. In view of these separations, and of the distance between their riverbank and the pleasures to be found on the verdant island, the boy on the right assumes a tinge of poignancy as he makes his noise echo over the water. It is as though his activity, albeit a modest one, could bridge the distance; he is the only figure in the foreground who moves his arms away from his body, who partly escapes from the bas-relief gravity of the others. He does not, however, significantly modify the solemn mood that is Seurat's distinctive trait.

1. For the early history of the Société des Artistes Indépendants, see P. Angrand 1965, Sutter 1970, and Lily Bazalgette, *Dubois-Pillet, sa vie et son oeuvre (1846–1890)*, 1976.

2. Alexis [Trublot], in his regular column, "À minuit," for *Le cri du peuple* (May 17, 1884); the anonymous reviewer of a New York journal (the *Baignade* was shown there by Durand-Ruel in 1886), "The Impressionist Exhibition," *The Art Amateur* 14 (May 1886): 6: "In this gallery a big bathing scene by Seurat, though it has the advantage of the full length of the room, cannot yet be seen from a sufficient distance. It has some of the qualities of an early Italian fresco, and if placed at the top of Trinity steeple and viewed from Wall Street Ferry, it might look very well." (Citation communicated by Dr. Helen Cooper.)

3. *Grammaire* 1867, ed. 1880, pp. 339, 446.

4. The two paintings were first compared by Benedict Nicolson in the unpaginated supplement to the *Burlington Magazine* 95 (1953): 609. Earlier the two artists had been compared (Rich 1935, Nicolson 1941), and in my article of 1959 (Herbert 1959) I summarized what could be known of the relationship between the two artists. There is no proof they ever met (despite later speculation, bordering on assertion, that they had), but at least three of Seurat's school companions worked with the Lyons master (Laurent, Séon, and Osbert), proof enough that Seurat was familiar with his work. *Doux pays* was a well-known picture; van Gogh praised it in a letter of 1888 (*The Complete Letters of Vincent van Gogh* [Greenwich, Connecticut, 1958], vol. 3, no. 539).

5. Seurat's link with Blanc's mural aesthetic and his republicanism has been discussed in Zimmermann 1989 and more extensively in Boime 1990.

6. Of de Hauke's grouping, few today would accept one panel (H 83) and one drawing (H 592) as sufficiently close to the canvas to warrant inclusion. To the remainder one should add an uncatalogued drawing of the "echo" boy, once in the collection of Henri de Régnier, now in a private collection, Paris. It is a three-quarter-length figure in the fully finished black conté of the others.

7. Benedict Nicolson (Nicolson 1941, p. 146) was the first to have remarked that in the *Baignade* there is social meaning in the isolation of Seurat's figures from one another. This isolation is one factor that argues against the recent interpretation of the picture that relates it to "saint lundi," the workers' unauthorized abstention from work on Monday, as distinct from the Sunday leisure of the bourgeoisie (House 1980, Clark 1984, Clayson 1989). Representations of "saint lundi" invariably show drink and camaraderie. Given the lack of such attributes, there is little reason to associate Seurat's canvas with this tradition. Moreover, these interpretations do not take into account either the pervasive theme of male bathers from the Renaissance onward or the possibility that the *Baignade* might suggest Sunday or a holiday, hinted at by the pleasure boating in the background.

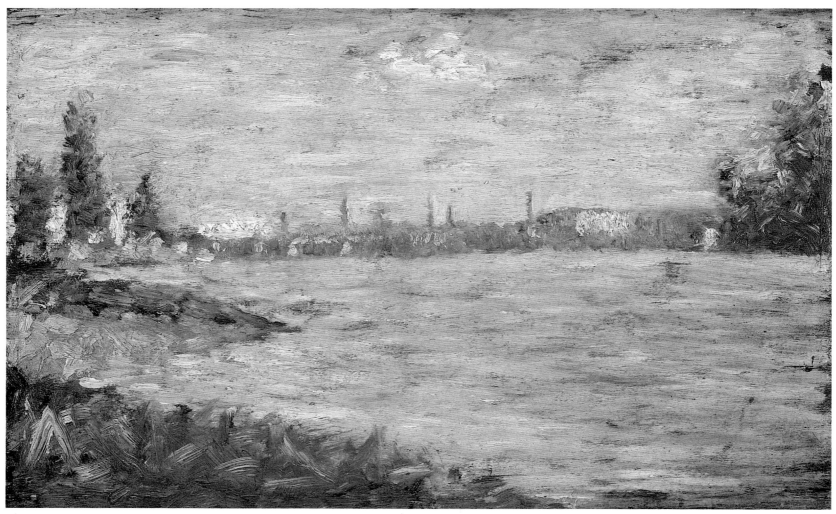

103

103. *Les deux rives.* 1882–83

THE RIVERBANKS

Oil on wood, 6¼ x 9⅞ in. (15.9 x 25.1 cm.)

Glasgow Art Gallery and Museum

Exhibited in Paris only
H 79; DR 84

PROVENANCE
The artist until 1891. Included in the posthumous inventory but not numbered. Inherited by Madeleine Knoblock, Paris, in 1891, until 1892; sold to Jean de Greef, Auderghem, Belgium, in February 1892, until no later than 1894;* Félix Fénéon, Paris, by at least 1908,

until at least 1920; with Étienne Bignou, Paris; Percy Moore Turner, London, by 1930; William McInnes, Glasgow, until 1944; his bequest to the Museum, 1944

EXHIBITIONS
1886 New York, no. 133 (no. 3 in a frame of "12 studies")
1887 Paris, no. 447 (one of "douze croquis")
1892 Brussels, no. 1 (one of "douze esquisses")
1908–09 Paris, no. 21
1919–20 Paris, no. 53
1978 London, no. 14

* See provenance note, cat. no. 89.
 The 1886, 1887, and 1892 exhibition listings do not appear under de Hauke's entry for this work; by error, they were printed under

his entry for H 76. See H, I, p. xxx, and Errata, p. 305.
 Fénéon and de Hauke's identification of the dozen panels shown in a single frame in the 1886 New York exhibition on p. xxx should be considered a more definitive accounting of this group of objects than that offered by Fénéon's cut-and-paste annotations in the reprinted exhibition catalogues for the 1886, 1887, and 1892 shows on pp. 216–17, 221, 229. The errors in cataloguing and annotation are noted under Errata in H, I, p. 305 (see also cat. nos. 126 and 130).

In the early 1880s Seurat drew and painted frequently at Asnières and Courbevoie. He may have done this panel without regard to a larger composition, only returning to

the site when he decided on *Une baignade*. Because it lacks color contrasts, this little picture, usually dated 1883, may instead have been painted in 1882, perhaps in the autumn given the lack of green in the distant foliage and the cold effect of the whole. The embankment consists only of tints of green mixed wet with yellowish cream, plus the exposed wood color, whereas the comparable areas of other *Baignade* panels have blues and usually other colors as well. The apparent spontaneity of the brushwork suggests Impressionism, but Seurat was still following the mid-century practice of exploiting the light brown of the wood.

104. *L'arc-en-ciel*. 1883

RAINBOW

Oil on wood, 6⅛ x 9⅝ in. (15.5 x 24.5 cm.)
Signed lower left: Seurat

Berggruen Collection on loan to the National Gallery, London

H 89; DR 92

PROVENANCE
The artist until 1891. Included in the posthumous inventory but not numbered. Inherited by Madeleine Knoblock, Paris, in 1891, until 1892; sold to Jean de Greef, Auderghem, Belgium, in February 1892, until no later than 1894;* Félix Fénéon, Paris; with Étienne Bignou, Paris; D.W.T. Cargill, Lanark, Scotland, by 1932, probably until his death in 1939;** with Bignou Gallery, New York, by 1940, until 1944; sold to M. Knoedler and Co., New York, in January 1944 (stock no. A2748); sold to Mrs. Dwight F. Davis, Washington, D.C., in February 1944, until 1984; sold from her collection to Acquavella Galleries, New York, in 1984; sold to present owner in 1984

EXHIBITIONS
1886 New York, no. 133 (no. 6 in a frame of "12 studies")
1887 Paris, no. 447 (one of "douze croquis")

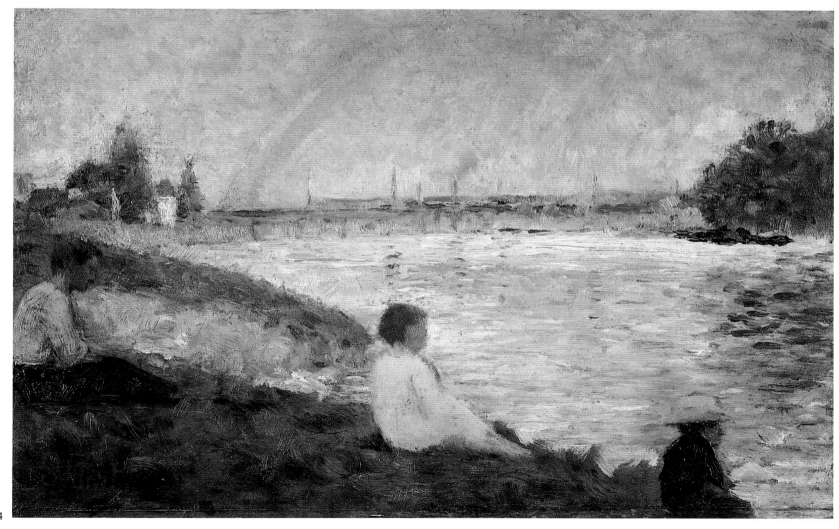

104

1892 Brussels, no. 1 (one of "Douze esquisses")
1919–20 Paris, *hors cat.*(?)
1926 London, *hors cat.*(?)
1932 London, no. 554
1949 New York, no. 5
1988 Geneva, no. 17

* See provenance note, cat. no. 89.
** See second provenance note, cat. no. 150.

Compared with those in the previous panel, the trees in the left distance seem farther away, and the site may be slightly farther back from the bridges and factories. If this is true, the embankment's shape would not reflect an arbitrary alteration but would represent a different spot along the shore (which had many sandy gullies). The picture seems like one done at the site, not in the studio, although it is not a quick sketch. The boy on the far left looks like a life study; the commercial barges on the right and the distant architecture have the marks of visual response rather than studio reworking. The rainbow is such a conventional image that it appears trite, and yet the moist sky explains its appearance. Both sky and water are far richer than in the previous panel, and the architecture is more brilliantly colored than the rainbow. The hand of the organizing artist is evident: the dark background forms produce light halos in the sky, and the water around the boys in the foreground changes to dark or light according to their tones.

105. *Chevaux dans l'eau.* 1883

HORSES IN THE WATER

Oil on wood, 6 x 9¾ in. (15.2 x 24.8 cm.)

Private collection, London

H 86; DR 88

PROVENANCE
The artist's mother, Mme Ernestine Seurat, Paris; Bernheim-Jeune, Paris; acquired by Olaf Ørvig, Bergen, before 1921;* Galerie Barbazanges, Paris; Percy Moore Turner, London, until 1925; sold to Samuel Courtauld, London, in 1925, until his death in 1947; bequeathed to Lady Aberconway (Christobel Mary Melville McLaren), London, from 1948 until her death in 1974; to present owner

EXHIBITIONS
1978 London, no. 15
1979–80 London, no. 197
1987–88 Cleveland, New York, et al., no 32

* In an article dated January 1921 by Johan H. Langaard, "Georges Seurat," *Kunst og Kultur* 9 (1921), p. 38, the caption accompanying the illustration of this work identifies the collector as Olaf Ørvig, Bergen.

Auguste Renoir, *Canotiers à Chatou* (Canoeing party, Chatou), 1879. National Gallery of Art, Washington, D.C. Gift of Sam A. Lewisohn, 1951.5.2

In the likely sequence of painted studies, four panels (H 85, 87, 82, and 80) intervened between this and *L'arc-en-ciel* (cat. no. 104), but this one was probably also done at the site. There is little as yet that was "systematic" in the artist's procedure. He was trying out different kinds of figures and arrangements, keeping some, rejecting others. Here the horses, not used in the final composition, give meaning to the word "baignade," which refers to a place along the river—there were many of them—where animals could be washed. The sandy gullies in the bank resulted from horses moving back and forth, as well as from their use as impromptu boat landings. Boys frequented such places, hoping to earn a few pennies by assisting those who brought horses and dogs to be bathed.

This work is Impressionist, both in its free brushwork and its palette, which comes close to Renoir's of the late 1870s. The coral reds and the blues of the architecture and the medley of blues, off-whites, and yellows in the water recall Renoir. Seurat, however, avoided the opposition of large areas of orange and blue that the older artist favored, and brown panel color, rather than white, underlies his brushwork. For the first time in the *Baignade* studies,

color contrasts are interwoven, if a bit timidly. Roseate tints in the foreground oppose the greens, and blues vibrate against the orangish yellows and the warm tones of the exposed wood. Contrasting darks and lights around the two boys and their horses are conspicuous, emphasized by the arbitrary brushstrokes that form the figures. These young men and their animals are part of the distinctly working-class environment of Asnières and its factories, as opposed to the middle-class world of Renoir's boaters at Chatou. Yet the sailboat here is a token of pure leisure, and in the midst of these splendid colors washing horses seems more like play than work.

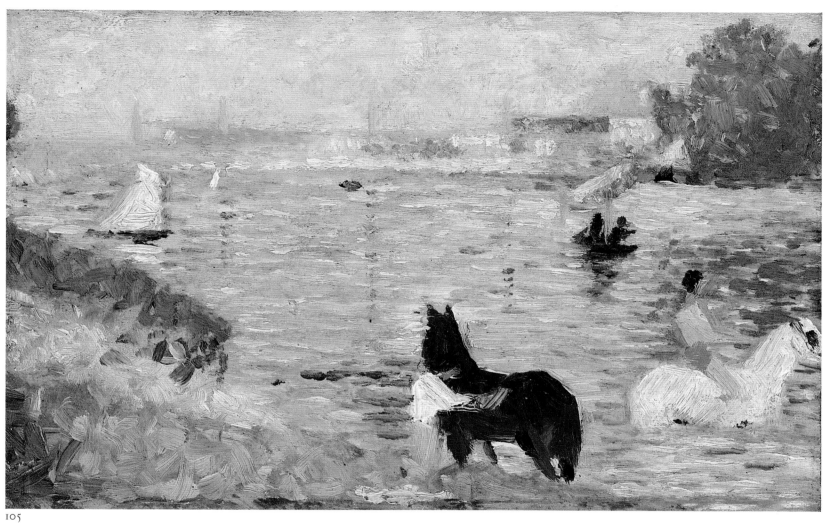

105

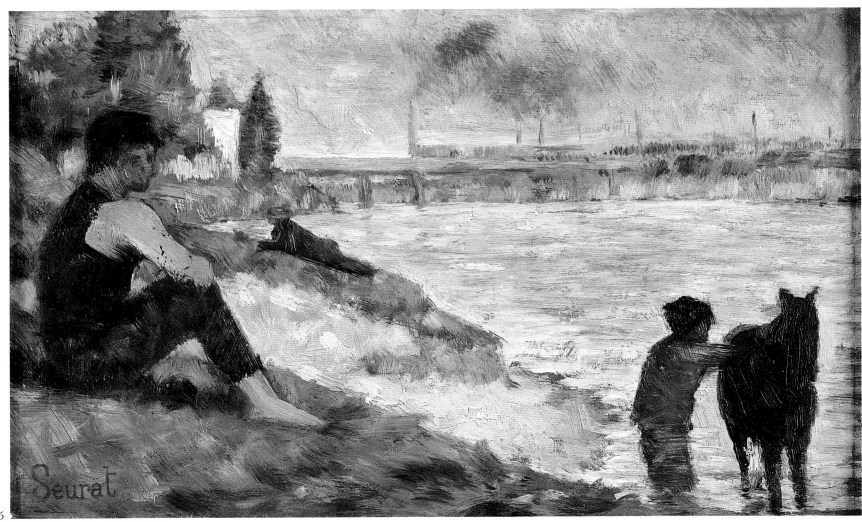

106

106. *Le cheval noir.* 1883

THE BLACK HORSE

Oil on wood, 6¼ x 9¾ in. (15.9 x 24.8 cm.)
"Moline" stamp lower left: Seurat

National Galleries of Scotland

H 88; DR 95

PROVENANCE
The artist until 1891. Presumably inherited by Madeleine Knoblock, Paris, in 1891 (her surname is inscribed on the reverse of the panel); purchased from the artist's family by Étienne Bignou, Paris, by 1926; sold to Reid and Lefevre, Glasgow, in 1926, until 1927; with Reid and Lefevre, London, in 1927; sold to Lord Ivor Spencer Churchill, London, in 1927; Miss Helen C. Sutherland, until 1958 (sale, Sotheby's, London, March 26, 1958, no. 152, for £12,000); purchased at this sale by Arthur Tooth, London, for Mr. and Mrs. Alexander Maitland, 1958, until 1960; his gift to the museum, 1960

EXHIBITION
1895 Paris

In this study Seurat included more of the embankment than in cat. no. 105, while eliminating the tip of the island of La Grande Jatte on the right. He chose a different pose for boy and horse. It is usually assumed that when he painted this and the previous study, he had determined the final landscape and that each study was therefore conceived as a fragment of it. However, it is equally logical to believe that Seurat regarded each as a trial for the entire final canvas. Each is a well-balanced composition with well-defined oppositions of light and dark that would make more sense in a larger scale. The boy, the horse, and the land produce light reactions in the water, and the architecture generates a glow in the sky. Despite the foreground's angularity this panel was probably painted at

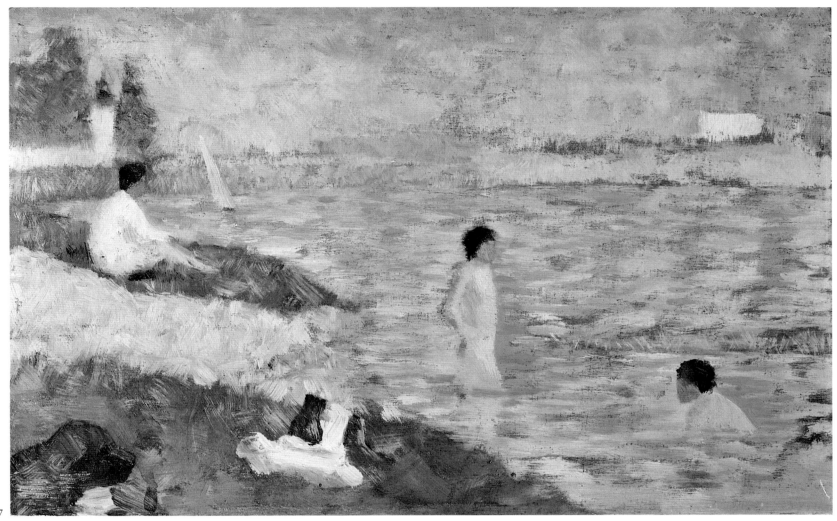

107

the site. The shaping of the shoreline and the gully's edge is different from the earlier studies, and smoke now belches from the factory chimneys. The horse disappears from future studies (and with it an explanation for the sandy ravine). On the other hand, the seated and reclining figures are the first among these studies who will appear with only minor alterations in the large canvas.

107. *Personnages dans l'eau.* 1883

BATHERS IN THE WATER

Oil on wood, 6⅛ x 9⅞ in. (15.5 x 25 cm.)

Musée d'Orsay, Paris, Gift of Baronne Eva Gebhard-Gourgaud, 1965 R.F. 1965-13

Exhibited in Paris only
H 84; DR 91

PROVENANCE
The artist until 1891. Posthumous inventory, panneau no. 75. Inherited by the artist's brother, Émile Seurat, Paris, in 1891; André Corneau; with Georges Bernheim, Paris; Baron Napoléon Gourgaud,

Paris, until his death in 1944; by inheritance to Baronne Eva Gebhard-Gourgaud, in 1944, until her death in 1959; her estate, 1959–65; given to the Musée du Louvre, 1965; transferred to the Jeu de Paume, 1965; transferred to the Musée d'Orsay (Palais de Tokyo), 1977; transferred to the Musée d'Orsay, 1986

EXHIBITIONS
1892 Paris, Indépendants, no. 1110
1900 Paris, Revue Blanche, no. 6
1936 Paris, no. 15

Here bathing boys replace the youths with horses, and the subject shifts to one of pure leisure. Even the factories lose

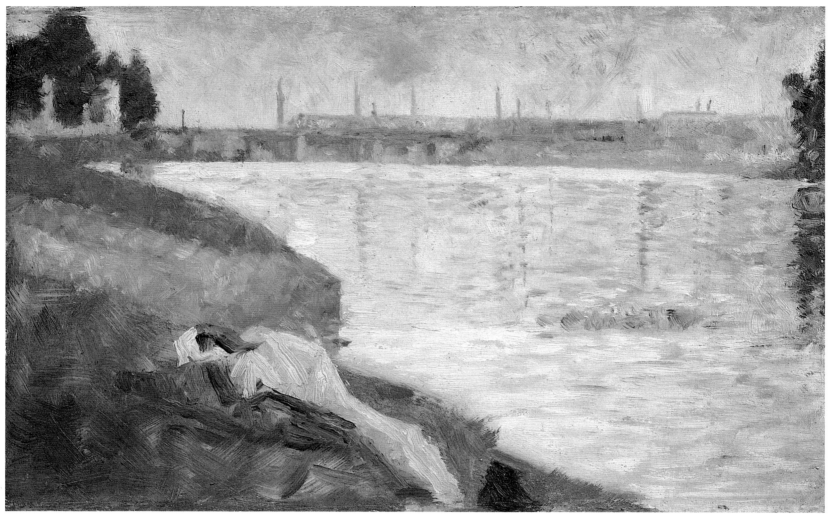

108

their definition, although this is the accidental result of making a simple color study (a green glow in the sky now opposes the pinks of the massed buildings). Other motifs, somewhat altered, found their way into the final composition: the foreshortened sailboat, the horizontal patch of reeds in the water, the seated figure in white, the russet-colored dog, and a still life of boots and clothing. The warm brown of the panel shows everywhere in this summarily executed work.

108. *Vêtements sur l'herbe*. 1883

CLOTHING ON THE RIVERBANK

Oil on wood, 6⅜ x 10⅛ in. (16.2 x 25.8 cm.)

Lent by The Trustees of The Tate Gallery
H 81; DR 89

PROVENANCE
The artist until 1891. Posthumous inventory, panneau no. 76. Ambroise Vollard, Paris; Eugène Druet, Paris; Maurice Fabre, Aude; Jos Hessel, Paris; Reid and Lefevre, London, until 1926; their gift to the museum, 1926

EXHIBITION
1908–09 Paris, no. 23

With minor differences, this study duplicates the landscape of *Personnages dans l'eau* (cat. no. 107), but whereas that panel tested the position of several figures, this one is a more sustained consideration of color. Beneath the foreground greens is a layer of yellow-green which shows through here and there, and under the surface colors of the water is a coating of pale pinkish cream. The sandy ravine, darker here than in other studies, is a ruddy brown

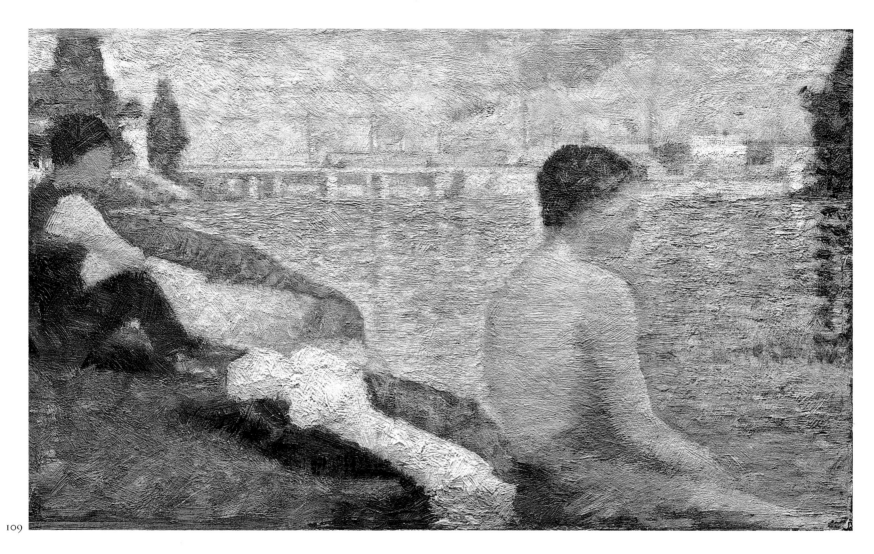

109

mixture of tans, reds, oranges, and blue. More color contrasts are used than previously: pale rose in the water next to the greens of the bank; oranges and blues juxtaposed in the water and the architecture; and green in the sky above the coral roof. The still life is broadened to assume roughly the mass it has in the final painting; its wine reds resonate against the greens of the bank. At the right edge is the tip of La Grande Jatte and its band of reflections. This band and the reflections of the chimneys foreshadow the geometry that increasingly characterized Seurat's work.

109. *Baigneur nu.* 1883

SEATED BATHER

Oil on wood, 6⅞ x 10⅜ in. (17.5 x 26.3 cm.)

The Nelson-Atkins Museum of Art, Kansas City, Missouri (Nelson Fund)

H 91; DR 96

PROVENANCE
The artist until 1891. Included in the posthumous inventory, but not numbered. Inherited by Madeleine Knoblock, Paris, in 1891, until 1892; sold to Jean de Greef, Auderghem (Belgium), in February 1892, until no later than 1894;* Jorgen B. Stang, Oslo, by 1921, until

at least 1928; with the Independent Gallery, London, until January 1929; sold to De Hauke and Co./Jacques Seligmann and Co., New York, in January 1929, until March 1929 (stock no. 3352);** sold to M. Knoedler and Co., New York (stock no. A565), in March 1929; sold to Stephen C. Clark, New York, in March 1929, until September 1931; returned to Knoedler's in September 1931, until January 1933 (stock no. A1379); sold to the Museum, 1933

EXHIBITIONS
1886 New York, no. 133 (no. 5 in a frame of "12 studies")
1887 Paris, no. 447 (one of "douze croquis")
1892 Brussels, no. 1 (one of "douze esquisses")
1929 New York, no. 62
1935 Chicago, no. 4
1949 New York, no. 3

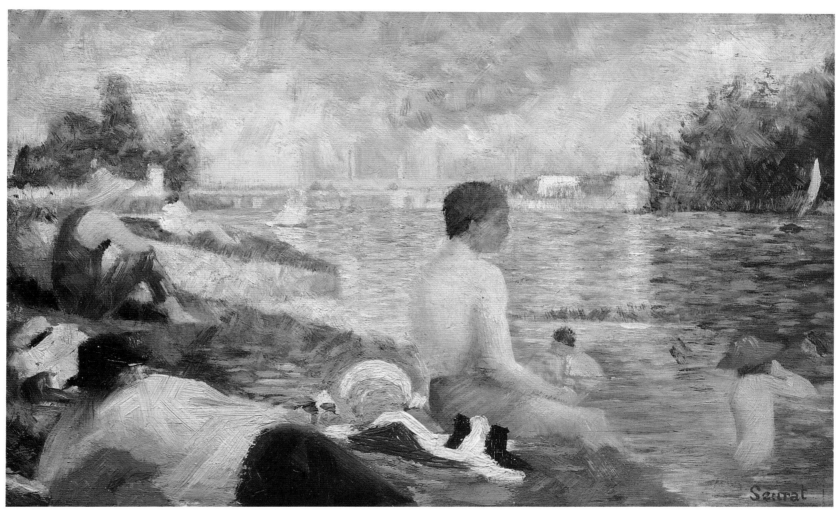

110

160 BAIGNADE 1883–1884

* See provenance note, cat. no. 89.
** See provenance note, cat. no. 30.

The brushwork here is denser and more regular than that of the earliest panels, and this study may well have been done mostly in the studio, based principally on the preceding study. To the still life Seurat added the seated boy from *Le cheval noir* (cat. no. 106) and the bather who will dominate the center of the large picture. Together they have something of the monumentality of that painting, even in this small scale. The sky recalls Renoir's palette of the early 1880s in its greens, green-blues, blues, corals, and pinks, but the broken hues are still based upon Seurat's knowledge of Delacroix. The larger boy's red trunks have blue and green in the shadow; his hair combines wine red and blue, and his flesh intermixes blues and pink. Contrasts are pronounced in the water around him: pure blue on the right and warm pinkish tan on the left; the body adjacent areas reverse this order of hues.

110. *Étude complète*. 1883

FINAL STUDY FOR "BATHING PLACE, ASNIÈRES"

Oil on wood, 6½ x 9¾ in. (16.5 x 24.8 cm.)
Signed lower right: Seurat

The Art Institute of Chicago, Gift of Adele R. Levy Fund

H 93; DR 97

PROVENANCE
Robert Caze, Paris, until his death in 1886; by inheritance to his widow, Mme Robert Caze, Paris, from 1886 until her death in 1887;* M. Gary; M. Sprenger, Paris; with Wildenstein and Co., New York, from 1948 until 1949; sold to Dr. and Mrs. David M. Levy, New York, in 1949, until 1962; gift of Adele Levy to the Art Institute of Chicago in 1962 but not deposited at the museum until 1977

EXHIBITIONS
1953 New York, no. 4
1958 Chicago and New York, no. 57
1968 New York, no. 72

* This panel was presumably sold early on at public auction. Dorra and Rewald record that it was included in "Vente Caze, Paris, 1887." No such sale catalogue has come to light. On the reverse of the panel the word "Vente" appears, but unfortunately whatever followed this has been obscured by labels. (See cat. no. 44, note 1.)

By the time he made this complete study, Seurat may already have been at work on the canvas, or at least he may have blocked in its landscape. In this hypothesis Seurat would have used this study to establish the essential color harmonies as well as the positions of the figures, before he proceeded with the large picture. In any event, this study would not alone have sufficed, for the rendering of the background architecture is too schematic. The same area of *Baigneur nu* (cat. no. 109) is far closer to the final canvas and would have been needed to map it out. Since the canvas was too large to take to the Seine, Seurat depended upon his sketches. This does not mean that he simply propped them up in his studio and worked exclusively from them. He must have returned to the site, taking one or more of the panels with him to record more nuances and to verify certain elements for the large picture. Such a course is far more likely than the lockstep that is usually posited, in which Seurat would put each study behind him as he marched implacably on to the next stage.

The present study was surely based on other panels, since a number of features reappear virtually unchanged. Seurat, however, probably took this panel to Asnières to study the pattern of reflections in the water and the distant foliage, closer here to the final composition than in any other sketch. This panel's colors are more brilliant than those in most of the others, an effect aided by the brownish reds, reds, and pinks spread across the foreground. The grass and distant trees, however, lack the strong orange highlights that mark the final painting. For the

Study for *Baignade* (cat. no. 110) showing lines that were incised on surface

grass Seurat used three tints of green and some strokes of pale orange and cream; for the trees he again used three greens along with bright blue, deep blue, and some lavender, but no orange or yellow. In this sketch the brushwork is not at all uniform in size, and it changes direction and character with each kind of image it describes.

Horizontal lines pressed into the surface of this study have suggested to some that Seurat was using geometric proportions, but there seems to be a simpler explanation. Examination at the Art Institute of Chicago has revealed two sets of lines.[1] Before he began painting, Seurat bisected the panel horizontally and vertically by scoring the wood with the aid of a straightedge. These two lines were subsequently covered over. After the painting was well under way, he added two verticals and two horizontals in freehand with a blunt point, largely but not entirely covering them over in the final stages. He apparently made these to assist his incorporation of the earlier *Baigneur nu*, for they frame that composition quite exactly. In fact, most of the panels concentrate on this more limited slice of the landscape, so it is likely that when he did *Baigneur nu*, he thought of it as the model for the large canvas and only subsequently expanded it to include more figures and more space.

1. Douglas Druick, curator of paintings, prints, and drawings, supervised this examination in March 1990 and kindly communicated the new findings.

111. *Garçon de dos*. 1882–83

BOY VIEWED FROM BEHIND

Conté crayon, 12⅝ x 9⅝ in. (32 x 24.5 cm.)

Private collection

H 596; DR 97c

PROVENANCE
Paul and Berthe Signac, Paris, by at least 1898;* by inheritance to Ginette Signac, Paris; to present owner

EXHIBITIONS
1905 Paris, no. 28
1908–09 Paris, no. 170
1926 Paris, Bernheim-Jeune, no. 57
1957 Paris, no. 58
1958 Chicago and New York, no. 56

* Signac 1898, p. 59 ill.

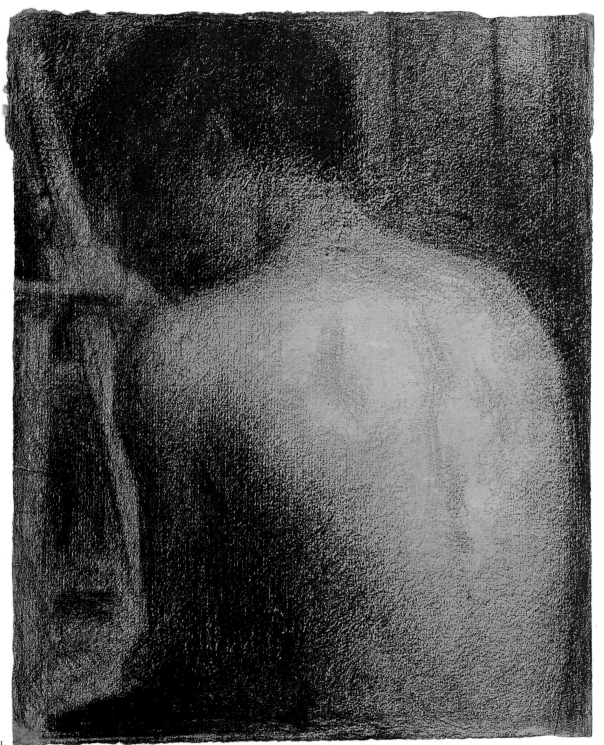

In his sensible discussion of the genesis of *Une baignade, Asnières*, Benedict Nicolson remarked that because of the easel in the background, this drawing may have been made for its own sake or for a purpose other than the famous painting.[1] Its soft grays, especially in the lower left, show more hesitation than the other studies, and if it were not for the association with the picture, it could as readily be dated 1882 as 1883. Seurat would not have been the first painter to look among existing drawings when composing a painting (this had long been a standard procedure in the École des Beaux-Arts).

This drawing has far more character than its abbreviated simulacrum in the oil, partly because of the great difference between its left and right halves. On the left the dark, constantly shifting silhouette of the boy's face and arm is set against the angular easel, whereas on the right there is only the continuous curve of the boy's back, surmounted by a dark zone of vertical streaks.

1. Nicolson 1941.

112. *Garçon assis portant un chapeau de paille.* 1883

SEATED BOY WITH STRAW HAT

Conté crayon, 9½ x 12⅜ in. (24.2 x 31.5 cm.)
Inscribed upper right: G. Seurat (probably not in artist's hand)

Yale University Art Gallery, New Haven, Everett V. Meeks, B.A. 1901, Fund

H 595

PROVENANCE
Probably Gustave Kahn, Paris, by 1892; Victor Claessens, Brussels, until 1929; by inheritance to his widow, Mme Victor Claessens, from 1929; by inheritance to Armand Claessens, Waereghem, Belgium; sold by the Claessens family to Michel Callawaert, Waereghem, until 1960; purchased by the Gallery through Germain Seligman, New York, 1960*

EXHIBITIONS
1892 Brussels, probably no. 26
1983–84 Bielefeld and Baden-Baden, no. 62

* Provenance per Robert Herbert, "A Rediscovered Drawing for Seurat's 'Baignade'," *Burlington Magazine* CII, no. 689 (August 1960), p. 368.

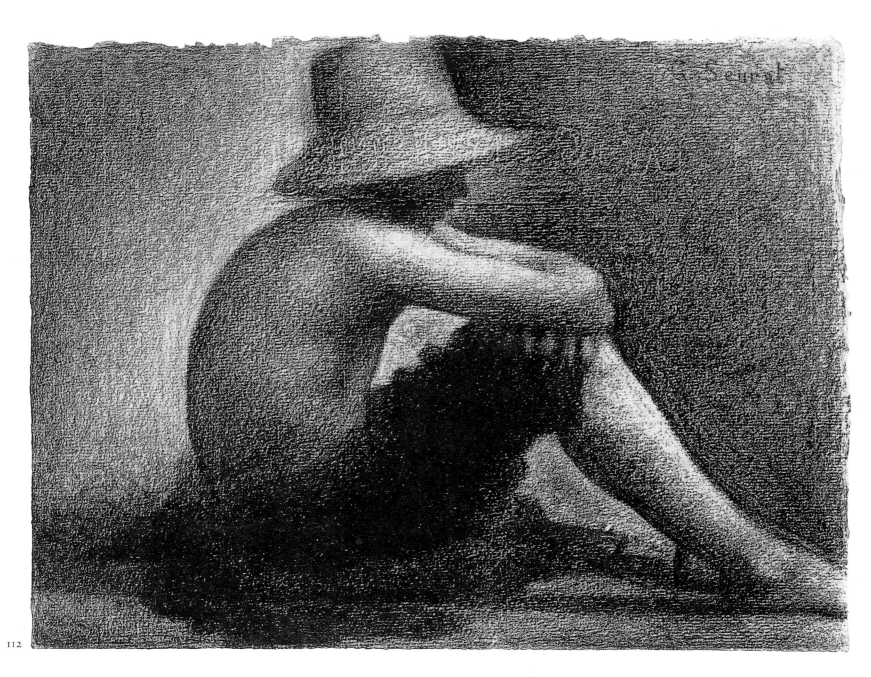

112

Seurat first presented this figure in the panel *L'arc-en-ciel* (cat. no. 104) and confirmed its pose in *Le cheval noir* (cat. no. 106). He might then have made this drawing, for there is no reason to believe that all the drawings for the *Baignade* follow the last oil studies. It would have been quite practical to work out definitive poses in light and dark in his studio, once he had decided on their positions in the painting, rather than to make drawings on the site. (Seurat made a separate reprise of this boy's legs [H 594; private collection] which shows the base of the studio wall.) He could pose his model in the familiar surroundings of his studio, with the benefit of its strong overhead light, and utilize his Beaux-Arts training which had been devoted to the preparation of large oils.

In this drawing Seurat lightened the background on the left and darkened it on the right to meet the opposed values of the figure. The dark profile of the boy's face is outlined against a light tone which delicately glows, an

effect retained in the oil by a halo of lighter greens. The painted figure is made more "natural" by the landscape setting and by his clothing. He is seated upon an orange cloth that contrasts sharply with his dark blue trousers (instead of merging with them as in the drawing); his upper body is clothed in two colors that separate torso from both shoulders and hips; and his hat has a bright orange band. When we turn back to the drawing, we see how unnatural it is—how much it depends upon an armature of triangles: leg and thigh, the gap below them, the background to the right, the visible portion of the head, the whole figure. This geometry is the drawing's "modern" quality but is also its link with the classicizing tradition in which the young artist had been nurtured: antique sculpture, early Renaissance painting, and Puvis de Chavannes, art that met Charles Blanc's conception of style by emphasizing the permanent over the transitory.

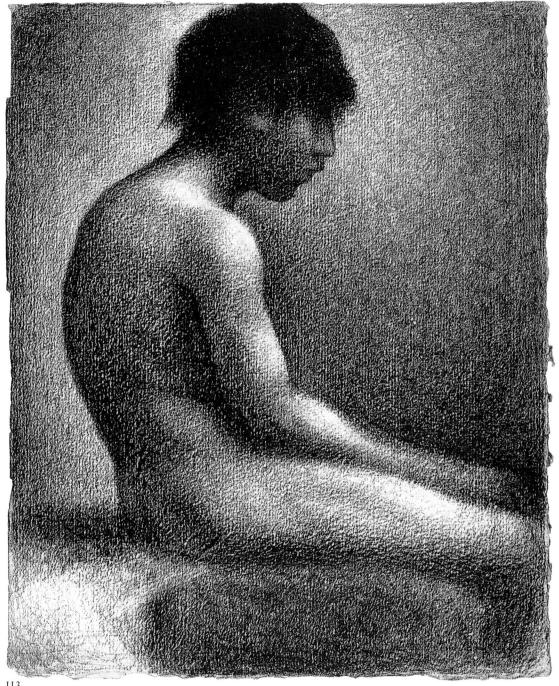

113

113. *Garçon nu assis.* 1883

SEATED BOY, NUDE

Conté crayon, 12½ x 9¼ in. (31.7 x 24.7 cm.)

National Galleries of Scotland

H 598; DR 97b

PROVENANCE
Georges Lecomte, Paris; Dr. Alfred Gold, Berlin, until 1928; sold to
Reid and Lefevre, London, in 1928; with Étienne Bignou, Paris;
S. A. Morrison, London; purchased by private treaty sale through
Christie's from a private owner in London, 1982

EXHIBITIONS
1926 Paris, Bernheim-Jeune, no. 148 suppl.
1978 London, no. 16

Like that of the previous drawing, the modeling here is
exceptionally smooth, contributing to the impression that
light is washing over a sculptural solid. The marks of
Seurat's crayon are hardly noticeable. This is in contrast to
their prominence in many of his independent drawings,
where, instead of creating separate three-dimensional
masses, they often embed his forms in an interlace of
figure and ground. These traces of his hand make us aware
of his expressive eloquence and artistic presence. Here we
can more readily credit the fiction of a solid mass that has
been rendered impersonally, as though the artist had only
disclosed what was already there. A nude boy sits with
slumped shoulders. He is not quite in the rigid profile of
his painted simulacrum, for we can make out the faint
crease of his buttocks and a hint of his spinal column.
Seurat's customary alternation of light and dark creates a
continuity of figure and background but allows the nude
body a separate existence. This figure was taken over
largely intact into the large oil; Seurat added only a
bathingsuit and made the boy slightly more erect.

114. *L'homme au chapeau melon.* 1883

MAN IN A BOWLER HAT

Conté crayon, 9½ x 11¾ in. (24 x 30 cm.)

Berggruen Collection on loan to the National Gallery, London

H 591; DR 97f

PROVENANCE
The artist until 1891. Posthumous inventory, dessin no. 320 (per
inscription in red crayon on reverse; not recorded by de Hauke).
Inherited by the artist's brother, Émile Seurat, Paris, in 1891; Félix
Fénéon, Paris, by at least 1926, until January 1929; sold to De Hauke
and Co./Jacques Seligmann and Co., New York, in January 1929,
until at least 1935 (stock no. 1353);* transferred to the private
collection of Mr. and Mrs. Germain Seligman, Paris and New York,
by 1940 (formed part of their Parisian collection when it was
impounded during the German occupation of France; recovered by
1945), until his death in 1978; his estate, with Artemis S.A., 1978;
sold by E. V. Thaw, New York, to present owner, 1978

EXHIBITIONS
1922 Paris, no. 11
1926 Paris, Bernheim-Jeune, no. 102
1935 Chicago, no. 9
1977 New York, no. 24
1978 London, no. 17
1983–84 Bielefeld and Baden-Baden, no. 61
1988 Geneva, no. 18

* See provenance note, cat. no. 30.

Few drawings by Seurat pay as much attention to folds of
clothing as the present one. His independent drawings
always sacrifice surface detail to overall form, whereas
here, in making a life study for his first major figure
picture, he thought in more traditional terms. The drawing
holds its own admirably. The folds are controlled by the
massive pyramid of the shoulder, which is offset by the
dark head. Another interesting study of fabric is *Jupe* (cat.
no. 148).

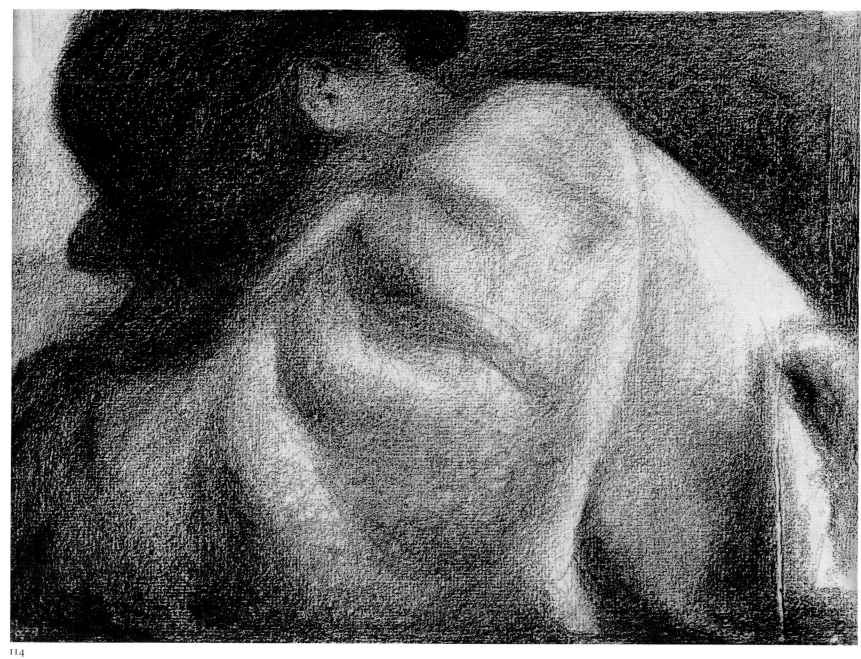

114

166 BAIGNADE 1883–1884

115. *L'homme couché.* 1883

RECLINING MAN

Conté crayon, 9⅝ x 12⅛ in. (24.5 x 31.5 cm.)

Beyeler Collection, Basel

H 589; DR 97h

PROVENANCE
Camille Platteel, Paris; Bernheim-Jeune, Paris; Bernhard Koehler, Berlin; to present owner by at least 1959

EXHIBITIONS
1963 Hamburg, no. 113
1983–84 Bielefeld and Baden-Baden, no. 60

115

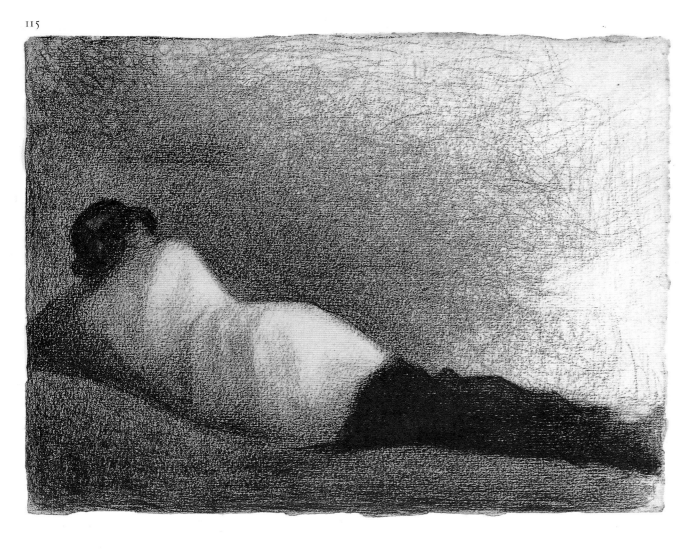

Although this full-length figure does not show the complicated fabric folds of the previous drawing, it is intimately related to it and was drawn just before or just after the other. The angle of the head, the shadowed face, and the gap between hand and hat brim are much alike in both. The whole figure, including the notched profile of the trousers, was transferred to the canvas. The head was reworked in the following drawing, and the environing light and dark were changed.

116. *Le dormeur.* 1883

DOZING MAN

Conté crayon, 9½ x 12¼ in. (24 x 31 cm.)

Musée du Louvre, Département des Arts Graphiques, Fonds du Musée d'Orsay, Paris R.F. 29.539

Exhibited in Paris only
H 590; DR 97g

PROVENANCE
Galerie Devambez, Paris; Félix Fénéon, Paris, by 1908, until his death in 1944; his estate, 1944–47 (Fénéon sale, Drouot, Paris, May 30, 1947, no. 31); purchased at this sale by the Musée du Louvre

EXHIBITIONS
1908–09 Paris, no. 182
1922 Paris, no. 12
1926 Paris, Bernheim-Jeune, no. 103
1936 Paris, no. 117
1937 London, no. 63
1957 Paris, no. 36
1958 Chicago and New York, no. 55

At first glance one might think that Seurat based this drawing on cat. no. 114 (another study of head and shoulder). It is also, however, probably a life study because the variations indicate close observation of a slightly different pose: here is the man stretched out in full sunlight and facing to the right. The man's head has been rotated to the right, so that we now see more of his aquiline nose; his ear is farther back and strong light forms his face into a broader plane. There is no longer a gap between the hat's brim and his hand covering the nape of his neck. All these changes are retained in the painting, and this drawing must therefore follow the full-length study. Although Seurat's studio was the likely setting, the expanse of untouched paper translates the effect of sunlight on a light garment. The drawing is a balance of opposites, since the dark head and light shoulder have equal visual force.

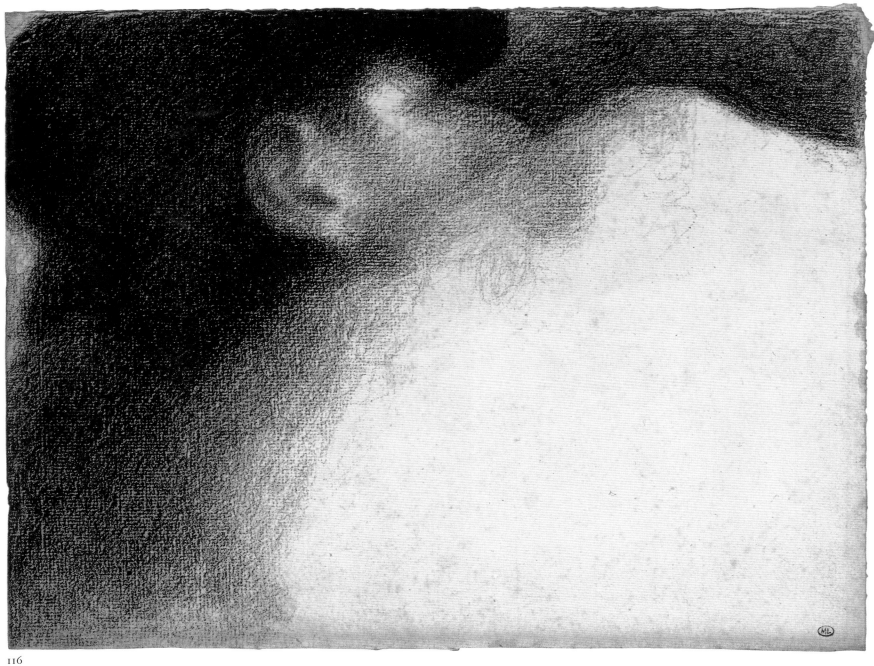

116

117. *L'écho.* 1883

THE ECHO

Conté crayon, 12¼ x 9½ in. (31.2 x 24 cm.)

Yale University Art Gallery, New Haven, Bequest of Edith
Malvina K. Wetmore

H 597; DR 97a

PROVENANCE
Paul Signac, Paris; Jean Ajalbert, Paris, by 1936, until 1938; sold to
Wildenstein and Co., New York, in 1938, until December 1941; sold
to Edith Wetmore, December 1941, until her death in 1966; her
bequest to the museum, 1966

EXHIBITIONS
1948 New York, no. 57
1949 New York, no. 26
1953 New York, no. 27
1958 Chicago and New York, no. 53
1983–84 Bielefeld, Baden-Baden, and Zurich, no. 64

Seurat's close focus on this figure is another distinctive
feature of his drawings. This study sits so well on the page
that it constitutes a satisfactory composition in itself.
Seurat's ambition was such that even his studies had to be
complete, impressive works, not mere aids for other
compositions. The whole form of this boy was treated in
an unpublished drawing (private collection; formerly Henri
Régnier), so here he limited himself to the play of light
and dark over the face and arms. In the painting the
vantage point is lower and discloses less of the left arm,
but a streak of light illuminates the bicep; here, however,
the arm is so delicately modeled in dark gray that it almost
floats free of the body. Much reworked, the painted figure
has little of the drawing's subtle shifts in the modeling of
its surfaces. Especially delicate are the depression below
the boy's cheek, the edge of his ear (lower than in the
painting), and the fluting of his wrist and hand.

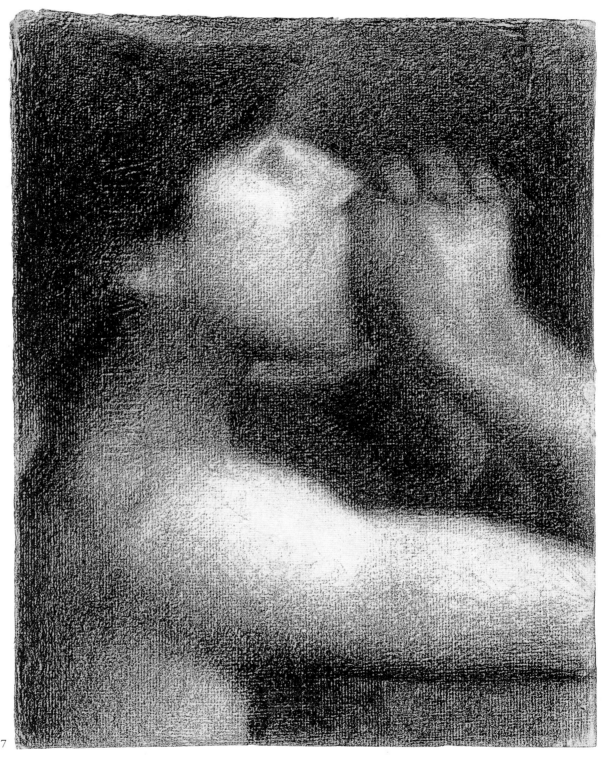

117

Un dimanche à la Grande Jatte 1884–1886

The eighth and last of the group exhibitions initiated by the Impressionists opened on May 15, 1886. Monet, Renoir, Sisley, and Caillebotte did not participate, but Cassatt, Degas, Gauguin, Guillaumin, and Morisot were among the seventeen present, as was Pissarro, his son Lucien, Signac, and Seurat. Seurat showed fewer works than the others: three drawings (cat. nos. 44, 45, and 158), one *croqueton* (cat. no. 97), and five canvases. Three canvases were from the previous summer's campaign at Grandcamp (including cat. nos. 160 and 161), and one was of the Seine at Courbevoie (cat. no. 153). Dominating them all was *Un dimanche à la Grande Jatte, 1884,* which became the most notorious picture of the exhibition. Word of it spread even to the London press, foreshadowing its eventual fame as one of the great landmarks of early modern art. Some critics passed it over in favor of works by better-known artists, such as Degas, who exhibited a controversial *Suite de nuds de femmes,* but most singled out *La Grande Jatte.* Its size, technique, and rigid figures were disconcerting; the long-tailed monkey became the butt of much humor. Nonetheless there were a number of generally favorable reviews, mostly by young naturalist critics writing for journals of the political left.

The spring exhibition alone would have established Seurat's celebrity, but in August *La Grande Jatte* appeared again, in the second exhibition of the Société des Artistes Indépendants. This time Seurat showed his large picture and a group of landscapes in a separate room, together with works by Charles Angrand, Henri-Edmond Cross, Albert Dubois-Pillet, Lucien Pissarro, and Signac. These six, plus the elder Pissarro, who did not exhibit, were baptized "néo-impressionnistes" by Félix Fénéon in his September review of the Indépendants.[1] The next month he published a brochure, *Les impressionnistes en 1886,* composed of his recent articles; in his section on Seurat's group, half of which was devoted to *La Grande Jatte,* he confirmed not only the term "néo-impressionnisme" but also Seurat's role as the movement's leader. (Fortunately, Seurat's own term, "chromo-luminarisme," never took hold.) Other reviewers distinguished *La Grande Jatte,* and an abundant literature—it was also shown in Brussels in February 1887—helped make it both the star turn of Neo-Impressionism and the most famous painting of the decade.

In his autobiographical letter to Fénéon (Appendix F), Seurat insisted that the studies for *La Grande Jatte* and the canvas itself were begun on

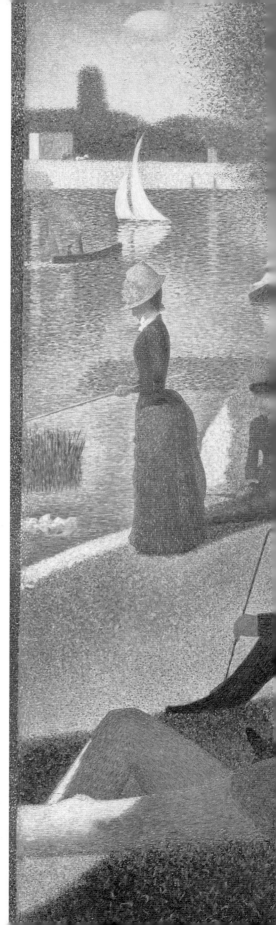

Seurat, *Un dimanche à la Grande Jatte,* 1884–1886. Oil on canvas, 81½ × 121¼ in. (207 × 308 cm.). The Art Institute of Chicago. Helen Birch Bartlett Memorial Collection, 1926.224 (H 162)

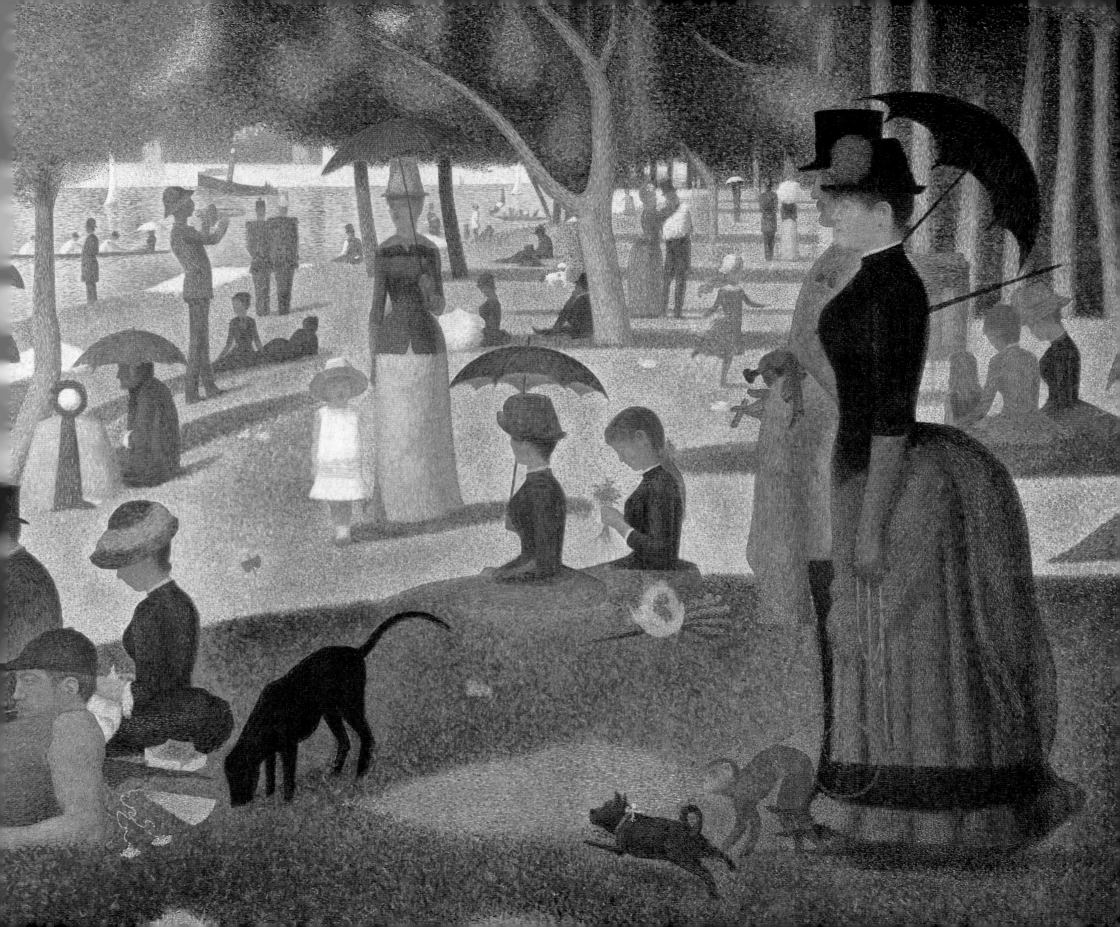

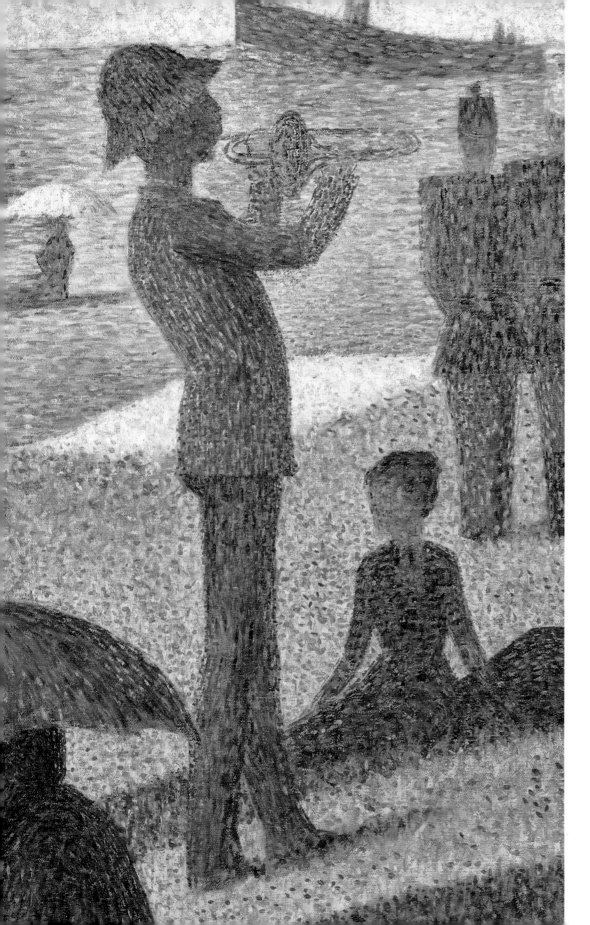

Ascension Day, May 22, 1884. The painted studies were probably completed before December 1884, when he exhibited the separate landscape (cat. no. 139). In March 1885, according to his letter, the big picture was ready for exhibition with the Indépendants. That show was postponed, however, and Seurat turned to other projects, taking up the canvas again in October. He reworked it, incorporating the lessons from his summer at Grandcamp, and exhibited the picture with the Impressionists in May 1886. In reworking it he unfortunately used some unstable pigments recommended by Pissarro; just six years later his friends noted the sad results. Emerald green turned to a dull olive, and oranges to brown.[2] The latter, obtrusive dark spots over the sunlit grass (instead of the light orange Seurat intended), are especially disfiguring.

We can learn something about the genesis of *La Grande Jatte* from the many studies associated with it, even though we cannot arrange them in a reliable sequence. Twenty-seven drawings, twenty-seven panels, and three canvases survive that are related to the final canvas.[3] Given this number, and cognizant of Seurat's "scientific" theories, historians have wanted to believe in a logical, step-by-step procedure: from drawings to panels to canvases. Most of the drawings did in fact establish the exact outlines of many of the foreground figures, but these drawings intervened late in the painting's evolution. As for the small panels, although most show the landscape arranged as it is on the canvas not all of them have the same placement of shadows, and only a few of their figures are found (often in different locations) in the finished work. Seurat was certainly a methodical worker (and the preparation of this canvas is a striking contrast with Impressionist practice), but his method was an empirical one in which he rejected as much as he retained.

In several panels he explored the park before he committed himself to his setting, including one (cat. no. 118) in which sunlight and shadow are reversed and another (cat. no. 119) in which overhead foliage and branches appear in the upper corners; the small triangle in the upper right corner of the finished picture is a curious remnant of those studies. These may have been painted before the day in May when Seurat decided on the large picture. In any event, all, or nearly all the panels were completed by that autumn.[4] At a relatively early stage he worked out the final disposition of the landscape; with only modest variations, it is the setting for many of the little oils. He almost certainly blocked it out on the large canvas by late spring or early summer, and he took time to perfect it in the small canvas (cat. no. 139) he exhibited in December 1884.

Seurat continued his explorations. On the little panels he painted different figures in his stagelike landscape. The prominent mother and child

Detail from *Un dimanche à la Grande Jatte.*

in the picture's center appear in several panels. The woman stands alone, without umbrella, in one (cat. no. 122); she has an umbrella in another (cat. no. 130), but her lowered hand is to our right; in another (H 119) the two figures are widely apart; and in yet another (H 124) they are together, but the child has an orange dress and they are off to the right, near the phalanx of tree trunks. In no panel do we see them as they are on the final canvas. Other individuals and groups are developed in like manner. At some point in late summer or early fall, Seurat worked out most of his composition on the medium-sized canvas now in the Metropolitan Museum (cat. no. 141). He then devoted the fall and winter to the large canvas, readied for exhibition, as we know, in March 1885. It was only in the final painting that many key features were introduced, among them the top hat and cane of the man seated to the left and the leaping dog in the lower right. Although several drawings were made to fix the ultimate forms of some of the major figures, we cannot say that this process advanced with any kind of predetermined logic; for example, none of the five drawings of monkeys listed among the studies was used for the canvas.

With the aid of the Metropolitan's oil study, we can guess at the appearance of the canvas in March 1885, before its reworking. Seurat widened the skirts of the large *promeneuse* on the right and of the fisherwoman on the other side by adding curved and scalloped outlines whose rhythms contrast with the rigid profiles of the 1885 forms. Of course, we do not know if Seurat would have regarded his composition as finished in 1885; he may have been willing to show a work in progress, with the intention of finishing it later. If we mentally subtract all the repaints that he undertook in late 1885 and in 1886, we discover a picture whose figures have an almost Egyptian aspect far more startling than their graceful successors.

The dominant fugue of the final composition, seen closely, is lightened by many grace notes: butterflies, puffs of smoke from pipe and cigar, bows, flowers, and caricatural faces, in addition to the leaping dog and the monkey. From a slight distance, however, and in the reduced scale of any reproduction, one senses the measured cadences of a geometric harmony. Through the darkened frame of foreground shadow and the foliage above we look into a brightly lit plane that rises, exposing diagonal and horizontal shadows that not only mark off receding depth like so many theater flats but also serve as pedestals for figures and trees, locking the humans into their environment. Figures are posed mostly in profile or seen from the front or back, which flattens them and adds greatly to their lack of involvement, structural and psychological, with their neighbors, even when disposed in pairs or triplets. This contrasts with a picture such as Dubourg's beach scene (p. 148), where vacationers are organized along similar

orthogonals as well as in isolated groupings, but where the figures of each pair overlap or turn to one another.

When the viewer gets as close to *La Grande Jatte* as Seurat was when he painted it, the color and brushwork appear quite varied and animated. Although it is so often stated that the surface is a screen of uniform dots, the strokes in fact vary from small dots (mostly added in the repainting of 1885–86) to long streaks. For tree trunks, the elongated dabs flow along the axis of the trunk and then change direction to move outward on the branches, as though they were the vital carriers of sap. The strokes similarly follow the imagined reality of the figures and their costumes, flowing in outward curves for bust and hips, vertically for upright torsos, and along the axes of each portion of an arm or leg as it changes direction.

Despite this actual variety of touch, from normal viewing distance the brushwork seems nearly uniform, and it is this uniformity that has always drawn attention. In the first—and still the most famous—analysis of what was already being called pointillism, Fénéon explained this effect in terms of "mélange optique" (optical mixture):

> If, in *La Grande Jatte* of M. Seurat, one considers, for example, a square decimeter covered with a uniform tone, one finds all its constituent elements on each centimeter of this area, in a swirling crowd of slender maculae. For this greensward in shadow: most of the touches give the local color of grass; other touches, oranges, are scattered about to express the feeble solar action; still others, purples, introduce the complement of green; a cyan blue, provoked by the proximity of a patch of grass in sunlight, increases its siftings toward the line of demarcation and then thins them out progressively beyond.[5]

This passage defines the essence of Seurat's optical mixtures, which Fénéon defended by calling upon Rood's treatise (see Appendix K), firmly attaching the technique to the world of science. The association with science, however, has tended to obscure the fact that Seurat's technique grew slowly from his practice and is predominantly a feature of his craft. Although the colors do indeed vibrate in our eye, optical mixture does not really work in Seurat's painting. What we see depends not upon separate colors combining in our eye to form new ones but upon the use of broken color that Seurat had learned from Blanc and Delacroix. Underneath those multicolored strokes are several variations of the local color; this determines what we see. In the shade we see dark green grass because Seurat first broadly brushed in several different tints of green and blue-green; he then enlivened the greens with scattered smaller touches of orange, yellow, blue, purple, and red. Where two areas meet, the contrasts identified by

Chevreul take place: the light becomes even lighter and the dark darker, with corresponding changes in coloration. All these reactions among areas of color result from several years of work with pigments; to describe them Fénéon used the "scientific" terms that Seurat himself used, convincing terms because they suited other aspects of *La Grande Jatte* that spoke for methodical procedure and impersonality. What was true of Seurat was at least partly true of the other Neo-Impressionists: Camille Pissarro called his erstwhile comrades "impressionnistes romantiques," whereas Seurat and his new associates were "impressionnistes scientifiques."[6]

In 1886 critics again compared Seurat to that "primitive" intermediary with the grand tradition, Puvis de Chavannes, but the insistent modernism of Seurat's technique and his contemporary subject matter separate him radically from the Lyons master. Puvis's brushwork and pale color are precisely what Seurat had been combating since he began to paint. Pissarro, including Seurat and Signac in his statement, claimed that Puvis "is our opposite in art, whatever his talent."[7] Seurat, in fact, liked to think of himself as a modern-day Phidias, not because he would emulate the appearances of classical art, as Puvis did, but because he would entirely remake art, as the Greek sculptor had done in his day. Surely thinking of his *La Grande Jatte*, he told Gustave Kahn that "the Panathenaeans of Phidias formed a procession. I want to make modern people, in their essential traits, move about as they do on those friezes, and place them on canvases organized by harmonies of color, by directions of the tones in harmony with the lines, and by the directions of the lines."[8]

Thus Seurat gave a radical twist to Blanc's formulation. He would create a new classicism and remake Impressionism by eliminating the accidental and the momentary, preserving the vitality of life in well-calculated forms that would embody enduring ideals. It was precisely this sense of permanence that attracted young Symbolist writers to Seurat, in whom they recognized an artist who had turned his back on naturalism and Impressionism, which they had come to regard as superficial:

The spectacle of sky, of water, of verdure varies from instant to instant, so professed the first Impressionists. To imprint one of these fugitive appearances on the receiving mind, that was the goal.—From that resulted the need to seize a landscape in one sitting and a propensity to make nature grimace in order to prove that the moment was unique and that one would never see it again.

To synthesize a landscape in a definitive aspect which perpetuates its sensation, that is what the Neo-Impressionists try to do.[9]

The Lady Tuya. Egyptian, New Kingdom. Musée du Louvre, Paris

Paul Signac, *Apprêteuse et garnisseuse (modes), rue du Caire* (Trimmer and finisher [fashionable dress], rue du Caire), 1886. E. G. Bührle Foundation, Zurich

Seurat's "classicism" (his link with Blanc and *la grande tradition*) is nonetheless marked by a pronounced "primitivism," so much so that in his art the two concepts merge, the latter subverting and at times overwhelming the former. According to Signac, when Degas saw *La Grande Jatte*, "he said dryly to Seurat: 'You have been in Florence, you have. You have seen the Giottos.'"[10] No other contemporaries referred to Giotto, but several saw in Seurat's canvas analogies with early Renaissance art. They articulated this in general terms (no painter was named), believing that the relative flatness and toylike elements of the painting were a return to what they also called Gothic art, that is, to quattrocento painting. We have come to accept the parallelism on a broad level; no debt to a particular quattrocento artist has proved convincing, however, despite modern historians' comparisons of Seurat with Piero della Francesca.[11] A more rewarding means of analysis is to look at Seurat's "primitivism" in relation to a number of other arts and to define it with the aid of these multiple parallels.

Several of Seurat's critic friends compared his promenaders to figures in Egyptian art. Indeed, the seated nurse on the left has the chunkiness of an Egyptian seated scribe, and the woman in the center has the exact pose of the ubiquitous standing priestesses of the New Kingdom. Other critics

likened his figures to wooden toys, puppets, old tapestries, colored engravings, and illustrations by Kate Greenaway,[12] for he rendered his images with the emblematic clarity of a primer. Some of these writers were probably responding to the curious departures from conventional proportions first remarked upon by Meyer Schapiro.[13] The fisherwoman is on the same plane as the central mother yet would come up only to her shoulders; the seated man in top hat, if erect, would reach only the waist of the tall *promeneuse* on the right. Equally curious are the small steamboat and racing shell that are on the same plane but patently not on the same scale. (These anomalies of proportion should have cautioned those of us who have overly insisted upon Seurat's "scientific" procedures.) Seurat, we know, collected popular broadsides in which such "primitive" features are found; a large number were discovered in his studio after his death (Appendix C). These are not "sources," but they are reflections of his interest in popular arts, an antiacademic current among artists and writers that dated to the mid-century (Courbet had been attracted to broadsides and Champfleury wrote about them). The popular arts were considered "primitive" in the sense of being original expressions of *le peuple*, untainted by official art, and therefore more democratic and more honest. Camille and Lucien Pissarro gave them a leftist political meaning; van Gogh found a Christian humility in them.

With the convenience of hindsight, we now see that *La Grande Jatte* was the first major statement of a new variant of "primitivism"; we might call it "neo-primitivism" to go with "Neo-Impressionism." Seurat was not alone in this, for one of the women in Signac's figure painting in the 1886

Camille Pissarro, *La cueillette des pommes* (Gathering apples), 1886. Ohara Museum of Art, Kurashiki, Japan

Indépendants exhibition has a cartoonlike silhouette, and the rest of the picture has a sharp-edged and decorative flatness. Pissarro gave the women a more atmospheric treatment in his major piece for the same exhibition. They have, however, a "hieratic" stiffness, they are separated from one another, and the whole has a tapestry aspect; he referred to his current work as having "the cachet of a *modern primitive*."[14] In the same year, Seurat borrowed from Gauguin an excerpt from a supposed Turkish painter's manual (Appendix P) that emphasized static poses over movement. By 1887 van Gogh, Gauguin, and Émile Bernard all showed pronounced interest in various "primitive" arts, and by the end of the decade Egyptian, medieval, early Renaissance, and folkloric arts had been taken up by the French avant-garde. Contemporary Symbolist writers amalgamated these various "primitivisms" as well.[15]

Such arts from the popular press as cartoon, caricature, and advertising —forms embedded in social interchange outside the boundaries of the fine arts—can all be detected in Seurat's neo-primitivism. The creators of those forms were, like Seurat, sophisticated artists who drew upon folkloric arts. In *La Grande Jatte* several details approach journalistic illustration: the hook-nosed profile of the reclining *canotier*, the silhouette of the top-hatted dandy, the cigar of the leading *promeneur*, the blast of the boor's French horn that calls the two cadets to attention. The very wit of these inventions and the amusement we derive from them takes us far from the classicism of Blanc and Puvis de Chavannes. Images from fashion display and advertising also found their way into Seurat's vocabulary. In department store advertisements for ready-to-wear clothing, bustles were commonly worn by several women, most of them viewed in profile, who were customarily placed in the setting of garden or park. This linked women with "nature" and with the places where social display was paramount, a convention to which Seurat's *Grande Jatte* adhered. The simplicity of the advertisements, partly a result of the medium of engraving, resembled the style of broadsides; their authors, however, were far from primitive and were instead consciously aiming for the clarity of an archetype to which they could affix the lineaments of their commodities. These advertisements have been linked with Seurat's *promeneuse*, sometimes with hints of influence or derivation. Seurat surely knew them, and his own drawings of women from 1881 onward charted the literal expansion of the bustle (it reached its extreme in 1885–86).

Like its predecessor *Une baignade*, *La Grande Jatte* represents a sunny day along the Seine northwest of Paris.[16] In the *Baignade* naturalism took precedence, for Seurat set the leisure of lower-class males against a

Édouard Manet, *Le déjeuner sur l'herbe*, 1863. Musée d'Orsay, Paris

backdrop of factories to form a social content uncharacteristic of Impressionism. In *La Grande Jatte*, Impressionism displaced naturalism. In this ritual of middle-class leisure among pleasant surroundings, there are no factories and hardly a hint of work. Too radical a separation of naturalism and Impressionism, however, is unwise, because the popular content of *La Grande Jatte* has ties with both. Duranty, Degas's friend and a leading naturalist writer, virtually predicted Seurat's painting in his novel of 1872, *Le peintre Louis Martin*: one of the paintings by his protagonist, Martin, a young Impressionist, is "a rather large painting full of air, light, and verdure, with crowds of people among the trees and on the lawns, the sort who were definitely a kind of mirror of Paris."[17] Zola created numerous scenes of picnics and promenades along riverbanks and in Parisian or suburban parks, and Manet's *Déjeuner sur l'herbe* (Musée d'Orsay, Paris), shown in the 1863 Salon des Refusés (Duranty's Martin sees and admires it there), was one of the key pictures of its era. By Seurat's day promenading in public gardens was a staple subject of painting, of the illustrated press, and of poems and prose vignettes in literary journals.

Seurat's site, directly opposite that of the *Baignade*, is the park that occupied the southern tip of the elongated island. From mid-century the central two-thirds of La Grande Jatte, circumnavigated by a road, had been taken over by private dwellings, boatyards, and café-restaurants. It no

longer had the chic of the Bois de Boulogne or the Parc Monceau, for nearby were the factories of Clichy (visible in the background of the *Baignade*), and the rapidly growing communities of Clichy and Asnières. Contemporaneous guidebooks describe activities characteristic of this and other riparian shores near Paris: rowing, boating, fishing, picnicking, dining, and dancing. Seurat shows us boating and fishing as he takes us away from the cafés to the greenswards and copses, where a varied and well-mannered population whiles away the afternoon hours.

The genesis of Seurat's picture, as we have seen, involved treating the park as a stage across which a variety of persons strolled or reclined. From these "auditions" he eventually selected the performers of his Sunday ritual, combining, as it were, the functions of both playwright and director. His picture should thus be seen as an artifice, devoted to a social institution whose setting is contrived—parks are not "nature," but artificial stages for human action—and whose participants deal in the stratagems of self-presentation. Parks were ideal places for strangers to display themselves to one another without providing clues to their individual identities.[18]

Some recent commentators on *La Grande Jatte* have interpreted it not as a decorous Sunday promenade but as a place of encounters among prostitutes and clients; they point particularly to the couple on the right. Only one contemporaneous reviewer, however, called the woman with a monkey a cocotte.[19] She has absolutely nothing of contemporary representations of "loose women" about her, either in gesture or in her costume, a kind widely advertised and bought by respectable middle-class women. It seems more likely that Seurat was mocking the pretentiousness of this elegant couple. In several of the small panels the woman appears by herself, so Seurat at one time thought of her as a lone promenader, courting notice with her monkey. By adding her consort he took up the theme of the promenading couple who appear in numerous contemporary illustrations and paintings. Some of these illustrations are indeed of rakes and their kept women, but in such cases the artist makes this evident by pose, gesture, and costume. In other instances, we see elegance and pretension, current costume and social parade, which is all we can be sure we see in Seurat's picture.

In the lower left a muscular boatman of brooding profile is juxtaposed with a dandified male, another figure whose pretentiousness is mocked by the artist, this time by means of his small size, formal dress, and ostentatious cane. Next to the men there is a woman rendered entirely in curves, a contrast to the angular male profiles. Above this group, a nurse sits like a boulder next to her elderly client.[20] Perhaps because she is the picture's one working-class figure she is the least individualized, identified solely by her costume. Her patient is characterized by an aged profile and slumping

Édouard Manet, *Jeanne, ou le Printemps*, 1881.
Private collection

A. Grévin, *J'parie qu'ça ne lui coûte pas plus d'vingt-cing sous l'mètre!* ("I bet that doesn't cost him more than twenty-five sous a meter"). Cover, *Journal amusant*, October 23, 1886

shoulders, unable to hoist her parasol aloft like the younger women. Above her is the boorish horn player in his summer helmet. In the humor of such figures there is a sting; Seurat manipulates them, like puppets, to make us smile. Elsewhere we see single figures staring out over the water, where Seurat presents an abridged schema of river activity: three sailboats, two steamboats, a fisherman, a racing shell, and, in the distance, a ferry.

Seurat's satirization of contemporary fashion in *La Grande Jatte* was immediately noted in the press. Henry Fèvre's review described "the stiffness of Parisian promenading, formal and shapeless, where even recreation amounts to posing"; for Paul Adam, "even the stiffness of the people, with their cookie-cutter forms, helps give the sound of the modern, the recall of our cramped clothing, glued to our bodies, the reserve of our gestures, the British cant imitated by everyone. We adopt attitudes like those of Memling's people. M. Seurat has perfectly seen, understood, conceived, and translated that with the pure drawing of the primitives."[21]

Contemporary fashion and the primitive were perfectly compatible to Adam and to Seurat's other friends who recognized his ambition to merge contemporary life with timeless elements of style. They also appreciated his ironic interpretation of fashion, which exploits elegance while mocking it. In this Seurat may have been deliberately confronting other artists' hom-

ages to fashion. Manet's *Jeanne, ou le Printemps*, a great success in the Salon of 1882, is a celebration of feminine beauty, fashion, nature, and springtime. The monkey in Seurat's panel of the lone *promeneuse* (cat. no. 133) is a send-up of such a woman, and in the final composition her pretension is reinforced by her arch solemnity. She stands somewhere between Manet's woman and a cartoonlike figure by Grévin. In contrast, Signac's painting of milliners (p. 174), shown in the same room with *La Grande Jatte*, shares Seurat's neo-primitivism, yet because they are workers his women are not on public display and hence not targets of mockery.

Through the juxtaposition of current fashion with the figures' manikin stiffness and their uniformity of presentation Seurat offers us a critical perception of society's artifice, particularly that of the lower classes, who took advantage of cheaper ready-made clothing to mask their true position while consorting with others of higher station.[22] This interpretation says, in effect, that Seurat's pictorial pattern, with its repetitive rhythms, is tantamount to actual social conformism; the stiffness and psychological isolation of the figures, however, argue for disjunction, so Seurat is said to engage the viewer in a dialogue of cohesion and separateness. Seurat's people assume roles in a collectivity, yet because they seldom communicate with one another, their actual isolation is revealed. Here we have nothing other than the dilemma of modern urban people under industrial capitalism, analyzed not only by Marx but also by Durkheim, Simmel, and such later thinkers as David Reisman.

This dialogue of cohesion and separateness constitutes the most convincing interpretation of *La Grande Jatte*. For some observers, however, the isolation of Seurat's figures borders on anomie, destroying any sense of social cohesion; the togetherness in the picture becomes merely a superficial mask. According to this interpretation, Seurat uses the apartness of his figures to assert his belief that modern society is disjointed: the picture thus portrays the opposite of a utopia.[23] This view apparently springs from the pessimism of our own generation, for it denies the optimism that Seurat expressed in more than one way. His credo (Appendix E), written in 1890 but surely based on his schoolboy convictions, was "Art is Harmony. Harmony is the analogy of opposites, the analogy of similarities." That *La Grande Jatte* embraces both isolation and harmonic integration conforms perfectly to the artist's balancing of dissimilar elements. Moreover, the social relationships in Seurat's painting are no colder than those in Monet's famous *Terrace at Sainte-Adresse* (Metropolitan Museum of Art) or Manet's *Sur la plage de Boulogne* (Museum of Fine Arts, Richmond, Virginia), where figures line up in twos or threes along similar orthogonals, equally "controlled" by the artist.

The optimism that is expressed through Seurat's ability to organize forms by means of a rational order whose units are made visible further argues against anomie. The irregular brushwork of the Impressionists, for example, seems an outgrowth of romanticism and individualism, as though it were the effortless result of an upper-class elegance. Through its impersonality, Seurat's technique endorsed the social more than the personal, the ordered rather than the irregular, the universal and not the idiosyncratic. He subordinated his painted individuals to the community of forms he constructed, a community in which each image has a determined place.

Once we are accustomed to Seurat's style, we find that his park is characterized not just by order but also by companionship and even by some loving relationships. Social malaise has no place here. No one in the foreground is literally alone; single persons are found only in the middle ground or distance. True, the canoeist is psychologically by himself, but he recalls the boaters in the background, and he is grouped with the top-hatted man and the nearby woman (she may be the top hat's wife; she is certainly no coquette, for her feet are splayed out and she is sewing). On the far right two women sit by a pram, one with her arm around a child; at a slight distance a girl in an orange dress runs across the grass. All others in the foreground are paired up. The center is occupied by two figures who should remove all doubts that this could be a place devoted to scandalous encounters. Both mother and child come toward us, and the child, embodiment of innocence, is the only person who looks directly at us. Beyond her, the two soldiers are companions, as are the two figures reclining in front of them. In the distance at the far right a couple strolls away from us, and nearer, to the left of the running girl, a woman raises her arms to the well-wrapped child her husband holds.[24]

Upon close inspection the apparent diversity of Seurat's society falls away to reveal a rather narrow band of the social spectrum, mostly lower-middle and middling bourgeois, with perhaps some artisans. The Impressionists had represented a broader range. Renoir, in his famous *Déjeuner des canotiers* (Phillips Collection, Washington, D.C.) of 1881, included the working children of the restaurant owners, artists' models, artists, journalists, a cavalry officer, and a wealthy collector. By eliminating such diversity Seurat created in *La Grande Jatte* a harmonic middle-class society, an ideal of peaceful leisure signaled by the Sunday of the painting's title. Fénéon, Seurat's foremost interpreter, gave a succinct description of this contemporaneous Cythera: "The subject: the island beneath a scorching sky, at four o'clock, boats slipping along its flanks, stirring with a fortuitous Sunday population enjoying fresh air among the trees."[25]

Seurat's island society has a long ancestry in the history of art,

although he need not have been emulating any of his forebears: Rubens's *Garden of Love* (Museo del Prado, Madrid); the *fêtes galantes* of the eighteenth century; and innumerable scenes of parkland fairs and picnics. A society "enjoying fresh air," yes, brought up-to-date, with a sense of ordinary behavior (no matter how idealized) that recalls the middle-class Monet more than the upper-class Manet. Monet, in his 1865–66 *Déjeuner sur l'herbe* (Musée d'Orsay, Paris), celebrated the contemporary middle class when he remade Manet's famous *Déjeuner*, whose foursome of artists and nudes had appropriated Renaissance art for the purposes of a provocative elegance. Like Monet, Seurat looked at Manet's picture (it was exhibited in the 1884 retrospective of Manet's work); the three figures in the lower left of Seurat's big composition are probably a half-conscious reworking of the famous painting. However, he made his scene of leisure into a common event, devoid of sexuality, a reserved scene that looks with bemused irony upon middle-class relaxation on a sunny Sunday.

By removing the most mundane aspects of reality (no wine bottles, no picnic debris, and only one worker, the nurse), by eliminating conflict although admitting contrast, by generating memorable types rooted in current fashions, Seurat created an allegory of summer, a procession of moderns that he hoped would give him the rank of Phidias. His satiric wit gave him the distance from his contemporaries that he needed in order to treat them like puppets and spared him the ponderous weight the term "classical" sometimes evokes. The same wit separates his picture from Monet's and Renoir's paintings of leisure-seekers; we can find pleasure in their images, but never Seurat's humor, tinged as it is with his distinctive brand of mockery.

Seurat's huge picture has been granted the status of a classic in the twentieth century, so he achieved his goal. *La Grande Jatte* has become the most commonly reproduced painting for advertisers and designers who wish to evoke summer leisure, uncontaminated by work and worry. Its decorative clarity lends itself to graphic reproduction, and its satirical edge—its finely tuned irony—entertains as much as it instructs. It is a suburban arcadia, a neatly planned harmony in which amusement cohabits with relaxation, and irony with approbation, both in the picture's images and in our reaction to them. It does not demean the picture to recognize its appeal to designers of commercial publicity, whose use of it proves its reciprocity with the traditions of popular culture.

1. Fénéon, September 1886. Rewald's account of Fénéon's role in 1886 (Rewald 1948) has been greatly expanded in Halperin 1988, pp. 92ff.
2. Thanks to the careful detective work of Inge Fiedler, conservation scientist at the Art Institute of Chicago, we now know that the unstable agent Seurat used is zinc yellow, which he mixed with both

green and red (Fiedler 1989). Fénéon (1892) specified the visible changes mentioned, and in the same year three other critics lamented the alterations (Arnay 1892, Christophe 1892, Demolder 1892). According to Signac (who apparently confused repaints on *La Grande Jatte* with those on the *Baignade*), these colors were made by a certain "Édouard" (diary entry of December 29, 1894, in Signac Journal, ed. J. Rewald, p. 114). It was apparently Pissarro who recommended "Édouard" to Seurat and to Signac. Fénéon annotated the verso of a photograph of Signac's *Le Petit-Andely* (Fénéon sale, Drouot, Paris, December 4, 1941, no. 8) as follows: "Peint en avril 1886 avec des couleurs Édouard. Repeint en mai 1898 avec des couleurs Blockx" (photograph, formerly collection Gina Doveil, Saint-Ouen).

3. De Hauke lists thirty panels, but two (H 108 and 116) are definitely not studies for the big picture, and the authenticity of one (H 136) should be questioned. Of the twenty-eight drawings listed, one (H 623) is of doubtful authenticity.

4. Because none of the panels has the facture of paintings produced in pictures of 1885 and none is an excerpt of the final composition, we should abandon the supposition that some were done in 1885.

5. Fénéon, June 1886.

6. He also gave Fénéon advice on color theory and wrote the dealer Durand-Ruel in phraseology that reads like a scientific handbook. For Pissarro's views of "romantic" and "scientific" impressionism, see his letters from May 1886 through February 1887.

7. Letter of January 8, 1887, in CP, ed. Bailly-Herzberg, vol. 2, no. 374.

8. "Exposition Puvis de Chavannes," *La revue indépendante* 6 (1888): 142. In this article Kahn made a parallel between Puvis and Seurat (as "un des jeunes novateurs impressionnistes"), stating that each were innovators, Puvis in line, Seurat in color, and that they shared "hiératisme" and "synthèse." Kahn later acknowledged Seurat's dissension from the parallel in *Silhouettes littéraires* (1925), p. 112. Pissarro protested against Kahn's admiration of Puvis in the letter cited in the preceding note.

9. Fénéon, May 1887.

10. Signac, interviewed by Gustave Coquiot on July 8, 1923, recorded in the manuscript for Coquiot 1924, formerly in the archives of Dr. Jean Sutter.

11. For example, Longhi 1950 and Boime 1965.

12. For example, Kate Greenaway was invoked in Javel, May 1886, colored engravings in Fourcaud 1886, wooden toys and tapestries in Maus 1886. Because Egyptian art was invoked in many reviews of 1886 and 1887, including several by Seurat's friends, it is tempting to think that these references sprang from conversations among the critics and painters grouped around the Société des Artistes Indépendants.

13. Schapiro 1935, p. 12.

14. Pissarro's phrase, referring to his *Vue de ma fenêtre par temps gris* (Ashmolean Museum, Oxford) shown in the May–June exhibition (that is, the last Impressionist exhibition) is in a letter to Lucien of July 30, 1886, in John Rewald, ed., *Camille Pissarro, lettres à son fils Lucien* (1950), p. 109. The relevant sentence (portions were inadvertently omitted in CP, ed. Bailly-Herzberg, vol. 2, no. 348) reads: "Il paraît que le sujet n'est pas de vente à cause du toit rouge et la basse-cour, justement ce qui donne tout le caractère à cette toile, qui a un cachet *primitif moderne*" (It seems that the subject didn't sell because of the red roof and the poultry yard, just what gives character to this canvas, which has the cachet of modern primitive).

15. "Primitive art and popular art, which is the continuation of primitive art in the contemporary world, are symbolic in this fashion. Popular broadsides only draw outlines. In the perfection of their craft, ancient painters used this technique. And so too, Japanese art," from Édouard Dujardin, "Aux XX et aux Indépendants—Le cloisonnisme," *La revue indépendante*, xxx (May 19, 1888), significantly reprinted in Alfred Jarry's review *Perhinderion*, 2 (June 1896), along with an essay on "Imagerie populaire."

16. House 1980, House 1989, Clark 1984, and Clayson 1989 discuss the two pictures in terms of the contrast between workers' Monday ("saint lundi," when workers stayed away from their jobs) with Sunday leisure. House makes the paintings into pendants, with rather forced interrelationships; Clark offers a more circumspect and convincing reading of the paintings but exaggerates the range of social class portrayed in *La Grande Jatte*; Clayson equates the *Baignade* with "saint lundi" and its typically male world, *La Grande Jatte* with Sunday, characterized more by women and children than by men or whole families. To the extent that "saint lundi" is concerned, these comparisons are hard to accept, for the *Baignade* has none of the carousing that is the identifying feature of that ritual. Ward 1986 deals effectively with the difficulty of identifying the social class of Seurat's figures from contemporary reviews of the spring exhibition.

17. 1872 ed., p. 347.

18. This aspect of the island of La Grande Jatte is perceptively treated by T. J. Clark (1984).

19. An anonymous writer for *The Bat* (London), May 25, 1886. Could this woman be a prostitute? And could the fisherwoman on the other side also be a prostitute? These identifications have recently been widely accepted (Thomson 1985, Thomson 1989, Eisenman 1989); even the reclining figures in front of the two cadets have been called promiscuous women whom the soldiers are ogling! The idea that the fisherwoman is a prostitute depends upon analogies with cartoonists who exploited the homophonous pun, *pêcher* (to fish) for *pécher* (to sin). Such puns, however, depend upon a context of flaunted sexuality that is entirely absent from Seurat's figure, who is, moreover, accompanied by a woman. Dozens of illustrations in journals and a large number of Salon pictures show women fishing (so, too, did Daubigny), without a hint of impropriety. There is perhaps more reason to debate whether or not the *promeneuse* is a tart, for she is accompanied by a monkey, sometimes the emblem of profligacy. Seurat's friends among artists and writers nowhere mention the woman as a prostitute in their private letters and diaries, where they could speak without inhibition and neither do Signac or Kahn, who wrote of Seurat's social convictions shortly after his death. Furthermore, in the Goncourts' *Manette Salomon*, the monkey "Vermillon," an important resident of Coriolis's studio, is never given the attributes of lust.

20. This nurse has entered confusingly into the analysis of *La Grande Jatte*. In Thomson 1985, Nochlin 1989, and elsewhere she is called a wet nurse and extensive analogies are drawn with nurses who breast-feed infants, their military lovers, and so on. This woman, however, is simply a nurse caring for the elderly woman next to her.

21. Fèvre 1886 and Adam, May 1886, both among the reviews in Seurat's argus (de Hauke archives). The association of fashion with high art was common in this era. Huysmans, writing in 1886, said that dressmakers' dummies were infinitely superior to Greek art and that when one saw them, Greek art ceased to exist. ("Croquis parisiens," in *Oeuvres complètes*, vol. 8 [1929], pp. 137–40.)

22. This analysis was persuasively made in an unpublished lecture of 1983 by Leila Kinney but is best known from its development by T. J. Clark (1984).

23. Ernst Bloch, reading the stiffness of Seurat's figures in purely negative terms, qualified *La Grande Jatte* as a non-utopia: *Das Prinzip Hoffnung* (Berlin, 3 vols., 1954), vol. 2, pp. 393–94. His view has been opposed by O. K. Werckmeister in *Ende der Aesthetik* (Frankfurt, 1971), pp. 50ff., and more recently by Albert Boime (1990), who sees the picture as bearing out the anarchist conception of utopia. Bloch has found support in Linda Nochlin's recent essay (1989), in which she accuses Seurat's figures of "dehumanizing rigidity" and "monotony," with implications of "alienation" and "anomie."

24. The existence in the picture of only this one intact family has prompted speculation on why Seurat's crowd is dominated by nonfamily groupings and why there are more women than men (Clayson 1989). It should be noted, however, that Seurat was observing many of the conventions of paintings of leisure, which in turn probably reflect the actual composition of holiday societies that artists could observe. In Dubourg's beach scene, for example, there is not a single nuclear family, and few men; in Monet's *Parc Monceau* (Metropolitan Museum of Art, 59.142) there is only one man.

25. Fénéon, June 1886, also in Fénéon, October 1886.

118

118. *Paysage et personnages.* 1883–84

LANDSCAPE WITH FIGURES

Oil on wood, 6¼ x 9⅞ in. (16 x 25 cm.)

Berggruen Collection on loan to the National Gallery, London

H 112; DR 110

PROVENANCE
The Appert family, Paris; with Étienne Bignou, Paris; with Reid and Lefevre, London, by 1929: owned jointly with M. Knoedler and Co., New York, between July 1929 and February 1936 (stock no. A863); with Reid and Lefevre, London, from February 1936; Georges Renand, Paris, by 1937, until about 1966; sold to Wildenstein and Co., Paris and New York, in 1966; sold to Florence J. Gould, Cannes,

in 1966, until her death in 1983; her estate, 1983–85 (Gould sale, Sotheby's, New York, April 24, 1985, no. 29); purchased at this sale by present owner

EXHIBITIONS
1933–34 Paris, no. 77
1936 Paris, no. 30
1937 Paris, no. 411
1957 Paris, no. 10
1958 Chicago and New York, no. 88
1988 Geneva, no. 20

Among the very first studies of the site of the famous painting, this panel was painted in the morning, reversing the sun and shade of the other studies and the large

canvas. Shining from the southeast, the sun splashes light over the foreground; it cannot penetrate the overhead foliage, so the middle ground is in shadow. The panel's golden color shows through everywhere as a warm tint that enlivens and unifies the surface. It helps form the yellow-green of the sunlit grass, accompanied by large touches of orange, yellow-green, and green. In the shaded grass it seems to be a brighter orange by contrast with the dark and medium greens; the panel color and greens dominate, but there are strokes of orange, light wine red, pink, and some light blue. The greens are for the local color, the oranges represent scattered sunlight, the reds

119

and pinks are mixed reflections and color contrasts, and the pale blue indicates indirect light reflected from the sky. Although all these colors are a response to staring at the landscape, they also confirm the young artist's knowledge of Delacroix's theory and his readings of Blanc and Rood. Purplish tints are scattered along the edges of the sunlit patches, since he was using the color-light contrast of purple and green rather than the traditional opposites, red and green. In the water yellows, creams, and pinks are mixed with blues to suggest the reflections of the unseen architecture on the far bank. Seurat's color harmonies are already more complex than in his *Baignade* studies.

119. *Groupe de personnages.* 1883–84

STUDY WITH FIGURES

Oil on wood, 6⅛ x 9½ in. (15.6 x 24.1 cm.)

The Metropolitan Museum of Art, New York, Robert Lehman Collection, 1975 1975.1.207

Exhibited in New York only
H 117; DR 114

PROVENANCE
The artist until 1891. Posthumous inventory, panneau no. 96. Inherited by the artist's mother, Mme Ernestine Seurat, Paris, in 1891; her

gift to Lucien Pissarro, Paris, in 1891; Félix Fénéon, Paris; Bernheim-Jeune, Paris; Maurice Lonquety, Paris; by inheritance to his widow, Mme Maurice Lonquety, by 1933, until 1937, and thereafter on consignment with Wildenstein and Co., Paris, until November 1954; sold to Robert Lehman, New York, in 1954, until his death in 1969; his bequest to the Museum, 1975

EXHIBITIONS
1933–34 Paris, no. 162
1936 Paris, no. 29
1937 London, no. 46
1958 Chicago and New York, no. 91
1977 New York, no. 48

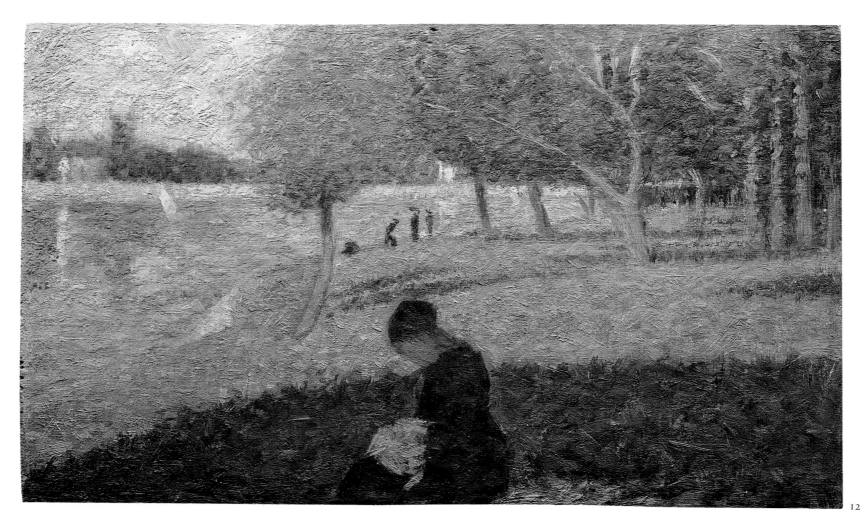

120

The tree trunks slanting in from the right bear some of the foliage that casts the large foreground shadow in the studies and the finished picture. Had Seurat retained these trees and the foliage that dangles down in the upper left corner, the large canvas would have seemed less flat because we would have been aware of the canopy of foliage above our heads. (Seurat himself remained conscious of the foliage: almost unnoticed in the extreme upper right corner of the large canvas is a dark triangle, the surviving vestige of these tree trunks.) Compared with the previous panel and with the canvas, this landscape is deeper and airier. Its horizon line is lower, so we see more of the sky and the tops of the trees in the middle

ground. Its several figures are placed over foreground and middle ground; those on the left are stationed along a neat line into depth. The distribution of these figures and the view well back along the Seine mean that this panel is closer to the *Baignade,* whose site is directly across the river, than are the subsequent studies of the island. Much of the wood color is covered, but it still shows between the brushstrokes and acts as an orange tint in most areas. The tree foliage, shot through with yellows and yellow-green, almost matches the intensity of the sunlit grass, an effect that Seurat relinquished in the final canvas.

Lucien Pissarro was the first owner of this little panel, a gift from Seurat's mother shortly after her son's death.

120. *Couseuse.* 1884

WOMAN SEWING

Oil on wood, 6⅛ x 9⅞ in. (15.5 x 25 cm.)

Private collection

Exhibited in Paris only
H 126; DR 125

PROVENANCE
The artist until 1891. Posthumous inventory, panneau no. 106. Paul Signac, Paris, in 1891, until his death in 1935; by inheritance to Ginette Signac, Paris; to present owner

EXHIBITION
1908–09 Paris, no. 38

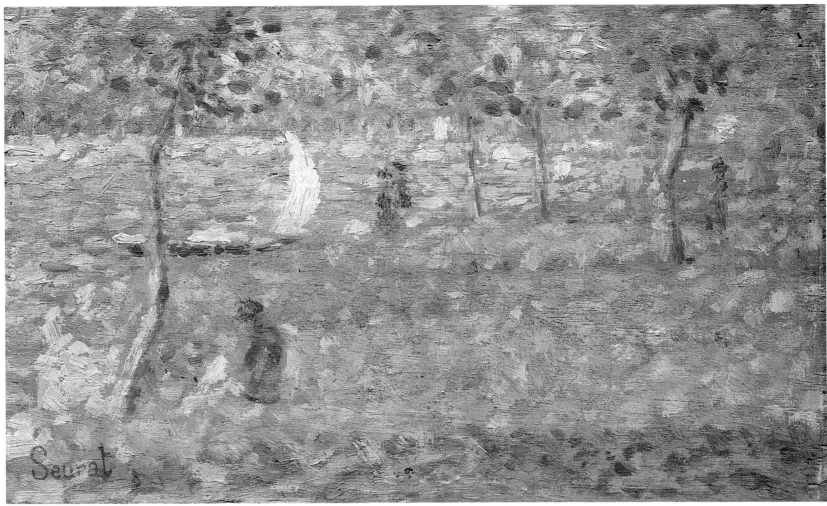

121

This study takes a large step toward the final composition. There is still a lot of foliage at the top of the canvas, and enough sky to allow a deep vista on the left, but the lateral trees and the dangling foliage of the previous panel have disappeared. The large tree right of center, in mid-distance, has achieved its more complicated branching; the phalanx of trees to the right is now prominent. The shadows have nearly the pattern of the large canvas (the curious double shadow of the nearest tree is explained in a drawing [H 616; Von der Heydt-Museum, Wuppertal] which discloses a second tree largely hidden behind the visible one). The brushstrokes are more refined than in the earlier studies, so that they more closely imitate the textures of

water, grass, and foliage; the far bank comes into sharper focus, as do the tree trunks. The sewing held by the woman is shown the way white cloth would look in shadow—a pale blue, resulting from tints of blue and some faint pink. Pink tints are also seen in the light patch to her right, in the water, and in the sky, acting as color opposites of the greens that suffuse the whole panel. In the small patch of light near the woman, pink dominates a mixture of orange-brown and pale blue. In the water it blends with pale lavender, cream, green, and the prevailing blues, and in the sky it tempers the blues and creams.

This is one of several panels for *La Grande Jatte* that once belonged to Paul Signac (another is cat. no. 126).

121. *Une voile sur l'eau.* 1884

SAILBOAT

Oil on wood, 6¼ x 9⅞ in. (15.9 x 25 cm.)
"Moline" stamp in red lower left: Seurat

National Gallery of Art, Washington, D.C., Ailsa Mellon Bruce Collection 1970.17.81

H 110; DR 109

PROVENANCE
Probably Madeleine Knoblock, Paris, from 1891; Bernheim-Jeune, Paris; Percy Moore Turner, London, by 1933, until at least 1937; Wildenstein and Co., London; Edward Molyneux, Paris, by 1943,

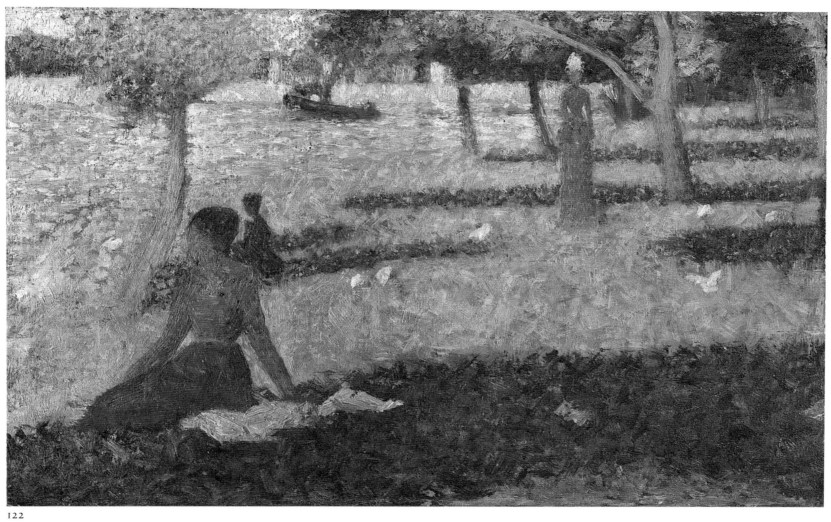

122

until 1955; sold to Ailsa Mellon Bruce, New York, in 1955, until her death in 1969; her bequest to the museum, 1970

EXHIBITIONS
1895 Paris
1933–34 Paris, no. 67
1937 London, no. 39

The preceding and the following panels are patiently studied works, with little of the wood panel showing through, but here the golden color of the wood is everywhere exposed. This is one of several panels that take a section of the whole landscape and subject it to a quick color study. Seurat touched the panel lightly with round dabs of rather thin paint, placed side by side without much overlapping. Quickly done, the panel nonetheless exhibits his essential color harmonies. The shaded grass has blue, violet, and purple as well as greens, while the sunny areas have yellow-tans and yellow-greens. The dark sides of the tree trunks are dark blue and purple, contrasting with the yellow and cream of the light sides.

122. *Paysage et personnages*. 1884
SEATED AND STANDING WOMEN

Oil on wood, 6⅛ x 9¾ in. (15.5 x 24.7 cm.)

Albright-Knox Art Gallery, Buffalo, New York, Gift of A. Conger Goodyear, 1948

H 125; DR 124

PROVENANCE
Jos Hessel, Paris, until 1929; sold to A. Conger Goodyear, Buffalo and New York, 1929, until 1948; his gift to the museum, 1948

EXHIBITION
1958 Chicago and New York, no. 98

The shadows in this study, compared with those of the large canvas, indicate a slightly earlier hour of the afternoon when the sun is not quite so far in the west. Some writers have felt that Seurat manipulated the landscape entirely in his studio. In fact, painting on the island would have served his purposes best, although he probably continued to work on some panels in his studio. Each excursion to the island allowed him to study the effects of light at different times of the day and to try various positions for the figures. Here the figures are like chess pieces that can be moved about the landscape. The woman in the foreground is found farther back in the final picture, and the standing woman in the middle ground is moved forward and joined by a young girl. To the rear the steam tug makes its first appearance, in the same position it will have in the final composition. Its red hull produces a strong green reaction in the water. Elsewhere color reactions are more conservative, with relatively fewer contrasts than the later panels. The sunny grass, for example, consists only of variations of yellow, orange-yellow, and green, and the shaded grass, only of dark green, purple, and blue. By exception, there are dabs of pink in the grass on either side of the seated woman, but these were probably added later. The other woman's skirt is an intense brick red that sounds loudly against the surrounding greens. In *La jupe rose* (cat. no. 130) this red is converted to a softer pink.

123. *L'arbre*. 1884
TREE

Conté crayon, 24⅜ x 18½ in. (61.9 x 47 cm.)

The Art Institute of Chicago, Helen Regenstein Collection

H 619; DR 116a

PROVENANCE
The artist's family; by inheritance to Mme Léopold Appert, Paris; private collection, Paris, until 1966; sold to Wildenstein and Co., New York, March 1966; sold to the museum, June 1966

EXHIBITIONS
1957 Paris, no. 29.
1958 Chicago and New York, no. 71.

At some point early in the genesis of his big picture Seurat fixed upon the landscape and made drawings of its principal trees. The water, shorelines, and grassy terrain could easily be transferred to canvas from the small panels because of their broad, simple lines, but the trees needed careful definition. In one conté crayon drawing (H 616; Von der Heydt-Museum, Wuppertal), he drew the bent tree to the left of the final composition, giving it the exhibition quality of his independent drawings. The present study of the prominent tree in the middle ground of the canvas resembles Seurat's drawings of antique statues and nude models of five or six years earlier. The modeling has the delicate refinement of those studies, and the trunk twists in an anthropomorphic way. The other trees, farther in the distance, are mere silhouettes. To position them, Seurat did not include the long branch that slants leftward from the principal tree in the final composition, an editorial suppression that is duplicated in a number of the oil panels. He marked its growth from the trunk but suspended working further on it in order to map out the other trees. It is not surprising that this branch appears and disappears, for like other artists Seurat considered foliage to be an impermanent feature, like clouds, that could be adjusted to suit a composition without violating natural truth. In the final composition the foliage that at times blocks this branch is eliminated, allowing the limb to provide an important rising diagonal.

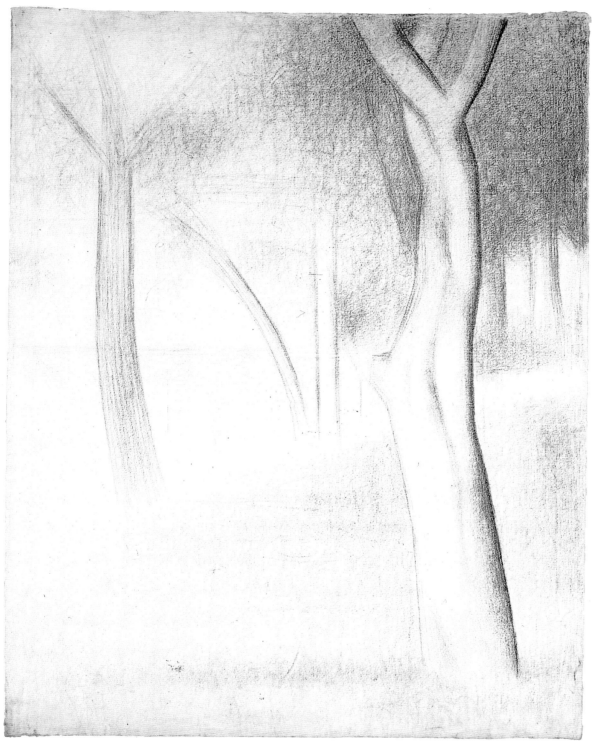

123

124. *Troncs d'arbres.* 1884

TREE TRUNKS

Conté crayon, 18⅝ x 24½ in. (47.4 x 61.5 cm.)

The Art Institute of Chicago, Helen Regenstein Collection

Exhibited in New York only
H 620

PROVENANCE
The artist until 1891. Posthumous inventory, dessin no. 358. Inherited by the artist's family, in 1891; by inheritance to Mme Léopold Appert, Paris; private collection, Paris; with Brame et Lorenceau, Paris, until 1987; sold to the museum, 1987

Like the previous drawing, this study documents the trees in the right background of the final canvas. The other was drawn in conté crayon; this one is in pencil and has a corresponding lightness. Although one could undoubtedly have found these trees on the island, they recall both Seurat's schoolboy drawings and the schematic renderings of trees that were said to be the models for Greek temple fronts. In that regard they combine "primitive" and classical qualities, as do the works of Puvis de Chavannes. Seurat's intention of mapping the trees rather than making a convincing atmospheric description is shown by the thin horizontal lines that mark their positions, like so many stage flats, instead of the streaks of shadow that they will acquire in paintings. Even so, the principal trees sway gently and display individual rhythms.

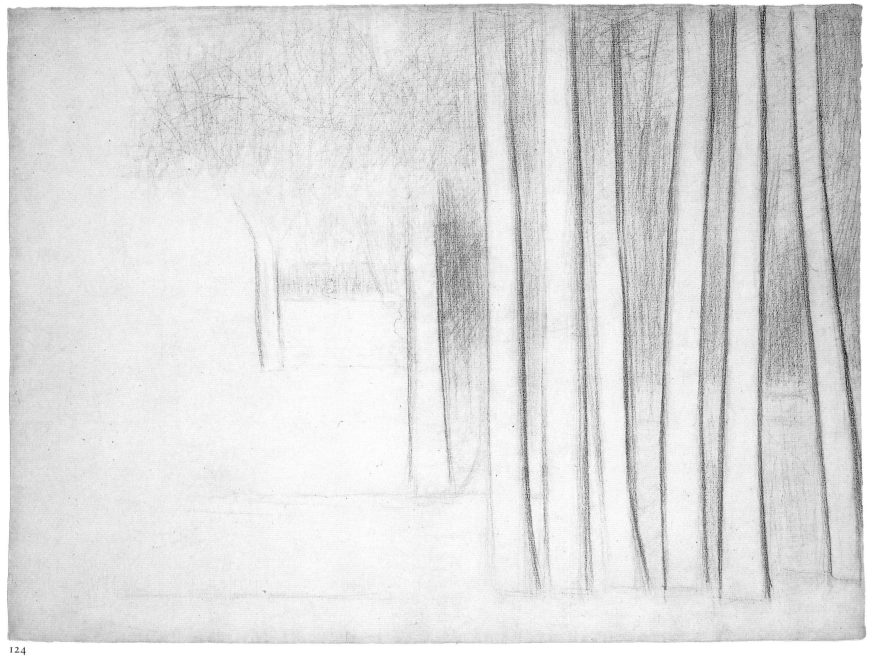

124

125. *La pêcheuse à la ligne.* 1884
A WOMAN FISHING

Conté crayon, 12⅛ x 9¼ in. (30.8 x 23.5 cm.)

The Metropolitan Museum of Art, New York, Purchase, Joseph Pulitzer Bequest, 1951; acquired from The Museum of Modern Art, Lillie P. Bliss Collection 55.21.4

Exhibited in New York only
H 635; DR 131a

PROVENANCE
The artist until 1891. Posthumous inventory, dessin no. 354 (per inscription on reverse in orange crayon; not recorded by de Hauke). Inherited by the artist's brother, Émile Seurat, Paris, in 1891, until no later than 1906; Félix Fénéon, Paris, by at least 1926, until January 1928; sold to De Hauke and Co./Jacques Seligmann and Co., New York, in January 1928, until March 1928 (stock no. 1141);* sold to William Macbeth Inc., New York, in March 1928; Lillie P. Bliss, New York, by 1929, until her death in 1931; her bequest to The Museum of Modern Art, New York, 1934, until 1951; purchased by the Metropolitan Museum, 1951

EXHIBITIONS
1908–09 Paris, no. 43
1926 Paris, Bernheim-Jeune, no. 107
1935 Chicago, no. 17
1947 New York, no. 3
1948 New York, no. 61
1950 Venice, no. 9
1958 Chicago and New York, no. 73
1977 New York, no. 31

* See provenance note, cat. no. 30.

Of all the studies for *La Grande Jatte*, this one most closely resembles Seurat's figure drawings of 1882–84. It could well stand alongside *La dame en noir* (cat. no. 37) as a suburban equivalent of that haughty urban promenader, for it is created in essentially the same manner. For each Seurat drew the background in parallel horizontals, soft rubbings, and light swirls and dashes and the base in darker crosses and grays. Each figure is surrounded by a glowing halo, although the darker woman provokes a more radiant reaction. The fisherwoman, in fact, may at first have been independent of the large picture and appropriated when Seurat turned to the sketch (cat. no. 141) where she makes her first appearance in oil. In *Petite esquisse* (cat. no. 127) a woman stands in about the same pose but well away from the shore; in another oil sketch

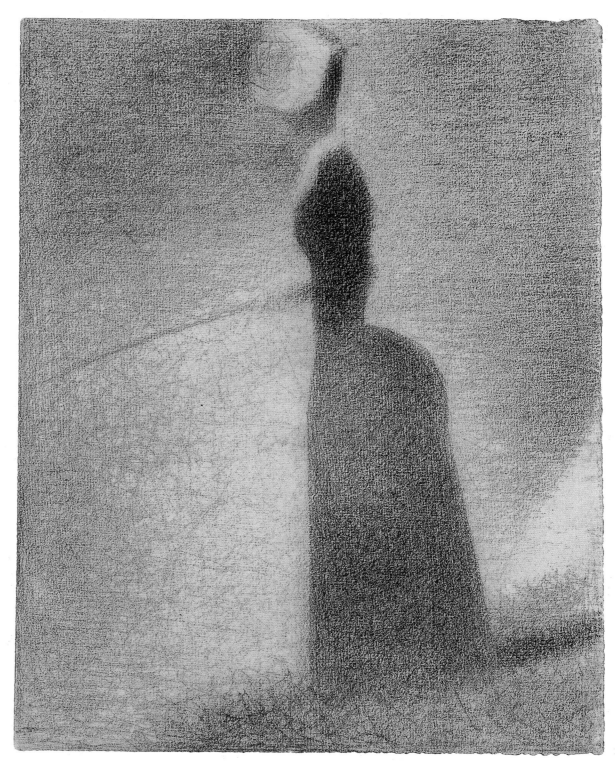

125

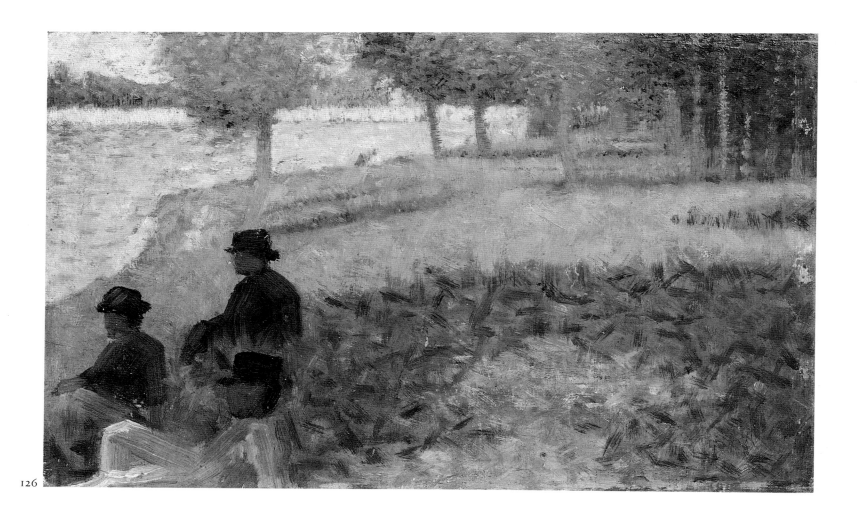

126

(cat. no. 128) a similar woman stands closer to the water's edge, but she is in a different costume and is not fishing. The present drawing is therefore the more likely source for the final image. When Seurat put this figure in the large sketch, he made her far smaller than the central woman who is on the same plane. In the final painting, although she is somewhat larger, she remains "too small," an effect that could be attributed to Seurat's working in a tiny studio and therefore lacking distance from his canvas. However, the sketch is small enough to exclude this reasoning, so we are left with the conclusion that the anomalies of proportion are due to Seurat's assembling his cast from different studies, without worrying about conventional integration. If we look closely at the final

painting, we see that when Seurat reworked it in 1885–86 he widened the fisherwoman's skirt with the falling arabesque that now forms its right edge. Underneath the repaints the woman has the form of this drawing.

126. *Trois dos.* 1884

THREE MEN SEATED

Oil on wood, 6⅛ x 9⅞ in. (15.5 x 24.9 cm.)

Private collection

Exhibited in Paris only
H 122; DR 121

PROVENANCE
The artist until 1891. Posthumous inventory, panneau no. III. Given by the artist's family to Dario de Regoyos, a Spanish artist who was one of Les Vingt, in 1891;* Paul Signac, Paris, by 1908, until his death in 1935; by inheritance to Berthe Signac, Paris; by inheritance to Ginette Signac, Paris; to present owner

EXHIBITIONS
1908–09 Paris, no. 36
1957 Paris, no. 22
1958 Chicago and New York, no. 96

* Dario de Regoyos's name appears on a list (found among the papers of Théo van Rysselberghe) of individuals in Belgium who were to receive works from the family. He is listed as Dario (de Regoyos) with an indication that he was to receive "1 panneau,"

inventory number III. This list is transcribed in DR, 1959, p. LXXVI.

When cataloguing this work, de Hauke erroneously included it among the dozen panels shown in a single frame in the following exhibitions: 1886 New York, no. 133; 1887 Paris, no. 447; and 1892 Brussels, no. 1. This work was certainly not among the group of a dozen panels, none of which had inventory numbers. The above exhibition listings should have appeared under his entry for H 121 (here cat. no. 130). See H, I, p. xxx, and Errata, p. 305. Also see provenance note, cat. no. 103.

The landscape of this panel is essentially that of the final composition, although Seurat painted it at a slightly later hour (the sun reaches farther to the right). For the first time among the studies the composition's top cuts the trees and the sky along the same line as in the canvas, and the "temple front" of trees now appears to the right. The group of three figures in the lower left will be retained, as will two of the three poses; instead of the leftmost man, the seated woman of another panel (cat. no. 128) will join the two men, to the right. Seurat was thinking still of a few reclining figures, rather like those of the *Baignade,* and had not yet conceived the animation of the large painting. He is now using a greater number of hues without exposing very much of the panel color. In the foreground the sunlit patch, mostly orange-yellow, has yellow-greens, pure yellow, dull oranges, lavender, and a few strokes of pale blue and pink. The lavender changes to light purple in the adjacent shaded grass, and purples are prominent in the darker areas of the foliage above.

127. *Petite esquisse.* 1884

SKETCH WITH MANY FIGURES

Oil on wood, 6 x 9⅛ in. (15.2 x 24.5 cm.)

The Art Institute of Chicago, Gift of Mary and Leigh B. Block

H 128; DR 119

PROVENANCE
The artist until 1891. Posthumous inventory, panneau no. 87. Maximilien Luce, Paris, from 1891 until his death in 1941; his heirs, 1941–55; sold to Wildenstein and Co., Paris and New York, May 1955 (arrived in New York, October 1955); sold to Mr. and Mrs. Leigh B. Block, Chicago, November 1955, until 1981; their gift to the museum, 1981

EXHIBITION
1958 Chicago and New York, no. 94

Ten prominent figures in the foreground of this panel and many more in the distance give it the complexity of the final composition. Few of them, however, will be retained: the tall male on the right, a pair of seated girls, and a standing woman in orange who later becomes the fisher-woman. Also retained is the idea of large figures spread across the foreground, some of them along neatly receding orthogonals, and smaller figures along the shore and among the trees. This assortment of people seems clumsily arranged, even allowing for the small size of the panel. They are mostly independent of one another, as are those of the large picture, but they are not as carefully orchestrated; the three figures on the right seem particularly awkward. This shows Seurat's willingness to try various arrangements and reject those that did not suit, a procedure of trial and error rather than one of implacable logic. As if in compensation for the awkwardness, these figures in purples and wine reds resonate beautifully against a medley of greens, blue-greens, yellow-greens, blues, and yellows.

This panel once belonged to Maximilien Luce. The artist's mother may have given it to him after her son's death.

128. *Plusieurs personnages assis; Petite esquisse.* 1884

FISHERWOMAN AND SEATED FIGURES

Oil on wood, 6 x 9½ in. (15.2 x 24 cm.)

Private collection

Exhibited in New York only
H 120; DR 128

PROVENANCE
Bernheim-Jeune, Paris; Jorgen B. Stang, Oslo, before 1921; Dr. Alfred Gold, Berlin, until January 1929; purchased jointly by Reid and Lefevre, London, and De Hauke and Co./Jacques Seligmann and Co., New York (stock no. 3354),* in January 1929, until March 1929; sold to Mr. and Mrs. Howard J. Sachs, New York and Stamford, Connecticut, in March 1929, until at least 1958; to present owner

EXHIBITIONS
1929 New York, no. 64
1949 New York, no. 8
1953 New York, no. 6
1958 Chicago and New York, no. 87

* See provenance note, cat. no. 30.

Like the previous panel, which it probably followed by a few days or weeks, this one is an essay in multiple figures. It seems calmer and more resolved because it is not as crowded and its figures seem more naturally disposed. The fisherwoman, now in her definitive location, is standing; the other holiday-goers in the foreground are seated in the huge shadow. In the left foreground, is the seated woman in a straw hat who will accompany the two men in the final painting. Above her, in the shadow of the bent tree, sits a woman who foretells the elderly woman of the final composition. Seurat did not keep the seated male on the far right in the final painting, but he retained two of the three women seated nearby. To make room for this group of three, Seurat moved the forked tree on the right farther from the twin trees in the distance.

Despite her summary form, the fisherwoman recalls Seurat's earlier drawings: here he carried out in color the logic of those black-and-white works. The figure's sunlit side is a cream color, and the adjacent water is darkened to oppose it. Her shaded side, dominated by blue, has a golden halo for the same purpose, so that reading from left to right there is the familiar alternation of dark-light-dark-light. Seuat brushed in this woman and the other figures

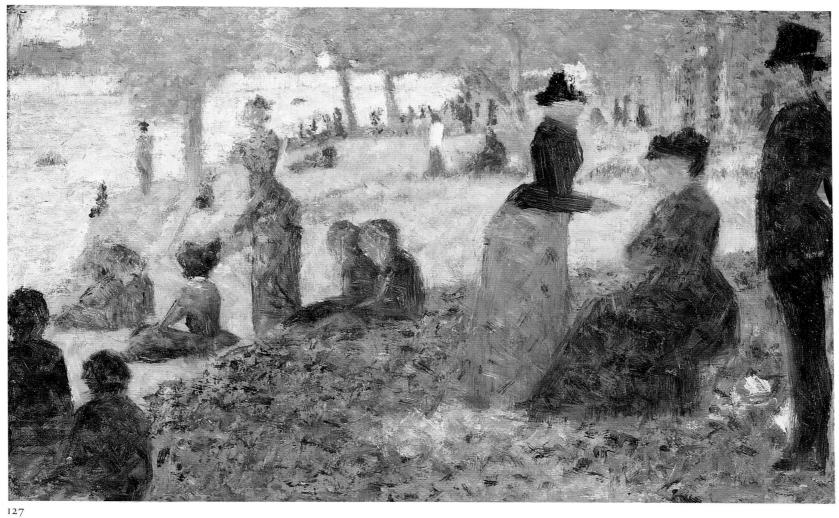

127

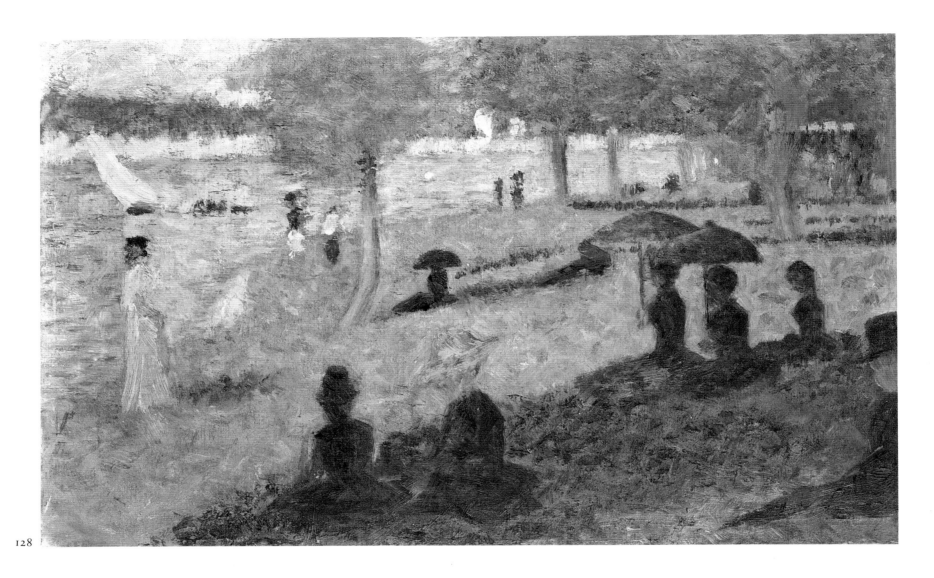

128

silhouetted against the Seine before he painted the water—
he did not add the figures to an already completed
landscape.

129. *Homme assis, femme étendue*. 1884

SEATED MAN, RECLINING WOMAN

Oil on wood, 6⅛ x 9⅞ in. (15.5 x 25 cm.)

Musée d'Orsay, Paris, Gift of Thérèse and Georges-Henri Rivière, in
memory of their parents, 1948 R.F. 1948-1

Exhibited in Paris only
H 109; DR 126

PROVENANCE
Berthe Signac, Paris, in 1891; her gift to Marguerite Rivière, Paris, in
1891, until 1948, and by 1933, owned jointly by Mme Rivière and
her children, Thérèse and Georges-Henri Rivière, Paris; because of
the hospitalization of Thérèse Rivière in the Hôpital Ste.-Anne, their
intended gift to the Louvre in 1948 was not realized until 1963;* in
the interim, the work was sold at auction: sale, Biens des Internés de
Ste.-Anne, 145bis rue d'Alésia, Paris, March 8, 1955; purchased for
100,000 francs by Maurice Montagné and immediately consigned by
him to another auction (sale, "Atelier Boldini et à divers amateurs,"

Galerie Charpentier, Paris, June 16, 1955, no. 152); not sold but
instead sequestered by the commissaire-priseur, Maurice Rheims,
from June 1955 until 1963; after several lawsuits the work was
recovered by the Jeu de Paume in 1963; transferred to the Musée
d'Orsay, 1986

EXHIBITIONS
1933–34 Paris, no. 78bis
1936 Paris, no. 32
1937 London, no. 45
1957 Paris, *hors cat.*

*See *Les donateurs du Louvre*, Paris, 1989, p. 305.

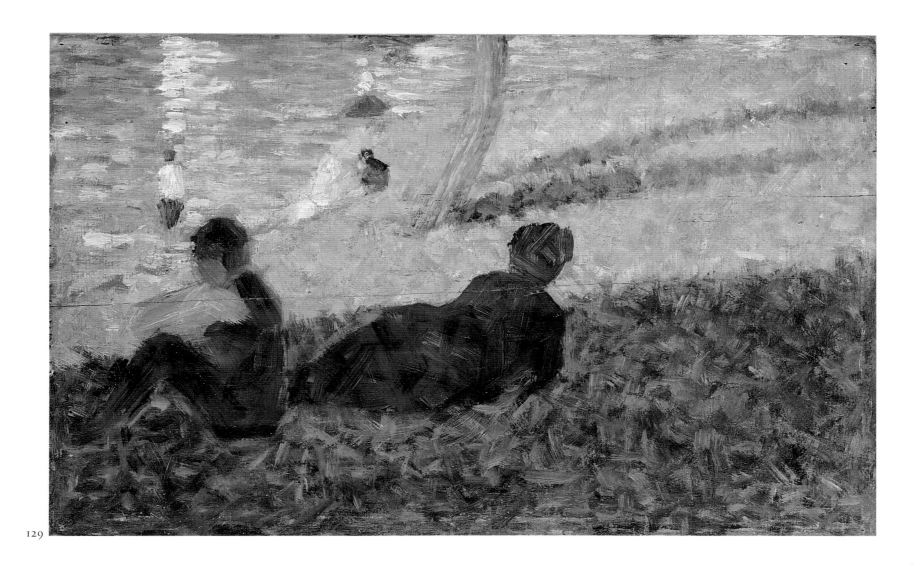

129

From this panel Seurat borrowed the reclining woman for the final canvas, where he placed her in mid-distance and gave her the company of another woman; he transformed the man into the dandy with cane and top hat. In the water, touching the upper edge, is a fisherman in a foreshortened boat; he reappears at about the same spot in the large picture. Once again a panel helped in planning the canvas but not in an especially logical fashion. It was one of a number of studies that formed a repertoire of motifs from which Seurat chose some figures, often rearranging them, while rejecting others. Each study served

another purpose: the continual experimentation with pigments. Here the shaded grass has in large measure the components of the canvas: dark and medium greens, dark purple and lavender, dark and light blue, and occasional spots of orange and pink. The golden color of the wood is prominent in the water; from a distance it appears to be orange pigment. It shows less conspicuously among the greens and yellows of the sunlit grass, but there too it is a basic constituent.

130. *La jupe rose*. 1884

THE ROSE-COLORED SKIRT

Oil on wood, 6 x 9½ in. (15.2 x 24.1 cm.)
Private collection

H 121; DR 127

PROVENANCE
The artist until 1891. Included in the posthumous inventory but not numbered. Inherited by Madeleine Knoblock, Paris, in 1891, until 1892; sold to Jean de Greef, Auderghem, Belgium, in February 1892, until no later than 1894;* Bernheim-Jeune, Paris; Charles

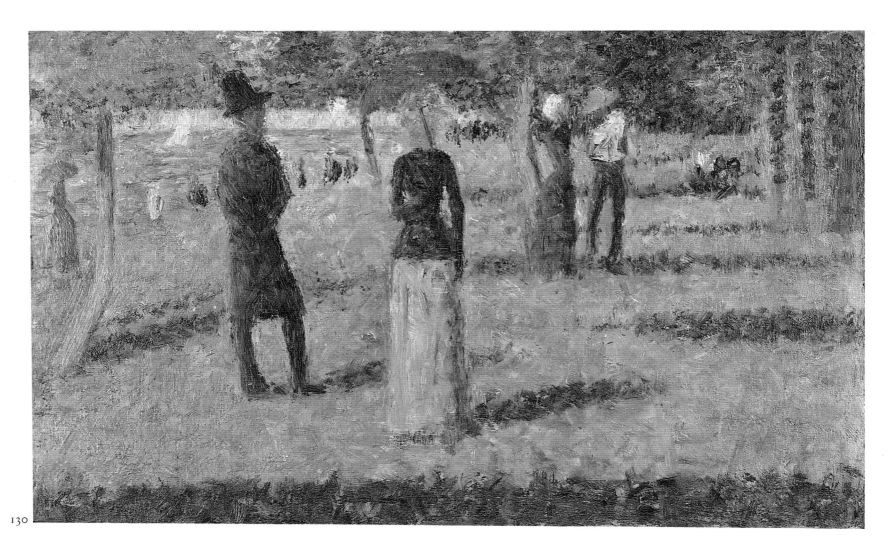

130

Vignier, Paris, until 1926; sold to Reid and Lefevre, Glasgow, in 1926, until January 1929; owned jointly by Reid and Lefevre, London, and De Hauke and Co./Jacques Seligmann and Co., New York (stock no. 3350),** from January 1929 until March 1929; sold to M. Knoedler and Co., New York, in March 1929, until April 1929 (stock no. A563); sold to Robert Treat Paine II, Boston, in April 1929, until his death in 1943; by inheritance to Ruth Paine Cunningham, Brookline, Massachusetts, from 1943 until her death in 1956; to present owner

EXHIBITIONS
1886 New York, no. 133 (no. 2 in a frame of "12 studies")
1887 Paris, no. 447 (one of "douze croquis")
1892 Brussels, no. 1 (one of "douze esquisses")
1958 Chicago and New York, no. 93

*See provenance notes, cat. nos. 89, 103, and 126.
**See provenance note, cat. no. 30.

The central woman of the large picture appears prominently here. Comparing her with other studies and the canvas reveals Seurat's way of working. In one of the earliest studies (cat. no. 112) a mother and child are found in the distance in small scale. The woman is alone in the Buffalo panel (cat. no. 122); in another (H 119; Barnes Foundation, Merion, Pennsylvania) she and the child in white both appear but in separate locations. Seurat combined them on the canvas, and in so doing adjusted the pose of the woman from the present panel. To accommo-

date the child, he reversed her arms but kept the umbrella at the same angle. From this panel he repeated the couple, putting them on the far side of the central tree in the canvas. Even in the abbreviated strokes of this tiny pair, we can see that the man holds a swaddled baby in his arms and bends toward his wife. As for the other man, so amusingly assertive, he will not again be seen.

Figures and tree trunks are modeled in the round in this panel, more than in the preceding ones, and the wood is thoroughly covered over. The sun strikes each figure from the left, so that one side is orange, opposed on the other side by dark blue. The central woman is a miracle of brilliant color and observation. Her hat (about one centi-

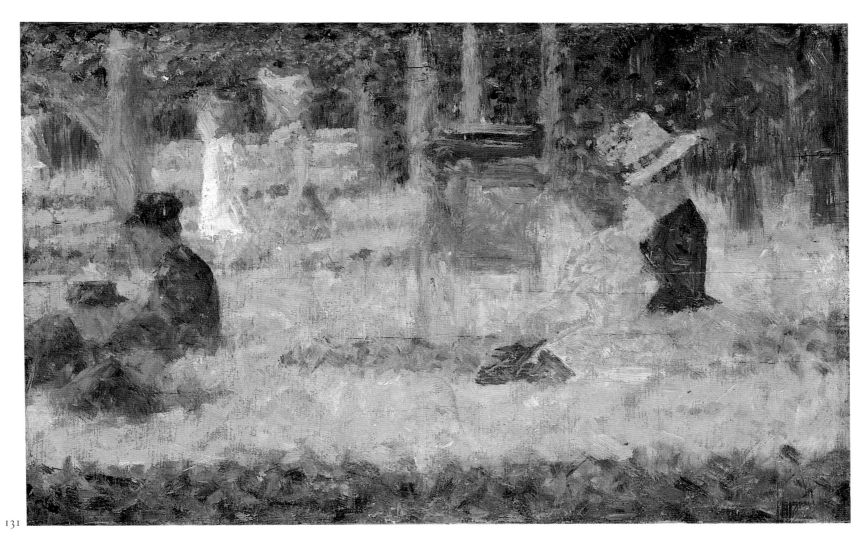

131

meter square) has touches of green, pink, and orange that result in a light brown effect from conventional viewing distance. An intense orangish red marks the sunlit side of her umbrella; it is the brightest color present. Her person is more subtly modeled. Her upper body is made of orange and wine red, with dark blue and wine red for the shaded side. Green is added at her waist, forming a brownish hue that contrasts with the reds and purples. Her skirt, rose color from a distance, consists of pinks, streaks of wine red, orange, some yellow, and pale blue; away from the sun it has darker blues and wine reds and a deeper lavender-pink. This woman is truly one of the most beautiful figures of all the panels.

131. *Femmes assises et voiture d'enfant.* 1884

WOMEN SEATED AND BABY CARRIAGE

Oil on wood, 6¼ x 9⅞ in. (16 x 25 cm.)

Musée d'Orsay, Paris, anonymous gift in memory of Charles Henry, 1930 R.F. 2828

Exhibited in Paris only
H 129; DR 129

PROVENANCE
The artist until 1891. Presumably given by the artist's mother to Charles Henry, Paris and Versailles, in 1891, until his death in 1926;

his estate, from 1926; sold to Henry's disciple Gustave Pimienta, Paris, by 1930, when he gave it to the Louvre as an anonymous gift in memory of his mentor; transferred to the Jeu de Paume, 1947; transferred to the Musée d'Orsay (Palais de Tokyo), 1977; transferred to the Musée d'Orsay, 1986

EXHIBITIONS
1933–34 Paris, *hors cat.*
1958 Chicago and New York, no. 90

More than most of the *Grande Jatte* panels this one gives the impression of having been painted on the spot. The summarily painted forms have the stamp of immediate observation. On the left two men recline on their elbows,

looking toward the right; the sun tints their backs with orange-tan. With them is another man facing left and beyond him two girls also face the water. On the other side are two women sitting near a baby carriage, a grouping that Seurat used in the canvas. Radically fore-shortened, the pram tilts slightly to the right; two broad slashes of bluish purple convey its folded-down top. The women retain a rudimentary version of their colors in the large picture, the left one in lavender and blue, the right one in a dark purple blouse, a lavender and blue skirt, and a straw hat. The panel's bright gold outlines the carriage and the trees, whose trunks are verticals of orange-tan, modeled in purple and blue. Small round dots were added to most of the figures, the shadow strips, and the foliage beyond, a premonition of the large picture's facture.

The mathematician and aesthetician Charles Henry (1859–1926) was the first owner of this study; Mme Seurat *mère* probably gave it to him after her son's death.

132. *Le Saint-Cyrien*. 1884
CADET FROM SAINT-CYR

Oil on wood, 6 x 9½ in. (15.2 x 24.1 cm.)

Private collection

H 130; DR 115

PROVENANCE
The artist until 1891. Given by the artist's mother to Henri-Edmond Cross, Le Lavandou, France, in 1891, until his death in 1910; by inheritance to his widow, Mme Henri-Edmond Cross (née Irma Clar), from 1910; Félix Fénéon, Paris, probably around 1910, when he purchased the contents of Cross's studio,* and certainly by 1923; Percy Moore Turner (Independent Gallery), London, by 1925, until January 1929; purchased jointly by Reid and Lefevre, London, and De Hauke and Co./Jacques Seligmann and Co., New York (stock no. 3351),** in January 1929, until March 1929; sold to M. Knoedler and Co., New York, in March 1929, until April 1929 (stock no. A564); sold to Robert Treat Paine II, Boston, in April 1929, until his death in 1943; by inheritance to Ruth Paine Cunningham, Brookline, Massachusetts, from 1943 until her death in 1956; to present owner

EXHIBITIONS
1908–09 Paris, no. 41
1958 Chicago and New York, no. 92

*Rewald, "Félix Fénéon," *Gazette des beaux-arts*, XXXIII, February 1948, p. 120.
**See provenance note, cat. no. 30.

In contrast to the previous panel, which was rather quickly painted, this one was built up patiently, primarily as a color study. The lone cadet is an odd presence, emphasizing the unpeopled quality of the landscape (especially since we have the large picture in our minds). He was perhaps a fortuitous promenader, whom the artist used as a measure of human scale. Seurat paid surprising attention to the color-light changes in the smallest areas here. The trunk of the nearest tree is pinkish tan, changing to orangish tan as it rises; a blue streak models its right side. The trunk of the forked tree is a brownish orange, turning to pink above; its leftward branch mixes blue and dull orange, with hairlike streaks of pink along its upper edge. The two tree trunks to the right of the cadet consist of blue and wine red, but the one to the right (farther from the light) is decidedly darker. In all these instances we are looking at tiny portions of an already small painting. Only 1½ inches (3.8 cm.) tall, the cadet has red epaulets, and

the top of his shako is touched in red. We can make out the flesh color of his face and even see his belt. The red of his trousers is the most brilliant hue; it vibrates against the neighboring greens and his dark blue-green jacket. Most of the wood is covered with pigment, but it shows through delicately here and there, as usual blending well with the oranges of the sunny area. Contrasts are well developed, for the tree trunks and cadet produce halos on the water, and in the foreground, orange intensifies in the sunlit grass as it nears the bluish green shade. In response the latter accumulates more purple and darker blue. The opposition of light orange and yellow to dark blue and purple modulates the greens of the foliage above. This panel served as the principal model for the corresponding portion of the large canvas.

In 1891, after Seurat died, his mother gave this study to Henri-Edmond Cross, a Neo-Impressionist friend.

133. *La femme au singe*. 1884
WOMAN WITH A MONKEY

Oil on wood, 9¾ x 6¼ in. (24.8 x 15.9 cm.)

Smith College Museum of Art, Northampton, Massachusetts, Purchased, 1934

H 137; DR 134

PROVENANCE
Jean Ajalbert, Paris, in 1886; Gaston Bernheim de Villers, Paris; Étienne Bignou, Paris; with Galerie Barbazanges, Paris, until October 1926; sold to M. Knoedler and Co., New York, in October 1926, until November 1928 (stock no. 16592); sold to Mr. and Mrs. Cornelius J. Sullivan, New York, in November 1928, until 1934; purchased by the Museum, 1934

EXHIBITIONS
1929 New York, no. 65
1935 Chicago, no. 5
1948 New York, no. 49
1949 New York, no. 15
1953 New York, no. 7
1958 Chicago and New York, no. 86
1968 New York, no. 74

Seurat depicted a single promenading woman in several of his panels, but it is only here that he painted the profile view, with her monkey, that dominates the right side of the

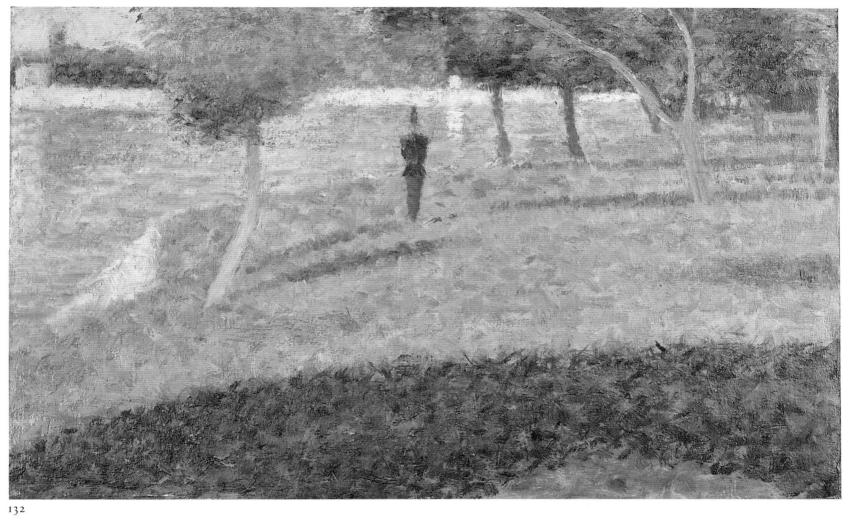

132

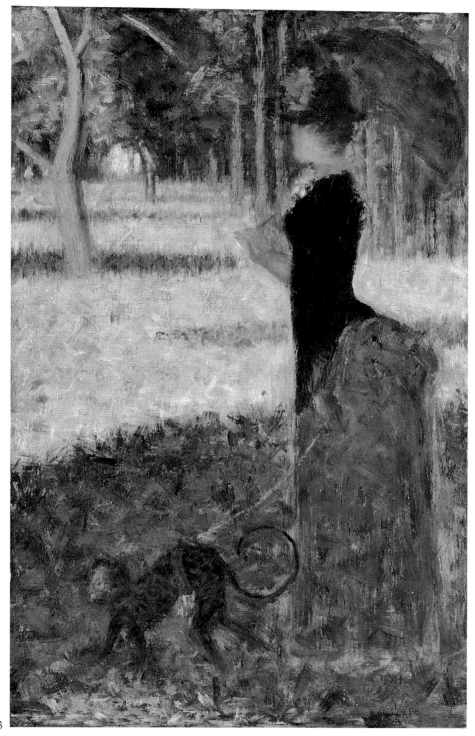

133

final canvas. Such a woman had long been a familiar image in journalistic illustrations, advertisements, and paintings that celebrated fashion in association with nature. One thinks of Manet's famous *Jeanne, ou le Printemps* (private collection), a great success in the Salon of 1882. Seurat's different sense of irony and his fondness for popular culture led to the inclusion of the monkey.[1] The saturated orange-red on the woman's hat draws attention to her finery. Her dress is dominated by a blue of greater intensity than that of the large picture (whose blues later turned purplish). Mixed with this blue are a wine red and a few strokes of a purer red. Jacket, parasol, and hat have different blends of the same wine red and blue, which also appear in the shaded grass and the background foliage. Optical mixture is effective for the monkey: at normal distance it appears a mixed brown, which is in fact made of strokes of deep blue, purplish blue, and a dull orangish brown.

In 1886 Seurat listed Jean Ajalbert as the owner of this picture (see Appendix D). He must have given it to him, a politic move since Ajalbert was one of his principal champions in the press.

1. The monkey's traditional association with lust has been used (Thomson 1985 and elsewhere) to proclaim the *promeneuse* a cocotte, but since she appears here without a male consort and has none of the attributes of a prostitute, it is more likely her pretentiousness that Seurat is mildly satirizing.

134. *Singes.* 1884

MONKEYS

Conté crayon, 11⅝ x 9 in. (29.5 x 23 cm.)

Feilchenfeldt Collection, Zurich

H 640; DR 134a

PROVENANCE
Félix Fénéon, Paris, by at least 1908, and probably in 1891, until 1941 (Fénéon sale, December 4, 1941, no. 12, for 52,000 francs); purchased at this sale by Galerie Georges Petit, Paris; sale, Drouot, Paris, March 10, 1944, no. 20, for 70,000 francs; with Galerie Kurt Meisener, Zurich, until 1947; sold to present owner, 1947

EXHIBITIONS
1900 Paris, Revue Blanche, *hors cat.*
1908–09 Paris, no. 192
1920 Paris, no. 44
1926 Paris, Bernheim-Jeune, no. 111
1936 Paris, no. 119
1958 Chicago and New York, no. 76
1978 London, no. 21
1983–84 Bielefeld, Baden-Baden, and Zurich, no. 72

When Seurat decided that his promenading woman would have a monkey, he went to the zoo and made five separate drawings. Three of them are in the present exhibition. The other two are of single monkeys, one seated (H 637; Solomon R. Guggenheim Museum, New York) and another on all fours (H 639; private collection, Massachusetts). This was not the first time he had drawn monkeys: there are two tiny views of the animal, seen from behind, in one of his early notebooks of 1879–81 (anonymous loan, Yale University Art Gallery, New Haven). In the present drawing the monkey at the top has a shadow under its feet that might be cage litter; its swirls suggest the animal's movement back and forth. The other studies reveal Seurat's way of drawing quickly from life, first a very faint outline, then gray for the body, and finally some short lines to correct and reinforce the contours.

135. *Le singe.* 1884

MONKEY

Conté crayon, 7 x 9¼ in. (17.7 x 23.7 cm.)

The Metropolitan Museum of Art, New York, Bequest of Miss Adelaide Milton de Groot (1876–1967), 1967 67.187.35

Exhibited in New York only
H 636; DR 134d

PROVENANCE
The artist until 1891. Posthumous inventory, dessin no. 361 (per inscription on reverse in black pencil, not recorded by de Hauke). Félix Fénéon, Paris, probably in 1891; Eugène Druet, Paris, by 1908, until at least 1926; Jacques Rodrigues-Henriques, Paris, by March

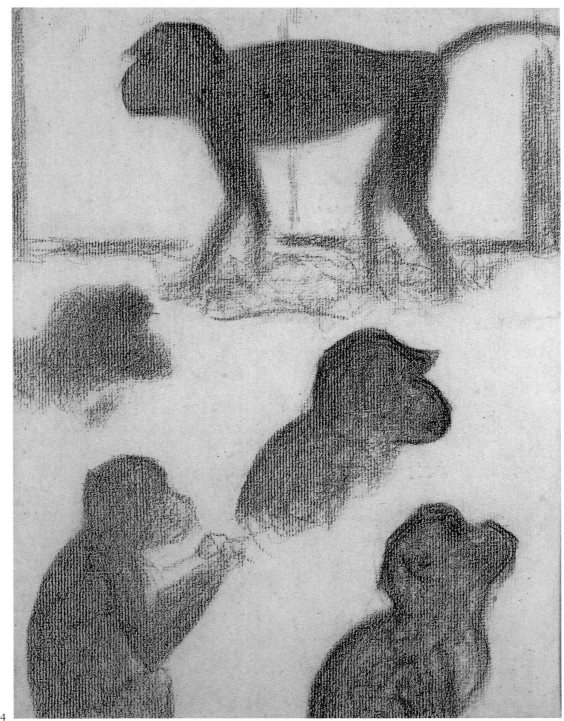

134

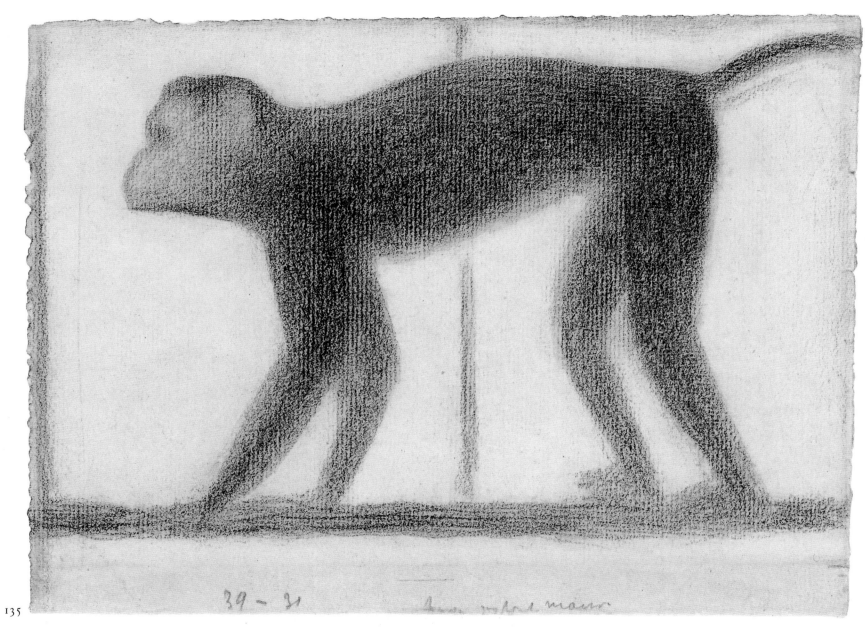

135

1928, until at least 1929; Miss Adelaide Milton de Groot, New York, by 1935, until 1967; her bequest to the Museum, 1967

EXHIBITIONS
1908–09 Paris, no. 186
1926 Paris, Bernheim-Jeune, no. 106
1958 Chicago and New York, no. 80
1977 New York, no. 32

This is the same pose, with slight variations, seen in the monkey at the top of the preceding drawing. The paper is actually the same size but is folded over, which isolates the animal as a self-contained composition. In the other drawing the monkey's feet are seen from above so we sense the cage's floor, but this monkey and its cage are viewed in strict profile. Its body is darker, its legs are wider, and its face is lighter—changes that work with the rectilinear lines to make the kind of hieratic pattern that typifies Seurat's style.

136. *Sept singes.* 1884

SEVEN MONKEYS

Conté crayon, 11¼ x 9¼ in. (30 x 23.5 cm.)

Musée du Louvre, Département des Arts Graphiques, Fonds
du Musée d'Orsay, Paris, Gift of Camille Pissarro, 1904 R.F. 29.547

Exhibited in Paris only
H 639; DR 134c

PROVENANCE
The artist until 1891. Posthumous inventory, dessin no. 351. Inher-
ited by the artist's brother, Émile Seurat, Paris, in 1891, until 1900;
sold to Camille Pissarro, Paris, in 1900, until his death in 1903; his
gift, realized by his son Lucien Pissarro, to the Musée du Luxem-
bourg, Paris, April 15, 1904; transferred to the Louvre, 1947

EXHIBITIONS
1900 Paris, Revue Blanche, *hors cat.*
1908–09 Paris, no. 185
1926 Paris, Bernheim-Jeune, no. 105
1957 Paris, no. 37
1958 Chicago and New York, no. 82

The large profile study on this sheet represents a slenderer
animal, perhaps a different species or a younger specimen.
Its legs are proportionately longer, and its tail is held
differently. Seurat's parallel lines suggest fur and empha-
size the elongated limbs, whereas the monkeys on the
preceding sheets were drawn in uniform tones. This
animal is closest to the one that Seurat finally painted
because its back also arches upward. We do not know
whether Seurat modeled the final monkey on a drawing no
longer extant or whether he knew the animal well enough
to draw the different pose directly on his canvas. What is
apparent is that none of the five known drawings is the
model for the painting. Each of Seurat's studies was not
part of a well-conceived series that led ineluctably toward
the final composition; instead he made many drawings and
paintings that would be used, or not, as his ideas evolved.

This lively page is one of seven drawings by Seurat that
Camille Pissarro bequeathed to the French nation in 1904
(see cat. no. 28).

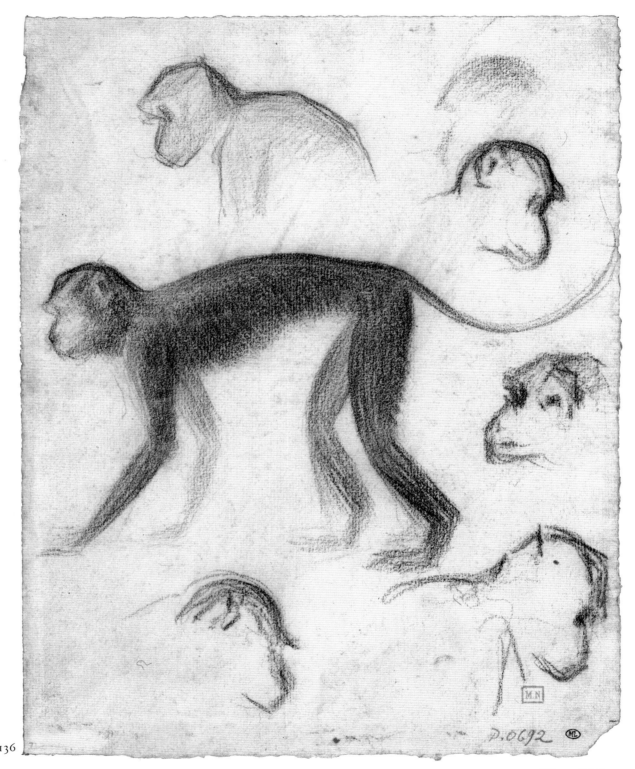

136

137. *Le couple.* 1884

THE COUPLE

Oil on canvas, 31⅞ x 25⅝ in. (81 x 65 cm.)

Lent by the Provost and Fellows of King's College, Cambridge (Keynes Collection); on loan to the Fitzwilliam Museum, Cambridge

H 138; DR 136

PROVENANCE
Maximilien Luce, Paris; Léon Marseille; G. Tanner; Bernheim-Jeune, Paris; Sir John Maynard Keynes, London, by 1935; to present owner

EXHIBITIONS
1937 London, no. 36
1978 London, no. 18
1979–80 London, no. 198

Because this canvas is unfinished, it allows us to understand Seurat's working methods. The canvas reveals a number of horizontal and vertical lines that were probably used to locate the forms on the final canvas with the same loose weave of color and the same schematic shapes. It also shows that the colors he obtained in more finished works were based on this kind of underpainting in a few closely related tints of the local color, laid over a white priming rather than the darker tone of his wood panels. We see the deep green of shaded grass, for example, because of its basic greens, not because of an optical mixture of blue and yellow. Other hues were added to produce a broken hue more lively than a uniform one, the technique that Seurat had learned from Delacroix and then found in the work of the Impressionists. He was still using palette mixtures here, as he did in the first stage of the large picture.[1] For example, he used a brown mixed on the palette both for the left arm of the *promeneuse*, where it is combined with orange, and for her raised arm, where it is brushed in with orange, green, blue, and purple to form a greenish brown.

When he painted this canvas, Seurat was testing the laying in of the basic colors while consulting some of his panels for figure distribution. To the right are the seated women and the pram of *Femmes assises* (cat. no. 131); farther back, near the tree left of center, are a few strokes that indicate the skirt and trousers of the couple with a baby from *La jupe rose* (cat. no. 130). (These and the rest of the principal figures were also on the lost panel

137

[H 141] of the whole composition, which may have been Seurat's principal model for this large fragment.) The man of the promenading couple is summarily indicated, with a too small top hat. A folded umbrella projects downward from his blue coat (these elements would be replaced by a cane and a coat thrown over his arm).

This canvas was first owned by Maximilien Luce; it was one of several paintings and drawings that he had, perhaps gifts from the artist's mother in thanks for carrying out the inventory of her son's studio, together with Paul Signac and Félix Fénéon.

1. Fiedler 1989.

138. *Le couple.* 1884
THE COUPLE

Conté crayon, 12¼ x 9¼ in. (31.2 x 23.6 cm.)

Trustees of the British Museum

Exhibited in New York only
H 644; DR 135a

PROVENANCE
Georges Lévy, Paris, until 1927 when it was sold from his collection (sale, "Collections of MM. de T… and L. G.," Drouot, Paris, May 31, 1927, no. 424, for 28,000 francs);* with Hodebert,** Paris, 1927 until May 1928; sold to De Hauke and Co./Jacques Seligmann and Co., New York, in May 1928, until January 1930 (stock no. 1273);† purchased by César M. de Hauke, New York and Paris, in January 1930, until his death in 1965; his bequest to the museum, 1968

EXHIBITIONS
1932 London, no. 1003
1935 Chicago, no. 8
1949 New York, no. 37
1950 Venice, no. 11
1950 Rome, no. 7
1958 Chicago and New York, no. 102

*The *procès-verbal* for this sale indicates that the collector listed as "L. G." was Georges Lévy, 4 rue Girardon, Paris; his initials were simply inverted in the sale catalogue. Records at the Archives de Paris refer to this part of the sale as "Vente de Monsieur Georges Lévy" and confirm that this work, lot 424, was sold for 28,000 francs to Hodebert.
**See provenance note, cat. no. 45.
† See provenance note, cat. no. 30.

138

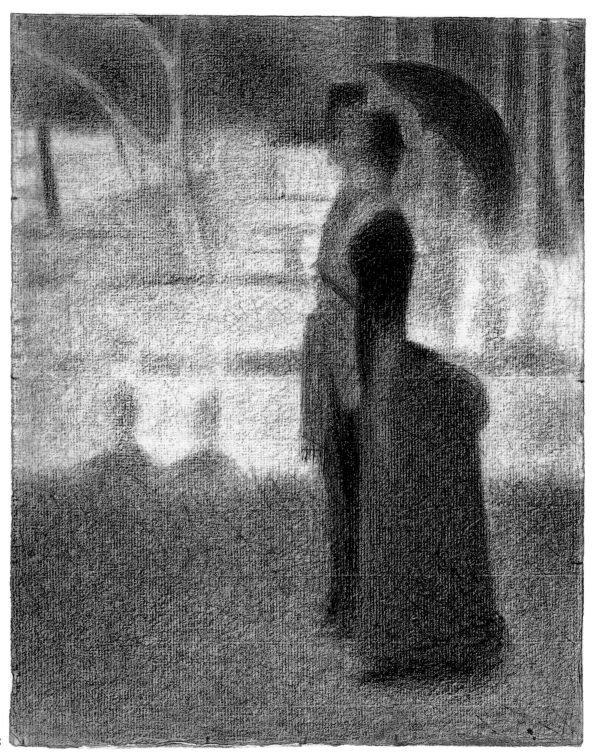

Drawings like this one established patterns of light and dark for Seurat's final canvas. Unlike the Impressionists, who substituted color for traditional chiaroscuro, Seurat thought in terms of the underlying tonalities of light and dark, which were as important as color to his theory of contrast. Here he duplicated the composition of the preceding color study; these separate essays in color and in value were merged on the final canvas. This drawing follows the color study. The man has exchanged the umbrella for the coat held over his arm, as in the final picture, although he does not yet have his cane or his cigar. To the right, faintly, are the two women and the pram of the earlier panel, and to the left are the upright bodies of the two seated girls (their heads seem to be missing at first glance, but delicate ovals can be found, slightly separated from the horizontal shadow behind them). Elsewhere Seurat engaged in what was an uncommon practice for him: he used pen and ink to reinforce shapes that he did not want to leave unclear—the parasol, the woman's raised arm, and the projecting portion of the man's costume.

139. *Paysage, l'Île de la Grande Jatte.* 1884

LANDSCAPE, ISLAND OF THE GRANDE JATTE

Oil on canvas, 27½ x 33¾ in. (69.9 x 85.7 cm.)
Signed and dated lower left: Seurat—84
Retouched about 1885; painted border added about 1888–89

Mrs. John Hay Whitney

H 131; DR 116

PROVENANCE
Inherited by the artist's brother-in-law, Léon Appert, Paris, in 1891, until at least 1905; to his son, Léopold Appert, Paris, by 1908–09,* until 1926; sold to Reid and Lefevre, Glasgow, in 1926; purchased by M. Knoedler and Co., London and New York (stock no. 16671), on joint account with C. W. Kraushaar Galleries, New York, in October 1926, until April 1929; sold to Reid and Lefevre, London, in April 1929; sold to Mrs. Chester Beatty, London, in April 1929, until her death in 1952; by inheritance to Sir Alfred Chester Beatty, Dublin, from 1952 until 1955; sold to Paul Rosenberg and Co., New York, in 1955; sold to present owner, 1955

EXHIBITIONS
1884–85 Paris, no. 241
1886 New York, no. 112
1892 Paris, Indépendants, no. 1088
1900 Paris, Revue Blanche, no. 15
1905 Paris, no. 2
1908–09 Paris, no. 50
1932 London, no. 519
1958 Chicago and New York, no. 68

*In the 1908–09 Paris exhibition catalogue, this work appears as no. 50, lent by "M. Ld. A." Owing to broken type in the printing of these initials there has been some confusion about the early ownership of this work (for example, DR list the owner in 1908 as "I. d'A."). Léopold Appert's initials are clearly printed as lender of no. 57.

This landscape inevitably brings to mind the large final composition with its many figures, and it may therefore seem unpeopled, somehow desolate. We should nonetheless try to take it on its own terms and not treat it simply as a study. Monet and other landscape artists frequently painted parks and meadows without prominent figures, so Seurat was not being markedly unusual here. Three boats animate the water and signal this area as a place of leisure, and a dog in the distance gives perspective to the broad

greensward. It is "empty" only in the sense of being a landscape destined for strollers and picnickers who are absent for the moment; it is a piece of nature that has been manicured into a serviceable pattern.

Since both this study and the final picture are on canvas, Seurat was able here to try effects different from those he could achieve on wood panels. But there is no reason to believe that Seurat began this canvas after all the small panels were done. Its essential composition is found among the earlier panels such as *Couseuse* (cat. no. 120), and he probably worked on it while he was going back and forth to the island in summer 1884.

Originally exhibited in December 1884, with the Indépendants, this canvas was reworked not long afterward, probably before its second exhibition (spring 1886 in New York). The painted border was added later, apparently in 1889 or 1890. In 1884 the canvas would have lacked the many small dabs that now are found across the shaded and sunlit grass and in the shaded portions of the distant trees. We can still see its original facture in the sky, the water, and the sunny foliage of the trees, as well as in those areas of the grass (for example, below and to the left of the nearest tree) that were not reworked. For the water Seurat emulated Monet's technique of squeezing out much of the oil from his paint, then dragging it sideways so that the canvas's vertical threads caught the thickened paint, creating a corduroy effect. The result is a shimmer that works well with the horizontal strokes to simulate the look of gently agitated water. For the sunlit grass Seurat first brushed in light brownish green in relatively large strokes; he then went over it with smaller touches of several greens, yellow-green, light creams, and oranges. For the shaded grass he followed the same procedure: first deep greens to establish the local color, then several tints of green, blue-green, blue, and wine red. When he reworked the picture, probably before mid-autumn 1885,[1] he used smaller strokes principally to add contrasting hues, especially the solar orange sprinkled over the shaded grass and the pinks that oppose the bluish purples.

At the end of the decade he added the narrow painted border, a change he made on many of his canvases, including the huge final composition, in order to provide a

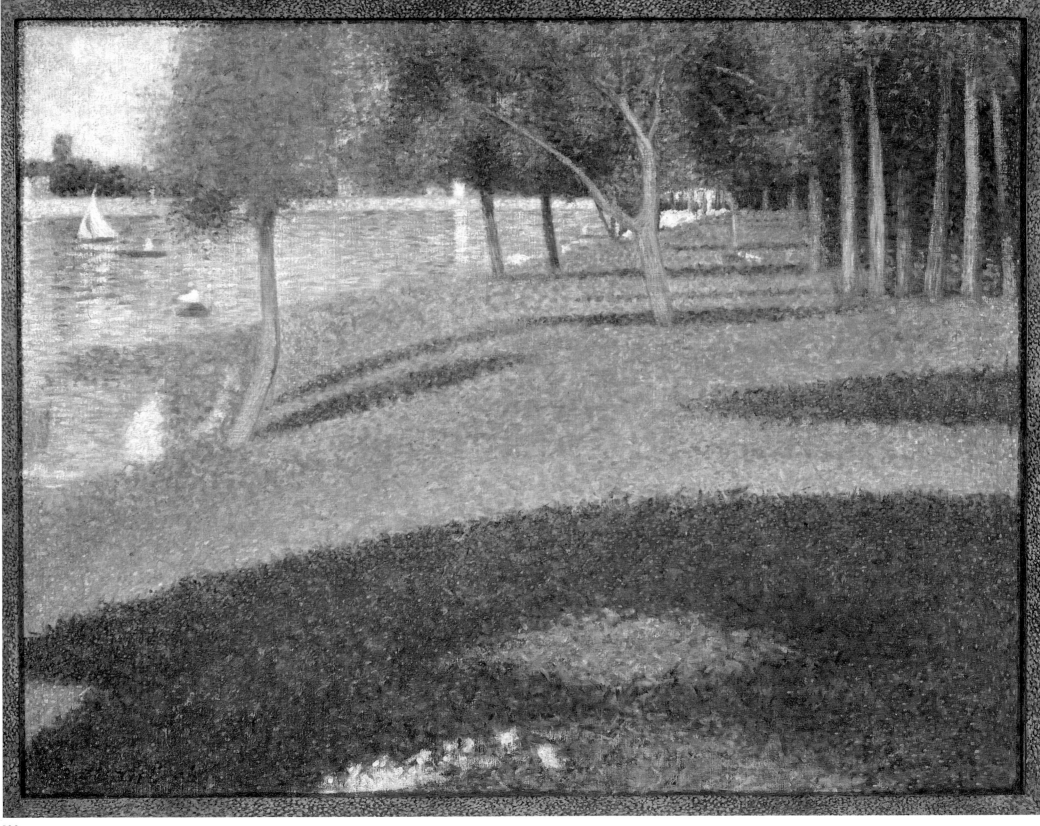

transition to the frame and hence to the outer world. About ¼ inch (6 mm.) wide, it is proportionately narrower than the borders on his late marines and simpler than most of them. It is nearly pure blue next to the water and along the bottom, adjacent to the yellow and reddish patches; next to the sky it is a mixture of blue and orange dots. Elsewhere, next to foliage and grass, it is largely limited to blues and reds that give a purplish result. When he painted the border, Seurat also added to the nearby surface a faint trace of light-colored strokes, as a counter-reaction to the border's prevailingly dark tone.

1. Inge Fiedler (1989) examined this picture when she was studying the pigments of *La Grande Jatte*. She verified three stages of painting: the original one, a reworking, and the added border. She did not find in the second stage the zinc yellow which, being unstable, changed the look of the large canvas (bright yellows degraded to ocher, orange to brown, green to olive). We know from Seurat's testimony that he began repainting *La Grande Jatte* after October 1885. Since the zinc yellow characterized this repainting but is absent from the Whitney landscape, the smaller picture may have been reworked before mid-autumn 1885.

140. *Paysage, l'Île de la Grande Jatte.* 1884

LANDSCAPE, ISLAND OF THE GRANDE JATTE

Conté crayon, 16¼ x 24¼ in. (42.2 x 62.8 cm.)
Signed lower right: Seurat

Trustees of the British Museum

Exhibited in Paris only
H 641; DR 116c

PROVENANCE
The artist's mother, Mme Ernestine Seurat, Paris, from 1891, probably until her death in 1899; by inheritance to the artist's brother, Émile Seurat, Paris, from 1899; Louis Bouglé, Paris, by 1900, until at least 1909; André Berthellemy, Paris, by 1935, until no later than 1943; César M. de Hauke, Paris, until his death in 1965; his bequest to the Museum, 1968

EXHIBITIONS
1892 Paris, Indépendants, no. 1119
1900 Paris, Revue Blanche, no. 48
1908–09 Paris, no. 184
1958 Chicago and New York, no. 84

Seurat made this drawing to tailor the proportions of his landscape to those of the final canvas. Comparison with the preceding painted landscape shows that he lowered the top edge of the rectangle and raised the bottom. This still did not give enough lateral room, so he stretched the distance between the two nearest trees. Now there appear the flashes of whitish sand along the shore that mark the final composition, as well as the steamboat farther back and the black dog in the foreground. The steamboat came from one of the panels (cat. no. 122) and the dog from a separate drawing (H 642), but Seurat must also have worked on the island to make such a fine adjustment of the lights and darks that play over the grass. The dog gives scale to the drawing and permits the foreground shadow to tip back; without it the shadow would seem to rise up very flatly. Beyond the steamboat the horizontal of the far shore, which elsewhere appears as a continuous white band, is here a gray region barely distinguishable from the water. This has the effect of flattening that area and bringing it forward. Oddly enough the stark light horizontal of the finished picture stays more convincingly in the distance.

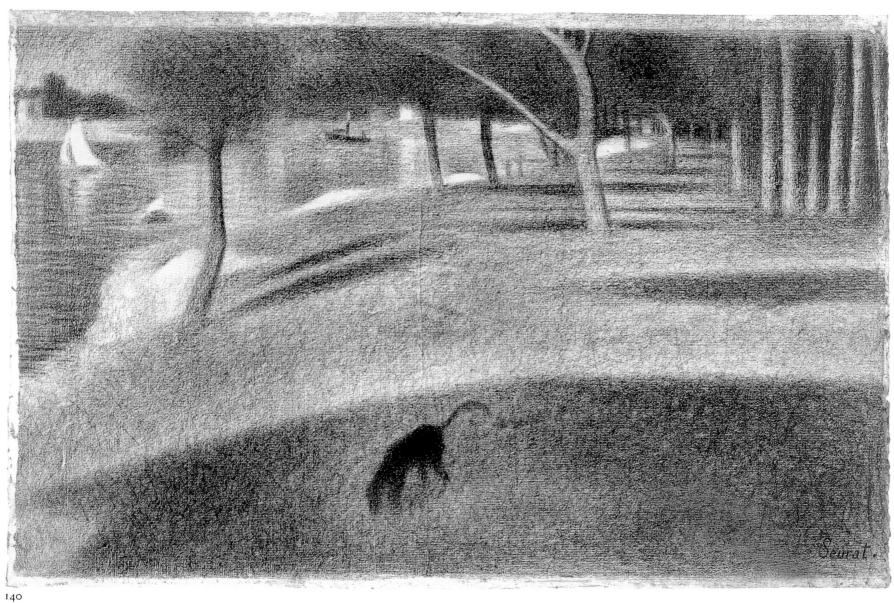

140

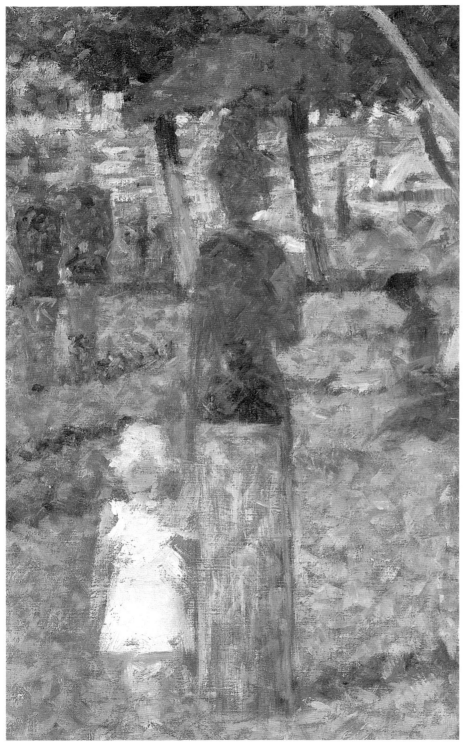

Detail from cat. no. 141

141. *Étude d'ensemble.* 1884
STUDY FOR "A SUNDAY ON LA GRANDE JATTE"

Oil on canvas, 27¾ x 41 in. (70.5 x 104.1 cm.)
Painted border by the artist

The Metropolitan Museum of Art, New York, Bequest of Sam A. Lewisohn, 1951 51.112.6

H 142; DR 138

PROVENANCE
The artist's brother-in-law, Léon Appert, Paris, by 1892; Félix Fénéon, Paris, by 1900, until at least 1909; Stephan Bourgeois, New York, in 1918; Adolph Lewisohn, New York, from 1919 until his death in 1938; by inheritance to his son, Samuel A. Lewisohn, New York, from 1938, until his death in 1951; his bequest to the Museum, 1951

EXHIBITIONS
(?)1886 New York, *hors cat.*
1892 Paris, Indépendants, no. 1088
1900 Paris, Revue Blanche, no. 16
1905 Paris, no. 5
1908–09 Paris, no. 45
1929 New York, no. 56
1932 London, no. 523
1935 Chicago, no. 15
1940 New York, no. 369
1948 New York, no. 50
1949 New York, no. 7
1958 Chicago and New York, no. 100
1968 New York, no. 76
1977 Düsseldorf, no. 104
1977 New York, no. 49

X-ray photograph of cat. no. 141. Department of Paintings Conservation, The Metropolitan Museum of Art

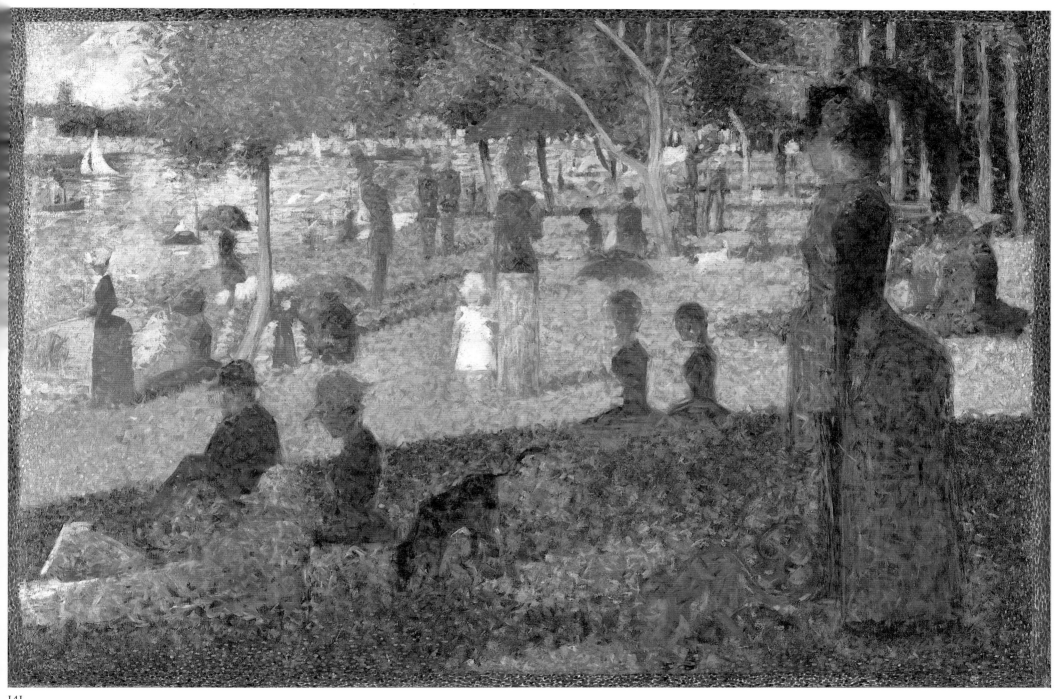

141

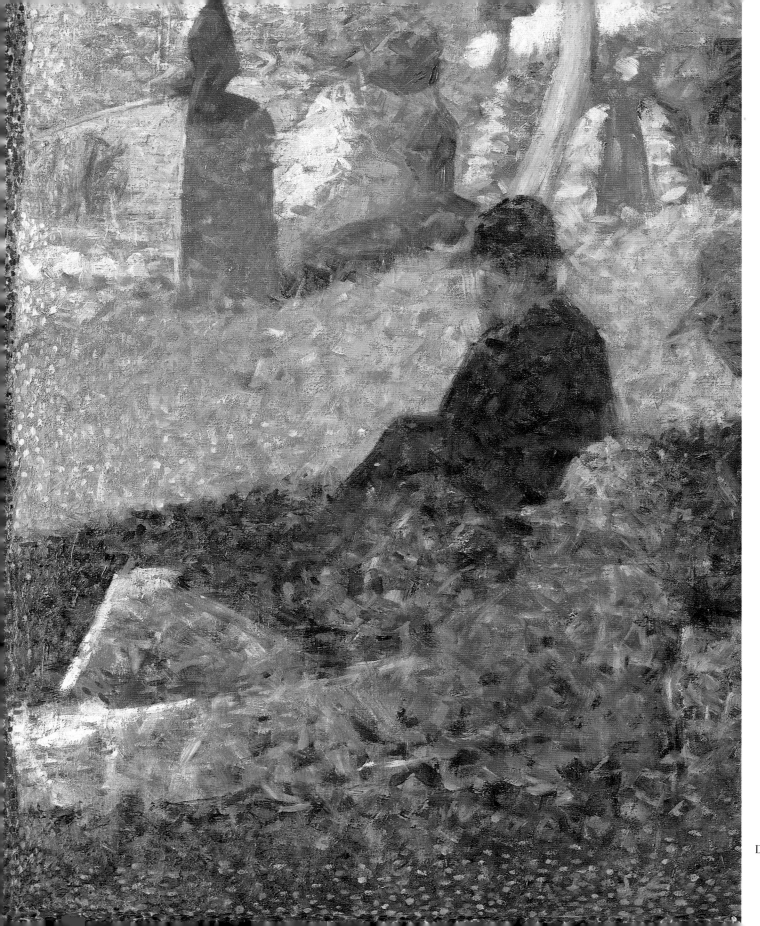

Seurat's 1890 letter to Fénéon (Appendix F) relates that the final composition was first readied for exhibition in spring 1885. Because several months would have been needed to bring it to that stage, this large sketch must have been completed in summer or fall 1884. The sketch was later restretched to allow room for a painted border, and in reaction to this border, a few light yellow dots were added to the edges of the composition. It was based principally upon the lost panel of the whole composition (H 141), but Seurat probably also used several of the wood panels and drawings in which some of the figures appear separately. Here the changes from the lost panel and *Le couple* (cat. no. 137) include the movement rightward of the central horizontal shadow. Since the shadow no longer backs the heads of the two seated girls, they are more effectively isolated against the brightly lit grass. More interesting still are the differences between the final composition and this study, many of which depended upon intermediate drawings. When he defined the edges of his figures, Seurat often changed their characters. The seated man in a bowler hat in the lower left becomes the dandy with top hat and cane. The woman to his right is all curves to fulfill the traditional contrast of masculine and feminine shapes. Her hat has been changed to reinforce her rhythms. Seurat's penchant for contrasts shows everywhere in the final composition. Compared with the two seated girls in this sketch, those in the Chicago canvas are a crisscross of oppositions within their harmonic pairing. The one has lofted her parasol and wears a hat; the other's umbrella and hat are on the ground. One looks up, the other down; one has a red upper body and a blue skirt, the other, the reverse. The *promeneuse* in her final form is less slender and her bustle has been considerably widened. The latter alteration was made during the repainting of the picture after October 1885; among similar changes is the widening of the dress of the fisherwoman on the other side. We can therefore assume that in its first stage the Chicago canvas had the more slender, rather wooden shapes of the present sketch and would have appeared less graceful, more "primitive."

The sketch is free of the zinc yellow that contaminated the pigments of the large picture, so its colors are closer to what Seurat would have wished, although they are more intense because they lack the finely stitched mixtures of the finished composition. The colors are not placed over a white priming, as are those in *Le couple*, but over a brown

Detail from cat. no. 141

ground, which gave Seurat the middle value he knew from working on wood. This canvas brown enters into most colors, showing between the surface strokes as a stable matrix. It tones down the fiery shirt of the reclining man in the lower left, combining with orange-red, wine red, both dark and light greens and blues, and traces of pink. The canvas brown is a constituent also of his trousers, creamy yellow in the sun and blue in the shade (blues, orange, wine red, green, and pink). The canvas does not show in the dark portions of most of the figures, which were undercoated in bright red, over which Seurat put several tints of blue and wine red and a purple resulting from the mixture of these two.

In September 1990 Charlotte Hale, associate conservator at The Metropolitan Museum of Art, made a thorough examination of the painting, employing both infrared reflectography and X-radiography. Her work revealed a grid of lines underneath the picture, dividing it horizontally and vertically into halves, and also horizontally into thirds. This division into quarters and sixths (each of the sixths forms a square) was simply an aid in enlarging the composition and in locating the relevant distances between figures; it is not a complicated scheme like the golden section, which Seurat seems never to have used. The horizontal bisection coincides with the base of the shadow and seated group just beyond the large couple to the right, and two of the verticals pass through the centers of two seated figures, but no other matches of grid to pattern are evident. The recent examination also revealed that Seurat restretched the canvas on the left and right sides to make room for the painted border but found enough room on the top and bottom of the existing canvas for his additional work. Whereas the composition itself has no ground or priming layer, the strip under the border on all four sides was prepared with a white coating.

Detail from cat. no. 141

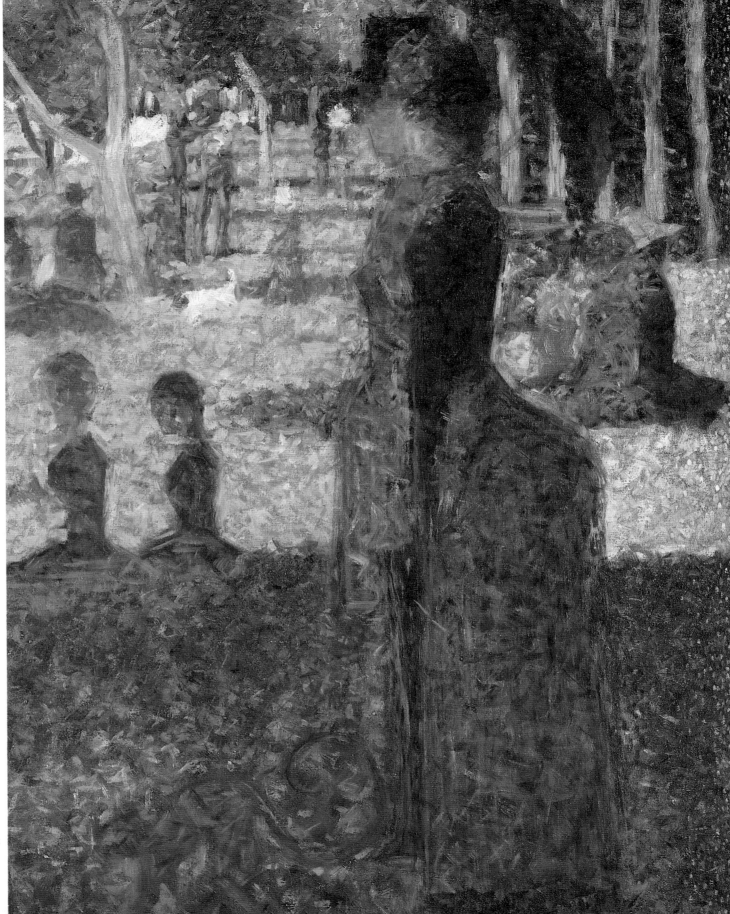

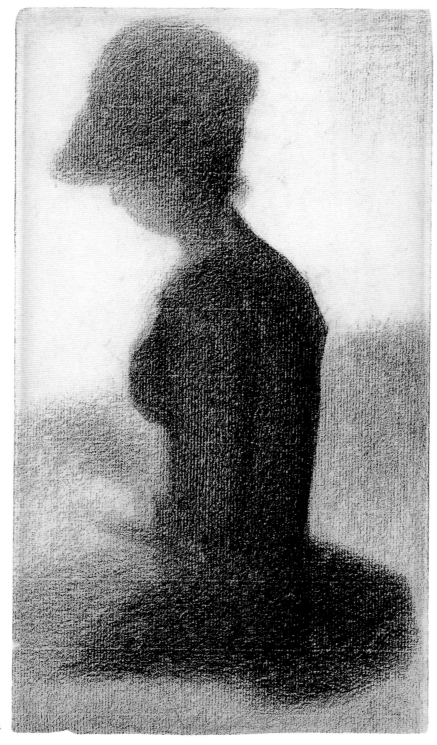

142

142. *Jeune femme assise.* 1884
YOUNG WOMAN SEATED

Conté crayon, 11⅞ x 6½ in. (30.2 x 16.6 cm.)

Philadelphia Museum of Art, The Louis E. Stern Collection

H 632; DR 138i

PROVENANCE
The artist until 1891. Posthumous inventory, dessin no. 347 (per inscription on reverse, not recorded by de Hauke). Possibly Maximilien Luce, Paris; Comte Antoine de la Rochefoucauld, Paris; sold to Leo Michelson, New York, until April 1947; sold to Louis E. Stern, New York, in 1947, until his death in 1962; gift of the Trustees of the Stern Foundation to the museum, March 4, 1964

EXHIBITIONS
1926 Paris, Bernheim-Jeune, no. 149 suppl.
1953 New York, no. 30
1958 Chicago and New York, no. 77

Seurat transferred the composition of the large sketch to his final canvas sometime in late summer or early autumn 1884. He then refined each figure, making a number of drawings that established their shapes and their structures in light and dark. In this drawing he revised the form of the woman seated in the lower left. He gave her a rounded hat instead of an angular one and lengthened her neck (of course, the woman in the painted sketch was only roughly conceived); he also moved the line of the shaded grass to its definitive position. The subtle modeling of the woman's head and the nuanced rendering of the clothing she wears indicate that he probably worked from a model. Despite her strong silhouette the woman's form reads as a three-dimensional mass illuminated from the left. In a subsequent study of her head (H 634; Smith College, Northampton, Massachusetts) Seurat more closely observed the light-and-dark pattern of her hat and the shadows it cast upon her face.

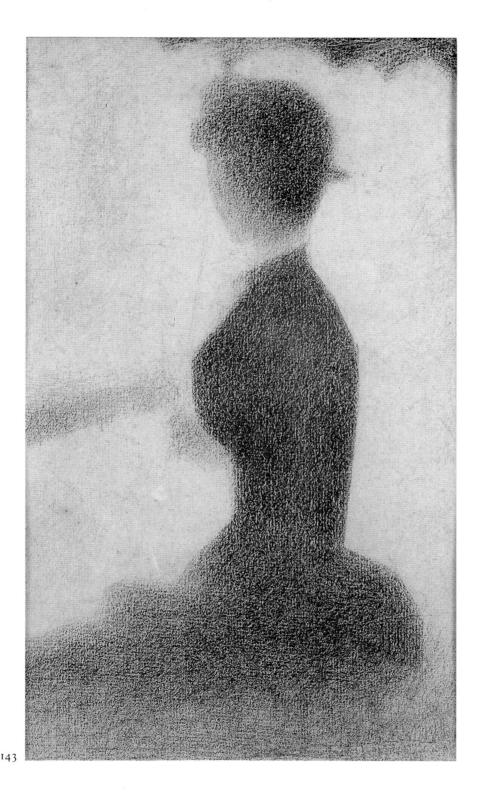

143

143. *Femme à l'ombrelle.* 1884
WOMAN WITH PARASOL

Conté crayon, 11¾ x 7⅛ in. (30 x 18 cm.)

Private collection

H 628; DR 138g

PROVENANCE
Paul Signac, Paris, until his death in 1935; by inheritance to Berthe Signac, Paris; André Dunoyer de Segonzac, Paris, by at least 1958, until his death in 1974; by inheritance to his widow, Mme André Dunoyer de Segonzac, Paris; Mme Thérèse Dorny; to present owner

EXHIBITIONS
1957 Paris, no. 62
1958 Chicago and New York, no. 83

Seurat made two drawings of the young woman with a parasol seated to the right of center, neither of which he followed with exactitude in the final canvas. Here he presents the torso as virtually a flat silhouette, with only a slight darkening under the bust and at the base of the skirt. He drew the grass with a lighter, slightly different touch so that it is readily distinguished from the skirt without creating a sharp transition. The model's face reflects light as it turns slightly away from us, and the hand that holds the parasol shows only faintly. Like the preceding drawing, the figure is centered on the page and crowded by the sheet's edges, so that it has the close view of many of his earlier independent drawings. Seurat was evidently determined to make a masterpiece of each of his drawings, even studies for paintings.

144. *Jeune femme à l'ombrelle.* 1884
YOUNG WOMAN WITH PARASOL

Conté crayon, 18⅞ x 12⅜ in. (48 x 31.4 cm.)

The Museum of Modern Art, New York, Abby Aldrich Rockefeller Bequest

H 629; DR 138f

PROVENANCE
Félix Fénéon, Paris, by at least 1905, until 1923; sold, through Henri Pierre Roché, to John Quinn, New York, in 1923, until 1924; his estate, from 1924; Arthur B. Davies, New York, until his death in 1928; his estate, 1928–29 (Davies estate sale, American Art Galleries, New York, April 16–17, 1929, no. 402, for $4,000); purchased at this sale by C. W. Kraushaar Galleries, New York; Abby Aldrich Rockefeller, New York, by 1934, until her death in 1948; her bequest to the museum, 1948

EXHIBITIONS
1905 Paris, no. 6
1908–09 Paris, no. 193
1929 New York, no. 67
1949 New York, no. 51
1958 Chicago and New York, no. 85
1977 New York, no. 29

This woman's body is more volumetric than that of the previous drawing, since we see the outline of her arm, and her skirt is lighter than her torso. Her head is proportionately larger than that of the other variant, her bust is smaller, and her body flares out below her waist, changes that bring her closer to her painted simulacrum. In the painting, however, the woman's arm is farther to the right, the brim of her hat is lower, and its rear profile is slanted more to the left. As he worked on the canvas, Seurat made constant adjustments. We will never know to what extent he used live models for his pictures, but this drawing seems closer to a life study than the other, whose flatness and proportions are more arbitrary. By positioning the woman to the right, Seurat exposed more paper, a change that heightens the effect of glaring sunlight that surrounds her on the large canvas.

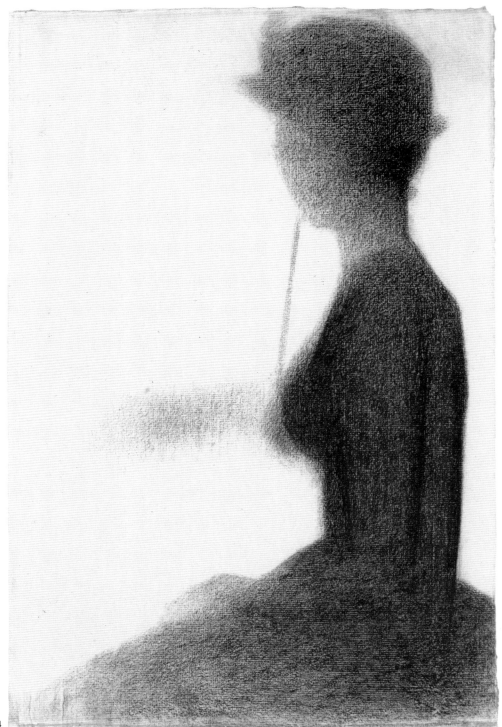

144

145. *L'enfant blanc.* 1884

CHILD IN WHITE

Conté crayon and chalk, 12 x 9¼ in. (30.5 x 23.5 cm.)

Solomon R. Guggenheim Museum, New York, Gift, Solomon R.
Guggenheim, 1937

H 631; DR 138b

PROVENANCE
The artist until 1891. Posthumous inventory, dessin no. 350 (per
inscription on reverse in red crayon, initialed in blue crayon by
Maximilien Luce, not recorded by de Hauke);* Félix Fénéon, by at
least 1905, and probably in 1891, until 1930; sold to Solomon R.
Guggenheim, New York, in 1930,** until 1937; his gift to the
museum, June 1937

EXHIBITIONS
1905 Paris, no. 7
1908–09 Paris, no. 189
1920 Paris, no. 43
1926 Paris, Bernheim-Jeune, no. 109
1958 Chicago and New York, no. 72
1977 New York, no. 30

*Without recourse to Fénéon's description of the numeration of
drawings included in the posthumous inventory (H, I, p. XXIX), it
would be difficult to decipher, with any degree of certainty, the
inventory number inscribed on the reverse. Luce had a curious way
of writing the number "5" (see also provenance note, cat. no. 184),
so the number could be read: 350 or 390 or even 380. Fénéon notes,
however, that the inventory included twenty-three drawings for *La
Grande Jatte* that were numbered 330 and from 340 to 361.

**Date of purchase based on registrar's shipment invoice, dated
November 12, 1930.

More than any other drawing for *La Grande Jatte*, this one
shows how Seurat based his forms upon the atmospheric
play of light and dark. It is an exact study for the final
composition, for above and below are the shadows that
figure in the painting. The untouched paper represents the
blinding effect of a white garment in direct sunlight.
Everything in the drawing is keyed to this glowing white,
as indeed is true also of the painting. Seurat followed
Corot, who stressed the need for a single "point lumineux"
(luminous point) in a painting. Like Corot, he first thought
of "the value of the tones; color, for me, comes afterward"
(Appendix M).

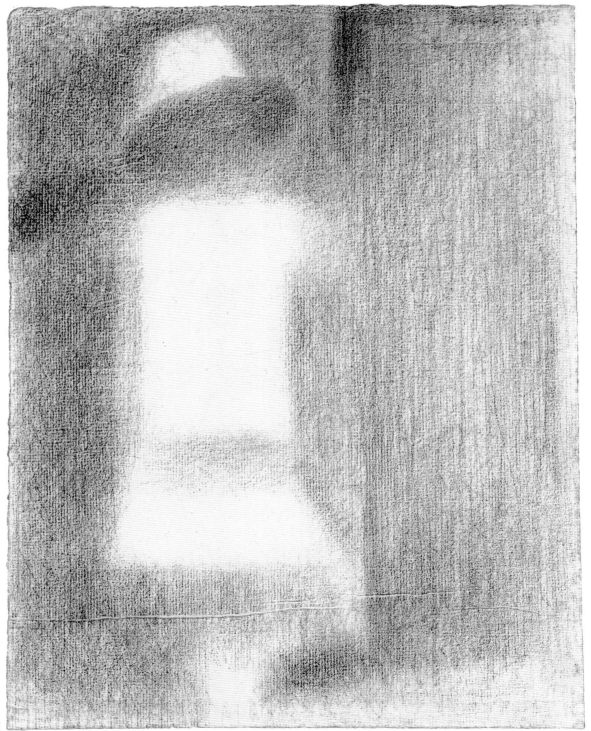

145

At first glance the child's hat seems to float above her body, but the oval shadow lets us sense her head, and there are hints of her face in delicate shifts of gray. Seurat drew the mother's long skirt and the child's lowered arm in very light verticals that suit their columnar forms. The drawing embraces a variety of rubbed and drawn textures which range from near-white to black.

146. *La nourrice*. 1884

NURSE

Conté crayon, 9¼ x 12¼ in. (23.5 x 31.1 cm.)

Albright-Knox Art Gallery, Buffalo, New York, Gift of A. Conger Goodyear, 1963

H 630; DR 138c

PROVENANCE
Félix Fénéon, Paris, by 1905, until at least 1909 and probably until 1923;* John Quinn, New York, in 1923, until his death in 1924; his estate, 1924–26; purchased from the estate for $400 by A. Conger Goodyear, Buffalo and New York, probably between February and April 1926,** until 1963; his gift to the museum, 1963

EXHIBITIONS
1905 Paris, no. 8
1908–09 Paris, no. 187
1920 Paris, no. 42
1929 New York, no. 68
1935 Chicago, no. 18
1936 New York, no. 259
1947 New York, no. 7
1949 New York, no. 43
1958 Chicago and New York, no. 75
1968 New York, no. 77
1983–84 Bielefeld and Baden-Baden, no. 69

*Fénéon, who was affiliated with Bernheim-Jeune from 1906 until 1924, was probably the anonymous lender to the 1920 exhibition at Bernheim-Jeune; it is likely that he sold the work to Quinn in 1923.

**See Judith Zilcher, *"The Noble Buyer": John Quinn, Patron of the Avant-Garde*, Washington, D.C., 1978, no. 70, pp. 140–41.

With the chunky simplicity of a seated Egyptian scribe, a nurse, seen from behind, sits next to her elderly patient. The old woman lacks the energy to raise her parasol aloft; she holds it in an arm supported on her lap. Her shoulders are slumped and her head is settled down on her chest, altogether a striking contrast with the picture's young women and with the nurse who has the strength of a boulder.[1] The nurse is the only certain working-class figure in the painting (the reclining man in the lower left may be another worker but is more probably a canoeist). In earlier drawings and paintings Seurat had shown a sympathetic understanding of working people, but here he reduces the woman to her class and function by treating her so abstractly. The black square in the lower left is the

top hat of the seated dandy so, like *L'enfant blanc* (cat. no. 145), this drawing is a veritable excerpt of the large painting. Seurat nonetheless framed it with cunning to make it an admirable composition in its own right. The nurse looms up flatly from the base of the sheet, and her charge's parasol touches its upper edge. The bent tree and the diagonal shadows provide counterpoint for the large shapes and help locate them in illusionary space. Seurat used his crayon to produce a neutral, shimmering texture except in the lower right, where his dashes evoke the cropped grass of the island.

1. In a number of recent studies (principally Nochlin 1989) this figure is called a "wet nurse," and much is made of the absence of a baby and of her nurturing role, as well as of her frequent representation with a male admirer. However, she is simply a nurse, an attendant hired to care for an elderly woman or man.

147. *Trois jeunes femmes*. 1884

THREE YOUNG WOMEN

Conté crayon, 9¼ x 12 in. (23.5 x 30.5 cm.)

Smith College Museum of Art, Northampton, Massachusetts, Purchased, Tryon Fund, 1938

H 633; DR 138d

PROVENANCE
Félix Fénéon, Paris, by 1905, until at least 1926; Mrs. Cornelius J. Sullivan, New York, by 1929, until 1938; purchased by the museum, June 1938

EXHIBITIONS
1905 Paris, no. 9
1908–09 Paris, no. 191
1926 Paris, Bernheim-Jeune, no. 110
1929 New York, no. 69
1935 Chicago, no. 7
1947 New York, no. 4
1949 New York, no. 47
1958 Chicago and New York, no. 78

In this drawing Seurat reworked the figures from one of the panels (cat. no. 131) to establish their tones and shapes for the large canvas. He separated them in his characteristic maneuver of isolating figures against their background; this also flattens them into a lateral plane.

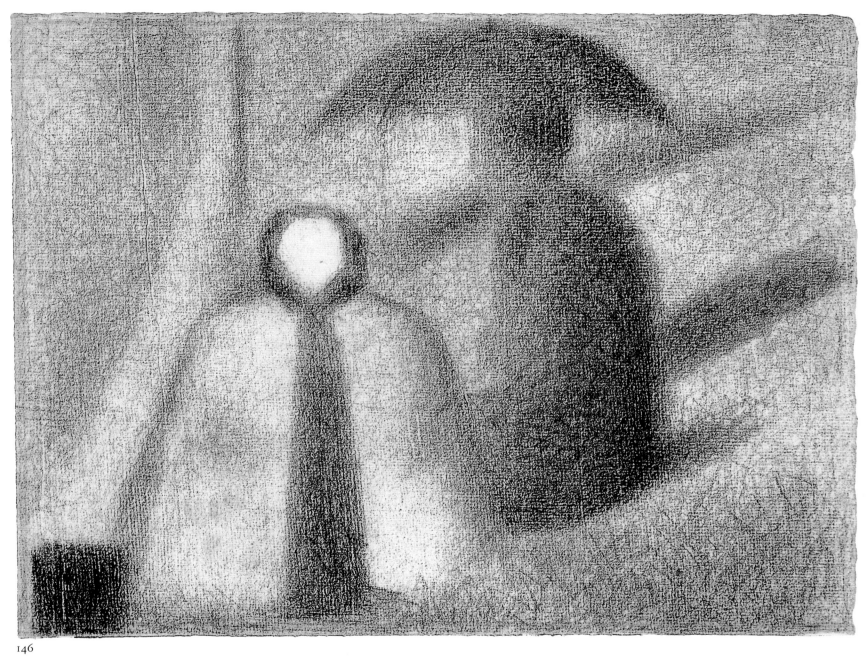

146

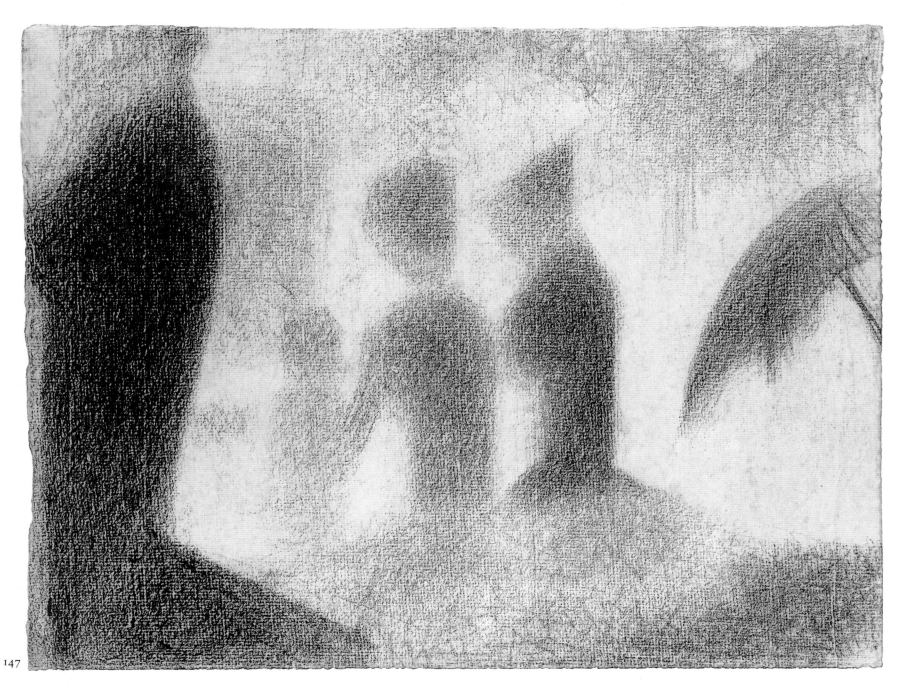

147

Different costumes explain the fact that one woman's torso is darker than the other's, but atmospheric distance accounts for the fainter gray of the shapes immediately to the right of the large *promeneuse*. Without the aid of the painting we might not have deduced that these shadowy forms represent a small child (her mother's arm is extended to her back) and, above and beyond her, a baby carriage. Like the preceding two, this drawing is a fragment of the large canvas in its first stage (the promenading woman has not yet acquired her larger bustle). To the right a parasol leans into the drawing, explaining the orange arc on the edge of the final painting.

218 LA GRANDE JATTE 1884–1886

148. *Jupe*. 1885

SKIRT

Conté crayon, 11¼ x 6⅛ in. (30 x 17 cm.)

Musée Picasso, Paris

Exhibited in New York only
H 624; DR 133c

PROVENANCE
The artist until 1891. Posthumous inventory, dessin no. 280. Inherited by the artist's brother, Émile Seurat, Paris, in 1891, probably until 1900;* Félix Fénéon, Paris, probably in 1900, until 1941 (Fénéon sale, December 4, 1941, no. 21, for 10,000 francs); Raoul Pellequer; Pablo Picasso, probably from about 1942, until his death in 1973; his heirs, 1973–79; acquired by the Musées Nationaux, in lieu of state taxes (by *dation*), in 1979; transferred to the Musée Picasso, 1985

EXHIBITIONS
1900 Paris, Revue Blanche, *hors cat.*
1908–09 Paris, no. 195
1926 Paris, Bernheim-Jeune, no. 112
1936 Paris, no. 121

*Seurat's family sold some fifty drawings from the Revue Blanche exhibition in 1900; Pissarro purchased several drawings at this time and Fénéon even more. See Rewald, "Fénéon" *Gazette des beaux-arts*, 1948, p. 116; and Halperin 1988, p. 317.

When Seurat reworked his large canvas in autumn 1885, he greatly widened the bustle of the promenading woman by adding a flow of curves along its front and a wider undulation along its back. The principal model for this alteration is *Promeneuse à l'ombrelle* (H 625; Museum of Modern Art, New York), but as an interim measure he made this close study. Its folds are less graceful than those of the full drawing of the woman or her painted form. Unlike most other drawings, which are complete in themselves, this one is a technical study of the way the cloth revealed its underlying harness (he made a caricature of the support mechanism in a small drawing [H 615]). The bustle reached its greatest extent in the mid-1880s. Several yards of material were needed to make it, and here Seurat uses it to point up the ostentation of the woman and her companion.

148

149. *La charrette attelée*. 1884

HORSE AND CART

Oil on canvas, 13¾ x 16⅛ in. (32.4 x 40.9 cm.)

Solomon R. Guggenheim Museum, New York, Gift, Solomon R. Guggenheim, 1941

H 46; DR 31

PROVENANCE
Percy Moore Turner, London, until 1928 (his sale, "Mr. T... of London," Drouot, Paris, April 2, 1928, no. 39); Félix Fénéon, Paris, by 1929, until 1938; sold to Solomon R. Guggenheim, New York, in 1938, until 1941; his gift to the museum, 1941

EXHIBITION
1936 Paris, no. 11

Painted after the *Baignade,* during the summer Seurat was working principally on *La Grande Jatte,* this is among his last canvases on a rural theme. Most pictures that he did after 1883 show the banks of the Seine and other subjects that share the Impressionists' orientation toward sites of leisure. That shift was rather sudden, yet this picture is witness to the lingering attraction of country subjects for the young artist, as well as for Pissarro, Gauguin, and van Gogh. The modernity of this picture lies in its brilliant colors, its arbitrary brushwork, and Seurat's signature composition of rather flat planes and abruptly separated shapes. The wagon's wheels are not shown, so that the raised brake arm and the shaft give a strange effect to the still horse. The animal's head and the tree trunks are sharply outlined against the central white building, but elsewhere the planes come forward to the surface. The composition is held together by the governing harmony of oranges and yellows versus greens and blues, and also by the way the arabesques of the trees repeat the shape of the building and contrast with the flat stripes across the foreground.

The palette of this picture lets us date the work to 1884. Superficially it looks like *Paysannes au travail* (cat. no. 93) of 1882–83, but here the chopped straw (*balayé*) of paint is more finely interwoven, the contrasts of orange and blue are more pronounced, and the particular light blue that marks many studies for *La Grande Jatte* now appears on a canvas. Furthermore its range of colors and the way Seurat applied his paints are found in *La luzerne, Saint-Denis* (cat. no. 152) and *La Seine à Courbevoie* (cat. no. 153) of 1884–85, if we make allowance for the subsequent retouching of these two. Only in the horse might earth colors have been used, but even there the browns may result solely from the admixture of orange and wine red with blue. Lavender-pink now appears in all the green growth—Seurat could have found precedents for this use of broken colors in Delacroix, although his brushwork is more arbitrary and his coloration more intense than those of his famous predecessor. In the sunny areas of the trees, the pink enhances the dominant yellow-green (which consists of orange, orange-tan, yellow, and yellow-greens); in the sunny grass the pink is altered to lavender to suit the prevailingly greener tint. In the shaded areas some pink is scumbled with blue—a traditional way of unifying a picture by interweaving its colors. The pink is very strong along the narrow pathway, where it mediates between the orange and yellow (that is, where it suggests the red that those two colors would form if mixed on the palette). In this fashion Seurat hoped to convince our eyes that an optical mixture was taking place, although he actually painted the hoped-for result alongside the constituent hues.

149

150

150. *Le Pont Bineau.* 1884

THE BINEAU BRIDGE

Oil on wood, 6⅛ x 9¾ in. (15.5 x 24.5 cm.)

Nationalmuseum Stockholm

Exhibited in Paris only
H 106; DR 103

PROVENANCE

The artist until 1891. Posthumous inventory, panneau no. 115. Inherited by the artist's brother, Émile Seurat, Paris, in 1891, probably until 1900; Félix Fénéon, Paris, by at least 1905, and probably in 1900, until at least 1926; Georges Bernheim, Paris; Étienne Vautheret, Lyons; with Hodebert,* Paris; D. W. T. Cargill,

Lanark, Scotland, probably until his death in 1939;** with Bignou Gallery, New York, by 1940, until 1944; with French Art Galleries, New York, by 1944; owned jointly with M. Knoedler and Co., New York, from November 1944 until February 1945 (stock no. A2974); with French Art Galleries, after February 1945; with Fine Arts Associates, New York, by May 1949; sold to M. Knoedler and Co., New York, October 1949 (stock no. A4255); sold to Dr. Philip Sandblom, Stockholm, in December 1949, until 1970; gift of Grace and Philip Sandblom to the museum, 1970

EXHIBITIONS
1900 Paris, Revue Blanche, *hors cat.*
1905 Paris, no. 16
1908–09 Paris, no. 46

1919–20 Paris, no. 52
1924 New York, no. 11
1926 London, no. 8

*See provenance note, cat. no. 45.

**Cargill died in September 1939, and his collection was dispersed in the United States during World War II. See R. Pickvance, "Introduction," in *A Man of Influence: Alex Reid (1854–1928)*, Edinburgh, 1967, p. 13.

In painting this little panel, Seurat literally stood on the ground the Impressionists had already trod. Both Sisley and Monet had painted along the same shore, although

151

their compositions are less crowded and give more prominence to the river. The Pont Bineau crosses the island of La Grande Jatte at about its middle. Its attenuated arch shows here on the left before it disappears behind the island's foliage, an effect that both Monet and Renoir were fond of. In front of the bridge a French flag floats above a low horizontal mass, which may be a barge. Nearer to us is a short post, and to the right are small shanties and boat sheds of the kind seen in an earlier panel, *Homme peignant son bateau* (H 66; Courtauld Institute Galleries, London). That panel, probably painted in 1883, has larger brushstrokes and lacks the bright yellows of this work, which must be from 1884. The painting shows greater freedom of han-

dling than contemporaneous studies for *La Grande Jatte*; this looser quality may result from fresh study on the site. Blues and tints of purple, together with dark greens, mark the shadows; they contrast with the greenish yellows and oranges of the sunlit foliage, so intense that medium greens virtually disappear.

151. *Le pêcheur.* 1884–85

RIVERMAN; FISHERMAN

Oil on wood, 6¼ x 9¾ in. (15.9 x 24.8 cm.)
"Moline" stamp in red lower right: Seurat

Yale University Art Gallery, New Haven, Bequest of Edith Malvina K. Wetmore

H 65; DR 99

PROVENANCE
Probably Madeleine Knoblock, Paris, from 1891; Félix Fénéon, Paris; Étienne Bignou, Paris, until 1929; sold to M. Knoedler and Co., July 23, 1929, until 1937 (stock no. A903); sold to Edith

Wetmore, New York, March 3, 1937, until 1966; her bequest to the museum, 1966

EXHIBITIONS
1895 Paris
1949 New York, no. 16

Despite the title, the riverman shown here is not fishing but plunging a long pole into the water, probably to rake up gravel or sand used in building projects. About two years earlier Seurat had painted the identical subject in more traditional brushwork (H 63; Courtauld Institute Galleries, London). In that picture the colors are not as separate from one another, and there are fewer oppositions. In this panel Seurat placed more of his colors in separate strokes over the water and only partly brushed them together to render the barge and the boat. The dark purple hulls of both the barge and the boat have bright green reflections in the water, whereas in the earlier panel the similar-colored boat produced a grayish blue reflection. The sandy strip on the island to the right, bordered both above and below by purple, displays the traditional yellow-purple complementaries, and the broad zone of reflection below is a medley of green, purple, and yellowish tan.

This panel was probably painted along the Seine at Asnières or Courbevoie, not far from the site of the canvas *La Seine à Courbevoie* and its study (cat. nos. 153 and 154). Seurat portrayed men and women in conventional roles dictated by sex and class: here he painted a man at work and put a commercial barge in the background to specify his environment, whereas in *La Seine à Courbevoie* he represented a woman taking a walk against a backdrop of suburban villas nestled in foliage, with no hint of the river's industrial uses.

152. *La luzerne, Saint-Denis.* 1884–85
FIELD OF ALFALFA, SAINT-DENIS

Oil on canvas, 25¼ x 32⅞ in. (64 x 81 cm.)
Signed lower left: Seurat

National Galleries of Scotland

H 145; DR 159

PROVENANCE
Bernheim-Jeune, Paris, by 1920; Roger Fry, London, by 1922, until his death in 1934; the executors of the Estate of Roger Fry, on deposit at the Courtauld Institute, London, from 1934; Mrs. Pamela Diamand, Maldon, Essex; purchased with a Treasury grant, the National Art Collections Fund, and the family of Roger Fry, 1973

EXHIBITIONS
1886 Paris, Indépendants, no. 359
1920 Paris, no. 24
1932 London, no. 535
1950 London, no. 78
1978 London, no. 18
1984–85 Los Angeles, Chicago, and Paris, no. 101

In Seurat's day there was still a broad plain that separated Saint-Denis from Paris, and farming had not yet given way entirely to housing and industry. By painting these fields, Seurat avoided the city's factories, as had Monet and Pissarro before him. With a kind of innocent directness he characterizes the region in this rudimentary composition. Across the field of alfalfa, reddened by invasive poppies, we find a low wall, then a hayfield, and finally a string of structures that are probably both farm buildings and residences. Daubigny, Monet, and Renoir had painted fields full of poppies, but they had provided more pictorial incident than Seurat does here. Because of its high horizon line and its uninterrupted plain, the canvas has the flatness and "allover" texture that would appeal to artists after 1945.

When one views this picture firsthand, the broad plain seems to tip back in an illusion of receding space. This effect results partly from the brushstrokes, but just why it succeeds is not clear, for the strokes are very evidently the marks of the artist. Apparently we allow our perception to shift from a recognition of brushwork in the foreground, where the marks are very large, to an acceptance of illusion in the middle distance, where they have become progressively smaller. The sky has an even more recessive, *tamponné* stroke. Color also helps create the illusion of depth. In the lower right is the shadow of an overhead tree in resonant greens mixed with tans and accompanied by blues and lavender-pinks (all these over orange-tan strokes). The basic color of the field is an unblended mixture of greens and orange-tans, along with blues, lavenders, and some purple, but farther back the poppy reds are more numerous and the blues virtually disappear. In the distance all the intensity is gone and our eye can sink into the sky.

This picture has usually been dated 1885, and some of the finer crisscross strokes in the foreground may have been done then, but it was probably begun the previous year. Most of its brushstrokes are broader and less regular than those Seurat used at Grandcamp in the summer of 1885, and it lacks the denser weave of *La Seine à Courbevoie* (cat. no. 153), also of 1885. The blues and lavenders are found in the studies of 1884 for *La Grande Jatte,* and so is the type of shadow at the lower right, with its contrasting blues and oranges along the border between shade and sunlight.

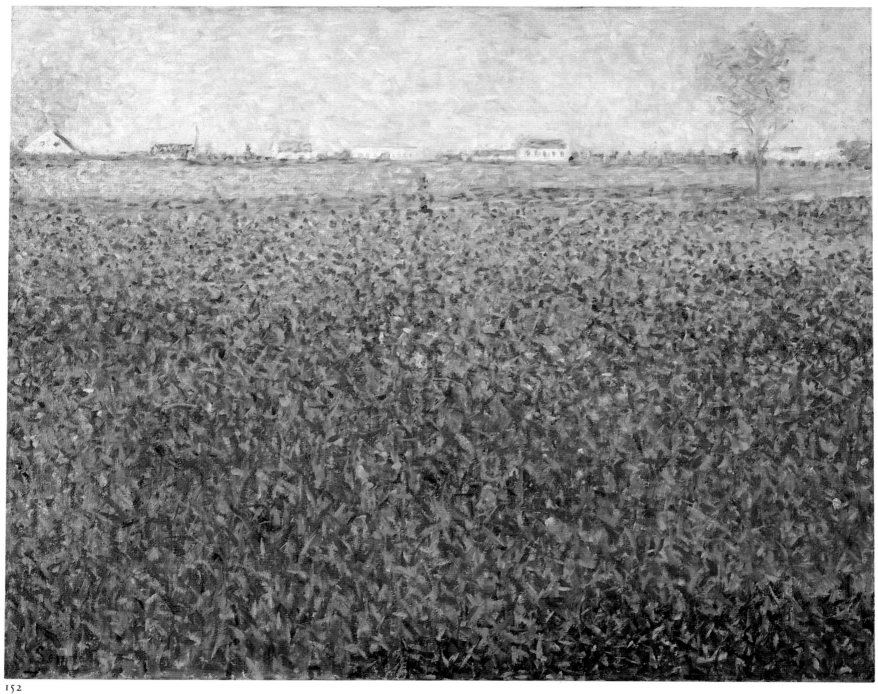

152

153. *La Seine à Courbevoie.* 1885

THE SEINE AT COURBEVOIE

Oil on canvas, 32 x 25⅛ in. (81.4 x 65.2 cm.)
Signed lower right: Seurat

Private collection

H 134; DR 161

PROVENANCE
Paul Signac, Paris, in 1886, until his death in 1935; by inheritance to
Ginette Signac, Paris; to present owner

EXHIBITIONS
1886 Paris, rue Laffitte, no. 179
1886 Paris, Indépendants, no. 356
1892 Brussels, no. 2
1892 Paris, Indépendants, no. 1089
1905 Paris, no. 21
1908–09 Paris, no. 47
1919–20 Paris, no. 50
1927 Lyons, no. 9a
1933–34 Paris, no. 158
1937 London, no. 88 suppl.

From the shelter of the shaded foreground, we look past
the woman and her dog to the buildings of Courbevoie,
resplendent in their opposed oranges and blues. The
sailboat gliding out of the composition and the *promeneuse*
tell us of the principally middle-class leisure activities to
which the island was devoted. The canvas has many
characteristics of *La Grande Jatte,* for both boat and woman
move laterally, not into pictorial depth. These images,
placed on a sequence of flat planes, share some of the
toylike stiffness of the huge composition. We nonetheless
find depth in the picture, owing to the contrast between
the dark tree trunks and foliage and the bright colors of
the opposite bank, with the multicolored water serving as
a transition. The woman is virtually propelled to the right
by the pressure of the midday sun, which illuminates one
side of her in orange, cream, lavender, and bluish purple
while leaving the other predominantly in blues, with some
purples and greens. Bright orange touches on her upper
body, hat, and parasol guarantee her prominence. Seurat's
brushstrokes work closely with his imagery: a refined
chopped straw (*balayé*) is used for the grass and foliage,
vertical strokes for the woman and the tree trunks (curv-
ing with their profile), horizontal strokes for the water, and

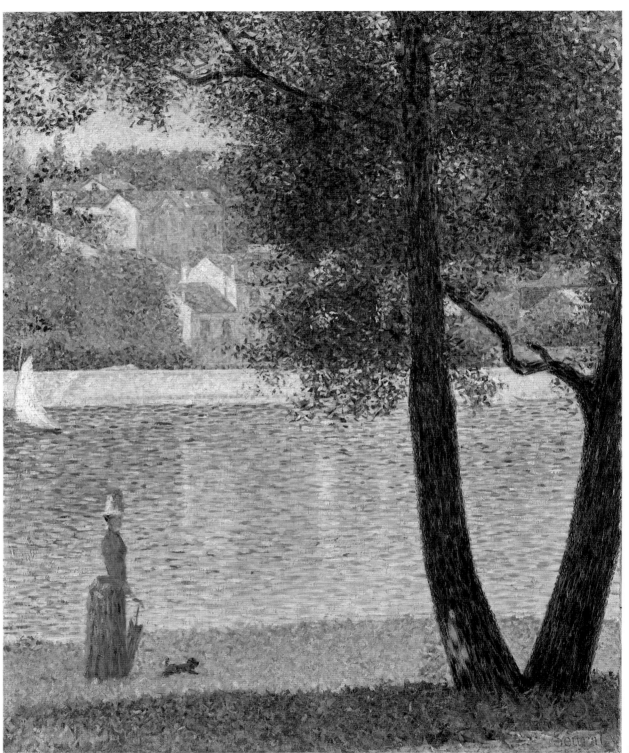

153

smooth strokes for the sky. Light halos around the woman and the trees are conspicuous because of the deliberateness of the short strokes that form them. The small dots on the tree trunks were probably added in 1886, in anticipation of the picture's exhibition.

154. *Étude pour "La Seine à Courbevoie."* 1885

STUDY FOR "THE SEINE AT COURBEVOIE"

Oil on wood, 9¾ x 6⅛ in. (24.9 x 15.7 cm.)

Berggruen Collection on loan to the National Gallery, London

H 133; DR 160

PROVENANCE
The artist until 1891. Posthumous inventory, panneau no. 89 (per inscription on reverse in blue pencil, not recorded by de Hauke). Probably given by the artist's family to Léo Gausson, Paris, in 1891, until his death in 1944; by inheritance to his daughter and son-in-law, M. and Mme Georges Tardif, Paris; sold (by Alice Tardif) to Wildenstein and Co., New York, in November 1956, until January 1957; sold to Henry Ittleson, Jr., New York, January 1957, until his death in 1973; by inheritance to his widow, Mrs. Henry Ittleson, Jr., from 1973 until 1982; sold to Acquavella Galleries, New York, in 1982; sold to present owner, 1982

EXHIBITION
1988 Geneva, no. 21

This panel gives every sign of having been painted rather quickly with eyes fixed on the site. The brushstrokes vary with the objects they describe, but they are rather large and not built up in several layers as in some of the contemporaneous studies for *La Grande Jatte*. The roofs in the distance are painted with strokes of carmine and yellow that partly mix together because they were applied while wet; the same is true of both the vertical patches of lavender-blues and white that form the walls and the yellows and greens of the foliage throughout the little panel. The warm brown color of the wood shows here and there, most prominently in the tree trunk, where it adds its color to the dark blues and wine reds.

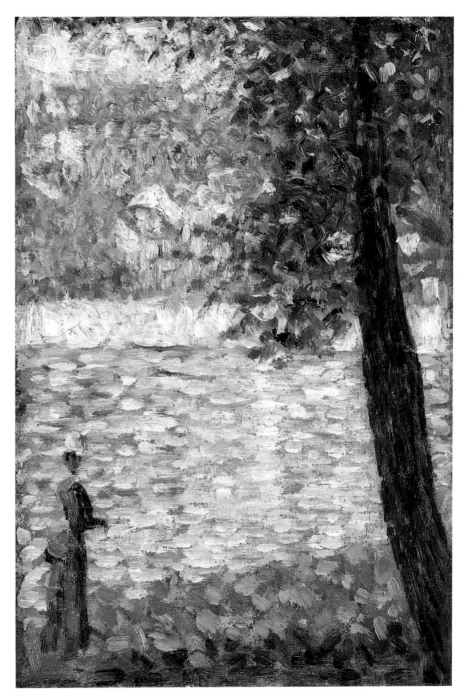

154

155. *Le cireur de bottes*. 1884–86

BOOTBLACK

Conté crayon, 6¾ x 4¾ in. (17 x 12 cm.)

Private collection, Paris

Exhibited in New York only
H 447

PROVENANCE
The artist's brother-in-law, Léon Appert, Paris; by inheritance to
Mme Léon Roussel, Paris; private collection, Paris (sale, Ader
Picard Tajan [George V], Paris, June 22, 1988, no. 6); with Hazlitt,
Gooden and Fox, London, until 1989; sold to present owner, 1989

EXHIBITION
1957 Paris, no. 47

The contrast between the rather squat and hunched-over
bootblack with his quite tall and long-legged client has a
wit that is also found in some of the figures in *La Grande
Jatte*. This wit is purely pictorial and nonnarrative, con-
veyed not through grimacing features but through flat
silhouettes. The marching feet of passersby at the top are
just sufficient to establish our vantage point: looking
across the reflected light of an urban pavement. This
drawing is as close as Seurat ever came to contemporary
cartoons. "Chinese shadows," or shadow plays in which
black silhouettes were scrolled across an illuminated screen,
were then a popular distraction in Parisian cabarets,
emulated by Caran d'Ache and other artists in journalistic
cartoons. Without imitating these works, Seurat's boot-
black is on the border between popular and "high" art.

156. *Frileuse*. 1884–86

WOMAN WITH A MUFF

Conté crayon, 12⅜ x 9⅜ in. (31.3 x 23.8 cm.)

The Art Institute of Chicago, Gift of Robert Allerton

H 612

PROVENANCE
Roger Marx, Paris, until his death in 1913; his estate, 1913–14 (Marx
sale, Drouot, Paris, June 12–13, 1914, no. 244, for 315 francs);
Bernheim-Jeune, Paris; Alphonse Kahn, Paris; with Jos Hessel,

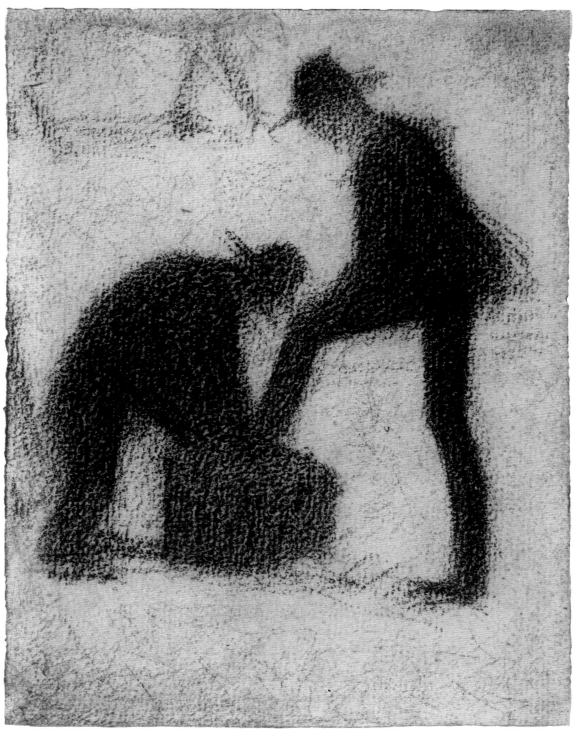

155

Paris, until 1926; purchased by the museum, with funds from Robert Allerton, 1926

EXHIBITIONS
1935 Chicago, no. 23
1947 New York, no. 23
1949 New York, no. 38
1958 Chicago and New York, no. 63

This is one of a number of drawings that show a woman, sometimes holding a muff, walking in profile. In some ways this is the most polished of them because Seurat modeled his figure a bit more smoothly and placed her in a street setting that the others lack. The blanched foreground forms a sidewalk, and at the upper right is the shadowy form of a large dog, his nose to the pavement. (Uncharacteristically, Seurat used an eraser in vertical swipes to lighten the area around the dog.) Because of the elementary setting, a strong shadow is needed to give the woman a three-dimensional presence. Her form, so like those of *La Grande Jatte*, glides to the left owing to the slight forward tilt of her upper body. Lacking feet and facial features, she is a nameless promenader. Her anonymity, however, is not that of Baudelaire's stranger in *Les fleurs de mal* (1857), seductive because her identity is unknown. She is instead a toylike creature, a male artist's idea of the doll-woman, bundled against the chill.

157. *Femme à l'ombrelle.* 1884–86

WOMAN RAISING HER PARASOL

Conté crayon, 12⅛ x 9⅝ in. (31.3 x 24.6 cm.)

Oeffentliche Kunstsammlung Basel, Kupferstichkabinett

H 503

PROVENANCE
The artist until 1891. Posthumous inventory, dessin no. 311. Inherited by the artist's brother-in-law, Léon Appert, Paris, in 1891; Thadée Natanson, Paris, probably by 1900, until 1908 (Natanson sale, Drouot, Paris, June 13, 1908, no. 35, for 60 francs); Poznanski; Baron Robert von Hirsch, Basel, by at least 1943, until his death in 1977; his estate, 1977–78 (Von Hirsch sale, Sotheby's, London, June 27, 1978, no. 846); purchased at this sale by the museum

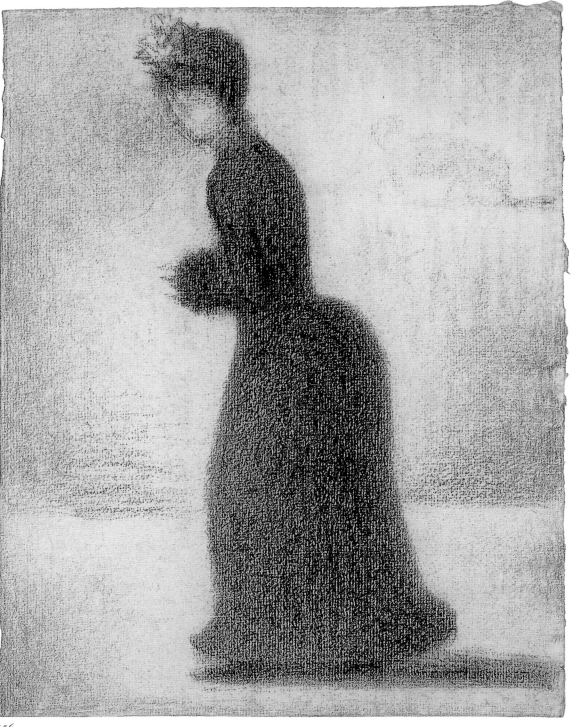

156

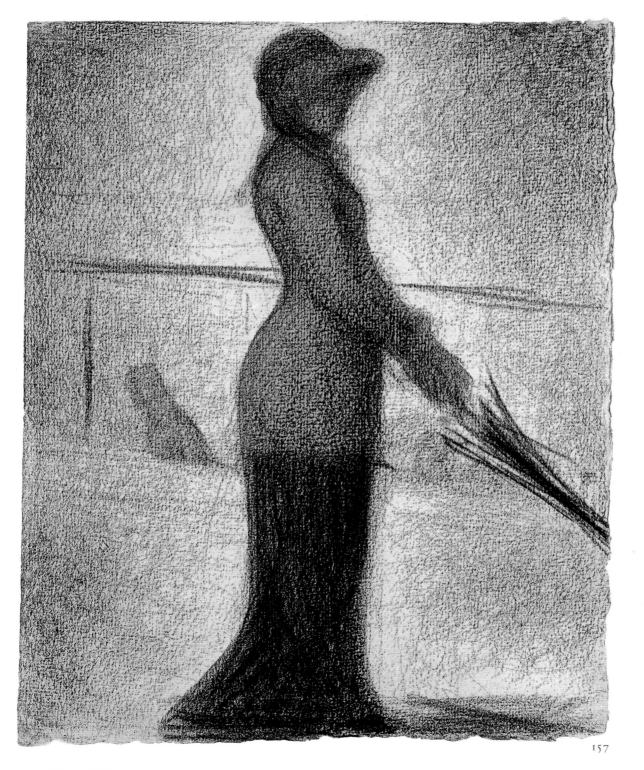

157

EXHIBITIONS
1900 Paris, Revue Blanche, *hors cat.*
1983–84, Bielefeld, Baden-Baden, and Zurich, no. 33

In contrast to his *Frileuse* (cat. no. 156), at whom the artist pokes fun, this *parisienne,* dressed in fashionable clothing and filling the whole page, is meant to be admired. With a skill and economy reminiscent of Daumier, Seurat drew a sculptural silhouette of a woman who is performing the most ordinary of gestures. She has simply paused to open her parasol. She stands on a sidewalk or terrace raised above the street and its crowds. Beyond its railing a man in a top hat glides by to the left, while on the other side the heads of more passersby are suggested. The woman's spiky parasol sets off the rounded solidity of her body, with its sensual curves. Any doubts about Seurat's ability, however disciplined, to evoke sexuality, can be resolved by comparing this woman with the figure in *La nourrice* (cat. no. 26), whose curving back is more descriptive than sensual, or in *La dame en noir* (cat. no. 37), whose combination of curves and angles is less yielding to our gaze. This drawing has usually been dated 1882,[1] but the smooth modeling of the woman's body and the nuanced grays of the background liken it to drawings for *La Grande Jatte.*

1. Most persuasively by Erich Franz (Franz and Growe 1983), passim and no. 33.

158. *Condoléances; Réunion de famille.* 1885–86

CONDOLENCES; FAMILY GATHERING

Conté crayon, 9½ x 12½ in. (24 x 31.7 cm.)

Berggruen Collection on loan to the National Gallery, London

H 655

PROVENANCE
Joris-Karl Huysmans, Paris, by May 1886, possibly until his death in 1907; Lucien Descaves, Paris, by 1908–09, until no later than 1949; sale, Galerie Charpentier, Paris, April 6, 1954, no. 22; purchased at this sale by César M. de Hauke, Paris, until his death in 1965; his estate, with Brame et Lorenceau, Paris, from 1965; with Hazlitt, Gooden and Fox, London, until about 1978; sold to E. V. Thaw and Co., New York, by 1978, until 1982; sold to present owner, 1982

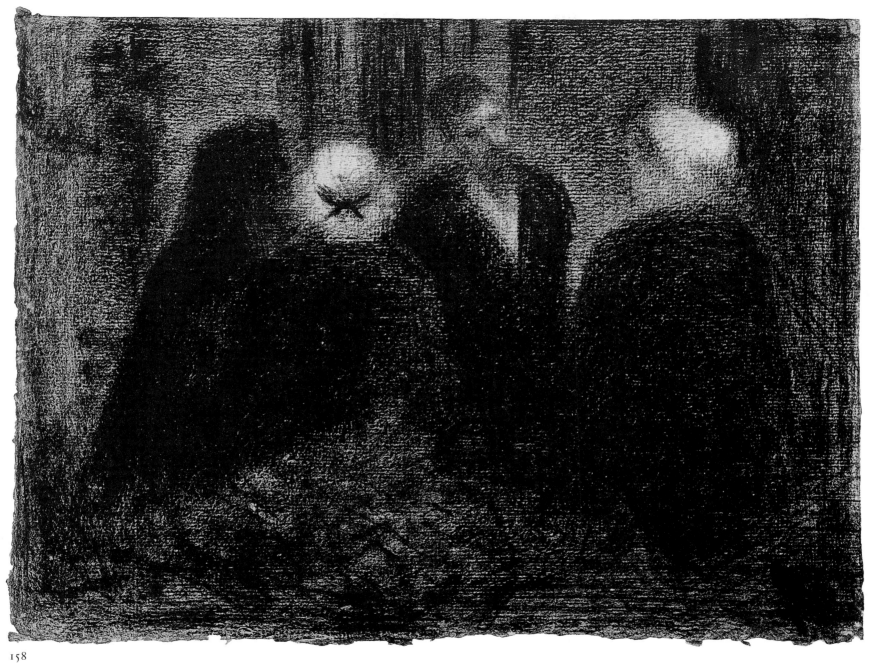

158

EXHIBITIONS
1886 Paris, rue Laffitte, no. 182
1908–09 Paris, no. 128
1958 Chicago and New York, no. 112
1978 London, no. 13
1983–84 Bielefeld and Baden-Baden, no. 74
1986 Washington, D.C., and San Francisco, no. 153
1988 Geneva, no. 22

This sober funeral scene has the dignity of a Rembrandt, without evoking any particular work by that master of light and dark. Family tradition says that it refers to the death of Seurat's maternal grandmother, but the date of that event has not been established. It would not be surprising if Seurat presented tragic family events in a drawing—he later drew his mother's sister on her death-bed (cat. no. 179). Here a woman in a mourning veil stands to the left, next to a young man who addresses one of the two female visitors. Perhaps Seurat identified himself with this man (whose hair and beard are trimmed like his own). Not only is he the tallest figure, but seen frontally and framed by the two light hats, he has the privileged place in the composition. The calm dialogue in which he is en-gaged gives a hint of animation to this dark interior and opens up space on the right side. In the foreground the mysterious form generated by swirls of the conté crayon seems impossible to decipher; this charges the work with an even more lugubrious quality. The drawing brings to mind not just Rembrandt's group portraits but also his etchings where shadowy chiaroscuro illuminates only faces, hands, and a few other salient elements.

Like *Une parade* (cat. no. 178), this drawing was lent to the last Impressionist exhibition by J.-K. Huysmans. (Seurat recorded them both in a list of owners of his works that he made late in 1886 [Appendix D].) We should speculate on Seurat's strategy for exhibitions. In addition to six oils, including *La Grande Jatte,* he showed three drawings with the Impressionists: the two belonging to Huysmans and *La banquiste* (cat. no. 44), lent by the widow of Robert Caze (Caze had been killed in a duel the previous March). Both Huysmans and Caze were naturalist writers whose preferred subjects have strong echoes in Seurat's work. It is likely that Seurat gave them the drawings. The gifts need not have been deliberate attempts to court favor, but they did cement relationships that were potentially helpful to the artist. Huysmans had a circumspect view of Seurat (he disliked *La Grande Jatte* while he admired the land-scapes) but gave the artist prominent treatment in his reviews. The publication of Huysmans's and Caze's names in the catalogue of the exhibition identified Seurat with vanguard writers and may have been among his reasons for choosing these drawings. Another strategy might have been involved as well—namely, to display a range of moods. The somber *Condoléances* is balanced by the more cheerful *Parade; La banquiste* takes something of a middle position between the other two.

Seascapes: Grandcamp and Honfleur 1885–1886

Beginning in 1885, Seurat regularly spent several weeks each summer painting along the Channel coast, staying in Grandcamp in 1885, Honfleur in 1886, Port-en-Bessin in 1888, Le Crotoy in 1889, and Gravelines in 1890. In 1887 he remained in Paris, probably because he did not want to interrupt his work on two major figure pieces: *Poseuses* (Barnes Foundation, Merion, Pennsylvania) and *Parade de cirque* (cat. no. 200).

French artists had long been in the habit of concentrating on major studio pieces over the winter and then going to the country in the warm months to steep themselves in nature. In this they emulated the well-to-do, for the rise of landscape painting in France coincided with the growth of summer tourism and vacationing (*villégiature*). Painters were supplying a growing market because increasing familiarity with "nature" (usually well-peopled sites) meant that more people wanted images of vacation spots, ranging from cheap topographical prints to costly oil paintings. A few artists —Eugène Boudin (1825–1908) is the leading example—virtually depended upon a clientele of vacationers.

By undertaking a series of marine landscapes, Seurat extended his command of traditional subjects. From the beginnings of the modern landscape tradition in France, in the work of Claude-Joseph Vernet (1714–1789), the nation's ports and coasts had been regularly celebrated. Corot, Rousseau, Isabey, Millet, Courbet, Daubigny, Boudin, Morisot, Manet, Renoir, Cézanne, and Monet gave coastal views such prominence that one could adequately trace in them alone the evolution of landscape painting in the nineteenth century. Normandy and the Channel coast were favored, partly because after mid-century the railway brought them within easy reach of Paris and partly because French commerce and culture were increasingly attracted to the industrial north. Many British investors in French industry and commerce resided in Normandy, and they and British tourists were instrumental in converting fishing villages into vacation resorts. Furthermore, British painters and illustrators had flooded northern France after the Napoleonic era, painting its rivers, valleys, and seacoasts. Among them were J. M. W. Turner and Richard Bonington, who contributed significantly to landscape's new prominence in France in the second quarter of the century. British and Lowlands painting rapidly displaced the Italianizing tradition of Poussin and Claude.

On the eve of Impressionism a number of painters made the region around Le Havre a favored site. They included Boudin, Daubigny, and the Dutch-born Jongkind—all mentors of the young Monet. Seurat was deliberately following in their footsteps when he began painting along the coast of Normandy. Signac, whom he met in 1884, was an enthusiast of Impressionism and had himself painted at Port-en-Bessin in the two previous years. Increased exposure to Impressionism probably encouraged Seurat to head north as well; indeed, echoes of Monet can be found in the paintings he did during his first two summers in the region. Seurat was also observing a middle-class ritual, for his family regularly vacationed on the coast, visiting unpretentious places—such as Grandcamp in 1881, Les Petites Dalles in 1885, and Mers-les-Bains in 1887—like the ones he chose for himself.

It was the moist light of the northern shore that Seurat so loved. Referring to the estuary of the Seine, he wrote Signac from Honfleur: "You may find Les Andelys colored but as for me, I see the Seine. The sea is a nearly indefinable gray, even under strong sunlight with a blue sky." And he ended another letter to Signac: "And then what more can one say, that's all for today. Let's go get drunk on the light once more, that's a consolation."[1] As his summers passed, the pearly light of the English Channel dissolved more and more of solid matter until, at Gravelines, his pictures consisted of sandy tans, pale aquamarines, attenuated blues, and evanescent lavenders. These pallid colors are distinctively his and so are the scenes he painted— prosaic choices compared with those of Monet and older artists. A few of Seurat's views at Grandcamp and Honfleur echo the past—sunset over the water, a careened boat, a lighthouse—but thereafter he chose the most ordinary aspects of port and shore. They present a striking contrast with Monet's seascapes of the same decade, which are equally unpeopled but frequently devoted to rocky promontories in which we imagine ourselves alone in front of an agitated sea.

From his first marines to his last, Seurat's particular note is a luminous stillness. Not for him Courbet's or Monet's attempts to paint turbulent seas—he represented absolutely calm waters. If we see the sails of pleasure boats, they are more like emblems of the seacoast than active presences. One picture (cat. no. 209) has human figures of some significance; a few others have tiny streaks on distant quays that can be interpreted as vacationers or fisherfolk; most have no people at all. Since the time of Bernardin de Saint-Pierre and Chateaubriand in the late eighteenth and early nineteenth century, the seashore had frequently been associated with

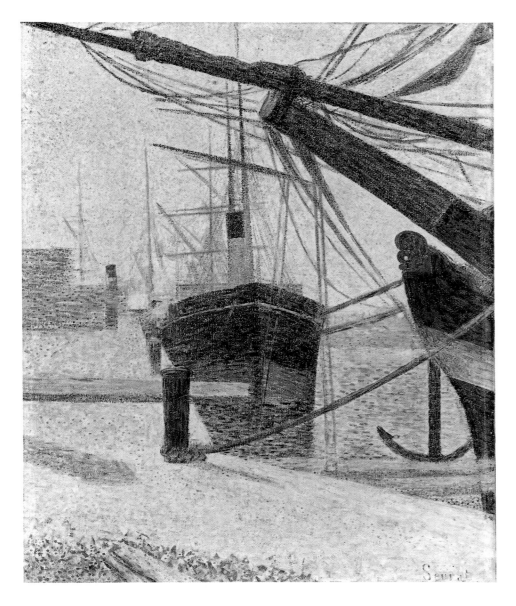

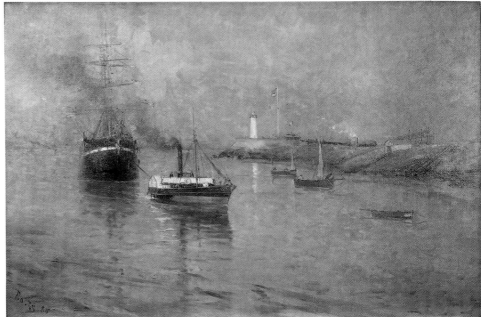

Frank Boggs, *The Harbor at Honfleur,* 1886. Brooklyn Museum. Gift of Mrs. J. Lester Keep, 18.45

Seurat, *Coin d'un bassin, Honfleur* (Corner of dock basin, Honfleur), 1886. Rijksmuseum Kröller-Müller, Otterlo (H 163)

calmness, infinity, and a dreamlike state in which the poetic soul could escape from the city-dweller's body. The cleansing effect of the sea, celebrated in Jules Michelet's famous book *La mer* of 1861, was good not only for the body but also for the soul. Seurat's paintings embody this view of the contemplative seashore, a conception commonly found among the naturalists and the Symbolists. Writers and painters, emphasizing the distance between city and seacoast, equated the ocean with poetic moods,

frequently melancholic. From 1886 onward, many reviewers found a penetrating melancholy in Seurat's seaside views. Eugène Demolder, reviewing a posthumous exhibition, had this to say of his marines:

A suave light passes among his frames, something very gentle, very calm. A true redemption of daylight. . . . But from these vibrant heavens light showers down, like the gentle petals of springtime. One hears a

calm and rather white symphony which sings among the masts, alongside the lighthouses, and over the beaches' sands. It charms by its limpidness, its transparency, its *immateriality*. It is almost the innocent and exposed soul of the region which rises up in a pure resuscitation or *albe* toward the heavens. This clear silence of the atmosphere, the contemplativeness of the cloudless sky, the immobility of becalmed ships, the untroubled surfaces of rivers, the deserted quays, unpeopled beaches, and dunes without promenaders: everything that gives impressions of peace, of solitude, of tranquil space, is said in these paintings. It is a tender and contemplative poetry.[2]

For his first campaign of seascapes, in the summer of 1885, Seurat went to Grandcamp, a tiny fishing port to the west of Bayeux, just before the Cherbourg peninsula juts northward. Fronting the English Channel from below wooded cliffs, it lacks a substantial harbor and even a prominent landmark, except for the Bec du Hoc, a promontory a little more than a mile to the east. Seurat reconnoitered as he produced a dozen small panels, the most that survive from any one summer's work. He subsequently depicted the Bec du Hoc in one of his most memorable paintings (cat. no. 161) and the environs of the little port in four other canvases: two dominated by the flat strand, one a lateral view from above the port, and another showing an offshore regatta (cat. no. 160). These five canvases, the young artist's first group of landscapes, were intended for exhibition. By bringing them to a finished state, he gained new experience in building up his colors in finely divided brushwork; this must have been helpful when he repainted *La Grande Jatte* that autumn and winter.

The following year, shortly after the end of the Impressionist exhibition in June, Seurat went to Honfleur, where he remained until mid-August. Unlike Grandcamp, Honfleur was once an important port. It had lost out in prosperity to Le Havre, across the Seine estuary, and had a population of only about ten thousand, but it retained its fame among artists, both British and French. The best documented of Seurat's summers is that of 1886, the only one from which several letters survive. From correspondence with Signac and Verhaeren,[3] we learn that Seurat rented or boarded on the rue de Grâce, on the western side of the port, partway up the steep slope that leads to Honfleur's most famous lookout point by the chapel of Notre-Dame-de-Grâce. He did not follow other painters in choosing that vantage point, however, and also ignored the picturesque inner port (painted by Monet twenty years before) and the nearby half-timbered church and market, all of which had been favored by artists since the beginning of the century. He was not unaware of earlier artists but rather determined to strike a new note

in his choice of subjects as well as in his technique. (Even so, as we shall see, there are evident relationships with earlier painters, including Jongkind and Monet.)

The key document for the Honfleur pictures is Seurat's letter of mid-August to Signac. With his customary telegraphic brevity, he writes:

only 6 paintings
4 size 25
1—15
1—10
1 considered finished,
the motif having since
been dispersed (boats,
corner of a harbor)
2 others worked upon
but not yet satisfactory (beaches)
1 canvas size 10, cloudy weather,
still needing more work
(end of a jetty). Remaining
still a canvas size 25 and
1 size 15, both begun.[4]

The unfinished picture, abandoned when the ships that were its "motif" moved, is *Coin d'un bassin, Honfleur*, which Seurat told Verhaeren was "une grande esquisse" (a large sketch) that he worked on for only a week. Its striking composition takes up a theme common in seaport painting since Turner's time: the juxtaposition of steam and sail. Across the foreground slants the prow and forward rigging of an old vessel, symbolically framing the steamer (which had auxiliary sails) of more recent vintage. The older ship was probably then greeted as a picturesque visitor from the past, for it can also be seen in *The Harbor at Honfleur* of 1886 by the American Frank Boggs, where it is being brought into port by a steam tugboat.

Six other pictures of Honfleur were eventually completed (an additional "toile de 15" was added to those listed above); most required work in Paris that fall and winter. These were dependent on study of the actual sites, so presumably Seurat had advanced all six while still in Honfleur. Taken together, the seven canvases form a portrait of the port and its activities. Three represent midday or early afternoon light, two early evening (*Maria*: about 6 o'clock; *Coin d'un bassin*: about 7:30), and one sunset (*Embouchure de la Seine*).[5]

Both pleasure craft and trade vessels appear in these pictures, but people are absent, as though the artist were presenting a perpetual

off-season Sunday. Three of the paintings show the beach west of the port, usually frequented by strollers but now given entirely to the viewers; two of these (cat. nos. 166 and 167) have a tinge of romantic melancholy despite the modern look of their strictly ordered compositions. Two other pictures show ships moving in the outer harbor and another two, craft moored along the interior commercial quays. These four works, marked by silence, seem to offer the artifacts of human activity, as though we were looking at an orchestra miming.

1. Letter of June 25, 1886, and another undated, probably mid-July 1886, Signac archives.
2. Demolder 1892, p. 348.
3. Dorra and Rewald 1959; Herbert, *Gazette des beaux-arts*, 1959.
4. Signac archives. The numbers are those traditionally used for prepared canvases: 25 = 65 x 81 cm. (25⅛ x 31⅞ in.); 15 = 54 x 65 cm. (21¼ x 25⅛ in.); 10 = 46 x 55 cm. (18⅛ x 21⅛ in.).
5. Smith 1984.

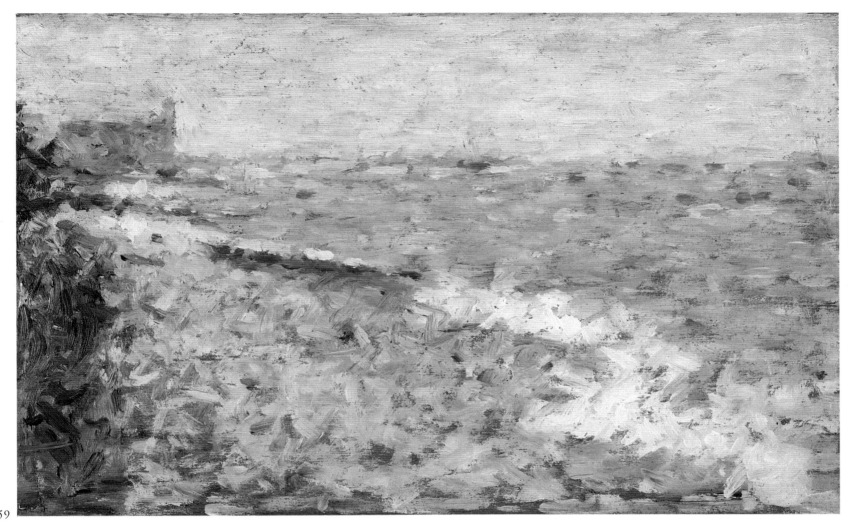

159

159. *Le mouillage à Grandcamp*. 1885

THE ANCHORAGE AT GRANDCAMP

Oil on wood, 6¼ x 9⅞ in. (16 x 25 cm.)

Private collection

H 146; DR 142

PROVENANCE
The artist until 1891. Posthumous inventory, panneau no. 128bis.
Inherited by the artist's brother, Émile Seurat, Paris, in 1891; Félix
Fénéon, Paris, by 1905; Alfred Vallotton; Léon Marseille; Georges
Lévy, Paris; private collection, New York, until 1947 (sale, Parke-
Bernet, New York, February 6, 1947, no. 63, for $1,400); to present
owner

EXHIBITIONS
1900 Paris, Revue Blanche, *hors cat.*
1905 Paris, no. 15
1908–09 Paris, no. 52
1920 Paris, no. 17
1936 Paris, no. 43

Before he began to work on his canvases, Seurat studied
the seashore near Grandcamp and produced a number of
panels that familiarized him with the Channel's light, so
different from that of Paris. *Le mouillage à Grandcamp,*
among the first he did, is a spirited study of light surf on a
sunny shore with a palette quite different from his studies
on the island of La Grande Jatte and with more varied
brushwork that suggests greater spontaneity. The beach is
a tan of a pinkish cast, turning violet as it nears the water
and green next to the dark area on the left. Beyond the
frothy surf the sea is a mosaic of green, blue, and purplish
blue, along with some orange and pink. These light tones
are set off by the dark strip on the left, where beach
foliage, shaded by an unseen wall or structure, changes
from dark green at the bottom to light green as it rises. It
consists of blue, green, and white mixed together in wet
strokes, interlaced with the ruddy color of the exposed
wood and touches of red and orange.

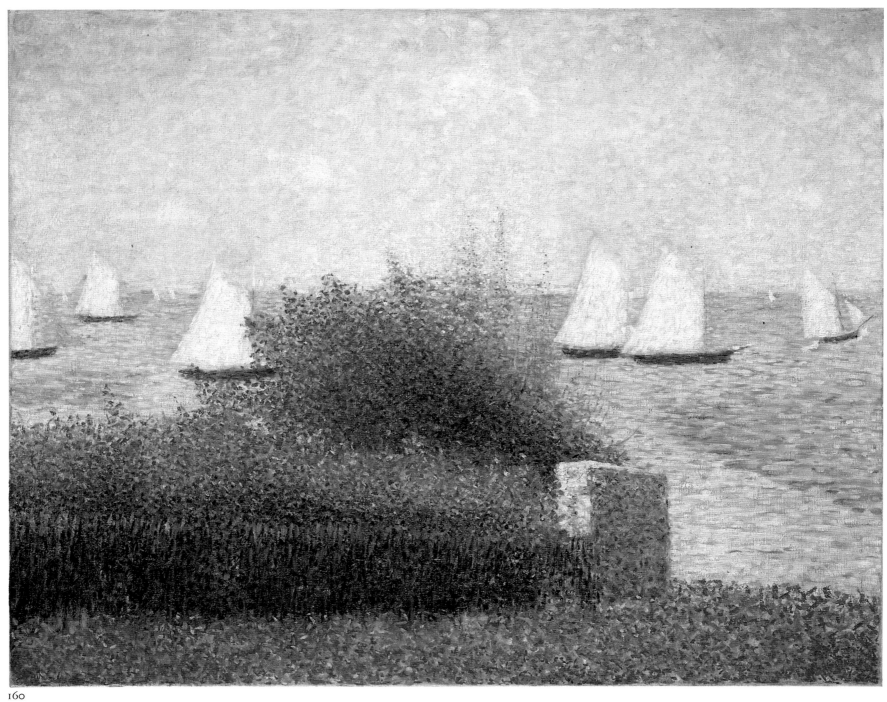

160

160. *La rade de Grandcamp.* 1885

THE ROADSTEAD AT GRANDCAMP

Oil on canvas, 25⅛ x 31⅞ in. (65 x 80 cm.)
Signed lower right: Seurat

Private collection

Exhibited in New York only
H 160; DR 154

PROVENANCE
The artist until 1891. Inherited by the artist's mother, Mme Ernestine Seurat, Paris, in 1891, until 1892; presumably sold by Félix Fénéon, Paris, in 1892;* Mme Aghion, Paris, by 1900; Josse and Gaston Bernheim-Jeune, Paris, by 1904, until at least 1925; with Reid and Lefevre, London, by 1928; owned jointly by Reid and Lefevre, London, and M. Knoedler and Co., New York (stock no. A609), from January 1929 until December 1934; sold to Étienne Bignou, Paris, in December 1934; with Reid and Lefevre, London, in 1936; sold to Mrs. Chester Beatty, London, in May 1936, until her death in 1952; by inheritance to Sir Alfred Chester Beatty, Dublin, from 1952 until 1955; sold to Paul Rosenberg and Co., New York, in 1955; sold to present owner, 1955

EXHIBITIONS
1886 Paris, rue Laffitte, no. 178
1886 Paris, Indépendants, no. 355
1887 Brussels, no. 3
1888 Paris, Revue Indépendante (see Fénéon, January 1888)
1892 Brussels, no. 3
1892 Paris, Indépendants, no. 1092
1900 Paris, Revue Blanche, no. 18
1900 Paris, Exposition Universelle de 1900, no. 610
1904 Brussels, no. 144
1908–09 Paris, no. 55
1920 Paris, no. 20
1929 Lucerne, no. 21
1932 London, no. 553
1958 Chicago and New York, no. 106
1986 Washington, D.C., no. 152

*Reid and Lefevre catalogues indicate that the painting was sold from the collection of Félix Fénéon in 1892. Yet de Hauke's provenance, based on Fénéon's notes, does not include his name as owner; presumably Fénéon sold the work on behalf of the family in 1892.

This seascape was exhibited at the last Impressionist exhibition in late spring 1886 and again that fall with the Indépendants, both times alongside *Le Bec du Hoc* (cat. no. 161) and the lost *Fort Samson, Grandcamp* (H 157). These were the first exhibitions in which Seurat showed more than one landscape canvas; many reviewers preferred them to his controversial *La Grande Jatte*. Like that huge figure painting, the landscapes rivaled Impressionist works in both technique and composition.

The present painting takes up the theme of pleasure boating that Monet and Manet had frequently treated in the 1870s. Seaports hoping to attract vacationers and tourists encouraged regattas, which were often the highlights of the summer season. In Seurat's painting the hedge and clump of trees separate two groups of boats, but this interruption seems to enhance rather than diminish their processional movement from left to right. It is not a day of brilliant sunshine but instead a typical Channel day when the sun does not quite dissipate the gray haze. We look out upon the boats from near the enclosure of a garden, so this picture suggests the sociable pleasures of summer at the shore. It generates a mood quite different from the lonely isolation of *Bec du Hoc*, but one that equally accompanies vacationing at the shore, since shared social rituals and poetic solitude were the alternating benefits of *villégiature*.

This picture was probably the first canvas Seurat undertook during the summer of 1885. Its more varied brushwork places it closer to the Impressionists than other Grandcamp pictures. Pissarro's technique of the early 1880s is brought to mind, although precedent for the present composition of lateral planes is found in Manet's *Pier at Boulogne* of 1869 (private collection), exhibited in 1884. Seurat's sky consists of a subdued and blended mottling of blue-grays, whites, pale yellows, and pinks. The water is rendered by a horizontal stitching whose multicolored touches give the look of lapping waves. For the foliage and grass Seurat used a varied crisscross of small strokes that suggest natural growth without closely imitating it. The rich play of different touches disguises the fact that underneath the sky and water lies a coating of gray and underneath the foreground, one of brown. These were laid in with large strokes of rather thin paint that did not hide the weave of the canvas. Over the gray undercoating of the water, Seurat brushed his surface colors with horizontal touches that picked out the vertical strands of the canvas. The effect is to break up individual strokes, making them vibrate when we look closely.

161. *Le Bec du Hoc, Grandcamp.* 1885

THE BEC DU HOC

Oil on canvas, 25½ x 32⅛ in. (64.8 x 81.6 cm.)
Signed lower right: Seurat
Painted border added about 1888

Lent by The Trustees of The Tate Gallery, London

H 159; DR 153

PROVENANCE*
Camille Laurent, Belgium, by 1892, until at least 1904; George
Famenne, Brussels, by 1908–09, probably until 1914; with Bernheim-
Jeune, Paris, by 1916, until at least 1920; with Alfred Flechtheim,
Berlin and Düsseldorf, by about 1923; private collection, Berlin;
with Bignou Gallery, New York, by March 1935; Julio Kocherthaler,
Madrid, by June–September 1935; Sir Kenneth Clark, London, by
October 1936, until 1952; sold, through Marlborough Fine Art,
London (Grant-in-Aid), to the National Gallery, London, in 1952;
transferred to the Tate Gallery, 1953

EXHIBITIONS
1886 Paris, rue Laffitte, no. 176
1886 Paris, Indépendants, no. 354
1887 Brussels, no. 2
1888 Paris, Revue Indépendante, February
1892 Brussels, no. 4
1904 Brussels, no. 145
1908–09 Paris, no. 56
1920 Paris, no. 19
1936 Paris, no. 42
1949–50 London, no. 292
1958 Chicago and New York, no. 107

*For the painting acquired by Henri van Cutsem in 1887, see
cat. no. 164.

The dates for ownership above are based on information gleaned
from various exhibition catalogues. Presumably George Famenne, a
lender to the Paris 1908–09 exhibition, owned the work until 1914
(see London, New Burlington Galleries, "Exhibition of Masters of
French 19th Century Painting," October 1–31, 1936; no. 17, under
collections, indicates "Private Collection, Brussels, until 1914)".

The painting was included in Bernheim-Jeune's "Exposition de
Peinture," Série C (June 19–30, 1916), no. 159, and in their Seurat
retrospective of 1920, no. 19; an asterisk in the latter catalogue
indicated that it was for sale. When exhibited by Bignou Gallery,
New York, "A Nineteenth Century Selection, French Paintings,"
March 1935, no. 8, the entry indicated "Formerly in a private
collection, Berlin." Possibly this is a reference to Alfred Flechtheim,
who purportedly exhibited the painting in 1923 (according to de
Hauke) and in 1928 (according to the 1936 London catalogue) and
who, in any event, is recorded as an owner of the work. The painting

was presumably sold by Bignou to Kocherthaler, who lent it anony-
mously to an exhibition in Brussels, Palais des Beaux-Arts,
"L'impressionnisme" (June 15–September 29, 1935), no. 78.

A short walk to the east of Grandcamp, the Bec du Hoc
thrusts its narrow mass out over the Channel, giving some
relief to an otherwise dull stretch of coast. Today it is
much reduced by World War II bombardments, but in
Seurat's time one approached it from a gradual rise, which
dipped before the final ascent along its "beak." Although
distinctive in shape, the promontory has the character
of many worn cliffs along the northern coast, from those
of the Cherbourg peninsula, painted by Millet, to those of
Étretat, Varengeville, and Pourville, all painted by Monet.
Monet's many views of the cliffs of Pourville, painted in
1882, were probably in Seurat's mind when he undertook
Le Bec du Hoc. Monet often positioned seabirds and boats
off the peaks of his cliffs and adjusted horizon line to
clifftops as Seurat does here. Seurat has five seabirds ride
the thermal updrafts above the Bec, which projects above
the horizon just enough to call attention to its soaring
height. To the right, the white sail of a yacht and the
darker ones of a fishing boat point to the cohabitation of
leisure and work along the nearby shores. All these small
accents are nearly overwhelmed by the undulating mass of
the cliff, which, like some beached Moby Dick, heaves its
bulk upward with an energy that is barely contained by
the symmetry of Seurat's composition. When the painting
was first exhibited in 1886, most critics judged it to be
"melancholy," for it makes the viewer confront the sea
alone, as though threatened by the bleak headland.

The best reproduction does not render the rich variety
of this picture's surface. If one looks closely at the gorselike
growth in the foreground, for example, one sees that
Seurat first laid down long sweeping strokes (some about
15 cm. [6 inches] long) and then stitched a fabric of smaller

crisscross strokes of blue, green, cream, tan, orange, pink,
red, yellow-orange, and brown. No one color results, even
at a distance; instead there are unresolved mixtures tend-
ing toward a light brownish green, a ruddy orange, an
olive green, and, near the shaded cliff face, a pinkish
cream. Later, probably just before the painting's fourth
public exhibition, in February 1888, Seurat restretched the
canvas to allow room for a narrow painted border. Some-
what simpler than the borders he did in 1890, its color
shifts with every change in the adjacent composition. At
the same time Seurat reworked the canvas in fine touches,
including the small strokes on the water of greens, pale
blues, and pale oranges, which are not fully integrated
with the older surface. He also added a narrow band of
light touches, mostly yellow-tan, all along the border, to
contrast with the dark border. At some point he widened
the cliff by adding to the middle third of its left side a band
about ¾ inches (2 cm.) wide, dominated by pinks and tans.
This change, which softened and lightened the original
edge, may have been part of the studio work carried out
after Seurat's return from Grandcamp. The water along
the left side of the cliff is slightly darkened; the principle of
contrast is more obvious, however, on the right side, where
a light halo borders the shaded cliff and is in turn bordered
by an umbra.

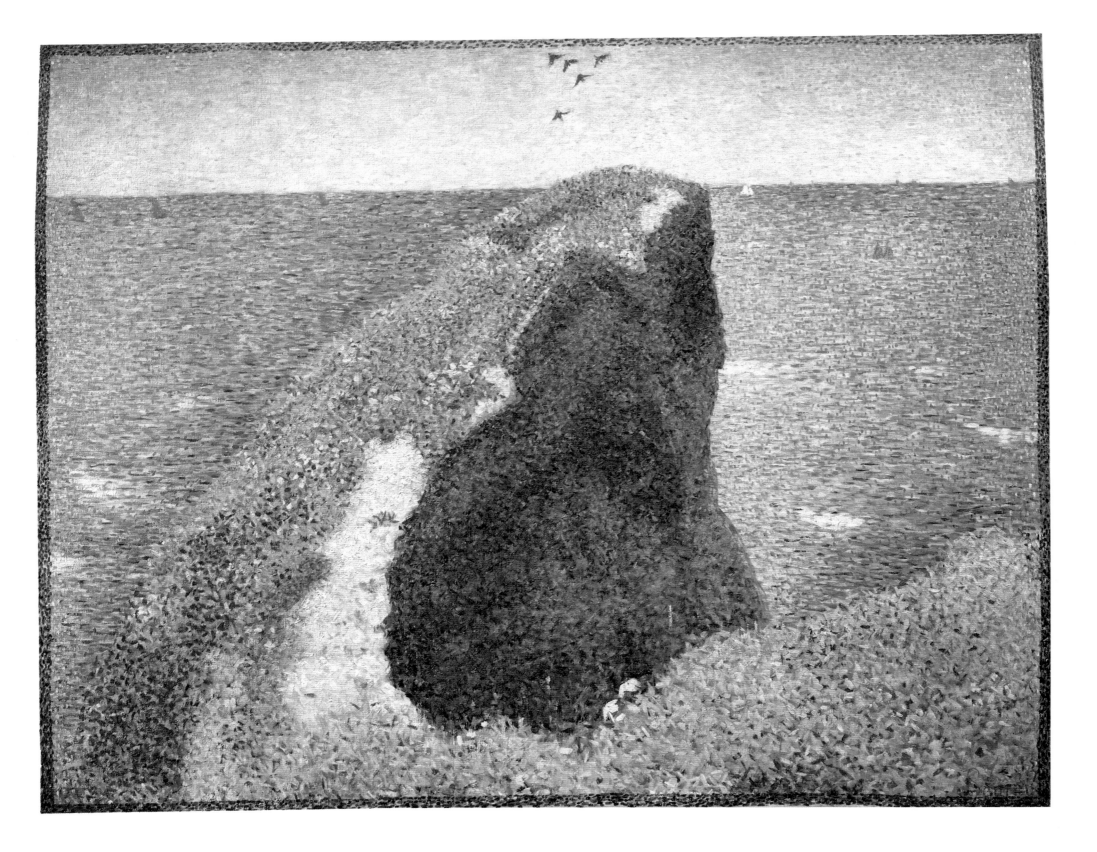

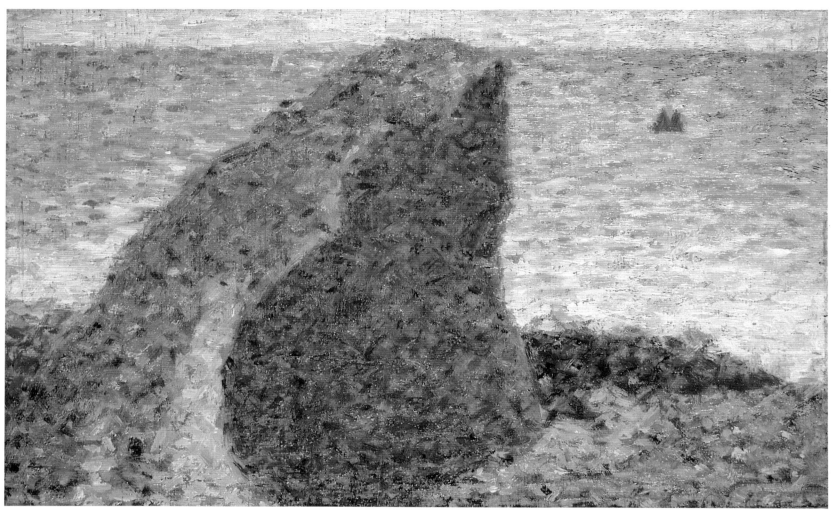

162

162. *Étude pour "Le Bec du Hoc, Grandcamp."* 1885

STUDY FOR "THE BEC DU HOC"

Oil on wood, 6⅛ x 9⅝ in. (15.6 x 24.5 cm.)

Purchased from proceeds of The Great Impressionists Exhibition Collection, Australian National Gallery, Canberra

H 158; DR 152

PROVENANCE
The artist until 1891. Included in the posthumous inventory but not numbered. Inherited by Madeleine Knoblock, Paris, in 1891, until

1892; sold to Jean de Greef, Auderghem, Belgium, in February 1892, until no later than 1894;* Alfred Tobler, Berlin; with Bernheim-Jeune, Paris, by 1920; Charles Hall Thorndike, Paris; private collection, France; private collection, Switzerland; with Galerie Schmit, Paris, in 1983; with Reid and Lefevre, London, until 1984; sold to the Gallery, 1984

EXHIBITIONS
1886 New York, no. 133 (no. 10 in a frame of "12 studies")
1887 Paris, no. 447 (one of "douze croquis")
1892 Brussels, no. 1 (one of "douze esquisses")

*See provenance note, cat. no. 89.

Confined to a small surface, the colors of this panel seem more intense than those of the canvas for which it served as a study. Some of this intensity results from Seurat's having viewed the site at low tide when patches of dark shore intervened between the clifftop and the water. In the water, following Seurat's customary principle of contrast, these patches produce light halos, so that from bottom to top and from side to side, there are more zones of alternating light and dark than in the canvas. The warm brown color of the wood is largely covered in the water, but it shows prominently in the foreground. For the

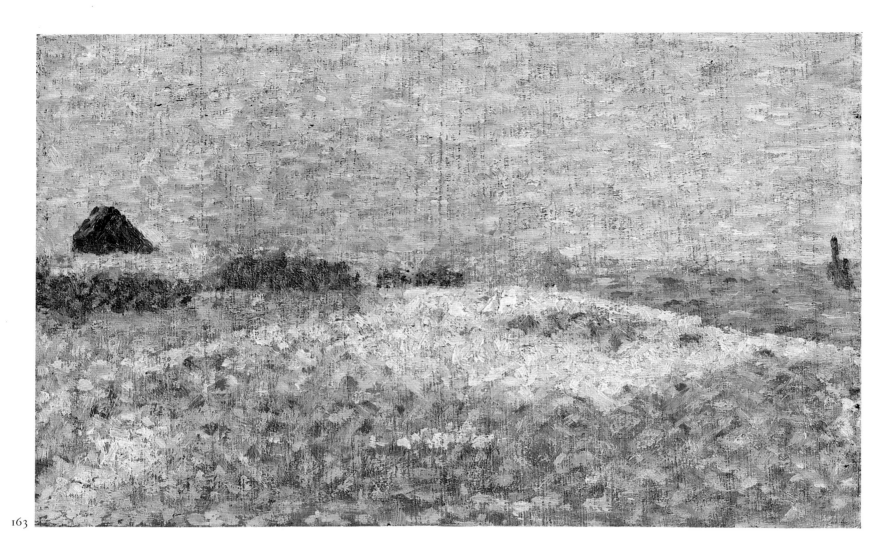

163

163. *Étude pour "Le Fort Samson à Grandcamp."* 1885

STUDY FOR "FORT SAMSON AT GRANDCAMP"

Oil on wood, 6 x 9⅝ in. (15.2 x 24.5 cm.)

Private collection

Exhibited in Paris only

H 156; DR 156

PROVENANCE
Paul Signac, Paris, in 1886, until his death in 1935; by inheritance to Berthe Signac, Paris; by inheritance to Ginette Signac, Paris; to present owner

EXHIBITIONS
1905 Paris, no. 24
1908–09 Paris, no. 54
1957 Paris, no. 14
1958 Chicago and New York, no. 141
1963 Hamburg, no. 102

vertical face of the promontory, shaded from the afternoon sun, the panel color almost merges with the strokes of blue, orange-brown, orange-red, wine red, and purplish blue. For the sunlit grasses the panel instead acts as a color opposite because it takes on an orange tinge next to the greens. In turn these same greens assume a different guise out on the water, where they are accompanied by blues and yellow-tans.

Guidebooks of Seurat's era recommended the fifteen-minute walk from the little port of Grandcamp to Fort Samson (called simply "l'ancien fort"), where low tide revealed extensive oyster beds. In Seurat's panel, a study

for a canvas (H 157) presumed destroyed in World War II, we look across a sandy rise covered in sparse salt grass toward the fort's low walls. This structure is surmounted by two roofs: one dark blue and the other orange-red. The latter, the brightest color on the panel, vibrates against the dark green of the bushes along the wall to make it the coloristic center of attention. On the right edge a dark-sailed boat glides upon the wedge of water, while in the distance a trail of cream and pink touches indicates the shoreline farther west.

This may be the last of a dozen panels Seurat painted in the summer of 1885, for in comparison with others in the group, its surface is made up of finer strokes of the brush and more colors enter into each area. The sky, for example, has blues, green-blues, pale earths, oranges, and lavenders, and the greens in the foreground are formed of several tints of green, pink, pale blue, off-white, orange-tan, and the ruddy color of the wood panel. The brushwork varies with the area: small and partly blended for the sky; larger and mostly horizontal for the water; still larger and *balayé* for the foreground. The prominent vertical grain of the wood acts rather like the warp of a delicate tapestry of color.

164. *La grève du Bas-Butin, Honfleur.* 1886

THE SHORE AT BAS-BUTIN, HONFLEUR

Oil on canvas, 26 x 32⅛ in. (66 x 81.5 cm.)
Signed lower left: Seurat

Musée des Beaux-Arts de Tournai, Bequest of H. van Cutsem

Exhibited in Paris only
H 169; DR 165

PROVENANCE
Purchased from the artist for 300 francs by Henri van Cutsem, Brussels, in February 1887, until his death in 1904; his bequest to the city of Tournai, 1904, with Guillaume Charlier retaining life interest until 1925

EXHIBITIONS
1886–87 Nantes, no. 969
1887 Brussels, no. 6
1887 Paris, no. 440
1958 Chicago and New York, no. 111
1963 Hamburg, no. 103
1988 Amsterdam, no. 4

The shore of the Bas-Butin was on the west edge of Honfleur, beyond the shelter of the harbor and only a short distance from Seurat's rented rooms. Its name (*butin* means "booty") is redolent of earlier days of illicit traffic, but the site had a prosaic plainness by Seurat's day. In his painting the steamer and sailboats allow us to imagine the harbor around the cliff to the right. Breakwaters stick up from the sand, and above the high-tide mark is a covering of stubborn beach growth. Nearest to us rise the orange-brown branches of a gorselike bush, whose unkempt lines, like the strange humanoid shapes of the cliff above, contrast with the calm sea. Sunlight floods the scene, leaving shadows only in the darker patches of the nearby foliage. Seurat ended one of the letters he wrote in the summer of 1886 to Signac (Signac archives) with the heartfelt phrase "Let's go get drunk on the light once more, that's a consolation." Seurat, like many painters and vacationers, sought release from city cares at the seashore.

Paul Adam was particularly taken with this picture. Seurat, he wrote, was "the prodigious evocator of calm shores and of seas with infinite flocks of waves. In restful blue and tender green, immense floating expanses rise toward the vaulted clouds and cottony skies. Thus *La grève du Bas-Butin*, so adorably powdered in blond sand, from

which stretches out a sea with changing tints of malachite and emerald, also of lapis lazuli, while the firmament vibrates like a large fan full of minuscule gems. Yonder, thin and crafty, runs a steamboat coquettishly adorned in its rapid colors."[1]

This kind of site and its composition (land below a diagonal of the canvas, water and sky above) are found in the work of many earlier marine painters, from Isabey in the second quarter of the century to Courbet, Daubigny, Jongkind, L.-A. Dubourg (a native of Honfleur), and Monet. Monet was not far from Seurat's mind, for in another letter from Honfleur to Signac (Signac archives), in his customary telegraphic manner, he wrote, "Beautiful the cliffs of Étretat and the little water's edge with silvery willows. Very beautiful." Monet had exhibited, in 1885 and 1886, a number of paintings of the shore and cliffs of Étretat and before that, views of the coast at Les Petites Dalles, Fécamp, Varengeville, and Pourville. In all of these, however, Monet's energetic brushstrokes seem to capture a spontaneous and emotional response to the sea and its constant threat to the land. By contrast, Seurat's careful procedure gives an appearance of refinement and rationality, an expression of "scientific" rather than "romantic" ideals. Technique and subject work together, for Seurat chose unruffled days when sea and land were in harmony and when the light could offer him its consolation.

The Brussels collector Henri van Cutsem bought this painting for 300 francs in 1887. Émile Verhaeren purchased *L'hospice et le phare de Honfleur* (cat. no. 167) the same year, so Seurat's first two documented sales were to Belgians (one or more of the works already in the possession of acquaintances may have been purchased, but they were more likely gifts from the artist). These sales confirm the significance of Brussels as the second home of Neo-Impressionism. The city earned this position through the enthusiasm of Belgian writers like Verhaeren who were familiar with Paris, and especially through the impact of Seurat and the other Neo-Impressionists in the exhibitions organized by Les XX, the Belgian avant-garde group.

1. Adam, September 1886, p. 143.

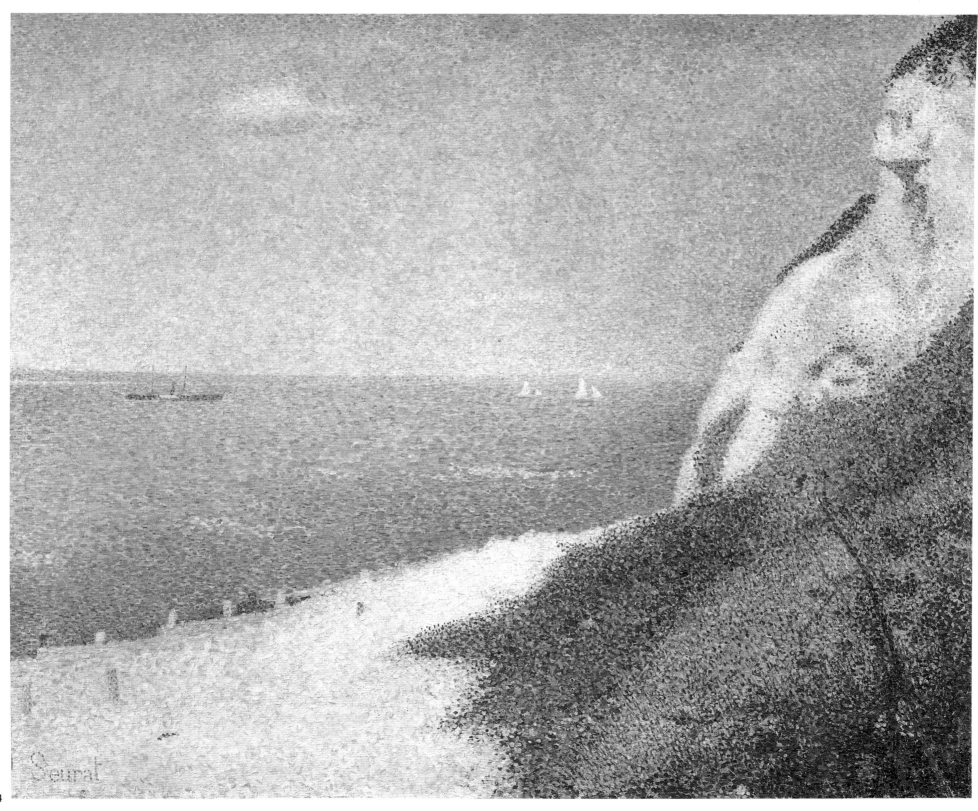

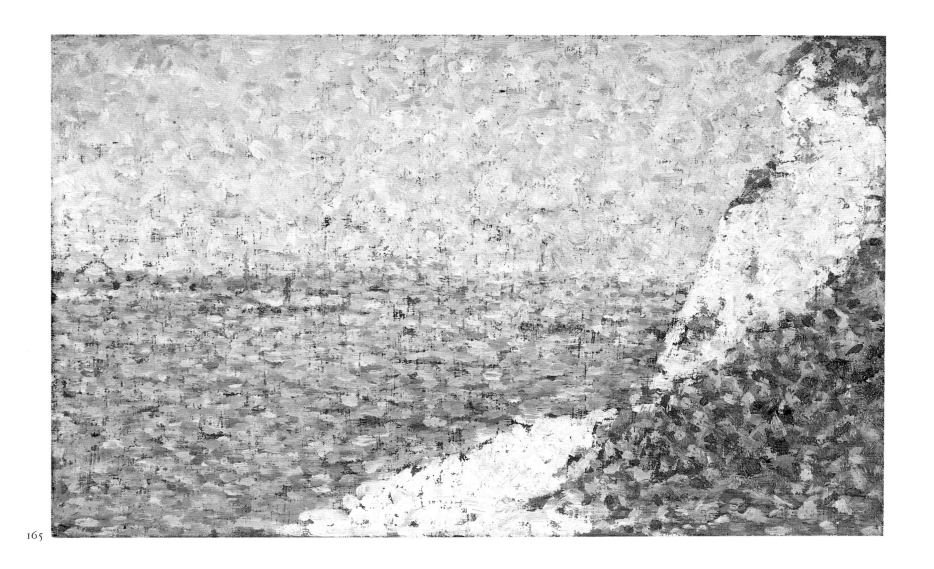

165

165. Étude pour "La grève du Bas-Butin, Honfleur." 1886

STUDY FOR "THE SHORE AT BAS-BUTIN, HONFLEUR"

Oil on wood, 6¾ x 10¼ in. (17.2 x 26.1 cm.)

The Baltimore Museum of Art, Bequest of Saidie A. May 1951.357

H 168; DR 164

PROVENANCE
Étienne Bignou, Paris; Bernheim-Jeune, Paris, until 1925; sold to Saidie A. May, 1925, until 1951 (by 1941 deposited on permanent loan to The Baltimore Museum of Art); her bequest to the museum, 1951

In 1886 Seurat continued his practice of using the warm brown tone of his panels as a constituent color. Here the brown is mostly hidden in the sky and the light portions of the foreground but adds its color to the water and the beach growth at the lower right. In the water it is a subdued presence among the rich blues, accompanied by touches of green, creamy tan, and ruddy brown. The panel color is more prominent in the herbage, dominated by green and interspersed with dabs of light and dark blue, lavender, and brown. There are also touches of bright pink, a way of enlivening an area with contrasting color that Blanc had taught him to find in Delacroix's work.

166. *Embouchure de la Seine, soir, Honfleur*. 1886

EVENING, HONFLEUR

Oil on canvas, 25¼ x 32 in. (65.4 x 81.3 cm.)
Signed lower right: Seurat
Painted frame added in 1889 or 1890

The Museum of Modern Art, New York, Gift of Mrs. David M. Levy, 1957

Exhibited in Paris only
H 167; DR 171

PROVENANCE
Madeleine Knoblock, Paris, from 1891; Gustave Kahn, Paris, by 1892; Victor Claessens, Brussels, until 1929; by inheritance to Armand Claessens, Waereghem, Belgium, until 1937; sold to Wildenstein and Co., New York, in 1937, until November 1938; sold to Dr. and Mrs. David M. Levy, New York, in November 1938, until 1957; her gift to the Museum, 1957

EXHIBITIONS
1887 Brussels, no. 7
1887 Paris, no. 441
1888 Paris, Revue Indépendante
1892 Antwerp, no. 3 (of "Seurat, peintures")
1892 Brussels, no. 8
1940 New York, no. 367
1948 New York, no. 47
1949 New York, no. 18
1958 Chicago and New York, no. 104
1968 New York, no. 79
1979–80 London, no. 199

This sunset view, as seen from the shore close to the site of the previous picture, faces nearly the opposite direction and serves as its nocturnal pendant. The posts of the breakwaters, inconspicuous in the full sun in *La grève du Bas-Butin* (cat. no. 164), loom prominently here, with the man-made forms sharing the twilight with the irregular rock to the right. The inherent romanticism of the scene is greatly subdued by the reduction of the lonely promontory often found in earlier paintings (including Monet's) to one small, worn stone. It is, however, silhouetted against the column of sunlight and retains an emotional edge. Off in the distance a plume of smoke rises from a steamship, and to its left is a sail; their modesty is appropriate to this quiet view of one of the busiest estuaries in France. Long, thin clouds float above like serene fish; their regularity is another indication of calm winds. In contrast to the very urban *Pont de Courbevoie* (cat. no. 171), with which it has structural analogies, this composition tells us much about the immensity of ocean and sky.

The brushwork here, as in *La grève du Bas-Butin*, varies less from area to area than in the Grandcamp canvases and probably reflects the long months of work on *La Grande Jatte*, when Seurat refined and tightened his textures. (It is possible that the smallest strokes were added three or four years later, when the painted frame was made.) As usual, the small touches that dominate our view are only the final coating of the surface. For the water, for example, over an initial layer of rather broad strokes Seurat added innumerable dabs of varied greens and creamy tans, increasing their intensity near the sun's reflection where he introduced pale oranges and browns. Many of the touches in the foreground are exactly centered upon larger, contrasting disks of paint—a practice that he would use more frequently in the summer of 1888.

When Seurat added the wide frame in 1889 or 1890, he made it engage in a curious dialogue with the composition. Its basic colors are intermixed dabs of blue and orange, but he added many red spots in the upper left and to the right, below the longest cloud, because the sky has more green in the adjacent areas. In the lower left, both above and to the right of the corner, green was added to blue and orange, apparently to react to the purple-reds of the breakwaters and shore. More curious is the fact that the lower left corner of the frame is much lighter in value than the upper right corner, as though the fictional sunlight were coming out of the picture, partly lightening the lower left while leaving the upper right corner in shadow. The narrow inside edges of the frame are also painted but in a simpler fashion, with fewer strokes and colors.

167. *L'hospice et le phare de Honfleur*. 1886

LIGHTHOUSE AND MARINERS' HOME, HONFLEUR

Oil on canvas, 26¼ x 32¼ in. (66.7 x 81.9 cm.)
Signed lower left: Seurat

National Gallery of Art, Washington, D.C., Collection of Mr. and Mrs. Paul Mellon 1983.1.33

H 173; DR 168

PROVENANCE
The artist until 1887; sold from the 1887 Les XX exhibition to Émile Verhaeren, Brussels, in February 1887, until at least 1905; Curt von Mützenbecher, Wiesbaden, by 1908–09; Bernheim-Jeune, Paris, by 1910, until at least 1912; Richard Goetz, Paris, by 1914,* until 1922 (Goetz sale, "Liquidation des biens Richard Goetz Wendland et Siegfried Hertz, Ayant fait l'objet d'une mesure de séquestre de guerre," Drouot, Paris, February 23–24, 1922, no. 181, for 19,000 francs); purchased at this sale by Mr. Grunwald; with Mr. Loewenstein, until 1929;** purchased jointly by Reid and Lefevre, Glasgow and London, and De Hauke and Co./Jacques Seligmann and Co., New York (stock no. 3380), in June 1929, until November 1933; with Reid and Lefevre, London, from November 1933 until June 1934; sold to Mrs. Chester Beatty, London, in June 1934, until her death in 1952; by inheritance to Sir Alfred Chester Beatty, Dublin, probably until at least 1961; Mr. and Mrs. Paul Mellon, Upperville, Virginia, by 1966, until 1983; their gift to the museum, 1983

EXHIBITIONS
1886–87 Nantes, no. 968
1887 Brussels, no. 5
1887 Paris, no. 439
1892 Brussels, no. 6
1892 Paris, Indépendants, no. 1095
1892 Antwerp, no. 2 (of "Seurat, peintures")
1904 Brussels, no. 146
1905 Paris, no. 37
1908–09 Paris, no. 63
1910–11 London, no. 55
1929 New York, no. 60
1986 Washington, D.C., and San Francisco, no. 155
1988 Amsterdam, no. 3

*According to Dorra and Rewald, with the declaration of World War I in 1914, Richard Goetz, a German citizen living in Paris, offered this work in vain to the Musée du Louvre. (See also third provenance note, cat. no. 211.)

**Annotated sale catalogues indicate the purchaser's name as Grunwald; the name Loewenstein appears next to the previous lot, no. 180

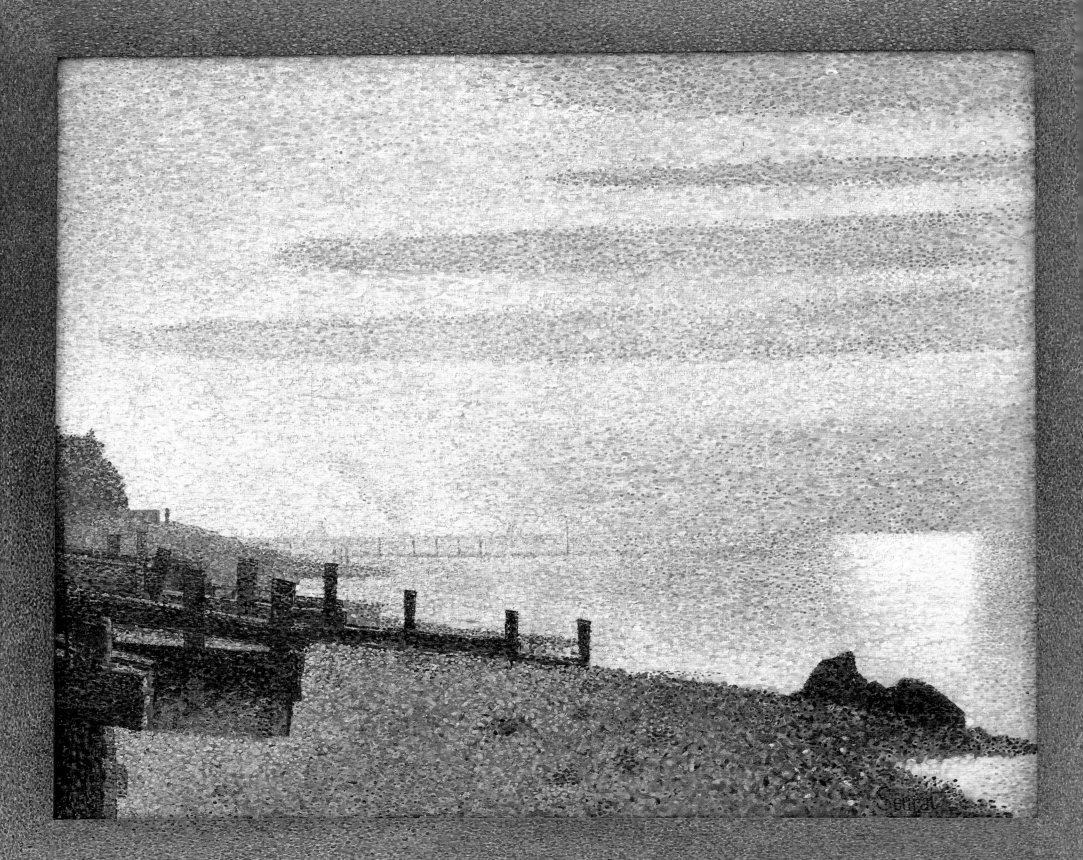

(see provenance, cat. no. 211). Loewenstein must thus have known of the sale of the work to Grunwald and probably purchased it from him at a later date. In any event, the work was with Loewenstein by 1929 when he sold it in Glasgow to Reid and Lefevre, whereupon it was purchased in partnership with the London office and De Hauke and Co./Jacques Seligmann and Co., New York.

This site, another to the west of the harbor at Honfleur, is closer to the center of the city than the settings of the previous two pictures. The view, looking east across the mouth of the Seine toward Le Havre, was long favored by painters; the identical view, from farther back, had already been painted by Boudin, Jongkind, Lépine, and Monet. Boudin had once lived nearby, just inland from this beach, and Baudelaire had stayed in the same area, so Seurat was knowingly treading upon artistic ground. The two low buildings to the right belonged to a ramshackle shipyard,[1] which accounts for the careened boat, the boat cradle, and the transport wheel lying rather forlornly in the sand. They surely symbolize the lot of the old mariners who were pensioners of the large building beyond. In contrast to these signs of age and abandonment, the lighthouse stands erect in the midday sun, and to the left a ship sails out of the harbor. While all earlier paintings of the site leave a lot of sky above, here Seurat made the lighthouse touch the top of his canvas, simultaneously bringing it forward to the surface and giving it prominence. Illuminated from the side, it is the picture's most volumetric image. It reminds us of the vertical human form, for poets and painters had long since portrayed lighthouses as surrogates of human presence at the edge of the sea.

J.-K Huysmans, who did not like *La Grande Jatte,* responded well to this picture when it was exhibited in 1887:

Last year M. Seurat exhibited, in addition to his view of *La Grande Jatte,* several really beautiful seascapes, with their quiescent seas underneath a calm firmament. These clear and blond canvases, enveloped by a powder intoxicated with sunlight, disclosed a very personal and true grasp of nature. . . . The seascapes that he exhibits this year, his views of Honfleur, especially his light-

house, . . . rest again on this particular feeling that he expresses of a nature more lulling than melancholy, a nature that reposes indifferently under skies without passion, sheltered from the winds. Those who wish to are free to prefer less cold and more vivid impressions or to love beaches more bustling and noisy; for me these works have a particular charm that I cannot deny. I find in them a fullness of expansive air, a siesta of a quiet soul, a distinction of wan indolence, a caressing lullaby of the sea that soothes and dissipates my weary cares.[2]

When Seurat sold this canvas to the poet and critic Émile Verhaeren in 1887, he said that he had worked on it for more than two and a half months, as compared to one week for the unfinished *Coin d'un bassin, Honfleur.* This remark is the only evidence of the time Seurat spent on his seascapes.

The buildings to the right are prime examples of the complexity of Seurat's color. The hospice walls have dabs of red and red-orange over and between purples and blues, giving a purplish but not uniform color from a distance. The roof appears slate gray as a result of separate touches of green, cream, blue, pink, tan, and orange; it is bluer toward the sky and greener toward the red-and-blue wall below. To the windows Seurat added green, which vibrates against the reds only when examined closely; more conspicuous is the green halo provoked on the walls of the red-roofed shanty nearby.

One of the most miraculous bits of painting here is the lighthouse, whose granite blocks are rendered both by the shape of the strokes and by the unblended juxtaposition of oranges and blues. As for the signature, it is "Seurat" in word and principle, for it consists of alternating dots of color opposites, pale blue and brownish orange.

1. The buildings, with identical coloring and shape, appear in a painting of the site signed and dated 1877 by Léon-Pierre Herpin (1841–1880), sold at Christie's, New York, February 23, 1989, lot 89.
2. Huysmans 1887, p. 53.

168. *Étude pour "L'hospice et le phare de Honfleur."* 1886

STUDY FOR "LIGHTHOUSE AND MARINERS' HOME, HONFLEUR"

Oil on wood, 6¼ x 9⅞ in. (16 x 25 cm.)
"Moline" stamp in red lower left: Seurat

Private collection

Exhibited in Paris only
H 172; DR 167

PROVENANCE
The artist until 1891. Posthumous inventory, panneau no. 124. Probably inherited by Madeleine Knoblock, Paris, in 1891. Camille Platteel, Brussels and Paris; Félix Fénéon, Paris, by 1908, until his death in 1944; his estate, 1944–47 (Fénéon sale, Drouot, Paris, May 30, 1947, no. 106, for 470,000 francs); purchased at this sale by P. Metthey; Roger Gros, Paris, from 1947;* private collection; to present owner

EXHIBITIONS
1895 Paris
1908–09 Paris, no. 62

*According to an annotated sale catalogue, this panel was purchased by P. Metthey; presumably he purchased it for, or sold it immediately to, Roger Gros, Paris, who, according to Dorra and Rewald, owned the work since 1947. It should be noted that Roger Gros was present at this sale: he purchased lot no. 100 for 400,000 francs (H 26) and he successfully bid on the two lots purchased on behalf of Pierre Lévy: a Modigliani (lot no. 94) and a Seurat (lot no. 101, see provenance, cat. no. 82). These records, including an annotated bill of sale, are preserved in the Étude Loudmer, Paris.

Like other panels in the present exhibition, this work is here reunited with its canvas for the first time in many years; the two were last together in a 1908–09 exhibition. On the canvas the brushstrokes are proportionately small and include a whole scale of tints; the colors on the panel appear more saturated because they are laid down in larger touches, and there are fewer intermediate tints. The shaded wall of the hospice is rendered with tints of red, purple, and blue that do not coalesce into the purplish tone of the canvas, and for that reason they contrast more with the yellows and tans of the beach. To give the effect of the late morning sunlight, Seurat poised dabs of more intense chroma in a thin vertical column on the right side of the lighthouse. Because the boat cradle is viewed from a lower

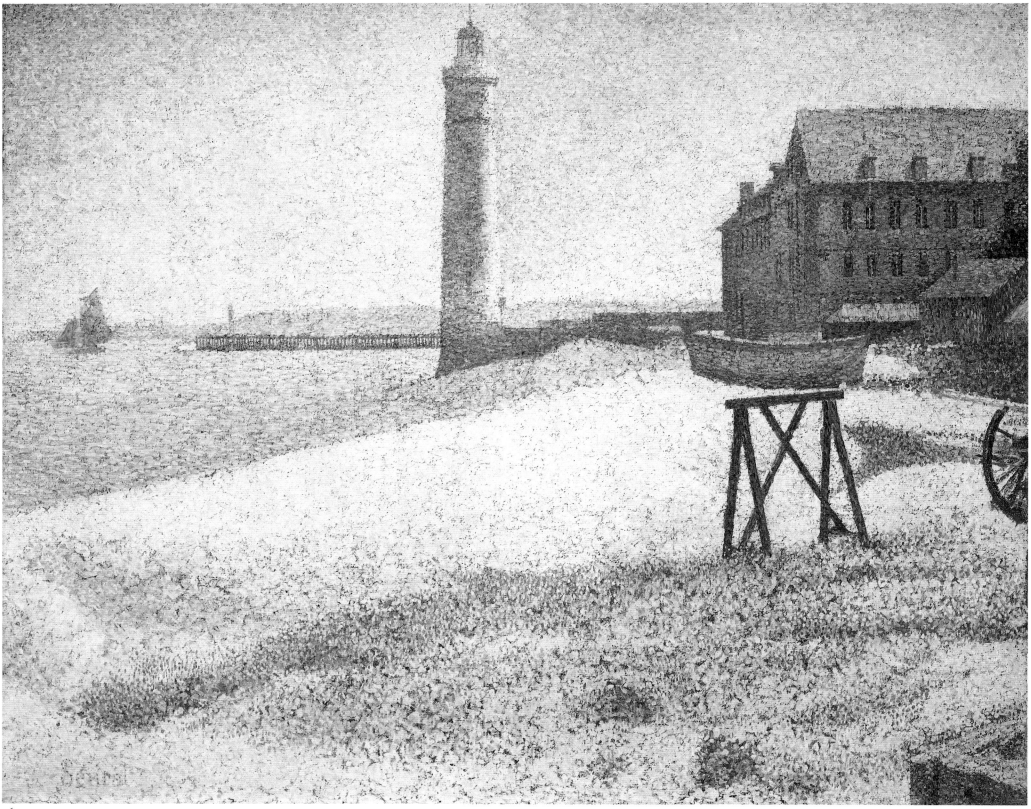

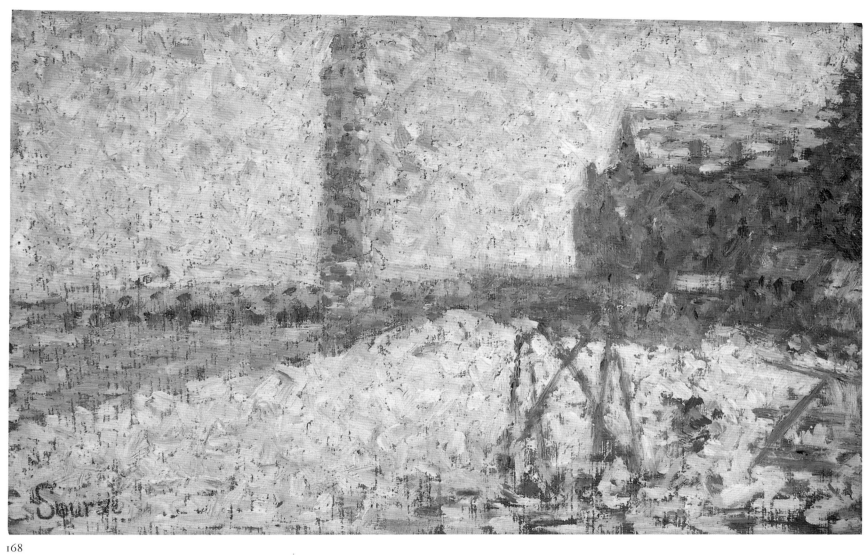

168

vantage point, its top is partly integrated with the boats and buildings beyond, so it is not as distinctly linear as it is on the canvas. Since the panel lacks the deep foreground beach of the larger work, the effect is less that of a silent and abandoned stretch of shore and more that of a close-up view of a maritime establishment. The panel was Seurat's first response to the site, and in it the mood and symbolism of the final painting were not yet fully developed.

169. *Le phare de Honfleur.* 1886

LIGHTHOUSE AT HONFLEUR

Conté crayon and gouache, 9½ x 12 in. (24.1 x 30.8 cm.)

The Metropolitan Museum of Art, New York, Robert Lehman Collection, 1975 1975.1.705

Exhibited in New York only
H 656; DR 163a

PROVENANCE
The artist until 1891. Posthumous inventory, dessin no. 105bis. Inherited by the artist's brother, Émile Seurat, Paris, in 1891, until his death in 1906; by inheritance to his widow, Mme Émile Seurat, Paris, from 1906; Félix Fénéon, Paris, by 1923, until his death in 1944; by inheritance to his widow Mme Fanny Fénéon, from 1944; her gift to John Rewald, New York, by 1946, until 1960 (Rewald sale, Sotheby's, London, July 7, 1960, no. 115, for £5,000); purchased at this sale by Mr. Jacobson, as agent for Paul Rosenberg and Co., New York, until March 1961; sold to Mr. Robert Lehman, New York, in March 1961, until his death in 1969; his bequest to the Museum, 1975

EXHIBITIONS
1922 Paris, no. 17
1924 New York, no. 22
1926 Paris, Bernheim-Jeune, no. 81
1932 Paris, no. 23
1936 Paris, no. 123
1948 New York, no. 62
1949 New York, no. 48
1950 Venice, no. 14
1950 Rome, no. 10
1953 New York, no. 32
1958 Chicago and New York, no. 110
1968 New York, no. 78
1977 New York, no. 37
1983–84 Bielefeld and Baden-Baden, no. 75

This is one of two drawings known from the summer at Honfleur. The other (H 657; private collection) is a study for *Entrée du port de Honfleur* (H 171; Barnes Foundation, Merion, Pennsylvania), whereas this one seems to have been done for its own sake. Seurat stationed himself at twilight—the lighthouse is illuminated—on the low strand opposite the jetty. A rise of land between him and the water hides the hull of the boat whose sail glides majestically into the harbor. Here and there on the jetty near the two sheds are minuscule figures. They are dwarfed by the lighthouse, which has an anthropomorphic character. Adding to the drawing's twilight mystery are the unexplained dark patch and the luminous glow in the foreground.

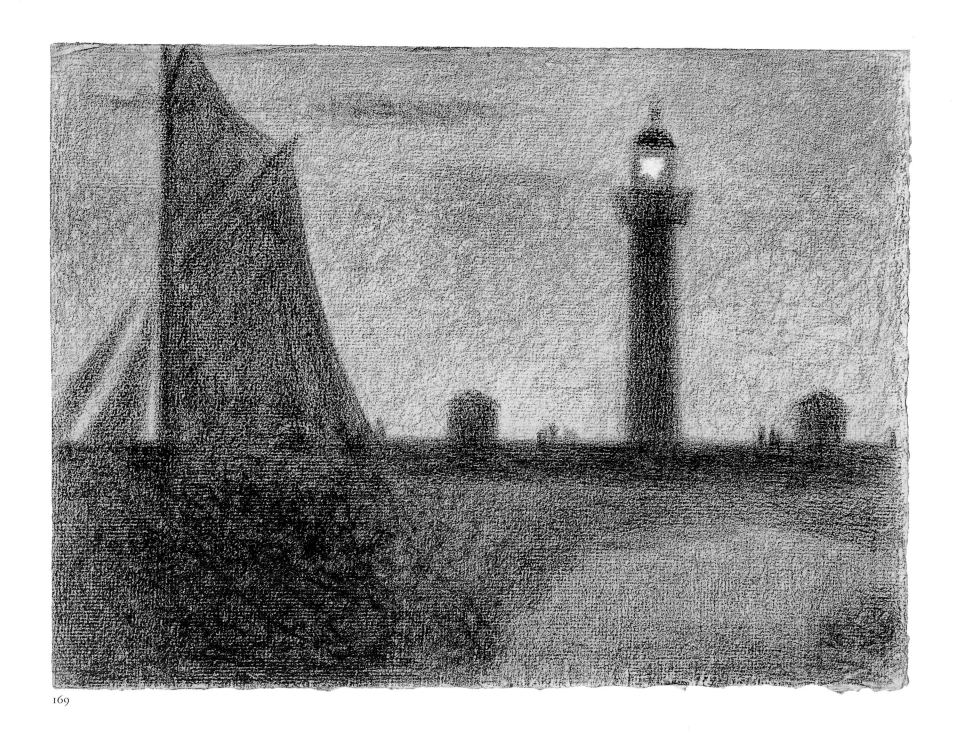

169

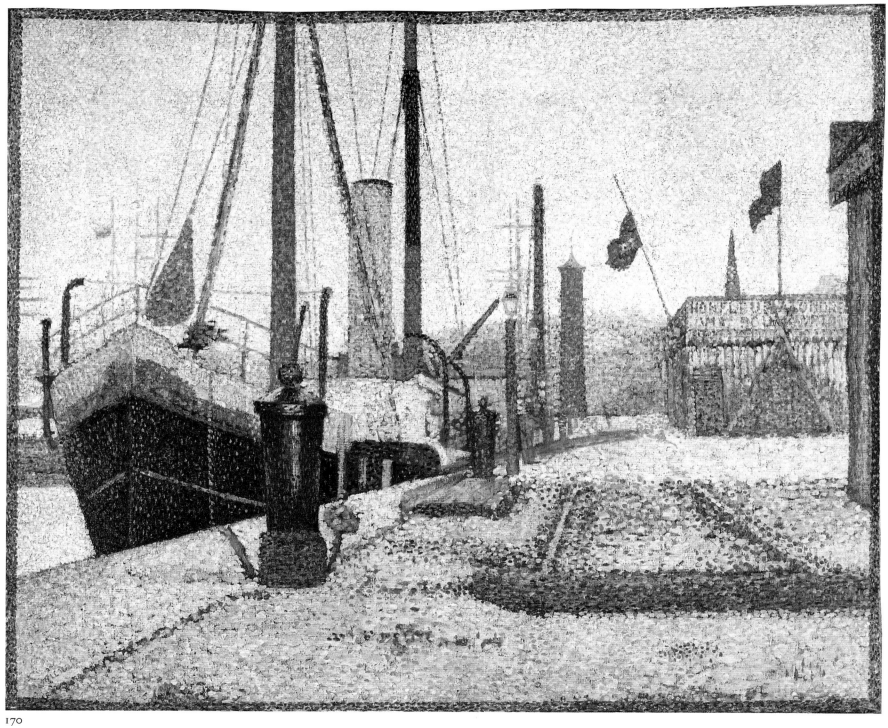

170

170. *La "Maria" à Honfleur.* 1886

THE "MARIA" AT HONFLEUR

Oil on canvas, 20⅞ x 25 in. (53 x 63.5 cm.)
Signed lower left: Seurat
Painted border added about 1888

The National Gallery, Prague (Národní Galerie v Praze)

H164; DR 169

PROVENANCE
Probably inherited by Madeleine Knoblock, Paris, in 1891, until at least 1892;* Émile Verhaeren, Saint-Cloud, by 1914; Galerie Barbazanges, Paris, until 1923; purchased by the state, 1923, thence to the museum

EXHIBITIONS
1887 Paris, no. 444
1892 Brussels, no. 9
1892 Paris, Indépendants, no. 1097
1908–09 Paris, no. 61
1986 Washington, D.C., and San Francisco, no. 156

*Presumably Madeleine Knoblock lent this work to the 1892 exhibition in Brussels. See Marie-Jean Chartrain-Hebbelinck, "Les lettres de Paul Signac à Octave Maus," *Bulletin*, Musées Royaux des Beaux-Arts de Belgique, 1969/1–4, p. 70, letter 12, of 1892, Signac to Maus: "Madame Knoblock has lent two Honfleur canvases and about fifteen panels in a single frame." See also ibid., p. 72 n. 2; the works belonging to Madeleine Knoblock do not carry the lender's name (three Honfleur canvases were lent anonymously to the 1892 exhibition).

Jongkind, two decades earlier, had made etchings and drawings of the commercial quays at Honfleur, but he subordinated them to a vast sky and the broad expanse of the harbor. Seurat not only brings us right into the maritime setting, but he also fills his composition with marks of commercial activity: ship's rigging, masts and smokestack, metal bollards, and iron rails in the foreground; a brick chimney and flag-bedecked wharf buildings in the background. Were it not for the delicate greens of the distant hillside, the only "nature" here would be the sky and a small patch of water. There is scant precedent for this picture in Seurat's earlier work. He had already drawn and painted suburban factories, but never before had he given such importance to the lineaments of commerce. Signac's painting *Les gazomètres à Clichy* (National Gallery of Victoria, Melbourne), exhibited with the Im-

pressionists in late spring, may well have been the stimulus for this composition. In both paintings, technique and subject have analogies with industrial organization.

Paul Smith's study of shadows puts the time of this picture at early evening, about 6 P.M., and Eric Darragon has documented the *Maria,* an iron-hulled steamship (it carried auxiliary sails) that ferried cargo and passengers between Honfleur and Southampton.[1]

The picture is crammed full of structural incident, but since there are no humans present and no visible activity, the weight of commerce falls on these silent forms. As Darragon remarks, "Control of the site brings about a fragmentation, a design in which exactitude is not an end in itself but a means of harnessing the calculation and rhythm that inform and justify reality." The bollards seem like human sentinels, lending to the scene a haunting quality that is not dissipated by the jaunty flags. Some strange features can be explained by Seurat's attention to specific effects of sunlight. The two forms that flare from the base of the nearest bollard are shadows cast by ropes and a rat baffle; the rails to the right do not really disappear: the light flooding in from the west, beyond the edge of the adjacent building, is so strong that it largely obliterates their tracks.

The specific nature of sunlight and shadow (and therefore coloration) in this work shows Seurat's dependence upon study of the actual site. The left side of the *Maria,* superficially similar to the right, is subtly differentiated from it because it is in shadow. For the lower area of the hull on the right side, there are orange and orange-brown touches to go with the blues and dark purple-reds; on the other side these are replaced by dull greenish browns. Above, for the lighter area on the shaded side, there are touches of yellow and lavender, whereas the sunlit side has orange and pink.

Later, perhaps in 1888, Seurat added a painted border to his canvas. It may be among his first, for it is simpler than most others, consisting almost solely of orange and blue, with red added wherever green tones are found in the composition. He signed his name in blue and red dots along an inward angle, as though it were sharing in the picture's perspective. He did not use this form of signature again, for his stitched surname elsewhere is flat and abstracted from his compositions.

1. Smith 1984 and Darragon 1984.

171. *Le pont de Courbevoie.* 1886

THE BRIDGE AT COURBEVOIE

Oil on canvas, 18⅛ x 21⅛ in. (46 x 55 cm.)
Signed lower left: Seurat

Courtauld Institute Galleries, London (Courtauld bequest)

Exhibited in Paris only
H 178; DR 172

PROVENANCE
Arsène Alexandre, Paris, by March 1887, until 1903 (Alexandre sale, Georges Petit, Paris, May 18–19, 1903, no. 57, for 630 francs); with Georges Petit, Paris; L.W. Gutbier, Dresden, in 1908–09; with Étienne Bignou, Paris; with Reid and Lefevre, London, until 1926; sold to Samuel Courtauld, London, in 1926, until his death in 1947; his bequest, 1948

EXHIBITIONS
1887 Paris, no. 442
1892 Paris, Indépendants, no. 1090
1900 Paris, Revue Blanche, no. 25
1908–09 Paris, no. 64
1926 London, no. 4
1929 New York, no. 58
1932 London, no. 541
1933–34 Paris, no. 65
1937 London, no. 33
1937 Paris, no. 413
1958 Chicago and New York, no. 115
1987–88 Cleveland, New York, et. al., no. 34

On a still, humid afternoon, a silvery sunlight washes over the embankment of the island of La Grande Jatte, turning its grass to light olive green. Dark strips parallel to the water's edge are probably caused by depressions in the embankment that turn away from the western light. In the lower left corner and in the narrow shadow of the tree trunk to the right, we see the deeper greens of fully shaded grass. Off in the distance a factory in Courbevoie sends up a fragile plume of smoke, while the Pont Bineau hovers in the moist light, disappearing at both ends into foliage. In a small boat below sit two figures, patiently fishing. Nearer to us a man stands on a dock, perhaps fishing or adjusting a rope. On the shore stand two other men with the isolated, doll-like silhouettes found in Seurat's contemporary drawings and in his large painting of the island.

Along the left edge of the picture, two shadows penetrate the triangle of the foreground and a boatyard fence slants inward. Above, a frothy mass of foliage floats down from an unseen tree, while on the far side, as if in compensation, rises a tree that lacks foliage. It adds a brooding touch to a scene that might otherwise be banal. To its right a tall mass (a building?) is reflected in the water to form a band along the picture's edge that would look as though it were applied by a roller, were it not for its myriad small touches of different shapes and colors. The tree and the foliage on the opposite side have organic curves that contrast with the parallel verticals over the water. These in fact are not quite vertical but mostly tipped slightly to the left. They hint at the way that even calm water makes boats rock gently, and it is therefore not surprising to find that they do not evenly subdivide the canvas.

Viewed closely and contemplatively, this picture translates the look and the emotions of a quiet moment along the Seine. In comparison with works by Corot or Daubigny, however, the painting seems willfully geometric. In his *Pont de Mantes*, Corot avoided the changes that had been altering the Seine and its banks, so instead of painting new rail and road bridges he chose an ancient structure and put in the foreground a traditional riverman's boat rather than a commercial or pleasure craft. His trees undulate in the foreground, screening the bridge with the

Camille Corot, *Le pont de Mantes* (Bridge at Mantes), about 1865. Musée du Louvre, Paris

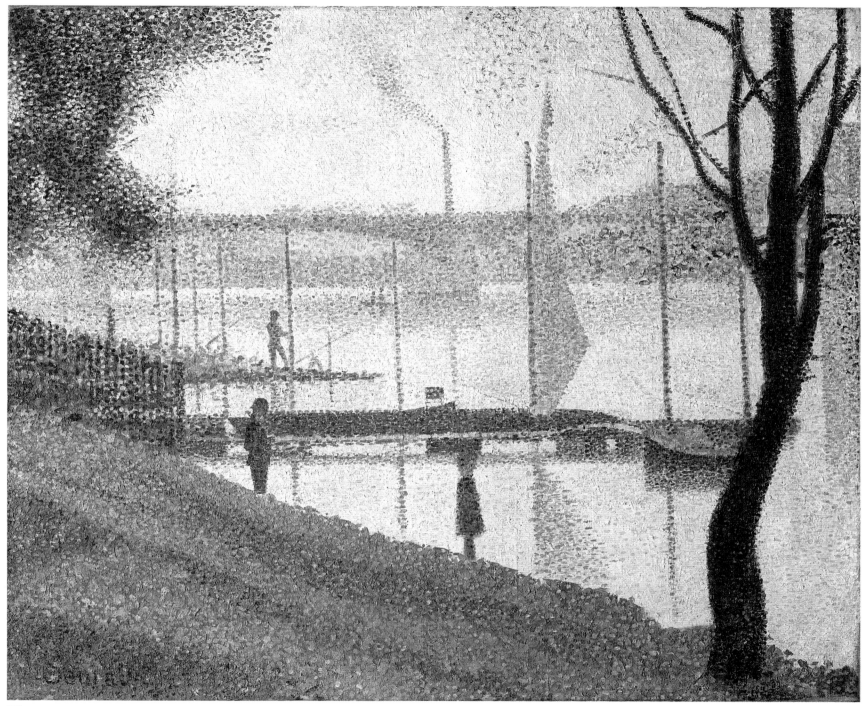

171

rhythms of nature. Seurat's composition has essentially the same structure as Corot's, but its images are deliberately contemporary and its composition taut and flat. Between the works by Corot and Seurat came Monet's paintings of the railroad and highway bridges at Argenteuil. (By 1886, however, Monet had given up such subjects and for several years had been painting pictures along the Channel coast whose images of rocky promontories and rolling seas were borne along on crests of agitated pigment.)

Le pont de Courbevoie is a deliberate statement of "scientific" Impressionism, a picture that takes up the familiar imagery of Impressionist scenes of leisure, including a distant reminder of suburban industry, but gives it a new technique and a new organization. It is the counterpart, in landscape, of the remaking of Impressionist figure subjects in *La Grande Jatte* (whose site, in relation to this view, would be behind us to our right).

This small picture, which has less than one-half the surface area of the related *Temps gris à la Grande Jatte* (cat. no. 173), is among the first landscapes conceived from beginning to end in Seurat's mature technique. It was exhibited with the Indépendants in March 1887, but it was apparently completed several months earlier, for Seurat recorded it as belonging to the critic Arsène Alexandre in a list he made in late autumn 1886 (Appendix D). This means that somehow, in that prodigious year, he not only completed *La Grande Jatte* in the spring but spent the summer at Honfleur, completed the Honfleur pictures in

the fall and winter, and still found time for this canvas. As a guide he used a conté drawing of the composition's principal features (H 653), making slight alterations here and there, particularly in the foreground, which is evenly toned in the drawing. He worked on the light brown of an unprimed canvas, largely covering it in each area with an appropriate underlayer of large, crisscross strokes that show between the surface dabs. The water is formed of such a layer in oyster white, which shows liberally between touches of pale yellows, pale blues, and other colors appropriate to the reflections. Dabs of green are found in reflections of the lavender sail and in the purplish blues and reds of boats—a play of opposites that is closer to Rood than to Chevreul. The foreground areas were first painted in a *balayé* of olive green, to which were added several hues mixed with green and some touches of purer oranges, dull oranges, pinks, blues, and reds, the mixture varying with the light and shade. The pinks, which have a slight cast of mauve, are there to enliven the greens; Seurat had noted this mixture of opposites in Delacroix's paintings. The strokes, of course, are far from those of Delacroix and are smaller and more uniform than just a year earlier, as in *La Seine à Courbevoie* (cat. no. 153).

The picture was lent to the exhibition of the Indépendants in 1887 by Arsène Alexandre, who had begun to write favorably about Seurat the previous year and who drew closer to him as the decade progressed. It is not known if he purchased it or if it was a gift from the artist.

172. *Le pont de Courbevoie*. 1886

THE BRIDGE AT COURBEVOIE

Conté crayon, 9½ x 12 in. (24.1 x 30.5 cm.)

Private collection

H 653; DR 172a

PROVENANCE
The artist's family; Alexandre Natanson, Paris, until 1929 (Natanson sale, Drouot, Paris, May 16, 1929, no. 63, for 68,000 francs); Chester Dale, New York, probably until 1944 (when the drawing was sold at auction as "Property of a New York Private Collector"); sale, Parke-Bernet, New York, March 16, 1944, no. 31, for $4,250); Mr. and Mrs. Francis Kettaneh, New York, by 1946, until at least 1958; to present owner at a subsequent date

EXHIBITIONS
1949 New York, no. 59
1958 Chicago and New York, no. 114

Clues to the relationship of study drawing with painting can be found in this handsome sheet, although admittedly we are dealing with deductions, not certitude. Seurat probably made the drawing on the spot and subsequently used it to rough out the painting (cat. no. 171) in his studio. Then he took the canvas to the island, more than once, and eventually finished it in the studio. In the drawing there is the same slight leftward tilt of the boats' masts and the same irregular rhythm in their placement (despite the appearance of measured distances), suggesting that he was interpreting an actual site.

When he turned to his canvas, Seurat extended the view on the left and top, and very slightly on the right. This expansion allowed him a more generous and natural setting, including the complete chimney and its smoke in the center, more of the leafless tree, and more of the foliage in the upper left. He slightly altered the position and shape of the little figure and added two others, as well as the distant fishermen. He also added the prominent sail along the dock and altered the sequence of light and dark patches below its deck. In the realm of black and white, the simple triangle of the foreground makes sense, but in a painting a uniform swatch of color would be too abstract, so he painted the embankment's depressions and shadows. Some of these additions may have resulted from Seurat's wish to embrace characteristic features after repeated visits to the island, but equally important was his wish for the richer composition appropriate to an oil painting.

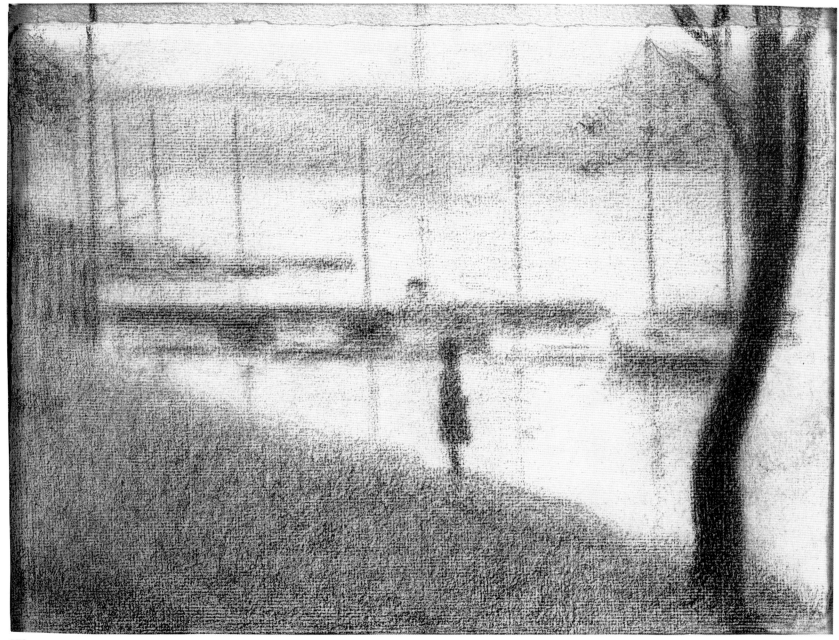

172

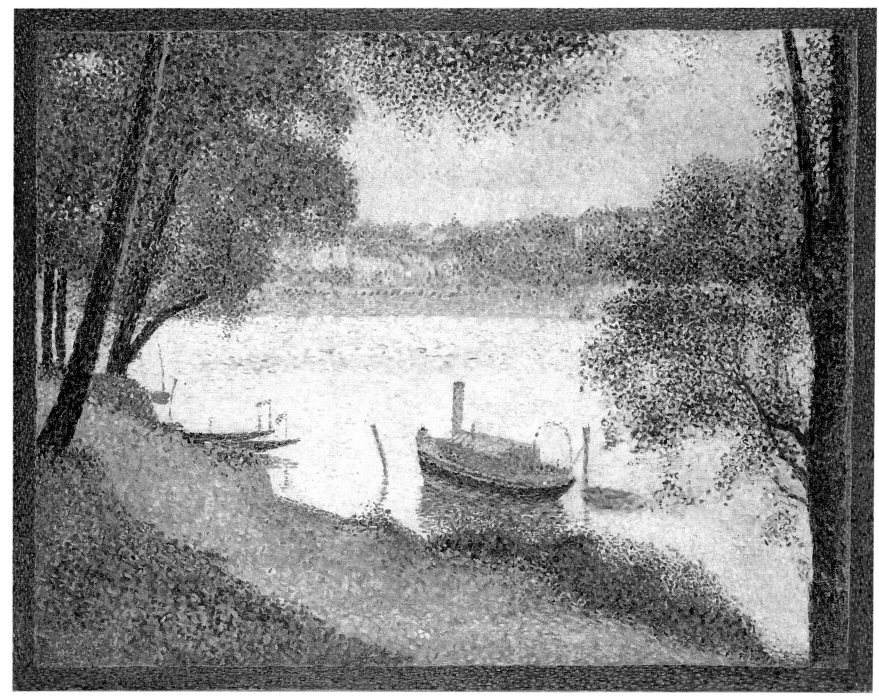

173

260 1886–1888

173. *Temps gris à la Grande Jatte.* 1886–87

GRAY WEATHER ON THE GRANDE JATTE

Oil on canvas, 27¾ x 34 in. (70.5 x 86.4 cm.)
Signed lower right: Seurat
Painted border added about 1888–89

From the Collection of The Honorable and Mrs. Walter H. Annenberg

Exhibited in New York only
H 177; DR 190

PROVENANCE
Given by the artist to Alexandre Séon, Paris, after April 1890, until at least 1905, and possibly until his death in 1917; Walter Halvorsen, Paris, before 1921; John Quinn, New York, from 1921 until his death in 1924; by inheritance to Julia Quinn Anderson, New York, from 1924; by inheritance to Mary Anderson Conroy, San Mateo, California, until her death in 1970; by inheritance to her husband, Dr. Thomas Conroy, San Mateo, from 1970 until 1971; sold to Wildenstein and Co., New York, in November 1971, until 1972; sold to present owner, January 1972

EXHIBITIONS
1889 Brussels, no. 3
1890 Paris, no. 733
1892 Paris, Indépendants, no. 1091
1904 Brussels, no. 148
1905 Paris, no. 41
1924 New York, no. 16

Gray weather intrigued many landscape painters who wished to explore the effects of a light that does not produce strong shadows or bleach what it strikes. The Parisian basin is characterized by a moist gray light which Monet especially loved; he had earlier painted along the shores of La Grande Jatte. Here, against the evanescent grays of sky and water, Seurat placed a rich chromatic array. The sandy strand in the foreground consists of lavenders, pinks, tans, orange-tans, and blues over larger buff-colored strokes, resulting in no single hue but in a mixed tone between ruddy brown and tan. The foliage at the upper left, despite its relative darkness, is a dazzling mixture of intense medium blues, several strong greens, some lavenders, orange-yellows, and oranges. The leaves at the center top and right, closer to us and perhaps from a different species of tree, have little of the intense blue and instead show wine reds and darker greens.

Temps gris is virtually a pendant of *Le pont de Courbevoie* (cat. no. 171). Despite its gray light, it has richer color

than the other canvas. It is less austere and closer to the work of Corot and Monet, not only because it lacks the insistent verticals of *Le pont* but also because its foreground is more varied along the water and the foliage of its framing trees takes the form of sheltering arabesques. It lacks the spectators, the fisherman, the bridge, and the factory chimney, all of which give the other picture its marks of activity. We face instead the red-roofed residences of Courbevoie or Asnières from the vantage point of a quieter mooring. The principal boat is a small steamer named "la Félicité," according to Maximilien Luce,[1] more likely a pleasure boat than a commercial one. To the left protrude the bows of riverboats, like two pikes; they bear the red, white, and blue pennants of a rental agency or boat club. Along these well-manicured shores the boats lend a quiet expectancy to the calm day.

Although first exhibited in Brussels in 1889, *Temps gris* was painted earlier. Its brushwork is closest to that of *Le pont de Courbevoie*, which can be dated 1886–87; its palette is also like that of the earlier picture and of the still earlier *La Seine à Courbevoie* (cat. no. 153). *Temps gris* unquestionably predates another of the riverscapes along this part of the Seine, *Printemps à la Grande Jatte* (H 176; Musées Royaux, Brussels), painted in the spring of 1888. The latter has a white undercoat, whereas *Temps gris,* like *Le pont,* is painted over unprimed canvas of a light brown color. The dinghy to the right of the steamboat consists primarily of this brown, on top of which Seurat put separate strokes of blue, pink, orange, and orange-tan. Underneath and between the surface touches of the tree to the right are large vertical strokes of dark wine red like those in *La Seine à Courbevoie.* Before he exhibited the picture, Seurat applied the painted border and added many small touches elsewhere, including the yellows and carmines that extend the foliage at the river's edge out over the water; numerous off-whites on the water; and pale oranges along the edges of the composition, in reaction to the dark border. The border, unlike the composition, is painted over a white ground. Although its colors shift with neighboring hues (reds increase alongside the greens of foliage), there are fewer of them than in the borders of the seascapes painted during the summer of 1888.

1. In an undated letter to Signac (Signac archives), written in 1916 or 1917, Luce describes the picture as "a landscape of Asnières with the boat 'la Félicité.'" His words are so definite that they seem to rule out mere conjecture.

174. *L'échafaudage.* 1886–87

SCAFFOLDING

Conté crayon, 12½ x 9⅝ in. (31.7 x 24.6 cm.)

Private collection

Exhibited in Paris only
H 567

PROVENANCE
Paul Signac, Paris, by at least 1905, and probably in 1891, until his death in 1935; by inheritance to Ginette Signac, Paris; to present owner

EXHIBITIONS
1905 Paris, no. 32
1908–09 Paris, no. 169
1926 Paris, Bernheim-Jeune, no. 56
1958 Chicago and New York, no. 125

From the early 1850s onward, buildings under construction, the visible signs of the extensive remodeling of Paris, were a staple of illustrators and photographers. About 1881, in a small notebook, Seurat had made a pencil drawing of two workers on scaffolding (H 566). The present work, one of his most complicated mature drawings, is a far cry from that little sketch, but it shows that he continued to be an heir of mid-century naturalism well after he took up Impressionist subjects in his paintings. Like his earlier *Badigeonneur* (cat. no. 46) or the slightly later *Balayeur* (cat. no. 182), this drawing shows city men at their work, a subject hardly ever undertaken by the Impressionists.

Gustave Kahn evoked the writings of J.-K. Huysmans when he described this drawing: "The powerful silhouette of *L'échafaudage* which recalls one moment of the realist aesthetic, the discovery of the beauty of working-class labor and the robust slenderness of architectural preparations, and also this idea of Huysmans, read and referred to by all young painters then, that scaffolding is always more beautiful in its lines, in its willowy openwork, than the building whose construction it serves."[1] Naturalism, of course, did not mean an unthinking record of things seen, and Huysmans's own writing, like that of Zola and the Goncourts, is full of passages of affective chiaroscuro. The magic worked by Seurat's drawing lies in the tension between its geometry and its mysterious levels of depth. The measured units formed by the scaffolding, the gray

wall, and the ladder are marks of artistic control, revealed elements of the structure of the drawing that have merged with its subject.

Seurat's view of this construction, like that of his *Parade de cirque* (cat. no. 200), is so radically foreshortened that we cannot readily sort out the structure's several levels. The vertical pole lies on the surface, the horizontals slightly behind. The worker on the left is clearly in front of the gray wall, but the space between the white horizontal that cuts off his feet and the lowest horizontal is not easily discerned, all the more so because of a few indecipherable slanting shapes. The ladder projects toward us—its visible tip catches the light—but it is flattened because the other tip is obscured by the cloth flung over the scaffolding; the way it crosses the gap in the wall lower down is unclear. The man in a white smock is well beyond the ladder, so between the two workers we sense considerable depth, but we cannot see clearly into the region above. Behind the near worker the pattern of dark and light can be read as a farther wall with an opening in the upper corner, but the upper right quadrant is an undefined place, pierced by slender light verticals. It is perhaps overly romantic to compare this network of definite shapes and unclear spaces with a prison, but the workers do seem to be captives of the scaffolding. The vertical pole, in its arresting nearness, has more reality than the men. They are subordinated to this scaffolding and must perform their labor within its shifting levels. The play of light and dark threatens to push us, as well, into a realm of enigma.

1. Kahn 1928, 1, n.p.

175. *Maurice Appert assis.* 1886–88

MAURICE APPERT

Conté crayon and gouache, 12¼ x 9½ in. (31 x 24 cm.)
Signed lower right: Seurat

André Bromberg Collection

H 607

PROVENANCE
The artist's brother-in-law, Léon Appert, Paris, probably until his death in 1925; by inheritance to Mme Léon Roussel, Paris, until at

174

least 1934; private collection, Paris (sale, Ader Picard Tajan [Drouot], Paris, November 18, 1989, no. 6); to present owner

EXHIBITIONS
1900 Paris, Revue Blanche, no. 41
1908–09 Paris, no. 160
1933–34 Paris, no. 173
1957 Paris, no. 50
1958 Chicago and New York, no. 64

Seurat's rendering of his nephew is one of his most iconic images. Not only did he pose the young boy in a rigidly frontal position, he also seated him on a bench so there is no chairback to frame his body. His thighs and legs would merge entirely with the bench were it not for the lighter portion of his legs revealed above his stockings or boots. The closest analogy to such a pose is found in sculptures of seated Egyptian pharaohs, in which the figure's legs are only partly detached from the block on which the ruler sits. There is no direct evidence to prove Seurat's interest in Egypt, but some admiring critics had already likened *La Grande Jatte* to this ancient art, and his *Parade de cirque* (cat. no. 200) evokes the rhythms of Egyptian frescoes and reliefs. His "primitivism," in other words, probably encompassed an admiration of Egyptian solemnity, anticipating the more evident Egyptianizing of Gauguin just a few years later.

The background has little more differentiation than the stone into which Egyptian reliefs are cut. Removed, like Egyptian relief figures, from a specific environment, Seurat's subject similarly exists in an intangible, timeless world. Of course, Seurat worked in conté crayon and paper and created an illusion of atmospheric light and dark that is far from the opaque flatness of Egyptian surfaces. He divided the background into two zones with the broad splash of light that marks the plane of the floor. The farthest point, curiously, is this streak of light that does not "come forward" as conventional wisdom would predict. Through its skein of crayon marks, each zone pulsates as it reacts to the darks and lights of the boy's form. Figure and ground are welded together, not separated by such contrasts, and the boy's feet disappear into the dark scumble along the base of the drawing.

Rigid though the pose is, Seurat adjusted it so as to suggest the potential for movement. The boy is slightly to the left of the sheet's center and sits toward the right side of the bench; the seat's two edges have different profiles.

175

The slight curve of the boy's thigh to the right shows that this leg is pressed outward more than the other. These departures from bilateral symmetry are hardly noticed at first glance, but once registered, they endow the image with the conviction of life.

176. *Blouse blanche.* 1886–88

WHITE SMOCK

Conté crayon, 12¼ x 9½ in. (31.1 x 24.1 cm.)

Robert Owen Lehman Collection

H 475

PROVENANCE
The artist until 1891. Posthumous inventory, dessin no. 150(?) (per inscription in orange crayon on reverse, not recorded by de Hauke). Bernheim-Jeune, Paris, by 1908–09; Baron Napoléon Gourgaud, Paris, until his death in 1944; by inheritance to Baronne Eva Gebhard-Gourgaud, Paris, from 1944; Paul Rosenberg and Co., New York, by 1949, until 1966; sold to Robert Lehman, New York, in January 1966, until his death in 1969; by inheritance to present owner

EXHIBITIONS
1908–09 Paris, no. 109
1936 Paris, no. 105
1949 New York, no. 53

Seurat created another iconic presence in this drawing by again using bilateral symmetry and frontality. Because the man sits on a low ledge, his knees thrust upward, forming a black receptacle for the white hexagon of his upper body. Such compact geometry nearly makes the figure into a sculpted idol, an effect abetted by the polygonal head with fezlike cap, which creates a continuous shape with the black Y below the face. This Y-shape has not yet been explained. It seems at once like a dark collar and tie (with a shadow to the right) and like the gap in a collarless garment. Only the man's dark trousers seem part of a conventional costume. As with the drawing of Maurice Appert (cat. no. 175), a few moments' contemplation yields a slightly more naturalistic effect. The man's face is actually turned well to the right, although the frontality of

176

264 1886–1888

his body at first makes us assume that he faces us. This slight rightward impulsion is seconded by the vertical that differentiates that side of the drawing.

When we examine *Blouse blanche* carefully, we no longer want to credit the view that sees Seurat as a theoretician applying his rules. Its felicitous variation in hatching and shading reveals the artist's sensitive hand and its inscrutable image, his poetic gifts. Its departure from "rules" evinces the primacy of invention: although the man's upper body engenders dark and light reactions in the background, his black legs do not induce a light halo against the front of the ledge.

177. *Lecture.* 1886–88

READING

Conté crayon and gouache, 12⅛ x 9½ in. (31 x 24 cm.)
Signed upper left: Seurat

Private collection

H 585

PROVENANCE
The artist's mother, Mme Ernestine Seurat, Paris, in 1891, until at least 1893 and probably until her death in 1899; by inheritance to the artist's sister, Mme Léon Appert (neé Marie-Berthe Seurat), Paris, probably until her death in 1921; by inheritance to Mme Léopold Appert, Paris; Henry and Irena Moore, Much Hadham, England, by 1960, until his death in 1986; to present owner

EXHIBITIONS
1888 Paris, Indépendants, no. 620
1892 Brussels, no. 21
1892 Paris, Indépendants, no. 1122
1892–93 Paris, no. 55
1900 Paris, Revue Blanche, no. 42
1933–34 Paris, no. 169 suppl.
1957 Paris, no. 65

In several drawings Seurat shows a seated woman with a book—a pose that embodies mental activity within a nominally domestic interior. Fénéon, in his review of the exhibition of the Indépendants in 1888,[1] mentioned a drawing of "une femme près d'une fenêtre" (a woman near a window), verifying the identification of the present

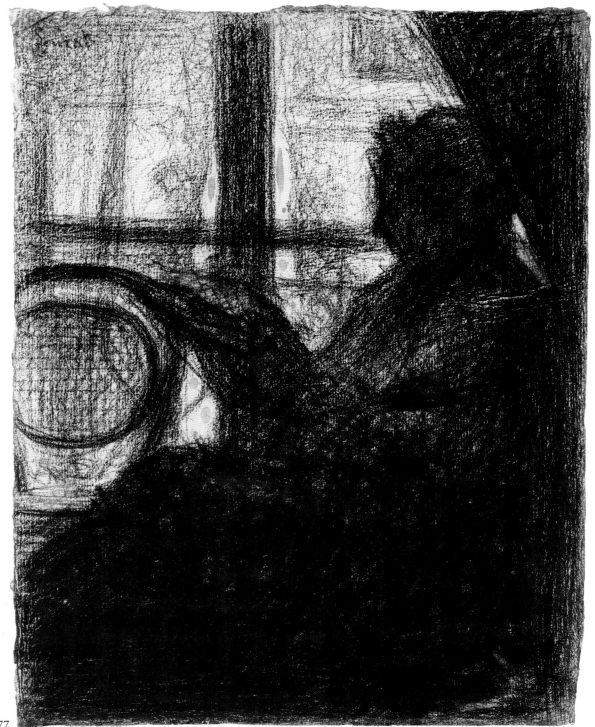

177

drawing with no. 620, *Lecture*. Family tradition said that the model was Seurat's mother, and the setting is indeed that of the parental apartment as in *Devant le balcon* (cat. no. 28). Outside the window the same railing can be detected, although it is partly occluded by the foreground elements. Chief among them is the cane-backed chair, which invites comparison with the volutes of the earlier drawing. *Devant le balcon* has the blocky neoprimitivism of Seurat's early work, and its low vantage point and absence of detail encourage us to read it as a symbolic juxtaposition. This later drawing has a more conventional vantage point and is a more spatial and naturalistic rendering in which we can locate more of a tangible environment. Beyond the French window (whose vertical is partly outlined in conspicuous touches of white gouache) we can make out the rectilinear structure of the building across the street.

Henry Moore, who owned this drawing and also *La lampe* (cat. no. 34), said that he admired them because Seurat avoided lines and sharp edges, and instead built form in large masses, like a sculptor.[2]

1. Fénéon, "Le néo-impressionnisme," 1888.
2. Personal communication during an interview, 1960.

178. *Une parade*. 1886–88

TWO CLOWNS

Conté crayon, 9¼ x 12⅛ in. (23.4 x 30.8 cm.)

The Fine Arts Museums of San Francisco, Achenbach Foundation for Graphic Arts, Archer M. Huntington Fund

H 675

PROVENANCE
The artist until 1891. Posthumous inventory, dessin no. 281 (per inscription on reverse in orange crayon, initialed by Maximilien Luce, not recorded by de Hauke). Presumably given by the artist's family to the Belgian artist Georges Lemmen in 1891, until no later than 1916;* Gustave Geffroy, Paris, until no later than 1926 ("G. Geffroy" is inscribed in graphite, possibly in Fénéon's hand, on the reverse); presumably acquired from him by Félix Fénéon, Paris, by 1926, until about 1937; sold to Wildenstein and Co., London and New York, by October 1937, until April 1947; sold to the Museum, April 1947

EXHIBITIONS
1950 Venice, no. 17
1950 Rome, no. 8
1958 Chicago and New York, no. 131
1983–84 Bielefeld and Baden-Baden, no. 80

*Georges Lemmen's name appears on a list, found among the papers of Théo van Rysselberghe, of individuals in Belgium who were to receive works from the family. He is listed as "Lemmen," with an indication that he was to receive "1 dessin," inventory number 281. This list is transcribed in DR, 1959, p. LXXVI.

In other cases, the history of ownership and inventory numbers recorded by de Hauke are consistent with the designees and inventory numbers that appear on this list (see provenance note, cat. no. 126, and cat. no. 91). Here the inventory number (dessin no. 281) was not recorded by de Hauke, nor was the drawing's ownership by Lemmen and Geffroy; Félix Fénéon appears as its first owner.

Although Georges Lemmen was clearly the designee of this drawing, it is always possible that this one was given by the family to Gustave Geffroy, and another drawing was given to Lemmen instead (see, for example, provenance, cat. no. 63). That is, one cannot discount the possibility that the inscription on the reverse, "G. Geffroy," dates to the posthumous inventory, as opposed to being a subsequent notation by Fénéon (see first provenance note, cat. no. 69).

On the shallow platform of a sidewalk fair, two clowns engage in the patter designed to attract the attention of passersby. Flanked by the partial figures of two other entertainers, they are a study of opposites. One clown has a dark costume and a light hat, the other a light costume and dark hat. The former's shape is short, rounded, and tapering toward the bottom, whereas his partner's is tall, rectangular, and wider at the base. The contrasts are carried to the smallest details, for the rounded contours of the short clown are complemented by his angular cap, while the rectilinear body of the taller is set off by his domed cap; the white triangle of the left figure's cap is echoed in the V-neck of the other, and the rhythm of his rotund form is found in his companion's cap. This balance of contrasts, achieved with an uncanny economy of means, epitomizes Seurat's powers of expression.

In contrast to those of the earlier *Clowns et poney* (cat. no. 45), the forms of this drawing are smoothly edged and flat. Because they are evenly spaced and are placed in a composition that lacks a foreground, they have a "primitive" simplicity and regularity that recalls the rhythms of both popular broadsides and Egyptian bas-reliefs. The wide plane behind the two clowns is so simple that it resembles the surfaces against which Egyptian relief figures are set. Because the lateral figures are cut off, we imagine the continuity of a frieze and find ourselves not in a jostling urban crowd but in a silent, almost sacred place, confronted by the icons of a popular religion.

Like *Clowns et poney*, this drawing has been called a study for the painting *Parade de cirque* (cat. no. 200), but both are independent drawings.

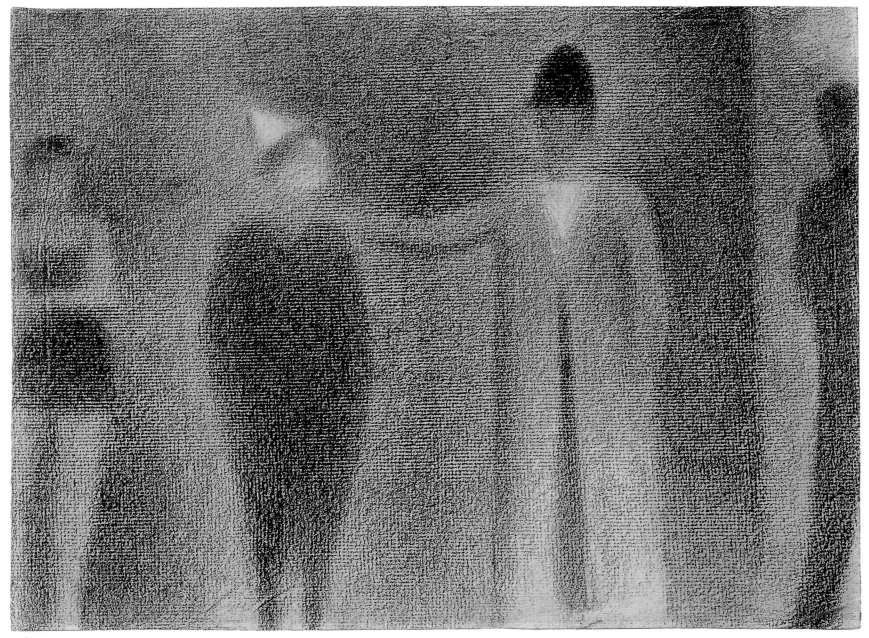

178

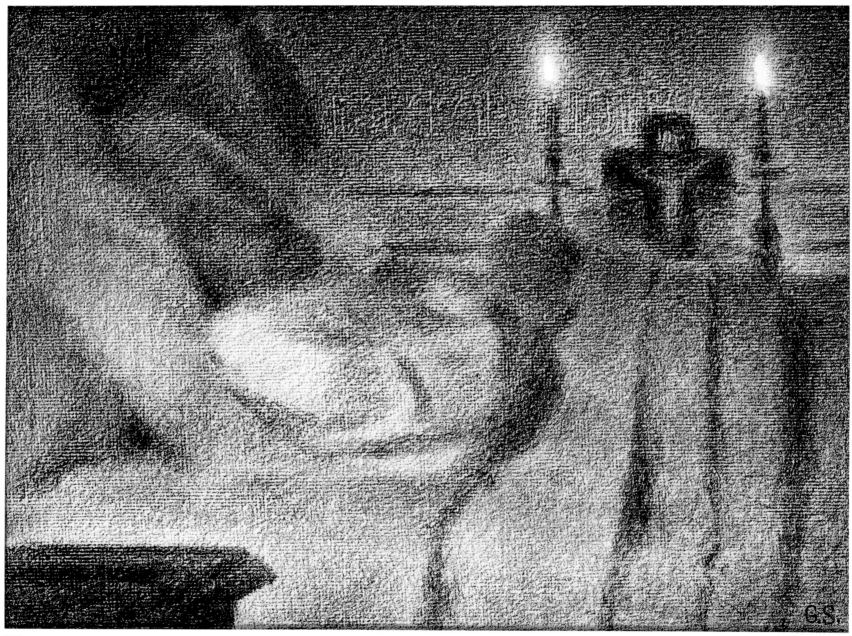

179

179. *Anaïs Faivre Haumonté sur son lit de mort.* 1887

ANAÏS FAIVRE HAUMONTÉ ON HER DEATHBED

Conté crayon and gouache, 9 x 11¾ in. (23 x 30 cm.)
Signed lower right: G.S.
An inscription on the back of the frame indicates that Anaïs Faivre died November 5, 1887

Musée du Louvre, Département des Arts Graphiques, Fonds du Musée d'Orsay, Paris, Bequest of Étienne Victor Morin, 1989 R.F. 42.225

Exhibited in New York only
Not in H

PROVENANCE
Given by the artist to the Haumonté family; by inheritance to Mme Canu; by inheritance to Étienne Victor Morin, until his death; his bequest to the Museum, 1989

EXHIBITION
1968 New York, no. 83

Anaïs Faivre Haumonté, Seurat's mother's sister, died at age fifty-six on November 5, 1887. She had been widowed in 1869, when the artist was almost ten years old, and thereafter was with his mother almost daily; she is probably the subject of several of Seurat's drawings of a woman seated in an interior.

Seurat's deathbed portrait of her is not as astonishing as, for instance, Monet's painting of his dead wife (Musée d'Orsay, Paris), but Mme Haumonté was a virtual member of his mother's household, and to draw her required that he distance himself at the same time that he was mourning her (and he must have been surrounded by the bereaved families). *Condoléances* (cat. no. 158) might possibly refer to the funeral of a relative, but in that drawing we witness a social act of mourning and can therefore adopt a more conventional attitude than is possible when we face the image of the artist's dead aunt.

We are brought close to the aunt's body. From the vantage point of a nearby seat we look slightly upward to find her head. It is this closeness that is so startling, for we are given few clues to suggest how we should react. The woman's face is dark amid the light tones of bedding and clothing, so we know that life has drained away from her. The principal agents of mourning are the votive candles and the cross, the expected signs of a conventional Catholic home. They are given great prominence not only because of the candles' light but also because they perch on top of the verticals of the bedclothes. The deft use of these folds calls attention to the drawing as a work of art with a strong surface pattern (so does the prominent watermark MICHALLET running upside down across the top). We can set aside our emotions by admiring the art, but was the process of composing his structural devices a way for Seurat to discipline his mourning? We know that he gave the drawing to his aunt's children (it belonged to their heirs until recently), so he was consciously rendering homage to her. Nonetheless, we are left to wonder about an artist who seems to have been compelled to make such an image by some kind of Faustian pact with art.

180. *Cocher de fiacre.* 1887–88

HACKNEY COACH

Conté crayon, 9½ x 12¼ in. (24 x 31 cm.)
Signed lower left: Seurat

Huguette Berès, Paris

H 481

PROVENANCE
Paul Signac, Paris; to present owner before 1961

EXHIBITION
1957 Paris, no. 43

Hackney cabs crowded the streets of nineteenth-century cities, along with smaller and larger carriages, both commercially and privately owned. As vehicles of contemporary life, urban carriages figured in the repertoire of naturalist writers and artists by mid-century. Constantin Guys (1805–1892) made a specialty of them, and he was among the artists whose works Seurat displayed on his walls.[1] Guys focused on the roles that carriages played in social life, usually portraying men and their elegantly dressed women (many of them believed to be prostitutes) in drawings and watercolors of a Baudelairean mood. Seurat's approach here, as usual, is more matter-of-fact. No clients are visible because his subject is the anonymous cabbie at his trade, as in several other drawings (including cat. no. 59). In only one instance do we see a passenger, the evocative *La voilette* (cat. no. 42), and there we do not see the woman's carriage.

Except for the personages of his large pictures, Seurat treated his fellow citizens as isolated types, so in his drawings of carriages he shows either client or coachman; to show both would be to suggest a social engagement which, no matter how rudimentary, would have been less congenial to him. Here he represents one of the small licensed cabs, the predecessors of the standard taxis of later decades. It is in motion, as we can tell from the position of the hind legs of the horse and from the multispoked wheels (a convention borrowed from popular illustrations). We are poised somewhat above the cab, for we see both its rear wheels; this view, as compared with a strict profile, aids the impression of movement. The cabbie wears the official uniform, a large hat and a light-colored

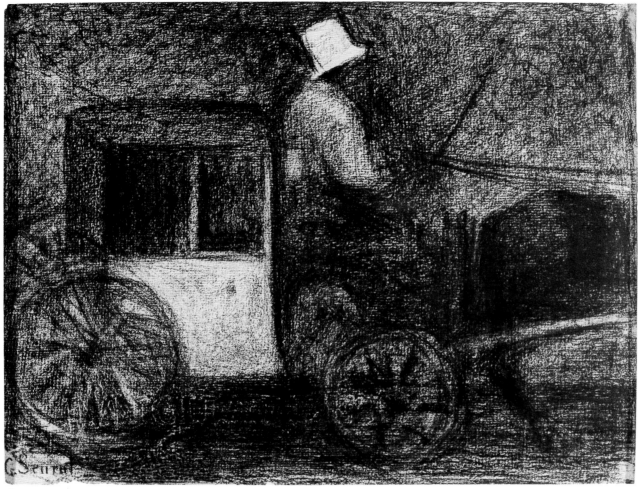

180

181. *Jeune fille au chevalet; Lecture.* 1887–88

WOMAN READING IN THE STUDIO

Conté crayon, 12 x 9⅛ in. (30.5 x 23.3 cm.)

Fogg Art Museum, Harvard University, Cambridge, Massachusetts, Collection of Maurice Wertheim, Class of 1906

Exhibited in New York only
H 601

PROVENANCE
The artist until 1891. Posthumous inventory, dessin no. 300. Probably given by the artist's family to the Symbolist critic Francis Vielé-Griffin in 1891. Félix Fénéon, Paris, by 1928; Mr. and Mrs. Cornelius Joseph Sullivan, New York, by 1929, until 1937 (Sullivan sale, American Art Association, Anderson Galleries, New York, April 30, 1937, no. 202, for $5,700); purchased at this sale by John H. Lutz, as agent for Maurice Wertheim, New York, until his death in 1950; his bequest to the Museum, 1951

EXHIBITIONS
1888 Paris, Indépendants, probably no. 622 (*Jeune fille*)
1929 New York, no. 70

A woman seated by an easel, frequently represented in French painting, is always the artist's muse, whether she be model, lover, or visitor. In one of Seurat's early notebooks (anonymous loan, Yale University Art Gallery, New Haven) he made a quick pencil drawing of a woman, dressed in overcoat and hat and seated on a high stool facing an easel. In this mature drawing the woman is next to the easel rather than facing it and is preoccupied with her reading. She was, of course, the model for the drawing, but in her fictional presence she is reading, and therefore a visitor. By showing her reading, Seurat points to her intellectual capacities, but he also makes her hat flare out extravagantly, and so identifies her prominently with current fashion and femininity. Her upper body and arm are a brilliant exercise in silhouette: bodice, shoulder, and arm are welded into a virtually flat plane that nonetheless seems a convincing representation of three-dimensional form. Her raised hand brings to mind Seurat's earlier portrait of Aman-Jean (cat. no. 30), with which it shares the same general profile. This drawing, however, is more luminous because the grays, though somewhat flatter, are more penetrated by light. Equally characteristic of Seurat's later work are the less prominent halos and

frock. Seurat was thoroughly familiar with this costume, for he had drawn the head and shoulders of coachmen several times in one of his early sketchbooks (anonymous loan, Yale University Art Gallery, New Haven).

The dating of this drawing is highly conjectural, but it seems to be of about the same period as Seurat's drawings of the café-concert (cat. nos. 194–199). Its facture is more energetic, as befits an outdoor subject, but it has a similar complexity of surface composition and it lacks the quality of Redonesque mystery that marks so many earlier drawings, including *La voilette* and *La carriole et le chien* (cat. no. 70). Faithful still to his principle of contrast, Seurat sets off

the cabbie's light costume by dark tones and the darker horse and carriage by light glows. These juxtapositions are, however, less conspicuous than in most of his early drawings and more easily accepted as part of a natural environment.

1. Kahn 1891.

umbras in the background and the beautiful sequence of curves and notches that form the woman's outline.

It is possible that this drawing should be identified with *Jeune fille*, no. 622 in the exhibition of the Indépendants in 1888. De Hauke attached that entry number to another drawing (H 662), but this one conforms better to Seurat's ambitions since it is a more finished work and closer in date to the exhibition. If it did appear in the exhibition, it would have made a revealing comparison with the matronly image of *Lecture* (cat. no. 177) as well as with the studio models of *Poseuses* (cat. nos. 183–192).

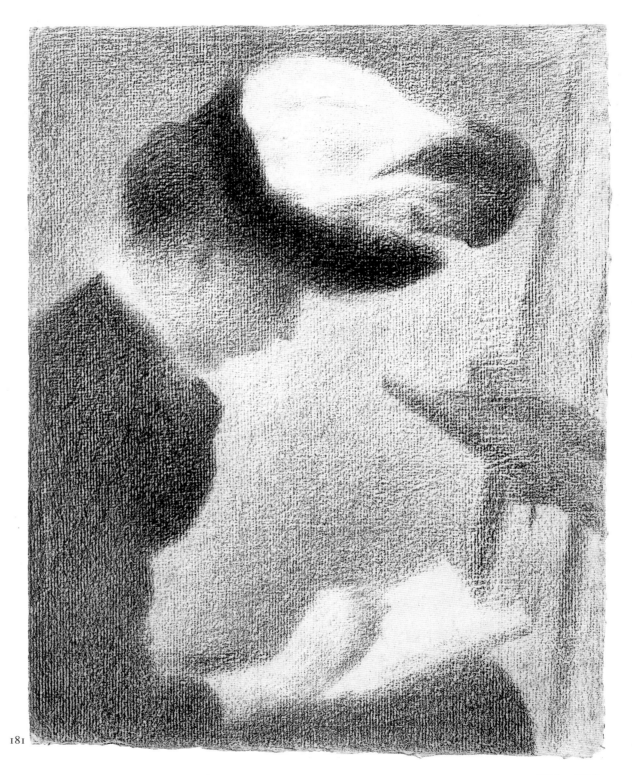

181

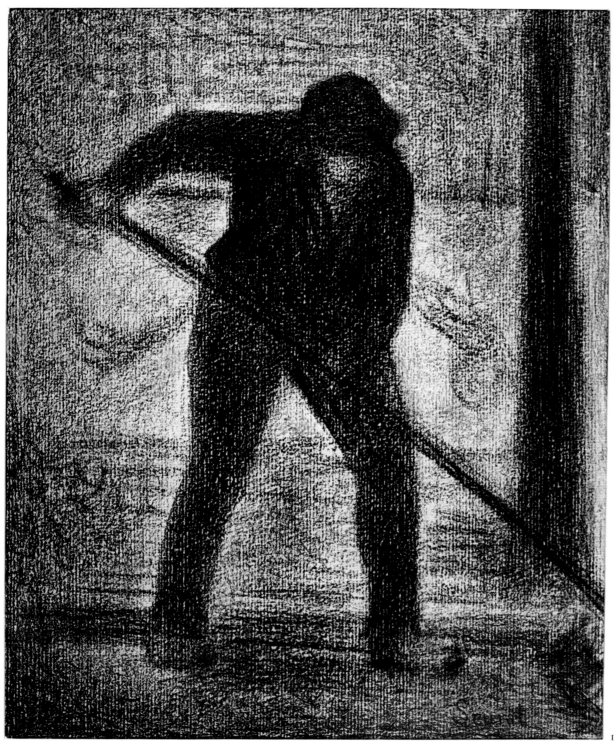

182

182. *Balayeur.* 1887–88
STREET SWEEPER

Conté crayon, 12⅛ x 9¼ in. (30.7 x 23.5 cm.)
Signed lower right: Seurat

Museus Raymundo Ottoni de Castro Maya, Rio de Janeiro

H 560

PROVENANCE
The artist until 1891. Posthumous inventory, dessin no. 383. Inherited by the artist's brother, Émile Seurat, Paris, 1891, until his death in 1906; by inheritance to his widow, Mme Émile Seurat, from 1906; Félix Fénéon, Paris, by at least 1926, until his death in 1944; his estate, 1944–47 (Fénéon sale, Drouot, Paris, May 30, 1947, no. 38, for 83,000 francs); purchased at this sale by H. Jacques; to the museum by 1949

EXHIBITIONS
1888 Paris, Indépendants, no. 621
1922 Paris, no. 15
1926 Paris, Bernheim-Jeune, no. 83
1936 Paris, no. 69

Seurat's drawing of a sweeper was exhibited at the Indépendants in 1888 as one of eight drawings that appeared alongside *Parade de cirque* (cat. no. 200) and *Poseuses* (cat. nos. 183–192). His choice of drawings displayed the range of his interests: four of café-concerts (including cat. nos. 193 and 196), a male and a female figure indoors (none other than his father and mother, cat. nos. 33 and 177), the sweeper, and probably the young woman next to an easel (cat. no. 181). His street figure has close analogies with his drawings for *Parade.* From the sidewalk behind the sweeper rises a tree, and beyond it are figured rectangles, perhaps illuminated shop windows. Seurat's mastery of silhouette gives the worker a believable energy. He is the urban correlative of Millet's peasants, such as his *Reaper,* not just because he is a single figure that dominates the page but also because his impact derives from the convincing way the large movements of the body are conveyed. Most of Seurat's drawings after 1886 were given over to scenes of suburban and seaside leisure and of urban entertainment, so his sweeper stands out as a rare reprise of his earlier preoccupation with country and city workers. In fact Millet was given a huge retrospective at the École des Beaux-Arts in 1887, and it is tempting to surmise that this event rekindled Seurat's early admiration of the Barbizon artist.

Poseuses 1886–1888

Françoise Cachin

"I committed myself to four large canvases *of combat* [toiles *de lutte*] if you permit me to speak that way, and I prefer them to all my landscape studies."[1] When Seurat wrote these words in 1890, he was clearly including *Poseuses* (Barnes Foundation, Merion, Pennsylvania) in this group of four. But what "combat" did he have in mind? Many interpretations have been put forward, but Seurat's meaning is still uncertain. He spoke little and wrote briefly,[2] and critics in his own day and later art historians have tended to project their own ideas on him. One thing is sure: no element in any of his annual grand efforts for the Salon des Indépendants resulted from chance; everything was rooted in a carefully thought-out conception. The very size of *Poseuses*—81¾ x 121¼ in. (207.6 x 308 cm.)—announces that Seurat's ambition lay in applying a then-new and controversial method to a *grand genre* theme: the nude trio of women, so often seen in mythological works such as those depicting the Judgment of Paris, the Three Graces, or the Hesperides. This traditional iconography obviously underlies Seurat's naturalistic view of a studio scene, which he rendered even more contemporary by depicting in it his "scandalous" *Grande Jatte* of the previous year.

Seurat had been thinking of *Poseuses* since the summer of 1886. The reviews of *La Grande Jatte* had appeared, and even his defenders had expressed doubts about whether his little dots of paint could adequately represent the human figure.[3] He was eager to demonstrate that what he called his "scientific" method was appropriate for "noble" subjects: figures and nudes, which ranked higher than landscape in the classical tradition. (In the same spirit, Manet had remarked twenty-five years earlier: "I'm told I must do a nude. All right, I will! I'll do them a nude."[4]) The critic Arsène Alexandre, who met Seurat at this time, describes him as "working away with unbelievable concentration, cloistered in a little studio on the boulevard de Clichy, denying himself everything, spending all his slender means on expensive work. This time he meant to prove that his theory, so well suited to plein-air subjects, was applicable to large-scale figures and interiors, and he did his canvas *Poseuses*."[5]

The term *poseuse* itself, possibly suggested by Fénéon, who liked odd words, is unusual. The word *pose* was common enough, but she who assumed the pose was called, then as now, *modèle*. The dictionaries of the time are quite clear on the point: *poser* (to pose) means "to assume an attitude for the purpose of being drawn or painted,"[6] but *poseur* refers, first, to a workman who lays or installs parquet, hardware, or tracks and, second,

"in the language of today: *poseur, poseuse* one whose attitudes, gestures, looks are studied for effect" or "one who, out of vanity, seeks to attract notice by an artificial or affected manner."[7] The title *Poseuses* may therefore refer not only to the nude women whose task it is to pose but also to those parading fully dressed in the picture behind them.

If the title was new, the subject—women posing in the nude in front of a painting in a studio—was not. On the contrary it was a cliché of genre painting at the Salon. In 1886 one could have seen Cartier's *Coin de mon tableau au Salon* (A corner of my Salon picture), in which a nude model regards her painted and framed likeness, and Chantron's *Toilette du mannequin* (Dressing the dummy), showing a nude putting her own clothes on a manikin (the hat and parasol similar to those in *Poseuses*) in front of a picture, also framed, on an easel. At the 1888 Salon Dantan showed his model seated in a sculptor's studio in *Un moulage sur nature* (A cast from life), and Tillin showed his in a provocative pose on a studio couch in *La sieste* (The siesta). All these salons of the 1880s had their usual complement of bathers, nymphs, Arcadias, Springs, and miscellaneous female allegorical figures. Seurat's inspiration was to combine the two traditions—to adopt a familiar genre scene, raise it to the level of noble allegory, and announce the transformation from reality to allegory in the very title. The use of a neologism for the title distances the viewer from the genre scene while paradoxically emphasizing the activity of posing. Thus, the trinity of young models of the Clichy quarter was to hold for eternity their modernized version of the Three Graces.

Seurat certainly knew the famous Hellenistic marble that had recently come to the Louvre.[8] He reversed the antique scheme, however, turning the middle figure around to face us; the one to the left turns her back to us; and the third, more realistic, turns her back to the others. In the antique sculpture the three women are associated closely and naturally by the friendly movement of the central figure, who extends her arms around her two companions. In *Poseuses*, however, the three nudes are isolated from each other, not only spatially but also psychologically. Seemingly preoccupied, plunged in reverie, or even somewhat ill tempered, like the *poseuse de face*, each ignores the others.

It has been noted that the central nude recalls Seurat's academic sketches from antique art at the École des Beaux-Arts (looking more like a Praxitelean Apollo,[9] however, than a nymph). The drawings from his

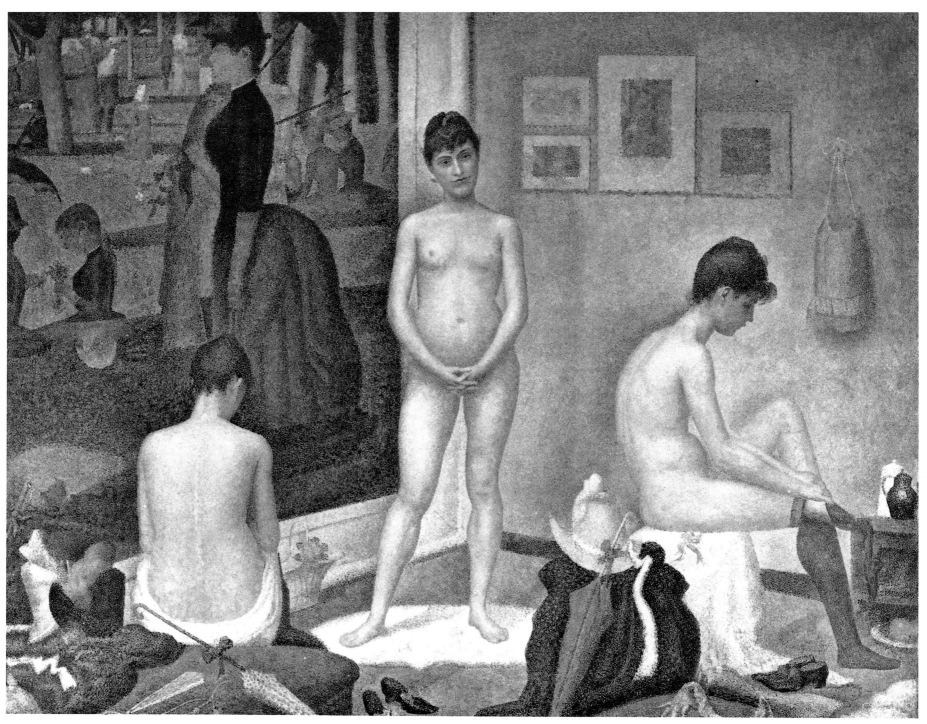

Seurat, *Poseuses*, 1886–1888. Barnes Foundation, Merion, Pennsylvania (H 185)

Cartier, *Un coin de mon tableau du Salon* (A corner of my Salon picture). Reproduced in Dumas, *Catalogue illustré du Salon*, 1886, p. 169

Chantron, *La toilette du mannequin* (Dressing the dummy). Reproduced in Dumas, *Catalogue illustré du Salon*, 1886, p. 150

The Three Graces. Roman copy of a Greek original of the second century B.C. Musée du Louvre, Paris

studies with Lequien and Lehmann indicate that Seurat drew comparatively few female nudes and rarely ever from life,[10] as opposed to his numerous academic studies of males (three females against nineteen males). Chance circumstances in the studio might account for this disparity, but the tally is still more uneven in his drawings of antique sculptures or casts (three females against thirty males), where one might expect the choice of subject to have been freer. Apart from these few examples, the only drawings of the female nude are after Ingres—*La Source*, which came to the Louvre in 1878 (H 313), *La Stratonice* (H 236), and *L'Angélique au rocher* (cat. no. 8)—or after Delacroix, among unrelated sketches on a page of notes on *Les convulsionnaires de Tanger* (H 386). One exception, however, dates from much later: the

reclining nude, undoubtedly from life, of his mistress, Madeleine Knoblock (H 660).

This statistical summary may merely reflect a pedagogic modesty that restricted study of the female nude, but it may also illuminate an aspect of the artist's sensibility. It seems that while masculine form—sculpture or live model—was interpreted directly by Seurat, he filtered the female nude through a pictorial model. This distance between the painter and the reality of female nudity may not have unconscious causes (such as those a hasty psychoanalytic interpretation might put forward); instead it might reflect Seurat's association of the female nude with the Renaissance concept of ideal beauty and with the very essence of painting. More than the male nudes, already portrayed in a naturalistic manner in *Baignade*, his citified Three Graces enabled him to present a meditation on the relationship between art and nature, the ideal and the real. This may be one of the keys to this work, so simple and so mysterious.

Unfortunately little is known about the origin and development of this canvas, which occupied Seurat for more than a year. In autumn 1886, after the shock waves caused by *La Grande Jatte*, Seurat was determined to paint a third large-scale work, continuing to treat the *grand genre* in avant-garde terms. For a variety of reasons—but most important to explore systematically all the possibilities of his method—he decided to do an indoor scene by daylight. He would very soon plan an outdoor scene by artificial light, *Parade de cirque* (cat. no. 200), begun well before he had completed *Poseuses* and exhibited to contrast with it in 1888. Many similarities may be observed: the same frontality of an exactly central figure, who has the same posture and the same proportion in relation to the composition as a whole. There is also the same division of space into two large regions (the musician in the left area of *Parade* corresponds to the *Grande Jatte* figures in *Poseuses*; the *poseuses* are presented to the spectators as are the musicians of the Cirque Corvi). Incidentally, Seurat employed a *Poseuses* model for several spectators in *Parade*, as evident especially in the drawing representing the *poseuse* clothed.[11] It is as though *Poseuses* had brought on *Parade*, in the same way that *La Grande Jatte* had led to *Poseuses*.

In autumn 1886 (or perhaps as early as June of that year), before he had the idea for the large painting, Seurat applied his method to the nude (cat. nos. 183 and 184). The idea of doing a modern studio scene, which itself would carry on the grand tradition, may have already occurred to him.[12]

We may think of Seurat, reflecting, revisiting the Louvre, leafing through portfolios of admired masters. Besides *La baigneuse de Valpinçon* of Ingres, which he emulates in his own way in *Poseuse de dos* (cat. no. 187),

Seurat, *Jeune fille* (Young girl), after Ingres, about 1876. Private collection (H 236)

two Renaissance pictures seem to have struck him particularly. One was Raphael's celebrated *Three Graces*, whose recent purchase by the duc d'Aumale had caused a sensation in the Parisian art world[13] and which repeated the traditional antique pattern of three female nudes in a sort of arrested dance.

Perhaps still more direct was the influence of a painting that had only just come to the Louvre, *Apollo and Marsyas*, then attributed to Raphael.[14] Not only does the combination of two nudes, one standing and one seated, recall the two nudes—reversed—at the right in *Poseuses*, but the position of Marsyas and even the modeling of his trunk and legs suggest the final state of the *poseuse de profil*. The standing *poseuse*'s legs are like those of Apollo in their slenderness, in the rendering of the knee, and in the modeling, round and soft within a rather dry outline. We might suggest that after seeing the Louvre painting, or seeing it again, Seurat gave his model, whom he had already painted full face, legs together (cat. no. 184), the contrapposto posture of "Raphael's" painting (cat. no. 185), except that Apollo's pose was more supple and graceful than the somewhat awkward one of the *poseuse de face*. J. J. Henner (1829–1905), a celebrated artist of the time, had already drawn inspiration from the same source; in his *Idylle*, also then a recent acquisition of the Louvre, he had gone so far as to transform the two male nudes into nymphs.[15]

The depiction of nude models together with their clothing had, of course, been anticipated in Courbet's *L'atelier* and Manet's *Déjeuner sur*

Seurat, *Nu couché* (Reclining nude), about 1888. Ex coll. Félix Fénéon (H 660)

Raphael, *The Three Graces*, 1504–05. Musée Condé, Chantilly

Perugino (formerly attributed to Raphael), *Apollo and Marsyas*. Musée du Louvre, Paris, R.F. 370

l'herbe. The conjunction of a nude woman with a painting in a studio likewise derives from *L'atelier*, except that Courbet's model watches awestruck as he paints the landscape, while Seurat's *poseuses* are stubbornly indifferent to the picture on the studio wall.

The grouping of the three nudes was not exceptional. *Poseuses* resembles *Jeunes filles au bord de mer* by Puvis de Chavannes,[16] which Seurat may have seen at the Salon of 1879 and which was again on view at Durand-Ruel's when he was creating his composition. Puvis's work has the same pyramid composition and the same erect central figure, but seen from the back. Closer still is Puvis's *Automne*; this painting was sent to Lyons after it was sold in 1864, but Seurat could have seen a replica at the Salon of 1885. As in *Poseuses*, the central nude is shown frontally, another figure is in profile, and a third is seen from the back. The phrase "Puvis modernisant"[17] (modernized Puvis) is even more apt for Seurat's transposition of allegory into a contemporary studio scene than for *La Grande Jatte*.

Outside academic circles, other painters—notably Cézanne and Renoir —were essaying the same theme, remote though it was from Impressionism. There is no evidence that Seurat saw Cézanne's *Trois baigneuses* of 1879–82.[18] If he did, he might well have been struck by its triangular composition, with figures viewed at three different angles. Nor do we know what Seurat thought of Cézanne's work, so much admired by his friends Signac and Pissarro. From Pissarro, in any event, he must have heard mention of Renoir's monumental *Grandes baigneuses*, after a Girardon relief, which had been in progress for several years. Seurat probably saw that painting at Georges Petit's international show in summer 1887, but if he later thought of the work at all, it may have been as an example not to be followed. Still, it is remarkable how in the 1880s such very different avant-garde artists reacted to the perceived weaknesses of Impressionism by re-creating one of the grand themes of classical art.

The three Musée d'Orsay panels (cat. nos. 185–187), far more laden with references to past masters than the first study (cat. no. 183), suggest that Seurat painted them after an interval of time for thought. Then he proceeded as he had with his two previous large canvases—but using fewer preparatory studies—to assemble all the hitherto isolated figures into one composition. He saw at once the opportunity to associate the models with the canvas of *La Grande Jatte*, set against the studio wall; it can already be glimpsed beyond the *poseuse de dos* in the small sketch (cat. no. 188), done rather early in winter 1886–87. In June 1887 Pissarro wrote to Signac that the "canvas is progressing . . . he has already finished some of the background,"[19] and it is reasonable to suppose that Seurat had then been working on it for some months.

Puvis de Chavannes, *L'automne* (Autumn), 1864. Musée des Beaux-Arts, Lyons

Cézanne, *Les trois baigneuses* (Three bathers), 1879–82. Musée du Petit-Palais, Paris, inv. no. 2099

Renoir, *Les grandes baigneuses* (Large bathers), 1884–87. Philadelphia Museum of Art. Collection Mr. and Mrs. Carroll S. Tyson Jr., inv. no. 1963–116–13

It is most interesting to note the changes, adjustments, and corrections the artist made as he moved from the small painted or drawn studies to the large scale. The greatest change took place in the right portion of the canvas. Seurat quickly saw the imbalance that might result in the large canvas between the left portion, showing *La Grande Jatte*, and the emptier right portion. He had to "refill," to "enrich" this side, so he greatly enlarged the *poseuse de profil*. If standing, she would be gigantic, exceeding the height of the frame. The pudgy little girl of the studies became a tall adolescent. We recognize the long nose and face of the central *poseuse* (and of the lost drawing, H 662), as if caricatured, in the Barnes canvas, but the face in

profile is finer and more delicately painted, perhaps to individualize the models. It has generally been thought that one model posed for all three figures.[20] This seems possible for those at the right and at center but less likely for the one at the left (cat. no. 187). The small sketch (cat. no. 188) anticipates the prominence given to the green bag on the wall in the large canvas, and the two preparatory drawings of 1887 (cat. nos. 189 and 190) organize the props surrounding the *poseuse* removing her stockings. Little by little everything falls into place, in the direction of establishing a closer relationship between the studio scene and *La Grande Jatte*. The red parasol and the hat in the studio seem to be those of the seated girl with a bouquet in *La Grande Jatte*; the blue dress with red dots in the foreground echoes that of the woman walking; the little painted hats are matched by the "real" ones, and so on.

The grouping at right—*poseuse de profil* and accessories—makes a triangle, whose two sides are the line of the red parasol and the green stocking and whose apex is the young woman's forelock. Seurat punctuates the wall behind the profile of her back with dark stippling, which he called "irradiation"—accentuating brightness through contrast with a dark form (or through shadow behind a light form), a procedure conspicuous in his drawings (for example, in *Le noeud noir*, cat. no. 36). This darkening of the wall behind the profiled back meets with the lightened portion of the same wall along the darkly modeled figure of the *poseuse de face*—creating the inexplicable line on the wall between the two women. Taken for a screen at the time,[21] this line represents in part the shadow of the standing figure, but most of all it is a demarcation between two regions of unlike luminosity.

While Seurat was at work on the large canvas, he must have recognized that it would not be ready for the 1887 Salon des Indépendants. He then reworked his panel of the *poseuse de face* (cat. no. 185) in order to show a finished work rather than a study. The figure is quite faithfully repeated in the large picture except that the white cloth—her petticoat or a rug—beneath her feet is there dotted with pink indicating her garters (mistaken by Fénéon for rose petals).[22] Her head, somewhat out of proportion, forbidding, and caricatured, stands out against the white frame of *La Grande Jatte*. This contrast is more heightened than in the panel (cat. no. 185), where the head is surrounded by the greenish ivory matting of the *croquetons*, whose abundance on the studio walls was often noted by Seurat's visitors.[23]

The blue studio bench on which the *poseuse de profil* sits in the sketch (cat. no. 188) was changed to red in the large painting, perhaps to contrast with the green lawn of *La Grande Jatte*. An array of objects is piled up on this side: a blue-dotted yellow parasol, a closed fan, two hats with red feathers. A somewhat artless basket of flowers, set on the floor against the frame, answers the gesture of the seated girl in the painting above. Every item of dress in the studio finds an echo among those in the picture, as if to give the impression that these women had descended from the canvas and undressed. Among the critics of the day, Paul Adam was alone in noting the contrast between the straitlaced women of the painting and the models: "Here we have creatures in the simplicity of nature . . . here in the grip of ceremony, stiff and corseted, solemn."[24] The scene represented is more timeless than that of the "picture within the picture," which is paradoxically more contemporary; in this opposition, an art historian of today can see "a sardonically humorous statement of the contradictions involved in modern society in the relationship between life and art."[25] As a matter of fact, the formal analogies are more striking than the divergences between the draped and the nude figures: it is as if the central model, no less erect than the woman walking, has stepped down from her picture, disrobed, and turned toward us, coolly sizing us up. The leaning motion of the girl with the flowers is repeated in the *poseuse de profil*. The various figures seem united in one ambiguous spectacle and in one pictorial fabric. The foreground, with objects carefully disposed from left to right in a whimsical enumeration—hats, gloves, fan, parasol, shoes, garters, parasol, hat, gloves, shoes, stockings—provides the scene with a baseline like the frieze of heads at the bottom of *Parade de cirque*. One feels that Seurat afterward reinforced the rather antic character of the scene by displaying these accessories in a sort of "comedy of clothing." These "tools of the trade" used by the *Grande Jatte* women here seem to have been laid down, as weapons are, revealing the candor, awkwardness, "naïveté," and slightly astringent charm of these bodies. There is perhaps even a sweetness beneath the impassivity, expressed for the first time in Seurat's oeuvre.

However, when he wrote in 1890 of a "canvas of *combat*," the artist was not referring so much to the content as to his intention of demonstrating the possibilities and validity of a method, applied more systematically and more radically than in his previous works. In *Poseuses* he heaped difficulty upon difficulty. The first was to adopt, on a very large scale, the close grain of minute dots that he had added to the small full-face *poseuse* for the Indépendants show (cat. no. 185)—a technique appropriate, he thought, to the treatment of flesh. The transition to a large format of a system of minuscule strokes rendered the endeavor strange, its execution lengthy, and the result somewhat lifeless. Next he decided to paint on a white surface, canvas coated with plaster. A letter of August 1887 to Signac ("Canvas with plaster very discouraging. Can't understand a thing. Everything stains—very heavy going"[26]) explains the unusual slowness of execution—occupy-

ing at least the whole year of 1887—and probably the extensive corrections, deletions, and overpaintings. A scientific study of this sequestered canvas would be instructive on this point.[27]

Studious attention has been paid to the painting's composition, which dates from the period when Seurat and his friends were interested in the work of Charles Henry,[28] and perhaps too much weight has at times been given to Seurat's "scientism," disregarding Fénéon's caveat: "In pseudoscientific fantasy, the red parasol, the yellow parasol, and the green stocking are oriented in the directions assigned to red, yellow, and green in Charles Henry's color circle."[29] If taken literally, the "scientific" theories of expression to which Seurat supposedly gave the key in his letter to Beaubourg (Appendix E)—joy expressed by warm colors and ascending lines, sorrow by cool colors and descending lines—would lead to such aberrations as "two happy parasols, and one rather sad stocking."[30] In any event, the general impression intended by Seurat was one of serene harmony, in which social commentary and mythological allusion are tinged with his acerbic wit.

When shown at the Indépendants, the painting elicited the usual sardonic comments—"rachitic models daubed in all colors of the rainbow . . . suffering, it would seem, from some horrible skin disease"[31]—but in general the picture was credited with being "serene," "chaste," and "distinguished."[32] There was indeed something entirely new in the impassivity of the figures, as compared to the agitation that generally appeared to seize groups of bathers or nymphs, even those of Renoir, who run forward, raise their feet and arms without apparent reason, clutch their hair, and, in short, strike poses. In contrast, Seurat's models mimicked no mythological image, no bathing party, no studio drama; they calmly presented themselves simply as models.

Good naturalist that he was, Gustave Geffroy saw a social image in the representation of "skinny girls, hothouse plants, precociously pubescent . . . small profile, bent over, long neck, arched back, extended arm, busy adjusting some unspeakable green stockings—all this is both cruel and sweet in a very special way,"[33] and Paul Adam, the Symbolist, discerned "women who are pliant, alert, sleek, at ease, . . . ready to live, to set out, to laugh, to desire."[34]

To those close to Seurat—Fénéon, Kahn, Adam—*Poseuses* was a masterpiece, a successful answer to a challenge, a work that "shames one's memories of nudes of legends and art galleries" and attains "perfection."[35] Vincent van Gogh, visiting Seurat's studio with his brother some hours before their departure for Arles on February 19, 1888, saw *Poseuses* and other canvases. He later wrote to Theo: "Say, what is Seurat doing? If you see

him, tell him once more from me that I am working on a scheme of decoration which has now got to 15 square size 30 canvases, and which will take at least 15 others to make a whole, and that in this work on a larger scale, it is so often the memory of his personality and of the visit we made to his studio to see his beautiful great canvases that encourages me in this task."[36] Van Gogh regarded Seurat as "the master of the Petit-Boulevard [that is, the avant-garde]," and his serenity remained for the Dutch artist an ideal to emulate. When he painted his bedroom at Arles, van Gogh wrote that he "enormously enjoyed doing this interior of nothing at all, of a Seurat-like simplicity."[37]

Poseuses did not sell when it was shown in Brussels in 1889. (Seurat, when asked to put a price on it, suggested this modest calculation: "I calculate its cost as one year at seven francs a day."[38]) Gustave Kahn bought it from the Seurat family a year after the artist's death but sold it again soon afterward. In 1897 Signac lamented seeing it "hanging around rag-fairs for some years. The canvas is, unfortunately, too large for me to buy!" Soon after, he helped arrange its purchase by Count Kessler, who "hopes in a few years to be able to have the *Poseuses* enter the Berlin Museum."[39] It was later resold, however. Shown at London in 1926, before it finally went to the Barnes collection, the work aroused the enthusiasm of Roger Fry, who felt that its "harmony has been arrived at almost by trial and error, by a perpetual adjustment and readjustment." He found it "a wonderfully strange and original composition almost disquieting in its fixity. It is a very epitome of its author's theories of analogy. The analogies run through it even to the minutest details, analogies of form and analogies of colour."[40]

Such were the formal qualities, the almost abstract aspect, of the continuous pictorial texture that interested the generation of Cubists and post-Cubists. Apollinaire, influenced by Picasso and especially Delaunay, having seen this painting at Bernheim's in 1909, spoke of Seurat's works "in which are contained all the newness that modern art can reveal."[41]

For more than sixty-five years this painting has been seen only by the few visitors to the Barnes Foundation, where it is hung very high. That institution's charter does not allow it to be photographed or lent. This ill-starred work is really known only through its reduced version (cat. no. 189), and its strange and slightly aggressive power has perhaps been preserved by that fact. "The most ambitious effort of the new art,"[42] *Poseuses* has been unfairly excluded from the modern pantheon. Its sister nudes by Manet, Cézanne, and Picasso have been more fortunate. In *Le déjeuner sur l'herbe*, *Les grandes baigneuses*, and *Les demoiselles d'Avignon*, pictorial invention and provocative style were derived in every case, as with Seurat,

from the confrontation of an entirely new personal vision with the most traditional, most academic of themes: the female nude.

1. Draft, Seurat to Maurice Beaubourg, 1890 (see Appendix E). Note that he crossed out the end of the sentence, as though he had said too much. The four paintings are, in chronological order, *Une baignade, Asnières, La Grande Jatte, Poseuses,* and *Parade de cirque* or *Chahut,* then his latest work.

2. As he himself said, "But I don't talk much." (Seurat to Signac, August 26, 1888, in DR, p. lxv.) As for the texts, his famous letter to Beaubourg is always mentioned; although he wrote several versions (see Appendix E), he never sent it.

3. These defenders included E. Hennequin, J. Christophe, and others.

4. A. Proust, "Édouard Manet, souvenirs," *La revue blanche* (February 1897), republ. *L'échoppe,* Caën 1988, p. 30.

5. Alexandre 1891 (obituary).

6. It is only the thirteenth sense of the word, moreover, in Littré (1877 ed.).

7. Mozin's dictionary, 1842, adopted in Littré (1877). The word "poseur" was first used in English in the 1870s to mean "an affected or insincere person."

8. Thought to be a Roman replica of a painted, rather than sculpted, prototype. Gift of La Salle in 1878, inv. no. MMB3227.

9. Herbert 1962, p. 20.

10. The drawn nude sometimes reproduced (Kahn 1928; Thomson 1985, p. 27) does not appear to me to be from the hand of Seurat; perhaps it is Angrand's. De Hauke, who worked from Fénéon's archives, does not include it in his catalogue, but it is accepted by Herbert 1962, pp. 24–25.

11. H 662: the drawing was lost in a fire in April 1931. The one shown at the Indépendants of 1888 with *Poseuses* was either this or H 601 (cat. no. 181).

12. I previously thought that the drawing entitled *Loge de l'artiste* (H 659) might be a preliminary "naturalistic" treatment of the three models, but I now agree with R. Herbert in doubting the attribution to Seurat.

13. In December 1886 the painting was already at Chantilly; there is no evidence to indicate whether Seurat saw it, but it was illustrated at the time and often reproduced.

14. Now attributed to Perugino. The painting, then extremely famous, was purchased by the Louvre in May 1883. On its vicissitudes, see F. Haskell, "Un martyr de l'attribution. Morris Moore et l'*Apollon et Marsyas* du Louvre," *Revue de l'art,* no. 42 (1978): 77–78.

15. J. J. Henner, *Idylle* or *La fontaine,* 1872, now in the Musée d'Orsay, Paris. The nymph at right repeats Apollo literally; the one at left, the flute player, in the same pose as Marsyas but almost in dorsal view, is closer to Seurat's *poseuse de dos.*

16. This similarity noted by Schapiro 1958.

17. Fénéon, April 1888.

18. Formerly Henri Matisse collection; now Musée du Petit Palais, Paris.

19. Pissarro to Signac, June 13, 1887, DR, p. lx.

20. J. Rewald, P. Courthion, J. Russell, and others have expressed this view.

21. See Maurice de Faramond, "Les artistes indépendants," *La vie franco-russe* (March 24, 1888), p. 114.

22. Fénéon, April 1888.

23. "On the wall, frames crowded together, quantities of those little thumbnail sketches that, he said, were his pride and joy." Angrand to G. Coquiot, in Coquiot 1924, p. 39.

24. Adam 1888.

25. Nochlin 1989.

26. Seurat to Signac, August 1887, DR, p. lxi.

27. The painting at the Barnes Foundation has never been on loan, examined closely, X-rayed, or even properly photographed.

28. Homer 1964, p. 217.

29. Fénéon, April 1888.

30. House 1980, p. 351.

31. *Écho du nord,* March 29, 1888; *L'observateur français* (March 26, 1888).

32. See, for example, *La paix* (April 4, 1888); Geffroy 1888; Fénéon, April 1888.

33. Geffroy 1888.

34. Adam 1888.

35. Fénéon, April 1888; Adam 1888.

36. V. van Gogh to T. van Gogh, 553 F, *Correspondance,* p. 246.

37. V. van Gogh to P. Gauguin, B 22, *Correspondance,* p. 254.

38. Seurat to O. Maus, see Chronology.

39. P. Signac, December 28, 1897, and January 2, 1898, *Signac Journal,* ed. J. Rewald, pp. 270–72.

40. Fry 1926, pp. 192–93.

41. Apollinaire, December 23, 1910, quoted in *Chronique d'art,* p. 171.

42. Fénéon, April 1888.

183. *Poseuse de face.* 1886

MODEL FACING FRONT

Oil on wood, 10 x 6¼ in. (25.5 x 15.8 cm.)

Private collection, Paris

Exhibited in Paris only
H 179; DR 173

PROVENANCE
Paul Signac, Paris, by at least 1908, and probably from 1891;
Georges Renand, Paris, by at least 1939, until 1987 (Renand sale,
Drouot, Paris, November 20, 1987, no. 35); to present owner

EXHIBITIONS
1908–09 Paris, no. 66
1936 Paris, no. 48
1952 Venice, no. 15
1954 Paris, no. 1
1957 Paris, no. 11
1958 Chicago and New York, no. 120
1963 Hamburg, no. 104

This panel's spontaneity and freshness, impetuosity
(unusual for Seurat), and apparitionlike character, due to
its dazzling pink and blue shimmer, suggest that it was the
first conception of the central nude of *Poseuses.* Apparently
it even preceded the drawing (cat. no. 184).

From the outset Seurat chose strict frontality and axial
symmetry, treating this figure as an archaic icon; her
fixity and simplicity anticipate Giacometti's nudes. The
timeless, abstract quality of the *poseuse,* her face just sug-
gested, was lost in the more finished version (cat. no. 185),
which is more individualized and precisely located in time
and place.

The separate strokes, occasionally interwoven, allow
the color of the panel to show through. This technique is
characteristic of 1885–86 rather than of 1886–87. This
nude may have been painted in May–June 1886 when
negative comments about *La Grande Jatte* were published.
Fénéon's remark—that "at least, dotted painting recom-
mends itself for the execution of smooth surfaces and in
particular the nude, where it has not yet been used"[1]—
may have been prompted by discussions with Seurat.

1. Fénéon, June 1886.

183

184

184. *Poseuse de face*. 1886
MODEL FACING FRONT

Conté crayon, 11¾ x 8⅞ in. (29.7 x 22.5 cm.)

The Metropolitan Museum of Art, New York, Robert Lehman
Collection, 1975 1975.1.704

Exhibited in New York only
H 664; DR 174a

PROVENANCE
The artist until 1891. Posthumous inventory, dessin no. 365 (per
inscription on reverse in red crayon, initialed in blue crayon by
Maximilien Luce, not recorded by de Hauke).* Maximilien Luce, Paris,
by at least 1903, and probably from the artist's estate in 1891, until at
least 1934; possibly with Jacques Rodrigues-Henriques, Paris; con-
signed by A. and R. Ball, New York, to M. Knoedler and Co., New
York, on May 2, 1949 (stock no. A3291); sold by Knoedler's to Robert
Lehman, New York, on June 1, 1949, until his death in 1969; his
bequest to the Museum, 1975

EXHIBITIONS
1908–09 Paris, no. 198
1926 Paris, Bernheim-Jeune, no. 115
1933–34 Paris, no. 86
1936 Paris, no. 124
1949 New York, no. 55
1958 Chicago and New York, no. 119
1977 New York, no. 39
1983–84 Bielefeld and Baden-Baden, no. 79

*See provenance note, cat. no. 145. According to Fénéon's descrip-
 tion of the numeration of drawings included in the posthumous
 inventory (H, I, p. XXIX), the five studies for the *Poseuses* were
 numbered from 362 to 365 and 363bis.

The same nude appears here as in cat. no. 183, but the
more rigorous treatment of the decor and the individual-
ized face indicate that this drawing was probably done
after the panel. Of special interest are the dark baseboard,
carefully represented in all versions; the small iron stove,
apparently unlit; and the framed panels behind the mod-
el's head. The shadow indicates that the model is in full
light and that Seurat has his back to the studio window.
The pose is that of the antique Venus Pudica, except that
the pubis is concealed not by one hand as in ancient
sculpture but by both, clasped in a naive gesture. The
palms are turned downward, bringing the arms out slightly
from the torso; this lends the model's rather stiff posture

(she stands as if at attention) an air of assertiveness and also timidity. She appears to be an adolescent; the juvenile body persists in the later versions, but her face becomes harder.

The drawing was owned by the artist Maximilien Luce. He included this work in his 1903 portrait of Félix Fénéon, perhaps alluding to the shared memory of Seurat that formed a bond between subject and painter.

Luce, *Félix Fénéon*, 1903. Musée des Beaux-Arts, Nevers, inv. no. NP 635

185. *Poseuse de face.* 1886–87

MODEL FACING FRONT

Oil on wood, 9⅞ x 6¼ in. (25 x 16 cm.)
Signed lower right: Seurat
Painted border added and picture retouched, April–May 1890

Musée d'Orsay, Paris R.F. 1947–13

Exhibited in Paris only
H 183; DR 174

PROVENANCE
Presumably given by the artist to Félix Fénéon, Paris, in 1890 but included in the posthumous inventory of 1891, panneau no. 136. Fénéon's collection, presumably from 1890, and certainly by 1892, until his death in 1944; his estate, 1944–47 (Fénéon sale, Drouot, Paris, May 30, 1947, no. 105); purchased at this sale by the Musées Nationaux for the Jeu de Paume; transferred to the Musée d'Orsay, 1986

EXHIBITIONS
1887 Paris, no. 446
1892 Paris, Indépendants, no. 1116
1900 Paris, Revue Blanche, no. 29
1905 Paris, no. 11
1908–09 Paris, no. 68
1920 Paris, no. 25
1924 New York, no. 7
1936 Paris, no. 46
1937 London, no. 59
1958 Chicago and New York, no. 124
1968 New York, no. 81

This panel seems to have been done in two stages, undertaken some months apart.[1] Infrared photographs show that the strokes were at first larger and more spontaneous, something like those in the first study for the central nude (cat. no. 183).[2] The pose here, however, is more relaxed, and the setting more elaborate. The slightly contrapposto stance, with the weight on one leg, is a more classical pose, one easier for the model to hold. The more pronounced slant of the baseboard places the model closer to the wall; her head is thus framed by a panel, which provides a lighter background than the wall itself and emphasizes her black hair. The white cloth on the floor and the framed paintings on the wall bracket the figure between two light areas. Seurat's association of the model

with his past works is perhaps deliberate—a precursor of the strong relationship between the *poseuses* and the *Grande Jatte* figures that would be established in his first conception of the final composition (cat. no. 188).

The present panel was conceived as a study, in the same spirit as cat. nos. 186 and 187, and was painted soon after them in autumn 1886. Subsequently, when Seurat had not completed the large canvas of *Poseuses* for the 1887 Salon des Indépendants, he decided to make a more finished work of this nude and submit it instead. Closely spaced, ultrafine touches were superimposed on the original surface, creating a misty halo around the figure and emphasizing the shadow emanating from the right foot so that it envelops the entire left flank. The mouth seems to have been added at that time, as well as the red barrette (or comb) in the hair; the eyes and hair were reworked. These changes give the face a willful, perhaps unpleasant cast, in contrast to the girlish body. The face is slightly in shadow, making the neck seem abnormally short. The disproportionately large head (almost as though the young woman were a dwarf) seems older than the pubescent body, provoking questions: Is this contrast deliberate? Did Seurat mean to arouse a feeling of malaise? The light but precise outline of the body may also have been added later. It is accentuated in a later drawing (cat. no. 191).

A penciled note in Fénéon's hand on the panel's verso records that "the inner frame was painted by Georges Seurat in April–May 1890" and mentions some retouching and *piquetages* (dottings) also done at this time.[3]

Seurat exhibited seven landscapes at the 1887 Salon des Indépendants; this was his only figure painting on view, and it attracted much attention. Gustave Kahn noted its "dark-complexioned, Jewish head" on "a curiously *pointillé* background";[4] for Jules Christophe, it was "simply a pure masterpiece. Absolutely irreproachable drawing, exquisite tranquillity, rare naïveté and honesty; much stronger than the sly *Source* of *père* Ingres."[5] As for Fénéon, he saw "a tiny picture, but a miracle of art," a work "that would do credit to the proudest museums."[6]

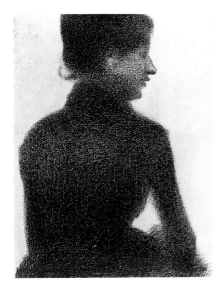

Seurat, *Une poseuse habillée, buste de profil*
(Clothed model, profile bust), about 1887.
Destroyed in fire at the Gare de Batignolles,
Paris

Fénéon was so taken with this panel, which Seurat purportedly gave him,[7] that he later acquired two other studies for *Poseuses* (cat. nos. 186 and 187). He never parted with it, and he had a black velvet case made so that he could carry it, unframed, with him on his travels. He did the same with the other two studies once they were in his possession.[8]

1. Like cat. nos. 186 and 187, this panel was first studied by R. Huyghe, *Bulletin des musées de France*, 1947.
2. I am indebted to the laboratory of the Musées de France for permitting photographic and X-ray analysis of the three panels from the Musée d'Orsay.
3. "Retouches et cadre en avril–mai 90," in 1900 Paris.
4. Kahn 1887.
5. Christophe 1887.
6. Fénéon April 1887; reprinted May 1887.
7. In 1890 Fénéon probably told this to de Hauke (see the latter's remarks on H 183).
8. Halperin 1988, p. 142. I can confirm the anecdote by the testimony of Jeanne Selmersheim Desgranges, Signac's second wife, who was well acquainted with Fénéon from 1914 on.

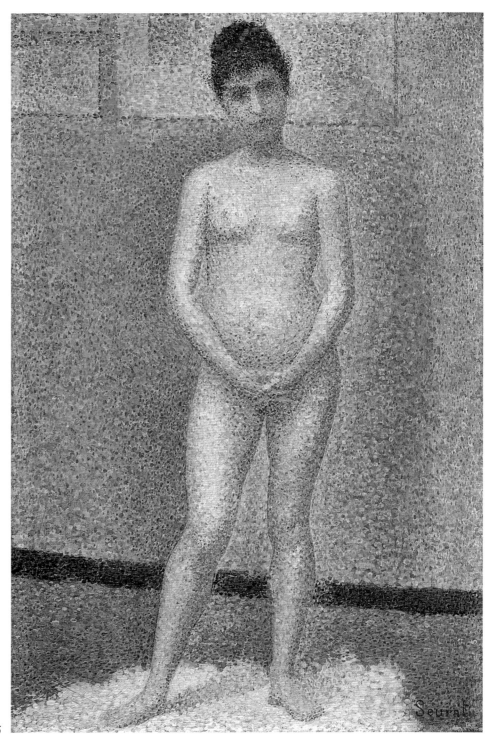

185

186. *Poseuse de profil*. Late 1886

MODEL IN PROFILE

Oil on wood, 9⅞ x 6¼ in. (25 x 16 cm.)
Painted border by Seurat

Musée d'Orsay, Paris R.F. 1947-14

Exhibited in Paris only
H 182; DR 175

PROVENANCE
The artist until 1891. Posthumous inventory, panneau no. 135.
Inherited by the artist's mother, Mme Ernestine Seurat, Paris, in
1891, until at least 1892 and probably until her death in 1899; by
inheritance to the artist's brother-in-law, Léon Appert, Paris; sold to
Félix Fénéon, Paris, by 1905, until his death in 1944; his estate,
1944–47 (Fénéon sale, Drouot, Paris, May 30, 1947, no. 103);
purchased at this sale by the Musées Nationaux for the Jeu de
Paume; transferred to the Musée d'Orsay, 1986

EXHIBITIONS
1892 Paris, Indépendants, no. 1115
1900 Paris, Revue Blanche, no. 28
1905 Paris, no. 12
1908–09 Paris, no. 67
1920 Paris, no. 26
1924 New York, no. 8
1936 Paris, no. 47
1937 London, no. 60
1958 Chicago and New York, no. 123

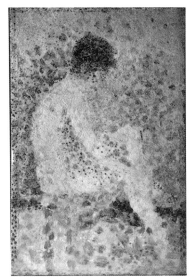

Infrared photograph of
Poseuse de profil

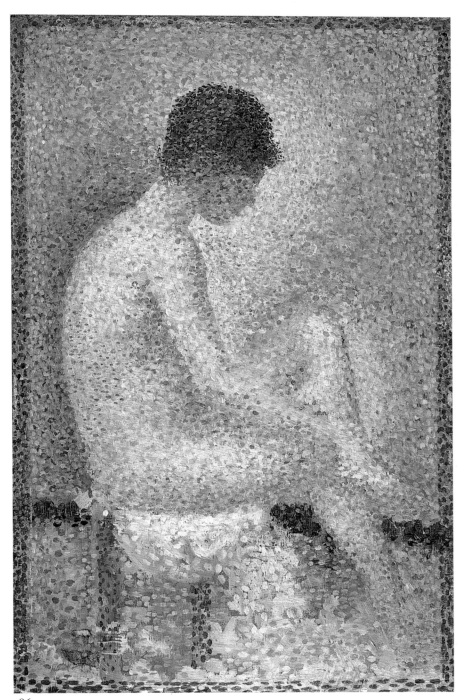

186

The standing *poseuse* (cat. no. 185) that Seurat chose to sign and exhibit may be regarded as a first statement for what would become the Neo-Impressionist nude. The present study and the *poseuse de dos* (cat. no. 187) are, however, far more sensitive, spontaneous, and intimate (he never signed them, and they were not exhibited during his lifetime). Photography of the present panel in raking light shows a first stage painted in long, crisscross strokes which determine the positions of the back, arm, and legs. In a second stage (visible through infrared photography) Seurat distributed large darker strokes around the back to bring out the pale skin, to darken the face, and to accentuate the bright touches along the profile and shoulder. The first sketch of the *pointillé* border appears clearly at this stage. Once the balance of structure and atmosphere was set down, the scheme was dotted over, with divided colors in the background and in the shadows.

The model sits on a small blue hassock, otherwise found only in the small overall sketch (cat. no. 188), covered with a light-colored cloth. The white garment on the floor was replaced in the final version by a pair of boots. The model removes her pink-beige stockings, which became bright green in the finished painting.

The overall harmony—blue, pink, gold—is delicate and subtle. The face, however, more highly colored than the body, is in shadow. The dark umbra along the gentle curve from the nape of the neck to the hip gives the impression of a more substantial figure than that of the completed painting, where the *poseuse* has been modified and "stylized."

Robert Herbert has suggested that the antique Spinario may have been a source for the pose,[1] and it is not unlikely that Seurat would use a classical image for the everyday act of taking off or putting on her stockings.

Fénéon, who already owned the *poseuse de face* (cat. no. 185), bought this panel from Seurat's brother-in-law after the artist's death.

1. Herbert 1962, p. 128.

187. *Poseuse de dos*. Late 1886

MODEL FROM THE BACK

Oil on wood, 9⅝ x 6⅛ in. (24.4 x 15.7 cm.)

Musée d'Orsay, Paris R.F. 1947-15

Exhibited in Paris only
H 181; DR 176

PROVENANCE
The artist until 1891. Posthumous inventory, panneau no. 134bis. Inherited by Madeleine Knoblock, Paris, in 1891 until no later than 1903; sold to Félix Fénéon, Paris, by 1903, until about 1910; Gabriela Zapolska, Krakow, presumably by 1910;* Bernheim-Jeune, Paris, by 1920; Félix Fénéon, Paris, by 1928, until his death in 1944; his estate, 1944–47 (Fénéon sale, Drouot, Paris, May 30, 1947, no. 104); purchased at this sale by the Musées Nationaux for the Jeu de Paume; transferred to the Musée d'Orsay, 1986

EXHIBITIONS
1920 Paris, no. 27
1924 New York, no. 9
1936 Paris, no. 45
1937 London, no. 61
1958 Chicago and New York, no. 122

*See note 4 below.

Poseuse de dos is the most sensitive and perhaps the most sensual of the three studies. Even given the apparently impersonal color technique, there is a simplicity and mellowness reminiscent of the black-and-white modeling of drawings in conté crayon of the early 1880s, such as the study of a boy's back for *Baignade* (cat. no. 111).

Poseuse de face (cat. no. 185) invited comparison with Ingres's *Source*, and had Seurat shown the present work, contemporary critics would certainly have noted the obvious reference to Ingres's *Baigneuse de Valpinçon*. The latter work had entered the Louvre collections with much fanfare seven years earlier,[1] when Seurat was at the École des Beaux-Arts, studying under Ingres's pupil Henri Lehmann. Seurat greatly admired Ingres, as witness the reproductions in his studio (Appendix C) and the copies he drew and painted. He was evidently impressed by the monumental simplicity of the *Baigneuse de Valpinçon* (he echoed it earlier in the drawing for *Baignade* mentioned above). As Ingres had done, Seurat seated the model on white linen and highlighted her neck and shoulders.

The upper torso stands out against *La Grande Jatte*;

the figure is farther to the right than it is in the final composition—here she sits where the *poseuse de face* would later stand. *La Grande Jatte* seems to be without its white frame (the canvas's edge appears to reach to the baseboard): perhaps this nude was painted before *La Grande Jatte* was reframed and sent to Brussels,[2] which would date it to late autumn 1886.

The artist's tenderness, the nude's voluptuous body, high, rounded shoulders, dark hair, and protruding ears,[3] and the choice of a back view to prevent identification of the figure, all suggest that the woman is Madeleine Knoblock and not the professional model who posed for the *poseuse de face*. Knoblock's arrival in Seurat's life has hitherto been dated later (none of his family and friends knew of her existence until the artist's death). However, in an 1891 letter she wrote to Signac, she mentions that her liaison with Seurat had lasted six years (see Chronology). Madeleine Knoblock also owned a handsome drawing of a nude, *Femme nue étendue* (H 660; p. 226), doubtless representing herself; it passed into Luce's collection and then into Fénéon's. The lightly hatched treatment of the foreground suggests that it was done before 1888 (the date given to it by de Hauke) which would corroborate her intimacy with Seurat from about 1885–86. Another circumstance reinforces the identification of this figure as Knoblock: of the three studies of the *poseuses*, this is the only one that she received from the estate. Fénéon later acquired it directly from her; it was not exhibited before 1910.[4]

Laboratory photographs reveal Seurat's technique: at first his brushwork was quite loose; he then worked in broad strokes, particularly in the background; finally he applied minuscule dots (especially for the flesh). Originally the head was slightly more erect. The light on the upper back was achieved by strokes in pink and pale blue. The finely dotted blue outline is far more softly drawn than that of the *poseuse de face*.

When Seurat used this study for the sketch of the large painting (cat. no. 184), the model's broad hips were draped with a half-circle of white cloth, accentuating her Ingresque character. Her hair became orange-red to contrast with the violet skirt in *La Grande Jatte* and perhaps to further cloud the identity of the woman who had posed.

1. It was purchased by the Louvre in 1879 for 60,000 francs, then a considerable sum.
2. Seurat shipped his canvases on January 13, 1887.
3. See *Jeune femme se poudrant* (cat. no. 213).
4. That is, after Madeleine Knoblock's death (see Sutter 1964). It was shown outside France at Krakow, in a show organized by Gabriela Zapolska.

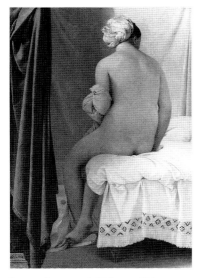

Ingres, *Baigneuse de Valpinçon* (Valpinçon bather), 1808. Musée du Louvre, Paris, R.F. 259

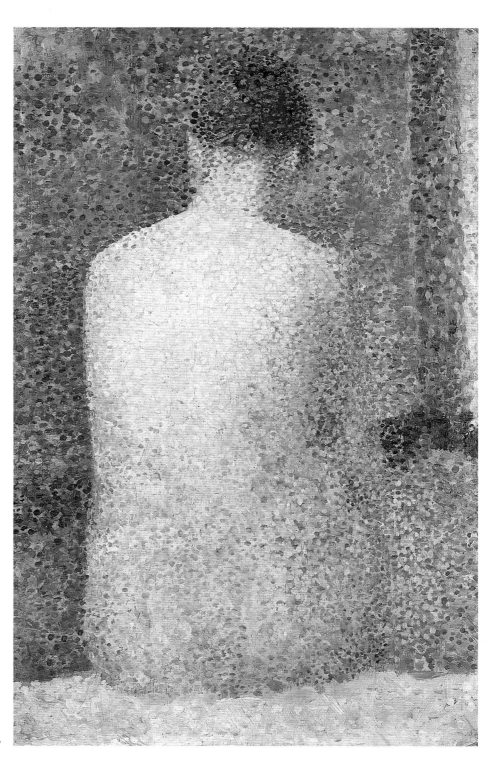

187

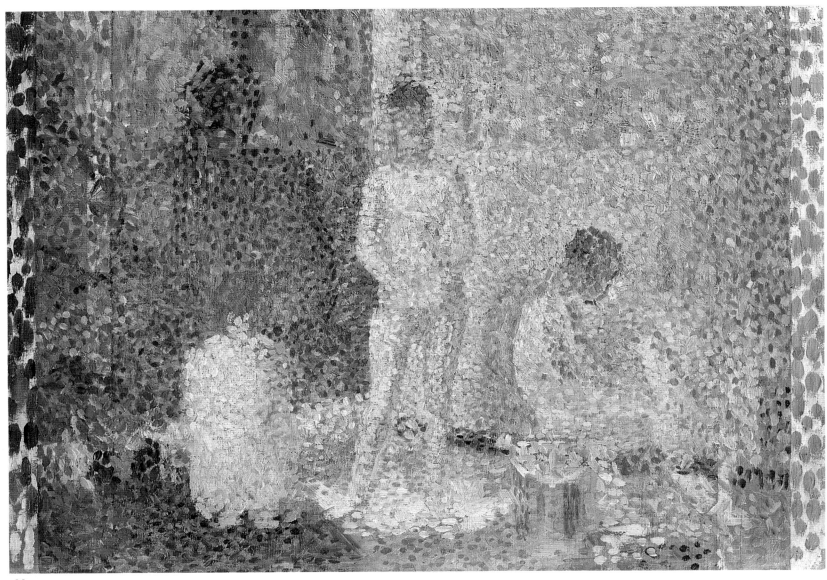

188

288 POSEUSES 1886–1888

188. *Poseuses, petite esquisse.* Late 1886

MODELS, SMALL SKETCH

Oil on wood, 6¼ x 8⅛ in. (15.8 x 22 cm.)
Painted borders at left and right by Seurat

Private collection

Exhibited in Paris only
H 180; DR 177

PROVENANCE
The artist until 1891. Posthumous inventory, panneau no. 134. Paul Signac, Paris, by at least 1905, and probably in 1891, until his death in 1935; by inheritance to Ginette Signac, Paris; to present owner

EXHIBITIONS
1905 Paris, no. 22
1908–09 Paris, no. 65
1932 Paris, no. 21
1933–34 Paris, no. 63
1936 Paris, no. 48
1957 Paris, *hors cat.*
1968 New York, no. 80

This sketch of the final painting has a great freshness, while fixing the essentials of the complex composition. Here the overall ideas are evident: the nude models were to be set against the fully dressed women in *La Grande Jatte*—nearly half the studio scene would be given to depicting another painting. Later changes concerning the size and importance of the *poseuse de profil* affected only the right section. Here all three models are alike in size and are much the same distance from the picture plane. They are placed in a pyramidal composition centered on the standing figure. This figure, seen in cat. no. 185, has been moved to the left toward *La Grande Jatte*; like the vertical column of a balance or the central section of a triptych, she stands between the portion at left (*La Grande Jatte* and the Ingresque nude), which symbolizes art, and the naturalistic one at right (the model removing her stockings), which represents real life.

Seurat knew that the equilibrium between the dark, rich, detailed mass of *La Grande Jatte* at left and the rather vacant, light mauve wall at right might be maintained in a small format but would be difficult to achieve in a very large one—hence, in the final composition, he enlarged the nude at right. Here he simply places the individual nudes from the three studies (cat. nos. 185–187) in the

studio space. He had followed this procedure with the *Grande Jatte* figures, which were artificially juxtaposed in the landscape from separate sketches. He performed the same operation here, apparently with no models before him, and worked out the composition and balance of the color masses. The *poseuse de dos* is given red hair, set off against the green and violet of *La Grande Jatte*. A touch of red, emphatic against the green grass, indicates the feather of the hat resting on the blue hassock. Seurat kept in mind the colors of the final painting (and its reduced version, cat. no. 192)—if he had not, these minute red dots would have no meaning.

The frame, painted by Seurat in colors contrasting with those of the picture, was one of the chief novelties of the final work when it was exhibited at the 1888 Salon des Indépendants. Here it is roughed in on both sides, with dark carmine touches at left against the blues and greens and with yellow-green at right against the pink-mauve wall.

189. *Coin de l'atelier; Le fourneau.* 1887

CORNER OF THE STUDIO; THE STOVE

Conté crayon, 9⅛ x 12⅛ in. (23.2 x 30.7 cm.)

Musée du Louvre, Département des Arts Graphiques, Fonds du Musée d'Orsay, Paris, R.F. 29.540

Exhibited in Paris only
H 661; DR 178a

PROVENANCE
The artist until 1891. Posthumous inventory, dessin no. 362. Inherited by the artist's brother, Émile Seurat, Paris, in 1891, until no later than 1906; Félix Fénéon, Paris, by at least 1908, until his death in 1944; his estate, 1944–47 (Fénéon sale, May 30, 1947, no. 32); purchased at this sale by the Musées Nationaux

EXHIBITIONS
1900 Paris, Revue Blanche, *hors cat.*
1908–09 Paris, no. 196
1920 Paris, no. 54
1922 Paris, no. 19
1926 Paris, Bernheim-Jeune, no. 116
1936 Paris, no. 125
1957 Paris, no. 35
1958 Chicago and New York, no. 118

This is a study of the lower right section of the final picture.[1] After first placing the *poseuse en profil* on a draped hassock (cat. nos. 186 and 188), Seurat gave her a larger piece of furniture on which her dark garments rest, contrasting with white linen. The small cast-iron studio

Seurat, *Chapeau, souliers, linge* (Hat, slippers, undergarments), study for *Une baignade*, 1883–84. Orswell Collection, Pomfret Center, Connecticut (H 593)

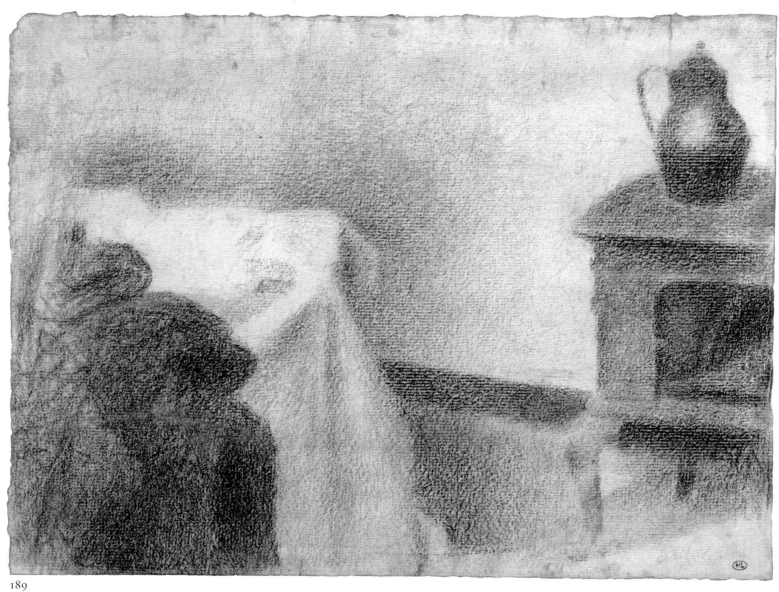

189

stove is that seen in the first preparatory drawing (cat. no. 184); here a pot stands on it (there is again no indication that the stove is lit). In the final composition this pot is paired with a white jug; this characteristic contrast of dark and bright may also be a witty allusion to the pair of hats on the far left or to the couple's double silhouette in *La Grande Jatte*.

Seurat presented a similar scene in *Baignade*, where the boy in profile sits beside his white clothing and black boots. The preparatory drawing for this section of *Baignade* (H 593; Fogg Art Museum, Cambridge, Massachusetts) is strongly reminiscent of the present study, which was executed four years later. In the final compositions of *Poseuses* (cat. no. 191) and in *Baignade*, a pair of shoes imposes its dark, incongruous shape on the white fabric. And in both Seurat places a hat behind the seated model—a droll but forgotten emblem.

1. J. Bouchot-Saupique, "Trois dessins de G. Seurat," *Bulletin des musées de France*, no. 7 (August 1947): 16–17.

190. *Chapeau et ombrelle*. 1887

STILL LIFE WITH HAT, UMBRELLA, AND
CLOTHES ON A CHAIR

Conté crayon and white gouache, 12¼ x 9⅜ in. (31 x 23.8 cm.)

The Metropolitan Museum of Art, New York, Bequest of Walter C. Baker, 1971 1972.118.235

Exhibited in New York only
H 663; DR 178b

PROVENANCE
Félix Fénéon, Paris; Pierre Bonnard, Paris, by 1926, until his death in 1947; his estate, 1947–54 (Bonnard sale, Galerie Charpentier, Paris, February 23, 1954, no. 9); César M. de Hauke, Paris; Walter C. Baker, New York, by 1958, until 1971; his bequest to the Museum, 1971

EXHIBITIONS
1926 Paris, Bernheim-Jeune, no. 113
1958 Chicago and New York, no. 121
1977 New York, no. 38

This study for the garments beside the *poseuse de profil* is part of the final stage in the painting's evolution. After the overall composition had been planned (cat. no. 188),

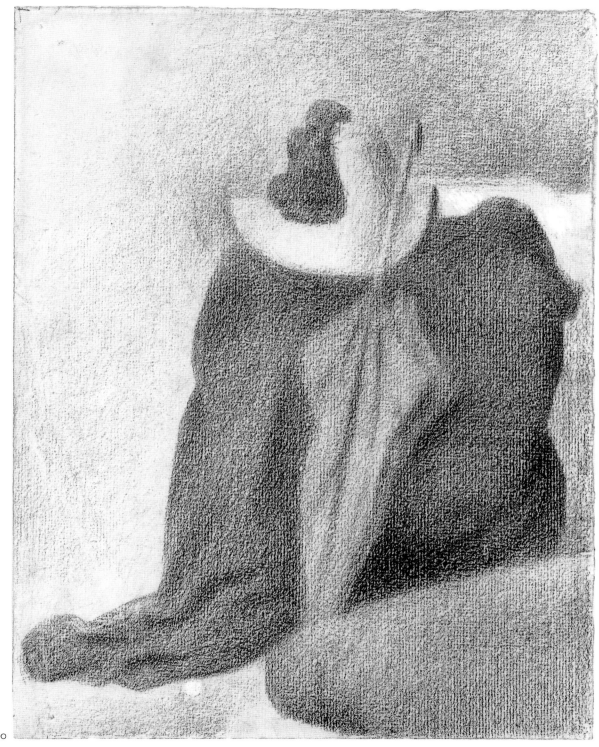

190

Seurat turned his attention to the subtle placement of garments associated with each *poseuse.*

Here the hat (which appears to be straw rather than felt) and the parasol (not an umbrella, as the de Hauke catalogue states) mark the season as spring or summer. This part of the total composition had earlier been somewhat empty. Seurat may have laid it out anew during the spring or summer of 1887 in order to strengthen it for the large format. The indication of season is one of a series of signs that establish the connection between Seurat's "real" *poseuses* and the "painted" strollers of *La Grande Jatte* behind them.

Seurat made some striking changes when he moved from this study to the final painting. The parasol was lengthened, stylized, and adorned with a frivolous ribbon, presaging the extravagant bow on the mirror in *Jeune femme se poudrant* (cat. no. 213). The brim of the hat was turned up more sharply, and its crown was pointed—the little straw hat of the drawing became a bit of a caricature.

The monumentality given to modest feminine accessories in this drawing was not lost upon Pierre Bonnard, who acquired the work from Fénéon, perhaps in exchange for a painting. At the time Fénéon was working at the Galerie Bernheim-Jeune, where he had placed Bonnard under contract.

191. *Poseuses, ensemble.* 1888

MODELS

Oil on canvas, 15½ x 19¼ in. (39.5 x 49 cm.)
Painted border by Seurat

Berggruen Collection on loan to the National Gallery, London

H 184; DR 179

PROVENANCE
Jules Christophe, Paris, by 1892; B. A. Edynski (and Max Hochschiller), Paris, by 1908–09; with Bernheim-Jeune, Paris (inv. no. 17565R); Alphonse Kann, Paris, by 1910, until at least 1917;* Marius de Zayas, New York; John Quinn, New York, from May 1922 until his death in 1924; by inheritance to Julia Quinn Anderson, New York, from 1924; by inheritance to Mary Anderson, New York, until 1936; sold to Henry P. McIlhenny, Philadelphia, in 1936, until 1970 (McIlhenny sale, Christie's, London, June 30, 1970, no. 16); purchased at this sale by Artemis S.A., until 1973; acquired by present owner, 1973

EXHIBITIONS
1892 Paris, Indépendants, no. 1083
1908–09 Paris, no. 70
1913 New York, no. 455
1924 New York, no. 17
1937 Paris, no. 414
1948 New York, no. 51
1949 New York, no. 19
1958 Chicago and New York, no. 136
1978 London, no. 23
1988 Geneva, no. 25

*Alphonse Kann lent the painting to several exhibitions between 1910 and 1917. The work may have still been in his collection as late as 1921 (see Johan H. Langaard, "Georges Seurat," *Kunst og Kultur*, 1921, p. 34, ill., as Alphonse Kann collection).

Félix Fénéon, who had followed Seurat's work closely, noted in the catalogue for the exhibition he arranged at Bernheim-Jeune's in 1908 that this canvas was a replica of the large one, not a sketch as indicated in the booklet for the 1892 exhibition in which it was first shown.[1] If Fénéon was right, this would be the only instance in which Seurat made a reduced version of one of his large paintings. This canvas is not, however, a small replica of the sort an artist will make when he or she wants a souvenir of a sold work. Instead it seems to have been an attempt to solve difficulties that Seurat encountered while he was painting the large version, probably in the summer of 1887.[2] The figure at

right and the arrangement of the foreground, for example, are departures from the sketch (cat. no. 188) and may well have been devised here for use in the larger work. A decision on this point must await X-ray analysis of the Barnes painting.

Whatever the circumstances of its creation—a sketch for a work in progress in 1887 or subsequent reduction made in 1888—it is of immense importance to our knowledge of Seurat. Through this version Seurat's large canvas, twenty-five times its size, has been known to us. Art historians' studies of *Poseuses* have generally been based on this version rather than on the "official" one,[3] which has spent the last sixty-five years in isolation at the Barnes Foundation.

The small canvas has a grace—Seurat would have said a harmony—not achieved in the full-sized composition, which is arresting but rightly felt to be a little hard.[4] The colors seem better preserved here than in the final version, which was painted on gesso. Moreover, as Signac remarked in 1897, the minuscule stippling of the large picture "gives a mechanical aspect to this fine painting.... The plain portions, such as the wall, covered with these tiny strokes, are unpleasant, and the labor seems futile and harmful, giving a gray tonality to the whole."[5] In the large canvas the realism of figures and faces contrasts strangely —perhaps deliberately so— with the very finished style of the rest of the picture. The face and body of the central *poseuse* have an almost polished appearance, so small and closely shaded are the dots. But the foreground objects, the blue garment and the yellow parasol, are rendered in large contrasting colored spots, presenting a magnified, almost caricatured demonstration of complementary color contrast.

Here, however, a homogeneous *pointillé*, vibrant and silky, weaves into a single fabric the women's flesh, the picture on the wall, the objects, and the luminous space that bathes and unifies the whole. Seurat abandons the

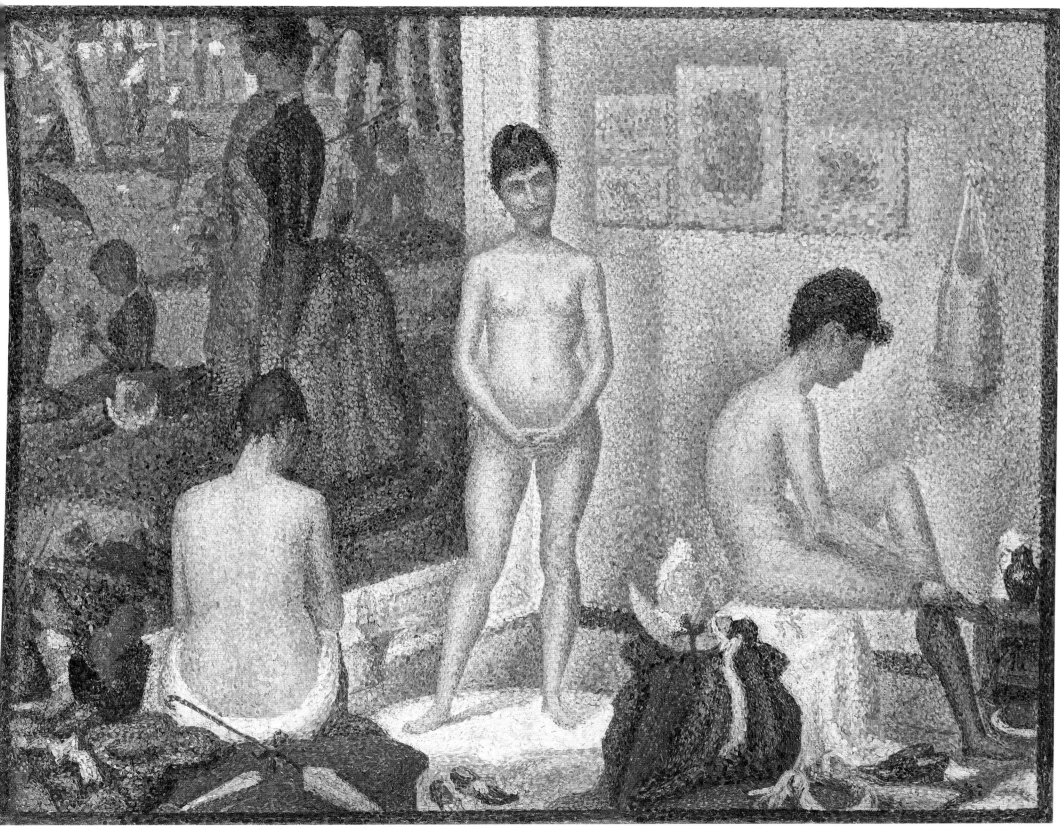

forceful or sarcastic mood of the large picture exhibited at the Indépendants, his canvas "*of combat,*" and paints a more intimate and balanced work.

The dark border painted around the canvas reinforces the interplay of vertical and horizontal in the composition and recalls the original painted frame, now lost, of the full-scale painting.

1. Probably upon information of the lender, Jules Christophe, who was less familiar with Seurat's work than was Fénéon.
2. R. Herbert, who shares this opinion, believes in particular that the special difficulties of painting on plaster (gesso) led Seurat to try the same colors on canvas. Had he been satisfied with the result, he would perhaps have decided midway to scrap the preparatory coat of the large painting.
3. Homer 1964, pp. 167–75.
4. A contrast generally felt by all who have discussed this work. See, for example, Schapiro 1958; Russell 1965, p. 208; 1978 London, pp. 63–67.
5. *Signac Journal*, ed. J. Rewald, pp. 270–71.

192. *Poseuse debout.* 1888

MODEL STANDING

Ink and graphite, 10¼ x 6⅜ in. (26.2 x 16.3 cm.)
Signed lower left: Seurat

The Armand Hammer Collection at the National Gallery of Art, Washington, D.C.

H 665; DR 179a

PROVENANCE
The artist until 1891. Posthumous inventory, dessin no. 363bis. Inherited by the artist's brother, Émile Seurat, Paris, in 1891, probably until 1900; sold to Alexandre Natanson, Paris, probably in 1900, until at least 1909; Bolette Natanson, Paris, by 1926, until at least 1936; Jean-Charles Moreux, Paris, by 1943, until his death in 1956; by inheritance to his widow, Mme Jean-Charles Moreux, Paris, from 1956 until 1962; sold to Wildenstein and Co., New York, in 1962, until 1963; sold to Norton Simon, Los Angeles, in 1963, until 1971 (Simon sale, Parke-Bernet, New York, May 5, 1971, no. 46); purchased at this sale by Armand Hammer

EXHIBITIONS
1900 Paris, Revue Blanche, *hors cat.*
1908–09 Paris, no. 197
1926 Paris, Bernheim-Jeune, no. 114
1936 Paris, no. 130 suppl.
1957 Paris, no. 55

Seurat made this drawing to illustrate Paul Adam's highly favorable article about him in *La vie moderne* of April 15, 1888. There its caption read: "Les poseuses. Drawing by M. Seurat after his painting." Indeed, while he presented only the central *poseuse,* he included the line of the back of the *poseuse* at right and of the arm of the one at left. These lines would be a mystery without knowledge of the picture and its compositional elements—*La Grande Jatte,* the flower basket, the hat, the parasol, and so on. Signac, Pissarro, and Dubois-Pillet—his fellow Neo-Impressionists —had done dotted drawings, but this was Seurat's first use of a technique so different from that of conté crayon. In this drawing he worked with a view to reproduction—he had carefully copied a text by Charles Blanc on *pointillé* engraving (Appendix G). Curiously, however, he surrounded the storm of tiny dots and pen strokes with a sharp, firm outline. In fact, he may have traced his small *poseuse de face* (cat. no. 184), which was still in his studio (the two works are similar in size).

The face is more pleasant here than in the painted versions, recalling Paul Adam's remark that for him the *poseuses* were "creatures in the simplicity of nature, lips curved in the enigmatic feminine smile."

It is likely that van Gogh, then at Arles and thirsting for news of the Parisian avant-garde, saw the reproduction of this drawing in *La vie moderne,* which would have been among the journals his brother Theo regularly sent to him. Vincent would have received it in early May 1888, just when he began to do his pen-and-ink drawings; their dots and dashes may combine the possible influence of Seurat, an artist he admired, with techniques used since the seventeenth century in the Netherlands and Japan.[1]

This drawing was purchased from Seurat's brother by Alexandre Natanson, director of *La revue blanche,* probably on the advice of Fénéon, who was editor in chief from 1894 to 1903.

1. F. Cachin, "Van Gogh and the Neo-Impressionist Milieu," *Van Gogh International Symposium "Japonism,"* Tokyo Shimbun, 1988, p. 235.

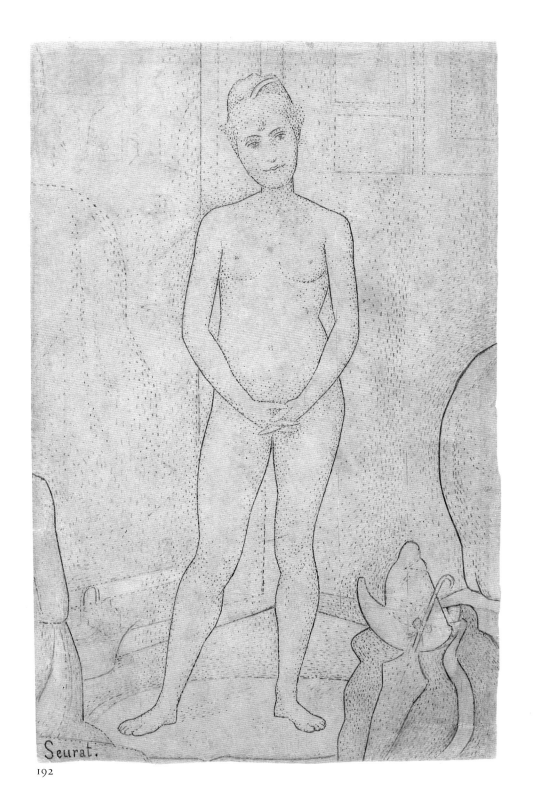

192

The Café-Concert 1886–1888
Gary Tinterow

In 1887–88 the imagery of Seurat's Paris work centered on nighttime scenes of popular entertainment: cafés-concerts, fairgrounds, the circus —the types of entertainments frequented by the same class of working people that populate *Un dimanche à la Grande Jatte*. Perhaps as an announcement of his new interest or as a claim to new pictorial territory, Seurat sent *Eden Concert* to the 1887 Salon des Indépendants. Although Gustave Kahn admired it there, it was otherwise overlooked by the press. The following year the undaunted artist sent to the 1888 Indépendants, in addition to four drawings of miscellaneous subjects, four new drawings of the café-concert. Three were identified by place, *Au Concert Européen*, *À la Gaîté Rochechouart*, *Au Divan Japonais*, and one characterized a performer, *Forte chanteuse*; they clearly formed a group, in essence a tour through the most popular music halls of the day.

This time the drawings were much commented upon by critics. Gustave Kahn was once again enthusiastic: "M. Seurat is surely the best draftsman I know. He gives the small singers and ballerinas of the cafés-concerts a noble bearing and simplified aspect. In general his exhibition gives the impression of a subtle and healthy art: human beings are given a matchless nobility in their unmannered poses."[1] Other writers, while noting that Seurat's distinctive drawing style had not changed, stressed the synthetic and hieratic quality of the work: "One can think that there is nothing innovative [in his art]. But there is, which is also worth noting, proof of an intelligent observer—a sureness of touch and an understanding of light."[2] "And then an entire series of charcoal drawings in which real city folk, musicians, café-concert singers are synthesized in hieratic and definitive poses."[3] Félix Fénéon was succinct: "Eight charcoal drawings state precisely by the undulation of white and black; there is never a defining line."[4] And Paul Signac was equally to the point: "Eight drawings: form becomes synthesized by an absorbent preoccupation of shadow and values."[5]

1. Kahn, April 1888, p. 161.
2. Geffroy, April 1888.
3. Christophe, May 1888.
4. Fénéon, April 1888, quoted in Halperin 1970, I, p. 85.
5. Signac, March 1888.

Richard Ranft, *Paris l'été, aux Ambassadeurs* (Summer in Paris at the Ambassadeurs). Cover, *La vie moderne*, August 8, 1885

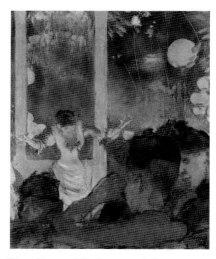

Edgar Degas, *Mlle Bécat au café des Ambassadeurs*, 1885. Mr. and Mrs. Eugene Victor Thaw, New York

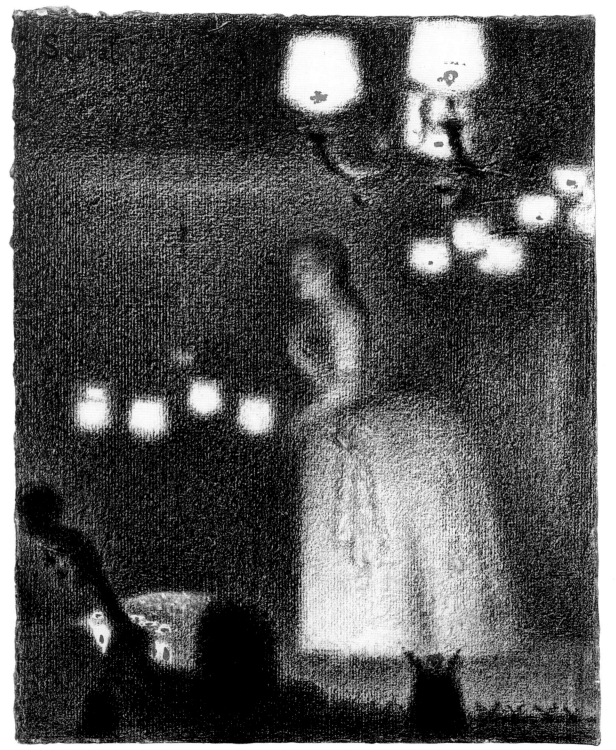

193

193. *Eden Concert.* 1886–87

EDEN CONCERT

Conté crayon, gouache, and pastel, 11⅛ x 8⅞ in. (29.5 x 22.5 cm.)
Signed upper left: Seurat

Rijksmuseum Vincent van Gogh (Foundation Vincent van Gogh),
Amsterdam

Exhibited in New York only
H 688

PROVENANCE*
Contributed by Seurat to the sale for the benefit of Marguerite Pillet
(Pillet benefit sale, Drouot, Paris, March 2–3, 1888, no. 82, for 17
francs); purchased at this sale by Émile Bernard on behalf of Theo
van Gogh, Paris, 1888, until his death in 1891; by inheritance to his
widow, Johanna van Gogh-Bonger, Bussum, the Netherlands, from
1891 until her death in 1925; by inheritance to her son, Dr. V. W. van
Gogh, Laren from 1925, until 1962; purchased by the Vincent van
Gogh Foundation, 1962; thence to the museum, 1973.

EXHIBITIONS
1887 Paris, no. 448
1888 Paris, Vente Pillet, no. 82
1888 Amsterdam, no. 108
1958 Chicago and New York, no. 128
1983–84 Bielefeld and Baden-Baden, no. 78
1988 Amsterdam, no. 5

*De Hauke confused this work with another café-concert drawing
when he erroneously assigned to it a posthumous inventory
number of dessin no. 378. See Herbert 1962, p. 185, no. 129.

In addition to the extraordinary group of six canvases
depicting the port of Honfleur (cat. nos. 164–68 and 170),
Le pont de Courbevoie (cat. no. 171) and *Poseuse de face* (cat.
no. 185), Seurat sent twelve sketches and one drawing to
the 1887 Salon des Indépendants, testimony to the impor-
tance the artist continued to attach to his work in black
and white. The drawing was *Eden Concert.* In it the harsh
glare of gas lamps illuminates a corpulent diva—whose
girth is mocked by the enormous bustle that extends
behind her—frozen in the middle of a song, her mouth
open. At the lower left the composition is framed by the
silhouette of a bass player, a motif Seurat later employed
in *Chahut.* Although the paintings were noted in the press,
critics did not spill much ink on Seurat's drawing. Gustave
Kahn was a lone enthusiast: "Seurat's drawings are al-
ready known; in this one as in others [one finds] the

arrested masses and the skillful grading of light and shade."[1] Nothing about the subject, a café-concert scene, was exceptional in the context of contemporary French painting, and perhaps the artist's singular drawing style had become too familiar to remain noteworthy. Dubois-Pillet and Signac also sent drawings to the Indépendants, but theirs were pointillist rather than chiaroscuro.

After its uneventful debut, *Eden Concert* subsequently became much discussed for other reasons. Seurat contributed it to an auction held on March 2 and 3, 1888, for the benefit of the daughter of the recently deceased auctioneer Charles Pillet.[2] Although it fetched only seventeen francs, it was acquired by the painter Émile Bernard, acting on behalf of Theo van Gogh, Vincent's brother. Theo van Gogh had recently taken over the purchasing of contemporary art for Boussod et Valadon, a Parisian gallery known as a source of Barbizon painting. This was the first Seurat he acquired, and he seems to have bought it for himself, rather than for gallery stock.[3] His brother Vincent was delighted. Only hours before he left Paris definitively for Arles in February 1888, Vincent had stopped at Seurat's atelier to pay homage to the author of *La Grande Jatte*. As soon as Vincent learned of Theo's acquisition he congratulated him and suggested that he attempt to arrange an exchange of their works.[4] The exchange was never made, but Theo kept his drawing, sending it, along with works by Vincent, to an 1888 exhibition in Amsterdam, where it was noted in *La revue indépendante*.[5] After Theo's death it remained with his wife, and it is still preserved with the family's collection at the Rijksmuseum Vincent van Gogh in Amsterdam.

The work is the sole conté drawing by Seurat to include anything other than white highlights. He applied blue pastel over the conté crayon to tint the black to a midnight blue. And, according to Gustave Kahn's description of the drawing at the 1887 Salon des Indépendants, Seurat had originally colored the singer's scarf pink. Kahn deplored the color: "But why color mix into the black and white? The emphasis on the pink scarf and its coloration seems useless to us."[6] Today the scarf is almost white. It is possible that over time the scarf has faded, since pink is a notoriously fugitive color; it is also possible that Seurat modified the color after the work returned from exhibition. However, the dark gray spots visible today amid the white highlights are certainly unintentional: the lead oxide in Seurat's white gouache has oxidized to gray.

Robert Herbert has suggested that another drawing of a café-concert singer may have served as a study for this work.[7] The technique of this work on Gillot board is exceptional in Seurat's oeuvre. Instead of his normal process, in which he draws shadow with dark lines of conté crayon, here Seurat "drew" highlights by scraping away the dark coating of the Gillot board to reveal the white beneath.

Seurat's choice of a performance at the Eden Concert as his subject should also be mentioned, for this theater, identified by name when the work was exhibited, differed from most cafés-concerts. Founded at 17 boulevard Sébastopol in 1881 by Mme Saint-Ange, the Eden Concert was known as a family music hall where high musical standards prevailed but where the racy and suggestive lyrics of the regular repertoire of songs were censored.[8] The performer in Seurat's drawing has not been identified.

Kahn's review of the 1887 Indépendants was accompanied by an illustration of *Eden Concert* reproduced in a wood engraving by Michelet, who proudly signed at lower right his subtle interpretation of Seurat's velvety technique. This wood engraving has often been reproduced mistakenly in lieu of the original drawing.

1. Kahn 1887, p. 230.
2. John Rewald, "Theo van Gogh as an Art Dealer," in *Studies in Post-Impressionism*, New York, 1986, p. 25 n. 37.
3. The drawing does not appear in the Boussod et Valadon stock books.
4. Vincent van Gogh, *The Complete Letters of Vincent van Gogh*, Greenwich, Conn., vol. 2, 1958, p. 531 (letter 468).
5. Zilcken, "En Hollande: notes," *La revue indépendante*, no. 22, August 1888.
6. Kahn 1887, p. 230.
7. Herbert 1962, p. 147.
8. François Caradec and Alain Weill, *Le café-concert*, 1980, p. 78.

194. *Au Concert Européen*. 1886–88

AT THE CONCERT EUROPÉEN

Conté crayon, chalk, and gouache, 12¼ x 9⅛ in. (31.1 x 23.9 cm.)
Signed upper left: Seurat

The Museum of Modern Art, New York, Lillie P. Bliss Collection

H 689

PROVENANCE
The artist until 1889, when it was sold from the exhibition of Les Vingt in Brussels.* Gustave Gervaert; Mme Octave Maus, Brussels; Théo van Rysselberghe, Brussels, by 1908; with Reid and Lefevre, London, by April 1926; Charles Vignier, Paris, by November 1926; Baron August Freiherr von der Heydt, Berlin, presumably until 1929; with Alfred Flechtheim, Berlin, until May 1929; sold to De Hauke and Co./Jacques Seligmann and Co., New York, in May 1929, until October 1929 (stock no. 1444);** sold to Lillie P. Bliss, New York, in October 1929, until her death in 1931; her bequest to the Museum, 1934

EXHIBITIONS
1888 Paris, Indépendants, no. 615
1889 Brussels, no. 11
1908–09 Paris, no. 177
1926 London, no. 11
1926 Paris, Bernheim-Jeune, no. 49
1935 Chicago, no. 20
1947 New York, no. 25
1948 New York, no. 63
1949 New York, no. 54
1953 New York, no. 36
1958 Chicago and New York, no. 130
1968 New York, no. 84
1977 New York, no. 42

*See Susan M. Canning, "A History and Critical Review of the Salons of 'Les Vingt,' 1884–1893," Ph.D. diss., 1980, The Pennsylvania State University (Ann Arbor, 1982), p. 260 n. 126, where *Au Concert Européen* is listed among the works sold from the 1889 exhibition of Les Vingt for a total profit of 4,662 francs.

**See provenance, cat. no. 30.

With this work Seurat comes closest to Degas's representations of the café-concert, in which the spectators assume a compositional role almost equal to that of the performers. The split register, actors above and audience below, had by the mid-nineteenth century become a device employed in almost all imagery associated with the the-

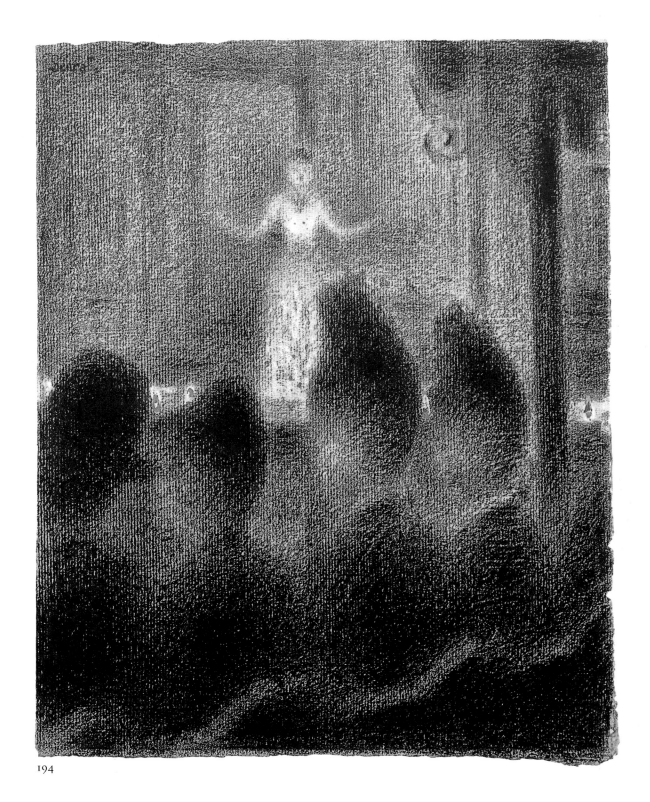

194

ater. In avant-garde circles the device was inevitably associated with Degas, who in the Impressionist exhibitions of the late 1870s established his preeminence as the painter of theatrical entertainment. Around 1885 Degas reworked in pastel some of the lithographs and etchings he had made about 1879; one of these (Corcoran Gallery of Art, Washington, D.C.) is especially close to the present work in the manner in which the women of the audience, attired in slightly comical workaday costumes, contrast with the woman working on the stage. Whereas Degas imparted individuality to each of the spectators by varying his or her dress and to the performer by catching a telling tilt of the arms or shrug of the shoulder, Seurat generalized his figures, making the two hatted women in the audience interchangeable and the singer marionettelike. The fact that no one seems to be watching the performance adds to the strange aura, as if a ritual that no longer had meaning were being enacted.

Seurat heightened this conté drawing with white chalk and white gouache, which now seem brighter compared to the paper, which has darkened with age.

195. *Scène de théâtre.* 1887–88
MUSIC HALL SCENE

Conté crayon, chalk, and gouache, 12 x 9¼ in. (30.5 x 23.5 cm.)

Musée du Louvre, Département des Arts Graphiques, Fonds du Musée d'Orsay, Paris, Gift of Baronne Eva Gebhard-Gourgaud, 1965 R.F. 31.208

Exhibited in New York only
H 683

PROVENANCE
Baron Napoléon Gourgaud, Paris, until his death in 1944; by inheritance to Baronne Eva Gebhard-Gourgaud, 1944, until her death in 1959; her estate, 1959–65; given to the museum, 1965

EXHIBITION
1936 Paris, no. 92

The cafés-concerts celebrated by Degas and Manet in the 1870s, the Ambassadeurs and the Alcazar d'Été, were outdoor, almost provisional stages on which stars such as Thérésa sang comic songs with exaggerated gestures. In

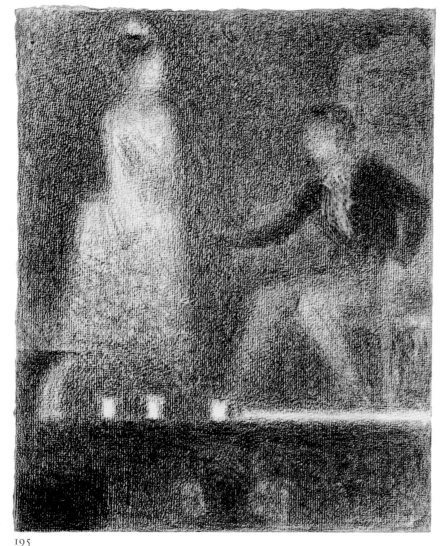

195

196. *À la Gaîté Rochechouart.* 1887–88

AT THE GAÎTÉ ROCHECHOUART

Conté crayon and white chalk, 12 x 9¼ in. (30.5 x 23.5 cm.)

Museum of Art, Rhode Island School of Design, Providence, Gift of Mrs. Murray S. Danforth 42.210

Exhibited in New York only
H 685

PROVENANCE
Félix Fénéon, Paris; De Hauke and Co./Jacques Seligmann and Co., New York, until December 1936 (stock no. 6234);* sold to Mrs. Murray S. Danforth, Providence, in December 1936, until 1942; her gift to the museum, 1942

EXHIBITIONS**
1892 Paris, Indépendants, no. 1126
1949 New York, no. 56
1953 New York, no. 35
1958 Chicago and New York, no. 129

* See provenance note, cat. no. 30.
**Presumably it was H 686, and not this work, that was included in the following exhibitions: 1888 Paris, Indépendants, no. 616, and 1889 Brussels, no. 12.

In a Montmartre music hall a singer, her arms raised in an exclamation of exasperation, leans forward and opens her small, round mouth to emit what must have been a pure, perfect note—if the conductor's rapt attention is a sure guide. The stage is empty, in accordance with the new fashion; the *corbeille* (basket) of singers waiting their turn no longer sit on the stage fanning themselves, on display for their admirers, here a heterogeneous crowd of hatted men and women. Seurat reinforced the intensity of the gas lights by heightening the reserves of bare paper with white gouache, which today seems even whiter because the underlying paper has yellowed with age.

Although Seurat exhibited a drawing titled *À la Gaîté Rochechouart* at the 1888 Salon des Indépendants, it is not known whether this sheet is the work in question, for there is another drawing of the same subject and composition at the Fogg Art Museum (Cambridge, Massachusetts) that is virtually identical—a unique occurrence in Seurat's oeuvre. In an important article James H. Rubin proposed that the Fogg drawing was the work that Seurat exhibited first in 1888 and again in Brussels in 1889 at the Exposition des Vingt.[1] His argument rested on a complicated geomet-

the 1880s, the decade of Seurat, the cafés-concerts shifted indoors, even in summer, into large and ever more elaborate theaters, and the entertainment developed into variety shows that included a wide range of performances, from star turns by Yvette Guilbert (1867–1944) and Mistinguett (1875–1956) to the first "girlie" reviews. This drawing depicts a scene, no doubt a comic love duet, from an act at one of the popular music halls whose attendance had been boosted by an exemption for cafés-concerts in the fire regulations enacted after the 1887 fire at the Opéra-Comique.

Since this work was not exhibited during the artist's lifetime, the original title is not known, thus the theater that Seurat had in mind when he made this work cannot be identified. However, it is likely that this drawing belonged to the series that includes cat. nos. 193, 194, 196, and 197, most of which are named after Montmartre music halls. Although Seurat's drawing is characteristically nonspecific, the seated man's obsequious gesture of entreaty and the standing woman's reluctant acceptance are universally recognizable.

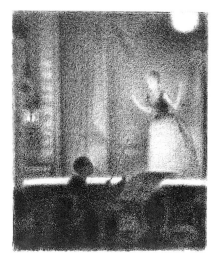

Seurat, *À la Gaîté Rochechouart*, 1887–88.
The Fogg Art Museum,
Harvard University, Cambridge,
Massachusetts, Bequest of
Grenville L. Winthrop

rical analysis of the two compositions in which he deter-
mined that the Fogg drawing displays a more "perfect"
use of the golden-section ratio, 1 : 1.6, and is therefore the
work Seurat more likely favored. Since it is now thought
that Seurat never used the golden section,[2] Rubin's argu-
ment must be discounted—but not his conclusion. In an
appendix Rubin also noted that each of the drawings
Seurat exhibited during his lifetime is signed; because the
Fogg drawing carries a barely visible signature at the
middle upper edge of the composition and the Providence
drawing is unsigned, the Fogg drawing is probably that
which the artist exhibited. The Providence drawing is
more delicate and less insistently worked than the Fogg
drawing; it is possible that the artist, already satisfied with
the composition, made the Fogg drawing as a stronger,
more legible work for exhibition purposes. Apart from the
relative tonality, the only differences between the two
works are found in the tilt of the singer's torso and the
angle of the conductor's baton.

1. Rubin 1970.
2. Herz-Fischler 1983.

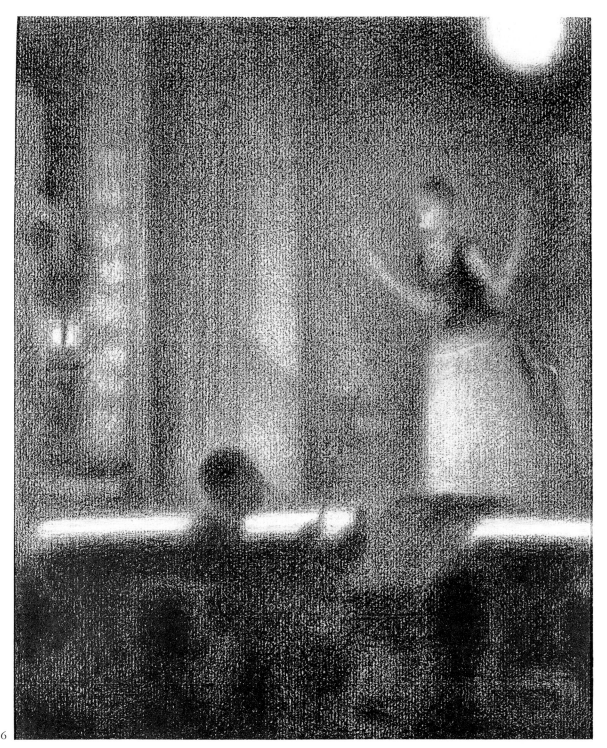

196

197. *Au Concert Parisien.* 1887–88

AT THE CONCERT PARISIEN

Conté crayon and gouache, 12¼ x 9⅛ in. (31.2 x 23.2 cm.)

The Cleveland Museum of Art, Leonard C. Hanna, Jr., Fund 58.344

H 687

PROVENANCE
The artist until 1891. Posthumous inventory, dessin no. 299. Jos Hessel, Paris, by 1926; with Lilienfeld Galleries, New York; with Buchholz Gallery, New York; Alexander Bing, New York, by 1947; César M. de Hauke, Paris, until 1958; sold to the museum, October 1958

EXHIBITIONS
1926 Paris, Grand Palais, no. 3223
1947 New York, no. 26
1983–84 Bielefeld and Baden-Baden, no. 82

Just as Seurat cropped the compositions of his studies for *Baignade* (cat. nos. 103–117) as if he were a modern cinematographer zooming in on his subjects for close-ups, so here he places his "camera" just behind the heads of spectators to zoom in on the singer. She is expressionless because the blinding stage light has reduced her to an apparition, her figure no more than an assemblage of geometrical shapes, while the spectators, their backs to us, are featureless silhouettes. With the most elementary means and minimal information, Seurat nevertheless conveys a persuasive impression of the experience of a performance.

Le Grand Concert Parisien dated back to the Second Empire. It was founded at 37 faubourg Saint-Denis in 1867, the year in which the law was passed that allowed cafés to mount full-fledged entertainments, but it first took on real celebrity at the end of the 1880s, when it was acquired by an impresario named Auguste Musseleck. Musseleck featured such popular performers as Paulus and Clovis; in 1889 he succeeded in wooing Yvette Guilbert away from Jehan Sarrazin's Divan Japonais. She brought a numerous following to the Concert Parisien, and when she left in 1891 her audience left too. Musseleck lost the hall in 1894.[1]

1. Romi, *Petite histoire des cafés concerts parisiens*, n.d., p. 44.

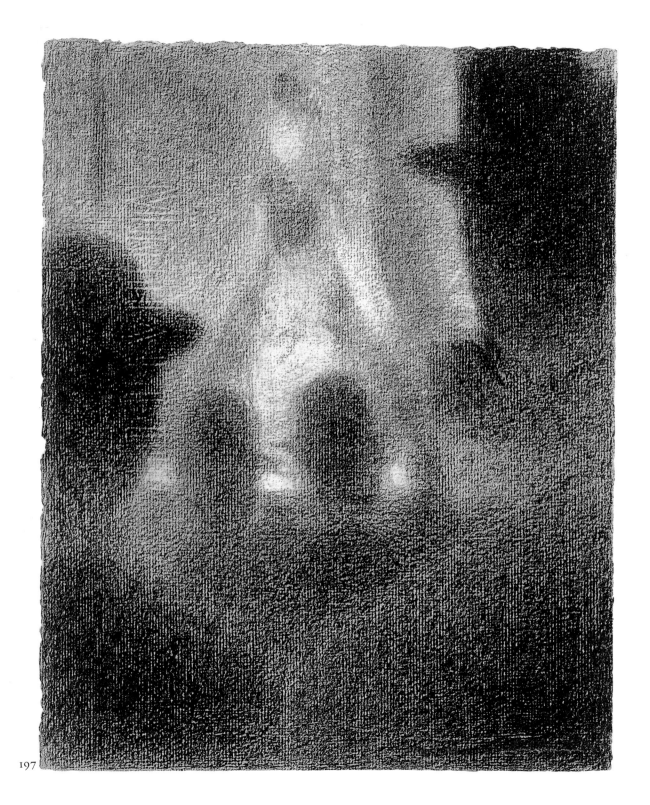

197

198. *Chef d'orchestre*. 1887–88

BANDLEADER

Conté crayon, 12⅛ x 9⅛ in. (31 x 24 cm.)

Private collection

H 672

PROVENANCE
Paul and Berthe Signac, Paris, by at least 1905; by inheritance to
Ginette Signac, Paris; to present owner

EXHIBITIONS
1905 Paris, no. 30
1908–09 Paris, no. 172
1926 Paris, Bernheim-Jeune, no. 59

The very ambiguity of this drawing has led to numerous
interpretations of its subject. De Hauke catalogued it as a
study for *Parade de cirque* (cat. no. 200) and subtitled it
Appel au public, thus identifying the figure at right as a
barker who drums up business for the circus show. Lucie
Cousturier called the drawing *Saltimbanques*, linking it
with drawings such as cat. no. 199. Robert Herbert came
up with a more persuasive identification when he called
the drawing *The Bandleader*,[1] seeing the principal figure as
a conductor waving his baton. However, the conductor
quite exceptionally wears a kind of hat. Bandleaders
were almost universally shown without hats, and in works
from *À la Gaîté Rochechouart* to *Chahut* (cat. nos. 196 and
217) Seurat conformed to tradition. Herbert recognized

that in this drawing the artist provided the viewer with
remarkably few details: "the bandleader's anatomy is
difficult to understand, and what is the enigmatic shape in
the lower right corner?" Fortunately a drawing by H. G.
Ibels depicts a similar scene more clearly, albeit more
prosaically; there a conductor also wears a hat with a

round crown. The "enigmatic shape" at the lower right of
Seurat's drawing may indicate spectators crowded close to
the conductor, as in Ibels's picture, and the figures to the
left may be musicians.

1. Herbert 1960, p. 150.

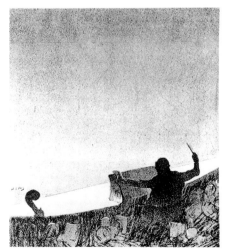

H. G. Ibels,
L'orchestre. Undated
lithograph

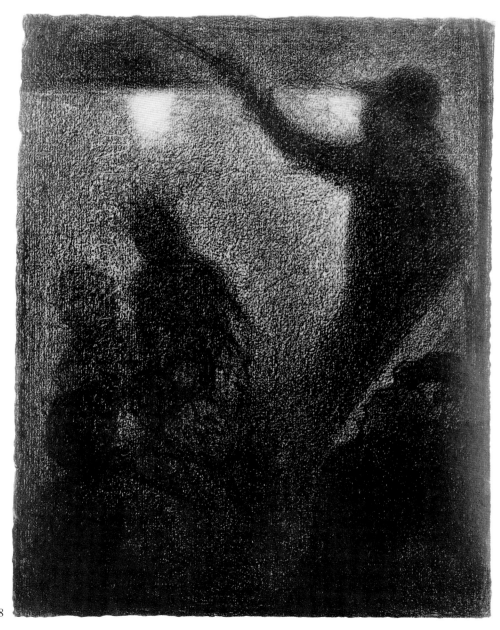

198

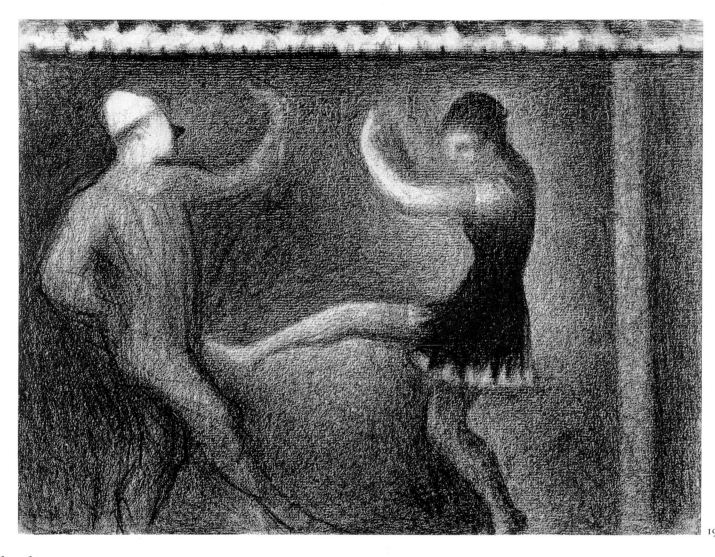

199

199. *Pierrot et Colombine.* 1887–88

PIERROT AND COLOMBINE

Conté crayon, 9¾ x 12¼ in. (24.7 x 31.2 cm.)

Fondation du Musée Nichido, Tokyo

Exhibited in New York only
H 674

PROVENANCE
Paul and Berthe Signac, Paris, by at least 1905, until at least 1943;
Mr. and Mrs. Leigh Block, Chicago, by at least 1958, until 1980; sold
to Acquavella Galleries, New York, in 1980, until 1982; sold to
present owner, 1982

EXHIBITIONS
1905 Paris, no. 29
1908–09 Paris, no. 201
1926 Paris, Bernheim-Jeune, no. 118
1958 Chicago and New York, no. 133

In connection with his series of drawings of café-concert
performances, and perhaps in anticipation of *Parade de
cirque* (cat. no. 200), Seurat executed several drawings of
performing saltimbanques or acrobats. Of the group, this
work is the most spirited. In contrast to the eerie depiction
of frozen movement characteristic of almost all of his work

in 1887–88, here Seurat shows performers energetically
dancing under a row of gas jets, their gestures emphasized
with repeated contours that suggest continuous move-
ment. Gustave Coquiot singled out this drawing for praise
in his 1924 monograph (where he misdated it to 1886): "a
wonderful drawing. . . . Strength and grace. Fluid—though
firm where it needs to be. How the light clings to the
man's head, on the woman's face, on her arms and
upraised leg!"[1]

1. Coquiot 1924, p. 185.

Parade de cirque 1887–1888

Gary Tinterow

Seurat's *Parade de cirque*, "so willfully pallid and sad,"[1] as Gustave Kahn characterized it at its debut, has, like the unwatched trombonist at center, been underappreciated from the start. Overshadowed at its first exhibition at the Salon des Indépendants in spring 1888 by the much larger *Poseuses*, it was subsequently neglected by Seurat himself, who did not include it among the large canvases listed in his "esthétique" of 1890 (Appendix E). Falling uneasily between the huge, early plein-air paintings *Baignade* and *La Grande Jatte* and the late indoor scenes *Chahut* and *Cirque*, *Parade* has neither the grandeur of the former nor the posterlike memorability of the latter. Yet it nonetheless demands a central role in Seurat's concise oeuvre. Not only is it his first painting of a nocturnal scene and therefore an important stage in the development of the artist's new "chromo-luminarist" style, it is also his first painting to depict the performance of a popular entertainment, a genre—already developed in drawings—that would dominate the artist's large projects for the remainder of his brief career. Apart from issues of chronological priority, however, *Parade* also distinguishes itself as Seurat's most mysterious painting, a brooding masterpiece that reveals its meaning reluctantly, a disarmingly simple geometrical schema that conceals a complex spatial arrangement.

Although the background in Seurat's *Parade* was identified by Kahn in 1888 as "the gaudy tents of the Cirque Corvi,"[2] in this century it was not until Robert Herbert published his seminal study in 1980[3] that the depicted scene was fully understood. For the Gingerbread Fair (*foire au pain d'épice*) in April 1887, Fernand Corvi, whose name appears on Seurat's small sketch for the ticket window (H 382), set up his traveling circus near the place de la Nation, a working-class quarter in eastern Paris. The entrance to the tent was up a broad flight of six steps at the center of an elevated platform where there was a ticket window and doors. On both sides of the doors, which in Seurat's picture are painted green, musicians, acrobats, and animals per-formed a sideshow on the balustraded platform to entice passersby. Ticket holders queued up parallel to the sideshow stage, as a photograph taken at the turn of the century shows, climbing up subsidiary stairs perpendicular to the main flight at center. (The diagonal line running immediately behind the trombonist's ankles is the handrail for the subsidiary stairs.) Those wishing to buy tickets from the ticket seller would climb the central stairs, as do the man and woman at the extreme bottom right of the painting.

Seurat shows a young girl with a woman buying a ticket on the platform just to the right of the ringmaster. They, like the musicians at the left, are bathed in the orange light of the nine gas jets that illuminate the platform from above. (The five yellow-white spheres visible through the ticket windows are the globes of interior lamps.)

A young boy with a ruffled collar, doubtless a performer although his specialty is not made evident, stands just in front of the platform at the top of the central stairs, out of the light. The door directly behind him, despite appearances, is not on the same plane as the ticket window, but rather far within the entrance passage to the tent, through the open doors at right in the photograph of the Cirque Corvi. The tall rectangle behind and just to the right of the trombonist, however, is a post defining the foremost edge of the platform; the post, also plainly visible in the photograph, has the price of admission plastered on it. Above the poster, just to the right of the trombonist's head, is the support for the gas pipe. The trombonist, deep in shadow, stands several yards in front of the platform on a pedestal to the left of the central stairs. The highlights glistening on his lower legs and on the edge of his pedestal indicate that the light comes from behind him, whereas the red faces of the clarinetist and two cornet players at left (the fourth musician, a tuba player, is faceless) indicate that they stand on the gaslit platform.

It is remarkable, given the fairylike apparition of Seurat's painting, that it so carefully conforms to the reality of the construction of the Cirque Corvi. Yet at every opportunity, Seurat conflated space, minimized depth, and implied planarity in order to create the appearance of a relieflike representation. Just as Seurat hoped to make his *Grande Jatte* a modern panathenaic frieze, it is probable that he aspired to give *Parade* the self-conscious geometry and monumental calm of Egyptian art, qualities that Charles Blanc had extolled at length. Rather than indicating distance in the conventional Western manner through foreshortening or in the con-ventional Egyptian manner through changing scale, Seurat more subtly establishes relative position through lighting. Those behind the gas jets are brilliantly lit, those in front are in the deep blue absence of light that is night.

The evocative depiction of ethereal, penumbral light is unquestionably the key feature of Seurat's *Parade*. Although the painting received little

comment upon its first showing in 1888, the reviewers who did mention it noted the novelty and difficulty of the light effects. Fénéon, who evidently did not admire the work, thought it was only "interesting insofar as it applies to a nocturne a method [pointillism] that has been mainly used for daylight effects."[4] Jules Christophe cited a "curious essay in nocturnal effects."[5] Paul Adam, after a long discussion of *Poseuses*, referred to "a saltimbanque sideshow, inundated with the light of stationary gas lamps."[6] Gustave Geffroy, after remarking on the drawings of cafés-concerts Seurat exhibited along with it, stated, "*Parade de cirque*, on the contrary, has little allure, a poverty of silhouette, a pallid appearance with awkward contrasts."[7] Gustave Kahn proffered some sympathy when he wrote, "In this research, new to him, into the effects of gas [lighting], M. Seurat perhaps may not arrive at the harmonious and seductive impression of *Poseuses*, but the effort was difficult and the qualities of the painter rest there."[8] When the painting was shown again in Brussels in 1892, the commentary was similar: "*Parade de cirque* is conceived in a note of hazy fairground light. The sideshow performers are blurred in a kind of mist through which the gaslights attempt to burn. A clown, in the middle of the picture, is silhouetted against a noisy stand. This painting is not as decisive as *Cirque* . . . which is incidentally the most beautiful painting in the exhibition."[9]

Seurat may have been stirred to execute a nocturne in friendly competition with Charles Angrand, who exhibited his night piece *Un accident* in the 1887 Salon des Indépendants.[10] Fénéon wrote at the time that "to give a canvas the sensation of artificial light when it will in fact be viewed in natural light is an interesting but intricately hard experiment. The spectator, plunged into the yellow gaslight, assumes that it is white and so adapts an inaccurate term of reference."[11] Years later Angrand recalled that while walking at night in Paris, "more than once along the way Seurat pointed out to me the complementary halo around the gas lamps. He was applying this in his *Parade*."[12] True to his desire to make explicit in paint such optical subtleties as halos, Seurat did in fact place faintly perceptible blue-violet auras around the gas jets in *Parade*. But he did not take his optical realism to the point of depicting the orange-yellow gaslight as white, which, as Fénéon cleverly observed, the brain automatically corrects for. Instead, Seurat painted the light as orange, which was the color he knew it to be. Perhaps, however, Seurat anticipated other factors that would influence the way the light in *Parade* would be perceived. Recently, when the painting was examined at the Metropolitan Museum's laboratory in light similar in color to that given off by gas lamps, an extraordinary transformation took place. Under the colored light the faces of the figures

Cirque Fernand Corvi, about 1900

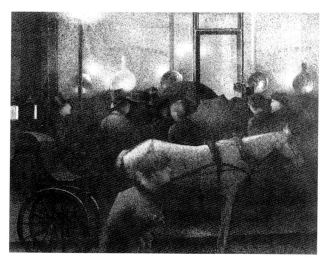

Charles Angrand, *Un accident*, 1887. Josefowitz Collection.

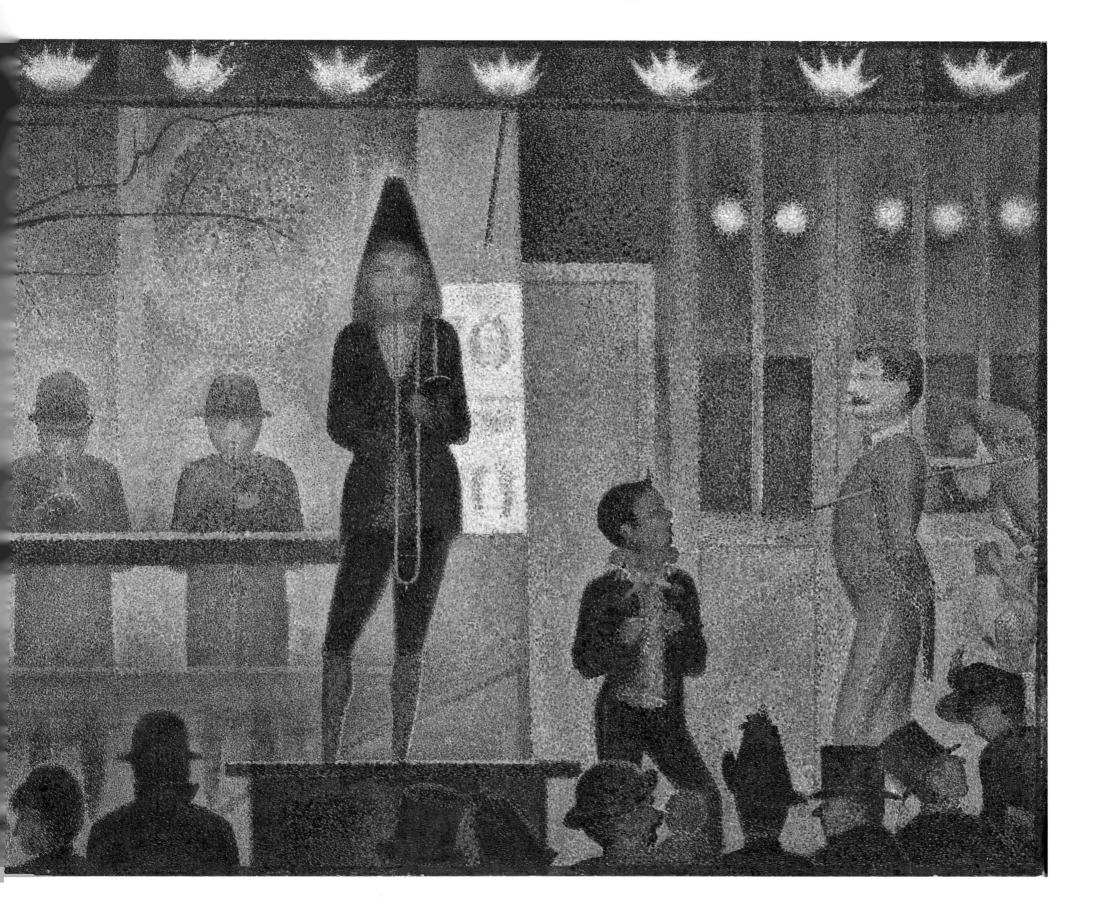

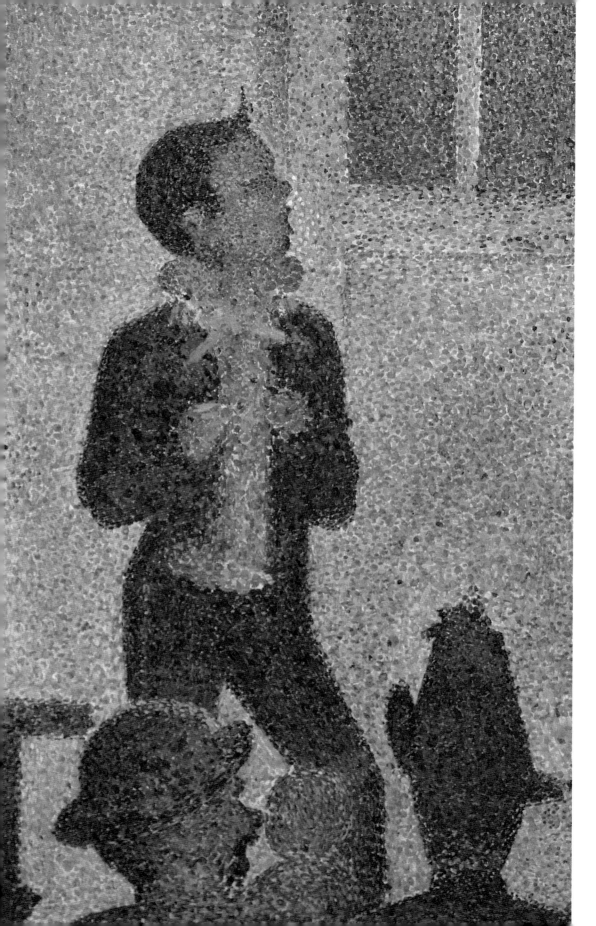

Seurat, page from sketchbook. Private collection (H 382)

on the platform no longer appeared unnaturally orange but flesh color, the shadows on the trombonist and on the spectators were no longer bright ultramarine blue but black, and the entire painting glowed as if it were lit from behind, which, of course, is precisely the effect of *contre-lumière* on which Seurat predicated the picture. The Salon des Indépendants, where *Parade* was first shown, was open during the day and presumably lit with daylight. However, the contemporaneous letters of Seurat's colleagues, such as Camille Pissarro, are filled with remarks regarding the viewing of paintings under gaslight. In December 1886, after a visit to the Durand-Ruel gallery, Pissarro noted that gaslight neutralized the orange tones in his pictures.[13] Several weeks later Pissarro recounted how the dealer Martinet cited gaslight and white frames as some of the excuses for not showing Seurat's paintings in his gallery.[14] Seurat may thus have countered by executing his nocturne so that it would actually improve in appearance under gaslight. Perhaps he even painted it at night. Regardless, however, of the conditions under which it was painted or in which it would be exhibited, there can be no doubt that the poetic mood of the picture is largely due to the effect of nocturnal lighting.

Seurat once protested that "people see poetry ... but I just apply my method."[15] Such a denial is typical of the artist, especially during the late 1880s, when he was preoccupied with demonstrating that he was the first in his group to apply science to art. (Exasperated with Seurat's relentless claims, Pissarro suggested that he be awarded a patent in order to quiet him.[16]) In *Parade*, as in the contemporaneous *Poseuses*, Seurat perfected his pointillist technique. On a prepared white canvas he sketched the composition in dotted blue lines and then covered the surface with warm and cool neutral tones—mostly violet-gray and blue-gray—which he applied in relatively conventional brushstrokes that conform to the direction and shape of the forms they describe. (Despite what has been written,[17] only in the faces of some of the figures and in the flames of the gas jets did Seurat

Detail from cat. no. 200

allow the bare white canvas to show between dots of paint.) He then applied the dominant colors of the composition—dark violet-blue, orange, and green— in medium-sized dots that in only a few instances define the shape of a form. (There were very few revisions at this stage.) Over these larger dots Seurat finally painted myriad smaller dots, often in a lighter value of the color underneath or in a complementary color. To cite two examples out of thousands: a typical large dark-blue dot on one spectator's hat is overpainted with many small orange dots and a few light-blue dots; a given section of the green doors is composed of dark- and light-green dots over blue-gray strokes, with scattered blue dots representing the blue shadows of night and orange dots representing the artificial light. The result, in the words of Meyer Schapiro, is the "marvelous delicacy of tone, the uncountable variations within a narrow range, the vibrancy and soft luster, which make his canvases . . . a joy to contemplate."[18]

No matter how far one stands from the painting, the dots of color never completely merge, contrary to Neo-Impressionist theory, nor do the complementary pairs of, say, orange light and violet shadows neutralize each other, as William Homer has suggested.[19] Instead, as Schapiro noted, the dots give vibrancy and luster to the painting. Seurat's final touch was the addition of the painted border over the extreme edges of the composition. It is not certain that Seurat anticipated the border, since it is painted over the composition—as well as being very narrow and in several places somewhat cramped—but he did not restretch the canvas to make more room for it, as he did elsewhere. *Parade* remains on its original stretcher and was never relined.

Art historians have searched nineteenth-century writings for an explanation of the unusual appearance and strange mood of *Parade*. Until recently the ideas of the philosopher Charles Henry, a contemporary of Seurat's who posited complex theories concerning the expressive qualities of lines, shapes, and colors (Appendix L), were thought to have been of primary importance to the conception of the painting. Indeed, Seurat copied out excerpts from Henry's 1885 treatise *Introduction à une esthétique scientifique* onto the paper on which he sketched the doors to the Cirque Corvi (H 382). Contemporaries, however, did not remark on a correlation between Seurat's work and Henry's theories until the exhibition of *Chahut*, two years after *Parade* was first shown.[20] And the emotion— calmness— that Henry identified with the dominant line in *Parade*—the horizontal—is so ill suited to the representation of a circus scene that it seems unlikely that Seurat used *Parade* as his testing ground for Henry's ideas. (*Chahut* and *Cirque* probably vie for that particular distinction.) Thus it could well be that there is not a scientific but a literary source at the root of *Parade*. Rimbaud's evocative poem "La parade," first published in the May 13, 1886, issue of the Symbolist review *La vogue*, was proposed by John Russell as a possible

Detail from cat. no. 200

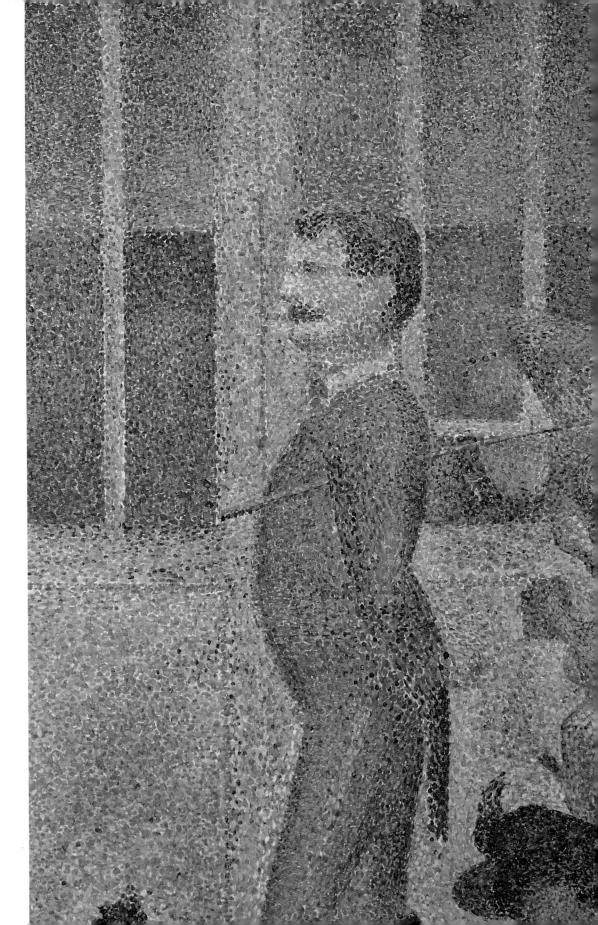

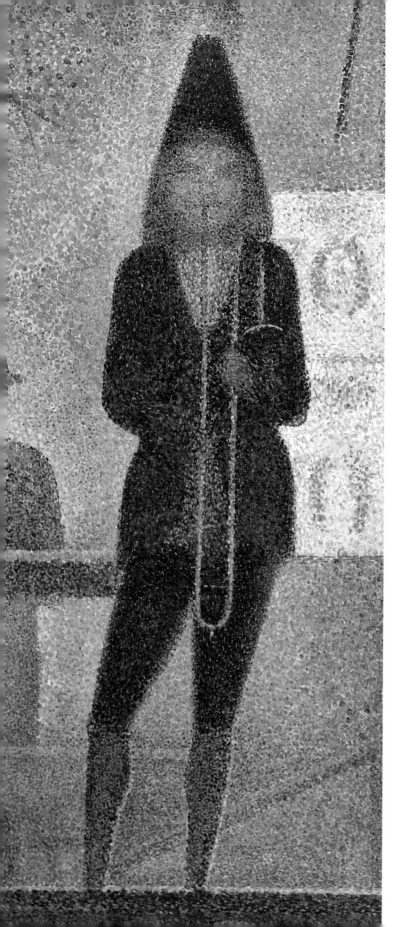

source.[21] Like Seurat, Rimbaud presents the sideshow spectacle as a mirror of contemporary civilization: "their bantering or their terror lasts one minute, or whole months." Robert Herbert proposed a different poem, "Soir de carnaval" by Jules Laforgue, which conveys a somber mood more closely related to that of Seurat's painting: "Oh, life is too sad, incurably sad / At festivals here and there I have always sobbed: / 'Vanity, vanity, all is only vanity!' / —Then I think: where are the ashes of the psalmist?"[22] Seurat almost certainly knew both poems, and either—or both—could have inspired him.

Circus scenes attracted all manner of artists throughout the nineteenth century. Satirists such as Gavarni and Daumier found the circus a convenient vehicle for political imagery and social criticism, whereas naturalist painters such as Renoir and Degas were attracted to the poignant charm of the performers and the unusual vantage points and light effects circuses offered. Some writers have found an underlying social message in Seurat's

Gavarni, illustration for *Le diable à Paris*, 1846

Honoré Daumier, *La parade foraine* (Parade: traveling circus). Musée du Louvre, Départment des Arts Graphiques, Paris

Fernand Pelez, *Grimaces et misères* (Circus performers), 1888. Musée du Petit Palais, Paris

Detail from cat. no. 200

Parade. "No amount of geometry," wrote John Russell, "can hide the fact that this picture offers a criticism of society. But the criticism is a poet's not a politician's."[23] If Seurat intended criticism, it is unclear what the artist's message was. There is no caricature of the spectators, who appear to be a group of ordinary fairgoers presumably drawn, if the hats are an accurate indication, from the middle and working classes: men and women out on a stroll; a pair of shopgirls or sisters; single men; a man with a baby; and a woman with a young girl. The performers have likewise been schematized to types, yet they too are free of caricature. Perhaps most important, spectators and performers do not acknowledge one another, as they do in *Chahut* and *Cirque*, which lends an air of indifference and alienation to the painting. Nevertheless, Seurat's performers are spared the brutal realism of Fernand Pelez's enormous, life-size picture, *Grimaces et misères*, which was exhibited at the 1888 Salon while *Parade* was on exhibit at the Salon des Indépendants.[24]

Roger Fry recognized the inscrutable mystery of *Parade* when he compared it to the works of Henri de Toulouse-Lautrec. "Toulouse-Lautrec would have seized at once on all that was significant of the moral atmosphere, would have seized most of all on what satisfied his slightly morbid relish of depravity.... But Seurat, one feels, saw it almost as one might suppose some visitant from another planet would have done. He saw it with this penetrating exactness of a gaze vacant of all direct understanding.... Each figure seems to be so perfectly enclosed within its simplified contour, for, however precise and detailed Seurat is, his passion for geometricizing never deserts him— enclosed so completely, so shut off in its partition, that no other relation than a spatial and geometrical one is any longer possible. The syntax of actual life has been broken up and replaced by Seurat's own peculiar syntax with all its strange, remote and unforeseen implications."[25] In *Parade* Seurat suggests but does not describe, he alludes but does not define, thus finally adopting in a painting the Symbolist aesthetic he had already perfected in his drawings.

1. Kahn, March 1888, p. 161.
2. Ibid.
3. Herbert 1980.
4. Fénéon, April 1888, quoted in Halperin 1970, I, p. 84.
5. Christophe, May 1888.
6. Adam 1888, p. 229.
7. Geffroy, April 1888.
8. Kahn, March 1888, p. 161.
9. Demolder 1892, p. 349.
10. Gustave Kahn suggested (Kahn 1928, pp. vi–vii) that the publication of Mallarmé's translation of Whistler's "ten o'clock lecture" in the May 1888 *Revue indépendante* may have inspired *Parade de cirque*. This is not possible: the article was published after the painting was completed.

Detail from cat. no. 200

11. Quoted in Halperin 1988, p. 75.
12. Coquiot 1924, p. 43.
13. CP, vol. 2, no. 362 (December 6, 1886).
14. Ibid., no. 374 (January 8, 1887).
15. Coquiot 1924, p. 41.
16. CP, vol. 2, no. 503 (late August 1888).
17. Homer 1964, pp. 178–79.
18. Schapiro 1978, p. 101.
19. Homer 1964, pp. 175–77.
20. On March 19, 1890, Theo van Gogh wrote to Vincent that "Seurat is showing a very curious picture [*Chahut*] there [at the Indépendants] in which he has made an effort to express things by means of the direction of the lines. He certainly gives the impression of motion, but it has a very queer appearance, and it is not very generous from the standpoint of ideas." *The Complete Letters of Vincent van Gogh*, vol. 2, Greenwich, Conn., 1958, p. 565, letter T 29.
21. Russell 1965, p. 218.
22. Herbert 1980, p. 19.
23. Russell 1965, p. 218.
24. See Robert Rosenblum's important article on Pelez and contemporary Post-Impressionist painting (Rosenblum 1981).
25. Fry 1929, p. 290.

200. *Parade de cirque.* 1887–88

CIRCUS SIDESHOW

Oil on canvas, 39¼ x 59 in. (99.7 x 149.9 cm.)
Painted border by Seurat

The Metropolitan Museum of Art, New York, Bequest of Stephen C. Clark, 1960 61.101.17

H 187; DR 181

PROVENANCE
The artist until 1891. Inherited by the artist's mother, Mme Ernestine Seurat, Paris, in 1891, until at least 1892; the artist's brother and brother-in-law, Émile Seurat and Léon Appert, Paris, until 1900; J. and G. Bernheim-Jeune, Paris, by 1908, until at least 1928; Reid and Lefevre, London, until January 1929; sold to M. Knoedler and Co., New York, London, and Paris, in January 1929, until November 1932 (stock no. A610); sold to Stephen C. Clark, New York, in November 1932, until his death in 1960; his bequest to the Museum, 1960

EXHIBITIONS
1888 Paris, Indépendants, no. 614
1892 Brussels, no. 10
1892 Paris, Indépendants, no. 1084
1900 Paris, Revue Blanche, no. 32
1908–09 Paris, no. 69
1920 Paris, no. 28
1926 Paris, Grand Palais, no. 3216
1929 Lucerne, no. 20
1929 New York, no. 55
1932 London, no. 552
1940 New York, no. 366
1949 New York, no. 22
1968 New York, no. 82

201. *L'arbre, étude pour "Parade de cirque."* 1887–88

TREE, STUDY FOR "CIRCUS SIDESHOW"

Conté crayon, 11¾ x 9⅛ in. (30 x 24 cm.)

Private collection

H 667; DR 180a

PROVENANCE
Paul Signac, Paris, probably in 1891 but not exhibited until 1933, until his death in 1935; by inheritance to Ginette Signac, Paris; to present owner

EXHIBITION
1933–34 Paris, no. 87

It is not known precisely when the studies for *Parade* were made. Seurat presumably visited the Cirque Corvi in April and May 1887 and exhibited his completed painting in March 1888. Sketches were made on site at the Gingerbread Fair near the place de la Nation, but work on the painting, a night scene, necessarily took place in the studio. Signac listed four panels and four conté crayon studies for *Parade* in his posthumous inventory of Seurat's studio, but only one panel (H 186) is known today. Each of three conté drawings (cat. nos. 201–203) constitutes a

third of the composition of the painting. This tripartite division was evidently preferred by the artist—the Metropolitan's large study for *La Grande Jatte*, for example, has pencil lines dividing the composition into three almost equal vertical units. (The fourth conté drawing inventoried by Signac may be *Une parade; Clowns et poney* [cat. no. 45]; some writers consider this a study for *Parade de cirque*, but Robert Herbert assigns it to 1881–84.)

This evocative study of the left section of the composition could well have been made on location outside the tent of the Cirque Corvi. The painted ovals of the tent's decoration, the musicians behind the balustrade, and the spectators have all been summarily indicated. But the tree, only slightly changed in the painting, is unmistakably the same tree depicted in contemporary illustrations of the Cirque Corvi, such as that by Jules Garnier, as Robert Herbert has observed.[1] Quite exceptionally for such a conspicuous compositional motif, the tree was not included in either the preparatory panel (H 186) or the drawing of the ensemble (cat. no. 204). Here, silhouetted against the powerful moonlike glare of a gas jet, it has all the portentous presence of a human figure.

1. Herbert 1980, p. 14.

Jules Garnier, *Cirque Corvi*. Illustration for *Hughes Le Roux*, 1889

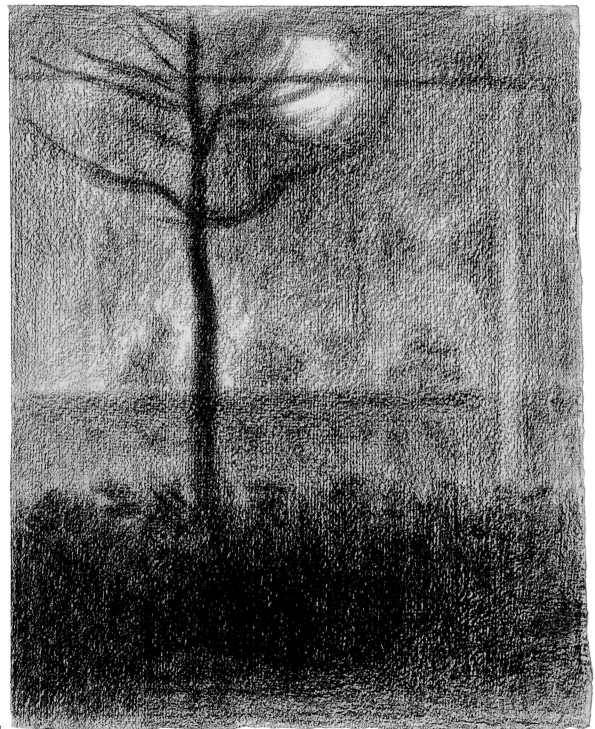

201

202. *Joueur de trombone, étude pour "Parade de cirque."* 1887–88

TROMBONIST, STUDY FOR "CIRCUS SIDESHOW"

Conté crayon and chalk, 12⅛ x 9¼ in. (30.8 x 23.5 cm.)
Verso, in artist's hand in pencil: ch orange/Habit rouge violet [four erased words]/culotte bleu vert violet/bas un peu rouge orangé/balustrade jaune rouge/les intest[?] lustres-éclairés/au dessus des pancartes rouge-orangé/toute puissante: fond bleu/terrain jaune [?] terne [?]/gilet jaune

Philadelphia Museum of Art, The Henry P. McIlhenny Collection in memory of Frances P. McIlhenny

Exhibited in New York only
H 680; DR 180b

PROVENANCE
Madeleine Knoblock, Paris, from 1891; Mme Gustave Kahn, Brussels, by 1892; G. Jacquart, Paris; with Le Nouvel Essor, Paris, until June 1928; sold to De Hauke and Co./Jacques Seligmann and Co., New York, in June 1928, until October 1932 (stock no. 1284);* sold to Henry P. McIlhenny, Philadelphia, in October 1932, until his death in 1986; his bequest to the museum, 1986

EXHIBITIONS
1892 Brussels, no. 25
1926 Paris, Bernheim-Jeune, no. 144 suppl.
1953 New York, no. 34
1958 Chicago and New York, no. 135

*See provenance note, cat. no. 30.

Of the three conté drawings for *Parade de cirque*, this work is closest in appearance to the final composition; it is also more densely worked and finely finished than the other two drawings. Seurat used the conté crayon to its advantage to create silhouettes in strong contrast with the glowing light reflected from the back of the performers' platform. True to his interest in depicting effects of simultaneous contrast, he has darkened forms at their contours and lightened the adjacent background. The effect is best seen here along the contours of the figure of the trombonist; it gives him an almost mystical aura.

This sheet is about half the size of the corresponding area of the painting, and the figures are thus at about half scale. When transferring it to canvas, however, Seurat seems to have allowed his composition to spread laterally. For example, although the figures in the painting align

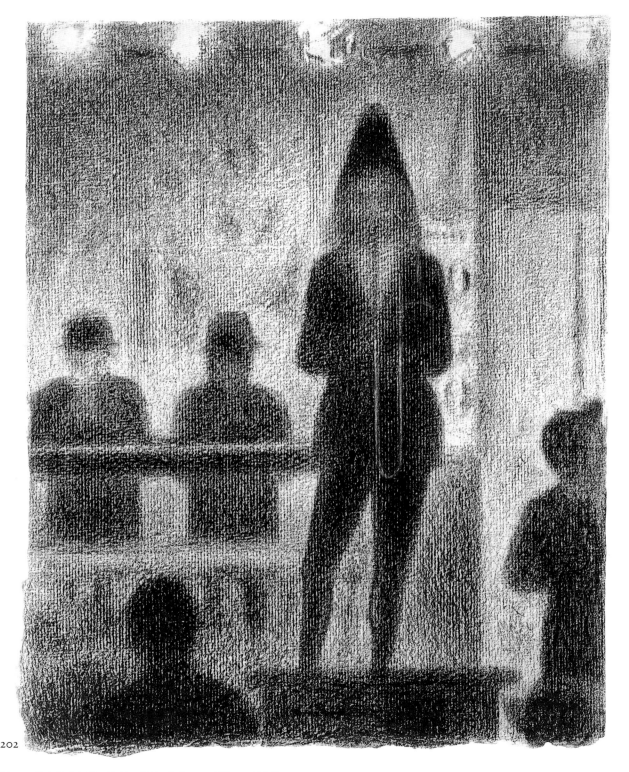

202

with the overhead gas jets at the same intervals expressed in the drawing, in the painting there is relatively more space between the figures. There are other small changes as well: the trombonist was shifted slightly to the left; the pillar behind him was made slightly wider; the boy in the ruffled collar, at the far right of this drawing, was moved even farther to the right; and two spectators were added just beneath the trombonist's feet.

Meyer Schapiro was the first to write about the affinity of the trombonist's "clean, graceful silhouette" to that of the central model in *Poseuses* and, further, to that of the Eiffel Tower, then under construction.[1] But the model for the clown, neither happy nor sad, who begs our attention at center stage can obviously be found in Watteau's *Gilles*,[2] a painting that also depicts a *parade*, although there are numerous examples of such a character in French popular imagery throughout the nineteenth century. Circus imagery, however, may have been less important to Seurat than music. As Jean-Claude Lebensztejn has observed,[3] musicians are ubiquitous throughout Seurat's large figure paintings. Perhaps he wished to make explicit the analogy—much discussed in Symbolist circles in the 1880s—between the abstract nature of music and the underlying principles of his unique art of "harmony."

1. Schapiro 1978, p. 107.
2. See Francis Haskell, "The Sad Clown: Some Notes on a Nineteenth-Century Myth," in *French Nineteenth-Century Painting and Literature*, Ulrich Finke, ed., New York, 1972, pp. 2–17.
3. Lebensztejn 1989, pp. 67–76.

203. *Monsieur Loyal et poney, étude pour "Parade de cirque."* 1887–88

MONSIEUR LOYAL AND PONY, STUDY FOR "CIRCUS SIDESHOW"

Conté crayon, 11⅛ x 8⅛ in. (29.5 x 22 cm.)

Private collection

H 669; DR 180c

PROVENANCE
The artist until 1891. Posthumous inventory, dessin no. 379bis. Inherited by the artist's brother, Émile Seurat, Paris, in 1891; Félix Fénéon, Paris, by at least 1908–09; Bernheim-Jeune, Paris, by 1920;

Gustave Coquiot, Paris, by 1923,* until no later than 1926; Jacques Rodrigues-Henriques, Paris, until January 1928; sold to De Hauke and Co./Jacques Seligmann and Co., New York, in January 1928, until 1948 (stock no. 1142); transferred to the private collection of Germain Seligman, New York, in 1948 (stock no. 7735);** Jean Davray, until 1963; sold to M. Knoedler and Co., New York (stock no. WCA3317), in December 1963, until 1966; sold, by exchange, to Galerie Krugier, Geneva, in March 1966; to present owner by 1983

EXHIBITIONS
1900 Paris, Revue Blanche, *hors cat.*
1908–09 Paris, no. 200
1920 Paris, no. 49
1947 New York, no. 13
1983–84 Bielefeld and Baden-Baden, no. 81

* Gustave Coquiot's ownership of this drawing is recorded in his manuscript for Coquiot 1924 (consulted by Robert Herbert; manuscript formerly in the collection of Dr. Jean Sutter).
** See provenance note, cat. no. 30.

In this drawing, which depicts most of the right portion of *Parade de cirque*, Seurat seems to have been concerned with testing the relationship of the silhouette of the pony at center to that of the ringmaster at right. Animals were constantly trotted out in circus sideshows, and the Cirque Corvi was no exception: its advertisements often touted their animals. Seurat included a pony in an early drawing of a sideshow (cat. no. 45), but by the time he had developed the composition of *Parade de cirque* to the point

Seurat, *Danseuse de Corvi*. Private collection (H 381)

Seurat, *Danseur à la canne* (Dancer with cane), 1887–88. Private collection (H 682)

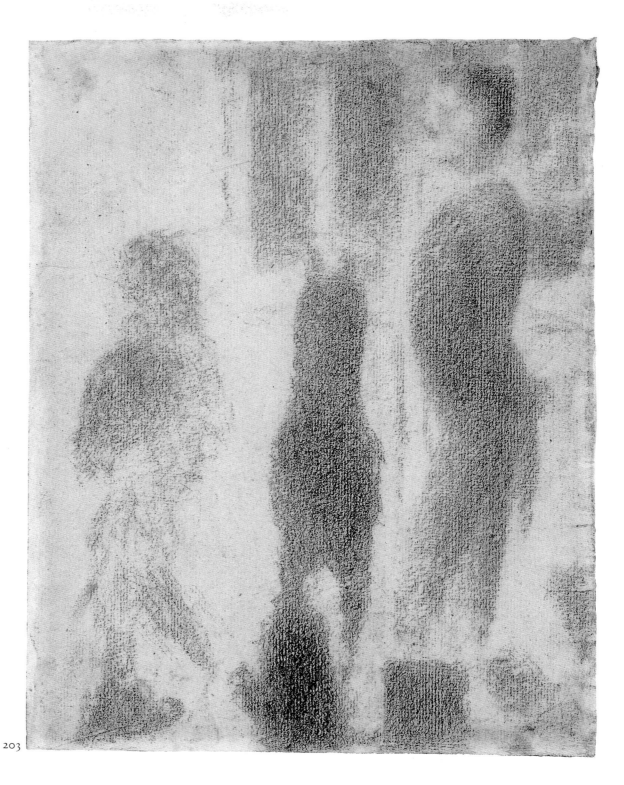

203

of painting a *croqueton* of the ensemble (H 186), he had eliminated the pony. Although its presence would have crowded the right third of the composition, its absence is still felt. As if to compensate for the loss in the painting, Seurat formed a slight shadow on the green door in the place that the pony would have occupied. It is clear, however, that the pony was never painted, since the picture itself shows no evidence of repainting and the pony was excluded from the drawing of the ensemble (cat. no. 204). Perhaps Seurat was also disturbed by the proximity of the pony to the woman's pointed hat at its feet. In the painting Seurat enlarged and extended vertically the woman's head and hat, making them proportionally much larger than they were in the preparatory studies.

Reproductions of this drawing often make it appear dark and coarse, whereas it is in fact extremely light and delicate. Seurat allowed the white sheet to represent the platform's brilliant illumination, which eats away at the edges of the forms, leaving ghostly shadowlike silhouettes. The figure of the boy at left is just faintly sketched in with minute lines of conté crayon, which can build up to dark passages such as that on the woman's hat only after much repetition.

The pose of the ringmaster, or barker, may derive from a drawing of a female acrobat in extreme profile (H 381) that appears to belong to an early group of circus drawings (including cat. no. 45), as Germain Seligman noted in 1947.[1] In 1961 César de Hauke was the first to attach the name Loyal to the ringmaster; previous references identified the drawing only as *Banquistes* or as a study for *Parade*. The pose of the young boy derives from a spirited drawing of a tap dancer in tails (H 682) that Seurat probably rejected as too active for his monumentally static composition.

1. Seligman 1947, no. 21, p. 59.

204. *Parade de cirque*. 1888

CIRCUS SIDESHOW

Ink squared in graphite, 4⅞ x 7⅛ in. (12.1 x 19.4 cm.)

Menard Art Museum, Komaki, Japan

Exhibited in New York only
H 681; DR 181a

PROVENANCE
Earliest whereabouts unknown; Wildenstein and Co., London, until 1937; sold to Baron Robert von Hirsch, Basel, June 1937, until his death in 1977; his estate, 1977–78 (Von Hirsch sale, Sotheby's, London, June 27, 1978, no. 847); purchased at this sale by John R. Gaines, Lexington, Kentucky, until 1986 (Gaines sale, Sotheby's, New York, November 17, 1986, no. 37); purchased at this sale by the museum

EXHIBITION
1937 London, no. 55

This drawing was probably one of the last studies Seurat made before undertaking the large canvas of *Parade de cirque*. The pony has already been eliminated from the composition, but other elements have not yet been assigned their definitive form or placement. For example: the woman wearing a cone-shaped hat who stands just to the left of the trombonist's feet was placed farther to the right in the painting, where her hat is bell-shaped; and the child below the young man on the platform became a baby in in the painting. Seurat adjusted the shape of most of the hats in the painting and made two conspicuous additions: the tuba player and the tree, both at the far left. The one surviving *croqueton* for *Parade de cirque* (H 186) was probably painted at about the same time as this drawing, since the compositions are virtually identical. Seurat seems to have painted the panel in order to study the blue-violet and yellow-green color harmony rather than to record something he had actually seen.

With pencil lines[1] Seurat divided the drawing horizontally into fourths and vertically into sixths to square it up for the transfer of the composition to the final painting. The 4 : 6 ratio corresponds to that of the dimensions of the canvas, which is one and one-half times wider than it is tall. He also marked additional vertical axes on this drawing, which, curiously, do not correspond to either the architecture or to the placement of the figures; neither do these axes denote the golden section, 1 : 1.6, as might be

thought. Instead, they correspond to simple arithmetic divisions similar to those noted by Seurat on his sheet of studies with citations from Charles Henry (H 382; p. 308). The left half of the composition was divided further into sixths and quarters, whereas the right half of the composition was divided into eighths, sixths, and quarters (of the full width of the composition). The white spots on the paper are patches of gouache Seurat used to cover mistakes. Over time, the paper has darkened, making the gouache more noticeable than it was in the artist's day.

Richard Thomson has doubted the authenticity of this drawing,[2] which he, like Dorra and Rewald,[3] considers a replica made after the painting. Yet this sheet obviously preceded the execution of the painting and is unquestionably the artist's finest pointillist drawing. Renouncing the contours he used in the pointillist drawing for the standing *poseuse* (cat. no. 191), Seurat allows the forms here to coalesce according to the concentration of minute ink dots. If there be any doubt, this drawing serves as ample proof that in Seurat's mind *Parade de cirque* was, in formal terms, fundamentally about the challenge of subtly integrating silhouettes into a persuasive representation of shallow space.

1. According to John Rewald, the pencil lines were erased in the 1930s (author's correspondence).
2. Thomson 1985, p. 148 n. 80.
3. DR, no. 181a, p. 227.

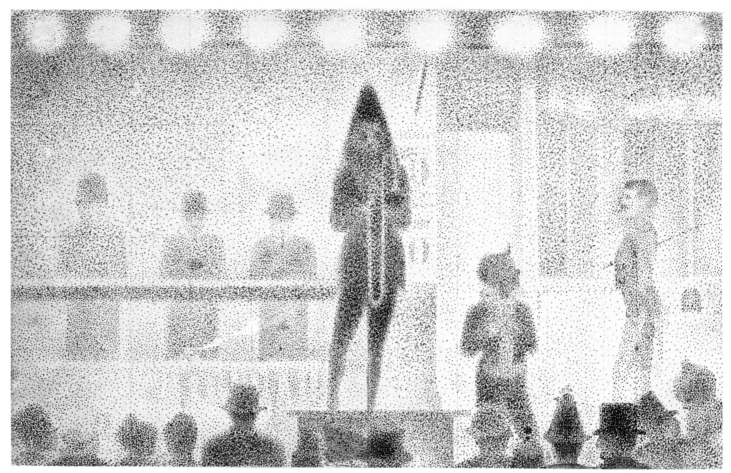

204

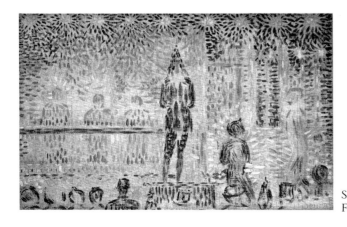

Seurat, study for *Parade de Cirque*, 1887–88.
Foundation E. G. Bührle Collection, Zurich

Seascapes: Port-en-Bessin 1888

In 1888, after two years' absence from the coast of Normandy, Seurat summered at Port-en-Bessin, a small fishing port like Grandcamp, its neighbor fifteen miles to the west. The town is situated in a notch in the chalk cliffs carved out by the Dromme River. Its outer harbor was formed in 1863 by two curving granite breakwaters that sheltered a projecting central quay, where the fish market depicted in two of Seurat's paintings was built. The artist began six paintings at Port-en-Bessin, but it is likely that he continued to work on them well after his summer in the village. There are no surviving panels for them, one indication of the assurance he had acquired since his work at Grandcamp, where he had painted twelve oil studies.

The six canvases form a composite image of the port, similar to the way he bracketed Honfleur. The group covers a range of time from mid-morning to mid-afternoon, including both high and low tides. Three are views within the port; the other three are views from the cliffs above, one looking west away from the port, another looking out across the harbor, and the third looking east, showing the disposition of the port. As we would expect, Seurat ignored the picturesque sights touted by the guide-books, such as a nearby ancient bridge, a Roman ruin, a church, and curious natural formations. Unlike the Honfleur pictures, there are no romantic echoes, unless we count the mood projected by the undulating cliffs in *Les grues et la Percée* (cat. no. 205). The contrast with Monet's paintings of 1882 to 1886 of Pourville, Varengeville, and Étretat could hardly be greater. Monet edited out all signs of contemporary life in favor of age-old imagery. He carefully kept buildings and harbors outside the frames of his pictures of the cliffs, and when he painted views from within Étretat, he showed not its streets but boats drawn up on the shore.

Seurat's determination to remake the tradition represented by Monet is especially evident in the three views from within the harbor of Port-en-Bessin. His brushwork in them is more regular and more tightly controlled than ever before. Somewhat more animated than the Honfleur pictures, they make a virtue out of the most ordinary architecture. In *Le pont et les quais* (cat. no. 209) there are three prominent, if small, persons, with several more near the fish market. In *Un dimanche* (H191; Rijksmuseum Kröller-Müller, Otterlo) there are nine or ten strollers barely visible in the distance; the animation here comes chiefly from the fluttering flags over-head, decorative anticipations of Art Nouveau. Still apparent, however, is the Sunday stillness that marks all six paintings of the port.

205. *Port-en-Bessin, les grues et la percée.* 1888

PORT-EN-BESSIN, THE SEMAPHORE AND CLIFFS

Oil on canvas, 25⅝ x 31⅞ in. (65.1 x 80.9 cm.)
Signed lower right: Seurat
Border painted by Seurat

National Gallery of Art, Washington, D.C., Gift of the W. Averell Harriman Foundation, in memory of Marie N. Harriman 1972.9.21

H 190; DR 185

PROVENANCE
The artist until 1891. Posthumous inventory, toile no. 35. Inherited by the artist's mother, Mme Ernestine Seurat, Paris, in 1891, probably until her death in 1899; by inheritance to the Appert family, Paris, until at least 1908–09; Félix Fénéon, Paris, by at least 1926, until 1937; Marie Harriman Gallery, New York, from 1937 until at least 1941; to the Honorable and Mrs. W. Averell Harriman, Albany, New York, by 1943, until 1972; gift to the Gallery, 1972

EXHIBITIONS
1889 Brussels, no. 9
1890 Paris, no. 732
1892 Paris, Indépendants, no. 1102
1892 Paris, Revue Blanche
1908–09 Paris, no. 72bis
1924 New York, no. 6
1926 Paris, Grand Palais, no. 3218
1926 Paris, Bernheim-Jeune, *hors cat.*(?)
1927 Lyons, no. 9B
1932 Paris, no. 20

Claude Monet, *Cabane du douanier, Pourville* (Custom-house, Pourville), 1882. Philadelphia Museum of Art

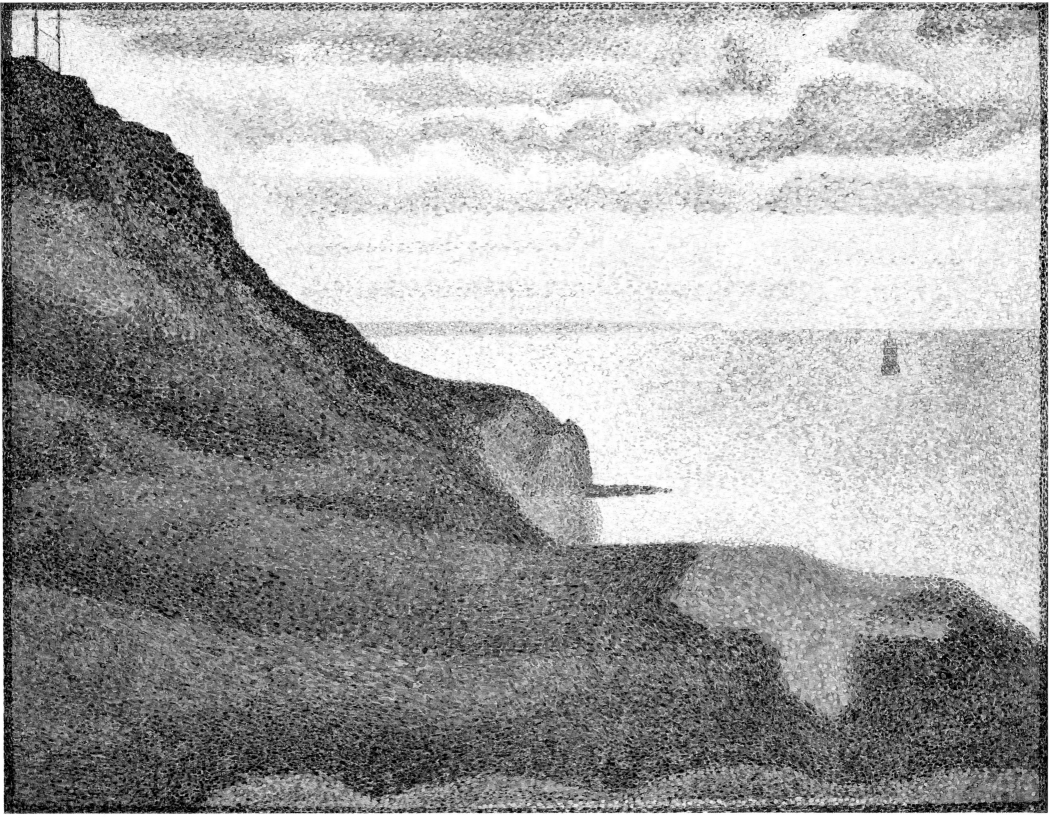

1936 Paris, no. 49
1937 London, no. 62
1953 New York, no. 10
1958 Chicago and New York, no. 140
1968 New York, no. 85
1984–85 Los Angeles, Chicago, and Paris, no. 124

For this painting Seurat stood on a horizontal gap in the steeply rising cliffs to the west of the port and looked toward the afternoon sunlight. Monet had painted many similar views of the coastal cliffs, but their massive forms have a more sculptural presence, and their spaces, even at their flattest, have more convincing depth. Seurat's shadows carve out an undulating terrain; because of its sharply delineated silhouette, however, it looms up flatly against sea and sky. In the upper left corner are the poles and crossarms of a semaphore; it appears to rest upon the surface of the picture despite its presumed distance. (By locating it in *Le pont et les quais* [cat. no. 209], one can estimate Seurat's position on the cliff.) The water also rises up rather flatly, although Seurat tried to make it recede with the halo of light tones near the cliff, the spit of shore that projects outward, and the old square-rigged ship off to the right. Above, the clouds, whose rhythms echo those of the cliff, acquire a curious plasticity that parallels the contemporary cloud forms in van Gogh's paintings. At the base of the picture, the evenly spaced arabesques again remind us of van Gogh because, although Seurat's tapestry of small strokes is so different, he shares with the Dutch artist this premonition of Art Nouveau. Seurat's clouds have a strange and oddly threatening life-force, and we feel that both sky and land have taken on the pulsation of the waves. In partly suppressed form, sky and land nonetheless confess the romanticism inherent in the scene.

The brushwork contributes to the tension between actual surface and imagined depth. In the sky and water near the cliff, the strokes cascade along the ground's profile. They stream around the large light spot on the cliff to the right, following its edges, and in the sky they adopt the flow of the animistic clouds. In this way they are attached to the surface structure as much as to the images they describe.[1] To this extent they function like Monet's and van Gogh's brushwork by calling attention to themselves as marks of the artist's action and, no matter how well controlled, to his emotions. In the foreground the lush and rolling greens shift from mixtures with strong

blues and bluish reds in the shaded areas to oranges and paler blues in the lighter zones. Viewed closely, they fold back into depth far more than when seen at a conventional distance. The painted border of this picture was added over the existing composition and is limited to only a few colors. Alongside the sky and the lighter tones of the ground it consists simply of blue touches, although elsewhere it varies with the contiguous hues of the composition.

1. Sakagami 1985, pp. 23f.

206. *Port-en-Bessin, l'avant-port (marée haute)*. 1888

PORT-EN-BESSIN, THE OUTER PORT (HIGH TIDE)

Oil on canvas, 26⅜ x 32¼ in. (67 x 82 cm.)
Painted border and frame by Seurat

Musée d'Orsay, Paris R.F. 1952-1

H 193; DR 188

PROVENANCE
The artist until 1891. Inherited by the artist's mother, Mme Ernestine Seurat, Paris, in 1891; purchased from her, on Signac's advice, by Paul Alexis, Marseilles, by 1892, until his death in 1901; presumably purchased from his estate by the dealer M. Garibaldi, Marseilles, until 1923; sold for 1,500 francs to Alfred Lombard, Aix-en-Provence, in 1923, until 1951; sold to Paul Rosenberg and Co., New York, in 1951, until 1952; purchased, with the arrears of an anonymous Canadian gift, by the Musée du Louvre, in 1952; transferred to the Jeu de Paume, 1958; transferred to the Musée d'Orsay, 1986

EXHIBITIONS
1889 Brussels, no. 6
1890 Paris, no. 730
1900 Paris, Revue Blanche, no. 30
1926 Paris, Grand Palais, no. 3217
1936 Paris, no. 50
1984–85 Los Angeles, Chicago, and Paris, no. 121

Seurat turned around to look eastward from his perch above the port to make this picture, a view that was standard in nineteenth-century guidebooks. It shows the quay, bearing its covered fish market, projecting into the

outer harbor and, beyond, the eastern arm of the encompassing breakwaters. It is a hazy-bright hour in late morning, with the sunlight striking the other side of the sails, leaving the side visible to us in shadow. The harbor is marked on the seaward side by sailing craft near and far and on the right by the outer buildings of the port. Farther back the land rises steeply again, framing the port. Although Seurat was not a topographer, the other paintings of Port-en-Bessin can be said to pivot around this one, thus orienting most of the setting he explored that summer.

The colors of the port's architecture, at normal viewing distance, blend sufficiently in our eye to give credence to the idea of optical mixture. A mottled grayish lavender results from separate touches of purples, lavender-reds, purplish blues, tans, and brownish oranges. In the foreground there is a greater range of hue, so we are more conscious of the separate colors. Underneath the surface touches are broader strokes of yellow-green that create the dominant tone. The greatest variation is in the lower right corner, where a dark patch blossoms in reds and blues, just above a small area of cream and rose. Elsewhere the dark areas are marked by blues and wine reds and the light areas by pale blues, pinks, tans, oranges, and several tints of green. One of the most curious features of this picture's

Vue à vol d'oiseau de Port-en-Bessin.

Port-en-Bessin. Anonymous engraving from Constant de Tours, *Du Havre à Cherbourg,* about 1890

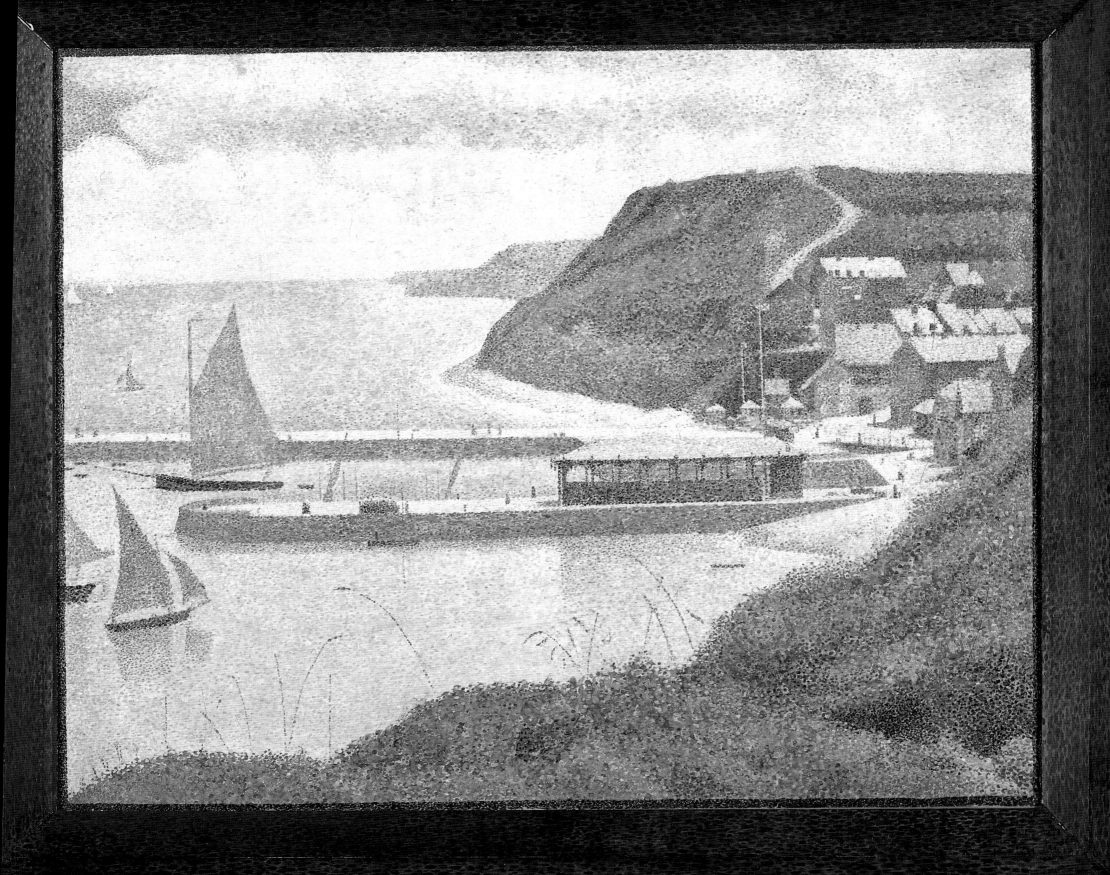

surface is the way Seurat placed small dots in the center of larger ones, a practice he began in 1886 (cat. no. 166). These are always light on dark or dark on light, sometimes even of contrasting hues, such as olive green on rose, or blue on orange. It is here that one senses most the man of theory, for these are like miniature Chevreul color charts showing halos of contrasting color and value. The close view that exposes these structures, however, also reveals the artist who bases his patterns upon nature. The wispy fronds that arch over the water have a childlike truth that must have resulted from Seurat's sitting for hours on this upland heath, looking through them to the water below.

As in the previous picture, the painted border here is elemental, consisting mostly of blue with the addition of color opposites when the adjacent hues call for them. Along the left side, for example, there are oranges next to the blue patch of sky in the upper left and reds alongside the greens of the water, but only blues adjacent to sail and quay since these lack green. On the left side of the composition itself, a pale display of off-white dabs replies to the dark tones of the border. The beveled wood frame has the same essential color scheme as the narrow border, but of darker tonality. The top, right, and bottom sides have wine red and dark blue over an undercoating of pale blue. Because, in Seurat's conception, the sun is coming from the observer's right and affects the frame, the left side is the sole area with heightened colors: orange-red, crimson, wine red, and blue next to the water, lighter orange-red next to the blue sky, but only blues next to the light cloud.

Paul Alexis, the naturalist writer and one of Seurat's earliest supporters in the press, purchased this painting from the artist's mother after Seurat's death. He then possessed six works by Seurat, for by May 1886 he owned three of Seurat's panels (H 70, 152, 153),[1] eventually acquiring another panel (H 95) and his own conté-crayon portrait.

1. Alexis, *Cri du peuple*, May 2, 1886.

207. *Port-en-Bessin, entrée de l'avant-port.* 1888

PORT-EN-BESSIN, ENTRANCE TO THE OUTER HARBOR

Oil on canvas, 21⅛ x 25⅛ in. (54.9 x 65.1 cm.)
Painted border by Seurat

The Museum of Modern Art, New York, Lillie P. Bliss Collection, 1934

H 192; DR 186

PROVENANCE
The artist's mother, Mme Ernestine Seurat, Paris, until at least 1892 and probably until her death in 1899; by inheritance to the artist's brother-in-law, Léon Appert, Paris, presumably until his death in 1925; acquired from Seurat's family in 1926 by Reid and Lefevre, London; owned jointly by Reid and Lefevre, London, and M. Knoedler and Co., New York (stock no. 16654) from December 1926 until July 1927; sold by Knoedler's, New York, to Lillie P. Bliss, New York, in July 1927, until 1931; her bequest to the Museum, 1931; transferred to the museum, 1934

EXHIBITIONS
1889 Brussels, no. 8
1890 Paris, no. 731
1892 Brussels, no. 12
1892 Paris, Indépendants, no. 1100
1900 Paris, Revue Blanche, no. 31
1926 London, no. 5
1929 New York, no. 57
1949 New York, no. 12
1958 Chicago and New York, no. 139

In Alfred Barr's sensitive formal analysis of this painting we can see why the picture suited the defense of modernism especially well. The design of the foreground, he wrote, is

> tentative, casual, muffled and a little monotonous as may be fitting for a prelude. But in the sea section the design is more complex and the themes are more clearly developed. It is a contrapuntal movement. The blue plane of the water is broken first and gently by theme one, the dark ovals of cloud shadows (*andante*), then by theme two (*allegretto*), the sharp angles of white sails, and then by motif three, the horizontal lines of the breakwater. Beyond, in the distance, the three themes develop their visual coun-

terpoint; the ovals become flatter, less curved, the sloops grow smaller, less incisive (*diminuendo poco a poco*), until they dwindle to a row of white, carefully spaced dots away in the distance.[1]

Barr treats the shapes and rhythms of the painting as though they had been generated solely by the demands of pictorial harmony, but with the waning of formalism we have come to recognize such patterns as responsive also to the artist's wish to characterize a particular site. Standing not far from the viewpoint of the previous pictures, Seurat looked down over the broad tidal strand toward the entrance of the artificial harbor formed by two stone jetties. Three ships tack out of the harbor to join others taking advantage of the light breeze of a sunny afternoon. Amoebalike shadows on the water suggest slowly moving clouds overhead and contribute their calm to this sun-drenched expanse of water. Symmetry tells us of balance and control and focuses our attention on two ships paired in the center. In the foreground the long track used by local wagons responds to the arms of the jetties and gives a sense of closure. The patterns that Barr so beautifully described speak for the way humans have put their stamp on this coast. Seurat here limits himself to the ways it has been shaped for pleasurable moments; labor and adverse weather are kept at great distance.

Seurat applied paint in what had become his standard practice—small and medium dabs placed over larger strokes that actually bind together a given area, although it requires close looking to see them. The water seems dominated by its surface touches but consists of horizontal and crisscross strokes of several blues, greens, greenish tans, tans, and lavenders. The strong greens of the shore are formed of several shades of green, plus tannish orange, pale orange, pink, several tints of blue, and some sparse reds. Sandy portions of the shore have as many hues, but these are so attenuated in pale mixtures that one has to stare patiently to find them. The painted border has a richer mix of colors than those of the other two cliff views. Along the base, in reaction to the greens, there are wine reds and reds mixed with the blues, whereas at the top orange and orange-reds are added to the dark blues to contrast with the blues of the sky.

1. Barr 1945.

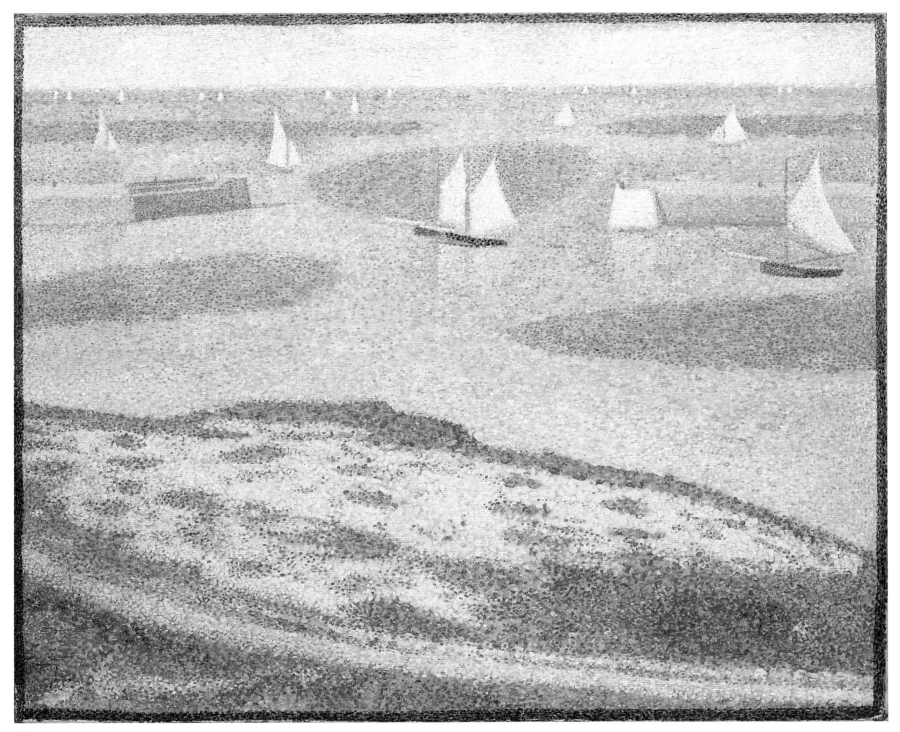

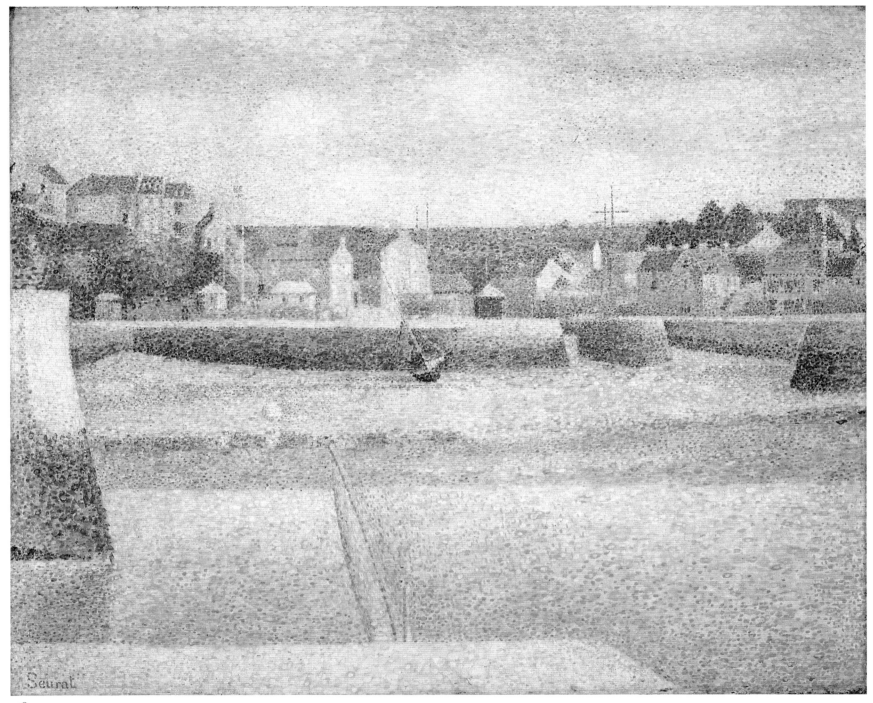

208

208. *Port-en-Bessin, l'avant-port (marée basse).* 1888

PORT-EN-BESSIN: THE OUTER HARBOR (LOW TIDE)

Oil on canvas, 21⅛ x 25⅞ in. (53.6 x 65.7 cm.)
Signed lower left: Seurat

The Saint Louis Art Museum, Purchase

Exhibited in New York only
H 189; DR 184

PROVENANCE
The artist until 1889; presumably purchased by G. de la Hault, from the 1889 exhibition of Les Vingt in Brussels,* until at least 1892; Théo van Rysselberghe, Brussels, by 1905, until at least 1909; Charles Pacquement, Paris, by 1926, until 1928; with George Bernheim, Paris, until February 1929; sold to M. Knoedler and Co., New York, London, and Paris, in February 1929, until December 1933 (stock no. A539); sold to the museum, December 1933

EXHIBITIONS
1889 Brussels, no. 7
1890 Paris, no. 729
1892 Brussels, no. 13
1892 Paris, Indépendants, no. 1101
1905 Paris, no. 38
1908–09 Paris, no. 72
1926 Paris, Grand Palais, no. 3219
1929 New York, no. 61
1958 Chicago and New York, no. 137
1984–85 Los Angeles, Chicago, and Paris, no. 122
1985 Tokyo and Kyoto, no. 19

*G. de la Hault lent this painting to the 1890 Paris exhibition (as well as to the 1892 Brussels and Paris exhibitions). According to Susan M. Canning, "A History and Critical Review of the Salons of 'Les Vingt,' 1884–1893," Ph.D. diss., 1980, The Pennsylvania State University (Ann Arbor, 1982), p. 260 n. 126, two works were sold from the 1889 of exhibition of Les Vingt in Brussels: *Au Concert Européen* (cat. no. 194) and a *Port-en-Bessin*; none of the other canvases of this subject had been purchased by 1890.

For this painting Seurat stationed himself on the outermost end of the west jetty, which shows in the foreground. To the left is the end of the other jetty. A sail sticks up, marking the opening between the two jetties. Low tide exposes the sand bars and, beyond, the walls of the port's quays, whose colors are a lesson in close observation. There are rich blues, greens, and reds nearest the water, green and orange-tans in the middle where marine growth clings, and, toward the top, blues, lavender, and orange-tans. Variations upon lavender unite all three zones, which flow from one to another without pronounced separations. To the right is the narrow entrance to the inner harbor, which is so thickly surrounded by buildings that only ships' masts give token of its location. The slate gray of the houses results from the juxtaposition of olive greens, orange, olive-orange, orange-tan, blue, and lavender-blue, enhanced by the contrasting tans, yellows, and oranges of the sunny sides facing the western sun. Above, the acid greens of the distant hills are accompanied by oranges, tans, and russets. The band of color from the base of the quays to the top of the hills is one of the most extraordinary of this summer's work. One can count more than thirty tints embracing the entire spectrum: purple, red, blue, green, yellow, and orange. Like cat. no. 206, this canvas has many small spots of paint centered on larger ones of contrasting value and hue. In the water they are quite conspicuous, as is the alternation of light and dark areas, each reacting to its neighbor.

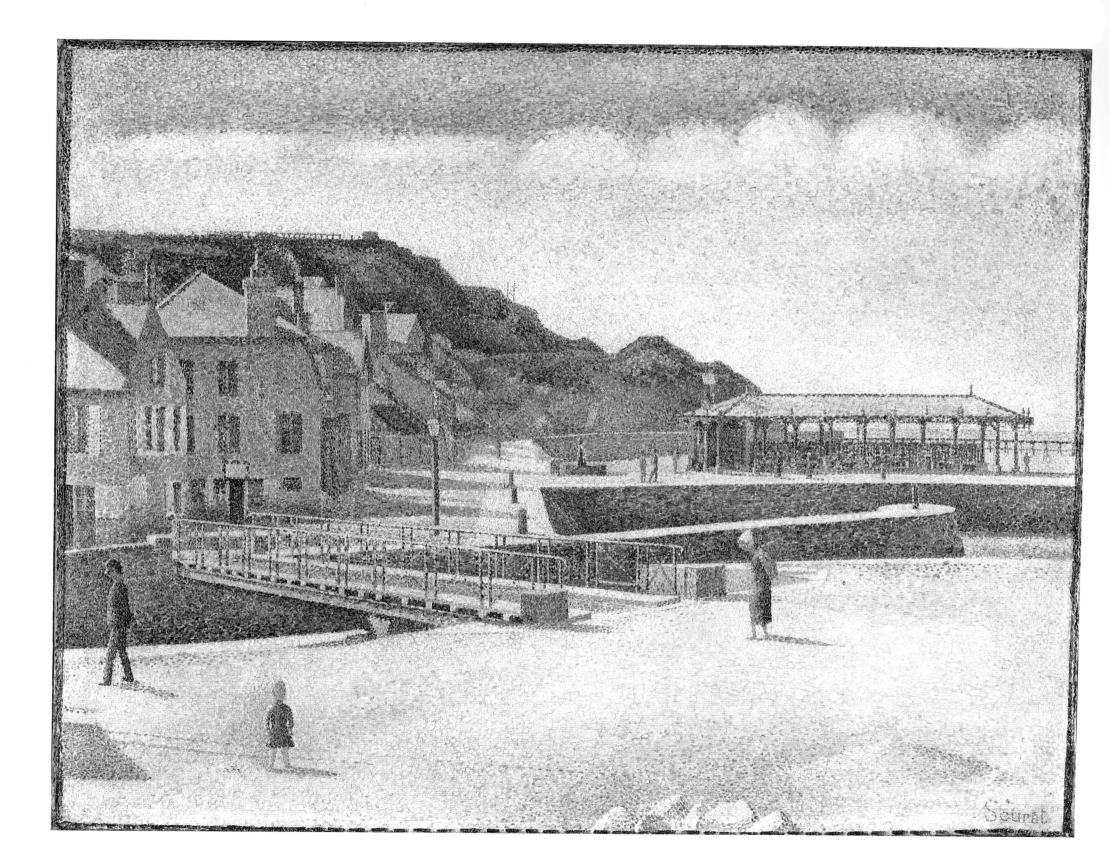

209. *Port-en-Bessin, le pont et les quais.* 1888

PORT-EN-BESSIN, THE BRIDGE AND THE QUAYS

Oil on canvas, 26⅜ x 33¼ in. (66.9 x 84.3 cm.)
Signed lower right: Seurat
Painted border by Seurat

Lent by The Minneapolis Institute of Arts, The William Hood Dunwoody Fund

H 188; DR 187

PROVENANCE
Presumably sold by the artist's family after the 1892 Paris exhibition; possibly with Galerie Barbazanges, Paris; Salomon van Deventer, Wassenaar and The Hague, from 1913 until at least 1937 (owned jointly by Étienne Bignou, Paris, from at least 1934–35); with Paul Rosenberg and Co., New York, in 1937; sold to Reid and Lefevre, London, in 1937; sold to Mrs. Chester Beatty, London, in 1937, until her death in 1952; by inheritance to Sir Alfred Chester Beatty, Dublin, from 1952 until 1955; sold to Paul Rosenberg and Co., New York, in 1955; sold to the museum, 1955

EXHIBITIONS
1889 Brussels, no. 5
1889 Paris, no. 243
1892 Paris, Indépendants, no. 1099
1936–37 Rotterdam, no. 44
1958 Chicago and New York, no. 138
1984–85 Los Angeles, Chicago, and Paris, no. 123

In some ways this composition is the opposite of *Entrée de l'avant-port* (cat. no. 207), for instead of a flat, decorative surface it has a well-articulated depth based on strong alternations of light and dark. Where the other painting deals with the stretched-out harmonies of beach and water, this one concentrates on the structure of the village and the quays. Opposed angles of bridge and projecting jetty create a dynamic space, relieved by the rhythms of the bridge railing, the fish market, and the accumulated curves of the clouds.

Port-en-Bessin, outer harbor, 1978

This is the only painting of Port-en-Bessin that is animated by figures (there are a few tiny persons in other pictures). Félix Fénéon did not like them when he saw the canvas in 1889: "One could wish the figures walking along the quay of *Port-en-Bessin* were less stiff; if the stray child has a charming and true look, the distracted customs officer and the woman carrying firewood or seaweed lack probability. The customs officer we have known for two years now; he was the director of the *Parade* by the same M. Seurat."[1]

Fénéon was right to exempt the child from his censure, for without it the two figures trudging along would ensure a dreary mood.[2] The child, whose form approximates that of a doll, looks out at us, as though intrigued by a painter at work above the quay (the rocks to the right place us part way up a rising slope). Our amused reaction to this small being establishes a vital contact with the village and gives us access to the arch humor with which Seurat has treated it, as though it were a toy theater. The elongated shadows of tower and poles next to the child are a witty touch, as is the succession of stitches that mark the gaps between the girders of the bridge. Farther back, three bollards are lined up with a distant figure; to the right, between the fountain and the fish market, a couple is engaged in conversation, while a half-dozen people stand or stroll near the pavilion.

The red tones of the market, heightened by the afternoon sun shining on the end facing the village, have an antiphonal relationship with the strong greens of the rising land beyond. Interceding between them are the lavenders, wine reds, and blues of shaded areas, enlivened with oranges. This picture's painted border was clearly an afterthought. At the bottom it consists merely of horizontal streaks of blue. Next to the sky it is a balance of dark blue and orange, whereas on the left, to contrast with the purples and reds of the buildings, the border acquires some green touches.

1. Fénéon, October 1889, p. 339.
2. Homer 1957, pp. 37f.

210. *La tour Eiffel*. 1889

THE EIFFEL TOWER

Oil on wood, 9½ x 6 in. (24.1 x 15.2 cm.)
Painted border by Seurat

The Fine Arts Museums of San Francisco, Museum Purchase,
William H. Noble Bequest Fund

H 196; DR 191

PROVENANCE
Roger Marx, Paris, until his death in 1913; his estate, 1913–14 (Marx
sale, Galerie Manzi, Joyant, Paris, May 11–12, 1914, no. 72, for
1,020 francs); purchased at this sale by Bernheim-Jeune, Paris, 1914,
until at least 1920 (although offered for sale by Zürcher Kunsthaus,
Zurich, in 1917); Princess Marguerite Caetani de Bassiano, Paris and
Rome, by 1924; Jacques Seligmann and Co., New York, by 1934,
until at least 1943 (stock no. 3469); Mr. and Mrs. Germain Seligman,
by 1949, until his death in 1978; his estate, with Artemis S.A.,
1978–79; sold by E. V. Thaw and Co., New York, to the museum, 1979

EXHIBITIONS
1895 Paris
1920 Paris, no. 32
1937 New York, no. 25
1940 New York, no. 370
1949 New York, no. 24
1953 New York, no. 15
1958 Chicago and New York, no. 146
1968 New York, no. 86
1978 London, no. 24
1979–80 London, no. 201

Meyer Schapiro once remarked that if the painter of
Seurat's pictures had no name, he could appropriately be
called the Master of the Eiffel Tower.[1] Doubtless the fame
of the tower has helped make this panel one of Seurat's
best-known works, but this was not Schapiro's only
meaning. In the tower Seurat found the forms and the
rationale of modern engineering to which he could re-
spond, a structure composed, like his painting, of clearly
visible units that reveal its technique. The tower, further-
more, was painted in five enamellike colors, from copper
at the base to yellow at the top; its broken colors and
reflections against the sky might well have had a special
appeal to the young artist. Seurat had drawn and occasion-
ally painted the industrial suburbs since the early 1880s, so
his choice of subject here is not surprising. In fact, it is
consistent with his treatment of the architecture of Honfleur

and Port-en-Bessin, for his seascapes often feature ele-
ments of homely contemporaneity rather than the pictur-
esque buildings and sites favored by tourists. His fellow
Neo-Impressionist Louis Hayet and the Douanier Rous-
seau were among the few artists who painted the tower,
which was roundly condemned by much of the art press
and by many other artists, including Pissarro.

The tower was not finished when Seurat painted it; it
still lacked the uppermost fifth of its final height. Compar-
ison with photographs of the tower under construction
(Fonds Eiffel, Musée d'Orsay, Paris) shows that he painted
it in January 1889. His point of view has never been
located, but since the sun comes from our right, he viewed
it either from across the river in late afternoon or from the
region of the quai de Passy to the southwest at midday.
The picture resists localization because of its indecipher-
able foreground. The dark geometric planes seem to rise
but cannot readily be associated with architectural walls,
nor does the prominent diagonal fall into focus as bridge,
roadway, or rooftops, though it may be one of these.
Equally unclear is the flutter of ruddy reds, oranges, and
blues that float into the tiny composition from the left;
they are probably wintry leaves from a nearby tree. What
is clear is that the gigantic tower rises from a dense urban
setting until it fades into the upper sky. To the right of the
tower are many touches of yellowish green, whose func-
tion is to lighten the sky because the sun is coming from
that direction. There are no greens on the left side, which
therefore remains slightly less bright and recedes more
effectively. The narrow painted border, predominantly
blue and orange, constantly changes along the bottom
perimeter in reaction to neighboring colors in the compo-
sition. It may be the first border to have been conceived as
part of a work from the beginning; the borders on paint-
ings before 1889 were all added after the fact (except for
the panel for *Poseuses* [cat. no. 185], which has crude
borders on two sides).

1. Schapiro 1958, p. 52. Seurat's priority among famous painters of
 the tower is indicated by a careful copy after his panel made early
 in this century by the German artist Charles Palmié (oil on wood,
 20¼ x 13½ in. [51.4 x 34.3 cm.], sold at Christie's, London,
 February 20, 1990, no. 166).

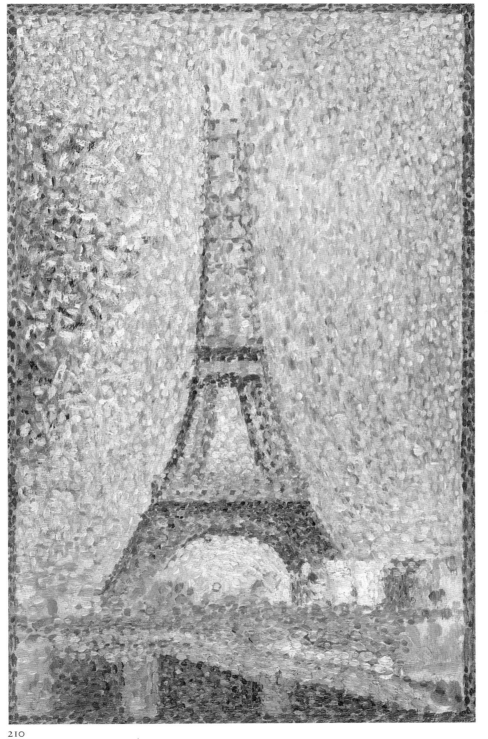

210

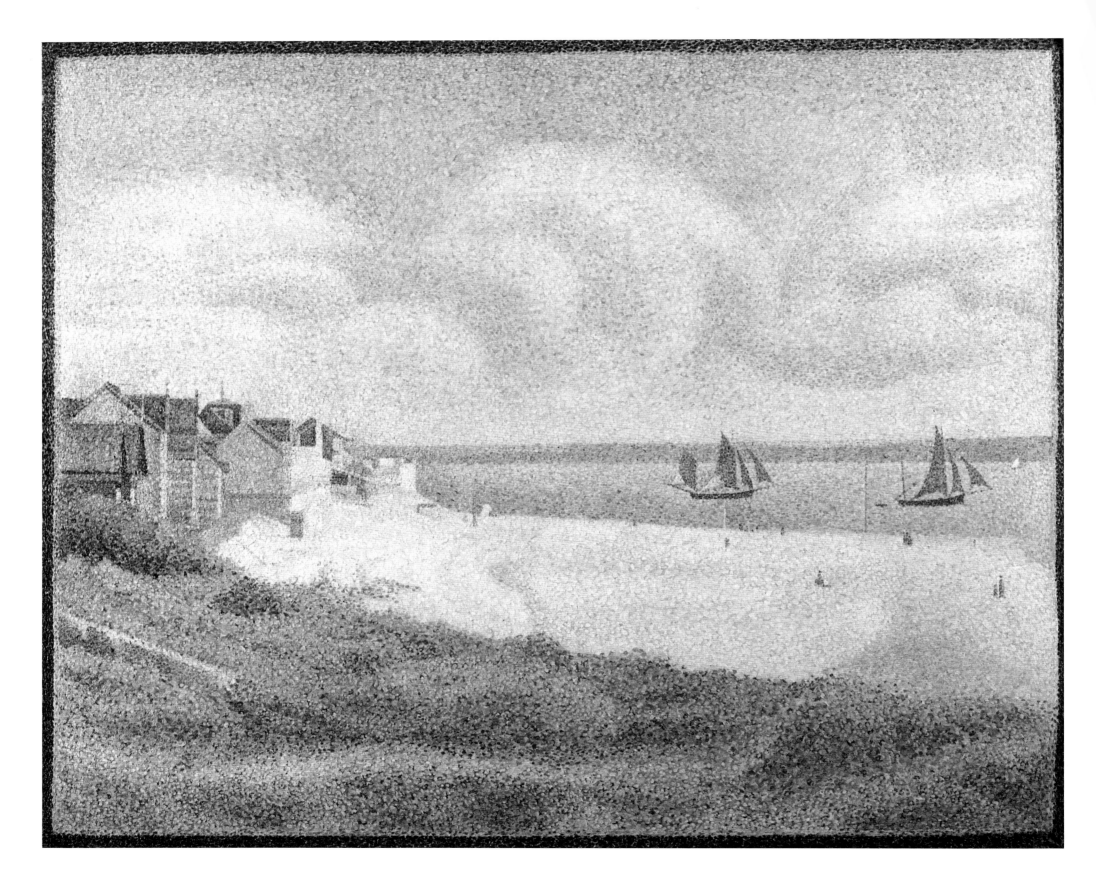

211. *Le Crotoy, aval.* 1889

LE CROTOY, DOWNSTREAM

Oil on canvas, 27¼ x 33⅞ in. (70.5 x 86 cm.)
Signed lower right border: Seurat
Painted border by Seurat; painted frame now lost

Private collection

Exhibited in New York only
H 195; DR 192

PROVENANCE
The artist until 1891. Inherited by the artist's family in 1891,* until
1892; Edmond Picard, Brussels, from 1892, until 1904 (Picard sale,
Galerie J. et A. Le Roy Frères, Brussels, March 26, 1904, no. 54);
Count Harry Kessler, Weimar, before 1908;** sale, Drouot, Paris
(salle 1), May 16, 1908, no. 40; presumably purchased at this sale by
Bernheim-Jeune, Paris, until at least 1911; Richard Goetz, Paris, by
1914, until 1922 (Goetz sale, "Liquidation des biens Richard Goetz
Wendland et Siegfried Hertz, Ayant fait l'objet d'une mesure de
séquestre de guerre," Drouot, Paris, February 23–24, 1922, no. 180,
for 16,500 francs); purchased at this sale by Mr. Loewenstein;
Richard Goetz, Paris, by June 1935;*** with Hector and Paul Brame,
until October 1935; purchased jointly by M. Knoedler and Co., New
York (stock no. A1574), and Jacques Seligmann and Co., Paris and
New York (stock no. 6024), in October 1935, until February 1938;
sold by Jacques Seligmann and Co., New York, to Mr. and Mrs.
Edward G. Robinson, Beverly Hills, California, in February 1938,
until 1957; acquired by present owner, 1957

EXHIBITIONS
1889 Paris, no. 241
1891 Brussels, no. 3
1892 Brussels, no. 16
1892 Paris, Indépendants, no. 1103
1892 Antwerp, no. 5 (of "Seurat, peintures")
1908–09 Paris, no. 74
1910–11 London, no. 54
1937 New York, no. 22
1937 Paris, no. 415
1958 Chicago and New York, no. 142
1968 New York, no. 87
1979–80 London, no. 202

*See H, I, p. XXVIII.

**Per a letter from Fénéon to Henry van de Velde, dated December
23, 1908 (van de Velde archives, Brussels).

***According to Dorra and Rewald, with the declaration of World
War I, in 1914, the painting was offered in vain by Richard Goetz,
a German citizen, to the Musée du Louvre. His collection,

impounded by the French authorities during the war, was put up
for auction as part payment against the German war indemnity.
Annotated sale catalogues list the purchaser's name as Loewen-
stein. Richard Goetz, however, seems to have reacquired the
work at a later date. M. Goetz, Paris, is listed as the lender of
this painting to the small "L'impressionnisme" exhibition held at
the Palais des Beaux-Arts, Brussels, June 15–September 29, 1935,
no. 76 (repr.).

Seurat painted only two pictures at Le Crotoy in the
summer of 1889; he was recalled to Paris, one assumes, by
news of Madeleine Knoblock's pregnancy. Le Crotoy is
another of those unassuming seaside villages that Seurat
preferred—fishing ports that housed vacationers without
providing the chic institutions of the more frequented
resorts such as Trouville. About thirty miles northeast of
Dieppe, just as the French coastline turns due north, Le
Crotoy occupies a stumpy peninsula that projects south-
ward from the northern side of the estuarial bay of the
Somme River. In this painting we are just beyond the
village on the northwest side, looking south across the
bay. Minuscule people speckle the beach in front of two
trawlers headed out to the Channel below huge rolling
clouds that take on oddly monstrous forms. The cluster
of buildings on the left reveals brick walls in yellows, tans,
oranges, and reds and slate roofs in blues marked with
reddish oranges. To their right the nearby sand is virtually
created by the underlayer of crisscross strokes that re-
mains prominent despite a surface coating of small spots.
The richest colors are reserved for the darker portions of
the verdure, which contains several greens, including
olive, plus several tints of orange, tan, blue, and red. The
painted border was conceived integrally with the picture
(borders for the previous summer's marines were after-
thoughts); it shifts colors with every change in the contig-
uous composition. The painting was exhibited in 1889
with a wide painted frame that subsequently disappeared.

212. *Le Crotoy, amont.* 1889

LE CROTOY, UPSTREAM

Oil on canvas, 27¾ x 34⅛ in. (70.5 x 86.7 cm.)
Painted border and frame by Seurat
Signed lower right border: Seurat
Signed on reverse of painted frame in gray-blue paint: Seurat
Dated and inscribed on reverse at top of stretcher bar in gray-blue
paint: 1889 Le Crotoy (Amont)

The Detroit Institute of Arts, Bequest of Robert H. Tannahill

H 194; DR 193

PROVENANCE
The artist until 1891. Inherited by the artist's mother, Mme Ernestine
Seurat, Paris, in 1891 ("Mᵉ Seurat" is inscribed on reverse of frame
in red chalk, visible only with ultraviolet light), until at least 1893,
and probably until her death in 1899; by inheritance to the artist's
brother, Émile Seurat, Paris, until his death in 1906; by inheritance to
his widow, Mme Émile Seurat, Paris, until at least 1909; Félix
Fénéon, Paris, until 1922; sold for $4,100 to John Quinn, New York,
July 1922, until his death in 1924; his estate, 1924–26;* Paul
Rosenberg and Co., New York and Paris, by at least 1929; Wildenstein
and Co., New York, by 1931, until 1935; sold to M. Knoedler and
Co., January 1935 (stock no. CA739); sold to Robert Tannahill,
Grosse Pointe Farms, Michigan, in 1935, until his death in 1969; his
bequest to the museum, 1970

EXHIBITIONS
1889 Paris, no. 242
1891 Brussels, no. 2
1892 Paris, Indépendants, no. 1104
1892–93 Paris, no. 52
1900 Paris, Revue Blanche, no. 33
1905 Paris, no. 1
1908–09 Paris, no. 75
1924 New York, no. 19
1929 New York, no. 59
1979–80 London, no. 203

*See Judith Zilczer, *"The Noble Buyer": John Quinn, Patron of the
Avant-Garde*, Washington, D.C., 1978, p. 186.

Today, one can still find this view of Le Crotoy when
approaching the peninsula from the southeast at low tide,
looking across the estuarial sands that were once rich in
mollusks. Although the village has expanded, it has the
same mixture of brick and stuccoed buildings and the same
tree-lined square along the eastern front of the seawall.
Seurat made the sandy expanse in the foreground an
exercise in closely related colors, intermixed with a sprin-

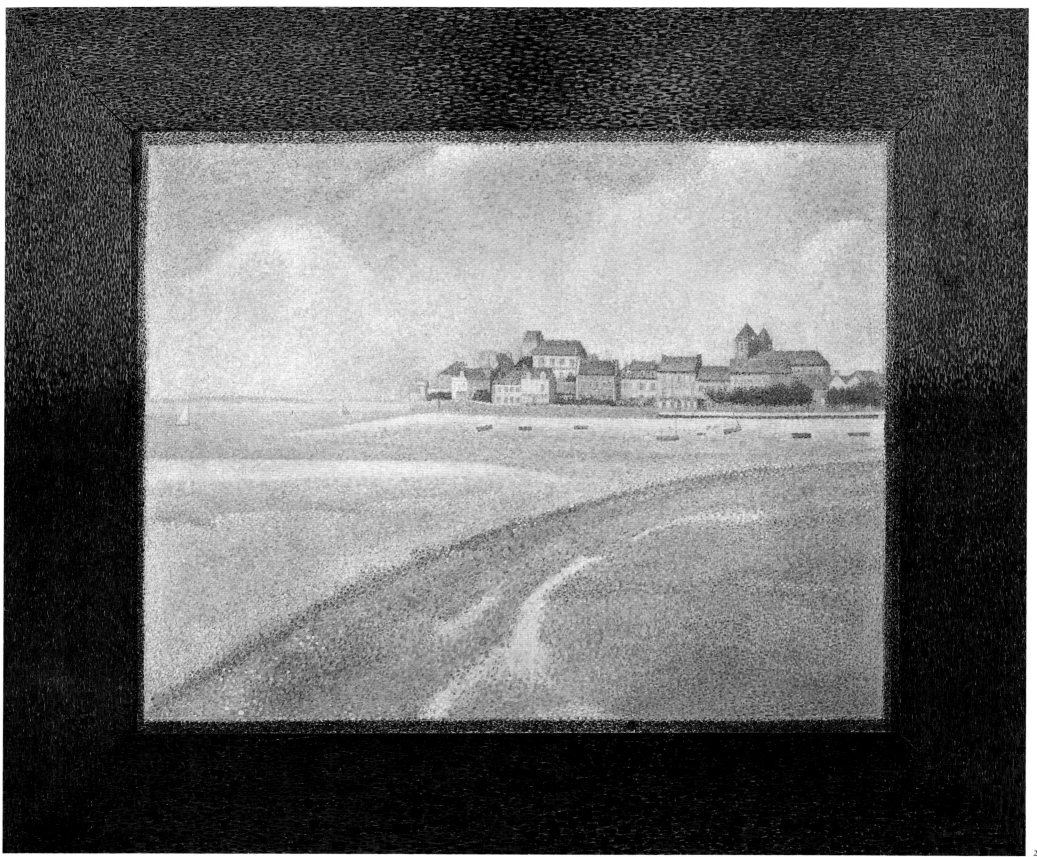

kling of contrasting hues. It is dominated by greenish yellows, but close inspection reveals more than a dozen hues, including pinkish tans that occasionally take on special prominence.

Fénéon, when he reviewed the Indépendants exhibition in 1889,[1] complained that this picture was too evidently beholden to Charles Henry's ideas of opposing directions; for some reason he was looking for an argument—he even objected to Seurat's signature—and superimposed his own awareness of Seurat's theory over a painting that does not seem to warrant it. He gave only lukewarm praise to the painted border and frame, whose raison d'être he nonetheless correctly explained: to receive the complementaries of the neighboring hues on the canvas. In this picture, border and frame are closely related, the only difference being that the border's tones are slightly lighter than the frame's. Below the horizon the frame is dominated by wine red and blue, in reaction to the yellows of the sand. Its upper half instead has oranges with the blue, to react to the blue of the sky. Within these two large zones the mixture constantly changes to suit not only the picture's contiguous hues but also the frame itself, to which Seurat granted a partial autonomy. For example, the upper half acquires green as it approaches the lower, reddish half, not in response to the adjacent sky, but to the reds of the frame. Similarly, the dotted strokes meet at right angles in the four corners of the wide frame, acknowledging its separate structure.

1. Fénéon, September and October 1889.

213. *Jeune femme se poudrant*. 1889–90

YOUNG WOMAN POWDERING HERSELF

Oil on canvas, 37⅛ x 31¼ in. (95.5 x 79.5 cm.)
Signed lower right border: Seurat

Courtauld Institute Galleries, London (Courtauld gift)

H 200; DR 195

PROVENANCE
Inherited by Madeleine Knoblock, Paris, in 1891;* Félix Fénéon, Paris, after 1897;** Dikran Khan Kélékian, Paris and New York, by 1921, until 1922 (Kélékian sale, American Art Association, New York, January 30–31, 1922, no. 154, for $5,200); purchased at this sale by Eugene O. M. Liston, New York; with Percy Moore Turner, London, in 1922; sold to John Quinn, New York, in 1922, until his death in 1924; his estate, 1924–26; with Paul Rosenberg, Paris, in 1926; with the French Gallery, London, in 1926; sold to Samuel Courtauld in 1926, until 1932; his gift, December 16, 1932

EXHIBITIONS
1890 Paris, no. 727
1892 Brussels, no. 14
1892 Paris, Indépendants, no. 1085
1900 Paris, Revue Blanche, no. 35
1908–09 Paris, no. 73
1920 Paris, no. 30
1924 New York, no. 18
1932 London, no. 503
1937 London, no. 31
1958 Chicago and New York, no. 147
1979–80 London, no. 204
1987–88 Cleveland, New York, et al., no. 36

*See Madeleine Knoblock's handwritten list of late April 1891 in H, I, p. XXVIII, where the painting is listed on her half of the roster as "mon portrait."

**According to Halperin 1988, p. 342, early on in their marriage, Fanny Fénéon noticed the painting in a shop window and purchased it for forty-five francs as a gift for her husband, Félix (they were married June 17, 1897).

Reviewers paid scant attention to *Jeune femme se poudrant* when it was exhibited at the Indépendants in March 1890—*Chahut* eclipsed it—but today we hover over it both for its strangeness and for the possibility that it might reveal something of the emotional life of this most secretive of artists. It shows a woman dressed and coiffed exactly like any number of café and vaudeville singers as they appear in contemporaneous posters and illustrations.

As such, she forms an amusing contrast with the dancing wraiths of *Chahut*. We see a woman of abundant form seated before a small rococo table (a *poudreuse*, often used as the picture's title), looking into a mirror as she raises a powder puff toward her body. The table looks like a department-store replica, with brass fitted to each leg; brass mirror and perfume stand speak also for cheap elegance. On the wall above, a still life is reflected in a folding mirror edged in bamboo, a bit of *japonisme* long after its initial vogue. All these furnishings have a spindly thinness that mocks the woman's volume; the hollow curves of table and brass stand recall her swelling lines. The pink bow surmounting the mirror, although it has subdued echoes in the woman's hair and shoulder strap, is a humorous flounce that caps this set of contrasts.

It is because Seurat's picture is so flat and confined that the contrast between figure and objects is so effective. The woman's volume rises from a rather flat skirt (no stool or chair is visible), which projects under the tiny table, rendering it all the more fragile. Her arms are parallel to the surface; the near one, preternaturally elongated, is linked to one of the sweeping curves of the skirt, as her bracelet is linked to her waist. Light portions of her body turn the background dark, and dark portions make light halos, which give her upper body its tangible relief. These and other contrasts and reflections turn the wall into a pulsating field that threatens to come forward to the surface. The still life in the mirror does not punch a hole in the wall because its angled view and gabled shape are not what we expect in a reflected world. The most effective indicator of space is the table, but it floats above the unseen floor; behind it appear leaves and flowers that must be part of the wallpaper, yet are not found elsewhere.

The woman's self-absorption and serious demeanor can perhaps be reconciled with her bargain-basement fittings if we believe that the picture deliberately points to the vanity of transient human existence. In their pretension, the cheap accouterments, in this interpretation, reveal the futility of her primping. The contrasts, after all, are flagrant. The pink bow, the top of the Japanese mirror, and the repeated upward flare of the wallpaper pattern are all embodiments of Humbert de Superville's "unconditional sign" of gaiety that Seurat diagrammed in his contemporary "esthétique." Contrasting with them is the figure's solemnity. Not only does she have an ample form, she also has the nearly iconic presence of a goddess or a woman on

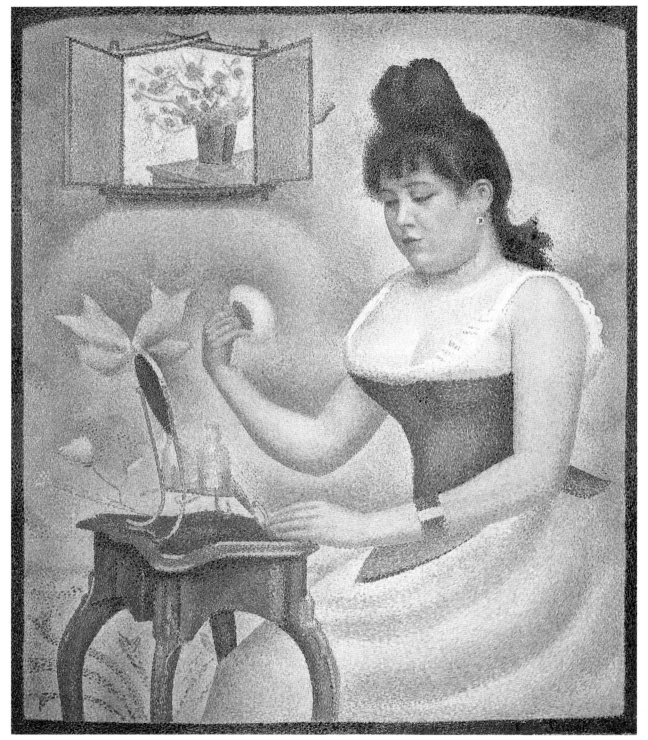

213

a Greek grave stela preparing herself for the afterlife.[1] It is not just her seriousness that creates this effect. Merely to be absorbed in her toilette would not distinguish her from her more recent forebears, vanitas paintings by Courbet and others in which a woman combs her hair and looks into a mirror. Unlike Seurat's canvas, however, those paintings combine sensuality and self-absorption, with no hint of his ironic humor. He subdues sensuality and entirely denies eroticism by the rather cruel humor with which he constructs this woman's plenitude.

Seurat's humor is not easily described, for its effect on us is ambiguous. This woman and her action are not, finally, laughable. Seurat gives her a neo-primitive simplicity that distances her from us and makes us hesitate to poke fun at her. Like certain figures in *La Grande Jatte*, she is both primitive and classical, yet this serious formal content also embraces the artifacts of popular culture that surround her. The primitivism has a contemporary flavor, for in their figure pieces, both Pissarros, Signac, and Dubois-Pillet cultivated a deliberate archaism; the portraits of Dubois-Pillet are particularly close to Seurat's *Jeune femme*. For all of them this primitivism had sources in popular broadsides (which Seurat collected) and therefore had a democratic, antielitist quality.

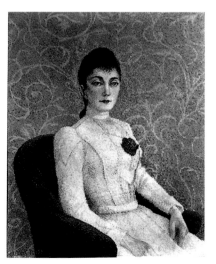

Albert Dubois-Pillet, *Portrait of Mlle M.D.*, 1886. Musée d'Art et d'Industrie, Saint-Étienne

Additional factors affect the way we look at Seurat's painting, for we have learned circumstances unknown to the visitors who saw it in 1890. No one, not even his close friends, knew then that it was modeled after his companion Madeleine Knoblock, who had given birth to their child a month before the opening of the exhibition. Thanks to the detective work of the late Dr. Jean Sutter,[2] we know the following. Early in 1889 Seurat began living secretly with Madeleine Knoblock (1868–1903), an artists' model, in his Montmartre studio at 128 bis boulevard de Clichy. She became pregnant late that spring, and when Seurat learned of it that summer, he cut short his painting campaign at Le Crotoy and returned to Paris. In October, perhaps to ensure privacy, they moved to a one-room studio sixteen feet (five meters) square in the nearby passage de l'Élysée des Beaux-Arts, where Pierre-Georges Seurat was born February 16, 1890. It was only thirteen months later, when the moribund artist was taken to his mother's apartment, that his family learned about his liaison. Pierre-Georges died of the same infectious diphtheria two weeks after his father. Madeleine was again pregnant, but the second child died at birth or shortly afterward. Seurat's family divided his paintings and drawings with her and gave her a pension, but she dunned his friends for money in a series of letters that do her little credit. In one of those letters she refers to "mon portrait," the source of the identification for the 1890 painting.

One more, this time dubious, piece of information should be mentioned. Forty years after the picture was shown, an unnamed friend of Seurat's told Robert Rey[3] that the artist had painted his own reflection in the mirror; when the friend suggested to the artist that this could make viewers smile, he had painted it out. Perhaps some credence can be given this story, because X rays reveal that there are indeed other forms underneath the still life.[4] Alas! These shadowy shapes cannot readily be construed as the image of a person. In view of the time that passed before this story was told and the lack of corroborating evidence, we must treat it with great skepticism. It has nonetheless passed as fact, making it impossible to disassociate the artist's private life from the picture.

Do we have the right to exclude knowledge of Madeleine Knoblock from our interpretation? In fact, we can't, although the first paragraphs here attempted to do so. Of course Seurat did not expect his liaison to be known. Are we not therefore wrong to join the persona of

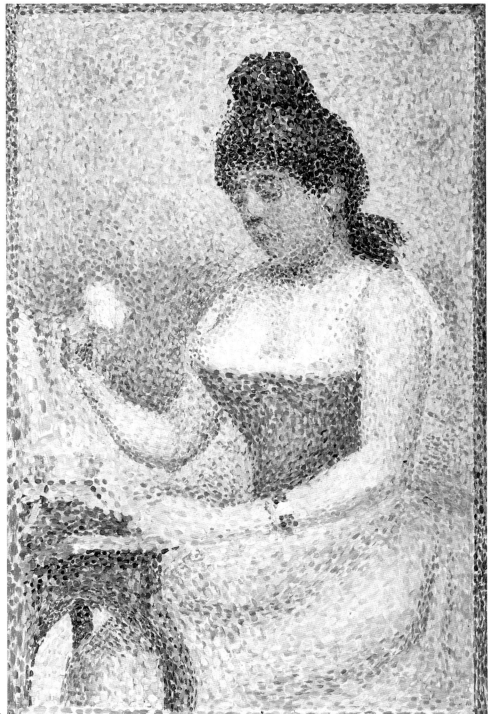

214

the model with her image, which is only a fiction? To inquire into the private lives of artists' models and then posit a relationship with the images based on them would seem a doubtful procedure. Still, a mote of knowledge often bespeckles the innocence of our viewing. Art is not "pure," it does not float in an ethereal realm above the living circumstances that engendered it. Whenever we have knowledge of those circumstances, we learn that there is a dialogue between model and image. It is now impossible to view Manet's *Olympia* and his *Déjeuner sur l'herbe* without awareness of the saucy independence of his model, Victorine Meurent. Gauguin's exploitation of his *vahine* cannot and should not be separated from the images of his Oceanic nudes. In Seurat's case, we know that his image is based on a professional model who was also his lover (her generous size may owe something to her pregnancy). We are bound to wonder at Seurat's using her as the model for a picture that elevates her to iconic power while also making of her an ironic image of life's vanities.

Like *Chahut* and *Cirque, Jeune femme se poudrant* depicts an interior. We are far now from the outdoor naturalism of *Baignade* and *La Grande Jatte*. Yet, even as we confront the artificial light of a painter's fiction, it is probably based on natural light coming from a window to our left and above. The top left edge of the mirror frame above is predominantly yellowish tan, facing the light, whereas the forward edge of the other wing is a balanced mixture of dark blue and red. Seurat's palette remains complicated here, though somewhat simpler than that of *La Grande Jatte*. The blues of the wallpaper, for example, painted over a creamy white coating, consist of a constantly shifting mixture. Dark areas have both purplish and greenish blues, plus oranges, olive greens, and both medium and dark greens; light areas have several tints of blue, plus pale greens, yellowish greens, and pale yellows. The oranges and yellows among the blues are faithful to Seurat's early interest in Delacroix's broken colors, in which small touches of the dominant hue's opposite produced a "gray" much livelier than a uniform tone. Painted over a creamy white ground that shows between the strokes, these colors almost blend at a distance, but in vaporous formations that elude focus. The oranges, yellows, and flesh tones of perfume stand, table, and figure resonate against the blues, a cool background for their warmth.

As usual, the small touches that appear regular from a distance are, when seen closely, of great variety and change direction with the imagined contours and surfaces. In combination with color, they often have a perky humor, as in the way they run along the rose-colored lever protruding from the Japanese mirror. The dabs of the painted border, conceived as a nonexistent receptor of color-light, run flatly along the surface without forming illusions of plastic planes. On the extreme outer edges, where the frame once overlapped the canvas, the border is incomplete. (This means that Seurat finished the border and picture after it was in its frame.) Everywhere the border contrasts with the picture, including its downward curve along the top, an innovation it shares with *Chahut.* Its colors change to oppose the adjacent hues of the imagery, even to the point of acquiring small green accents near the red bird-track motif of the wallpaper. On all four sides near the border there is an accumulation of cream-tans and other pale tones that form a delicate blush of light to oppose the surrounding dark. Border and picture therefore interact in the play of artifice and reality, decoration and imagery, that is unique to Seurat.

1. The profile form of Hegeso on her tomb stela (National Museum, Athens) is especially close to Seurat's figure, even to the pose of her arms. It is tempting to think that Seurat retained a memory of this well-known relief, which was illustrated in the same volume of the *Gazette des beaux-arts* (2, 11, 1875, p. 420) from which he made a schoolboy drawing of another Greek relief (Herbert 1962, no. 144).

2. Sutter 1964. Sutter's careful notes cite relevant birth and death certificates. Letters from Madeleine Knoblock to Seurat's close friends survive in the Signac and de Hauke archives, including one to Mme Félix Fénéon dated January 13, 1902.

3. Rey 1931, pp. 128–29.

4. X rays were taken in Chicago at the time of the exhibition in 1958. Seeing rather little on the X ray itself, technicians reinforced the darks with hand-drawn hatching and produced the bust of a man. More recent X rays, published in the 1987 catalogue of the traveling exhibition of Courtauld pictures, show how subjective this reinforcement was. It seems to have been unwittingly guided by the assumption of a self-portrait, which in 1958 still passed for fact.

214. *Étude pour "Jeune femme se poudrant."* 1889–90

STUDY FOR "YOUNG WOMAN POWDERING HERSELF"

Oil on wood, 10¼ x 6¾ in. (26 x 17.1 cm.)
Painted border by Seurat

The John A. and Audrey Jones Beck Collection, on extended loan to The Museum of Fine Arts, Houston

DR 194

PROVENANCE
Salomon collection, Nancy, until 1958; sold to Wildenstein and Co., New York, in May 1958; sold to Mr. and Mrs. Leigh Block, Chicago, in November 1958, until 1973; sold to Wildenstein and Co., New York, in April 1973; sold to present owner, May 1973

This small study is reunited with *Jeune femme se poudrant* for the first time since the 1890s. We should not make too much of the differences between them because the panel is only a study, and Seurat knew he would embark on a more ambitious composition when he turned to his canvas. Nonetheless, we are entitled to deduce that the image on the panel is closer to the model. Her head and upper body are thinner, which shows that the Buddha-like proportions of the final figure were deliberately fashioned. Also revised on the canvas was the costume above the skirt, which was darkened, altered in color, and given two extensions below the arm, in keeping with the added complications of Japanese mirror and table permitted by the wider format. The thin painted border has clearly become an integral feature of the initial design.

215. *L'homme à femmes.* 1890

Ink, 10¼ x 6½ in. (26 x 16.5 cm.)
Signed lower left: Seurat

Private collection

H 695; DR 196a

PROVENANCE
The artist until 1891. Posthumous inventory, dessin no. 377. Presumably given by the artist's family to Victor Joze in 1891; Félix Fénéon, Paris, by 1926; Baron Robert von Hirsch, Basel, by 1958, until his death in 1977; his estate, 1977–78 (Von Hirsch sale, Sotheby's, London, June 27, 1978, no. 848); private collection; to present owner

EXHIBITIONS
1926 Paris, Bernheim-Jeune, no. 97
1936 Paris, no. 127

Seurat made this drawing for the cover of the 1890 novel *L'homme à femmes* by Victor Joze, a Polish writer who circulated among the vanguard in Paris (both Toulouse-Lautrec and Bonnard did posters and covers for him, Lautrec's *Reine de joie* being the best known of these). In *L'homme à femmes* a naturalist writer, a café-concert singer, a prostitute, and others are involved in scandalous loves. Richard Thomson has convincingly demonstrated that "Georges Legrand" in the novel is Seurat himself, an artist whose current work included a picture of a *chahut*.[1]

Jules Chéret, *L'amant des danseuses*, 1888. Poster, Bibliothèque Nationale, Paris

215

Seurat's cover has the caricatural quality of his late work, including *Chahut* and *Cirque*, and like them it reveals not only his admiration of the poster artist Jules Chéret (1836–1932) but also his absorption in theories of linear expression. Seurat owned posters by Chéret, whose *L'amant des danseuses* is among the prototypes for *L'homme à femmes*.[2] Seurat registered gaiety by using Humbert de Superville's and Charles Henry's upward directions; in the unfamiliar realm of a book cover, however, his linking of a popular art form and "scientific" aesthetics seems patently obvious. The drawing nonetheless takes a logical place among Seurat's late works in which human performers become marionettes, befitting his concentration on the Montmartre world of entertainers and bohemians.

According to Fénéon, Seurat first did the small oil panel (H 211; Barnes Foundation, Merion, Pennsylvania) whose composition is the same as this drawing.[3] He probably thought the panel would be the appropriate source for the cover, only to discover that the publisher preferred a drawing (the painting is not well suited to a book cover because its nuanced colors would not reproduce well). It remains a mystery why Seurat was not interested in lithography and etching, to which his techniques of drawing would have been admirably suited. The little oil painting for Joze's novel suggests the answer: he conceived of art in terms of color and atmosphere (drawings done for their own sake were always atmospheric), for he was first and foremost a painter, remote from the craft of making prints.

1. Thomson 1985, pp. 212–14. In the Signac Album there are two articles by Joze that mention the Neo-Impressionists, both entitled "Sztuki plastyczne," appearing in *Przeglad-tygosmowy* (Warsaw), May 8, 1887, and either May or June 1888 (incomplete clipping). Georges Lecomte devoted an article to Seurat's cover (Lecomte, "Une couverture de M. Seurat," 1890) in which he emulated Fénéon's style and invoked Henry: "la volutante majesté des lignes topographiques, on les croirait calculées par M. Charles Henry."
2. I juxtaposed the two works in my article documenting Seurat's knowledge of Chéret: Herbert, "Seurat and Jules Chéret," 1958.
3. Fénéon, "Précisions concernant Seurat," 1924. Fénéon said that the painting preceded the drawing, but he does not speculate on the reasons for this. It is authentic, despite Richard Thomson's unaccountable dismissal of it (Thomson 1985, p. 234, no. 101).

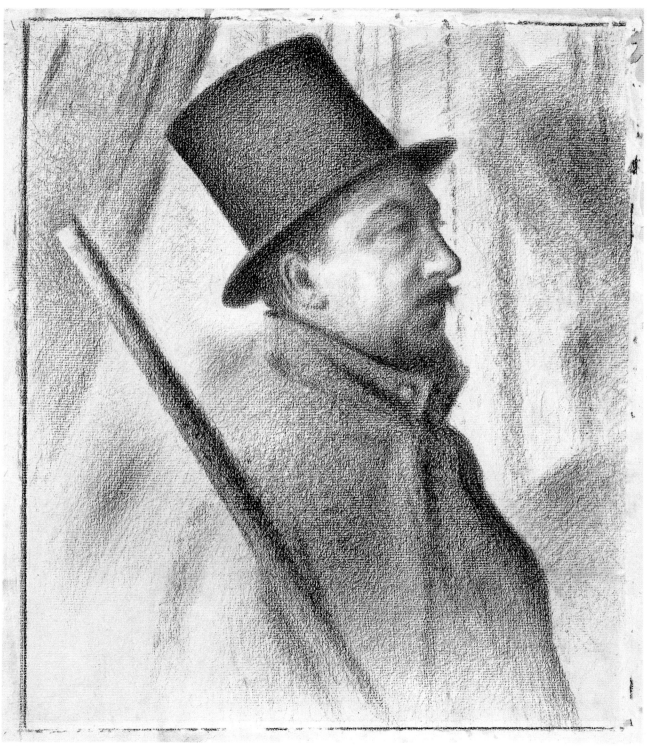

216. *Paul Signac*. 1890

Conté crayon, 14⅜ x 12½ in. (36.5 x 31.6 cm.)
Originally signed on the glass lower left: Seurat

Private collection

Exhibited in Paris only
H 694

PROVENANCE
Paul Signac, Paris, by at least 1892, and presumably by 1890 or 1891,
until his death in 1935; by inheritance to Ginette Signac, Paris; to
present owner

EXHIBITIONS
1890 Paris, no. 735
1892 Brussels, no. 22
1892 Paris, Indépendants, no. 1124
1900 Paris, Revue Blanche, no. 52
1908–09 Paris, no. 204
1926 Paris, Bernheim-Jeune, no. 62
1933–34 Paris, no. 85
1957 Paris, no. 56
1958 Chicago and New York, no. 148
1963 Hamburg, no. 119
1968 New York, no. 88
1983–84 Bielefeld and Baden-Baden, no. 83

Seurat was not a portraitist, yet this drawing of Signac
ranks among the greatest of portrait drawings. He may
have done it out of friendship, but it is more likely that he
made it for Fénéon's pamphlet biography of Signac pub-
lished in May 1890 as number 373 in the series *Les hommes
d'aujourd'hui* (the same series in which Seurat appeared
with text by Jules Christophe, portrait by Maximilien
Luce; see p. 410).[1] Except for the drawing of his aunt on
her deathbed (cat. no. 179), the only other portrait Seurat
drew in his last years was that of Paul Alexis. Alexis was
the leftist journalist who, as "Trublot" in the *Cri du peuple*,
had championed Seurat and Signac since 1886. His por-
trait, now lost from sight, was published in *La vie moderne*
in June 1888. In 1890 these two portraits by Seurat were
shown under one number in the Indépendants. They both
reveal Seurat's roots: *Paul Alexis* is as close as Seurat
ever came to Rembrandt, whereas *Paul Signac* recalls
Renaissance portraits, particularly those by Holbein, such
as *Saint Thomas More*. That Seurat knew Holbein's work is
certain, for a decade earlier he had copied two of Holbein's
portraits (H 283, 284). The echo of that Northern master,
including the presence of a curtain background and a cane
(which resembles Holbein's staffs), lends Signac the pres-
tige of tradition, and Seurat's choice of pose and costume
confers a cool dignity on his friend (like Fénéon, Signac
often dressed in top hat and elegant clothes).

In contrast to the portrait of Aman-Jean (cat. no. 30),
this drawing has no opaque blacks and none of the
swirling, restless lines that characterize Seurat's early
figure drawings. Here he stroked the paper with delicate
touches of crayon that suggest air as well as light. Coming
from the left, the light vaporizes Signac's shoulder and
casts a shadow on the curtain. The parallels of cane, figure,
and shadow create an illusion of depth, although a shallow
one. Opposed to these are the angles of the hat's brim and
its top, which just touches the upper edge of the paper.
Because of their gray tone, the folds of drapery that drop
from above remain in the shallow background. They
participate in the network of geometry that sets off the
marvelously notched and curviform contour that flows
from Signac's forehead down his body. This contour is the
very signature of Seurat's style and the element that gives
the drawing its energy.

1. It was rendered as a photoengraving retouched by hand and
 colored by stencil. The only known black-and-white proof of
 this print is in a private collection, Paris.

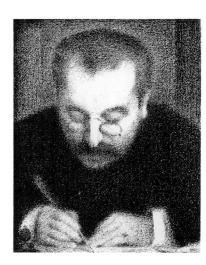

Seurat, *Paul Alexis*,
1888. Location
unknown (H 691).
Reproduced in *La vie
moderne*, June 17, 1888

Chahut 1889–1890

At the Société des Artistes Indépendants exhibition in early spring 1890, Seurat entered two drawings and nine oils. The drawings show his ambition to match the greatest old masters: *Paul Alexis* is a modern Rembrandt, and *Paul Signac* (cat. no. 216), a modern Holbein. The paintings included five of Port-en-Bessin and two of the Seine, pictures of austere tranquillity that reworked Impressionist motifs in a new manner. Seurat's largest exhibits were two figure paintings, *Jeune femme se poudrant* (cat. no. 213) and *Chahut*. Both are insistently modern, in contrast to the drawings, and insistently urban, in contrast to the landscapes. Both also have more than a touch of caricature and equivocal humor reminiscent of posters and cartoons. *Chahut*, the larger of the two and clearly the more ambitious, was widely discussed by Symbolist critics. A number of these writers were either friends of Seurat or had been granted interviews by him (Alexandre, Christophe, Kahn, Lecomte, van de Velde, Verhaeren, and de Wyzewa). They paid particular attention to two issues: the picture's Montmartre subject and its embodiment of Charles Henry's theories of linear expression. Few praised the picture unstintingly, for its linear structure struck many as too schematic. However, because Henry was an intimate friend of Laforgue, Fénéon, and Kahn and known to the whole Symbolist circle, Seurat's familiarity with his ideas confirmed both men as innovators.

In Georges Lecomte's account of *Chahut*,[1] Seurat's contemporaries read that his colors, dominated by the red end of the spectrum, expressed gaiety, as did the many lines and angles that flared upward, including even mouths, eyebrows, and mustaches. The arbitrariness of Seurat's visual signs pleased Lecomte, Fénéon, and other Symbolists, who opposed naturalism and praised the hieratic and ritual elements of *Chahut*. Their commentaries unwittingly echoed many of the terms and ideas of Charles Blanc, whose antinaturalism continued to influence Seurat's art. Blanc discussed Egyptian art in language that the Symbolists might have used for *Chahut*. The figures in Egyptian bas-relief, wrote Blanc, "are accentuated in a concise, summary manner, not without finesse but without details. The lines are straight and long, the posture stiff, imposing, and fixed. The legs are usually parallel and held together. The feet touch or point in the same direction and are exactly parallel. . . . In this solemn and cabalistic pantomime, the figure conveys signs rather than gestures; it is in a position rather than in action."[2]

Blanc's *Grammaire* deserves mention for another reason: behind every major feature of Seurat's theory of linear expression lies Blanc's vulgarization of Humbert de Superville's conceptions. Seurat's three-pronged motif, diagrammed in his "esthétique" of 1890 and embodied in *Chahut*'s bows and lamps, was in fact taken from Humbert's schema, not from any of Henry's diagrams. Blanc used Humbert's theories to support his contention that lines, like colors, have a direct relationship with feelings. Altering the direction of lines alters expression; therefore such linear directions are "unconditional signs" of emotion. Horizontals suit calmness because they embody ideas of equilibrium, duration, and wisdom. Expansive lines ("lignes expansives") induce gaiety by association with expansion, inconstance, and voluptuousness ("idées d'expansion, d'inconstance et de volupté"); they have a delicate and gracious character ("délicate et gracieuse"). With calmness he associated the severe Minerva and Egyptian art; with gaiety, Venus and Chinese architecture.[3] The Humbert-Blanc attributes of gaiety are found in *Chahut*'s voluptuous subject and its delicate figures as well as in its upward lines.

These remarks need not deny Henry's significance but should put it in proper perspective. It is true that Seurat listed Henry, his fashionable contemporary, among the key figures at the head of his "esthétique" and that neither Blanc nor Humbert figures there. Seurat, however, told Verhaeren that in Blanc's *Grammaire* he had found the basis of his theories of expressive line. Blanc would have denounced *Chahut* had he been alive to see it; nonetheless, his insistence upon the primacy of artistic thought over mere appearance and upon the expressive power of color and line had long ago given the ambitious young artist the foundation on which to build his art.

In Seurat's painting we see two women and two men with their legs in the air, a huge bass player, a mustachioed bandleader, two hands on a flute, a smirking male client, and two women peering up from the other side of the stage. The picture does not look like the abstruse theories of Blanc and Henry. Its forms are schematic but not abstract; they are instantly read as images identifying the world of commercialized popular entertainment that had loomed ever larger in Seurat's work after he moved to Montmartre in 1886. *Chahut* plunges us into the raucous world of a Montmartre dance renowned for its sexual provocation. The linear accents that incarnate

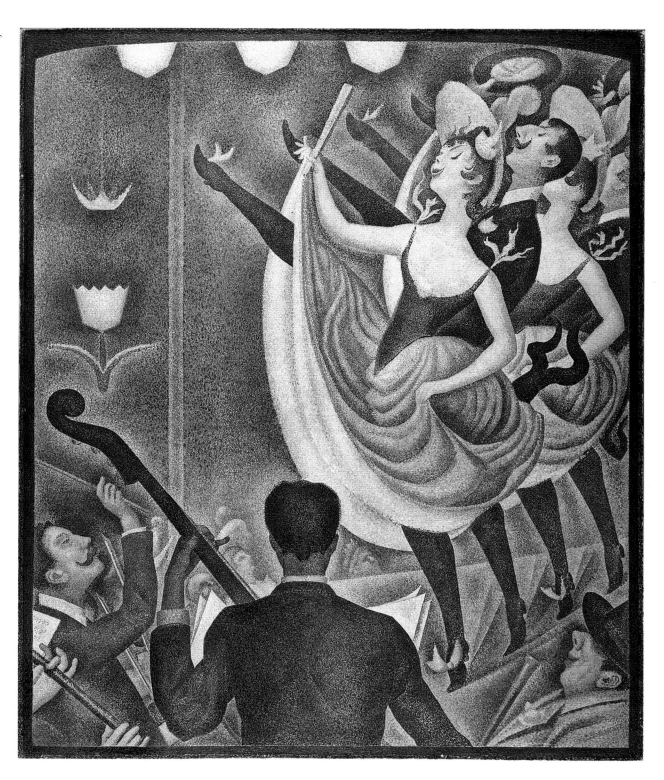

Seurat, *Chahut*, 1889–1890. Oil on canvas, 66⅞ × 54¼ in. (171.5 × 140.5 cm.). Rijks-museum Kröller-Müller, Otterlo.

RAPPORT DE L'ARCHITECTURE A LA FACE HUMAINE.

Correspondences between architecture and the human face, drawn by Charles Blanc, reproduced in his *Grammaire des arts du dessin* (ed. 1880), p. 108

Seurat's theory are also the elements of caricature that dominate the picture's expression. These same linear movements contribute to its posterlike appearance, which is why Seurat's contemporaries linked it with decorative painting. Subject, theory, caricature, and visual appearance are thoroughly intertwined.

In using the term "decorative," reviewers meant the flat appearance of the picture, as distinct from the more varied and rounded forms of earlier painting. Compared with Degas's *Café-concert*, the kind of work presaging Seurat's, the *Chahut* dancers are lined up with the repetitive rhythms of ornamental art. Parallel to the surface rather than spiraling into depth, they tilt or unfold in staccato bursts that fairly jump in our vision.[4] Indeed, ever since the exhibition of *Baignade* six years earlier, in 1884, Seurat had progressively flattened his major compositions and increased the number of small accents typical of decorative art, such as zigzags, darting curves, flaring rays, repeated parallels, and nonreceding flat zones. One impetus toward these changes was journalistic and commercial illustration, particularly the work of the poster artist Jules Chéret.[5]

From boyhood Seurat had liked journalistic and popular arts, whose references we detect first in youthful drawings, then in *La Grande Jatte*, and subsequently in drawings of the café-concert. The largest reservoir of circus and café-concert images were illustrations and posters, so it was natural that Seurat turn toward them in *Parade*, *Chahut*, and *Cirque*. By adopting some of their features, he identified his style with his subject matter. Chéret's *Folies-Bergère, les Girard* does not have the tactile complexity of an oil painting, but its decorative flatness and flamelike motifs predict some of Seurat's rhythms. Seurat's enthusiasm was widely shared, for Chéret was given a one-artist show in the winter of 1889–90, just as *Chahut* was being finished. Both artists figured prominently in the redefinition of the fine arts, initiated by Daumier, which increasingly absorbed elements of the graphic arts until, with Toulouse-Lautrec and artists of the 1890s, the sharp distinction between graphic arts and oil painting no longer existed. This process helped break the hegemony of the official regulators of the arts. Only a decade after he left the École des Beaux-Arts, Seurat was a leading member of the corps of Young Turks who replaced classical heroines with Montmartre performers.

As Chéret was admired by Seurat and the Symbolists, so too the café-concert and the circus were embraced by the vanguard. Several of the Symbolist journals ran regular columns on current café and circus programs, proof (if any were needed) of the co-opting of popular entertainments by modern artists. Manet and Degas had already treated them importantly in their work of the 1860s and 1870s. In keeping with the

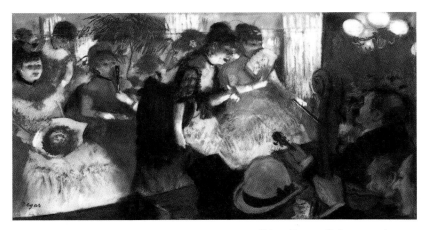

Edgar Degas, *Café-concert*, about 1877. Pastel on monotype. Corcoran Gallery of Art, Washington, D.C. Collection William A. Clark, 26.72

Jules Chéret, *Folies-Bergère, les Girard*, poster, 1877

heterodox nature of the café-concerts of that era, however, their work tended to stress the individuality of spectators, musicians, and entertainers. By the late 1880s the ever-expanding success of the café-concert encouraged more entrepreneurs to convert café rooms into veritable theaters, with fixed seats and stages. It became more and more difficult to distinguish them from music halls, and instead of the succession of singers and comedians typical of earlier playbills, they presented vaudevilles, one-act plays, and musical reviews. In the mechanical rhythms of Seurat's painting, compared with Degas's, we have a parallel to this regularization and commercialization of entertainment. We are not on the elegant Champs-Élysées, where Degas found the Café des Ambassadeurs, but in Montmartre, newly consecrated as Paris's center of merchandised low life.

The *chahut* (the origin of the word is disputed), or *quadrille naturaliste*, was well known before mid-century. Unpaid amateurs rivaled one another, and some became stars who gathered a considerable following.[6] By Seurat's day it had been transformed from the dance of habitués of popular balls to the work of paid professionals. In its canonical form two women and two men performed a mock quadrille, the women hiking one foot high to reveal legs and undergarments, the men emulating them but more especially revealing their prowess at splits and other acrobatic movements. Seurat's painting shows the dancers at the end of their performance, saluting the public with raised legs and hats. The artist's friend Jules Christophe (who interviewed him for a short biography published in spring 1890) described the painting as

> the end of a fanciful quadrille on the stage of a Montmartre café-concert: a spectator, half show-off, half randy investigator, who smells, one might say, with an eminently uplifted nose; an orchestra leader with hieratic gesture, seen from the back; some hands on a flute; and, with partners having serpentine suit tails, two young dancers in evening dress, skirts flying up, thin legs distinctly elevatory, with laughs on upraised lips, and provocative noses. On these working-class parisiennes [parisiennes de faubourgs], GEORGES SEURAT, the painter of these delicacies, nonetheless confers the nearly sacred character of priestesses accomplishing rites; and I am thinking of Mlles Wakiem, Taminah, Aya, and Lees of the Javanese Kampong [in the 1889 World's Fair]. All his paintings offer little more than ascending lines (above the perpendicular [he meant to write "horizontal"]), which, in M. Charles Henry's system, are encharged with expressing gaiety; do they express it?[7]

J. J Raffaëlli, *Le Quadrille naturaliste aux Ambassadeurs* (Naturalist quadrille at the Ambassadeurs). Cover, *Paris illustré*, August 1, 1886

Christophe crowds together many amusing and helpful observations that link Henry's theories with Seurat's satirical treatment of the provocative subject and with the Symbolists' preferred qualities of hieratism and ritual. The Javanese dancers at the World's Fair of 1889 had been very popular, and Christophe makes use of them to draw attention to the evocative and ritualized regularity of Seurat's dancers. He points to the snouted client in the lower right, leering up at the dancers, an embodiment of the male voyeur who, from mid-century, is regularly shown in journalistic illustrations of the *chahut* and similar dances. Christophe tags the women with the label of the faubourgs, shorthand for their origins on the margins of the city. Their lower-class standing made them all the more eligible as sexual objects for the men who frequented popular dances and café-concerts. Some of Seurat's reviewers noted that his young women appear chaste rather than voluptuous, but this does not deny the provocative air that Christophe remarks upon. Although Seurat avoided an overly saucy presentation, his snouted spectator and the prominence of the dancers' upraised skirts leave no doubt about his meaning. Furthermore, one anonymous contemporary writer on the café-concert said that some female *chahuteuses* deliberately flattened their breasts so as to appear more like their male partners; the flappers of the 1920s later proved that this kind of fashion does not suppress sexuality, only shifts its terms. We should discard any idea that Seurat was a prude: his *Jeune femme se poudrant* (cat. no. 213), exhibited alongside *Chahut* at the Indépendants, has an abundant bosom, so we can assume that the delicate form of his dancers was a deliberate interpretation of a contemporary type of performer.

This same anonymous writer who documented the masculine fashion of some female dancers in 1890 also described café performers in sociopolitical terms that expand our comprehension of Seurat's picture. He first reminds us that the typical café song had far more vitality than opera and operetta because, with the advent of the famous Thérésa, it took sustenance from street life:

> The song is bawdy, caricatural, peasantlike, military. It is also patriotic, and joyously so. . . . It has become political, not like the old songs but in a sudden new way, finding its coryphaeus and sending her from city to city to make propaganda. It is essentially alive and modern, in tune with the times and consequently malleable, transformable, chameleonic, an echo with repercussions of street noises, of daily events, of the cries of the cities' rutting. . . . One day socialism will certainly take it over.
>
> Already the singers had been decidedly decked out as acrobats. . . . Then came the distinctive costume: hats of Havana silk, twirling canes

held high, blue suits with gold buttons. The gestures of fingers and hands in long gloves . . . and the mouth, even the ears, moving strangely, gave a faunlike dislocation to their physiognomy. . . . Women exaggerated their masculinity by flattening their bosoms . . . and sometimes by the way they arranged their hair. . . . And from woman to man to woman successively or not at all or all at the same time, they achieved a curious asexuality, the artificial creation of the blasé and the refined.[8]

Here the songs and dances of the café-concert are associated with the irreverence, the changeability, the energy of the lower classes. Opera and the upper classes, by implication, are enervated and no longer the repositories of creative life. In this sense, song and dance were truly political, hence the comment that socialism would take them over. Since the time of the poet and songwriter Béranger early in the century, the cafés had been centers of political activity, and entertainers used innuendo and physical gestures to get around the omnipresent censor. Sex and politics were the realms monitored by the police spies who haunted the cafés, but despite this—and partly because of it—opponents of authority had regularly resorted to cafés as arenas of defiance and confrontation. Among Seurat's friends, Jean Ajalbert and Émile Verhaeren, both leftists, had written poems on the theme of the *chahut* and the café-concert in which they identified themselves with the oppositional character of working-class performers.[9]

Seurat's *Chahut* entered into social history not because it is a pictorial tract of the political left but because its subject and its unorthodox treatment could be assimilated into the left's cultural agenda. Most of the Symbolist critics friendly to Seurat were on the left, several of them sympathetic to anarchism, and they approved of him partly because of the popular content of his art. Both his subject and his admiration of Chéret signaled his rebellion against the canons of "high art," rebellion against the social elite. By 1891 we can prove that the Neo-Impressionists Camille and Lucien Pissarro, Luce, and Signac were all convinced anarchists, and both Angrand and Cross were sympathizers. Seurat's association with the left was assured, even if he made no direct political statements. Signac, writing for the leading Anarchist-Communist journal a year after *Chahut* was exhibited, said that innovation in art was tantamount to innovation in politics. He went on to say that the Neo-Impressionists showed their solidarity with the working class and anarchism not just by painting suburban factories, but "even more by the synthetic representation of the pleasures of decadence: balls, *chahuts*, circuses, as done by Seurat, who had so vivid a sense of the degradation of our era of transition."[10] According to Signac, the porcine

spectator of *Chahut* and the caricatured dance itself are among Seurat's insights into the decadence of his epoch. This view is seconded by another friend, Gustave Kahn, who found in the painting's male dancer a satire of an ignoble trade ("un ignoble métier"), proven by his devil's tail. If one looks for symbolism in the painting, Kahn wrote, it is in the contrast of the spectator's lewd ugliness with the female dancer's professional beauty; it is also in the hieratic structure ("faire hiératique") of the canvas and in its subject, a contemporary ignominy ("une contemporaine ignominie").[11]

Seurat's painting, of course, is no bitter attack on social ills, but a clever, bemused presentation. When Kahn praised its hieratic structure, and Signac its synthetic representation, they were calling attention to its modernist structure, its rejection of the conventions that Raffaëlli still adhered to in his depiction of the same kind of dance. Raffaëlli's interest in social subjects could have allied him with the critics on the left; they gave primacy to artistic merit, however, and so preferred Chéret and Seurat. Seurat pulled journalistic subjects into the web of vanguard preoccupations, into an altered definition of the fine arts. As he did so, he grafted elements of caricature onto a stem of aesthetic theory to produce the "contemporary ignominy" that Kahn wrote about. Caricature is not neutral; it is a form of social attack. The one who wields it is pointing out the foibles of persons and social institutions as subjects of ridicule. Artist and observer share the joke at the expense of those pinned to the surface of the imagery. In *Chahut* Seurat is the performer, the joke teller who has us in his grasp (his surrogate is the bass player). He has the caricaturist's distance from his subject, for he is not a participant in the scene he creates. He is the master puppeteer, and the dancers, musicians, and spectators are his marionettes. They grimace with Humbert de Superville's simplified emotions, and they turn their limbs upward along Henry's lines of movement.

Meyer Schapiro, in one of his most brilliant passages, revealed the many-layered meanings of these well-controlled images. Seurat, he wrote, appears to us

> as the engineer of his paintings, analyzing the whole into standard elements, combining them according to general laws and the requirements of a problem, and exposing in the final form, without embellishment, the working structural members.

Seurat's taste for the mechanical and his habit of control extend also to the human. The dancer and the acrobat perform according to plan, with an increasingly schematic movement. The grave Seurat is drawn to the comic as a mechanization of the human (or perhaps as a relief from the mechanical). The figures in the late paintings are more

and more impersonal and towards the end assume a caricatural simplicity or grotesqueness in expressing an emotion. They have no inner life, they are mannequins capable only of the three expressions —sadness, gaiety and neutral calm—which his theory of art also projects on the canvas as a whole in the dominance of the facial schemes of these three states—states which can be induced by the engineers of popular entertainment through the stimulus of the show in abstraction from individuals, counting rather on the statistical effect, the human average.[12]

1. Lecomte, "L'exposition des néo-impressionnistes," 1890.

2. *Grammaire* 1867, ed. 1931, p. 440.

3. Blanc's citations from Humbert and his incorporation of the Dutch artist's ideas can be found most readily in *Grammaire* 1867, ed. 1880, pp. 33ff., 66, 108, 145f., and 149; Blanc's words in the current text have been drawn from these pages. Long ago William I. Homer (Homer 1964, pp. 213f.) pointed to the risk of attributing to Henry the ideas Seurat had already found in Blanc.

4. The frozen action nonetheless argues against the purported influence of motion photography put forward in Scharf 1962 (effectively rebutted by William I. Homer in a letter to the editor, *Burlington Magazine* 104 [September 1962]: 391–92).

5. Robert Goldwater was the first to deal incisively with the evolution of the "decorative" in Seurat's major works (Goldwater 1941) and was among the first to see the significance of posters for modern art ("L'affiche moderne," *Gazette des beaux-arts* 6, 23 [1942]: 173–82). For Seurat and Chéret, see Herbert, "Seurat and Jules Chéret," 1958, and Thomson 1985, pp. 212–14. Verhaeren, in two articles based on interviews with Seurat, treated Chéret importantly. "*Chahut* completes the pictorial researches of *La Grande-Jatte*, this time by linear researches. Thus M. Seurat hopes to arrive at complete theories followed by clear applications. He is a technician, a risk-taker, an inventor [technicien, oseur, inventeur]. He was the first to adopt painting in divided colors. He wants to be the first to systematize lines. Chéret, who certainly does not reason as much but who is equally preoccupied by the mysteries of curved and straight lines, quickly initiated him [a été

l'initiateur rapide]." (Verhaeren, "Chronique artistique," 1891). Verhaeren also saw the link with Blanc's ideas: "The poster artist Chéret, whose genius he adored, had charmed him by the joy and gaiety of his drawings. He had studied them, he had wanted to demonstrate their expressive means and prise out their aesthetic secrets. On the other hand, he found in *La grammaire des arts plastiques* by Charles Blanc, the formulation of a whole theory which, in its fundamental givens, seemed correct. He started from there. A year later, this led to *Chahut*, then to *Cirque*" (Verhaeren, "Georges Seurat," 1891).

6. Years later Gustave Coquiot (Coquiot 1924, p. 108) said that Seurat began his studies for *Chahut* at the café-concert l'Ancien-Monde and that his performers were Coccinelle and La Houssarde, l'Artilleur, and Blondinet. This conflicts with the title Seurat gave the related drawing, *Au Divan Japonais*, exhibited in 1888; Coquiot had a rather elastic memory, however, that often stretched beyond the realm of exactitude. For the word *chahut* and the history of the dance, see the excellent book by François Gasnault, *Guinguettes et lorettes, bals publics à Paris au XIXe siècle* (1986), pp. 48, 50–56, 138f., 155f., 261f., 265f. Gasnault rather convincingly traces it to the Spanish dance *cachucha*, but popular wisdom in Seurat's day likened the term to *chat huant*, "yowling cat," and today *chahuter* still means "to rag a teacher" or, simply, "to create a rumpus." See also Lebensztejn 1989, pp. 48–54, and Gale B. Murray, "The Theme of the Naturalist Quadrille in the Art of Toulouse-Lautrec," *Arts Magazine* 55 (December 1980): 68–75.

7. Christophe, *Journal des artistes*, 1890, p. 101. His pamphlet biography was published the same month (April); we know from Seurat's own letters that it was based on one or more interviews (it includes an imperfectly edited version of Seurat's "esthétique").

8. "Le café-concert," *L'art moderne* 10 (1890): 338–39.

9. Ajalbert, an untitled poem in his *Paysages de femmes* (1887), with some striking parallels to Seurat's painting, and Verhaeren, the prose-poem "Au café-concert," *La cravache* 9, 421 (March 16, 1889), n.p.

10. "Impressionnistes et révolutionnaires," *La révolte* 4, 40 (June 13–19, 1891): 4, signed "un camarade impressionniste," portions reproduced and discussed in Herbert and Herbert, 1960.

11. Kahn 1891, p. 109; wrongly translated in Broude 1978, p. 25, who makes a contrast rather than a likeness between "hieratic structure" and "contemporary ignominy."

12. Schapiro 1958, p. 52.

217. *Étude pour "Chahut."* 1889–90
STUDY FOR "CHAHUT"

Oil on wood, 8½ x 6½ in. (21.5 x 16.5 cm.)
Painted border on three sides by Seurat

Courtauld Institute Galleries, London (Courtauld Bequest)

Exhibited in Paris only
H 197; DR 197

PROVENANCE
The artist's mother, Mme Ernestine Seurat, Paris; Félix Fénéon,
Paris; Percy Moore Turner, London; sold to Samuel Courtauld,
London, by 1931, until his death in 1946; his bequest, 1948

EXHIBITION
1987–88 Cleveland, New York, et. al., no. 35

This panel was based upon *Au Divan Japonais*, exhibited in
spring 1888, one of several independent drawings of
café-concerts and not a study for the later painting. When
he decided to transform the drawing into a painting,
Seurat began by shortening the height of the panels he
normally used in order to approximate the proportions of
the drawing. He retained the three foreground figures and
the rounded back of a seat, but he tilted the dancer to the
right, altered the rhythms of her dress, and added two
dancers (one of whose legs shows in the drawing). In the
lower left a lone hand plays a flute, while to the right
devilish coattails predict the satirical thrust of the large oil.
The greens, oranges, and blues of the background already

Seurat, *Au Divan Japonais*,
1887–88. Location un-
known (H 690)

217

throb to the rhythms of contrasts with the light or dark of the figures.

On three sides there is a narrow painted border, red and blue above the conductor's head, blue below. It has been assumed that someone sliced off the border on the right side, but the picture's width is the same as that of most of Seurat's panels. He may have added a narrow piece of wood to accommodate the border on that side. Signac, in his summary inventory of Seurat's studio (Signac archives), listed four panels specifically for *Chahut*; this, however, is the only one known.

218. *Étude pour "Chahut."* 1889–90
STUDY FOR "CHAHUT"

Oil on canvas, 21⅞ x 18⅜ in. (55.5 x 46.5 cm.)
Painted border and probably frame by Seurat

Albright-Knox Art Gallery, Buffalo, New York, General Purchase Funds, 1943 43.10

H 198; DR 198

PROVENANCE
Inherited by the artist's mother, Mme Ernestine Seurat, Paris, in 1891; her gift to Paul Signac, by March 1892, until at least January 1934 and probably until his death in 1935; presumably acquired from Berthe Signac by Wildenstein and Co., New York, in December 1936; with Wildenstein and Co., New York and London, from December 1936 until March 1943; sold to the Gallery, 1943

EXHIBITIONS
1892 Paris, Indépendants, no. 1086
1900 Paris, Revue Blanche, no. 34
1908–09 Paris, no. 76
1920 Paris, no. 29
1933–34 Paris, no. 60
1948 New York, no. 52
1949 New York, no. 23
1953 New York, no. 13
1958 Chicago and New York, no. 143

Seurat transferred his composition from the small panel to this canvas in order to refine the details of the final painting as well as to have room for a more elaborate tapestry of color. Particularly rich is the area to the right of the vertical pole, an unresolved mixture of green, purplish

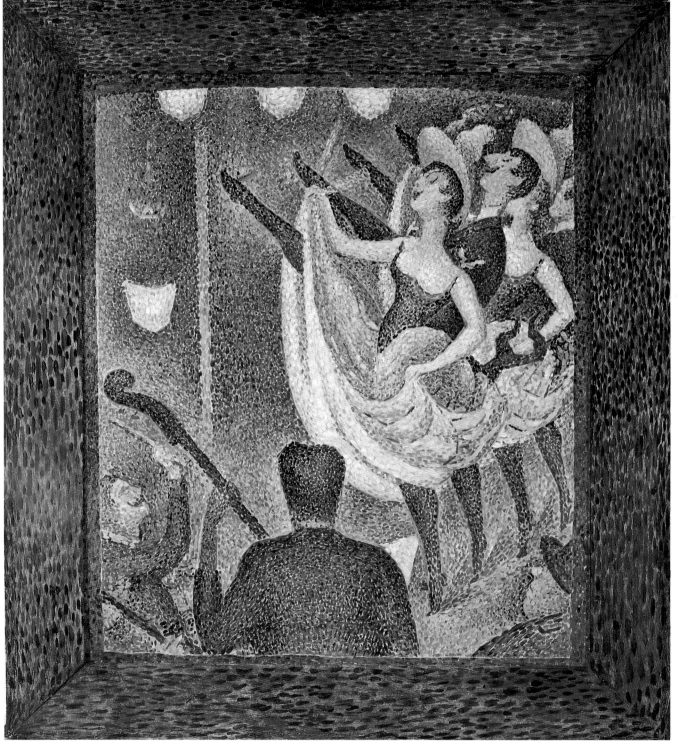

218

blue, purple, brick red, maroon, and dull orange. Closer to the dancer's skirt, the balance of the mixture changes to favor the blues and reds. Visible repaints show that he at first retained from the panel the positions of the conductor's arm and the lead dancer's fan, then altered them to their definitive angles. The four parallel legs of the dancers now appear, as do the prominent shadows cast by the footlights and the linear folds of the dancers' skirts. Many details, however, were presumably worked out on the final canvas (unless the missing panels intervened), including the complicated play of musical instruments and heads beyond the upraised arms of the conductor and bass player. The dancers' bows, inconspicuous on this small canvas, are eventually multiplied, and the two-part bows on the first dancer's shoulders change to the three-pronged motif diagrammed in Seurat's contemporary "esthétique."

Seurat first prepared the painted border in light blue then added the darker blues, blue-greens, and a sparse trail of orange dabs around the outer perimeter (this, presumably, to react to the blues of the now-missing external wood frame). The border was initially squared off, but Seurat later curved the top edge downward at the corners by painting over the composition. The downward curve, opposing the upward thrust of the dancers' legs, is another element of contrast that he diagrammed in his "esthétique." Although the authenticity of the painted wood frame has been doubted, it is probably Seurat's own because the medley of blues is consistent with the border and the same pigments were used. It may reflect the original version of the lost frame for the final picture.

Seascapes: Gravelines 1890

Seurat spent the last summer of his life on the Channel coast at Gravelines, not far from the Belgian border. The landscape differed greatly from the Normandy ports he had frequented, for Gravelines lies in a broad coastal plain marked only by low dunes. Perhaps the need to acclimatize himself explains why his production at Gravelines was so different from his most recent full summer of work, at Port-en-Bessin. There he had undertaken six canvases, for which no panels or drawings survive. At Gravelines Seurat worked on only four canvases (cat. nos. 219–221; H 206, Rijksmuseum Kröller-Müller, Otterlo); he also produced four oil panels and eight drawings, nearly all studies for the paintings. He bypassed the inland village itself, marked by a hexagonal seventeenth-century fortress; he instead painted downstream at Petit-Fort-Philippe and Grand-Fort-Philippe (both named for Spain's Philip II), hamlets that stood opposite each other on the Aa between Gravelines and the sea.

The four paintings Seurat did that summer have an austerity often attributed to his penchant for abstraction. They lack the variety and the moderate animation of his previous marines; their broad expanses, bounded by straight or shallow curving lines, form large geometric areas unbroken by internal incident. These qualities, however, are in large part the result of a sensitive artist's interpretation of a particular site—a flat, sandy area crossed by a narrow river so canalized it seems more man-made than natural.

In the sparse scaffolding of these pictures, delicate veils of paint bear the light that washes over an unruffled river, unpeopled quays, and smooth strands. Most of the boats are moored, but a few glide silently by the statuesque bollards. Monet's seascapes of this decade are also unpeopled, for he too refused to show vacationers; but his expressive brushwork and images of isolated headlands show the visible marks of his emotions. Seurat's technique distances the viewer, for it speaks of control, of mastery over both subjects and feelings—mastery over the "romantic" feelings he deliberately set aside in favor of those aroused by participation in rational pattern. In these quiet seascapes his emotions are the controlled responses of a city dweller who seeks not nature but arrangements of forms that express humankind's ability to construct. This is an art of renunciation and of extreme refinement, more like Mallarmé than Hugo, more like Proust than Zola.

GRAVELINES — Panorama du Grand-Fort-Philippe (Nord)

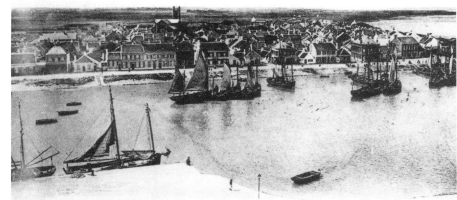

Photographie des Familles, rue Nationale

Nineteenth-century view of Gravelines

219. *Le chenal de Gravelines: Petit-Fort-Philippe.* 1890

THE CHANNEL OF GRAVELINES: PETIT-FORT-
PHILIPPE

Oil on canvas, 28⅞ x 36½ in. (73.3 x 92.7 cm.)
Signed lower right border: Seurat
Painted border by Seurat; modern frame (1982)

Indianapolis Museum of Art, Gift of Mrs. James W. Fesler in memory
of Daniel W. and Elizabeth C. Marmon

H 208; DR 205

PROVENANCE
The artist until 1891; by inheritance to his mother, Mme Ernestine
Seurat, Paris, from 1891 until at least 1893 and probably until her
death in 1899; by inheritance to the artist's brother-in-law, Léon
Appert, Paris, probably until his death in 1925; by inheritance to his
son, Léopold Appert, Paris, until 1926;* with Étienne Bignou, Paris,
and Reid and Lefevre, London, in 1926; D. W. T. Cargill, Lanark,
Scotland, by 1927, until at least 1935 and presumably with his
family until 1937 (private collector, Scotland); with Reid and Lefevre,
London, in 1937; with Bignou Gallery, New York, from 1937 until
1940; owned jointly by Bignou Gallery, New York, and M. Knoedler
and Co., New York (stock no. A2269) from October 1940 until
June 1945; sold by Knoedler's to Mrs. James W. Fesler (née Caroline
Marmon), Indianapolis, June 1945; her gift to the Museum, 1945

EXHIBITIONS
1891 Brussels, no. 6
1891 Paris, Indépendants, no. 1105
1892 Paris, Indépendants, no. 1105
1892–93 Paris, no. 50
1900 Paris, Revue Blanche, no. 37
1908–09 Paris, no. 79
1926 Paris, Grand Palais, no. 3217

1926 London, no. 2
1932 London, no. 559
1983 Indianapolis, unnumbered cat., pp. 62–65
1990 Indianapolis, no. 3

*It should be noted that when this work was lent to the 1926 Paris,
Grand Palais, exhibition as no. 3217, the lender, indicated by initials
only was listed as "M. A.L. . . ." The same intitials appear as lender
of Seurat's *Pierrot*, no. 3216 bis, an individual identified as Alfred
Lombard in de Hauke's entry for that work (H 95). It is highly
unlikely that Alfred Lombard was also the lender of the present
painting; instead one may presume a typographical error: the
initials of M. Léopold Appert were simply inverted. The earliest
recorded provenance for this work, the exhibition catalogue that
appeared two months later, 1926 London (no. 2), notes that the
work came "from Seurat's family."

The slanting embankments and deep perspective of this
picture show that the narrow river channel cuts across the
flat terrain around Gravelines like a watery highway. Here
we are looking inland from the quay at Grand-Fort-
Philippe. The centrally placed bollard anchors the fore-
ground securely; it and the gently curving revetment
allow the quay to zoom back with satisfactory conviction.
The careened boat tilting toward the lighthouse marks one
of the few contrasting rhythms in this composition, so
utterly devoted to summer somnolence. The central bol-
lard has a nearly graspable reality, and yet its Magritte-like
presence lends an otherworldly air to the picture. This
object is not shown in the foreground of the panel study
for this picture (H 207; art market, Tokyo), which was
painted from a spot a few feet farther inland. The only
drawing for the painting is a study of the white clipper (H
703; Solomon R. Guggenheim Museum, New York).

The painted border displays a dense array of contrasting
darker hues, changing its spots more precipitously than
most borders as it passes from one zone to the next. In the
lower left, abutting the aquamarine water, it is predomi-
nantly red (three different reds plus wine red and blue),
but above, as it meets the far bank, and along the bottom,
where it meets the quay, it shifts abruptly to blue.

Quay at Grand-Fort-Philippe, 1990. Photo: Stephen Kovacik

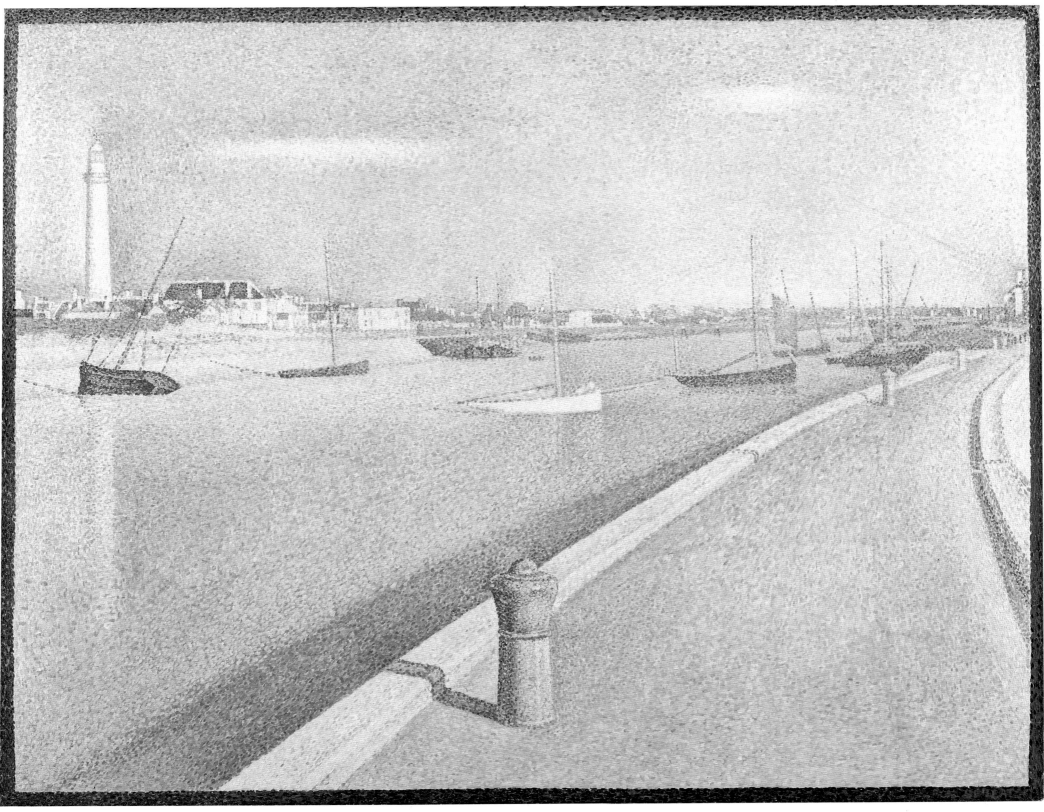

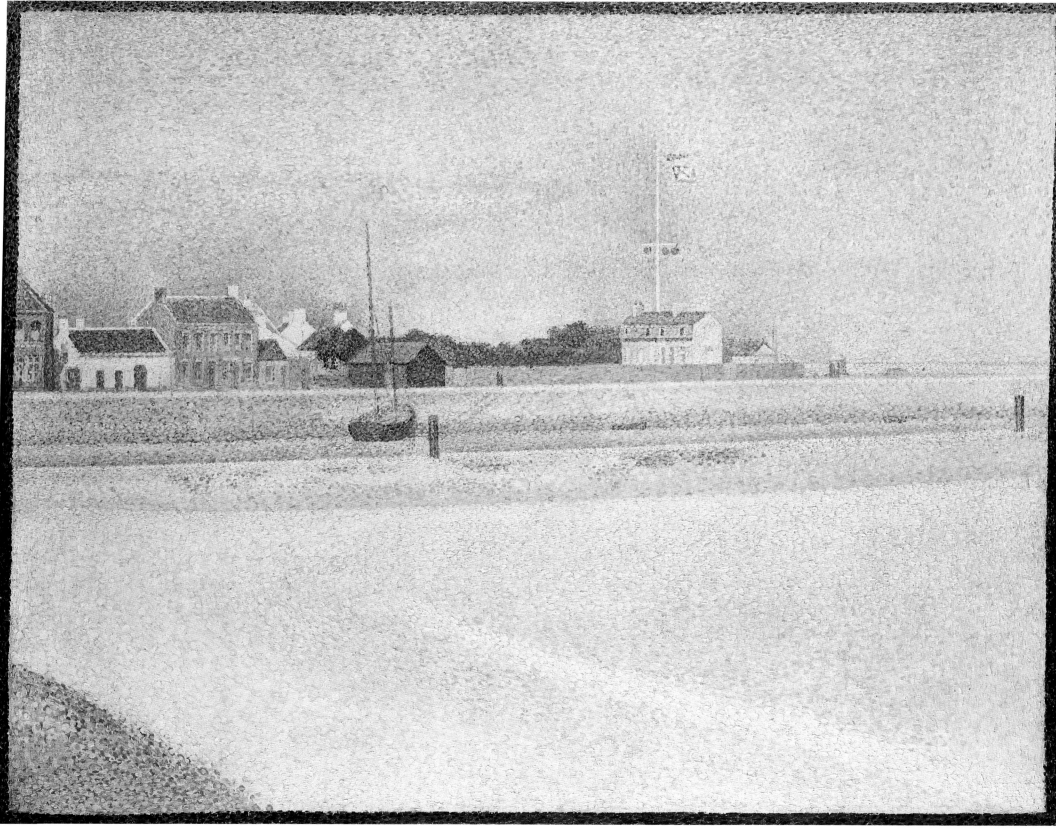

220. *Le chenal de Gravelines: Grand-Fort-Philippe.* 1890

THE CHANNEL OF GRAVELINES: GRAND-FORT-PHILIPPE

Oil on canvas, 25⅛ x 31⅞ in. (65 x 81 cm.)
Signed lower right border: Seurat

Berggruen Collection on loan to the National Gallery, London

H 205; DR 206

PROVENANCE
The artist's mother, Mme Ernestine Seurat, Paris, from 1891, probably until her death in 1899; the artist's brother-in-law, Léon Appert, Paris, by 1900, until at least 1909 and probably until his death in 1925; acquired from the Appert family by Étienne Bignou, Paris, and Reid and Lefevre, London, by 1926; sold by Lefevre to Samuel Courtauld, London, in 1926, until his death in 1947; his estate, 1947–48; inherited by the Honorable and Mrs. R. A. Butler, London, by 1949, until 1986; to present owner, 1986

EXHIBITIONS
1891 Brussels, no. 4
1891 Paris, Indépendants, no. 1103
1900 Paris, Revue Blanche, no. 36
1905 Paris, no. 3
1908–09 Paris, no. 79
1926 London, no. 3
1937 London, no. 32
1979–80 London, no. 205
1988 Geneva, no.26
1990 Indianapolis, no. 1

In this picture and the next we look directly across the narrow river at Grand-Fort-Philippe. Although we sense the wide reach of the sea beyond, both pictures consist of lateral planes that produce shallow spaces. Here the opposite bank gathers most of the strong colors and contrasts (reds and greens, oranges and blues); the area is further enlivened by the gentle throb of the forms against the sky, a result of Seurat's halos and umbras. Our eye, however, keeps returning to the foreground sand for we, like the artist, become almost hypnotized by its expanse. Seurat varied both underlying and surface strokes to create the texture of sand. A pathway, nearly white, slants back from the lower-right corner; it dissolves into a swirl of pale multicolored strokes whose texture imitates the way water and wind shape shifting sands. At the bottom of the the composition the strokes are larger than elsewhere; they diminish progressively as they recede toward the water. A range of pale pinks, blues, greens, tans, creams, oranges, and lavenders suggest gentle rises and dips in the sand. When we look across to the opposite quay, we notice several tiny strollers.

Seurat's painted border is one of his most satisfying in its blending of colors. The top band is an equal mixture of orange and blue, and the bottom, next to the sand, is mostly dark blue. The two sides show the complements of the composition's hues: on the left, for example, the mix changes from blues and wine reds (next to the green) to blues to dark reds and blues to greens and blues, increasing in reds and oranges until the top mixture of orange and blue is reached.

House at Grand-Fort-Philippe, 1990. Photo: Stephen Kovacik

221. *Le Chenal de Gravelines: un soir.* 1890

THE CHANNEL OF GRAVELINES: EVENING

Oil on canvas, 25 ¼ x 32 ¼ in. (65.4 x 81.9 cm.)
Signed lower right border: Seurat
Painted border by Seurat

The Museum of Modern Art, New York, Gift of Mr. and Mrs. William A. M. Burden, 1963

H 210; DR 203

Provenance
The artist until 1891; inherited by Madeleine Knoblock in 1891; purchased for 400 francs by Théo van Rysselberghe on behalf of his mother-in-law, Mme Monnom, Brussels, by February 1892,* until at least 1893; her gift to Marie and Théo van Rysselberghe, Brussels, by 1904 until at least 1909; with Alfred Flechtheim, Düsseldorf, in 1913; Rolf de Maré, Berlin and Paris, by 1923, until at least 1936; with Paul Rosenberg and Co., New York, until 1948; sold to Mr. and Mrs. William A. M. Burden, New York, in 1948, until 1963; their gift to the museum, 1963

Exhibitions
1891 Brussels, no. 7
1891 Paris, Indépendants, no. 1106
1892 Brussels, no. 17
1892 Paris, Indépendants, no. 1107
1892 Antwerp, no. 6 (of "Seurat, peintures")
1892–93 Paris, no. 51
1904 Brussels, no. 150
1905 Paris, no. 39
1908–09 Paris, no. 81
1928 Berlin (per DR)
1933–34 Paris, no. 61
1936 Paris, no. 51
1949 New York, no. 20
1953 New York, no. 15a
1958 Chicago and New York, no. 149
1968 New York, no. 89
1990 Indianapolis, no. 4

*Per an undated letter from Théo van Rysselberghe to Paul Signac reprinted in Guy Pogu, *Théo van Rysselberghe, sa vie*, Paris, 1963, pp. 16–17. Mme Monnom lent this work to the February 1892 exhibition of Les Vingt in Brussels.

The evening sky above Grand-Fort-Philippe glows with the greens at the top set off against lavenders, pinks, blues, and creams. Lavender light from the setting sun floods across the narrow spit of land, skips over the river channel (it reflects the greens of the upper sky) and turns the foreground sand into a medley of reds, pinks, lavenders, purples, blues, greens, tans, and oranges. From a distance the mixture assumes a brownish purple tone, but we never really lose sight of the separate colors.

The sand seems to pulsate, with halos around the arcs of the anchors and lighter tones along the base of the picture. Anchors and lamp, lit from behind, are linear accents that bridge all the planes in the picture, adding to its flatness. Japanese prints and drawings come to mind, and indeed French painters' long-standing admiration for them was surely shared by Seurat. His colors, on the other hand, have nothing of the flat tones of Japanese art, and both his luminous atmosphere and his tapestry of pigment are thoroughly Western and thoroughly wedded to oil paints.

The painting's imaginary space unfolds into the distance. The fishing boat headed out to sea helps form a diagonal that leads from the anchors back to the left, and the sunset pallor of the sky above the distant water draws us deeply into space. If we blink, however, this illusion of depth disappears, and we face instead a pattern of horizontal planes crossed by a few verticals and diagonals and by the sectioned curves of the sails. This striking surface pattern is not abstract because its symbols read insistently:

lamp for civilized promenades in a populated area, anchors for seaside inactivity, boats and maritime pennants for both work and leisure.

This is the only marine by Seurat for which there are several studies: four drawings and one panel. (Perhaps he regularly made such studies and others have not survived, but that seems doubtful.) Furthermore, this is a *paysage composé*, a reconstructed landscape. The buildings, the nearby lamp, and the profiles of the land are faithful to the site (cat. no. 224), whereas the movable elements, the boats and anchors, come from different drawings. The anchors appear in one drawing (H 697; art market, New York) with a different arrangement of boats and in another (H 698) that provides their definitive shapes. The principal boat was taken from yet another drawing (cat. no. 223) that looks down, not across, the channel. In developing *Baignade* and *La Grande Jatte*, of course, this former student of the École des Beaux-Arts had moved figures around in an unchanging landscape.

The painted border of this picture is different from most of the others Seurat made. Because the canvas shows an evening scene, it lacks daylight blues, so he did not use contrasting oranges in the border. Instead he put reds and blues next to green areas and greens and blues next to the composition's lavenders and pinks. Without the customary oranges along the top, the border is darker than others. Since it is about the same width as the stems of lamp and anchors, it tends to work with them as a graphic element.

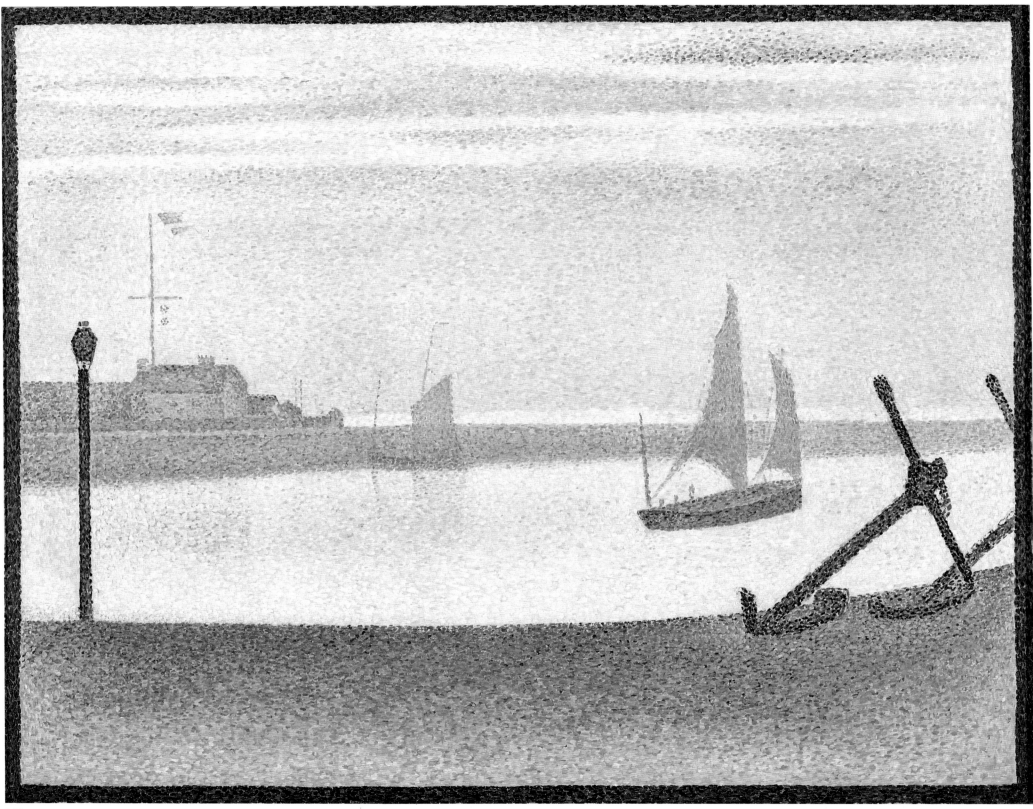

222

222. *Étude pour "Gravelines: un soir."* 1890

STUDY FOR "THE CHANNEL OF GRAVELINES: EVENING"

Oil on wood, 6⅛ x 10⅛ in. (15.6 x 25.6 cm.)

Musée de l'Annonciade, Saint-Tropez

Exhibited in Paris only
H 209; DR 202

PROVENANCE
The artist until 1891. Posthumous inventory, panneau no. 139; Paul Signac, Paris, by at least 1905 and probably from 1891 until his death in 1935; by inheritance to Ginette Signac Paris, Georges Grammont, Paris, by 1952, until 1955; his bequest to the museum, 1955

EXHIBITIONS
1905 Paris, no. 25
1908–09 Paris, no. 78bis
1942–43 Paris, no. 7(?) (as *Le chenal de Gravelines, peinture*)
1952 Venice, no. 19
1990 Indianapolis, no. 6 (not in exhibition)

In this panel Seurat established the lateral planes for his canvas and gave the near shore its upward curve. He has already stationed the lamppost in its prominent position. The two tall forms beyond the spit of land, to judge from drawings done that summer, are sailboats, seen from bow or stern. The colors of this beautiful little study are somewhat different from those of the large oil, perhaps reflecting a slightly earlier hour of day. None of the canvas's sonorous purples appear here, lavender is surpassed by pink, and the water has only a faint blush of green. Although sky and water contain many colors, each zone shares a common middle or light value, so the brushwork tends to blend. For the two strips of land, however, the darker tones produce more saturated colors and contrasts. As in the canvas, the foreground is lighter at the base and darker at the water's edge, where the mingling of greens, blues, reds, and orange tans is a delight.

223. *Voiliers, dessin pour "Gravelines: un soir."* 1890

SAILBOATS, STUDY FOR "THE CHANNEL OF GRAVELINES: EVENING"

Conté crayon, 9⅞ x 12⅛ in. (25 x 32 cm.)

Private collection

Exhibited in Paris only
H 702; DR 202b

PROVENANCE
Paul and Berthe Signac, Paris; by inheritance to Ginette Signac, Paris; to present owner

EXHIBITIONS
1926 Paris, Bernheim-Jeune, no. 123
1990 Indianapolis, no. 11 (not in exhibition)

Like the other seven drawings Seurat did at Gravelines, this one has a light touch, with few of the rich darks typical of his early landscapes. It also appears to have been rather quickly done as a record, not worked up carefully for exhibition. Even so, Seurat observed the contrasts of light and dark that were by now instinctive. The near boat has a light halo in the water, as does the edge of the embankment. Seurat made four similar drawings, each with a diagonal portion of the embankment on the right; they were probably done in his first days there as a way of reconnoitering the terrain. From this one he plucked the principal fishing boat to insert in *Un soir*, somewhat disingenuously maintaining the angle that in the drawing suits the slant of the river channel.

224. *Un soir, dessin pour "Gravelines, un soir."* 1890

EVENING, STUDY FOR "THE CHANNEL OF GRAVELINES: EVENING"

Conté crayon, 9¼ x 12⅜ in. (23.5 x 31.5 cm.)

André Bromberg Collection

H 696; DR 202a

PROVENANCE
The artist's brother-in-law, Léon Appert, Paris, probably until his death in 1925; by inheritance to Mme Léon Roussel, Paris; private collection, Paris (sale, Ader Picard Tajan [George V], Paris, June 22, 1988, no. 3); to present owner

EXHIBITIONS
1957 Paris, no. 44
1990 Indianapolis, no. 8

The recent reframing of this drawing has revealed a curving shoreline along the bottom of the sheet, formerly encroached upon by the passe-partout and therefore truncated in all prior reproductions. Now that it is visible this composition appears as the most satisfyingly complete of the Gravelines drawings. Its sky bears the delicate lines and rubbings of Seurat's late drawings, which here seem appropriate to the pervasive light of the flattened-out Channel coast. In the oil the boat under sail and the anchors on shore close off the right side of the composition and produce a quiescent balance. In the drawing their absence weights the composition heavily to the left and thus risks imbalance. On the drawing's right, however, a few vertical streaks of crayon mark the reflection of a small careened boat, and the near shore curves upward. With these delicate adjustments Seurat prevented our eye from rushing off the sheet while allowing us to sense the vastness of the Aa estuary.

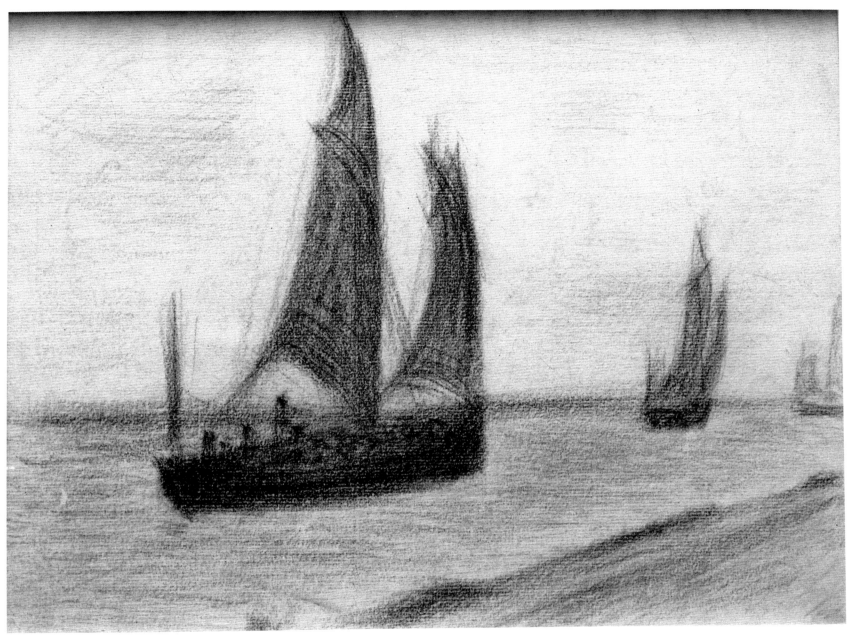

223

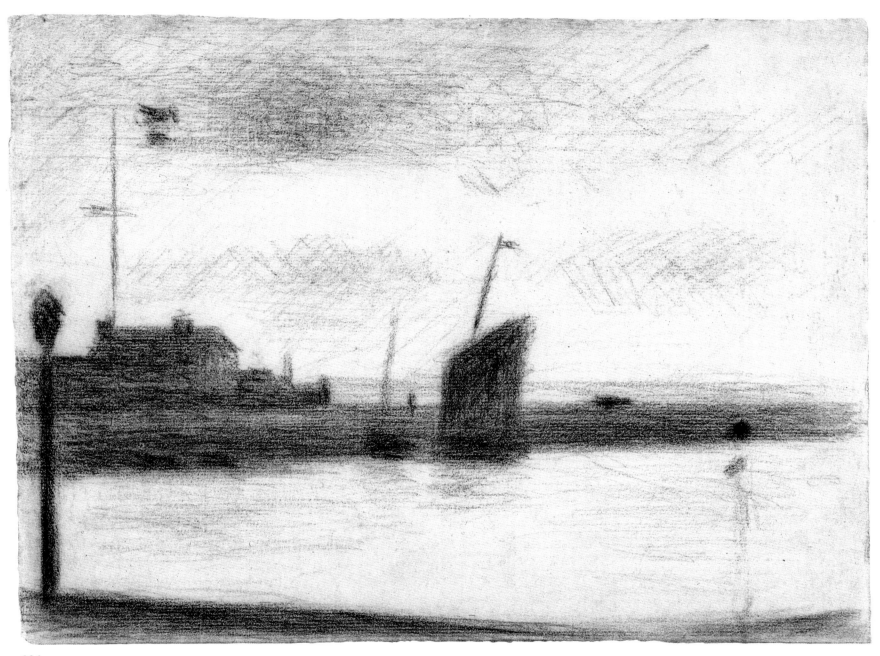

224

Cirque 1890–1891

ANNE DISTEL

Seurat sent *Cirque* to the 1891 exhibition of the Société des Artistes Indé-
pendants. This large multifigured canvas was somewhat bigger than the
previous year's *Chahut*. He also submitted four Gravelines landscapes (cat.
nos. 219–221 and H 206 [Rijksmuseum Kröller-Müller, Otterlo]), the fruit
of his labor in the summer of 1890 and the following months. The Indé-
pendants exhibition opened on March 20, 1891; scarcely a week later, on
March 29, Seurat died suddenly at the age of thirty-one.

The early reviews were not unfavorable, but an unspoken opinion
—that of Puvis de Chavannes, who had visited the exhibition but had not
looked at *Cirque*[1]—greatly disappointed Seurat. Later comment became
part of the obituary notices. Some critics continued to berate the *fumistes*
(jokers),[2] with whom they included Seurat, but even in favorable and
informed comments, reservations were expressed—especially concerning
Cirque, which was more severely judged than the landscapes.

Alphonse Germain first published an account of Seurat's theory[3] and
then commented on *Cirque*:

> In *Cirque* everything has been put together according to harmony by
> analogy, the reconciliation of opposites, with gaiety in mind: ascending
> lines in complementary directions (attitudes of the figures, details of
> costume, placement of objects); as much photographic warmth as its
> author's delicate, gray vision can provide; finally, thanks to the successive
> contrast of tones, a very strong orange dominant, accentuated by a frame
> opposed in its tones and tints to the whole. The theorem is rigorously
> demonstrated, if anything too much so . . . the figures in *Cirque,* presented
> geometrically (especially the yellow clown), have the stiffness of automatons.[4]

Although this judgment repeats some earlier criticism of the figures of *La
Grande Jatte,* Germain, paraphrasing Jules Christophe's biography,[5] empha-
sizes theories of tone, tint, and line.

Cirque was also, it was said, "despite some curious and bizarre ordering
of lines . . . without any perspective whatever"[6] and "primarily of experi-
mental interest."[7] Georges Lecomte stressed the "demoniac rhythm" of the
composition, without actually giving his opinion.[8] He also noted the
classification of the audience according to social hierarchy; their "complete
passivity"; the "lazy, elbow-leaning" spectators in the cheapest and least
comfortable seats in the upper galleries. Another critic wrote that "science in

the colors almost excuses the errors of draftsmanship."[9] The most favor-
able opinions were those of L. Roger-Milès[10] and Adolphe Retté, who
nevertheless declared: "M. Georges Seurat is a very fine painter of sensa-
tion but does not make one think."[11] The Symbolists were deserting Seurat.
But there was little excitement, especially in comparison with previous
years. The artist's friends, notably Fénéon, held their peace.

The early accounts did not mention that Seurat probably would have
reworked the painting; the brushwork is much looser than in earlier works,
allowing the white ground and a fine grid of blue lines to be seen. This
possibility was, however, often discussed (see cat. no. 225).

In painting this circus scene, Seurat made no thematic innovations but
used a repertoire akin to that of *Parade de cirque* (cat. no. 200) and *Chahut*
(see pp. 340–45). The picture shares the same elements—audience and
performers—but the artificial character of the light is less evident here than
in those paintings. As a depiction of regular mechanical movement (eques-
trienne on horseback), matched with unpredictable activity (the tumbling
clown), *Cirque* is related to *Chahut.* As in *Parade,* however, the composition
introduces a broad public—or, more accurately, a collection of headgear
that defines the social standing of the wearers. As in *Chahut,* one person,
seen from the back and cut off by the bottom margin, marks a foreground
"pasted" onto the figured space. The clown in *Cirque,* a profile looking
nowhere, recalls the porcine mask of the spectator at the lower right in
Chahut.

The circus, which became increasingly popular in France in the last
decades of the century, inspired both writers and artists, among whom
Renoir, Degas, Tissot, and Toulouse-Lautrec are the most famous.[13] None
can be considered a direct source for Seurat. It seems almost certain that he
was inspired by the Fernando (later Médrano) circus,[14] especially favored
by painters and, by virtue of its location at the corner of the boulevard
Rochechouart and the rue des Martyrs, quite close to the Seurat studio. It is
also apparent that he carefully avoided identifying a specific circus. The
Cirque Fernando was for him simply a symbolic stage for a female rider,
(such a figure appeared in a poem by his friend Ajalbert,[15] who had also
paid tribute to the *chahut*). Another friend of Seurat's, Paul Alexis, also
treated circus themes in association with Oscar Méténier. Their adaptation
of Edmond de Goncourt's *Frères Zemganno* opened at the Théâtre Libre on

February 25, 1890. It was followed on March 3 by their play *Monsieur Betsy* (whose heroine is a rider), starring Réjane, at the Théâtre des Variétés. Illustrated journals, almanacs, and chromolithographs published much circus imagery, and it is likely that Seurat, who was interested in such reproductions, was inspired by them.[16]

There is a clear connection between Seurat and his contemporary Jules Chéret, some of whose prints he owned[17] and whose work had been exhibited at the Théâtre d'Application. His influence, noted by Jules Antoine and Émile Verhaeren and mentioned by Meyer Schapiro, has been established in the case of *Cirque* by Robert Herbert.[18] Beyond a borrowing of motifs, Seurat derived from Chéret a fresh sense of line and color that accorded with his new formal concerns.

Like *Parade* and *Chahut*, *Cirque* marked a new stage in Seurat's development.[19] His way of working, revealed by the small number and sketchy nature of the preparatory studies (cat. nos. 225, 227–230), differed from that used for *Baignade* and *La Grande Jatte*. As contemporaries were quick to see, the emphasis in *Cirque* is on the rhythm of the composition, the dynamism of line, and the expressive symbolism of color (which meant a simpler palette). Seurat thus followed the principles he set forth in the Jules

Christophe brochure[20] and repeated in the text intended for Maurice Beaubourg (Appendix E). The sources Seurat mentions in the latter include Chevreul, Rood, and Henry (Appendixes J, K, L), although one wonders if he really understood Henry's rhythmic numbers "in a table calculated for the first ten billion by Mr. Bronislas Zebrowski."[21]

Less of a caricature than *Chahut*, *Cirque* does represent spectators and performers as "schemata sharpened to the point of animality"[22]—that is, the physiognomic schemata proposed by Charles Blanc and Charles Henry, as followers of Humbert de Superville (Appendixes G and L). The unremitting tension, the immutably "cheerful" colors (the pink flesh tones, which invade the floor, impart a certain softness), and the faces with their fixed grins—all these make *Cirque* a rather harsh image. Almost at the very first, Gustave Geffroy noted "stiff, geometrical arabesques" and "a palette that was too much like a laboratory exercise."[23] It may be wondered what Seurat would have done after *Cirque*—would he have moved away from this rather arid rigidity?

Yet the very qualities that prompted Geffroy's misgivings were later praised. "*Cirque* more than any other picture affirms the unwavering conviction that natural phenomena are to be considered according to their expressive value, not according to their real existence, and must even be denied if necessary," wrote Lucie Cousturier, who studied with Signac and who owned *La Grande Jatte* from 1900 to 1924.[24] *Cirque* became a twentieth-century icon. Eric Darragon recently retraced the journey of Seurat's white horse from *Cirque* to Picasso's overture curtain for the ballet *Parade*. In *L'intransigeant* of January 10, 1911, Guillaume Apollinaire remarked that Druet was publishing reproductions of art works and added, "I know someone who will quickly buy the photograph of *Cirque*, not because he likes photography but because he loves Seurat." He also wrote, "Seurat, with a precision akin to genius, made some pictures . . . in which the firmness of the style matches the almost scientific accuracy of the conception (*Chahut* and *Cirque* might almost be classified as scientific Cubism)."[25]

André Lhote[26] and André Salmon[27] echoed the enthusiasm of that generation of painters for Seurat. One could go on indefinitely with examples beyond this circle,[28] so when Florent Fels in 1924 announced that Seurat's *Cirque* was entering the Louvre's collections, he could write: "Seurat is unknown to the general public. But a reproduction of his work 'Le Cirque' is tacked to the wall in painters' studios all over the world."[29] *Cirque* had become "*LE Cirque*."

Although *Cirque* has been regarded as a formal exercise with an atmosphere of amused caricature, recent critics emphasize the image's deeper meanings. Does it offer a metaphor—the clown—for the artist's

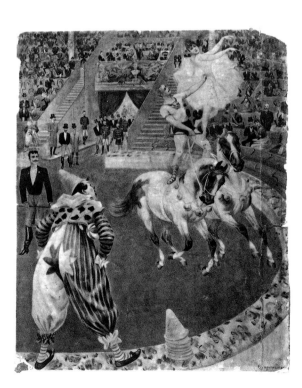

Karl Gampenrieder, *Au cirque*. Chromolithograph which probably belonged to Seurat and which was found in Signac's studio after the latter's death. Musée d'Orsay, Paris, Gift of Françoise Cachin, 1989, ODO 1981-1

role as revealer of society's mechanisms?[30] Seurat never made statements on any but formal issues. But *Cirque*, like his other large compositions, manifests a desire to rival the monumental work of Delacroix and Puvis de Chavannes. Having become, by the chance of an untimely death, a great artist's last creation, *Cirque* seems to symbolize, in the movement of the large clown's hands, two opposite poles that are evident throughout Seurat's oeuvre. The left hand, like an academic model from the École, holds a wand. The right hand, unveiling the world created by the artist, is a "real" hand, ruddy (in contrast with the white, painted face) and rather homely in its naturalism. The whole is seen through the prism of "scientific" theory.

At the close of the Indépendants exhibition, *Cirque* was returned to the artist's mother, who gave it a prominent place in the family apartment on the boulevard Magenta where Seurat had died. Paul Signac saw it again, at the end of the century; shortly before he bought it, he wrote: "Above the bed in which poor Seurat died hangs *Cirque*, his last work. I see him lying there, in the sad trappings of illness, in that somber reality, and above him, like a luminous apparition, his *Cirque*, his dream of color appearing to him in his agony. And I was reminded of certain primitive paintings in which the departed has a vision, a luminous apotheosis, of the happy souls awaiting him in paradise."[31]

1. Anecdote reported by the painter Charles Angrand (who is represented as a stocky little man, mustachioed, wearing a top hat, in the front row of spectators in *Cirque*), first in a letter to Signac, April 1900, in *Charles Angrand, Correspondances, 1883–1926*, ed. F. Lespinasse (1988), p. 121, and afterwards in the one addressed to G. Coquiot, in Coquiot 1924, pp. 166–67. On the identification of Angrand, see Fénéon 1926.
2. "Paul XXX," "Salon des Indépendants, les fumistes," *Le national* (March 21, 1891); Ernst 1891; P. Bluysen, "L'exposition des Indépendants," *La république française* (March 20, 1891).
3. Germain, *Moniteur des arts*, 1891.
4. Germain 1892.
5. Christophe, "Georges Seurat," 1890.
6. M. F., "Le Salon des Indépendants," *Le XIXᵉ siècle* (March 20, 1891).
7. Alexandre 1891.
8. Lecomte 1891.
9. "Chez les artistes indépendants," *Le jour* (March 27, 1891).
10. L. Roger-Milès, "Expositions des Indépendants," 2d part, *Le soir* (March 26, 1891).
11. Retté 1891.
12. See, for example, "Le Salon des Indépendants," *L'art moderne* (April 5, 1891); Cousturier 1912, p. 367; and Signac's opinion as reported by Fénéon in DR, pp. 279–81.
13. Seurat's predecessors have been mentioned by many authors, including Pearson 1977–78, pp. 48–49; Thomson 1985, p. 220. We may here list Renoir, *Le clown*, 1868 (Rijksmuseum Kröller-Müller, Otterlo); *Au cirque Fernando*, 1879 (Art Institute of Chicago); Degas, *Miss Lala au cirque Fernando*, 1879 (National Gallery, London); Tissot, *Ces dames des chars*, 1883–85 (Rhode Island School of Design, Providence, R.I.); *Cirque amateur*, 1883–85 (Museum of Fine Arts, Boston); Toulouse-Lautrec, *Au cirque Fernando*, 1888 (Art Institute of Chicago). Aside from these representations, there was the *Cirque* (location unknown) by one Wagner, which so impressed J.-K. Huysmans at the Indépendants of 1884 that he devoted a whole paragraph to it in *Certains* (1889).
14. Coquiot 1924, p. 102; especially Eric Darragon's careful study (Darragon 1989).
15. Jean Ajalbert, *Paysages de femmes, impressions* (1887), pp. 65–66.
16. See Pearson 1977–78 and Darragon 1989. Note that the question of the possible anteriority of an undated chromolithograph—"Au cirque," by Karl Gampenrieder—found in Paul Signac's boxes, which may perhaps have belonged to Seurat and exhibits disturbing similarities to Seurat's painting, is still unresolved.
17. Madeleine Knoblock to Signac (Signac archives).
18. Antoine 1890; Verhaeren, *Chronique artistique*, 1891; Schapiro 1958. Herbert 1958 emphasizes the connection between the horseback rider and Chéret's poster "L'amant des danseuses" of 1888; the acrobatic clown and the "Spectacle Promenade de l'Horloge" poster of about 1880; and the clown in the first study and those in the "L'Horloge: Les frères Léopold" poster of 1877. He was followed by Pearson 1977–78, Thomson 1985, and Darragon 1989, who suggest other comparisons.
19. See comments in Goldwater 1941 and by H. Dorra, in DR, pp. ciii–cvii.
20. Christophe, "Georges Seurat," 1890.
21. Charles Henry, "Rapporteur esthétique et sensation de forme," *La revue indépendante* 7, no. 18 (April 1888): 85. On *Cirque* and the theories of Charles Henry, see Homer 1964, pp. 228–34 and figs. 70 and 71.
22. Cousturier 1912, p. 397.
23. Geffroy 1892.
24. Cousturier 1912, p. 397.
25. Guillaume Apollinaire, *Les peintres cubistes* (1913), 1950 ed., pp. 44–45.
26. Lhote 1922, p. 13.
27. Salmon 1922, pp. 43, 44, 47.
28. See especially the analysis in Russell 1965, p. 266.
29. Florent Fels, "Seurat entre au Louvre," *Nouvelles littéraires* (November 22, 1924).
30. Thomson 1985, p. 220. See also Jean Starobinsky, *Portrait de l'artiste en saltimbanque*, 1970.
31. *Signac Journal*, ed. J. Rewald, p. 279.

225. *Cirque*. 1890–91

CIRCUS

Oil on canvas, 73¼ x 59½ in. (186.2 x 151 cm.)
Painted border by Seurat

Musée d'Orsay, Paris, Bequest of John Quinn, 1924 R.F. 2511

H 213; DR 211

PROVENANCE
The artist until 1891. Inherited by the artist's mother, Mme Ernestine Seurat, Paris, in 1891, until her death in 1899; by inheritance to Émile Seurat and to Marie-Berthe and Léon Appert, Paris, from 1899 to 1900; sold for 500 francs to Paul Signac, Paris, in 1900, until 1923; sold, through Henri Pierre Roché for 150,000 francs, to John Quinn, New York, in January 1923 (the painting arrived in New York on March 16, 1923), until his death in 1924; his bequest to the Louvre, 1924; entered the collection in 1926; transferred to the Musée du Luxembourg, 1929; then to the Musée National d'Art Moderne; to the Jeu de Paume, 1947; to the Musée d'Orsay (Palais de Tokyo), 1977; to the Musée d'Orsay, 1986

EXHIBITIONS
1891 Paris, Indépendants, no. 1102
1892 Brussels, no. 19
1892 Paris, Indépendants, no. 1087
1900 Paris, Revue Blanche, no. 39
1905 Paris, no. 20
1908–09 Paris, no. 83
1920 Paris, no. 34
1933–34 Paris, no. 59
1937 London, no. 30
1958 Chicago and New York, no. 152

Paul Signac bought *Cirque* at the Revue Blanche show in 1900 (see Chronology). He sold it to the New York attorney John Quinn (1870–1924) on the condition that Quinn bequeath the work to the Louvre,[1] thereby giving the French museum a masterpiece at a time when the artist's large canvases, already valuable, were going abroad.

Robert J. Goldwater first remarked that in *Cirque*, which continued a development evident in *Parade* and *Chahut*, Seurat was thinking in terms of decorative surface and line rather than depth of space.[2] The composition is marked by multiple points of view. We look down on the clown in the foreground. The spectators face us in the rectilinear tiers (they should be curved) with no receding effect; although we see the horse from above, we see its right hind leg from below.

Within this space, which tends toward a single flattened plane, the sweep of curved and oblique lines is strongly opposed by the verticals and horizontals of the stands. The rider's mount, in defiance of Muybridge's photographs,[3] gallops like a wooden merry-go-round horse. The upward movements of the equestrienne follow Humbert de Superville's rules for the representation of "gaiety."[4]

An infrared photograph taken by the research laboratory of the Musées de France[5] reveals the grid, visible in places to the naked eye, that Seurat drew in blue-green on the canvas. It shows, for one thing, that earlier attempts at reconstructing this framework were not accurate.[6] However, we are left in doubt as to the grid's significance. Seurat laid it over the entire canvas (even though he had from the first planned the dark blue *pointillé* border). But to what end? The figures of the composition frolic freely in this framework. And the force lines in *Cirque* follow a geometry quite different from that of the grid. The plausible explanation is that the grid was used by the artist to scale up a small format to the large format of the final canvas. The only known complete sketch (cat. no. 226) has no grid, but Seurat may have squared up a tracing of this study.[7]

The same infrared photo shows the first stage of the composition. Like its architecture, the figures of *Cirque* were drawn and sometimes strengthened by a network of small brushstrokes. Some repainting is evident in the man without a hat in the stands at left; there were also changes in the position of the dancer's leg, of the foot of the clown behind the ringmaster, and of the latter's whip. A figure in the center of the upper stands was removed, leaving a row empty. Some figures have very faint outlines, and they are instead built up of defined *pointillé* touches; the little girl and her mother in the upper stands are painted in this way in contrast to their neighbor who is clearly drawn. These lines, visible by infrared but not to the naked eye (except on the horse's belly), are to be distinguished from the line (often blue) that defines the figures in the painting with a prominence not seen in earlier compositions. This exploration of the underlying layers of the painting establishes the extent to which the composition had been determined when Seurat began the large canvas.

As we have seen, the dark border (ultramarine blue with touches of emerald green), abruptly detaching the bright composition from its surroundings, was in place from the very beginning. We now come to the frame, itself *pointillé*,

in which *Cirque* is seen at the Musée d'Orsay, Paris. Félix Fénéon, when reviewing the text on *Cirque* in César de Hauke's catalogue, confirmed the frame as autograph at a time when several scholars (Dorra and Rewald, in particular) were challenging its authenticity.[8] Several critics who saw the exhibition of 1891 mention Seurat's "somber" frames but always in connection with his landscapes.[9] Adolphe Germain alone refers to a *Cirque* "frame with tones and tints in opposition to the whole."[10] In vague terms Pissarro relates: "All his paintings are framed in chromatic colors, which together create a blue or violet stripe that I find quite unpleasant and inharmonious; the effect is something like velvet."[11] It is hard to tell whether the testimony of contemporaries refers to the border or to the frame. The *Cirque*'s frame consists of a thin board stiffened and assembled by bracing in back and painted in the dominant violet-blue with a green shimmer in places (near some orange-red elements). As in the border painted on the canvas itself, there is a pronounced crackling that suggests somewhat hasty execution. The painted frame is edged with a gray rod concealed by a white-and-gold fluted molding, which looks more recent but appears in a photograph published when the work entered the Musées Nationaux.[12]

On the reverse, in a corner, the frame bears the initials "P.S." in blue. Is this a "signature" affixed by Paul Signac after making, or completing, a frame in his friend's manner? Is it an authenticating mark made during the inventory, or is it simply a reminder that the work as well as the frame belonged to Signac? There is no testimony but Fénéon's to help us decide. In any case this frame is manifestly historical, and its retention is warranted.

Four study drawings for *Cirque* are discussed below (cat. nos. 227–230). Dorra and Rewald as well as de Hauke list two additional preliminary studies in conté crayon: one for the portion of the stands at right (H 711; DR 210a), lacking the acrobatic clown figure of both the sketch and the final composition; and one for the ringmaster (H 708; DR 210b). The spare conté-crayon drawings were probably done on-site[13] or as a record of first thoughts. The watercolor and the drawing on tracing paper are the only such studies that relate directly to the elaboration of a painted composition. Robert Goldwater (1941) early drew attention to the fact that compared to *La Grande Jatte*, for example, *Cirque* was preceded by very few studies. He also remarked their linear character. The studies in any event

reflect a disconcerting casualness of method and a radical change of practice in working out a major composition, less than ten years after Seurat's first efforts.

1. Judith Zilczer, *The Noble Buyer: John Quinn, Patron of the Avant Garde*, exh. cat., Hirshhorn Museum and Sculpture Garden, Washington, D.C., 1978, pp. 52, 68, nn. 26–27. J. Quinn celebrated the arrival of the work in New York on March 16, 1923.
2. Goldwater 1941; see also H. Dorra, in DR, pp. ciii–xvii.
3. From the late 1870s onward, the French could have known Eadweard Muybridge's photographs resolving the several gaits of a horse and experiments devised by Marey. Both prove among other things that a galloping horse's feet are gathered under the body and not extended as portrayed by painters from Géricault to Degas. Eric Darragon sees this as the "mistake" in drawing that Seurat feared had annoyed Puvis de Chavannes (Darragon 1989).
4. See Appendix H.
5. This study was conducted by Charles de Couessin, and we are indebted to M. Bernard, director of the laboratory, and his team, for permission to publish the document. An École du Louvre monograph on the subject was written by Blandine Salmon in 1989.
6. DR, p. cv; and Minerino Chastel 1973, p. 111.
7. Marguerite Neveux, whose thesis (Neveux 1991) is eagerly awaited, has very kindly helped us to interpret these complicated data. She suggests regarding that the grid was made by marking down from the top, and up from the bottom, a distance equal to the picture's width. Two overlapping squares were formed; the diagonals of these squares are then drawn, generating a central rhombus that becomes the module for the rest of the grid, the side of the rhombus being stepped off from the center. This would explain why the ends of the oblique lines are "fishtailed" in the margins. Then it is possible to draw verticals through the intersections. Henri Dorra (DR, p. civ) had observed that the verticals AA′ and BB′ are determined by approximation to the golden section of the width, as has been verified on the canvas itself within a millimeter. However, this is by no means proof that Seurat deliberately used this proportion, since the measurements follow necessarily from the fact that his format (151×186.2 cm.) corresponds to a double golden rectangle. The segment AB, by the way, measures 35.2 cm., equal to the difference between the two sides.
8. See comments for cat. nos. 225 and DR 211. Semin 1980 regards the frame as being by Seurat.
9. L. Roger Milès, *Le soir* (March 26, 1891); Retté 1891; Lecomte 1891; P.B., *La république française* (March 20, 1891); Alexandre 1891; "Paul XXX," *Le national* (March 21, 1891).
10. Germain 1891.
11. Camille Pissarro to Lucien Pissarro, CP, vol. 3, no. 647 (March 30, 1891). Pissarro, who had approved the painted frame at the time of *Poseuses*, found it ugly at the 1891 Indépendants.
12. *Excelsior* (March 10, 1926). The molding is similar to the frame provided by Signac for *La bouée rouge* (Musée d'Orsay, Paris). See Isabelle Cahn, *Cadres de peintres*, exh. cat., Paris 1989.
13. As stated in Coquiot 1924. p. 102.

226. *Esquisse pour "Cirque."* 1890–91

SKETCH FOR "CIRCUS"

Oil on canvas, 21⅞ x 18¼ in. (55.5 x 46.5 cm.)
Painted border by Seurat

Musée d'Orsay, Paris, Gift of Mme Jacques Doucet, in accordance with her husband's wishes, 1937 R.F. 1937-123

H 212; DR 210

PROVENANCE
The artist's family until 1900; sold to Félix Fénéon, Paris, in 1900, until 1924; sold to Jacques Doucet, Paris and Neuilly-sur-Seine, in 1924, until his death in 1929; by inheritance to his widow, Jeanne Doucet, from 1929 until 1937; her gift, in accordance with her husband's wishes, to the Louvre, 1937; transferred to the Jeu de Paume, 1947; to the Musée National d'Art Moderne, 1959; to the Jeu de Paume, 1972; to the Musée d'Orsay (Palais de Tokyo), 1977; to the Musée d'Orsay, 1986

EXHIBITIONS
1900 Paris, Revue Blanche, no. 38
1908–09 Paris, no. 82
1952 Venice, no. 18

When Seurat, using a canvas of standard format (10 F), painted the only known full sketch for *Cirque*, the main features—including the border—were already fixed. The preliminary drawings in conté crayon (cat. nos. 229 and 230) had indicated the major figures. In this sketch they take their respective places. The clown's head differs from the drawing; this and later versions show part of his whitened face, creating a link with the viewer. His right hand holds a curtain—a detail suggested in the drawing that would be used in the final painting. At left, a hand belonging to an unseen figure echoes the clown's gesture; it was not retained in the final painting. Here the horseback rider is also in a transitional state between the image in the drawing, where her legs are parallel, defying balance, and that in the larger work. The tumbling clown has been deprived of his tripod (present in the drawing). Seurat has not yet introduced the third clown figure, partly eclipsed by the tailcoated ringmaster in the large painting. The stands, the orchestra, and the entrance are more sparsely peopled than they would be. The snapping whip is dark on a light background (as is the equestrienne's crop)— tonal relationships that would be subsequently reversed.

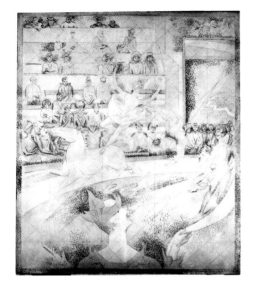

Infrared photograph of *Cirque*

Rendering of grid underlying *Cirque*

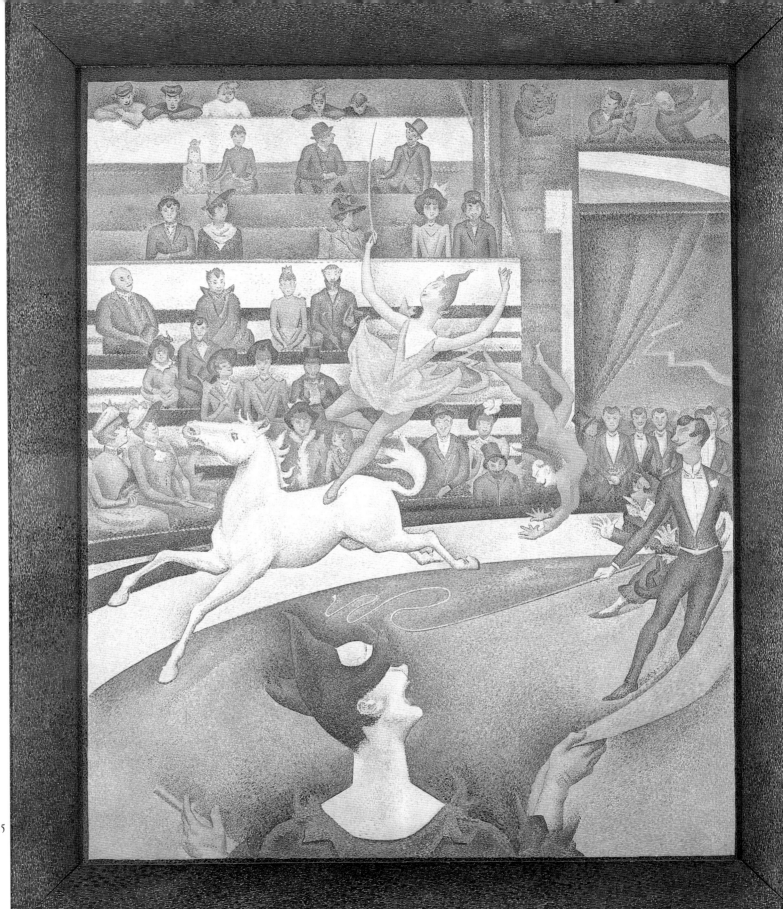

The most striking feature is the placement of the dominant colors— red, yellow, blue—in separate strokes on the raw white of the prepared canvas. Strokes in mixed tones, green or pink, are used for the equestrienne's skin. A green stroke emphasizes the clown's hand in the foreground and the tumbler's silhouette.

A handwritten annotation in Signac's catalogue of the Revue Blanche exhibition of 1900 suggests that this sketch was purchased by Fénéon at that time. A number of paintings were then sold by Seurat's family, and Signac bought the large composition. André Suarès and later André Breton convinced the couturier and collector Jacques Doucet (1853–1929) of Seurat's importance and of the wisdom of acquiring a major work by him.[1] In 1924 this sketch, along with Picasso's *Les demoiselles d'Avignon*, was to be seen hanging in Doucet's studio at 33 rue Saint-James in Neuilly.

1. François Chapon, *Mystère et splendeurs de Jacques Doucet, 1853–1929,* Paris, 1984, pp. 296, 381 n. 98, 382 n. 99.

Studio of Jacques Doucet. From Marie Dormoy, *La bibliothèque littéraire de M. Jacques Doucet,* 1929

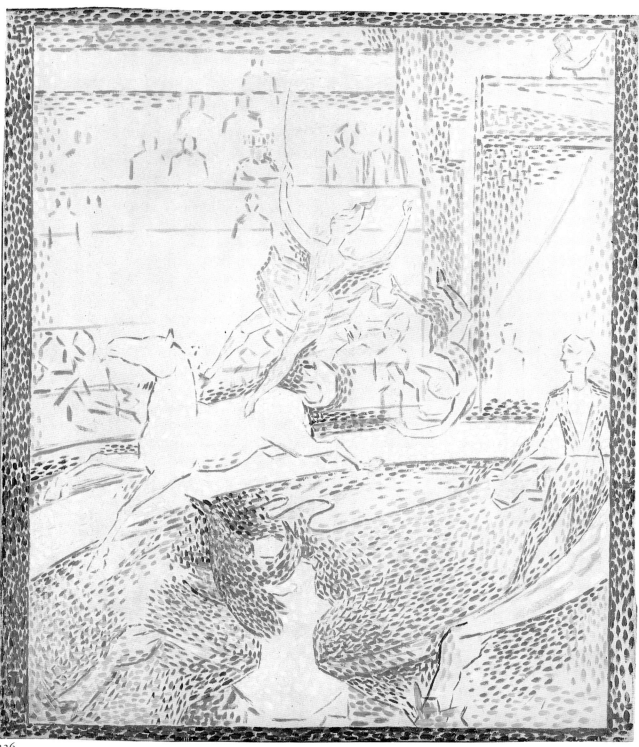

226

227. *Le clown et M. Loyal.* 1890–91

CLOWN AND RINGMASTER

Watercolor on tracing paper, 12¼ x 14 in. (31 x 35.5 cm.)

Musée du Louvre, Paris, Département des Arts Graphiques, Fonds du Musée d'Orsay R.F. 29.541

Exhibited in Paris only
H 710; DR 210e

PROVENANCE
The artist until 1891. Posthumous inventory, probably dessin no. 375 (not numbered, but inscribed in blue crayon on reverse of the original mount "Pour le Cirque"; initialed by Fénéon in blue crayon and by Signac in red crayon);* inherited by the artist's brother, Émile Seurat, Paris, in 1891; Félix Fénéon, Paris, until his death in 1944; his estate, 1944–47 (Fénéon sale, Drouot, Paris, May 30, 1947, no. 39); purchased at this sale by the Musée du Louvre

EXHIBITIONS
1936 Paris, no. 128
1957 Paris, no. 32
1958 Chicago and New York, no. 151

*According to Fénéon's description of the posthumous inventory (H, I, p. XXIX) there were two drawings for *Cirque* included in the inventory, which were numbered 374 (see provenance, cat. no. 228) and 375.

Like the study of the clown's head (cat. no. 228), this watercolor line drawing is unique in Seurat's oeuvre. The tracing, probably a fragment, is in the same scale as, and practically superimposable with, the figures in the painted sketch (cat. no. 226). It was most likely used in scaling up the small painted sketch to the large format. In fact, one can read, reversed, on a horizontal line, "1 m 46 + 0.16½ [cm.]" and, on a vertical, "1.85½ [cm.]"—dimensions very close to those of the large painting. However, the vertical and horizontal lines marked on the tracing bear no relation to the grid of the final painting.

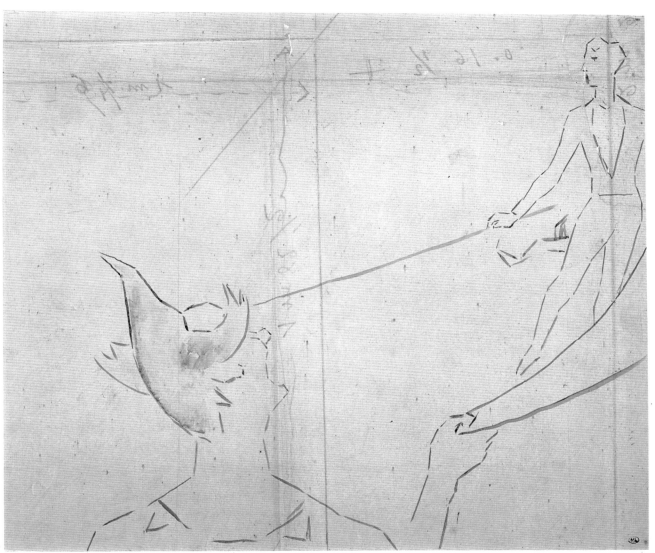

227

228. *Tête de clown.* 1890–91

HEAD OF A CLOWN

Pencil, 24⅜ x 18¼ in. (62 x 47.5 cm.)

Woodner Family Collection, New York

H 709; DR 210f

PROVENANCE
The artist until 1891. Posthumous inventory, dessin no. 374. Inherited by the artist's family in 1891; by inheritance to Mme Léopold Appert, Paris; private collection, Paris; with Brame et Lorenceau, Paris, until September 1988; sold to present owner, September 1988

EXHIBITION
1990 New York, no. 137

This study, on tracing paper and squared for transfer, is unique in Seurat's oeuvre. Although it is a same-size detail of the clown in the final painting, it is nevertheless not superimposable.[1] It may be, however, a fragment of a full-size study for the composition, though not an actual cartoon squared for transfer. The tracing includes verticals (not found in the painting) that do not meet exactly at the intersections of the diagonals. Seurat marked off distances on the verticals with dividers. The sides of the resulting pseudosquares are unequal. The whole suggests a trial related to the final composition, whose grid is, however, perfectly regular.

1. I am indebted to the Ian Woodner Family Collection and to Jennifer E. Jones, its curator, for their kind cooperation in the experiment of retracing the drawing and its scheme so that I could make a direct comparison with the Musée d'Orsay painting. Not only do the construction lines fail to superimpose, but if the contours of the wig are made to coincide, the shoulder lines diverge.

229. *Clown, dessin pour "Cirque."* 1890

CLOWN, STUDY FOR "CIRCUS"

Conté crayon, 6¼ x 13 in. (15.8 x 33 cm.)
Inscribed in an unknown hand lower left: Dernier dessin/de G. Seurat/Février 1891

Private collection

H 712; DR 210c

PROVENANCE
Paul Signac, Paris, until his death in 1935; by inheritance to Ginette Signac, Paris; to present owner

EXHIBITIONS
1900 Paris, Revue Blanche, no. 53(?)
1926 Paris, Bernheim-Jeune, no. 120

Seurat may have cut this drawing from the bottom of another. The artist may equally well have chosen this broad format for the clown's "dynamogenic" crest and hand; this hypothesis is supported by our knowledge of Seurat's habit of doing separate studies for each figure of a large composition. Here the relationship to the overall composition is suggested by the indication at the upper left of the horse's leg above the nervous zigzag of the ringmaster's whip.

The date "February 1891," in a hand that is neither the artist's nor, as has sometimes been said, Signac's, is confusing. In February Seurat had settled all the details of his large canvas. It seems unlikely that this drawing is after the final version; rather, like *L'écuyère* (cat. no. 230), it seems to be a preliminary idea which should be dated earlier than February 1891.

230. *L'écuyère.* 1890–91

BAREBACK RIDER; EQUESTRIENNE

Conté crayon, 11¾ x 12¼ in. (30 x 31 cm.)

Private collection

H 707; DR 210d

PROVENANCE
The artist's mother, Mme Ernestine Seurat, Paris, in 1891, until at least 1892; Paul Signac, Paris, until his death in 1935; by inheritance to Ginette Signac, Paris; to present owner

EXHIBITIONS
1892 Brussels, no. 23
1892 Paris, Indépendants, no. 1123
1900 Paris, Revue Blanche, no. 53(?)
1926 Paris, Bernheim-Jeune, no. 145 suppl.

This sketch of the circus rider shows the figure's placement in the composition. Robert Goldwater (1941) noted the absence of depth and suggested that Seurat at first envisioned his composition in terms of line. However, the tumbling clown at right, drawn to a much smaller scale, implies a receding space, as do the slight curve of the stands and the shadow surrounding the rider. The cut-out silhouette, fixed in an unstable and ill-defined position, was used in the painted sketch (cat. no. 226) but would be abandoned in the final version, and it has none of the nervous authority of the large painting's angles and ellipses. The light fog enveloping the somewhat wavy forms lends charm to the drawing.

To the left is a trace of a grid; particularly apparent is a vertical passing through the horse's withers, perhaps owing to a crease in the paper.

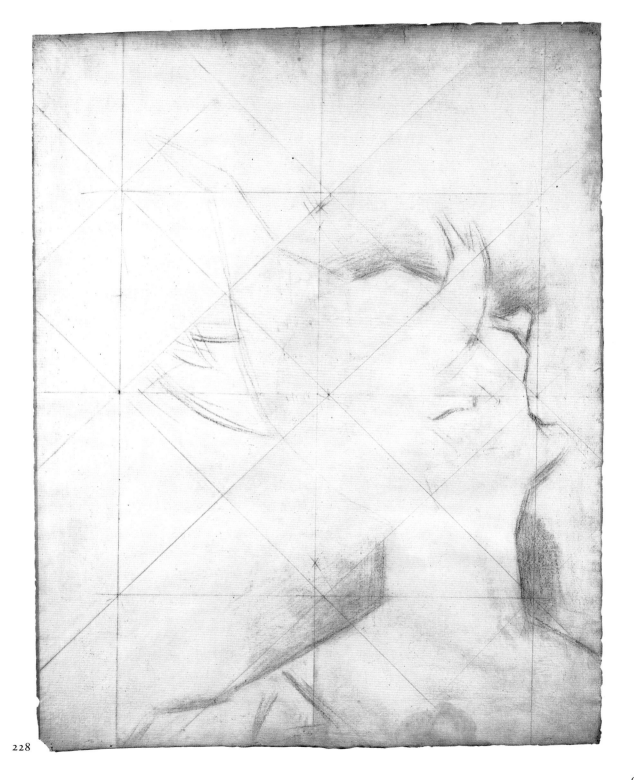

228

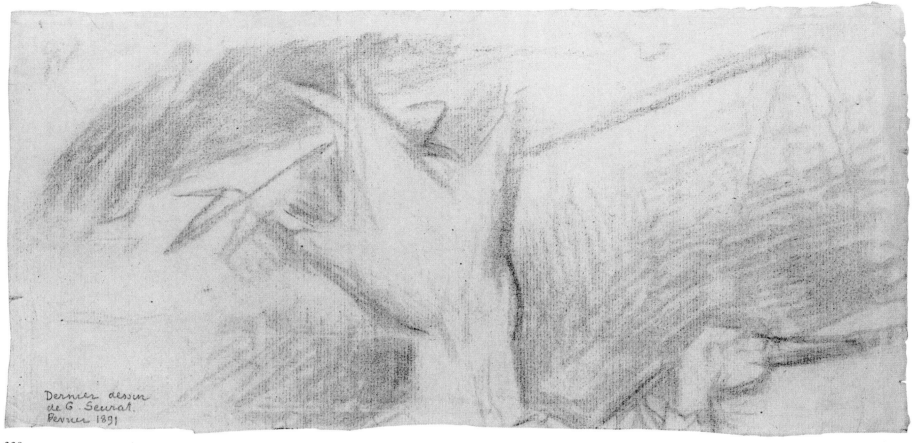

Dernier dessin
de G. Seurat.
Fevrier 1891

229

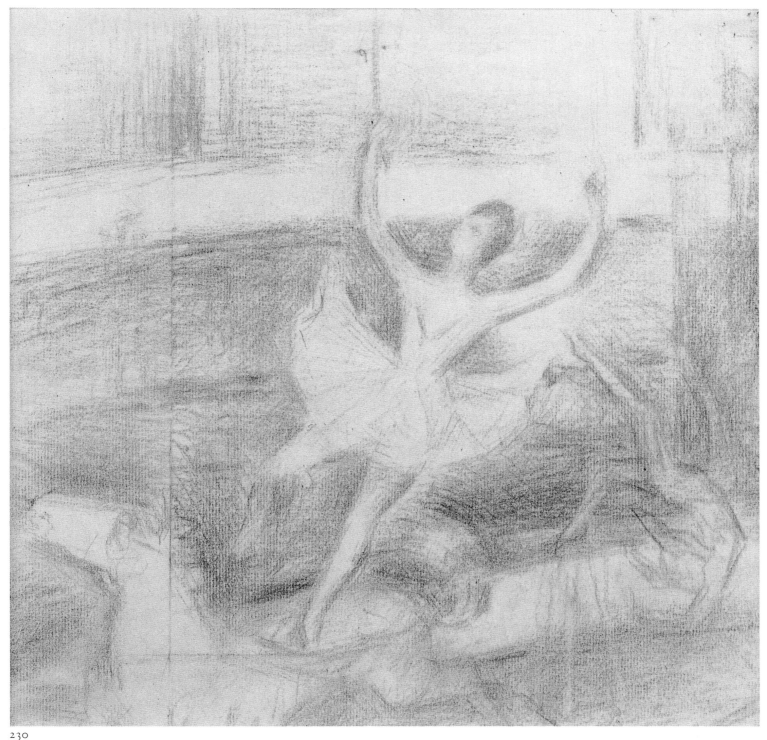

230

Seurat's *Esthétique*

231. *Draft of a letter from Seurat to Maurice Beaubourg, August 28, 1890*

Ink on paper, 9⅜ x 12⅜ in. (23.9 x 31.4 cm.)

Private collection

PROVENANCE
Never sent by Seurat to Maurice Beaubourg, Paris, in 1890. Acquired from the artist's estate by Félix Fénéon, Paris, in 1891 or later, until his death in 1944; by inheritance to César de Hauke, Paris, from 1944 until his death in 1965; to present owner by 1983

EXHIBITION
1983–84 Bielefeld and Baden-Baden, no. 86

231

Une notice bibliographique les hommes d'aujourd'hui me concerne
N° 368 texte de Jules Christophe
Le N° 373 de Félix Fénéon est pour Signac le 376 pour Luce
(Jules Christophe)
Les grandes toiles de Signac sont:
~~Les Modistes~~ Appréteuse et garnisseuse (modes) rue du Caire 85 86
La salle à Manger 87 Un Dimanche à Paris 89.90
Mais la notice que vous pourez facilement vous procurer
vous renseignera mieux que je ne puis le faire
Pour finir je vais vous dire la note esthétique et technique
qui termine le travail de Mr Christophe et qui vient de moi
je la modifie un peu n'ayant pas été bien compris par l'imprimeur

Esthétique :
L'Art. c'est l'Harmonie
L'Harmonie. c'est l'analogie des Contraires. l'analogie des semblables
de ton de teinte de ligne considérés par la dominante
et sous l'influence d'un éclairage en combinaisons
 gaies calmes ou tristes
Les contraires ce sont:
1° Le ton le plus (lumineux) clair pie un plus sombre
pour la teinte les complémentaires. c.a.d. un certain rouge opposé à sa complé
 mentaire etc..
 (Rouge – Vert
 (Orangé – Bleu
 (Jaune – Violet
pour la ligne elles. faisant un angle droit

La gaité de ton c'est la dominante lumineuse de teinte la dominante
chaude de ligne, les lignes au dessus de l'horizontale ⋏
Le calme de ton c'est l'égalité du sombre et du clair de teinte
du chaud et du froid et l'Horizontale pour la ligne

Le triste de ton c'est la dominante sombre de teinte
la dominante froide et de ligne les directions
abaissées ⋏

Technique
Etant admis ~~que~~ les phénomènes de la durée de l'impression
sur la rétine ~~sont les mêmes~~ lumineuse
~~Le moyen d'expression sera synthétique~~

 La synthèse s'impose comme résultante
Le moyen d'expression est le Mélange optique
des tons des teintes (de locatltes et de la couleur
éclairante soleil lampe à pétrole gaz etc) c'est à dire
des lumières et de leurs réactions (ombres)
suivant les lois du contraste. de la dégrada
tion de l'irradiation.

 Le cadre ~~n'est plus comme au commencement~~
est ~~opposé~~ dans l' harmonie opposée ~~à celle~~ des tons
des teintes et lignes du ~~motif~~ tableau

Appendixes A through P

Chronology

List of Exhibitions

Seurat in France

Bibliography

Concordance

Acknowledgments

Index

Appendix A

Seurat's Painted Borders and Frames

Seurat was first and foremost a painter, unlike Gauguin, who also worked in sculpture, graphic arts, and decoration. Even Seurat's drawings are the work of a painter who thinks in terms of mass and tone, not line. He showed no interest in printmaking either, despite the closeness of his conté drawings to lithography and etching. Within his chosen realm, however, he wanted to begin art all over again, and this ambition extended to the way his pictures were framed. He began by using white frames, then he painted them in colors, and finally he added contrasting borders along the edges of his canvases. (Borders and frames are described in this volume within catalogue entries.)

Many artists, including Whistler and Puvis de Chavannes, had earlier rejected gold frames, and several of the Impressionists had used both colored and white frames.[1] It is therefore not surprising that in 1886 Seurat, Signac, and the Pissarros put their pictures in white or off-white frames. *La Grande Jatte* had a heavy white frame (it appears in the background of *Poseuses*), and Seurat's landscapes in 1886 were also in white, apparently flat frames with parallel strips or grooves.[2] It was in early summer of 1887, when he was working on *Poseuses*, that Seurat first thought of painting his frames in colors complementary to adjacent picture hues. Both Pissarros and Signac greeted this as a surprising innovation,[3] and when the picture was exhibited the following March, it was widely commented upon. Unfortunately the frame was later destroyed, as were those for *La Grande Jatte*, *Chahut*, and several landscapes. Gustave Kahn left a description of the frame of *Poseuses*: "A fortunate detailed find of M. Seurat's is the interior polychromed frame, surrounded by the white strips of a large general frame isolated from the canvas by this polychromed frame that is enclosed, as it were."[4]

After 1888 no reviewer mentioned both a narrow and a wider wood frame, so we can assume that the borders that Seurat painted on the canvas replaced the narrow interior frame mentioned by Kahn. Contemporary reviewers thereafter describe his frames in rather general terms as "white" and, by 1890, as "gray" and "gray-blue." We know that *Chahut* was exhibited in 1890 surrounded by a frame painted gray or blue-gray (both terms are used), and that Seurat repainted it a year later, when it appeared in Brussels with a multicolored frame, presumably like the one that survives for *Cirque* (cat. no. 225). Evidence of it remains, as it were, in an embroidery of orange dots along the outside of the picture's painted border. These were added to react to the dominant blue of the now-lost wood frame—an extraordinary instance of the "analogy of contrasts," for it means that one element of the frame reacted to the other. Sad to relate, the German critic Jules Meier-Graefe, who acquired *Chahut* from Kahn, had Henry van de Velde replace Seurat's frame with one that suited other furnishings van de Velde designed for him.[5]

In 1888 Seurat began painting borders directly on his canvases rather than on an interior wood member, as he had done for *Poseuses*, and in the final three years of his life he displayed his pictures with these borders as well as with frames. It is possible that he was inspired partly by Chevreul, who urged attention to the harmonies of picture frames (although he did not suggest Seurat's colored frames);[6] Chevreul also devoted a whole section of his treatise to framing interior wall panels in borders of contrasting harmonies. Seurat's borders were narrow bands whose colors contrasted with the adjacent hues of the canvas. He added them to already-completed pictures, including *La Grande Jatte* and its principal study (cat. no. 141). Such works required considerable effort, for he sometimes had to restretch a canvas to allow for the additional border. This, in turn, meant making a larger external frame and painting it, too. Creating all these borders and frames took a lot of time, which may explain why there are fewer drawings in the artist's last years: working on current paintings and reworking earlier ones left him little time.

In 1890 Seurat exhibited both *Jeune femme se poudrant* (cat. no. 213) and *Chahut* with painted borders whose upper corners curve downward, to oppose the upward rhythms of the compositions. These borders brought together his concerns for color and for the ideas of linear expression of Humbert de Superville and Charles Henry.

That he was thinking in terms of harmonies of contrast is certain, for he wrote in his *esthétique* (Appendix E) that the frame's harmony should be opposed to the colors, values, and lines of the painting, and he penned in appropriate diagrams. Alert to his own era's preoccupations, Seurat likened his dark borders and frames to Wagner's darkening the theater at Bayreuth to isolate the stage from mundane surroundings.[7] Symbolist critics, well versed in *wagnérisme*, welcomed this as another sign of Seurat's vanguard position. He probably shared their fascination with *correspondance des arts*—that is, with the interchanges among painting, music, and dance that infuse our emotions by overcoming the separateness of our channels of sight, sound, and touch. *Parade de cirque* (cat. no. 200), of course, features music, while both *Chahut* and *Cirque* represent music together with the illusion of movement.

It should be said that few of Seurat's critics liked his painted frames, whose raison d'être was challenged by Fénéon. It was all right to note complementary colors on a frame, he wrote, for since it was theoretically white, it could logically receive the effects of contrast. However, Seurat went too far, for "he imagines that *in reality* it circumscribes the landscape and, according to the logic of this useless hypothesis, he punctuates it with orange or blue according to whether the sun is behind or in front of the spectator, therefore according to whether the frame is in sunlight or shadow: and the frame, although remaining white, acquires... an absurd reality."[8] An example of this "absurd reality" is the frame he added to *Embouchure de la Seine, soir, Honfleur* (cat. no. 166), whose lower left corner registers the effect of sunlight coming out of the picture. Fénéon was quite right to point out the curious pseudoreality of such painted frames, but Pissarro's first reaction (see note 3 below) was to admire the way the frame could participate in a composition's illusion of light, and Dubois-Pillet showed his agreement by emulating the innovation. Seurat's "absurd reality" was carried further in following years. In 1892 the Belgian artist A. J. Heymans continued the imagery of his picture out onto his frame,[9] a procedure followed later by Robert Delaunay, Matisse, Gino Severini, and other artists.

1. Didier Semin (1980) describes the Impressionists' colored frames in his excellent study of Seurat's frames. Robert Goldwater (1941) had shown Pissarro's priority in the use of colored frames and suggested that Pissarro, whom Seurat met in 1885, might well have given the younger artist the idea.

2. According to Kahn 1924: "with wide stripes" ("à grosses rayures").

3. Pissarro wrote Signac on June 16, 1887: "Yesterday I visited Seurat's studio. His big picture [*Poseuses*] advances. . . . It will evidently be a very beautiful thing, but what will be surprising will be the execution of the frame. I saw the beginnings. It's certainly indispensable, my dear Signac. We will be obliged to do the same. The painting is no longer at all the same thing in white or any other material. Positively one only gets an idea of sunshine or gray weather thanks to this indispensable complement" (CP, vol. 2, no. 441).

4. Kahn, March 1888.

5. The Neo-Impressionist Henry van de Velde, who knew Seurat, reviewed his works shown in Brussels in 1891. After framing his pictures in white, he wrote, Seurat now added colors: "Here created are his last borders of a logically contrasting *pointillé*, vibrating with teeming decomposed colors: especially horrible! Only *Chahut* holds up, which nonetheless pleased us more at the Indépendants [1890] in Paris, in its initial gray frame [encadrement gris]" (van de Velde 1891). "Gris" is a generic term and need not mean literally gray. All nine of Seurat's paintings at the Indépendants were said to be "in gray-blue frames" ("en cadres gris-bleu") (Christophe, *Journal des artistes*, 1890) or simply in gray frames (Alexandre 1890). John Rewald reproduces a photograph showing Meier-Graefe's interior with the *Chahut* in its van de Velde frame (*Signac Journal*, ed. J. Rewald). From Fénéon, César de Hauke learned that the frame around *Poseuses* (H 185) had been dismantled and that portions of it may have been used to frame other works, including *La tour Eiffel* (cat. no. 210). The frame of *La Grande Jatte* was cut up sometime in the 1940s; a facsimile is now in its place.

6. See Semin 1980.

7. The analogy with Bayreuth was attributed to Seurat himself in Verhaeren, *Société nouvelle* (1891) and in van de Velde, "Georges Seurat" (1891). Kahn (1891) used the Wagnerian term *leitmotiv* when he discussed *Chahut*. Paul Smith's recent work (1990) devotes a chapter to Seurat and *wagnérisme*.

8. Fénéon, April 1888.

9. For example, *La mine, environs de Charleroi*, sold at Christie's, New York, October 20, 1988, no. 47.

Appendix B

Aman-Jean on Seurat's School Years

In preparing his book *Georges Seurat*, published in 1924, Gustave Coquiot solicited letters about the artist from a number of Seurat's friends. Typescript copies of the originals were pasted down in the manuscript for the book, once in the collection of the late Dr. Jean Sutter, and excerpts were published. In their entirety, the letters from Aman-Jean (Amand-Edmond Jean, 1858–1935)[1] offer valuable insights not otherwise available. Coquiot's archives, mentioned below in his prefatory note, have not yet been located.

Letter from his faithful friend the painter Aman-Jean, which I received July 17, 1923 (original in the archives):

Dear Sir,
I have a very beautiful portrait of me by Seurat (one of those magnificent drawings that he did). If you wish, you could reproduce it in your book. I keep it in the country, at Château-Thierry, where very fortunately it was left alone by the Germans, and very fortunately also by the bombardments. . . . Unfortunately I didn't do his portrait although he did mine.

As for his physical personality, he resembled Donatello's Saint George now in the Bargello Museum in Florence and formerly in a niche in Or San Michele. He was handsome.

Instinct and talent dominated Seurat's whole being. He was prodigiously gifted to have done what he did so young; if he had lived, he would have achieved great mastery. I owe him much; our discussions were endless, our sojourns in the country prolonged.

When we left the École des Beaux-Arts, we took a studio, whose rent we shared so as to work together and try to find what stuff we were made of; to add, to complete, and to erase partly what was inane and so incomplete in the *Grammaire des arts* taught at the École.[2] (We were in Lehmann's studio.) Not the slightest idea about art came to him from his family: his father was a bailiff at La Villette. Everything came from his own talent. We became acquainted at a little municipal drawing school on the rue des Petits-Hôtels, near Saint-Vincent-de-Paul; his parents lived in that district,

so did mine. From there we went to the École des Beaux-Arts under the iron rule of Henri Lehmann, a pupil of Ingres's; he was only one of Ingres's pawns and never said anything that opened up a vista or gave young people a leg up.

It's drawing, thoroughly understood, that put Seurat on the right path. Drawing is always quibbled over; many well-known professionals will never understand anything about it. In our youth Puvis de Chavannes did not know how to draw; for a lot of people the imbecilic wiry line of Jules Lefebvre was drawing, and so it has remained.[3] The theory of complementary colors was our passion. Divided brushwork, the visible part of craft that became a method, would have reached perfection with him. He had in embryo the most beautiful things. He was well read and had a taste for the difficult. He would not have tolerated the carelessness of most painting today, even less the superficially finished.

Second letter from Aman-Jean, received at Bel-air on August 4, 1923 (original in the archives):

Château-Thierry / Aisne
August 2, 1923

Dear Sir,
It's from here and a little late that I reply to your letter, forgive me.

Seurat's father visited the little studio we shared, rue de l'Arbalète. To the disrespectful dauber I must have been then, Mr. Seurat was the perfect type of the bourgeois. I never noticed nor heard that he was one-armed and provided with some kind of orthopedic device.[4] His mother, whom I saw only once, was also the typical good woman of the ordinary bourgeoisie. They had a property in Le Raincy; I never went there. During the events of the Commune in 1871, his parents, like good bourgeois living on income, waited things out at Fontainebleau; Georges went there, naturally, and his brother; I never heard him speak of his sister. He considered his brother far removed from us. "He likes to have good suits," he said. His father and his whole family were all the opposite of what we were, thanks to our tastes and our passion for art. How on earth did this passion come to him and to me? It's the mystery of what can lie asleep underneath the most bourgeois covering. Speaking one day of that, he said that his father, when

buying prints for Le Raincy or their apartment on the boulevard Magenta, habitually preferred religious subjects; there was his whole aesthetic.

When young, he was certainly sensible and disciplined. Some of our comrades, ignoring that a sense of order is the basis of all art, said that Seurat must have been a Communard.[5]

A teacher at home is unlikely.[6] I think he simply went to the Turgot school, but I cannot certify that. Our municipal drawing school was on the rue des Petits-Hôtels, headed by a sculptor, Justin Lequien, who taught us to hemstitch noses and eyes after lithographed models. How from this teaching he accomplished what he did remains the mystery of what lies dormant underneath.

We read tirelessly, judging literature. Goncourt was our god then. For a long time Ingres was Seurat's god. His judgment, his tastes, his initial way of understanding and fulfillment, everything with him was instinctive, but the kind of instinct that does not deceive and that leads to the rapid achievement of those who are destined to disappear young.

If I remember other things, I will not fail, dear sir, to share them with you. My portrait, which I just saw again here, is *very, very beautiful*; I will not fail to take it to Paris, and I will notify you as soon as I arrive in November. It was done in the little studio we shared in the rue de l'Arbalète. One year we spent our vacation in Pontaubert near Avallon. He had his own studio in the horrible rue de Chabrol near his parents.[7]

1. Aman-Jean's correct name and birth date were only recently discovered by Anne Distel while doing research for the Chronology of this catalogue.
2. By saying that the two took a studio after leaving the École (Seurat enrolled in Henri Lehmann's class in March 1878), Aman-Jean seems to indicate that they were on their own before Seurat left for military service in November 1879. This is apparently true of Seurat, but Aman-Jean took classes at the École for several more years (students normally had an outside studio while enrolled in the École). Despite Aman-Jean's disparagement of Charles Blanc's *Grammaire des arts du dessin* (1867), Blanc remained important to Seurat all his life.
3. Pierre Puvis de Chavannes (1824–1898); Jules-Joseph Lefebvre (1836–1911).
4. Coquiot had obviously shown Aman-Jean the text of a letter he had received from Paul Signac (partly reprinted in his book), who had said Seurat's father had only one hand. Signac may well have

embellished his memory of the artist's father, but it seems unlikely that he would have entirely invented the missing hand and its replacement with a hook. Antoine Seurat may have lost his arm after 1884, in which case Aman-Jean is unlikely to have known about it since he was no longer close to his son.

5. "Pour certains de nos camarades ignorant que le sens de l'ordre est la base de tout art, Seurat devrait être communard, disaient-ils." It now seems curious that Aman-Jean would link order and discipline with the epithet "Communard." By "camarades" did he mean fellow students at the École? It seems likely, for the context here is their school days, and Aman-Jean was never a comrade of the later Neo-Impressionists. The epithet might well refer to leftist political views or, equally likely, to independence and difference from the norm. This is given credence by Arsène Alexandre, writing in 1894, who said that twenty years earlier "Naturalistes et impressionnistes étaient d'exacts synonymes de communards" ("Tous les nommés Luce," *L'éclair* [July 16, 1894], cited in Jean Sutter, *Maximilien Luce 1858–1941, peintre anarchiste* [1971], 1986 ed., p. 68).
6. Aman-Jean is responding to Signac, who guessed that Seurat had been taught at home.
7. Seurat's portrait of Aman-Jean (cat. no. 30), exhibited in 1883, was presumably drawn in 1882–83. This is the only indication we have that Seurat still shared the studio in the rue de l'Arbalète with him, well after he had taken his independent studio-apartment on the rue de Chabrol. The trip to Pontaubert mentioned by Aman-Jean took place in the fall of 1881 (see Chronology).

Appendix C

Seurat's Collection of Prints, Reproductions, and Photographs

In 1956 Seurat's descendants showed me a large folio of drawings, reproductions, and popular broadsides dating from Seurat's early years (the "Seurat Folio"). Its contents were not included in the posthumous inventory of the artist's studio, for his brother-in-law, Léon Appert, had removed it as a memento of no enduring value. Eighteen drawings from the live model and twenty-nine after plaster casts were kept by the descendants and were subsequently catalogued by César de Hauke, but the other materials were inadvertently discarded. Not anticipating

this, I had made only a crude list of these prints and reproductions. I record it here because it gives an idea of the artist's interests, even though its lack of precision will frustrate most attempts to identify individual pieces. Of course we cannot know if Léon Appert discarded some items, but the disparate nature of the collection suggests that he did not. I first published the existence of the Seurat Folio in 1958 and discussed it briefly in later publications (including Herbert 1962, pp. 12, 166, and passim). All dimensions are approximate; the images were often trimmed, sometimes irregularly.

A partly cut-up copy of "Les eaux-fortes de Rembrandt" [Rembrandt's etchings], feature article of *Le Figaro*, supplément littéraire, April 8, 1882, including reproductions of four self-portraits [Münz 11, 12, 22, 24], *The Small Disciples of Emmaus* [Münz 203], *The Annunciation to the Shepherds* [Münz 199], *Six's Bridge* [Münz 156], *The Flight into Egypt* [Münz 195], *Jesus on the Cross* [Münz 202], *The Triumph of Mordecai* [Münz 178], *Joseph Recounting His Dreams* [Münz 175], *The Persian* [Münz 123], and *The Martyrdom of Saint Étienne* [Münz 205].[1]

The outer pages of these issues of *Le Figaro*: Sunday, February 20, 1876; Friday, August 9, 1878; Sunday, January 27, 1884. These were apparently used only for wrapping drawings, and there was no apparent interest in the contents. The one dated 1884 might mean that Seurat was then still actively interested in the Folio.

Popular broadsides:

Colored etching, 15.2 × 12 cm. [6 × 4¾ in.], of a party of people seated around a table at the base of a large tree.

Crudely colored etching, 12.5 × 9 cm. [5 × 3½ in.], of a partly ruined water mill.

Crudely colored etching, 15.2 × 11 cm. [6 × 4¼ in.], of a windmill.

A series, each 16.5 × 9 cm. [6½ × 3½ in.], roughly cut to oval shape, of colored broadsides: *Jardinier suisse, Fiti malin, Pirate, Napolitain, Jeune paysanne, Grec* [?], *Napolitaine, Jardinière suisse, Catalane, Cauchoise, Paillasse, Catalan* [Swiss gardener, Clever Fiti, Pirate, Neapolitan man, Young peasant woman, Greek (?), Neapolitan woman, Swiss woman gardener, Catalan woman, Norman woman, Clown, Catalan man].

A series, each 12 × 9 cm. [4¾ × 3½ in.], crudely colored etchings perhaps of the 1840s: five images of mounted soldiers, of which two are identical except for their colors.

A very "primitive" colored image, 19.5 × 14.3 cm. [7⅝ × 5⅝ in.], of a small home amid verdure and flowers.

An unlabeled engraving, 12.7 × 18.7 cm. [5 × 7⅜ in.], of an Italian cathedral, with many genre figures in fore- and middle ground.

Mannekin-Pis. Réélection de la Garde Civique en 1835 [Mannekin-Pis. Reelection of the Civil Guard in 1835], lithograph, 20.3 × 25.4 cm. [8 × 10 in.]. A child in soldier dress.

Maison Gruner, oval engraving by A. Wichmandel. A Schinkel-like house.

Jument, dessiné d'après nature à l'École d'Afat près de Paris en l'année 1766 par J. P. Houll [A mare, drawn after nature at the Afat School near Paris in the year 1766 by J. P. Houll], 13 × 22 cm. [5⅛ × 8⅝ in.]. A young donkey.

Engraving of Napoleonic era, 5.7 × 11 cm. [2¼ × 4⅜ in.], of a woman and two children in a classical garden.

Béranger, 4.8 cm. [1⅞ in.] diameter portrait engraving.

Landscapes of Erythrae, five lithographs by C. Werner, 25.4 × 20.3 cm. [10 × 8 in.]. Views of the castle and environs.

Nouveau Cayer de Paysages [A new sketchbook of landscapes], nine engravings, each 17 × 11.5 cm. [6¾ × 4½ in.]. Rustic scenes in a brownish red engraved line.

Series of trees, seven lithographs by Chénot, each 24 × 32 cm. [9½ × 12½ in.], one signed 1835: *Tronc de chêne, Intérieur de forêt, Maronnier, Terrain descendant, Pin, Cèdres du Mont-Liban, Acacia* [Oak trunk, Interior of a forest, Chestnut tree, Sloping land, Pine tree, Cedars of Lebanon, Acacia].

Cour de l'Hôtel Cluny [Courtyard of the Hôtel Cluny], lithograph by Lemercier, 25.4 × 20.3 cm. [10 × 8 in.].

Le plaisir, publié par Ch. Bance & Aumont de Paris [Pleasure, published by Ch. Bance & Aumont, Paris],

lithograph, 11.5 × 14 cm. [4½ × 5½ in.]. Napoleonic era portrait of a young woman.

Le Duc de Broglie, lithograph by Léon Viardot [1805–1900], 12.7 × 12.7 cm. [5 × 5 in.]. Bust portrait.

A hunting scene à la Claude Lorrain, by C. Develly, 34 × 26.3 cm. [13⅜ × 10⅜ in.], mounted on heavy paper.

A barn in a landscape, watercolor or reproduction of one, 9.8 × 14 cm. [3⅞ × 5½ in.], late 18th or early 19th c.

Engraving, probably Parisian, of a father surprising his daughter in a compromising state with a suitor, horizontal oval, 9 cm. [3½ in.]. Floral decoration above, and a cupid, in the style of the rue Saint-Jacques.

Napoleonic scene, 6.3 × 10.5 cm. [2½ × 4⅛ in.], departure of one military man from another.

France maritime, intérieur de la batterie d'une frégate [Maritime France, interior view of a frigate's battery], engraving, 26.6 × 17.8 cm. [10½ × 7 in.]. View into below-decks with guns.

Three romantic portrait engravings (rondels in rectangles), each 10 × 14 cm. [3⅞ × 5½ in.]: *Vive Louis XVII Roi de France, O cendres que j'adore, Il sut aimer, souffrir et pardonner.* [Vive Louis XVII, king of France, O ashes that I adore, He knew how to love, suffer, and forgive].

Unlabeled bust portrait, rondel, 8.2 cm. [3¼ in.] diameter.

Flensburg, lithograph, 20.3 × 31.7 cm. [8 × 12½ in.]. Landscape with couple and horse-drawn wagon in the foreground; in the distance, boats in a harbor, and houses, hills.

Le buveur, Der Sauffbruder [The drinker], "Ich. Iac. Haid, excud. Aug. Vind," 20.3 × 32 cm. [8 × 12⅛ in.]. Lowlands style; one man seated, holding a cup, another behind him lighting a pipe.

Portrait of a young girl, signed "E. M. 1844." Large, mounted on cardboard, either lithograph or perhaps original crayon drawing in naive style.

Les pèlerins bretons [Breton pilgrims], lithograph by "Vaurette," 25.4 × 17.8 cm. [10 × 7⅛ in.]. Outdoor scene, late Gothic chapel near a village.

After J.-A. Houdon, two large flayed nudes, "dessiné par Manlich d'après Le Grand Écorché de M. Houdon en 1761" [drawn by Manlich after the large flayed nude by M. Houdon in 1761]. "Paris, chez Jean, rue St. Jean de Beauvais."

Lithograph by T. Schommer, invitation and menu for a banquet offered by his students to Henri Lehmann, November 23, 1878, 40 × 28.5 cm. [15¾ × 11¼ in.]. A top-hatted man peers at a menu enclosed in a Baroque portal labeled "Atelier Lehmann." [The same illustrated in H, I, p. xxvi.]

Le printemps, L'hiver [Spring, Winter], two engravings by Cham, each 16 × 7.6 cm. [6¼ × 3 in.], on heavy paper stock.

A foot, drawing by Raphael, "gravé par Alphonse Leroy," from *Cours de dessin, Fac-Simile des grands maîtres. Sous le patronage, Surintendance des Beaux-Arts, Comte de Nieuwerkerke. 9* ["engraved by Alphonse Leroy," from *Drawing Lessons, Facsimiles of Great Masters. Under the patronage of the Count of Nieuwerkerke, Superintendent of Fine Arts. No. 9*]. This is the image Seurat copied about 1875 (H 289).

Reproduction of a peasant girl facing right, drawing for *The Harvesters* by J. F. Millet [now in the Institut Néerlandais, Paris].

Photograph mounted on cardboard, of Ingres's *Oedipus and the Sphinx* [Musée du Louvre], apparently from one of the following, whose printed descriptions were with it: *Ingres*, by Eugène Montrosier, from *Galerie contemporaine littéraire et artistique. Ludovic Baschet, ed. Goupil & Cie., 2e série, no. 142, "Ingres," à suivre*; and *no. 154*, same description [Contemporary Gallery, Literary and Artistic. Ludovic Baschet, editor (for) Goupil & Co., 2d series, no. 142, "Ingres," to be continued].

In a letter of March 18, 1927 to Fénéon (de Hauke archives), the widow of Seurat's brother, Émile, asked for advice about selling a group of objects she had, a group that she said Fénéon undoubtedly was familiar with. She was probably referring to a letter Émile had written Fénéon on March 8, 1905, enclosing a list of "prints" ("gravures") on which he had noted all the information from their captions. Alas, this early list is not among

Fénéon's papers. The objects listed by Mme Émile Seurat, like other works once owned by Émile, surely belonged originally to the artist. They parallel the contents of the Seurat Folio, and there is little reason to think Émile himself would have collected them. Furthermore, the photographs after Ingres that Mme Seurat lists might possibly be those by Charles Marville, from the album edited by Édouard Gatteaux, after which Seurat made at least six copies. The engraving after Ingres's *Tu Marcellus eris* is probably the source of Seurat's early drawing after a figure from this composition (H 250).

18 prints "watercolored" ("aquarellées"), each 36 × 28 cm. (14⅛ × 11 in.), 3 albums ("each collection consists of 6 prints") by Carle Vernet, engraved by Debucourt, dated 1814, 1815, 1816; military costumes of several nations, and other subjects.

Engraving by Pradier, 59 × 50 cm. (23¼ × 19¾ in.), trimmed size ("sans l'emmarg."), after Ingres's *Tu Marcellus eris* [*Virgil Reading from the Aeneid before Augustus and Livia*], painting now in the Musée de Toulouse.

Engraving, 60 × 50 cm. (23⅝ × 19¾ in.), trimmed size, after Ingres's *Martyrdom of Saint Symphorian* (she wrote "Saint Sébastien"), painting in the cathédrale d'Autun; four engravings and one lithograph after the painting are known.

Photograph, 55 cm. (21⅝ in.), of "La gloire couronnant la science" [Glory crowning science], probably *Cherubini and the Muse of Lyric Poetry*, painting in the Musée du Louvre.

10 photographs of drawings by Ingres.

Presumed photograph of Ingres's *Self-portrait at the age of 55*, drawing [Musée du Louvre] dedicated "Ingres à ses élèves, Rome 1835" [Ingres to his students, Rome 1835].

1. The implications of these reproductions for Seurat's work are treated in Broude 1976, and all nineteen of the etchings in the article are carefully identified.

Appendix D

Seurat's List of Owners of His Works, 1886

Toward the end of 1886 and the beginning of 1887, Seurat wrote out the names of owners of his paintings and drawings on three sides of a pair of sheets of identical size (6 × 7⅜ in. [15.3 × 18.6 cm.]). The fourth side is H 658, *Tabouret et soulier*, slight ink drawings of a stool and a woman's shoe unrelated to the other sides; internal evidence shows that it was done after the reverse had been written upon.[1] The two sheets are together in the de Hauke archives, although this is not recorded in the entry for H 658. They probably belonged to a now-disseminated notebook in which the artist kept private records. Seurat's notes bear the dates "23 Octobre," "fin Novembre 1886," and "actuellement 1886." References to the Belgian collector Henri van Cutsem and to the Belgian poet Émile Verhaeren can be dated by internal evidence to February or early March 1887; nothing suggests any entries after then. Van Cutsem was the only collector among all the owners named by Seurat. Léon Appert was his brother-in-law, Camille Pissarro and Paul Signac were painters, and the others were writers and journalists, in most cases presumably the recipients of politic gifts by the young artist.

Seurat listed the titles of twelve panels shown in one frame in Durand-Ruel's exhibition of Impressionism in New York in 1886, a list that was published by de Hauke (p. xxx) without saying that Seurat himself was its source. Only the first of the twelve bears the name of an owner, Camille Pissarro; in the margins, next to *Grande Jatte groupe à l'ombre à gauche* (Grande Jatte, group in shadow on the left), Seurat added "à Pis.r°." De Hauke failed to make use of this notation; elsewhere he and Fénéon associated that title with H 119 (Barnes Foundation, Merion, Pennsylvania), without mention of Pissarro. Possibly Pissarro or his heirs once owned that panel, or possibly Seurat meant another one entirely.

In addition to the list of twelve panels, Seurat recorded the owners of other paintings or drawings (his titles are given here but the sequence of his notations has been rearranged for convenience):

Paul Adam:
La jetée d'Honfleur [End of the jetty, Honfleur; H 170; Rijksmuseum Kröller-Müller, Otterlo].

Jean Ajalbert:
Pêcheur à la ligne [Fisherman] and *Femme au singe* [Woman with monkey; H 137, cat. no. 133], labeled "panneaux" (panels), and "Gr. Jatte" [H 115, formerly Lady Aberconway, London. Ajalbert's ownership of H 115 has not previously been noted].

Arsène Alexandre:
"une toile 10, *Coin de la Grande Jatte* [a painting size 10, Corner of the Grande Jatte; cat. no. 171].[2]

Paul Alexis:
"panneaux croquis mer à Grandcamp" [panels— marine sketches at Grandcamp; the phrase repeated to indicate two, which we know to be the following: *La mer à Grandcamp* and *Trois bateaux et un marin* (The sea at Grandcamp and Three boats and a sailor; H 152, 153; both Santara Collection, Geneva)].
Pierrot [H 95; Santara Collection, Geneva].
Croquis de la rue St. Vincent, effet de neige, Montmartre [The rue St. Vincent, winter; H 70, private collection, New York; de Hauke does not list Alexis's ownership].

Léon Appert:
Pêcheurs à la ligne [Fishermen; cat. no. 97]. "N° 180 Cat. r. Laffitte 1886" [that is, the last Impressionist exhibition, May–June 1886].

Robert Caze:
Esquisse de la baignade [probably *Étude complète*, cat. no. 110].
Une nounou de dos [A nurse seen from behind], "dessin à M. Ajalbert actuellement 1886" [drawing now with M. Ajalbert, 1886; unidentified among several: H 485, 486, 630].
Banquiste, femme de cirque, "dessin Mr Caze, N° 183 du catalogue 8e exposition rue Laffitte 1886" [Acrobat by the ticket booth; cat. no. 45].

Félix Fénéon:
L'entrée du port d'Honfleur [Honfleur, entrance to the harbor; H 171, Barnes Foundation, Merion, Pennsylvania].

Joris-Karl Huysmans:
Une parade foire au pain d'épice [perhaps cat. no. 45] and *Scène d'enterrement, condoléances* [cat. no. 158], both

called "dessins" (drawings) and noted respectively, nos. 181 and 182 "rue Laffitte."

Gustave Kahn:
"2 croquis peints à Kahn, 1° de la Baignade, 2° du dimanche à la Jatte" [2 painted sketches are Kahn's, 1 of the Baignade, 2 of Sunday on the Jatte; both unidentified].

Paul Signac:
Croquis peint du fort Samson [cat. no. 163] and *La Seine à Courbevoie* [cat. no. 153].

Henri van Cutsem:
La grève du Bas Butin [cat. no. 164].

Émile Verhaeren:
Coin d'un bassin (Honfleur) [Corner of the harbor, Honfleur; H 163, Rijksmuseum Kröller-Müller, Otterlo].[3]

1. The drawing was probably done in Seurat's Montmartre studio while he was working on *Poseuses* because the same kind of shoe and the wall with dark baseboard are found in the large canvas.
2. The following is crossed out as once having belonged to Alexandre: "1 toile de 10 représentant un chantier de cailloux près la Dhuis au Raincy" (1 canvas size 10 representing a stone quarry near the Dhuis in Le Raincy; that is, the Dhuis aqueduct that runs between Le Raincy and Montfermeil). This is the painting *Casseur de pierres à Montfermeil* (Stone breaker at Montfermeil), which was purchased by Albert Hirsch from the dealer Léonce Moline in 1895: see Herbert, *Seurat's Drawings*, 1962, p. 179. It was not catalogued in H or DR; it is reproduced in color in Sutter 1970, p. 27 (Sir Isaac Wolfson, England).
3. Verhaeren had purchased the picture no later than November 9, 1886: see Herbert, "Seurat and Émile Verhaeren," 1959. Verhaeren's name and address next to the date "Samedi 23 Octobre" are not in the artist's hand, which suggests that the poet himself wrote it out for Seurat while visiting him that day.

Appendix E

Seurat's *Esthétique*

In 1890, in response to an inquiry from the journalist Maurice Beaubourg, Seurat prepared several drafts of a letter outlining his theories, but he never sent it.[1] The letter consists of two parts, an autobiographical introduction and a formal statement of his theories. There is a separate draft (de Hauke archives) of the autobiographical introduction, in which there is this important sentence: "I committed myself to four large canvases *of combat* if you permit me to speak that way" ("J'ai commis 4 grandes toiles *de lutte* si vous voulez bien me permettre de parler ainsi"). Seurat named only two, using initials, B[aignade] and D[imanche à la Grande Jatte]. Following the word "ainsi," he wrote and then crossed out: "and I prefer them to all my landscape studies" ("et je les préfère à toutes mes études de paysage").

Of the *esthétique*, the key portion of the letter, there are four drafts. Only the fourth is printed here in its entirety; some punctuation and paragraphing have been added to ensure clarity. Words that Seurat crossed out appear in square brackets. "Ton" and "teinte" have been translated by their nineteenth-century equivalents, "tone" and "tint," although today many would say "value" and "hue" (the latter, however, is not the same as "tint," which incorporates the idea of a degree of saturation, as distinct from pure hue).

VERSION A
Signac archives. This is probably the first, and certainly the most complicated, of the drafts, with many words inserted and others crossed out. It is headed with a statement of great importance, later used by Signac and John Rewald to describe Seurat's ideas:

[chart] general practical theory grounded on Delacroix and oriental precepts, supported by the experiments of Chevreul, Rood, Helmholtz, C. Henry [and the Oriental tradition]

[tableau] théorie pratique générale partant de Delacroix et de préceptes orientaux, s'appuyant sur les expériences de Chevreul, Rood, Helmholtz, C. Henry [et la tradition orientale]

Chevreul, Rood, and Henry are discussed separately in this catalogue. It is likely that Seurat's knowledge of Helmholtz was limited to what he learned from Rood, who made clear the German scientist's seminal role in color theory (he had vindicated Thomas Young's theory of three retinal color receptors). The "Oriental precepts" and the "Oriental tradition" may refer to Gauguin's copy of a text supposedly by a Turkish artist (see Appendix P), but they probably also reflect the widespread notion that Asians had a special genius for color.

The most surprising feature of this and the next two versions is that Seurat did not know how to incorporate Charles Henry's ideas about linear proportion. In Version D, the only one known until now, he wrote of the expression of gaiety, calmness, and sadness in terms of tone, tint, and line. In writing of "line" in Version A, he substituted or added "silhouette," "direction," "form," and "modeling," and even more confusingly, for sadness of line he wrote "of curving form" (crossed out) and "curve" ("de forme courbe" and "courbe").

VERSION B
De Hauke archives. This is a much shorter text than Versions A and D, with four rather than three terms by which gaiety, calmness, and sadness could be expressed. Included is this section:

Gaiety of value is the *light* dominant.
————of color————*warm*————.
————of proportion————dominant given to the gayest directions.
————of direction is the dominant given to the gayest lines, that is, to those raised above the horizontal.

La gaité de valeur c'est la dominante *claire*
————de couleur————*chaude*
————proportion————donnée aux directions les plus gaies
————direction c'est la dominante donnée aux lignes les plus gaies, c.à. dire élévées sur l'horizontal

VERSION C
Signac archives. An equally short text, this version includes four terms of expression rather than three and is quite certainly derived from Henry. Included is this section:

Gaiety of tone is the luminous dominant.
 of tint the warm dominant.
 of proportion the dominant of measure given to
the direction [gay] the most
 of direction the dominant above the horizontal and
to the right of the upright vertical

La gaité de ton c'est la dominante lumineuse
 de teinte la dominante chaude
 de proportion la dominante de mesure donnée à la
direction [gai] la plus
 de direction la dominante au dessus de l'horizontale
et à droite de la verticale élevée

VERSION D
Private collection (cat. no. 231). First published by Fénéon
("De Seurat," 1914), this capital document was subse-
quently reproduced photographically in Rey 1931. In this
version the fourth term found in the other versions is
eliminated. Seurat was confused about the relative roles of
"proportion" and "direction," so he limited himself to the
term "line" in this final draft. In doing so, he reverted to
the traditional conceptions of expression that can be found
in Blanc, albeit with different terminology.

Thursday August 28

My dear Monsieur Maurice Beaubourg.
Permit me to thank you and to say how much I am
touched by your kind letter.
 Dubois-Pillet, the founder of the Société des Ar-
tistes Indépendants, was loyal-hearted, an up-
right nature whose loss we feel.[2] He was in addition a
researcher, as you can see in No. 370 of *Les hommes
d'aujourd'hui,* ed. by Vanier, text by Jules Christophe.
 I knew van Gogh less intimately. I spoke to him
for the first time in 1887 in a popular eatery near La
Fourche, avenue de Clichy (closed). A huge windowed
room was decorated with his canvases.[3] He exhibited at
the Indépendants in 1888, 1889, 1890.

 Signac told me of his death this way: "He gave
himself a bullet in the ribs; it passed through his body
and lodged in his groin. He walked for two kilometers,
losing all his blood, and went on to die in his inn."

Here are the titles of my large canvases:
Bathing Place (Asnières) 2 meters / 3 meters. ex.
 Indépendants (group) May 15, 1884. New York
 1885[4]

studies for A Sunday on the Grande Jatte. Indépendants
(Society) December 1884

 A Sunday on the Grande Jatte. 1884 3 meters / 2
meters.
 Indépendants August 1886. Impressionists May
 1886. Brussels February 1887.

studies at the Grande Jatte and at Honfleur at Grandcamp

Indépendants in 1887 studies done at Honfleur. Small
Model.

Indépendants 1888 [The] Models. 2 meters / 2 m. 50.
Drawings.
Brussels 1889 id.

Indépendants 1889 studies done at le Crotoy

Indépendants 1890 *Chahut* 1.m 50 / 2 m. Studies Grande
Jatte. Port-en-Bessin
 A bibliographic note: Les hommes d'aujourd'hui
concerns me, No. 368, text by Jules Christophe.
 No. 373 by Félix Fénéon is on Signac. No. 376 on
Luce (Jules Christophe).
 Signac's large canvases are:
 [The Milliners] Preparer and Fitter (fashion), rue
du Caire 85–86. The Dining Room 87. A Sunday in
Paris 89–90.
 But the article that you can easily obtain will
inform you better than I can.
 You will find there the technique of *optical mixture*
perfectly described from the scientific point of view.
 In conclusion I am going to give you the aesthetic
and technical note that concludes Mr. Christophe's

piece and which originated with me; I am modifying it a
little, not having been well understood by the printer.

Aesthetic:
Art is Harmony.
Harmony is the analogy of opposites, the analogy of
similarities *of tone, of tint, of line* taking account of a
dominant and under the influence of the lighting, in
combinations that are
 gay calm or sad

Opposites are:

for tone, a more luminous/lighter one for a darker one.

for tint, the complementaries, that is, a certain red
opposed to its complementary, etc.
 Red — Green
 Orange — Blue
 Yellow — Violet
for line, those making a right angle.

Gaiety of tone is the luminous dominant, *of tint,* the warm
dominant, *of line,* lines above the horizontal.

Calmness of tone is the equality of dark and light; of
tint, of warm and cool, and the horizontal for line.

Sadness of tone is the dark dominant; of tint, the cool
dominant, and of line, downward directions.

Technique
Given the phenomenon [that] of the duration of the
luminous impression on the retina [are the same],
 [The means of expression will be synthetic.]
 Synthesis is logically the result.

The means of expression is the optical mixture of tones,
of tints (of local color and the illuminating color: sun,
oil lamp, gas, etc.), that is, of the lights and of their
reactions (shadows) following the laws *of contrast,* of
gradation, of irradiation.

The frame [is no longer as in the beginning] is in a
harmony opposed to those of the tones, tints, and lines
of the [motif] picture.

1. Beaubourg to César de Hauke, October 6, 1937, de Hauke archives.
2. Dubois-Pillet had died in Le Puy on August 18, 1890, at age forty-three.
3. Van Gogh organized an exhibition of work by himself and a few others at La Fourche, the Y-shaped intersection of the avenues de Clichy and de Saint-Ouen.
4. He meant to write "1886."

Appendix F

Seurat's Letter to Fénéon, June 20, 1890

Reacting to an article on Signac by Fénéon that failed to mention his name,[1] Seurat prepared a letter to state his place as the initiator of Neo-Impressionism. It is the most important surviving letter from his hand, since it lists his readings among scientists, aestheticians, and artists, as well as the key steps in his development. Printed here is the longest version, C, the only one bearing a date and presumably the one mailed to Fénéon. The other two, found in his studio after his death, were acquired by Fénéon and came into the possession of César M. de Hauke together with the rest of Fénéon's papers.

VERSION A
Pierpont Morgan Library, New York. Gift of John Rewald, who had received it from de Hauke. Except for one sentence (given in note 6 below), its text was published in DR, pp. xxvii–xxviii.

VERSION B
De Hauke archives. Unpublished. In this draft with incomplete phrases, changes of mind are evident.

VERSION C
Bibliothèque Nationale, Département des Manuscrits, Paris. Gift of M. de Hauke. Reproduced photographically in H, I, p. xxi, and reprinted in translation below. Square brackets indicate words that Seurat crossed out. Minimal punctuation and paragraphing have been added for clarity. For the writers named by Seurat—Blanc, Chevreul, Corot, Couture, Delacroix, Henry, Rood, and Sutter—see Appendixes G, I–O.

Paris June 20, 1890

My dear Fénéon

Allow me to point out an inaccuracy in your biography of Signac, or rather, in order to set aside all doubt, allow me to specify:
 —It seduced—it was about 1885, p. 2, par. 4.[2] Begun [in] Pissarro's and Signac's evolution was slower. I object and I establish within about two weeks the following dates:
 The *purity of the spectral element being the keystone of* [*the*] *my technique*—[and being] that you were the first to devote yourself to,
 searching for an optical formula on this basis ever since I held a brush 1876–1884,
 having read Charles Blanc in school and therefore knowing Chevreul's laws and Delacroix's precepts,
 having read the studies by the same Charles Blanc on the same painter (Gazette des Beaux-Arts, vol. xvi, if I remember correctly),
 knowing Corot's ideas on tone (copy of a private letter October 28, 1875) and Couture's precepts on the subtlety of tints (at the time of his exhibition),
 having been struck by the intuition of Monet and Pissarro,
 sharing certain of Sutter's ideas on the ancient art of the Greeks that I meditated while in Brest (the review *L'art*) March and February 1880,
 Rood having been brought to my attention in an article by Philippe Gille, Figaro 1881,[3]
 I insist on establishing the following dates indicating my prior paternity. [and the discussions that I held]
 1884 Grande Jatte study, exhibition of the Indépendants
 1884–1885 Grande Jatte composition
 1885 studies at the Grande Jatte and at Grandcamp; took up again the Grande Jatte composition October 1886.[4]

 October 85 I make Pissarro's acquaintance at Durand-Ruel's.

 1886 January or February, a small canvas by Pissarro, divided and pure color, at Clozet's the dealer on the rue de Châteaudun.
 Signac, definitively won over and who had just modified The Milliners [*Apprêteuse et garnisseuse (modes) rue de Caire*, p. 174], following my technique at the same time as I was finishing the Jatte, executes:
 1. Le Passage du puits Bertin. Clichy. March–April 1886.[5]
 2. Gas Factories, Clichy [see cat. no. 63]. March–April 1886 (catalogue of the Indépendants). For these reasons
 Coolness with Guillaumin, who had introduced me to Pissarro and whom I saw thanks to his old friendship with Signac.[6]
 You'll agree that there's a nuance here and that if I was unknown in 85, I nonetheless existed, I and my vision that you have described in an impersonal fashion so superbly, aside from one or two insignificant details.
 Already M. Lecomte had sacrificed me to Charles Henry,[7] whom we did not know before the Rue Laffitte (error explained).[8]
 It was at Robert Caze's that we were put into contact with several writers of Lutèce and Le Carcan (Petit Bottin des arts et des lettres).[9] Pissarro came there with Guillaumin.
 Then you brought me out of the shadows along with Signac, who had benefited from my researches.
 I count on your loyalty to communicate these notes to Messrs. Jules Christophe[10] and Lecomte.
 I shake your hand cordially and faithfully.
 Seurat

1. See below, note 2.
2. The reference is to "Signac," *Les hommes d'aujourd'hui* 373 (1890). Fénéon wrote that the new "optical painting" "seduced—it was about 1885,—several young painters," but he named only Signac. Seurat was nowhere mentioned in the article.
3. In version B, Seurat provided more important information: "Rood was in my possession the day after the appearance of Philippe Gille's book review, published by Le Figaro 1881 (change of palette). I abandon *earth colors* from 82 to 1884. On Pissarro's advice I stop using emerald green 1885." ("Rood était en ma possession le lendemain du jour où paru la revue bibliographique de Philippe Gille, collection du Figaro 1881 [changement de palette]. J'abandonne les *terres* en 82 à 1884. Sur le conseil de Pissarro je lâche le vert émeraude 1885.")

4. He meant to write 1885. In version A, Seurat wrote "1884, Ascension Day: Grande Jatte, the studies and the *painting*. This canvas was ready in March 1885 for the *abortive* exhibition of the Indépendants, taken up again and finished after a trip to Grandcamp (1885) and exhibited May 15, 1886." ("1884, jour de l'Ascension: Grande Jatte, les études et le *tableau*. Cette toile était prête à être exposée en mars 1885 aux Indépendants *avortés*, reprise et terminée après un voyage à Grandcamp [1885] et exposée le 15 mai 1886.")

5. Collection unknown.

6. In version A: "Coolness with Guillaumin, who had introduced me to Pissarro in the month of October 85 at Durand-Ruel's."

7. That is, in Lecomte's two articles published in March 1890; see Bibliography. By the "Rue Laffitte," Seurat meant the Impressionist exhibition, May–June 1886.

8. In version B, Seurat wrote: "I count on your proven loyalty to communicate these dates to Mr. Jules Christophe, who has already explained Lecomte's mistake to me. Also to Mr. Lecomte." He then adds an incomplete sentence: "to support, if need be, opposed viewpoints since I have documents, letters, and witnesses that I will be happy to produce if dispute arises" ("de provoquer au besoin les opinions contraires comme j'ai documents, lettres et témoins je serai heureux de les produire en cas de contestation").

9. *Lutèce* and *Le carcan* were short-lived vanguard reviews. The *Petit bottin des lettres et des arts* (1886), edited by Fénéon, Paul Adam, and others, was a compilation of short, saucy aphorisms about avant-garde figures. In version B, Seurat wrote: "Mr. Pissarro made the acquaintance of the group of writers around *La vogue*, *Lutèce*, *Le carcan*, by way of Signac and me, who were at *Robert Caze's* last Friday gatherings. He came to the same *Robert Caze's* once or twice, like Guillaumin." For Caze, see entry for *La banquiste* (cat. no. 44).

10. Author of "Seurat," *Les hommes d'aujourd'hui* 368 (1890), and other articles on the Neo-Impressionists.

Appendix G

Charles Blanc

Seurat's readings in art, aesthetics, and science are known through notes that were found in his studio in 1891 and that are today in the archives of César de Hauke (who had obtained them from Félix Fénéon) and of Paul Signac. Because Seurat or his closest friends mentioned all of the authors, we would have been aware of their significance for him, but in his extracts and annotations we have the advantage of documentation that reveals his particular interests. Throughout this catalogue, Seurat's readings are discussed in the context of his drawings, paintings, and theories. In Appendixes G–O, they are separately recorded and commented upon, often with reference to his letter of 1890 to Fénéon (Appendix F) where most of the writers are mentioned.

From his autobiographical letter of 1890 to Fénéon, we know that Seurat, when he was about sixteen, read Charles Blanc's *Grammaire des arts du dessin* (*Grammar of Painting and Engraving*) (1867) and his essay of 1864 on Delacroix. Blanc (1813–1882), a lifelong republican and an important government functionary in the fine arts, was a prolific and influential art critic, historian, and aesthetician. Among his many accomplishments are the founding of the *Gazette des beaux-arts* in 1859 and the publication of *Histoire des peintres de toutes les écoles* (14 vols., 1861–76). The *Grammaire*, several times reedited and often reprinted, was his most influential book, read by van Gogh, Gauguin, and Signac, as well as by Seurat. It has extensive discussions of architecture, sculpture, painting, and the graphic arts, everywhere laced with the author's idealist aesthetics.

Seurat's sympathy with Blanc was deep, to the point of his using phrases that reflect the aesthetician's terminology. "Let me add that while talking with me," wrote Gustave Kahn, "Seurat defined painting as 'The art of hollowing out a surface' ['L'art de creuser une surface']."[1] More than once Blanc defined painting as the art of "hollowing out fictional depths on a flat surface" ("creuser des profondeurs fictives sur une surface plane") (pp. 503, 535). Seurat's phrases "the analogy of opposites" and "the analogy of similarities" ("l'analogie des contraires" and "l'analogie des semblables") can be found dozens of times in the *Grammaire* and the essay on Delacroix. Far from hiding his debt, Seurat readily acknowledged Blanc's priority in the development of his theories.[2] In the *Grammaire* he found an exposition of "optical mixture" ("mélange optique") that lay at the very heart of his own mature theory and practice. Although Blanc drew upon Chevreul's theory of color contrasts, which he summarized quite fully, it was Blanc, not the famous scientist, who devised the key phrase "mélange optique." He accompanied his explanation with dotted diagrams and with assurances that finely divided colors mixed in the viewer's eye. Blanc put Delacroix forward as the leading practitioner of optical mixture and must have encouraged Seurat's predilection for that artist's work. Since Seurat copied passages from writings by Chevreul and Delacroix and took notes on Delacroix's paintings, we know that he went to them independently, but the lessons he drew from them can all be found in Blanc. Blanc also featured the ideas of Humbert de Superville on the expressive power of line. The thoughts of the Dutch writer, like those of Chevreul and Delacroix, appears in many sections of the huge *Grammaire*; his ideas are thoroughly incorporated in Blanc's aesthetic.

Not only did Blanc pass on to Seurat the ideas of Chevreul, Delacroix, and Humbert, he did so in terms calculated to appeal to the young artist, for he constantly invoked science and rationality. According to Blanc, rules of proportion, like other rules of art, are not straitjackets but foundations on which the artist, freed from uncertainty and the anarchy of isolated observations, can build his own structures. Even color, traditionally treated as feminine, instinctive, and virtually unteachable, is subject to scientific investigation, and even Delacroix (although he is sometimes faulted by Blanc for his romantic excesses) is presented as a consummate master of the "mathematical rules" of color.

Dominating all of Blanc's writings is his conviction that art must not merely imitate nature but must transform

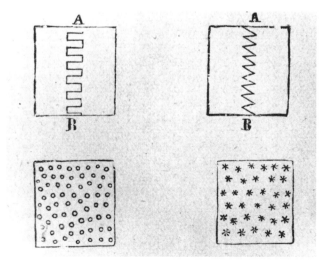

Diagrams for optical mixtures, from Charles Blanc, *Grammaire des arts du dessin* (1880 ed.), p. 539

her through imaginative thought. His ideas parallel the antinaturalist and anti-Impressionist tenets of the Symbolists who defended Seurat in the press. The artist imitates nature "not exactly as she is herself, but as he is, himself" (p. 19). Nature is feminine, awaiting the action of masculine thought. She is full of accidental and temporal vagaries, and it is the artist's job to penetrate to the underlying essences, to the ideal, to the permanent. In doing so, he escapes the trap of mere individualism and mere materialism inherent in imitation, and reaches the realm of the truly social and universal, the perfect type. Blanc therefore praised Egyptian art in terms that could have appealed to the author of *Chahut*, to Gauguin, and to their generation:

Egyptian art, which seems to have remained in an eternal childhood, is a great art, majestic and highly formulated. It is grand and majestic because of the absence of detail, whose suppression was willed, premeditated by the priest. Carved in bas-relief or sculpted in the round, an Egyptian figure is...finely drawn, of a deliberate simplicity in its lines and its planes, of an elegant delicacy in its forms or, to express it better, in its algebraic formulas (p. 440).

Of course, the artist must study life and not copy older art, for the ideal is the quintessence of life itself. Of past arts, Greek sculpture is unexcelled, superior to Egyptian art because humankind is more surely its center and because of its superior grasp of life forms: "The Greeks were destined...to marry these two elements, the ideal and nature, that is, the purity of essence and the charm of life. Remarkable thing, forever admirable, the Greeks were destined to create living abstractions!" (p. 337).

Ever the moralist and educator, Blanc taught that history painting was the highest calling since it allowed the painter to use the human form and noble ideals in order to instruct the public in society's values rather than those of the isolated individual. This conception was one with Blanc's republicanism, and in altered form it is manifest in Seurat's avoidance of individual traits in favor of types and in his ambitions as a painter of mural scale. Blanc was saturated in classicism and humanism, but not blindly so. He admired Delacroix and Decamps over the unimaginative classicism of much official art, he wrote a book on Rembrandt, and he had a taste for the "primitive"—witness his praise of Egyptian art and art of the

early Renaissance. The study of nature, not academic recipe, was the healthy route toward mastery; one should emulate the principles of Phidias but not imitate his forms.

It goes without saying that, despite these affinities in their aesthetics, the author of *Chahut* and *Cirque* was no disciple of Blanc's. In *Baignade* the nudes had retained something of Blanc's classicism, but thereafter Seurat moved steadily away from him. Blanc was too much the neoclassicist to value paintings of contemporary life; drapery, he tells his readers, is superior to contemporary costume. For all his insistence upon studying life, he intended the artist to reach a timeless realm untainted by too strong an evocation of present-day reality, which he equated with materialism. Seurat did what so many artists have done: he "distorted" the ideas of a predecessor. He kept large shards of Blanc's aesthetic but rearranged them, adding many other pieces to form a whole that Blanc would not have recognized.

For Seurat's knowledge of Blanc, the pioneering study is Homer 1964 (see pp. 29–36 and passim). Homer limited his discussion of Blanc largely to color theory, but he made clear Blanc's priority in many of Seurat's concerns. Herbert 1970 stressed Blanc's antinaturalism and its appeal to the Symbolists as well as to Seurat. Michael Zimmermann (1985 and 1989) has provided the most

d'un rayon du globe perpendiculaire à l'horizon. Maintenant, par rapport à ce rayon vertical, qui est l'axe du corps humain, il y a trois autres directions de lignes ou de plans, une horizontale et deux obliques.

La direction horizontale est invariable ; les lignes obliques, au contraire, se modifient selon leur plus ou moins d'obliquité ; mais, en un sens général, il n'y a que deux obliques, celle qui s'élève et celle qui s'abaisse.

Ces trois grandes lignes, l'horizontale et les deux obliques, en dehors de leur valeur mathématique, ont une signification morale, c'est-à-dire qu'elles ont un rapport secret avec le sentiment. La verticale, qui divise exactement le corps de l'homme en deux par-

Diagrams by Humbert de Superville, from Charles Blanc, *Grammaire des arts du dessin* (1880 ed.), p. 33

thorough analysis of Seurat's debts to Blanc; in his new book on Seurat (1991), he traces the origins of Blanc's thought to Quatremère de Quincy and republican neoclassicism. Misook Song's *Art Theories of Charles Blanc 1813–1882* (Ann Arbor, 1984), devoted principally to the *Grammaire*, is now supplanted by Zimmermann's work. Patricia Mainardi, in a lecture of 1987 ("Government Ambivalence towards Art in the Early Third Republic"), defined and emphasized Blanc's republicanism. In "Charles Blanc: Le moderniste malgré lui," *La critique d'art en France 1850–1900*, ed. Jean-Paul Bouillon (Université de Saint-Étienne, Travaux 63, 1989, pp. 95–104), Neil M. Flax showed how Blanc, in his early writings, made an ambiguous contribution to modernism by identifying materialism with realism.

The only surviving excerpt from Blanc in Seurat's hand (de Hauke archives) is a passage from the *Grammaire* (p. 645), which the artist transcribed faithfully except for the omission of Blanc's italics for the first use of *"pointillé"* and for *"Gazette des beaux-arts."* The handwriting is consistent with the years 1886 and after, although one cannot exclude an earlier date. The text may have attracted Seurat at the time he and other Neo-Impressionists were making dotted drawings (cat. no. 192). It would also have pleased him because it identifies a *pointillé* method (Seurat disliked the word, but it was widely applied to his art by others) and associates it with effects of light and color rather than line. It also legitimated a *pointillé* method by locating it in the Renaissance. A translation of Seurat's transcription reads:

gram.re d. arts du dessin page 645

One must distinguish crayon technique from pointillism, which is the art of modeling with dots spaced closely or farther apart, whose density expresses delicate flesh and translates its *morbidesse*. Pointillism is perfectly suitable when it is a question of reproducing a heavy, suave, and well-loaded brush like Correggio's. Roger and Copia have deliciously engraved Prud'hon's tender figures in *pointillé*. However, these excellent engravers are not the first who worked this way. Already at the beginning of the sixteenth century, a Paduan artist had interpreted in this technique the generous and savory paintings of Giorgione. "Giulio Campagnola," writes M. Émile Galichon (Gazette des

beaux-arts), "introduced pointillism in his engravings, using it first to model his figures and foregrounds, reserving the burin for the background, and sometimes covering with dots even the lines which fix the contours. But if this procedure admirably suits the interpretation of the light and color of a Giorgione, it is out of place and ineffectual when it is a question of expressing the superior qualities of a Mantegna or another painter of the severe style with well-defined lines." Thus pointillism is a very old way of engraving; hence it is true that in all inventions, great or small, there is always someone who has preceded the inventor.

1. Kahn 1891.
2. In addition to the letter to Fénéon, there is good evidence that he spoke about Blanc to other journalists and friends. In the wake of several interviews with Seurat, Émile Verhaeren, writing principally of Seurat's theories of expressive line, said that "in the *Grammaire des arts plastiques* [sic], by Charles Blanc, there is formulated a whole theory whose basic ideas seem to be accurate. He started from there." ("Georges Seurat," 1891, p. 434). Gustave Kahn, who also knew Seurat well, said that "he knew his Charles Blanc better than anyone" (Kahn 1928, n.p.), and Signac's *De Delacroix au néo-impressionnisme* (1899) is full of references to Blanc, in part reflecting Seurat's admiration.

In the discussion that follows here, all citations from Blanc are from his *Grammaire*, 1880 ed. (Blanc 1880).

Appendix H

D. P. G. Humbert de Superville and G. B. Duchenne de Boulogne

David-Pierre-Giottin Humbert de Superville (1770–1849), a Dutch Neoclassical artist and theoretician, is known chiefly for his book published in Leiden in installments from 1827 to 1839, *Essai sur les signes inconditionnels dans*

l'art. It was through Charles Blanc's *Grammaire* that Seurat learned of Humbert, for Blanc recapitulated Humbert's theory of linear expression and reproduced a number of his diagrams. Blanc also borrowed (without acknowledgment) other ideas from the Dutch theoretician, but by omitting much and altering the context, he presented a badly fractured view of Humbert's book. At the heart of Humbert's theory lies the idea that one of the universal absolutes is the vertical line, rising from the center of the earth and passing through the axis of the standing human to reach the heavens. The other absolute is its opposite, the horizontal direction. These two form a cross, modulated by the only other essential directions, two diagonals (left and right). These last, however, are not absolute, and their movement relative to the two unvarying axes is the basis of their expression. Humbert's most famous diagrams for this latter consideration are three schematic faces, which Blanc reproduces more than once. Facial features are represented by lines of identical length, so it is only change of direction that gives the three expressions of gaiety, calmness, and sadness. Direction alone, then, underlying representation but independent of it, is a universal sign of human emotion, and hence "unconditional."

Drawing upon religion and mythology and using associations with animals, plants, and historical styles of art and architecture, Humbert said that upward movements indicate "vacillation, agitation, dispersion, explosion, éclat"; their appropriate color is red. Horizontal movements indicate "equilibrium, calmness, order, clarity, light"; their analogous color is white. Downward movements are signs of "concentration, withdrawal, solemnity, depth, shadows"; their color is black. Humbert collated many of these ideas from artistic traditions of long standing, but he pulled them into a theory of considerable brilliance.

Blanc travestied Humbert by his selective appropriations, reducing him to the skeletal idea of linear direction while omitting Humbert's color associations and his rich array of mythological and spiritual meanings. He repeated, with abridgments, some of Humbert's leading examples, such as Egyptian architecture and sculpture as exemplars of (in Blanc's terminology) "calmness, fatality, duration" and Chinese art as embodiments of the upward expression of gaiety. He was especially taken with Humbert's taste for some non-European arts as well as for Egyptian and early Renaissance art. This interest of Blanc's was consistent

with the fact that his principal ideas can be traced back to the era of Neoclassicism, with its strong current of humanism as merged with a "primitive" predilection for the planar over the rounded and for the early, rather than the developed, phases of past arts.

It would suit the modernist well to think that Seurat also responded to this aspect of Humbert's work, but as has been said, he doubtless reached Humbert's work by way of Blanc's *Grammaire*. When Charles Henry mentioned Humbert in *Une esthétique scientifique*, he said that it was through Blanc that one knew about him. For the tripartite expression of human emotions, Seurat drew upon Blanc's specific terminology —*gai, calme, triste* (gay, calm, sad)—rather than Humbert's, and like Blanc, he eliminated Humbert's theory of color. The Dutch writer dealt extensively with mathematical proportions but so did Blanc, and one looks in vain for anything in Seurat that would prove knowledge of the original book. The artist uses none of Humbert's terminology in his *esthétique*, where there would be reason to do so.

The first to link Seurat with Humbert was Arsène Alexandre, who knew the artist. Of *Chahut* he wrote: "People will smile at these three [sic] extraordinary dancers executing cancanesque steps in front of a caricatural orchestra. 'You smile? So much the better,' M. Seurat will say. 'It's just as I wish. In effect I have pursued researches in combinations of *gay lines*!' See Humbert de Superville and, before him [torn and missing] Hogarth" (Alexandre 1891). The next reference to Humbert and Seurat is in Signac's *D'Eugène Delacroix au néo-impressionnisme* of 1899, where he simply lists the aesthetician among the several writers whom Seurat had consulted. Nonetheless we cannot deduce that Seurat told Alexandre or Signac that he had read Humbert in the original, for both men would have known Humbert from Blanc's *Grammaire*. The first modern historian to draw attention to Humbert and Seurat is André Chastel (1959); he was followed by William I. Homer (1964), who gave a much longer exegesis. Since then most writers on Seurat have acknowledged Humbert, but too often they ignore Blanc's essential role as intermediary. For Humbert himself one turns to the excellent book by Barbara M. Stafford (1979).

Did Seurat know the work of Guillaume-Benjamin Duchenne de Boulogne (1806–1875), an important intermediary between Humbert and the École des Beaux-Arts?

Duchenne was a physician who mapped the musculature of the face by using an electrode that made the muscles of his hired models twitch, revealing their function and interrelationship. Independent of the will of the model, he could produce a whole range of facial expressions, which he documented in his own photographs. In addition to gay and sad faces, which recall Humbert, he showed dozens of other expressions. Since he saw the utility to artists of this visual record, he published them in 1862 as *Mécanisme de la physionomie humaine . . . appliquable à la pratique des arts plastiques*. To his photographs of faces, he added others of models dressed and posed "artistically" to confirm his expressive heads, and he also reproduced classical sculpture that revealed similar expressions. French scientific reviews frequently referred to Duchenne, and Darwin reproduced some of his photographs and discussed his work in *The Expression of the Emotions in Man and Animals* (London, 1872). Darwin commented on what he regarded as typically French in Duchenne's method—namely, his preference for mechanistic and external explanations. This inclination, however, would have appealed to Seurat and would have been in keeping with the way he managed the strings of his painted puppets.[1]

Duchenne bequeathed his original photographs to the École des Beaux-Arts three years before Seurat arrived there. Could Seurat have known them? From the researches of Albert Boime (1985) we learn that Mathias Duval, who taught anatomy at the École while Seurat was there, used Duchenne's work in his instruction and that Duval's *Précis d'anatomie à l'usage des artistes* (preface signed 1881) linked Humbert with Duchenne and reproduced some of their illustrations. Unfortunately the records of the École do not tell us whether or not Seurat took anatomy, so we do not know if he was exposed to Duchenne; none of Seurat's friends and reviewers mention him. We can only guess that if Seurat was aware of Duchenne, he did not loom large in the artist's pantheon of sources and that for Seurat his work would at best have constituted scientific support for some aspects of Humbert's ideas. (Of course, this assessment does not deny Duchenne's considerable significance in the history of theories of expression.)

1. Duchenne's ostensibly objective and mechanical approach was specifically praised by Yves Guyot, "L'art et la science," *Revue scientifique* [*Revue rose*] 5 (July 30, 1887): 138–46. Typical of journalistic science of Seurat's decade, this article also gives a synopsis of Chevreul's color theory, praises scientific objectivity in the arts, reproduces motion photographs of both Marey and Muybridge, and uses all of these to assault the nonscientific idealism represented by Charles Blanc.

Appendix I

David Sutter

David Sutter (1811–1880) was the author of "The Phenomena of Vision" ("Les phénomènes de la vision"), published in successive installments in the revue *L'art* (6, 1 [February–March 1880]). In his letter of 1890 to Fénéon (Appendix F), Seurat names Sutter in his list of the salient readings of his youth, with a reference to himself as "sharing certain of Sutter's ideas on the ancient art of the Greeks that I meditated on while in Brest." These ideas that he "shared" were largely familiar to him from his earlier reading of Charles Blanc, but they seconded important notions that he was developing even as he undertook his year's military service and gave those notions the added assurance of origins in ancient art. He remembered Sutter's articles well enough to recall ten years later the months that he had read them (his tearsheets do not bear dates). Furthermore, Seurat clipped Sutter's obituary from *L'art* a few months later (de Hauke archives). The Swiss-born Sutter was also the author of eight books on aesthetics, perspective, musical harmony, and Greek sculpture; the best known is *The Philosophy of the Fine Arts Applied to Painting* (*Philosophie des beaux-arts appliquée à la peinture*), published in 1858 and reissued in 1870. He painted and drew (the Musée Carnavalet preserves an undated ink drawing of his in the manner of Théodore Rousseau: Topo 173B), and he was well known at the École des Beaux-Arts, where he lectured on aesthetics for several years beginning in 1863.

We do not know if Seurat read any of Sutter's books, but the article of 1880, written largely in the form of aphorisms, encapsulates many of the writer's principal ideas. He provided diagrams and analyses of the harmonic rhythms of Greek and Roman art, he commended Venetian painters and Delacroix for their color (specifically lauding the latter over Ingres), and he also praised Corot. He disliked "the academic *bromide*" ("le *poncif* académique") and said that, despite the excesses of realism, the love of truth was the basis of serious progress in art. His advice on color, loosely based on Chevreul, emphasized colored shadows, color opposites, the influence of neighboring colors, and the interrelationship of color and light. "Irradiation," the effect so often seen in Seurat's work when a dark form is edged by a glow of light, particularly interested him. According to Sutter, color, light and dark, and line affected one another, and all were related to emotions (but in rather general ways that lacked Humbert's systematic approach). Analogies with music were constantly mentioned. Like Charles Blanc, Sutter was an antimaterialist who exalted ideals that would rise above "vulgarity." Again like Blanc, he enlisted science in a moral crusade, with which he ends his essay.

Most of Sutter's ideas would have appealed to Seurat, whose annotations are nonetheless limited to asterisks next to certain passages, as given below (Sutter's final page). His choices show the young artist's ambition, couched in repeated urgings to look to the rules and logic of harmony. Between the third and the fourth of the paragraphs he marked, we should note Sutter's leading example, Aristotle's rule of three. In 1890, when Seurat told Fénéon that Sutter's articles had been important to him, he was composing his *esthétique*, based on the triumvirate of line, color, and light and dark.

From Félix Fénéon, Robert Rey (1931, pp. 127f.) learned that the tearsheets of Sutter's article and his obituary had been found in Seurat's studio after his death. William I. Homer (1964, pp. 43–47, 207f., and passim) gives the best account of Sutter's ideas and why Seurat was attracted to them. Sutter is briefly but perceptively mentioned in Stafford 1979, p. 181, and in Boime 1985, p. 51.

The following extract is a translation of Sutter's text (the asterisks were added by Seurat):

It is evident that the teaching of the fine arts is not at all on the level of modern science and that it lacked a criterion by which one could justify the beauties that genius made us accept as absolute rules.

One thing is common to all genres of painting, to all feelings, to all styles—namely, the perfect application of the laws of unity, order, and harmony. As all the arts have the same foundation, the same rules ought to form the basis of all artistic instruction.

** One should therefore find the clear and precise formulation of the rules of the harmony of line, light, and color, and give the scientific explanation of these rules. It should be all the more necessary because the artist devoted to routine only attains a relative perfection when his hair begins to turn white; the best years of his life pass amid gropings and endless researches.

** We insist on this essential point: All rules being derived from the very laws of nature, nothing is easier to know on principle or more indispensable. In the arts, everything should be willed. From that flows the need to descend to the smallest details, to understand them by a thorough analysis in order to reach perfection.

According to Pausanias, the first to find the laws of harmony was Pythagoras of Rhegium, the sculptor who was still alive in the era of Phidias. From this time onward (466 B.C.) and for several centuries, these laws directed artists in the execution of their works. No writer made known clearly what these rules consisted of; however, Aristotle, without giving the practical means, defined clearly enough the principles on which are founded the rules governing the fine arts.

"The number three," he said, "serves to determine harmony in all things; for two things cannot subsist without a third that connects them, and the better link is that which unites itself as much as possible to the connecting object so that the first is proportional to the second, as the latter is to the third. Consequently in this number is found the beginning, the middle, and the end."

Music gives a very clear idea of this theory, for the *tonic* and the *fifth* are connected by the *third*, which establishes harmony between these two extremes in order to constitute the consonant or perfect chord. Equally, the vertical and horizontal are linked by the diagonal, as the half-tint links shadow to light, and in colors, yellow to red and to blue, etc., etc.

Now in the arts the physical principle is always found together with the intellectual principle, so to formulate the science of the fine arts, one should find support in the sciences of observation and ask natural philosophy for the very laws of nature.

The secrets of nature are hidden; time unveils them successively, and this is why we know better than the ancients the laws that govern nature.

Instinct does not change, but reasoning ceaselessly progresses, and man takes advantage of his own experience and that of his peers. It is one of the most beautiful faculties of the human mind, and he who does not ardently seek to extend his acquaintance renounces by that very act his most wonderful privilege.

Among the causes that can retard the progress of the fine arts, the idea that the masterpieces that we admire are inaccessible to our efforts is an error that we can refute, for it derives more from insufficient instruction than from a lack of intelligence. Certain it is that every art requires an initiation and that Greek art does not cultivate banal admiration by flattering the senses; it addresses itself to our intelligence. In order to fight these causes of weakness, it is necessary to return studies to the simplicity and precision of formulas, to sincerity in their application; from that follows the necessary participation of the moral faculties. "The mind loves healthy, substantial nourishment," Montaigne said, "and does not dine on words devoid of meaning."

*** With the support of rules, which are simple as are all true things, one proceeds with certainty to the analysis of the works of the masters of all schools of painting, sculpture, and architecture; one proves clearly that there is not beauty without a logical relationship of taste submitted to the laws of harmony; and that these laws are constant, whatever the degree of elevation of the subject. One therefore finds the application of the same laws in the Apollo Belvedere as in a painting of Raphael or Rembrandt.

The seventeenth century in France, a century of the mind and reason, was also one of great poets and great artists. Poussin, Le Sueur, Claude Le Lorrain are the highest personalities in painting. Then, with the relaxation of morals, human dignity was weakened, art descended from its pedestal, and noble subjects were replaced by lascivious paintings that contributed to the corruption of morals. In Flanders the fine arts fell into decadence with the political decline of Belgium, and among the Dutch, with the loss of public wealth.

From decline to decline, art ended up by going back to its elementary form, and the realist school, leaving aside the masterly qualities of painting, provoked the reprobation of enlightened minds. Nevertheless, from an elevated viewpoint that lets the future appear, one can doubtless recognize that this aspiration and this love of truth were logical points of departure for any serious progress and that artists should be praised for having dared to react openly against what one calls the academic *bromide* [le *poncif* académique].

On the other hand, all intelligent persons tend to leave behind this humiliating materialism that is the mark of our era. Everything points to a regeneration. The united efforts of philosophy and science will lead society, in the near future, toward the possession of the real values of intelligence that alone raise man to his highest dignity.

Let us, sincere men, push away the spectacle of vulgarity, let us offer salutary examples, and firmly standing on the steps of the temple, let us pursue with ardor the beautiful idea, pushing ourselves to reproduce it in all our creations under the beneficial influence of truth. It is to moral progress, which will be the certain result, that art will owe the continuation of its upward climb toward ideal perfection.

Appendix J

Michel-Eugène Chevreul

According to his letter of 1890 to Fénéon, Seurat learned of Michel-Eugène Chevreul (1786–1889) by reading Blanc while "in college," about 1876 (he apparently meant Lequien's school). He copied out a number of maxims from Chevreul's most famous book, *The Principles of Harmony and Contrast of Colors (De la loi du contraste simultané des couleurs)*. Published in 1839, this influential book went through numerous editions. (Translations below are from Charles Martel's edition [London, 1860]; references are to Chevreul's numbered paragraphs.) Its principles were

adopted by French schools and widely used in industry and commerce, particularly in textile manufacturing. Its special virtue was the richness of its empirical observations, guided by clearly stated principles and exemplified in segmented color charts. Page after page lists the effects of placing colors next to one another in all media: painting, textiles, wallpaper, printing, interior decoration, clothing, and gardens. The book's underlying principles are based on the observation that a given color is always influenced by adjacent colors.

These influences are summarized in two laws: those of "simultaneous" and "successive" contrasts. These refer to the fact that when we look at a color, a faint version of its opposite is stimulated in our vision (usually unconsciously). In the "simultaneous contrast" of two colors seen side by side, each color will tint the other with its opposite, thereby heightening the contrast. If red is next to blue, for example, the red will engender a halo of its opposite, green, which will then alter the adjacent blue to greenish blue. At the same time, the blue stimulates a pale orange, which converts the nearby red to orangish red. "Successive contrast" operates when we look at one color for a time and then look elsewhere; in doing so, we tinge this other area with the pale opposite and therefore alter it.

Chevreul ranges the contrasts he observed into "harmonies of analogous colors" and "harmonies of contrasts," phrases borrowed from the classicizing aesthetics that were used by Blanc, Couture, and Seurat. Although his book deals with textiles and the decorative arts more than with painting, Chevreul frequently addresses himself to the painter. Art should speak directly to the eyes by virtue of clear organization, involving the editing of raw nature; the painter does not merely imitate what he sees.[1] The artist can choose a dominant color and alter the model for the sake of art, guided by "genius alone" (343ff.). If the artist wishes to be forceful with color, then "harmony of contrast" should be the guide (348). Despite later artists' interest in his "simultaneous" and "successive" contrasts, he alerts artists to the effects so that they will *not* paint them. Faithfully painting the local colors will reproduce the effects of contrast, he teaches.

Although Chevreul confused pigment colors with colored light, his observations of natural light and color would have appealed to Seurat. Shadows are actually colored, he showed, and are not merely darker versions of environing hues; the effect of direct sunlight is to add

orange to surfaces turned toward it; strong light overwhelms many effects of contrast, which are therefore more evident in indirect light. Also of interest to Seurat, we can assume, were Chevreul's discussions of color harmonies in the arts. It was by observing textiles—Chevreul was director of the dyeworks at the Gobelins tapestry manufactory—that the chemist learned the intricacies of color combinations. Interweaving threads of color opposites, for example, results in a dull gray tone (without using the phrase "optical mixture," Chevreul provided Blanc with evidence for his theory). From the decorative arts he derived his principle that flat colored areas ("à teintes plates") with little modeling are preferable for paintings that are seen from a distance: "The qualities peculiar to painting in flat tints are: a) Purity of outline. b) Regularity and elegance of form. c) Beautiful colors properly assorted. Whenever opportunity permits, the most vivid and most contrasting colors may be advantageously employed. d) Simplicity in the whole, so as to render clear and distinct view easy" (872).

One of the most intriguing possibilities of Chevreul's relevance to Seurat is found in his extended discussions of frames, both for paintings and for panels, doorways, and other features of interior decoration. All frames influence the paintings they surround, and one must avoid adverse effects. For a small composition, "the artist will be obliged beforehand to choose the frame for himself and to paint up those parts of his picture which are contiguous, but in such a way that they shall harmonise with it" (572). For landscapes in oils, gray frames are advisable because they accept the pale tint of the opposite of the picture's dominant hue. Seurat's use of painted frames may well have stemmed from Impressionist practice, but Chevreul's insistence upon the role of the frame perhaps contributed to his experiments. Chevreul favors color opposites in long passages (especially 599ff.) on the colors of borders for interior wallpaper, cloth, or painted decor, from which Seurat could have taken advice for his painted borders as well as for his painted frames.

Seurat's enthusiasm for Chevreul was transferred to Signac, who visited the chemist at the Gobelins (Signac 1899, ed. 1911, p. 46).[2] Several of the Neo-Impressionists also came to share this interest. Ogden Rood's handbook on color largely supplanted Chevreul among these artists, for he showed that the famous chemist had confused pigments with light. Nonetheless, Chevreul's observations

and his laws of simultaneous and successive contrasts remained powerful formulations that survived the changes in theory. The best study of Chevreul and Seurat is in Homer 1964, pp. 20–29, 82–84, and passim.

Seurat's extracts (de Hauke archives) are from sections 335 to 340 of Chevreul's book. He omitted the examples Chevreul gave for certain of these principles and shortened "such is the influence of black upon certain yellows" to "influence on certain yellows." Otherwise he copied the scientist's words faithfully. The extracts were published in H, I, p. xxiv. Fénéon thought them to be of Seurat's own invention, but William I. Homer correctly identified them for de Hauke.

1

Put a color upon a canvas, it not only colors that part of the canvas to which the brush has been applied, but it also colors the surrounding space with the complementary of this color.

2

To place white beside a color is to heighten its tone; it is the same as if we took away from the color the white light which enfeebled its intensity.

3

Putting black beside a color lowers its tone; in some cases it impoverishes it. Influence on certain yellows.

4

Putting gray beside a color, renders it more brilliant, and at the same time it tints this gray with the complementary of the color which is in juxtaposition.

From this principle it results that in many cases where gray is near to a pure color in the model, the painter, if he wishes to imitate this gray, which appears to him tinted of the complementary of the pure color, need not have recourse to a colored gray, as the effect ought to be produced in the imitation by the juxtaposition of the color with the gray which is near.

Besides, the importance of this principle cannot be doubted, when we consider that all the modifications which monochromous objects may present (excepting those which result from the reflections of colored light emanating from neighboring objects) belong to the different relations of position between the parts of the object and the eye of the spectator, so that it is strictly

true to say, that, to reproduce by painting all these modifications, it suffices to have a color exactly identical to that of the model and black and white. In fact, with white we can reproduce all the modifications due to the weakening of the color by light, and with black, those which are necessary to heighten its tone. If the color of the model in certain parts gives rise to the manifestation of its complementary, because these parts do not return to the eye sufficient of color and white light to neutralise this manifestation, the modification of which I speak is reproduced in the imitation by the employment of a normal gray tone properly surrounded with the color of the object.

If the preceding proposition be true, I recognize the necessity in many cases of employing, with the color of the object, the colors which are near to it; that is to say, the hues of the color. For example, in imitating a rose, we can employ red tinted with a little yellow, and a little blue, or in other terms, tinted with orange and violet; but the green shadows which we perceive in certain parts arise from the juxtaposition of red and normal gray.

5

To put a dark color near a different, but lighter color, is to raise the tone of the first, and to lower that of the second, independently of the modification resulting from the mixture of the complementaries.

An important consequence of this principle is that the first effect may neutralize the second, or even destroy it altogether: for example, a light blue placed beside a yellow tinges it orange, and consequently heightens its tone; while there are some blues so dark relative to the yellow, that they weaken it, and not only hide the orange tint, but even cause sensitive eyes to feel that the yellow is rather green than orange; a very natural result, if we consider that the paler the yellow becomes, the more it tends to appear green.

6

Put beside each other two flat tints of different tones of the same color, chiaroscuro is produced, because, in setting out from the line of juxtaposition, the tint of the band of the highest tone is insensibly enfeebled; while setting out from the same line, the tint of the band of the lowest tone becomes heightened: there is then a true gradation of light.

The same gradation takes place in every juxtaposition of colors distinctly different.

1. Among Chevreul's many publications is his book of 1864, *On Abstraction Considered Relative to the Fine Arts and Literature* (*De l'abstraction considérée relativement aux beaux-arts et à la littérature*), thoroughly saturated in classicizing aesthetics.

2. Long after Seurat's death, Signac said that Seurat had accompanied him on a visit to Chevreul (reported by Jacques Guenne, "Entretien avec Paul Signac," *L'art vivant* 1, 6 [1925]: 1–4, and by Edouard Fer, *Solfège de la couleur* [1953], p. vii). This statement seems to represent a lapse of memory, however, for in a letter to Octave Mirbeau, datable to 1894 by internal evidence (autograph market, Paris, January 1969), Signac wrote of the separate routes he and Seurat had taken toward Neo-Impressionism and said that before he met Seurat he had made a visit "to papa Chevreul where a preparator" had shown him things. In the Signac archives is a letter of January 2, 1885, to the artist from Émile David of the Gobelins, who writes, "If you would like to come to the Gobelins factory, I will put myself entirely at your disposal in order to let you witness a few simple experiments based on the reflection of white light." One can therefore deduce that Signac went to the Gobelins in early 1885 (not 1884, as he later said), well after his meeting with Seurat, and there saw Émile David, not Chevreul himself.

Appendix K

Ogden Rood

With his usual precision, Seurat told Fénéon in his letter of 1890 that Ogden Rood (1831–1902) was brought to his attention in 1881 by Philippe Gille in *Le Figaro*. He was referring to Gille's book review in the issue of January 26, 1881, p. 6, which included a simple announcement of the publication. Published in New York two years earlier as *Modern Chromatics, Students' Text-Book of Color*, it was translated as *Théorie scientifique des couleurs et leurs applications à l'art et à l'industrie* in the series Bibliothèque scientifique internationale (Librairie Baillière). This series was a kind of everyman's library, and at six francs a volume, it was

host to notable French, German, American, and British scientists, including Étienne-Jules Marey, Herbert Spencer, and Hermann von Helmholtz. Rood's volume was admirably suited to this series, for it is a very clear and up-to-date summary of color theory, expressed in layman's language and well seasoned with observations about painting that owed some of their appropriateness to the fact that Rood was an amateur painter himself who did landscapes of a Turneresque manner. He emphasized the perception of color as much as color's physical properties.

Rood, a professor of physics at Columbia University, is now remembered only for his *Modern Chromatics*, although he was the author of numerous scientific papers. By incorporating the findings of Helmholtz and Charles Maxwell in his book, Rood makes clear the distinction between color-light and color in pigments. (Chevreul, Sir David Brewster, and other scientists before 1850 had confused the two.) Colored light rays do not at all act like pigments. Prismatic beams of orangish yellow and blue, when superimposed, will create white without a hint of the green that results when similarly colored pigments are mixed. Another pair of color-light opposites, purple and green, produce white, whereas pigments of those colors produce a muddy brown. This is because, in Rood's helpful terminology, color-light is "additive": the intensities of constituent beams reinforce one another. Pigments are "subtractive," for being impure substances and not real light, each constituent absorbs, alters, and diminishes light.

Rood showed Seurat why pigment mixtures were inferior to natural light, and he must have reinforced the painter's desire to achieve more luminous effects. Rood rigorously separated color opposites in light from those in pigments and produced a chart of color relationships that was different from Chevreul's. Seurat had copied Chevreul's chart in a notebook of about 1879 and later, presumably in 1881, copied Rood's, so he was fully aware of the differences.[1] Rood endorsed most of Chevreul's observations (but not his faulty theory), and he also gave Seurat current scientific support for trying to approximate natural color-light with the aid of the "mélange optique" that the artist had been reading about in Charles Blanc, exemplified in the broken colors he had been observing in Delacroix. Although pigments could never be the same as light beams, Rood wrote that there was a way of mixing color that artists had been using for some time: "We refer to the custom of placing a quantity of small dots of two colors

very near each other, and allowing them to be blended by the eye placed at the proper distance. . . . This method is almost the only practical one at the disposal of the artist whereby he can actually mix, not pigments, but masses of colored light" (p. 140).[2] Rood's "masses of colored light" were reflected from pigments and were not the same as prismatic light, but Rood's phrasing was ambiguous, and it would have taken a careful reading of other passages to realize this distinction. It was easy for Seurat to believe that Rood was telling him how to achieve the effects of actual color-light.

Even so, for Seurat artistic practice took precedence over Rood. Until 1884, as Seurat says in his letter to Fénéon, he often used mixed pigments and earth tones rather than pure, intense ones, and he usually put dark grounds under his colors (Rood cited Ruskin, who recommended placing points of color over a white ground). It was probably the study of Impressionist paintings, particularly those of Monet and Renoir, whom Seurat mentions in the same letter, that led him gradually to use brighter colors. Rood, however, was both a source of information and a crutch that he leaned on as he developed the small strokes that eventually typified his Neo-Impressionist technique. His dependence upon Rood was passed on to Signac, Camille Pissarro, and the other Neo-Impressionists in France and Belgium, who made the book into the veritable bible of the movement. From 1886 onward, Rood was liberally cited and referred to by Fénéon and other critics when they wrote of Seurat and his colleagues.

For Rood, see Homer 1964; Edward L. Nichols's *Biographical Memoir of Ogden Nicholas Rood, 1831–1902*, a lecture published by the National Academy of Sciences, New York, in 1909; and the introduction and notes by Faber Birren in his reprinting of Rood (New York, 1973).

From Rood's book, in addition to the following abbreviated notes, Seurat traced the scientist's starburst diagram that names pairs of contrasting colors (Signac archives). His notes were based on a portion of Rood's chapter "On the Production of Color by Absorption" (pp. 65–91):

Production of colors b. absorption
 100 lum. of white paper
 5 ——— black ———
 surf. painted yellow as lum.ous as a white surf.ce
 100 lum.ty white paper

 25 vermilion
 48 emerald green
 75 or 80 emerald green [*sic*]
Pigts. in dry powder
Pigmts. covered by water
The medium with which pigments are mixed has an important influence o. th. appearance.
col. o. fabrics. ——— Col. of water
Simler's erythroscope
2 plates glass cobalt bl. and deep yellow

In the passages abridged by Seurat, Rood tells the reader that it is instructive to compare a given colored paper with a white and a matte black paper placed alongside. If 100 is taken as the luminosity of the light reflected from the white, only 5 percent of that luminosity will be reflected from the black. If paper is coated with powdered vermilion, it will reflect only 25 percent as much as untouched white paper; emerald green will reflect 48 percent, and chrome yellow (Seurat absentmindedly repeated "emerald green"), 75 to 80 percent. Further, examination with a spectroscope shows that any one of these pigments, including black, actually contains the full spectrum of color but that most are absorbed by the medium, allowing one color to dominate in normal vision.

Rood then describes repeating the same experiment after covering the colored surfaces with a thin layer of water. All the readings will change (some more than others) because the water, even though it seems transparent, will absorb some of the light and thereby alter the reflected colors. The lesson is that any substance (like varnish) that covers a colored surface or is mixed with the colors will affect their appearance. Mixtures of dark pigments will absorb so much color-light that we would see little color at all, so Rood advises what artists had long been doing—namely, mixing the pigments with white, or else spreading them in thin, translucent layers over a light ground.

The colors of textiles are also partly a result of absorption. Some light is reflected from the surface of the fibers, but some is partly absorbed and then cast back, altered. (Here Rood was explaining effects that Chevreul had described without recognizing their causes.) Rood then passes from fabrics to landscape, saying that natural substances absorb and alter light. He points to water and vegetation, both of evident importance to a landscape

painter. Water is actually colored, though faintly, and it reflects, refracts, and absorbs color-light; the strength of the light, both direct and indirect, and the depth of the water will help determine color. Green vegetation also absorbs light, but looking through Rudolph Simler's "erythroscope," a sandwich of cobalt blue and dark yellow glass, reveals its red component. The blue and yellow glasses absorb blue, yellow, and green, letting us see the red that is normally hidden by the dominant green. Rood then gives an ecstatic description of a landscape seen through the erythroscope, concluding that "the whole effect is as though a magician's wand had passed over the scene, and transformed it into an enchanted garden" (p. 84). It is tempting to speculate that, having singled out Simler's device, Seurat followed Rood's advice and experimented with it. However, the ruddy foliage of some of his early panels can be explained by sunset effects and we are left without evidence that he used the erythroscope.

1. His copy of Chevreul's color wheel is in an unpublished notebook (art market, New York); his copy of Rood's is in the Signac archives. The latter, first published in Rewald, *Art News*, 1949, was properly identified in Homer 1964.
2. Page references are to the original edition (New York, 1879).

Appendix L

Charles Henry

Charles Henry (1859–1926) was a mathematician and aesthetician prominent in Symbolist circles. His official career unfolded at the Sorbonne, where he was named to a minor library post (*sous-bibliothécaire*) in 1881, then teaching assistant (*maître de conférences*) at the École des Hautes Études in 1892, and in 1897, director of the Laboratoire de Physiologie des Sensations (very much a self-invented position). A brilliant polymath, he devoted his best-known work of the 1880s and early 1890s to the mathematical expression of psychic and biological phenomena. He was most influential in his unofficial career as editor and

author of innumerable reviews and articles as well as several books that asserted a scientific aesthetic: *Introduction à une esthétique scientifique* (1885, first published as an article in the *Revue contemporaine*), *Le rapporteur esthétique* (1888), *Le cercle chromatique* (1889), *Applications de nouveaux instruments de précision à l'archéologie* (1890), and *Harmonie de formes et de couleurs* (1891). From lycée days he was a close friend of Jules Laforgue and Gustave Kahn, and subsequently an intimate of Félix Fénéon, with whom he collaborated on several Symbolist journals and editing projects (it was they who first edited Laforgue's letters, many of them addressed to Henry). His closest relationship with a painter was with Paul Signac, who worked with him on several experiments and publications starting in 1888. Later, after World War I, he again entered avant-garde circles owing to friendships with Amédée Ozenfant, Juliette Roche, and Albert Gleizes. Ozenfant and Le Corbusier published Henry's "La lumière, la couleur, et la forme," in successive issues of *L'esprit nouveau* beginning in March 1921 and the following year issued it as a book, with additions from Henry's earlier work.

In his letter to Fénéon of 1890, Seurat said that he had met Henry at the time of the last Impressionist exhibition in 1886. It was probably between that date and the exhibition of *Parade* in 1888 that he copied out words from Henry's brochure of 1885, *Introduction à une esthétique scientifique*, along with diagrams and a portion of the background of the painting. Henry's ideas seem to lie behind the final phrases of Seurat's statement to Gustave Kahn about Phidias's panathenaic procession (cited in the discussion of the *La Grande Jatte*), where he said that his perambulating modern people would be placed "on canvases organized by harmonies of color, by directions of the tones in harmony with the lines, and by the directions of the lines, lines and colors assorted with one another." Seurat's familiarity with Henry's ideas cannot be doubted, for he headed a draft of his *esthétique* in 1890 (Appendix E) with the names of Delacroix, Chevreul, Rood, Helmholtz, and Henry. Beyond these recorded connections, everything is conjecture, and it now becomes apparent that most of us who have written about Henry have greatly exaggerated his influence, principally by attributing to him the ideas Seurat had earlier found in Blanc and Humbert de Superville. Share in righting the record should be given to Herz-Fischler 1983 and to Neveux 1990, for by discounting

Seurat's supposed use of the golden section, they implicitly questioned Henry's role in general.

For Seurat and Henry, given prominence in Rewald 1956, the first major studies were Dorra-Rewald 1959, Homer 1964, and Dorra, "Charles Henry's 'scientific' esthetic," 1969. Homer and Dorra recognized the danger of crediting Henry with Humbert's and Blanc's ideas, but with the convenience of hindsight, we see that they relied too much upon exacting analyses of Henry's mathematical angles and rhythms in Seurat's paintings. If transparencies of *Poseuses*, *Chahut*, and *Cirque* are projected fully to scale and then subjected to measurement, the angles and distances simply do not fit Henry's schemata with exactness. Equally unconvincing are attempts to associate the specific direction of lines in Seurat's paintings with Henry's concepts of "dynamogenic" movement (upward to the right) and "inhibitory" movement (downward to the left). Henry's theory referred to essential biological rhythms, not to surface appearances, and therefore he did not propose that pictures be so schematized. He warned his readers that directions were relative, not absolute, and not to be isolated from "other aesthetic elements." It is enough to say that he gave Seurat scientific support for the Humbert–Blanc ideas about the expressive value of linear directions and that he probably rekindled the painter's enthusiasm for those ideas after 1886. Analysis of the drafts of Seurat's *esthétique* show how much he depended upon Humbert and how little of Henry he was able to assimilate.

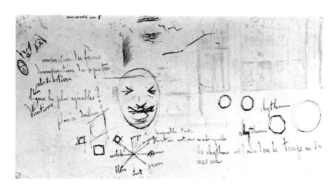

Seurat, *Studies with excerpts from Charles Henry,* 1887–88. Private collection, Paris

The basic work on Henry is François Warrain, *L'oeuvre psychobiophysique de Charles Henry* (1938). Joan Halperin (1988) gives the most thorough biographical account of Henry's relations with Fénéon and the Symbolist circle, and Michael Zimmermann (1991), the most searching study of Henry in relation to Symbolism and Seurat. A special issue of *Cahiers de l'étoile* (13 [January–February 1930]), devoted to Henry, has articles by Signac, Kahn, Roche, Gleizes, Paul Valéry, and many others. For Henry and Seurat, in addition to publications already mentioned, see Herbert 1970; Alain Mercier, "Charles Henry et l'esthétique symboliste," *Revue des sciences humaines* (Lille) 35, 138 (April–June 1970): 251–72; Herbert 1980 (taking note of the error mentioned above); and Zimmermann 1985. One should read with great caution José Argüelles, *Charles Henry and the Formation of a Psychophysical Aesthetic* (Chicago, 1972), an unconvincing attempt to make Henry into a mystic.

In 1980 (Herbert 1980) I reproduced for the first time the small sheet for *Parade* with excerpts from Henry's *Introduction à une esthétique scientifique* of 1885. The upper right quadrant consists of a faint pencil study of the Cirque Corvi, probably done on the site in the spring of 1887.[1] It shows the glazed wall of the circus: first two, then four vertical panes numbered "1, 2, 1, 2, 3, 4." The fourth pane does not appear in the oil and is one reason why the drawing must be a preliminary study. As in the painting, the lower portions of the panes are darkened, and interior gas globes are indicated. Above is a crude circle labeled "gaz" (for the external gas jets), and directly below it, "⅓" is repeated three times. These give the proportions preserved in the oil: the height of the dark portions is exactly the same as the distance from their upper edges to the top of the interior gaslights and from that point to the top of the canvas. On the left of the windows is one of the painted vertical pilasters with flaring base that are visible in the later photograph. To its left are two horizontal lines marking the musicians' balustrade; above is a short line marked "tête musicien," corresponding to the top of the musicians' heads in the painting.

Because all of this is in pencil but all the other words and diagrams are in ink, we must allow for the likelihood that the excerpts from Henry were not done at exactly the same time. Seurat presumably used the blank portions of a

sheet from a sketch pad (*calepin*) to jot down his musings as he puzzled over Henry's essay. He had met Henry in 1886, and the aesthetician's prominence in the circle of critics who championed Seurat would have attracted the painter's attention. It seems most likely that he began studying *Une esthétique scientifique* a year later, when working on *Parade*. The certainty with which I linked *Parade* and Henry in the article of 1980 should be challenged, but logic still favors the association. In the lower left of Seurat's sheet, the four small circles inscribed in squares and the spindly color chart result from the artist's confusions (discussed below) as he tried to interpret Henry's text. Beginning in 1888, Henry's publications provided the necessary diagrams to make his meanings clear, and by that year Signac was collaborating with Seurat so there would have been little reason for the latter to remain confused.

My contention (Herbert 1980) that Seurat used the golden section must be entirely discarded, although he did use the more familiar geometric relationships (⅝, ⅘, ¼, ⅓, etc.). I said that the polygons Seurat inscribed in circles on the right side of his small sheet were proof that he knew and used the golden section—a common error borrowed from amateurs' writings about that proportion and also a result of my adoption of the prevailing view of Seurat's "science." Only a pentagon inscribed in a circle defines the golden section,[2] so the encircled polygons mean instead that Seurat was simply schematizing Henry's way of demonstrating rhythmic numbers (hence the adjacent word "rhythme"): Henry marked a circle for one of these numbers or sets and joined the points to form a polygon.

Elsewhere on the sheet are diagrams and words taken from Henry's essay of 1885, and Humbert's three faces. Henry cites Humbert (he notes that Blanc popularized him) as an important precursor. Already familiar with Humbert, Seurat must have eagerly pored over Henry's "scientific" vindication of the Humbert–Blanc theories. On the upper left of his sheet are the three faces of calmness, gaiety, and sadness. He gave two of them ears, which are absent in Humbert, transforming them into the masks of comedy and tragedy appropriate to his circus theme. Toward the center, he drew the three faces, one over the other. The rest of the words and diagrams refer to Henry's own ideas. In the upper left are phrases from a paragraph in which the writer says that the scientific study

of the subjective impressions of movement, color, and sound has been retarded because prior generations ignored the "composition of forces" and the "decomposition of the spectrum."

Below these words are others that abridge the core of Henry's theory. The phrase "plaisir douleur?" encapsulates the idea borrowed from contemporaneous physiology that all emotional responses, including unconscious ones, can be traced to the activity of nerves and muscles that reflect the relative ease or discomfort induced by the stimulus—hence (expressed in extremes) "pleasure" or "pain." For example, we gesture upward in joy or excitement and slump downward in dejection. More subtly, we take pleasure in the normal clockwise motion of manipulating a crank but find the reverse slightly disagreeable. Seurat cites the words "the most agreeable lines?" and uses arrows to attach the words "abstraction" and "directions" to "lines." A line, Henry writes, is the result of a given direction and is therefore its abstract residue (and the sign of a bodily gesture). The scientist's job is to determine which lines are agreeable—that is, which ones conform to rhythms that suit human physiology. (The disagreeable, or unrhythmic, lines are defined by opposition; hence Seurat wrote below the center of his sheet "disagreeable any direction opposed to the agreeable.") Henry believed the best general definition of rhythm "is that of Aristide Quintilian and of Aristoxenus formulated by M. Charles Lévêque: 'Rhythm is order in time, or measure.'" Seurat copied the last words on the lower right, below the circles that refer to the geometric expression of rhythmic measurement.

On the left, four circles roughly inscribed in squares are Seurat's attempts to understand Henry's idea that a circle so inscribed is disagreeable because one has no idea of its direction (Henry had no diagrams in *Une esthétique scientifique*, so Seurat was trying to visualize his words as best he could). In Henry's dynamic conception, a circle is the result of a rotation; it is therefore a cycle and should be indicated by two, not four, tangents in order to induce the agreeable sensation of turning. One of the four inscribed circles seems attached to the adjacent color wheel, substituting for a color name we would expect to find there. Seurat's diagram resulted from the unclear way Henry verbalized his color wheel. (Henry's eight points, clockwise from the top, were red, orange, yellow, green,

blue-green, blue, blue-violet, and violet.) Henry used "bleu" as a collective term that meant blue-green, blue, and blue-violet, each requiring a point of the wheel, although the reader might think only one point was indicated. Because of this and other unclear phraseology, Seurat was left with the impossible task of labeling eight points with six colors—hence his two yellows, one of which has no partner. Perhaps it was deliberate that Seurat put one of Henry's signs for a disagreeable circle in place of the missing color term.

Despite Seurat's confusion, he would have been pleased with Henry's insistence that color was intimately allied with linear direction. Humbert had also said so, but in his formulation (echoing Goethe rather than Newton), upward was red, horizontal was white, downward was black. Henry's scheme located the colors by associating them with physiological sensations, so that red, orange, and yellow were toward the upper right as the most "dynamogenic," and the blues, toward the lower left as the most "inhibitory." We now see this as pseudoscience, but in Henry's day scientific circles showed widespread interest in such phenomena, seemingly confirmed by experiments whose subjective, or self-fulfilling, components were not then apparent. Seurat's friend Signac, by his own testimony, shared in some of Henry's experiments, but Seurat's *esthétique* of 1890 did not incorporate Henry's color theory. It was apparently enough encouragement for him that the mathematician supported the intimate association of color with line.

1. The sheet is 4⅛ × 7⅝ in. (10.5 × 19.5 cm.), approximately the same size as the lost double-sided drawing of the entrance of the Cirque Corvi and of a winged female entertainer (4½ × 7⅝ in. [11.5 × 19.5 cm.]; H 381 and 382), and probably from the same sketch pad. The only other drawing of similar dimensions in Seurat's oeuvre is the dotted version of *Parade* (cat. no. 204; 5 × 7⅛ in. [12.7 × 19 cm.]), so the three sheets form a logical cluster.

2. I am grateful to my colleague the mathematician Robert Szczarba for pointing out my error.

Appendix M

Camille Corot

Corot was among those whom Seurat judged crucial to his formation in the list he provided Fénéon in 1890 (Appendix F), where he describes himself as "knowing Corot's ideas on tone (copy of a private letter October 28, 1875)." By mentioning tone—that is, value or light and dark— Seurat showed that Corot sanctioned his own practice in which value preceded color: a conception quite different from that of Impressionism and one that still claimed Seurat's allegiance at the end of his life.

From a letter Madeleine Knoblock wrote to Signac not long after Seurat's death (de Hauke archives), we learn that Seurat had lent Maximilien Luce his Corot text, "inscribed in a notebook" (in the letter Knoblock asks Signac's help in reclaiming the text, which has disappeared). Then, on November 16, 1898, Signac pasted in his diary a copy of the text that was sent to him by Fénéon, who said Seurat had dictated it to him (*Signac Journal*, ed. J. Rewald, p. 284). It is this text that is translated below.

The first published history of Corot's text was given by Étienne Moreau-Nélaton, *Histoire de Corot et de ses oeuvres* (1905), pp. 285ff.: Corot several times visited his nephew Émile Corot at Méry-sur-Seine (Aube); Mme Jules Aviat, a neighbor, had been allowed to paint with Corot, and she wrote down the advice he gave during their conversations; Émile Corot's son Fernand transmitted them to Moreau-Nélaton. In 1914, presumably basing his account on Seurat, Fénéon wrote that "on October 7, 1875, J. Aviat passed them on to Seurat's father, probably to satisfy a curiosity expressed by Georges Seurat, then sixteen years old. There are three manuscript pages."[1] The notes that Moreau-Nélaton and Fénéon published are about three times the length of Seurat's version. The portions Seurat omitted (if, indeed, he had access to the whole set) concern Corot's insistence on his humility and do not bear on his technique.

Extract from the Souvenirs of my good and interesting talks with M. Corot, 1869, at Méry-sur-Seine, J. Aviat, October 17, 1875. I always try right away to see the effect. I act like a child blowing a soap bubble; it is tiny, but already spherical, then it gently swells until he fears it will burst. Similarly I work over all parts of my painting at the same time, gently improving it until I find the effect completed.

I always begin with the shadows, and that's logical because, as that's what strikes you the most, it's therefore what one ought to render first.

What one should see in painting, or rather what I look for, is the form, the whole, the value of the tones; color for me comes afterward. It's like a person one welcomes because he is upright, honest, without reproach; one will receive him without fear and even with pleasure. If he is ill-natured, his honesty will let him get by; now if he is good-natured, that will be an additional charm he will profit from, but that's not the essential point. It's why color for me comes afterward, because above all I like the whole and harmony in the tones, whereas color sometimes produces clashes that I do not like. It's perhaps because of the excess of this principle that it's said that I often make leaden tones.

There is always a luminous point in a painting, but it must be unique. You can place it where you wish, whether in a cloud, in reflections in water, or on a bonnet, but there should be only one tone of this value.

1. "Paroles de Corot," *Bulletin* (Paris, Bernheim-Jeune) 6 (April 29, 1914), in Fénéon 1970, I, pp. 290f. The manuscript has not been found among Fénéon's papers in the de Hauke archives.

Appendix N

Eugène Delacroix

This appendix is the first compendium of all of Seurat's known references to Delacroix, with their sources. Seurat's notes of 1881 on paintings by Delacroix have been known since Fénéon published them in 1922, and historians have taken them into account; the best analysis of the lessons that Seurat drew from Delacroix is in Homer 1964 (pp. 34–36, 48–51, 72, 76, 89, 93, 108). Because Signac's book of 1899, *D'Eugène Delacroix au néo-impressionnisme*, is steeped in citations from the Romantic master, many writers have felt entitled to assume that Seurat, a decade or more earlier, shared the same knowledge and opinions. As a result, even in the careful texts of Rewald 1948 and Homer 1964, the two artists' views of Delacroix have been entangled, and Signac's later statements and citations have been superimposed on Seurat's development. Signac himself made it clear that it was thanks to Seurat, whom he met in 1884, that he turned toward Delacroix. Seurat's readings from and about his illustrious predecessor preceded that meeting, so the evolution of his interests, from Delacroix to the Impressionists, was the reverse of Signac's. The book of 1899 certainly reflects shared interests, but it also embraces attitudes of the 1890s and incorporates Signac's study, after Seurat's death, of Delacroix's writings.

Heading the most important draft of Seurat's *esthétique* of 1890 (Appendix E) is the name of Delacroix, the only artist among a group of scientists. In Seurat's letter to Fénéon he gave 1876 as the beginning of his search for "the purity of the spectral element," and the date is presumably also that of his first readings about Delacroix in the writings of Charles Blanc: the *Grammaire* and "Eugène Delacroix," *Gazette des beaux-arts* 16 (January 1864): 5–27; (February 1864): 97–129. He read E. A. Piron's book on Delacroix no later than 1881, when he interpolated a few words from it among his notes on Delacroix's paintings (see below). Piron reprinted many extracts from Delacroix's published and unpublished writings, and they often take the form of aphorisms—hence Seurat's word "precepts" in his letter of 1890. Presumably by 1881 he had also consulted Philippe Burty's edition of Delacroix's letters, from which he copied out the painter's palette (see below). He communicated his admiration to Paul Signac when they met in 1884 and subsequently to the Symbolists who wrote about him and Neo-Impressionism.

Piron's extracts and Blanc's exegeses emphasize many aspects of Delacroix's work and thought that appealed to Seurat: Delacroix's rational, even "scientific," way of observing nature and constructing pictures, the superiority of artistic idea over raw nature; constant reference to the "laws" of nature and art that artists must discover; the intimate association of lines and colors with emotion; close study of reflected colors and colors in shadows; insistence that colors affect one another and therefore are relative; color harmonies that exalt contrast ("the analogy

of opposites," in Blanc's phrase); contrast of lines, also, as a requisite of all compositions; brushwork that divides color into several tones or hues to produce optical mixtures of greater vibrancy. Seurat's notes show that he studied Delacroix's paintings in the light of these ideas.

In his notes Seurat logically concentrated on brushwork and the craft of painting, but the statement on being a productive artist that he took from Piron shows that he also was attuned to the moralizing that characterized Delacroix (and even more, Blanc and Piron). That statement confesses Seurat's own ambition to found a school, and in choosing Delacroix as model, he must have thought of Blanc's descriptions of his predecessor as a man of distinction and reserve (in contrast to the fervor of his pictures), "withdrawn, silent, solitary, ceaselessly inventing, drawing, and painting, locking his door in order to keep his excitement to himself" (1864 essay, p. 24). These same traits were attributed to Seurat by his friends, not to flatter him (rather the opposite), but to describe his temperament.

The following notes were found among Seurat's papers after his death and first belonged to Fénéon; he subsequently gave them to Signac. It was Fénéon who published them (Fénéon, *Notes inédites*, 1922). He made frequent minor alterations of Seurat's prose and added capital letters and punctuation for clarity. Seurat's original words have been restored below, with only enough punctuation and capitalization to make his meaning clear. Fénéon remarked that the notes were quite certainly done in his studio or home, because the paper (30 cm. [12 inches] wide) is too big for jottings taken in front of pictures. Because of the hesitations of hand and phrasing (such as "I think"), Fénéon believed they were done from memory, not from notes. Given their detail, this would be an astonishing feat, and it is equally likely that when he wrote out these observations he was consulting abbreviated notes taken on the spot. The first page was written on the untouched portions of a sheet already used for figure studies that have no relation to the works he wrote about.

Thanks to the appendixes and entries in Lee Johnson, *The Paintings of Eugène Delacroix: A Critical Catalogue*, vols. 3 and 4 (Oxford, 1986), all but one of these works and their sources can now be identified. On February 23, 1881, Seurat studied three paintings from the collection of Alfred Edwards the day before their sale at public auction. On May 6 he made a record of two paintings from the collection of Frédéric Hartmann, also the day before their auction. Finally on November 11 he saw several more at the dealer Goupil's; all of them had been purchased on October 24 by the dealer Boussod et Valadon. We will never know how many other paintings Seurat studied in dealers' shops and auctions, but these surviving notes suggest that he regularly made the rounds of such places, at least when notable sales were being readied. Further, his remarks of May include a reference to Delacroix's *Noce juive* (Jewish Wedding), which proves that he indeed frequented the Louvre (where the work had been since 1874), and in November he refers to the chapel at Saint-Sulpice, the only proof from his hand of what his friends later asserted: that he was familiar with Delacroix's murals there.

February 23, 1881. Saw the fanatics of Tangiers [*The Fanatics of Tangiers*, 1828, Minneapolis Institute of Arts, 38½ × 51¾ in. (97.8 × 131.3 cm.), Johnson 360].

Effect of light concentrated on the principal fanatic. His shirt is striped with delicate red lines. Delicate tones of his head and arms, yellowish or orangish breeches. The one on the ground who is biting his arm: clothing striped in yellow and black with blue sleeves, I think. Subtlety of the orangish gray and blue-gray terrain. Little girl on the left in the foreground, she is frightened. Greenish gray white fabric accompanied by pink striped linen which shows on her arm and the bottom of her leg. (Red and green harmony of the street.)

(The flag is green with a red spot in the center. Above, the blue of the sky and the orangish white of the walls and the orangish gray of the clouds.)

The horse is blue-gray with orange-colored harness.

One of the fanatics, the one whose head is under the arm of another, has a garment that is red underneath. This red is keyed up by the green hem which borders his yellow-white-gray burnoose. Up on one of the houses a group looks at the scene. The painting's axis. Rugs hang down from the roof, one of them red atop which is a smaller one, occupying the central part; it is formed of a yellow-green and light gray (blue?) strip of cloth. In the foreg.d a red or rather orange man. To his right a young boy, dark blue clothing. Blue and orange are harmonized again in the man to the right of the fanatic who is falling over backward. He has on an outfit of vivid orange in which a lot of vermilion enters. This color is surrounded by the blue-grays of the fabrics worn by the figures in the middle ground. Elsewhere on the roofs a blue drapery made gray by distance hangs outside in harmony with the orangish white of the wall. In the right corner there are figures dressed in light yellow cloth accompanied by violet tones. On their feet are yellow babouches.

Sterility, wrote Eug. Del., is not only a misfortune for art, it's a blotch on the artist's talent. Everything made by a man who is not productive inevitably shows signs of fatigue. One only forms a school by offering large and numerous works as models. [Seurat borrowed the last three sentences from Delacroix's *Journal*, "Pensées sur l'abondance en fait d'art," as cited by E. A. Piron, *Eugène Delacroix, sa vie et ses oeuvres* (1865), p. 415. Seurat omitted some sentences between those he copied.]

At the same time as the Fanatics, saw

1. Watering place. [*Horses Coming out of the Water*, 1853, private collection, Los Angeles, 18⅛ × 22 in. (46 × 56 cm.), Johnson 393.] 2 horses, one mounted by a Turkish rider. They are followed by 2 greyhounds; mountains to the rear.

2. The Shipwreck of Don Juan, a sketch. [about 1839, Victoria and Albert Museum, London, 31 x 39¼ in. (81.3 × 99.7 cm.), Johnson 275.]

Friday May 6, 81. Saw the Lion attacked and the Procession of the Sultan of Morocco by Eug. Del. [*Lion in the Mountains*, 1851, Ordrupgaardsamlingen, Charlottenlund, Denmark, 10⅞ × 14 in. (27.5 × 35.5 cm.), Johnson 183. *The Sultan of Morocco and His Entourage*, 1856, Norton Simon Foundation, Pasadena, 25⅝ x 21⅝ in. (65 × 55 cm.), Johnson 401.]

The lion is on land covered in growth. In the lower right a plant with red flowers. Backdrop of mountains. The sky is yellow gray at the horizon then more like violet gray above. To the left above is a dark gray violet cloud.

The emperor of Morocco, dressed in a yellow burnoose, is mounted on a blue-gray horse; pink harness; the part of the saddle on the rump is in violet material. On each side are two figures whose clothing draws its harmony from red and green. Similarly the 3rd figure placed behind the horses holds a huge parasol, red inside, green outside, which is outlined against the sky.

The crowd and soldiers lined up are behind the group. Off in the distance are the yellow walls of a city and to the right a little patch of blue-gray mountains. The sky is gray blue and gray-orange. The ground is yellow gray and yellow.

The painting is dated 1858 or 56.

In execution it resembles the Jewish Wedding [1837–41, Musée du Louvre by 1874, 41 3/8 × 55 1/4 in. (105 × 140.5 cm.), Johnson 366] and the Fanatics, that is, there is not much impasto and the excessively subtle tones become even more so by superposition which is easily seen.

November 11, 1881. Saw at Goupils 5 Delacroix of which 4 very interesting from the point of view of the means of expression.

1. An Oriental [unidentified]. Very finished head, marvelous. What is especially interesting is the way this canvas is treated: a marvel of values, the background not done at all, the cloak painted thickly where the ornaments are stitched in gold.

2. Another scene. Algerians indoors. [*Jewish Merchants in Algiers*, 1852, R. Lopez, Paris, 14 3/4 × 17 3/4 in. (37.5 × 45 cm.), Johnson 365]. One clearly sees the preparation and how it came along.

3. Jesus and his apostles in the boat. [*Christ on the Sea of Galilee*, about 1853, Peter Nathan, Zurich, 19 3/4 × 24 in. (50 × 61 cm.), Johnson 453.] 2 magnificent little hatched torsos, finished tones.

4. A study, most likely for the Fanatics. [*The Fanatics of Tangiers*, 1857, Art Gallery of Toronto, 18 3/8 × 22 1/4 in. (46.7 × 56.4 cm.), Johnson 403.] Very interes.ng sky, delicate touches.

Whether Del. pts. St Sulpic. [Saint-Sulpice, Chapelle des Saints-Anges, with its two huge murals, *The Struggle of Jacob with the Angel* and *Heliodorus Chased from the Temple*] or the Oriental no. 1, who has a very delicate head, it's the same thing. The only difference is that the brushwork bec.ms sm.ler as the wk. is of a sm.ler dim.ion.

This little head is a marvel. Shadows and everything else are hatched and vibrate: cheekbones, the turban's shadows. It's the strictest application of scientific princ. seen through a personality.

Notes on Delacroix's palette are among the documents found in Seurat's studio upon his death; they are now with Fénéon's papers in the de Hauke archives. From Philippe Burty, ed., *Lettres de Eugène Delacroix* (1878), plate C, Seurat drew the outline of the palette Delacroix used for the room he decorated at the Hôtel de Ville, destroyed in a fire in 1874. Seurat used letters and numbers to locate the pigments on the palette. Below this he wrote out (with erratic capitalization and punctuation) the corresponding names of the colors.

Salon de la paix 1854 hot de ville

Unmixed colors: 1. white. 2. Naples yellow. 3. zinc yellow. 4. yellow ocher. 5. brown ocher. 6. Vermilion. 7. Venetian red. 8. Cobalt. 9. Emerald green. 10. burnt lake. 11. Sienna. 12. burnt sienna. 13. Van Dyck brown. 14. Peach Black. 15. Raw umber. 16. Prussian Blue. 17. Mummy. 18. Florentine Brown. 19. Roman lake. 20. Citron yellow. 21. Indian yellow.

Mixed colors. A. Van Dyck Brown and White. B. Umber and White. C. Cobalt, red lake and white. D. Cadmium and White. E. Naples yellow and white. F. Vermilion and white. G. Prussian Blue. H. Red lake and white. I. Zinc yellow, emerald green. J. Yellow ocher and white. K. Brown ocher, vermilion. L. Vermilion cadmium, lake, citron yellow. M. Venetian red and white. N. Florentine brown and White. O. Prussian Blue, red lake White [*sic*]. P. Peach black and White. Q. Sienna, burnt sienna. R. Vermilion, red lake. S. Sienna, emerald green.

cobalt

T. raw umber, prussian blue White. V. *Van Dyck brown* White. W. mummy white. X. prussian blue white. Y. *Prussian* Blue White

cobalt?

Appendix O

Thomas Couture

In his letter to Fénéon (Appendix F), Seurat listed among his debts one to "Couture's precepts on the subtlety of tints (at the time of his exhibition)." Seurat presumably read Couture's *Méthode et entretiens d'atelier* (Studio Methods and Conversations, 1867) at the time of the large exhibition of Couture's work in 1878. Couture recommended mixed rather than pure colors. He would limit the frank use of color opposites to certain strong effects, and he found Delacroix's brushwork "chaotic," but his text must nonetheless have supported Seurat's developing color theory and practice, in both its content and its phraseology: "For a long time it was believed that color harmony is obtained with analogous tones; it was a really false idea. True harmony comes from the concord of opposites; colors have different sexes, both male and female, so that red . . . is only happy and complete when it has green for a companion; in its turn orange requires blue" (p. 220).

Couture observed that Veronese placed greenish grays next to reds in his flesh tones and that at a distance these lose their shock, thanks to their finesse. Correggio, he pointed out, placed concentric halos of contrasting colors around the light female form in his *Antiope*, and "there is truly our rule of warm and cool tones in good concord, and the assemblage of pleasing opposites, like orange with blue, red with green" (p. 228). He praised "luminaristes" (luminists) over mere "colorists" (Seurat later proposed "chromo-luminarisme" [color-luminism] as the proper name for his own technique) because light was a vital component; light and dark preceded color for Couture, as they did for Seurat.

Couture might have appealed to Seurat, still in school in 1878, because he proclaimed his dislike of academic art and urged young artists to study contemporary life as a foundation for their mature work—locomotives, workers on scaffolding, soldiers, middle-class women (rather than exotic foreigners), all subjects that Seurat undertook in the early 1880s. Further, he urged artists to draw at twilight

because its suppression of detail encouraged them to construct with large masses. Details should be sacrificed to the "triumph of the dominants." In this last statement we detect the idealist lurking in Couture, who said that genre art is faithful to reality, but great art, to the *mind*. This is why he ended his book with two capitalized words that also have echoes in Seurat, "IDEAL, IMPERSONALITY."

For Couture, see Albert Boime, *Thomas Couture and the Eclectic Vision* (New Haven, 1980); Seurat's interest in Couture's "subtlety of tints" is briefly dealt with on pp. 491f.

Appendix P

Gauguin's Article (*Le papier de Gauguin*)

Seurat twice copied out remarks on art, supposedly by a Turkish painter, lent to him by Gauguin sometime between the fall of 1885 and early summer 1886 (when they had a falling-out). Seurat, wrote Gustave Kahn years later, "spoke to me of what among the Impressionists was called Gauguin's *article* [*papier*]. It was not known how else to designate this text. For a long time Gauguin carried it around in his pocket and sometimes showed it to his friends; it was surely the translation of some Oriental text concerning the distribution of hues in the making of Oriental rugs."[1]

Gauguin's source remains a mystery.[2] Between the published version and Seurat's there are numerous differences of phraseology, which suggests that both were looking at a now-missing "original" (Gauguin omitted several phrases found in Seurat's version). Seurat was obviously attracted to the text for several reasons, including the author's insistence on luminosity, colored shadows, working from memory, and static and silhouetted poses. The "Oriental tradition" that he cited in his *esthétique* had many sources, but this "Turkish" source would have confirmed them. Furthermore, Seurat was already familiar

with its ideas, for they can be readily found in Charles Blanc (even the sacrifice of Okraï has a nearly exact parallel in Blanc's sacrifice of Iphigenia, *Grammaire*, p. 487).

Both copies in Seurat's hand were once in the possession of Maximilien Luce. Luce gave one copy to Signac, who noted it in his diary on December 27, 1896 (Signac archives). The other he gave to his friend Charles Baillet, who wrote on it "document given me by Luce in 1939." This second copy was once among the papers of the late Dr. Jean Sutter but has disappeared from view. Two other copies of the text, not by Seurat, circulated among the Neo-Impressionists. One, in an unidentified hand, is in the Pissarro Archives in the Ashmolean Museum, Oxford, labeled by Camille Pissarro "Precepts on painting by a Turkish teacher" ("Préceptes sur la peinture par un professeur turc"; communication from Christopher Lloyd). The other, also unidentified, was with Luce's friend Baillet, who gave it to Dr. Sutter.

I first drew attention to "Gauguin's article" in 1958 (Herbert 1958, p. 151), but I wrongly indicated underlinings that were, in fact, added in an intermediate typescript given to me. Mme Ginette Signac had learned that the Département des Manuscrits in the Bibliothèque Nationale has an unpublished manuscript by Mohammed Sounboul-Zadé (cote Turc 1384) on various sciences and crafts, and was informed by a friend that this was the source of the Gauguin text. Subsequently the late Samuel Wagstaff determined that the two texts are not at all the same, although they share a few phrases. I published the correction in 1962 (Herbert 1962, p. 168).

The attraction of this document for artists of the 1880s cannot be doubted, for it was printed in the Belgian periodical that enthusiastically supported Neo-Impressionism, *L'art moderne*. It was introduced as follows:

> M. Félix Fénéon sends us the translation of some passages from the *Livre des métiers* [book of crafts], by the Hindu Wehli-Zunbul-Zadé. The advice and the good nature of Mani will be appreciated. Mani constantly encounters the Impressionists—and the Neo-Impressionists—when he says, "Each of your individuals should be in a static state." Witness M. Georges Seurat's figures, all of them. As for the conception of his figures, M. Georges Seurat is in the tradition of Greek sculptors,

not at all, like M. Degas, in the Japanese (7 [July 10, 1887]: 219).

Fénéon took liberties with the text, which he abridged and occasionally embellished: "raised" became "brandished"; "tragic" was rendered "pathetic," "sign maker" altered to "sign dauber."[3]

In the following text from the Signac archives, a few words have been capitalized and some punctuation added but only enough for clarity.

Taken from the book of crafts by Wehli-Zunbul-Zadé

Thus spoke Mani, the painter, giver of precepts.

Always use colors of the same origin. Indigo is the best base; it turns yellow when treated with spirits of niter and red in vinegar. Druggists always carry it. Limit yourself to these three colorings. With patience you will thus learn to form all your tints. Let the paper itself lighten your hues and serve as white, but never leave it entirely bare.

Linen and flesh can be painted only if one has art's secret. Who told you that light vermilion is for flesh and that linen is shaded with gray? Put white cloth next to a cabbage or a cluster of roses and you will see if it is tinted gray.

Spurn black and the mixture of white and black they call gray. Nothing is black and nothing is gray. What seems black is a compound of several colors, what seems gray is a compound of light nuances that an experienced eye sees into. The task of one who paints is not that of the mason who, compass and square in hand, builds a house on a plan furnished by the architect. It is good for the young to have a model, but let them draw a curtain over it while they paint. It is best to paint from memory, then your work will be your own; your feeling, your intelligence and your soul will thus survive the amateur's eye. He goes to his stable when he wants to count the hairs on his donkey, to see how many he has in each ear and determine the place of each one.

Who tells you that one should seek contrasting colors? What is more agreeable to the artist than to make us discern the tint of each rose in a bouquet? Two similar flowers could therefore never be the same leaf

for leaf? Look for harmony, not contrast, for agreement, not clash. It is an ignorant eye that assigns a fixed and unchanging color to each object; I have told you to watch out for this pitfall. Practice painting objects linked up or shaded, that is, neighboring or put behind a screen of other objects or similar colors, and then you will please by your truth and your variety. Go from light to dark and not from dark to light. Your work can never be too luminous. The eye tries to re-create itself in your work, so give it pleasure and not chagrin. While painting, avoid wearing light clothing. It is the job of a sign maker to copy someone else's work. If you reproduce what another has done, you have only made a mixture. You have blunted your sensitivity and immobilized your coloring. Let everything you do breathe calmness and soulful peace. Hence avoid poses in motion. Each of your individuals should be in a static state. When Oumra represented the torturing of Okraï he did not at all raise the executioner's saber, nor give the Klakhan [sic] a menacing gesture, nor twist into convulsions the mother of the patient sufferer. The sultan, seated on his throne, furrows his brow in anger; the erect executioner looks at Okraï as a prey who inspires pity; the mother leaning against a pillar gives witness to her hopeless despair by the sagging of her strength and of her body. Thus an hour passes effortlessly in front of this scene, more tragic in its calmness than if poses impossible to maintain after the first minute had caused smiles of disdain.

Apply yourself to the silhouette of each object; sharpness of contour is the prerogative of a hand unweakened by any hesitation of will.

Why deliberately embellish just for the sake of it? In that way truth, the scent of each personality, flower, man, or tree will disappear; everything fades into the same note of prettiness that thrills the connoisseur. This is not to say that one must banish a graceful subject, but it is preferable to render it just as you see it than to pour your color and drawing into the mold of a theory prepared ahead of time in your brain.

Do not polish too much. An impression is not so durable that the subsequent search for infinite detail will not blunt its initial spurt, cooling its lava and making a stone out of boiling blood. Were it a ruby, throw it far away from you.

I will certainly not tell you what brush you should prefer, what paper to use, nor the orientation to assume. Those are the kinds of things asked by girls long of hair and short in intelligence who place our art at the level of embroidering slippers or making succulent cakes.

1. "Paul Gauguin," *L'art et les artistes* 20, 61 (November 1925): 43.
2. Gauguin's hand copy is in the Bibliothèque Nationale, Département des Manuscrits. He recopied it in the manuscript "Diverses choses" of 1896–97 (Musée du Louvre, Département des Arts Graphiques). It is included in Jean de Rotonchamp's *Paul Gauguin* (Weimar, 1906), pp. 247–50, and in Gauguin's *Avant et après* (1923), pp. 56–59.
3. Fénéon published the text again: "Textes," *Bulletin* (Paris, Bernheim-Jeune) 4 (March 14, 1914), in Fénéon 1970, I, pp. 280–83.

Chronology

ANNE DISTEL

1859 *December 2*
Georges Pierre Seurat is born in Paris at 60 rue de Bondy (now rue René Boulanger), 10ᵉ arrondissement.

Son of Antoine Chrysostome Seurat, born in Dosnon (Aube) on August 28, 1815, bailiff at La Villette from 1840 to 1856, and Ernestine Faivre, born in Paris on March 3, 1828. The couple already has a son, Émile Augustin (1846–1906), who will later try his hand at writing for the theater, and a daughter, Marie Berthe (1847–1921), who in 1865 will marry Léon Appert (1837–1925), a well-known engineer and master glassmaker.

December 4
Georges Seurat baptized at Saint-Martin-des-Champs; his brother and sister stand as godfather and godmother.

The Seurat family moves to 136 boulevard Magenta (10ᵉ, at the intersection of the rue de Valenciennes and the rue La Fayette). They occupy a six-room apartment on the fourth floor of the building for an annual rent that was 2,200 francs in 1875. (In 1866 the building's number was changed to 110, which it still bears.) This will remain Georges Seurat's official address, although over the years he will occupy several studios.

Antoine Seurat also owns a villa at 8 boulevard du Midi, in Le Raincy.
Sutter 1964 and Archives de Paris, Buildings Registry AP/D1P4, Bd. Magenta, 1876

1870 During the Franco-Prussian War and the Commune, the Seurat family takes refuge in Fontainebleau.
Appendix B

1874–75 Seurat, in his last year at school, draws and becomes interested in Corot's ideas on color.
Christophe, *Georges Seurat*, 1890; Appendixes F and M; dates on drawings (H 217, 220, and 221)

1876 Begins to "take up the brush" and attends drawing classes at the École Municipale de Sculpture et de Dessin at 19 rue des Petits-Hôtels (10ᵉ, near his home), under the direction of the sculptor Justin Lequien (1826–1882). The school—founded by his father, Justin Marie Lequien (1796–1881), a better-known sculptor who also taught at the École Turgot, which Seurat may also have attended—had a reputation for turning out skilled artists. At the Lequien school Seurat meets Amand-Edmond Jean, later known as "Aman-Jean," born in 1858. (Aman-Jean, then living at 33 quai de Valmy, in Seurat's *quartier*, would be sponsored for the École des Beaux-Arts by J. Lequien *fils* (letter dated February 1878).
Seurat's drawing *Torse d'après l'antique* (H 238), dated 1876, bears the stamp of the Lequien school; for Lequien, see also "Nécrologie," *Chronique des arts et de la curiosité* (December 3, 1881), and Archives Nationales, AN/AJ152/263 dossier Jean

1878 *February 2*
Seurat takes the examination for admission to the École des Beaux-Arts.

Group of Lehmann's students at the École des Beaux-Arts. Seurat stands sixth from the left. Ex coll. Mlle Yolande Osbert

March 19
Enrolls officially in the studio of Henri Lehmann (1814–1882). Alphonse Osbert (b. 1857) preceded him on August 14, 1877, as did Alexandre Séon (b. 1855 and enrolled in 1877). Aman-Jean enrolls on August 13, 1878. Ernest Laurent (b. 1859) will enroll on August 12, 1879.
Archives Nationales, AN/AJ52/271, 263, 264, 268

March
Seurat places sixty-seventh out of eighty in the life-drawing course of M. Yvon, Professor of Drawing, École des Beaux-Arts (Osbert places fourth, Séon ninth).

August 13
Another competition places Seurat seventy-seventh out of eighty (Séon is fourth, and Aman-Jean is twenty-fifth; Laurent is in last place).
Archives Nationales, AN/AJ52/78

November 23
Seurat probably attends a banquet for Lehmann given by his students (a copy of the menu engraved by Schommer was found among his papers).
de Hauke archives

1879 *March 18*
Seurat places forty-seventh out of seventy in his Lehmann class (Séon is fourteenth, and Osbert is twenty-first).
Archives Nationales, AN/AJ52/78

April 10–May 11
Seurat may have visited the Fourth Impressionist Exhibition with Aman-Jean and Laurent. Works by Caillebotte, Cassatt, Degas, Forain, Lebourg, Monet, and C. Pissarro give the students an "unexpected and profound shock."
Rosenthal 1911

August 12
Seurat fails to place in the École competition. His name does not appear in the honors' list at year's end, although his friend Aman-Jean receives an honorable mention.
Archives Nationales, AN/AJ52/78

October 31
Seurat is granted a "conditional enlistment," which reduces his term of military service to one year in the 19th line regiment. His military dossier notes his height as 1.76 m. (about 5 ft. 8 in.).
Archives de Paris, census, class of 1879

At the École des Beaux-Arts an "Association of present and former students to facilitate the one-year enlistment of their young comrades" grants 500 francs to Laurent in October. (He returns to his studies following his military service and wins second place in the 1889 competition for the Prix de Rome.)
Archives Nationales, AN/AJ52/254

November 8
Seurat leaves for Brest to join his regiment.
Sutter 1964, p. 22

1880 *February–March*
Seurat reads the magazine *L'art* and Sutter's precepts on antique art. He draws (cat. nos. 15, 16).
Appendixes F and I

April 1–30
Fifth Impressionist Exhibition (with works by F. and M. Bracquemond, Caillebotte, Cassatt, Degas, Forain, Gauguin, Guillaumin, Lebourg, Levert, Morisot, C. Pissarro, Raffaëlli, Rouart, Tillot, Eugène Vidal, Vignon, Zandomeneghi).

July–November
Exhibition of works of Thomas Couture held at the Palais de l'Industrie, which Seurat probably visits. Seurat reads Couture's writings.
Appendix F

September
Takes part in maneuvers. His mother, on vacation in Étretat, is introduced "in bathing dress in the sea" to Henri Lehmann.
Sutter 1964, p. 22

November 8
Seurat completes his military service and returns to Paris.
Sutter 1964, p. 23

1881 Aman-Jean, who (like Osbert) does not appear to have attended the École des Beaux-Arts after July 1880, rents a studio at 32 rue de l'Arbalète, where Seurat works with him.
Archives Nationales, AP/D1P4, rue de l'Arbalète 1876; AN/AJ52/263 and 268; Appendix B

January 26
Philippe Gille, in his "Revue bibliographique" in *Le Figaro*, mentions Ogden Rood's *Théorie scientifique des*

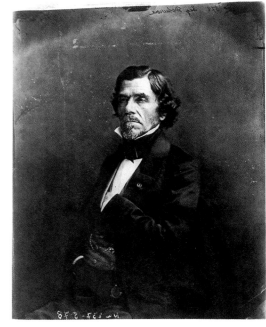

Nadar, *Eugène Delacroix*. From Nigel Gosling, *Nadar*, 1976, p. 132

couleurs, which Seurat purchases shortly afterward.
Appendix F

February 23
Seurat attends the public exhibition the day before the sale of a "collection d'amateur" [Alfred Edwards] at the Hôtel Drouot and takes notes on three paintings by Delacroix. Manet's *Enfant à l'épée* (Metropolitan Museum) is also in the sale, but Seurat does not mention it.
Appendix N

April 2–May 1
Sixth Impressionist Exhibition held (with works by Cassatt, Degas, Forain, Gauguin, Guillaumin, Morisot, C. Pissarro, Raffaëlli, Rouart, Tillot, E. Vidal, Vignon, and Zandomeneghi).

May 6
Visits the town house of the collector Frédéric Hartmann at 18 rue de Courcelles, where he sees paintings by Delacroix (*Lion attaqué* and *Cortège de l'empereur du Maroc*) prior to the sale of the collection the next day.
Appendix N

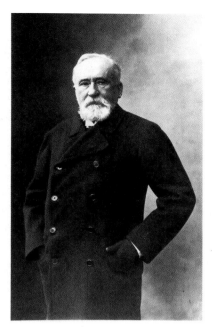

Nadar, *Pierre Puvis de Chavannes*. From Nigel Gosling, *Nadar*, 1976, p. 220

May 2–June 10
Puvis de Chavannes shows *Le pauvre pêcheur* at the Salon; Seurat makes a free copy (cat. no. 77).

Summer–autumn
Seurat spends two months at Pontaubert (near Avallon, in the Yonne) with Aman-Jean, returning to Paris on October 8.
Appendix B; family letters, Sutter archives

November 11
Seurat sees five works by Delacroix at the premises of the dealer Goupil.
Appendix N

1882 During the year, and probably until 1886, Seurat rents a painter's studio with fireplace in the right wing of a building at 16 rue de Chabrol (10ᵉ), stairway B, sixth floor, and, on the floor above, a small room with flue, accessible via an interior stairway; the annual rent is 560 francs. However, he continues to give his mother's address—110 boulevard Magenta (near the rue Chabrol)—in the catalogues of the 1883 Salon and the Salons des Indépendants of 1884 and 1886, as well as in the

catalogue of the 1886 Nantes exhibition. The rue Chabrol harbored a small colony of artists throughout the second half of the nineteenth century, particularly in the building at number 18.
Archives Nationales, AP/D1P4 rue Chabrol 1876; the next tenant, an artist named Garcia Messa, is listed as of 1887

March
Seventh Impressionist Exhibition held (with works by Caillebotte, Gauguin, Guillaumin, Monet, Morisot, Pissarro, Renoir, Sisley, and Vignon).

May
Courbet retrospective held at the École des Beaux-Arts.

1883 *May 1–June 20*
Seurat exhibits for the first time in the Salon, with a drawing listed in the catalogue as no. 3189, *Broderie* (cat. no. 32). According to Roger Marx (and later Jules Christophe), however, the work shown was a portrait of Aman-Jean (cat. no. 30). Unlike his friends Aman-Jean, Osbert, Séon, and Laurent, who also exhibited works, Seurat does not mention in the catalogue his teacher Henri Lehmann, whose posthumous retrospective exhibition held the same year

Ernest Laurent, *Georges Seurat*, 1883. Musée du Louvre, Département des Arts Graphiques, Fonds du Musée d'Orsay, Paris. Gift of Louis Lacroix, 1933, R.F. 23518

at the École des Beaux-Arts was, according to contemporary reports, a "total failure."
Marx 1883; Christophe 1890

Spring
Seurat begins work on *Une baignade, Asnières*.

September
Ernest Laurent works on his painting for the 1884 Salon, *Scène au bord d'un ruisseau (Beethoven, op. 68)*, also entitled *Le Concert Colonne* (presumed lost), for which Osbert and Seurat pose.
Drawing by E. Laurent, *Étude pour Scène au bord d'un ruisseau*, dated "18 7embre 83," *Alphonse Osbert et Georges Seurat*, dated 1883 (Musée du Louvre, Département des Arts Graphiques, Paris, R.F. 12930, 23928, and 23518)

October 6–10
Seurat and Aman-Jean visit Barbizon, staying at the well-known Auberge Ganne.
M. T. de Forges, *Barbizon, lieu-dit* (1962), p. 74, and Auberge Ganne, original ledger from M. T. Caille

1884 *January 6–28*
Manet retrospective held at the École des Beaux-Arts.

May 15–July 1
Rejected by the Salon, Seurat shows *Baignade* (no. 261) with the Artistes Indépendants, a loose grouping of artists who reject the principle of an admissions jury, in a temporary building erected in the courtyard of the Tuileries. His painting is relegated to the buffet but manages nevertheless to inspire a few brief notices in the newspapers.

Paul Signac (1863–1935), Charles Angrand (1854–1926), Henri-Edmond Cross (1856–1910), Albert Dubois-Pillet (1846–1890), Odilon Redon (1840–1916), and Émile Schuffenecker (1851–1934) also show at the Salon des Indépendants, and Seurat probably participates in the many meetings and petitions that lead to the creation of the Société des Artistes Indépendants and the drafting of its bylaws. The official date of the Société's founding is given as June 11, 1884.

Signac, who did not attend the École des Beaux-Arts but painted since the beginning of the 1880s, was particularly drawn to Impressionism. He became one of Seurat's few friends.

May 22
Seurat notes the genesis of his second large composition, *Un dimanche à la Grande Jatte*: "Ascension Day: Grande Jatte, the studies, the painting."

December 10, 1884–January 17, 1885
Seurat exhibits works with the (reorganized) Société des Artistes Indépendants in the Pavillon de la Ville de Paris on the Champs-Élysées:

241 *L'île de la Grande Jatte*, étude (cat. no. 139)
242 *9 croquetons*
243 portrait of M. A[man]J[ean], dessin (cat. no. 130)
Note by Félix Fénéon, de Hauke archives, referring to a list now lost but confirmed by a number of press notices

Chronique des arts et de la curiosité (January 17, 1885) reports: "There were approximately 350 visitors on the last day. During its 31-day span the exhibition of the Artistes Indépendants had approximately 7,000 visitors. That number included something like 3,600 paid entrances."

1885 **March**
Grande Jatte is ready for exhibition with the Indépendants, but exhibition is postponed.
Appendix F

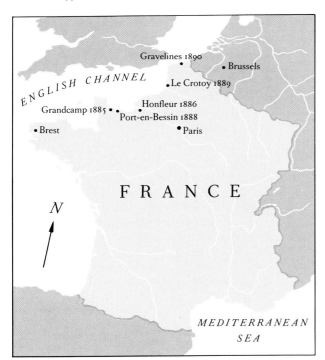

Map of France, showing places and dates of Seurat's summer holidays
Map: Wilhemina Reyinga-Amrhein

March–April
Exhibition of works by Eugène Delacroix held at the École des Beaux-Arts.

Summer
Seurat works at Grandcamp (cat. nos. 159–163).

August
Introduction à une esthétique scientifique by Charles Henry is published in *Revue contemporaine*. It later appears as a pamphlet; Seurat makes notes from it.
Appendix L

August 25–September 21
Serves a twenty-eight-day period of military duty with the Forty-fifth Regiment at Laon (Aisne).
Sutter 1964, p. 24

October
Resumes work on and finishes *La Grande Jatte*.

At Durand-Ruel's, is introduced to Camille Pissarro by Paul Signac and Guillaumin. The younger generation, which seems little interested in the "old Impressionists," probably views the connection as providing opportunities for possible future exhibitions.
Appendix F

December 30
Guillaumin writes to Pissarro and refers to the difficult preparations for the Impressionist exhibitions: "Degas, ignorant or almost so, of what both Signac and Seurat were doing, was probably a bit upset by the things people were saying. Last year Mme [Eugène] Manet [Berthe Morisot] saw the studies our friends had done, she seems to be on their side; thus she might, if need be, calm Degas's fears."
Sale catalogue of the Camille Pissarro archives, Hôtel Drouot, Paris, November 21, 1975, no. 78

1886 **January**
Seurat's name appears for the first time in Pissarro's correspondence: "Yesterday Durand [Ruel] went to see Signac to ask him for pictures for the American exhibition [see below, April 1886]; he also intends to call on Seurat and Guillaumin." Durand-Ruel's interest in Seurat was short-lived, although Seurat's relationship with Pissarro and Signac was to grow stronger, as the artist noted: "1886, January or February. A small canvas by Pissarro, divided and pure

Paul Cézanne (seated) and Camille Pissarro (standing) in Pissarro's garden at Pontoise, 1877. The boy is Lucien Pissarro. From John Rewald, *Camille Pissarro*, 1963, p. 24.

color, at Clozet's, the dealer on the rue de Châteaudun. Signac definitively won over."
C. Pissarro to L. Pissarro, in CP, vol. 2, January 1886, no. 306; Appendix F

In this period bonds are strengthened among the young painters and poets acquainted with the novelist and poet Robert Caze, whose "Mondays" are attended by Jean Ajalbert, Paul Adam, Félix Fénéon, Rodolphe Darzens, Ephraïm Mikhaël, Paul Alexis, Jean Moréas, Viélé-Griffin, and Henri de Régnier, as well as J.-K. Huysmans, whom Edmond de Goncourt meets at Caze's shortly before the latter's death on March 28, 1886, as the result of a duel (February 15) with Charles Vignier.
E. de Goncourt, *Journal*, ed. Robert Ricatte, reprinted 1989, vol. 2, p. 1232

March
Pissarro's correspondence with his son Lucien reveals the difficulties in getting Seurat and Signac accepted by the "old Impressionists" for a group exhibition.
C. Pissarro to L. Pissarro, in CP, vol. 2, nos. 319, 321, 331, 332, and 333

March 31
Seurat and Signac attend Caze's funeral at the church of Saint-Vincent-de-Paul. Those present include Edmond de Goncourt, Alphonse Daudet, Henry Fouquier, Paul Bourget, Hennique, Céard, Paul Ginisty, Gramont, Bourgeat, Degas, Dumoulin, Paul Adam, Paul Alexis, Francis Enne, Geffroy, Tavernier, Mirbeau, Ajalbert, and Maias.
Le cri du peuple, April 1, 1886

April 10–28
Exhibition entitled *Works in Oil and Pastel by the Impressionists of Paris* is held in New York, at the American Art Galleries and, from May 25, at the National Academy of Design. The Seurat works include: no. 112, *Island Grande Jatte*, price 700 francs; no. 133, *12 Studies* (see provenance note, cat. no. 89); no. 170, *Bathing*, price 2,500 francs. Durand-Ruel's decision to include Seurat and Signac probably eased the way toward their inclusion in the Paris exhibition. Durand-Ruel was to return Seurat's works to him at the end of November 1886 without having purchased any of them.
For Durand-Ruel, see Appendix D

May
Camille Pissarro reports on the latest skirmishes about the Impressionist exhibition: "Yesterday I had a run-in with M. Manet over Seurat and Signac; indeed, the latter was present, as was Guillaumin. You can be sure that I was very harsh with him. That is not apt to please Renoir. In short, I explained to M. Manet, who probably did not understand a word, that Seurat had contributed something new that these gentlemen, notwithstanding their talent, were unable to appreciate, that I was personally convinced that the progress represented in his art would, in time, produce extraordinary results.... Degas is a hundred times more loyal. I told Degas that Seurat's picture was extremely interesting: 'Oh, I would have noticed that myself, Pissarro, only it's so big!' So that's that. If Degas doesn't get it, it'll be his loss because he doesn't understand its unusual element. So everything's falling into place. We—you, me, Seurat, and Signac—will all be hanging in the same room, that way we can arrange the things to suit ourselves."
C. Pissarro to L. Pissarro, in CP, vol. 2, May 8, 1886, nos. 334, 335, May 8, 1886

A few days prior to the exhibition, at rue Laffitte, Louis Hayet, accompanied by Camille and Lucien Pissarro, admires *La Grande Jatte* in Seurat's studio at rue de Chabrol.
Manuscript autobiography by Louis Hayet; information furnished by Dr. Guy Dulon

May 2
In *Le cri du peuple*, Trublot (Paul Alexis) lists his collection, which includes: "two attractive seascapes by Seurat, another vividly committed Impressionist work of a corner of the rue Saint-Vincent and snow effects. On the butte [H 70; private collection, New York]."

Early May
Berthe Morisot (Mme Eugène Manet) visits the studios of Seurat and Signac to invite them to submit work to the Impressionist exhibition.
Schuffenecker to Pissarro, May 1, 1886, in sale catalogue of the Camille Pissarro archives, Hôtel Drouot, Paris, November 21, 1975, no. 163

May 15–June 15
Seurat participates in the eighth and last Impressionist Exhibition, held at 1 rue Laffitte (Maison Dorée, corner of the boulevard des Italiens). Bracquemond, Cassatt, Degas, Forain, Gauguin, Guillaumin, Morisot, C. Pissarro, L. Pissarro, Odilon Redon, H. Rouart, Schuffenecker, Signac, Tillot, Vignon, and Zandomeneghi also participate. Seurat exhibits the following works:

175 *Un Dimanche à la Grande Jatte* (1884)
176 *Le Bec du Hoc (Grand-Camp)* (cat. no. 161)
177 *Le Fort Samson (Grand-Camp)* (H 157)
178 *La Rade de Grand-Camp* (cat. no. 160)
179 *La Seine à Courbevoie* (cat. no. 153)
180 *Les Pêcheurs*, lent by M. Appert (Seurat's brother-in-law) (cat. no. 97)
181 *Une parade* (drawing) (cat. no. 45)
182 *Condoléances* (drawing), both lent by M. J.-K. Huysmans (cat. no. 158)
183 *La banquiste* (drawing), lent by Mme Robert Caze (cat. no. 44)

Many articles appear on the exhibition. Among them a few are unfavorable (Mirbeau, Paulet, Wyzewa); many others are positive (Adam, Ajalbert, Alexandre, Alexis, Auriol, Christophe, Darzens, Fevre, Fouquier, Geffroy, Hennequin, Henry, Hermel,

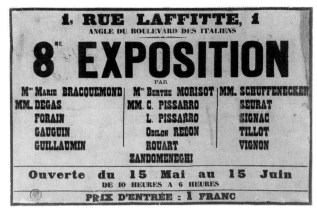

Poster for the Eighth Exhibition (1886), the last held by the Impressionists. From *The New Painting: Impressionism 1874–1886*, 1986, p. 19

Kahn, Maus, Régnier, Verhaeren, Vidal). Félix Fénéon notes that it was at this exhibition that he first met Seurat and his friends, although he does recall having seen *Baignade* in 1884.
DR, p. XI

June 16
Disheartened, Seurat writes to Signac: "Those in the rue Laffitte exhibition left with all the wind taken out of their sails, like real cowards," and he refers to the cabals fomented by Gauguin with Guillaumin's tacit approval. On the evening before, he attends the private view of the fifth international exhibition at the Galerie Georges Petit in the rue de Sèze, which include works by Renoir and Monet. At this time Seurat is often seen about town, at La Nouvelle Athènes on rue Pigalle or at Vetzel's (Taverne de l'Opéra) at 1 rue Auber.
Seurat to Signac, in DR, pp. XLVIII, XLIX

June
Seurat plans to exhibit again. Camille Pissarro writes to his son Lucien: "Seurat, Signac, Gauguin, and Guillaumin are planning to show with the Indépendants, and they suggest that you join them. Seurat will keep your things in his studio; I'll probably be keeping some of my own things at his place until Durand [Ruel] arrives."
C. Pissarro to L. Pissarro, June 1886, in CP, vol. 2, no. 339

June 19
In order to work before he leaves for Pont-Aven, Gauguin "borrows" Signac's studio, where Pissarro's

Paul Gauguin, *Self-portrait: "Les Misérables,"* 1888. Vincent van Gogh Foundation/Rijksmuseum Vincent van Gogh, Amsterdam

canvases are stored; informed of this "boorish sailorlike behavior" by Pissarro, Seurat complains to Signac, who attempts to smooth over the whole affair. (The incident foreshadows the fact that neither Gauguin nor Guillaumin would show in the autumn Indépendants exhibition.)
Seurat to Signac, June 19, 1886, in DR, p. XLIV; Gauguin to Signac and Signac to Pissarro, in *Correspondance de Paul Gauguin 1873–1888*, ed. Victor Merlhès, Paris, 1984, no. 103

The catalogue of the rue Laffitte exhibition lists for the first time the address of Seurat's new studio at 128bis, boulevard de Clichy. His presence there is confirmed in 1887 by the buildings registry, in which he is listed as inhabiting, on the seventh floor of the building, a courtyard studio and small room with a stove. Kahn later wrote that Seurat had "a tiny cell containing a low, narrow bed opposite some old canvases turned to the wall, the *Baignade* and some marines. The white-walled studio was hung with souvenirs from the École des Beaux-Arts, a small picture by Guillaumin, a Constantin Guys, some pictures by Forain, canvases and drawings to which he had grown accustomed and that had become colored patches on the wall, a red divan, a few chairs, a small table with some favorite journals, books by young writers, brushes and paints, and a wad of tobacco. Leaning on and completely concealing a panel, *La Grande Jatte*." The rent was

480 francs [a year]. Signac had a similar studio at number 130.
Kahn 1891

June 21–mid-August
Seurat is in Honfleur, determined to work, staying at the home of M. Hélouin, Chief Customs' Officer, at 15 rue de Grâce. The weather, fine at the outset, turns inclement. Seurat informs Signac that he has done "only 6 canvases" (cat. nos. 164, 166, 167, and 170 and p. 234), which he does not plan to show right away. "I'll probably leave on [August 13] at 9 P.M., a Friday. Superstitious as I am, that's really asking for it."
Seurat to Signac, Honfleur, June 25, after July 5, and early August 1886, in DR, pp. L–LII

August 21–September 21
The second (1886) exhibition of the Société des Artistes Indépendants opens at the height of a controversy between Dubois-Pillet's Indépendants and a rival group led by one Sardey; it is housed in a temporary structure erected in the Tuileries courtyard, Building B, adjacent to the Pavillon de Flore. Seurat exhibits

353 *Un Dimanche à la Grande-Jatte—1884*
354 *Le Bec du Hoc (Grandcamp)* (cat. no. 161)
355 *La Rade de Grandcamp* (cat. no. 160)
356 *La Seine à Courbevoie* (cat. no. 153)
357 *Coin d'un bassin, Honfleur* (H 163; Rijksmuseum Kröller-Müller, Otterlo)
358 *Grandcamp (soir)*
359 *La Luzerne (Saint-Denis)* (cat. no. 152)
360 *Bateaux* (H 155)
361 *Croqueton (Courbevoie)* (H 116)
362 *Bords de la Seine (Croqueton)* (H 132)

Other exhibitors (Angrand, Cross, Dubois-Pillet, Lucien Pissarro, Henri Rousseau, Signac) are hung together in the back room. Camille Pissarro, visiting the exhibition, opines that "the new Seurat was very good; he's right, the sunlight should be almost white."
C. Pissarro to L. Pissarro, in CP, vol. 2, September 17, 1886, no. 353

Félix Fénéon uses the term "Neo–Impressionist method" for the first time in an article.
Fénéon, *L'art moderne* 1886

September 18
Jean Moréas publishes "Un manifeste littéraire. Le symbolisme" in *Le Figaro*.

October 10, 1886–January 15, 1887
Exposition des Beaux-Arts held in Nantes at the Palais du Cours Saint-André. Seurat exhibits

968 *L'hospice et le phare de Honfleur* (cat. no. 167)
969 *La grève du Bas-Butin, Honfleur* (cat. no. 164).

Seurat's participation, together with that of Signac and Pissarro, is probably owing to the support of the painter John Flornoy, whom he thanks. A native of Nantes, Flornoy, a friend of Camille and Lucien Pissarro, is the son of the first owner of Renoir's *La loge* (Courtauld Institute Galleries, London).
J. Flornoy to C. Pissarro, November 23, 1886, de Hauke archives

End of October
Publication by *La vogue* of Félix Fénéon's pamphlet *Les Impressionnistes en 1886*, which Pissarro had vetted, asking Fénéon to "make clear, when dealing with Seurat, that he was the first to put conscientiously into practice the theories of Chevreul." In addition to *La vogue*, the Neo-Impressionists could also count on *La revue indépendante*, which began to

Théo van Rysselberghe, *Émile Verhaeren*. Musée d'Orsay, Paris

reappear in November 1886 under the editorial direction of Fénéon and, later, Jean Ajalbert.
C. Pissarro to L. Pissarro, in CP, vol. 2, autumn 1886, no. 356

October 23
The Belgian poet Émile Verhaeren, possibly accompanied by the critic Octave Maus, calls on Seurat in his studio and purchases *Coin d'un bassin, Honfleur* (H 163). Seurat is invited to show at Les Vingt exhibition in Brussels.
Seurat to Verhaeren, early 1887, in Herbert, *Gazette des beaux-arts*, 1959. Seurat noted the picture's date and title and Verhaeren's address on a piece of paper that also records the return of pictures from New York, the name of M. van Cutsem with the title of the picture he purchased after Les Vingt exhibition *(La grève du Bas-Butin;* see February 1887 below, and cat. no. 164), and the name of Paul Adam with the title *La jetée d'Honfleur* (H 170; Rijksmuseum Kröller-Müller, Otterlo; Appendix D)

Early November
Durand-Ruel asks Camille Pissarro to write an account of his "new artistic doctrines." The painter refers him to Fénéon's pamphlet and goes on to emphasize: "M. Seurat, an artist of great value, was the first to conceive of applying the scientific theory, after having studied it in depth. I only followed, like my other colleagues, Signac, Dubois-Pillet, the example set by Seurat." Pissarro also stresses that the dealer has nothing of his "nor of Seurat's or Signac's or even Dubois-Pillet's, painting or gouache, that is in any way related to these doctrines."
CP, vol. 2, November 4 and 6, 1886, nos. 357, 358

Early December
Charles Pillet (former auctioneer-appraiser turned agent-dealer, and Dubois-Pillet's uncle) appears to rally to the Neo-Impressionist cause and tries to place their works with collectors.

New skirmishes break out at the café La Nouvelle Athènes between Pissarro, who joins Seurat, Signac, and Dubois-Pillet, and the Gauguin-Guillaumin-Zandomeneghi faction, which has gone over to Degas. The news of Seurat's invitation from Les Vingt causes a sensation.
Fénéon, Seurat, Signac, and Pissarro are invited to Dubois-Pillet's home.
CP, vol. 2, December 3, no. 361

1887

January
"Seurat has sent two canvases to Martinet; Martinet, after having been full of enthusiastic praise at Seurat's, began to balk when it came to exhibiting: the gaslight, the white frame, the interest in the painter himself, etc. I went to see him and since he had asked me for something for his sale his excuses fell very flat. In the evening, strolling along the boulevards with Seurat, the two canvases were being shown, but on rue du Helder."
CP, vol. 2, January 8, 1887, no. 374

The reopening of the gallery on the boulevard des Italiens at the corner of the rue du Helder under the direction of Louis Martinet, painter and former impresario, is mentioned in the *Journal des arts* of February 11, 1887. "M. Martinet of the Fantaisies Parisiennes, of the Théâtre Lyrique, of the Cercle Vivienne. M. Martinet welcomes every style but the boring."

Pissarro urges his son Lucien to send his calling card to Seurat's mother, who had given the elder Pissarro a 100-franc commission for a "small, new-style canvas," one of six *Soleil couchant* pictures. Subsequently, Mme Seurat, who "knows people who like Degas," sets about to find a buyer for Pissarro, who is at the end of his rope and is thinking of selling a Degas drawing in his possession.
CP, vol. 2, January 8, 14, 15, 20, and 31, 1887, nos. 374, 381, 382, 383, 384, and 391

January 13
Seurat sends seven canvases to Brussels for Les Vingt exhibition (see below, February 1887). He dines with Signac in Asnières (probably at the home of the latter's mother), along with Pissarro and Fénéon, who were constant guests.
Seurat to Verhaeren, early 1887, in Herbert, *Gazette des beaux-arts*, 1959; CP, vol. 2, January 13–14, 1887, nos. 379, 381

January 19
Seurat writes to Octave Maus, secretary of the Brussels Les Vingt: "It is appropriate that I tell you of my horror of varnish. Often some paint-shop proprietor will apply varnish without being told to, thinking he's doing the right thing and then sending in his little bill. VETO. I'm against any varnishing of my canvases, either free or for a fee."
Seurat to O. Maus, January 19, 1887, Bibliothèque Royale de Belgique, Octave Maus archives

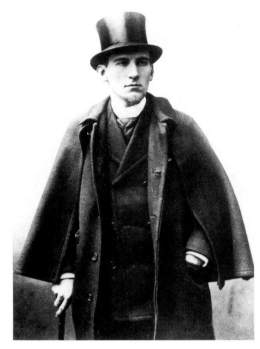

Félix Fénéon, 1886. Paulhan archives, Paris

February 2–end of February
Fourth annual exhibition of Les Vingt, Brussels. Seurat exhibits

1 *Un dimanche à la Grande-Jatte. 1884*
2 *Le bec du Hoc. Grandcamp* (cat. no. 161)
3 *La rade de Grandcamp* (cat. no. 160)
4 *Coin d'un bassin. Honfleur,* Lent by M. Émile Verhaeren (H 163; Rijksmuseum Kröller-Müller, Otterlo)
5 *L'hospice et le phare d'Honfleur* (cat. no. 167)
6 *La grève du Bas Butin, Honfleur* (cat. no. 164)
7 *L'embouchure de la Seine, Soir* (cat. no. 166)

Accompanied by Signac, Seurat attends the vernissage in the former Musée royale de peinture: "Huge crowd, incredible hubbub, very bourgeoisly anti-artist. In short, a great success for us: Seurat's canvas was invisible, the crowd was so large it was impossible to get near it."

Later, Signac would add: "In my opinion Seurat's *Grande Jatte* loses something in that huge room; there's a certain useless kind of work that gets lost at that distance. You get the feeling that the canvas was done in a small room."
Signac to C. Pissarro, in sale catalogue of the Camille Pissarro archives, Hôtel Drouot, November 21, 1975, nos. 171, 172

Other French guests were C. Pissarro, Morisot, Lebourg, Rodin, Raffaëlli, Marie Cazin, and Ary Renan. Henri van Cutsem (1839–1904) of Brussels bought *La grève du Bas-Butin* for 300 francs. Émile Verhaeren had already purchased *L'hospice et le phare d'Honfleur*.
Herbert, *Gazette des beaux-arts*, 1959

February
Signac suggests that Maus organize a Les Vingt exhibition in Paris: "Advanced French Art would be represented by Camille and Lucien Pissarro, Seurat, Dubois-Pillet, Redon and the Les Vingt group by Théo van Rysselberghe, Finch, Schlobach, Dario de Regoyos, and Charlet." The plan appears to have been backed by G. Lèbre, the "directeur" of *La vie moderne*, who was to lend the reception rooms of a town house for a small, "aristocratically discreet" exhibition from April 15 to May 15. Seurat, however, astonished his friends by refusing to see Signac, probably fearful of divulging his artistic experiments.
Signac to C. Pissarro, in sale catalogue of the C. Pissarro Archives, Hôtel Drouot, November 21, 1975, no. 172; C. Pissarro to L. Pissarro, in CP, vol. 2, February 25, 1887, nos. 397, 398

March
With Signac, Dubois-Pillet, Redon, Pissarro, and others, Seurat attends the banquet (called Le Rouge et le Bleu) of the Indépendants.
Trublot (Paul Alexis), "*À minuit*," *Le cri du peuple*, March 12, 1887

March 17
Portier, the dealer, thinks that a new Impressionist exhibition assembled by Degas is impossible to mount because, as he tells Pissarro, Degas would not agree to include Seurat or Signac or Dubois-Pillet.
C. Pissarro to L. Pissarro, in CP, vol. 2, March 17, 1887, no. 406

March 26–May 3
None of the plans for a one-man exhibition having materialized, Seurat submits work to the Société des Artistes Indépendants for its third exhibition (1887) at the Pavillon de la Ville de Paris on the Champs-Élysées:

439 *Le phare d'Honfleur*, Lent by M. Émile Verhaeren (cat. no. 169)
440 *La grève du Bas-Butin (Honfleur)*, Lent by M. Van Cutsem (cat. no. 164)
441 *Embouchure de la Seine (Honfleur)* (cat. no. 166)
442 *Le pont de Courbevoie*, Lent by M. Arsène Alexandre (cat. no. 171)
443 *Entrée du port d'Honfleur*, Lent by M. Félix Fénéon (H 171)
444 *La Maria (Honfleur)* (cat. no. 170)
445 *Bout de la jetée d'Honfleur*
446 *Poseuse* (cat. no. 185)
447 *Douze croquis* (twelve sketches)
448 *Eden concert* (cat. no. 193)

Other painters included are Angrand, Cross, Dubois-Pillet, Gausson, Luce, L. Pissarro, Redon, Rousseau, Signac.

April
Seurat, Signac, and Luce attend the trial of a murderer, Szubert, brilliantly defended by Jean Ajalbert.
Ajalbert 1938, p. 262

May 13
With his Indépendants friends, Seurat attends Le Rouge et le Bleu banquet, at which Ernest Hoschedé proposes a toast to Pissarro. Mention is made of the "pleasing results of the recent Indépendants exhibition: 6,500 paid admissions, 3,000 francs net profit for the Société after expenses."
Trublot [Paul Alexis], "*À minuit*," *Le cri du peuple*, May 13, 1887

Mid-May
According to Pissarro, Seurat severely criticizes the "old Impressionists" Monet, Renoir, and Sisley, brought together in the Sixth International Exhibition at the Petit gallery in May–June. His criticism spares only Pissarro and Morisot.
CP, vol. 2, May 15, 1887, no. 423

May–June
Jean-François Millet retrospective held at the École des Beaux-Arts.

May 31
Pissarro tells his son Lucien to warn Seurat and Signac that mixing the cadmium yellow (as recommended by Contet, a paint supplier) with other pigments will cause it to darken. This letter accords with Seurat's noting that "on Pissarro's advice I'm abandoning the emerald green 1885."
CP, vol. 2, May 31, 1887, no. 431; Appendix F

Early June
"Can you ask Seurat to tell me the price of the Algerian wine and to whom one might apply to obtain some?"
CP, vol. 2, June 5 or 6, 1887, no. 437

June 11
Seurat makes an appointment with Fénéon for the following day.
Seurat to Fénéon, June 11, 1887, de Hauke archives

Mid-June
Pissarro views *Poseuses*, in progress: "Yesterday I visited Seurat's studio. His large picture is coming along. Its harmony is already charming. It is obviously going to be a very beautiful object. However, the surprising thing is going to be the execution of the framing. I've seen the first stages. . . . We're going to be forced to do the same. The picture is quite another thing in white or any other material. You truly have no notion of sunlight or cloudy weather without this essential complement. I'm going to try the same thing myself; of course, I won't exhibit it until after our friend Seurat has established the priority of his idea, which is only fitting."
CP, vol. 2, June 16, 1887, no. 441

Late June
Verhaeren visits Seurat, who gives him a *croqueton* (oil sketch) but later worries about his true intentions. After having seen Angrand and van Rysselberghe, Dujardin, Vidal, and Picard *fils* (son of Edmond Picard, publisher of *L'art moderne*), who are planning the exhibition of Les Vingt, Seurat remarked that he was "the only Parisian Impressionist-Luminist in Paris, except for Dubois-Pillet, who

would rather parade around than work." (Dubois-Pillet was an officer in the Gardes républicains.)

Seurat to Signac, July 2, 1887, in DR, pp. LX–LXI; Seurat to Verhaeren, July 2, 1887, in Herbert, *Gazette des beaux-arts*, 1959

July
Dubois-Pillet and Seurat fail to persuade the Indépendants committee to agree to Signac's proposal to forbid members to exhibit in any Salon that has a jury. Dubois-Pillet asks Signac not to allow his impetuosity to compromise the dominant position the Neo-Impressionists have hitherto enjoyed within the Société des Artistes Indépendants.

Dubois-Pillet to Signac, September 30, 1887, and January 8, 1888, Signac archives

August
A drawing by Seurat (H 477) is used as an illustration in a deluxe edition of *La revue indépendante* (August 1887).

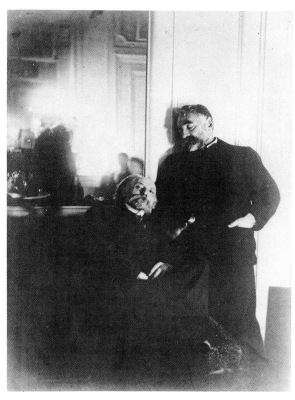

Edgar Degas, *Renoir and Mallarmé*, 1895. Gelatin silver print. Bibliothèque Littéraire Jacques Doucet, Paris

Seurat attends the funeral of Jules Laforgue (deceased on August 20) with Jules Christophe and Fénéon.

He works on *Poseuses*: "canvas with plaster very discouraging. Can't understand a thing. Everything stains—very heavy going."

Seurat to Signac, August 1887, in DR, p. LXI

September 1–21
Seurat undergoes a period of military training in Laon.

Sutter 1964, p. 24; Seurat to Signac, undated letter, Signac archives

Mid-September
Pissarro recounts how, during a luncheon, Renoir and one of his fans, the pastry-cook–writer–painter Murer, turn to "running down the young: Seurat has discovered nothing, he thinks he's a genius, etc. You can imagine my response. I had thought they had at least an inkling about our movement, but nothing, they don't understand a word."

CP, vol. 2, September 20, 1887, no. 452

November 5
Seurat draws his aunt, Anaïs Faivre Haumonté, on her deathbed (cat. no. 179).

November 15
Seurat attends Le Rouge et le Bleu banquet, a reunion of the Indépendants, at the restaurant Philippe in the Palais-Royal.

Trublot [Paul Alexis], "À minuit," *Le cri du peuple*, November 15, 1887

November
Vincent van Gogh, Émile Bernard, Anquetin, Toulouse-Lautrec, A. H. Koning, and possibly Guillaumin exhibit works at the Grand Bouillon–Restaurant du Chalet at 43 avenue de Clichy. Seurat visits the exhibition, where he meets van Gogh for the first time. The latter, who is acquainted with Signac, has already come under the influence of Neo-Impressionism.

Appendix E

Late November 1887–January 1888
Seurat, Signac, and van Gogh exhibit works in the rehearsal rooms of the Théâtre Libre d'Antoine at 96 rue Blanche.

Lucien Pissarro, *Van Gogh in Conversation with Félix Fénéon*. Ashmolean Museum, Oxford

December 15
Seurat informs Alphonse Osbert that he will attend the second "amicable dinner of former pupils of Lehmann's studio" planned for December 20. He probably attended the first one in 1884 or 1885 and would attend the third on November 20, 1888.

Copy of a letter, Sutter archives

1888 Charles Henry's *Cercle chromatique*, for which Signac designs a poster and publicity release, is published; over the next three years Signac provides illustrations for Charles Henry's lectures and writings.

January
Seurat exhibits *La rade de Grandcamp* (cat. no. 160) and *Embouchure de la Seine, soir, Honfleur* (cat. no. 166) in the reception rooms of the Revue Indépendante at 11, rue de la Chaussée-d'Antin.

Fénéon, March 1888

February
Seurat shows two café–concert drawings and *Le Bec du Hoc, Grandcamp* (cat. no. 161) in the reception rooms of the Revue Indépendante.

Fénéon, March 1888

February 19
A few hours before leaving for Arles, Vincent van Gogh comes to Seurat's studio with his brother,

Theo van Gogh, 1888–90. Rijksmuseum Vincent van Gogh, Amsterdam

Theo, to see Seurat's pictures, "a fresh revelation of color."
V. van Gogh to T. van Gogh, in *Correspondance complète de Vincent van Gogh*, 1960, vol. 3, May 1890, 633 F, p. 454

February 24
On the occasion of Les Vingt exhibition, in which Signac is represented, Pissarro writes to him: "The full weight of the 'Néo' is heavy on your shoulders. They don't attack Seurat because he's a mute. They treat me with contempt as a gaga old man; but you, by God, they snap at, because they know you've got a violent temper."
C. Pissarro to Signac, in CP, vol. 2, February 24, 1888, no. 472

March 2–3
At the sale of works for the benefit of Marguerite Pillet (her father, Charles, died in early November 1887) at the Hôtel Drouot, Theo van Gogh purchases a drawing by Seurat, *Eden-Concert* (cat. no. 193), for 17 francs.

March 10
Vincent van Gogh congratulates his brother on his purchase of a Seurat and suggests that he try to trade one of his canvases, a recommendation he repeats at a later date. He goes on to envisage a possible consortium of dealers to acquire and show the works of the Impressionists and younger painters, which would include Seurat.
V. van Gogh to T. van Gogh, in *Correspondance complète de Vincent van Gogh*, 1960, vol. 3, March 10, 1888, 468 F, p. 29

March 22–May 3
At the fourth exhibition of the Société des Artistes Indépendants at the Pavillon de la Ville de Paris, on the Champs-Élysées, Seurat shows

613 *Poseuses*
614 *Parade de cirque* (cat. no. 200)
615 *Au Concert européen* (cat. no. 194)
616 *A la Gaîté Rochechouart* (cat. no. 196)
617 *Au Divan japonais* (H 690)
618 *Forte Chanteuse* (H 684)
619 *Dîneur* (cat. no. 33)
620 *Lecture* (cat. no. 177)
621 *Balayeur* (cat. no. 182)
622 *Jeune fille* (probably cat. no. 181)

Other artists represented include Angrand, Anquetin, Cross, Dubois-Pillet, Gausson, Luce, Lucien Pissarro, Henri Rousseau, Séon, Signac, and Vincent van Gogh, who asks his brother to have him listed in the catalogue by the single name "Vincent."

Rumor was obviously rife that the City of Paris might purchase *Poseuses*; Vincent van Gogh again refers to the need to purchase a "big Seurat."
V. van Gogh to T. van Gogh, in *Correspondance complète de Vincent van Gogh*, 1960, vol. 3, March 1888, 471 F, p. 36

Spring
Seurat returns to work on the Grande Jatte with Angrand.
Angrand to Signac, April 2, 1898, in Charles Angrand, *Correspondance*, ed. François Lespinasse, 1988, p. 93

June
Vincent van Gogh writes to Theo that "the leader of the Petit Boulevard is undoubtedly Seurat," naming Seurat as the dominant figure of the younger generation, as opposed to the "Grand Boulevard" painters, or the elder Impressionists, whose works Theo sells.
V. van Gogh to T. van Gogh, in *Correspondance complète de Vincent van Gogh*, 1960, vol. 3, June 1888, 500 F, p. 100

Theo lends his Seurat drawing to the Nederlandsche Etslub exhibition (no. 108) in Amsterdam, of which he is an organizer.

July
Seurat stays in Port-en-Bessin.

A postcard to Signac (now in the Institut Néerlandais, Fondation Custodia, Paris) gives his address as "chez M. Marion."

August
Pissarro invites Seurat and Signac to stay at Éragny.
CP, vol. 2, August 22, 1888, no. 500

August 26
To Signac, Seurat denies having been the instigator of Arsène Alexandre's article "Le mouvement artistique" in the August 13, 1888, issue of *Paris*, in which the critic had written: "Seurat . . . the true apostle of the dot . . . constantly runs the risk of having the paternity of his theory contested by ill-informed critics or unscrupulous comrades"; but Seurat still maintains that "the more numerous we are, the less original we'll be" and says that he does not want to be referred to as a pupil of Pissarro. Pissarro good-naturedly suggests that Signac "give Seurat an inventor's patent, if that will flatter his vanity" but adds that "for the future of our art 'impressionnisme' we must remain absolutely free from the influence of Seurat's school—and, indeed, you yourself have hinted at it, *Seurat is from the école des Beaux-Arts*, he's steeped in it." Signac, however, continues to be upset by Seurat's rancor, and concludes: "The best thing is to treat his hypocritical and jealous nature as a minor matter and pay attention only to his works. . . . I will not bestow my friendship on a bailiff like that. I reserve my admiration for the artist."
Letter from Seurat to Signac, August 26, 1888, in DR, p. LXV; CP, vol. 2, no. 503, here collated with the original in the Signac archives; Signac to C. Pissarro, September 7, 1888 (which contains a copy of Seurat's first letter), sale catalogue of the Camille Pissarro archives, Hôtel Drouot, November 21, 1975, no. 180

1889

Early January
Seurat paints the Eiffel Tower before its completion (cat. no. 210).

To the sixth exhibition of Les Vingt in Brussels, Seurat submits nine paintings and three drawings:

1 *Les Poseuses*
2 *Bords de la Seine (Île de la Grande-Jatte)* (H 176; Musée d'Art Moderne, Brussels)
3 *Temps gris* (cat. no. 173)
4 *Port-en-Bessin—Un dimanche* (H 191; Rijksmuseum Kröller-Müller, Otterlo)
5 *Port-en-Bessin—Le pont et les quais* (cat. no. 209)
6 *Port-en-Bessin—L'avant-port (marée haute)* (cat. no. 206)
7 *Port-en-Bessin—L'avant-port (marée basse)* (cat. no. 208)
8 *Port-en-Bessin—Les jetées*
9 *Port-en-Bessin, Les Grues et la Percée* (cat. no. 205)
10 *M. Paul Alexis* (H 691)
11 *Au Concert Européen* (cat. no. 194)
12 *A la Gaîté Rochechouart* (cat. no. 196)

The exhibition also includes Albert Besnard, Bracquemond, Cross, Marcellin Desboutin, Paul de Vigne, Emmanuel Fremiet, Gauguin, Max Klinger, Luce, Constantin Meunier, Moreau-Nélaton, Monet, C. Pissarro, P. Wilson Steer, W. Stott, and W. B. Tholen.

February 17
Seurat thanks Octave Maus for his article in *La cravache* and sets a price of 60 francs per drawing. "As for my *Poseuses*, I find it very difficult to set a price for it. For expenses I count a year at 7 francs per day: you can see where that gets me. In short, I'd say that the collector can pay me the difference between his price and mine." The price would therefore be between 2,000 and 2,500 francs, as compared with Raffaëlli, who at the time asked 15,000 for a hundred drawings and budgeted himself at 1,500 francs per month. As for the Impressionists, Renoir was selling his small canvases for between 500 and 1,500 francs; Monet and Degas for twice that and more. Manet's *Olympia* brought his widow almost 20,000 francs. Finally, in 1888 the State paid 4,000 francs for Puvis de Chavannes's *Le pauvre pêcheur*, even though his dealer was asking 6,000 francs.

Seurat to Maus, February 17, 1889, in DR, p. LXVIII; E. de Goncourt, *Journal*, ed. Robert Ricatte, 1989, vol. 3, May 12, 1888, and June 21, 1889, pp. 123, 284

March 8
Theo van Gogh informs Camille Pissarro of the return of the pictures shown at Les Vingt exhibition. "It appears that Luce sold his two pictures.... Seurat and Gauguin were lucky enough to sell a picture apiece."
T. van Gogh to C. Pissarro, March 8, 1889, quoted in CP, vol. 2, p. 267 n. 1

On the back of a list of exhibitions drawn up for Félix Fénéon, Seurat mentions "Les Vingt artists favorable to optical painting, Anna Boch, Frantz Charlet, A. Willy Finch, Dario de Regoyos, Jan Toorop, Henry van de Velde, Théo van Rysselberghe, Guillaume Vogels, Georges Lemmen."
H, I, p. xx, de Hauke archives

April 14
Dubois-Pillet tells Signac that "the Salle d'Horticulture in the rue de Grenelle has been rented for the [Indépendants] exhibition for 2,200 francs." "It was Seurat's opinion and mine that we should show only two canvases each.... I never see anyone but Seurat at committee meetings [of the Indépendants]." A little later, Dubois-Pillet writes: "As for Seurat, he's disappeared, he asked the chairman of the committee to relieve him: I'd seen him a few days earlier and he didn't talk to me about it, always mysterious, he only chats with Séon."
Dubois-Pillet to Signac, undated, Signac archives

Spring
Given the fact of their child's birth (February 16, 1890) we can surmise that at this time Seurat had a relationship with Madeleine Knoblock, a young working-class woman (b. June 28, 1868). An unpublished letter from Madeleine Knoblock to Paul Signac (Signac archives), written after Seurat's death in early July 1891, indicates that their liaison began in 1885: "He loved me and kept me for himself alone and has for six years without your ever knowing anything about it."

Gauguin, inspired by Seurat and Signac, paints his *Nature morte ripipoint*, dedicated "à Marie [Henry] souvenir [du] Pouldu [18]89."
D. Wildenstein, *Gauguin*, 1964, no. 376

Summer
Stays in Crotoy (cat. nos. 211, 212).

September 3–October 4
Fifth exhibition of the Société des Artistes Indépendants held in the hall of the Société d'Horticulture at 84 rue de Grenelle, Saint-Germain. Seurat shows

241 *Le Crotoy (aval)* (cat. no. 211)
242 *Le Crotoy (amont)* (cat. no. 212)
243 *Port-en-Bessin* (cat. no. 209)

Other participants include Anquetin, Dubois-Pillet, Filiger, Gausson, Hayet, Lemmen, Luce, O'Conor, Osbert, L. Pissarro, H. Rousseau, Séon, Signac, Toulouse-Lautrec, and van Gogh. Seurat, who faithfully attends the various meetings, and Signac are members of the committee.

Pissarro reports: "I went to the exhibition on the rue de Grenelle, where I met Fénéon and Régnier. Kahn is doing his twenty-eight days in the reserves and couldn't get leave. I saw Hayet yesterday morning. He wasn't pleased with the hanging. The room is beautiful; upon entering I found the light not too bad. On each side of the main room are two small narrow galleries with dreadful harsh light: the touches of color all seem to stand out in relief in a dreadful way. However, it's very good in the main room. Yes, at first glance I find the "Néos" extremely thin, sickly, white—particularly Seurat and Signac. However, once the eye grows accustomed they seem much less so, aside from a kind of *stiffness* that I find unpleasant. There's a new Seurat in the large room that I find very handsome, very pale; a Signac of this year in the same room is also very beautiful, firm, but too close to Seurat's art."
C. Pissarro to L. Pissarro, in CP, vol. 2, September 9, 1889, no. 540

1890

January
Jules Chéret exhibition held on rue Saint-Lazare; Seurat and his mother both own Chéret posters at this time.

February
Publication of Victor Joze's novel, *L'homme à femmes* (cat. no. 215)

February 16
Seurat's son, Pierre Georges, is born at 39 passage de l'Élysée-des-Beaux-Arts, off the place Pigalle (today the rue André-Antoine), the artist's new address, which appears for the first time in the catalogue cited below.

March 20–April 27
Sixth exhibition of the Société des Artistes Indépendants held at the Pavillon de la Ville de Paris on the Champs-Élysées. Seurat exhibits:

726 *Chahut*
727 *Jeune femme se poudrant* (cat. no. 213)
728 *Port-en-Bessin un dimanche* (H 191; Rijksmuseum Kröller-Müller, Otterlo)
729 *Port-en-Bessin, l'avant-port (marée basse)* (Lent by M. de la Hault) (cat. no. 208)
730 *Port-en-Bessin, l'avant-port (marée haute)* (cat. no. 206)
731 *Port-en-Bessin, entrée de l'avant-port* (cat. no. 207)
732 *Les Grues et la Percée* (cat. no. 205)
733 *Temps gris. Grande Jatte* (cat. no. 173)
734 *Printemps. Grande Jatte* (H 176; Musée d'Art Moderne, Brussels)
735 *Paul Alexis* (H 691)
 Paul Signac (cat. no. 216)

Other exhibitors include Angrand, Anquetin, Anna Boch, Cross, Dario de Regoyos, Dubois-Pillet, Filiger, Finch, Gausson, Guillaumin, Lemmen, Luce, O'Conor, Osbert, Robert Picard, L. Pissarro, H. Rousseau, Signac, Toulouse-Lautrec, van Rysselberghe, van de Velde, and van Gogh. Seurat, Signac, and Osbert are members of the committee.

Sadi Carnot, the French president, visits the exhibition and is presented with a beribboned catalogue especially bound in blue and red: "Messrs. Goubot, Serendat de Belzim, Seurat, Signac, and Tessier had a lengthy conversation with the president of the republic, who demonstrated the utmost courtesy toward the young Indépendants throughout the course of his visit." "Messrs. Seurat and Signac, two young Impressionists, were presented to President Carnot and accompanied him to explain to him the methods and merits of the new school."
New York Herald, March 20, 1890; *Petite presse* and another daily newspaper, March 21, 1890; press cuttings furnished by Seurat's Argus

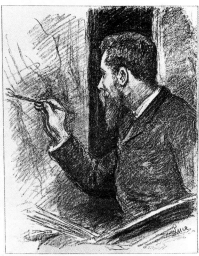

Les hommes d'aujourd'hui: cover of issue dedicated to Georges Seurat, no. 368, 1890. Drawing by Maximilien Luce.

April
Publication of Jules Christophe's "Seurat" in the series *Hommes d'aujourd'hui* (with a portrait by Luce) followed by Félix Fénéon's "Signac," which provokes a letter of clarification from Seurat to Fénéon, June 20, 1890.
Appendix F

June 22–24
Fénéon, with Lecomte, pays a call on Seurat at 5:25 P.M., finds him out, and leaves his calling card. The following day Fénéon writes Seurat an appeasing, albeit ironical, letter. On June 24 Seurat announces to Fénéon his departure for the "North, around Calais," reiterating his dismay at the way in which Fénéon presented the Signac chronology.
H, I, pp. XXII, XXIII

July 29
Vincent van Gogh dies. Seurat later writes: "Signac informed me of his death as follows: 'He shot himself in the side, the bullet went through his body

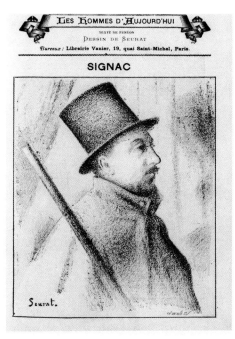

Les hommes d'aujourd'hui: cover of issue dedicated to Paul Signac, no. 373, 1890. Drawing by Georges Seurat.

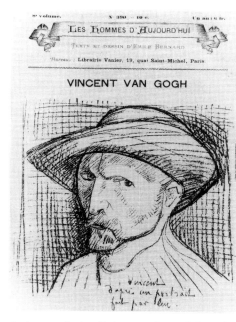

Les hommes d'aujourd'hui: cover of issue dedicated to Vincent van Gogh, no. 390, 1891. Drawing by Émile Bernard after a self-portrait by van Gogh.

and lodged in his groin. He walked two kilometers, lost all his blood and finally died at his inn.' "
Appendix E

August 18
Dubois-Pillet dies in Le Puy. He is buried in the Cimetière Montmartre, Paris, on August 25. Seurat learns of Dubois-Pillet's demise from the newspapers and writes the next day (with great constraint) to Signac that "stuck here [in Gravelines] by circumstances, I don't know what I can do to share in the sorrow caused by this death."

August 19
He writes in similar terms to the painter Edmond Valton, president of the Société des Indépendants, and sends his address: "Rue de l'Esturgeon, Petit Fort Philippe, near Gravelines North."
Seurat to Signac, August 19, 1890, Signac archives

Writes to Jules Christophe to acknowledge receipt of his *Hommes d'aujourd'hui* pamphlet, which he sends on to Maurice Beaubourg.
Seurat to Christophe, August 19, 1890, de Hauke archives

August 28
Composes his manifesto-letter to Maurice Beaubourg, which he never sends.
Appendix E

1891 *February 2*
Seurat attends a large literary banquet in honor of Symbolism, chaired by Mallarmé and organized by Barrès and Régnier; it is a tribute to Jean Moréas, whose *Le pèlerin passionné* has just been published and well received.
Le Figaro, February 2 and 3, 1891

February 7–March 8
Participates in the eighth annual exhibition of Les Vingt in Brussels at the Musée d'Art Moderne, showing

1 *Chahut*
 Le Crotoy:
2 *Amont* (Upstream) (cat. no. 212)
3 *Aval* (Downstream) (cat. no. 211)
 Le chenal de Gravelines:
4 *Grand Fort Philippe* (cat. no. 220)
5 *direction de la Mer* (H 206; Rijksmuseum Kröller-Müller, Otterlo)
6 *Petit Fort Philippe* (cat. no. 219)
7 *un Soir* (cat. no. 221)

Also participating are Charles Angrand, Jean Baffier, Maurits Bauer, Jules Chéret, Walter Crane, Charles Filiger, Gauguin, Guillaumin, Carl Larsson, Adolf Oberländer, Pissarro, Sisley, Eugène Smits, P. Wilson Steer, Charles van der Stappen, Floris Verster, and, posthumously, van Gogh.

March 20–April 27
Participates in the seventh exhibition of the Société des Artistes Indépendants at the Pavillon de la Ville de Paris, Champs-Élysées, contributing

1102 *Cirque* (cat. no. 225)
1103 *Le chenal de Gravelines: Grand Fort Philippe* (cat. no. 220)
1104 *Le chenal de Gravelines: Direction de la mer* (H 206; Rijksmuseum Kröller-Müller, Otterlo)
1105 *Le chenal de Gravelines: Petit fort Philippe* (cat. no. 219)
1106 *Le chenal de Gravelines: Un soir* (cat. no. 221)

Also participating are Angrand, Anquetin, Émile Bernard, Anna Boch, Bonnard, Cross, Maurice Denis, Toulouse-Lautrec, Dubois-Pillet, A. W. Finch, Paul Gachet, Gausson, Guillaumin, Ibels, Lemmen, Luce, Maufra, Osbert, L. Pissarro, Signac, van Gogh (posthumously), and van Rysselberghe. Seurat, Signac, Luce, Osbert, and Toulouse-Lautrec are on the committee.

March 23
Sadi Carnot, president of the republic, accompanied by General Brugère, visits the Indépendants exhibition.
Journal des arts, March 27, 1891

March 26
Seurat falls ill.

March 27
With the assistance of a friend, Seurat, accompanied by Madeleine Knoblock, who is pregnant, and his son, Pierre, makes his way to his mother's apartment on boulevard Magenta.

March 29
Seurat dies at 6 A.M. of what is diagnosed as infectious angina (probably malignant diphtheria). He is thirty-one years of age.

March 30
Funeral services at the church of Saint-Vincent-de-Paul.

March 31
Seurat is buried in the family vault in Père-Lachaise cemetery (66th division, first row, 65, no. 7).

April 13
Seurat's son dies and is buried alongside his father in Père-Lachaise.

April 21
Émile Seurat, the artist's brother, writes to Félix Fénéon: "M. Signac, who is forced to be absent for some time, has asked me to seek your assistance in dividing up the works left by my brother, Georges Seurat, between Mme Knoblock and myself, as representative of my brother's family. Mme Knoblock is to select someone, probably M. Luce, to represent her in this process, which you, if you would be so kind, will oversee."
Émile Seurat to Fénéon, April 21, 1891, de Hauke archives

May 3
A meeting is held in the studio to divide up the work. An inventory is drawn up, and the works are initialed by Fénéon, Signac, and Luce. The family expresses a desire to present Seurat's friends with either a panel or a drawing.
Émile Seurat to Fénéon, April 30, 1890, de Hauke archives

May 24
Death of Seurat's father at his property in Le Raincy.

July–August
A dispute arises between Fénéon, Signac, and Luce, on one side, and Gustave Kahn, Mme Kahn, and Lemmen on the other, each side accusing the other of wanting to profit from Seurat's death, especially at the the expense of Madeleine Knoblock, who is young, naive, and without means of support. Théo van Rysselberghe acts as arbiter, pacifies both sides, and draws up a list of the works reserved for Seurat's Belgian friends (van Rysselberghe, van de Velde, Finch, Dario de Regoyos, Boch, Verhaeren, Edmond and Robert Picard, Lemmen, Maus, Dubois, Olin, and Mme Kahn).
Dossier containing letters from Signac, van Rysselberghe, Gustave Kahn, Luce, Mme Seurat (the artist's mother), and

Madeleine Knoblock, Bibliothèque du Louvre, Paris, purchased at public auction at the Hôtel des Ventes, Fontainebleau, February 21, 1988; de Hauke and Signac archives

Gustave Kahn buys *Chahut* from Madeleine Knoblock, who had acquired it in the distribution; she expects his final installment of 500 francs on September 5.
M. Knoblock to G. Kahn, Signac and de Hauke archives

1892 *February*
Les Vingt organize an Homage to Georges Seurat.

March 19–April 27
Tribute to Seurat held at the exhibition of the Société des Artistes Indépendants.

December 2–January 8
First exhibition of *Peintres Néo-Impressionnistes* held at the Hôtel Brébant at 32 boulevard Poissonnière, including works by Seurat.

1894 *September 15*
Signac writes in his *Journal*: "How unjust people are toward Seurat. To think that they refuse to recognize in him one of the geniuses of the century! The young ones are full of admiration for Laforgue and van Gogh—these also dead . . .—and for Seurat oblivion, silence."
Signac Journal, ed. J. Rewald, p. 104

1895 *February 22–March 14*
Exhibition held at Léonce Moline's Galerie Laffitte at 20 rue Laffitte, of twenty-four paintings and thirteen drawings by Seurat, along with works by other artists.
Herbert 1962, p. 179

1898 *January 3*
Count Harry Kessler, who had purchased *Poseuses* from Vollard for 1,200 francs, calls upon Mme Seurat (the artist's mother) with Signac at boulevard Magenta.
Signac Journal, ed. J. Rewald. p. 273

March 12
Signac writes: "Seurat's poor mother is worried about what will happen to his large canvases after her death. She would like to leave them to some museum. . . . But what museum today would agree to take them."
Signac Journal, ed. J. Rewald, p. 279

Lucie Brû (later Cousturier) in front of *Un dimanche à la Grande Jatte,* which was bought by her father, Casimir Brû, in 1900

1899 Paul Signac's *D'Eugène Delacroix au néo-impressionnisme* is published by *La revue blanche*; extracts had appeared in that review and in *Pan* the year before.

July 30
The artist's mother dies, leaving a life annuity of 1,200 francs to Madeleine Knoblock.
Sutter 1964, p. 27

1900 *March 19–April 5*
Exhibition of Seurat's works held at the Revue blanche. Signac writes: "Seurat's principal works are all jammed higgledy–piggledy into the reception room at the Revue Blanche, one on top of the other, some resting on the floor, in bad light. And despite the lack of care, their serene and powerful beauty asserts itself. All the people who used to be shocked or laugh are now forced to admire. The family, although millionaires, is selling all of them . . .

I think mainly because the pictures are burdensome. Fénéon is buying *La baignade*, I'm buying *Le cirque* for 500 francs, and Monsieur Brû *La Grande Jatte* for 800 francs. He is asking for and getting (thrown in, as it were) one of the best of the drawings, the portrait of Mme Seurat. These people feel no shame at all in selling their brother's portrait of their mother! For these beautiful drawings they're asking 10 francs unframed and 100 francs when they're under glass. There will be a Seurat at the centenary exhibition. Naturally, they've selected the most banal one, the one that will attract the least attention."
Signac Journal, in DR, p. LXXVIII, and original in Signac archives

1903 *August 18*
Madeleine Knoblock dies of cirrhosis of the liver.
Copy of death certificate, Sutter archives

List of Exhibitions

ABBREVIATION	DATE	EXHIBITION[1]	LOCATION	CATALOGUE NUMBERS[2]
1883 Paris	May 1–June 20	Société des artistes français pour l'exposition des beaux-arts de 1883. Salon de 1883	Paris, Palais des Champs-Élysées	3189, listed erroneously as *Broderie*
1884 Paris	May 15–July 1	Salon des artistes indépendants	Paris, Exposition du Groupe des Indépendants, Cour des Tuileries, Baraquement B	261
1884–85 Paris	December 10–January 17	1re exposition de la Société des artistes indépendants, Salon d'hiver	Paris, Pavillon de la Ville de Paris (Champs-Élysées)	241–43 (no. 242: 9 *croquetons*)
1886 New York	First venue: April 10–28; second venue: opened May 25	Works in Oil and Pastel by the Impressionists of Paris (organized by Durand-Ruel under the management of the American Art Association)	New York, American Art Galleries and National Academy of Design	112, 133, 170 (no. 133: 12 studies)*
1886 Paris, rue Laffitte	May 15–June 15	8me exposition de peinture (the last Impressionist exhibition)	Paris, 1 rue Laffitte	175–83*
1886 Paris, Indépendants	August 21–September 21	Société des artistes indépendants, 2e exposition	Paris, rue des Tuileries, bâtiment B	353–62*
1886–87 Nantes	October 10–January 15	Les impressionnistes (organized by John Flornoy)	Nantes, salle IX , Palais du Cours Saint-André	968 and 969
1886–87 Paris	December–January		Paris, Galerie Martinet, 2 rue du Helder	2 paintings
1887 Brussels	February	IVe exposition annuelle des XX avec un préambule par Octave Maus	Brussels, Musée d'Art Moderne	Georges Seurat: 1–7*

1. Titles are based on exhibition brochures or catalogues.
2. An asterisk indicates that relevant pages from the exhibition catalogue are reprinted in facsimile in H, I, pp. 262ff.

1887 Paris	March 26–May 3	Société des artistes indépendants, 3ᵉ exposition	Paris, Pavillon de la Ville de Paris (Champs-Élysées)	439–48 (no. 447: 12 *croquis*)*
1887–88 Paris	late November–January	Seurat, Signac, and van Gogh exhibit in the lobby of André Antoine's theater	Paris, lobby of Théâtre Libre, 96 rue Blanche	
1888 Paris, Revue Indépendante	January–February	Exposition de Janvier; Exposition de Février	Paris, Revue Indépendante, 11 rue de la Chaussée-d'Antin	
1888 Paris, Pillet Sale	exhibition: March 1; sale: March 2–3	Vente au profit de Mlle Marguerite Pillet	Paris, Hôtel Drouot, salle no. 8	82
1888 Paris, Indépendants	March 22–May 3	Société des artistes indépendants, 4ᵉ exposition	Paris, Pavillon de la Ville de Paris (Champs-Élysées)	613–22*
1888 Amsterdam	June	Catalogus van de Tweede Jaarlijksche Tentoonstelling der Nederlandsche Etsclub	Amsterdam, Arti et Amicitiae	108
1889 Brussels	February	VIᵐᵉ Exposition des XX avec un Préambule par Octave Maus	Brussels, Musée d'Art Moderne	Georges Seurat: 1–12*
1889 Paris	September 3–October 4	Société des artistes indépendants, 5ᵉ exposition	Paris, Salle de la Société d'Horticulture, 84 rue de Grenelle	241–43*
1890 Paris	March 20–April 27	Société des artistes indépendants, 6ᵉ exposition	Paris, Pavillon de la Ville de Paris (Champs-Élysées)	726–35 (no. 735: two drawings)*
1891 Brussels	February 7–March 8	8ᵉ exposition annuelle des XX	Brussels, Musée d'Art Moderne	Georges Seurat: 1–7*
1891 Paris, Indépendants	March 20–April 27	Société des artistes indépendants, 7ᵐᵉ exposition	Paris, Pavillon de la Ville de Paris (Champs-Élysées)	1102–06*
1891 Paris, Boussod et Valadon	July	Exposition de dessins	Paris, Boussod et Valadon	
1892 Brussels	February 6–March 6	Neuvième exposition annuelle des XX	Brussels, Musée d'Art Moderne	Georges Seurat: 1–29 (no. 1: 12 *esquisses*)*
1892 Paris, Indépendants	March 19–April 27	Société des artistes indépendants, 8ᵐᵉ exposition	Paris, Pavillon de la Ville de Paris (Champs-Élysées)	1081–126*
1892 Antwerp	May–June	Association pour l'art	Antwerp	Georges Seurat: 6 paintings, 6 drawings

1892 Paris, Revue Blanche		Exposition posthume Seurat	Paris, La Revue Blanche	
1892–93 Paris	December 2–January 8	Exposition des Peintres Néo-Impressionnistes	Paris, Salons de l'Hôtel Brébant, 32 boulevard Poissonnière	50–55*
1893–94 Paris	December–January	Groupe des Peintres Néo-impressionnistes (organized by Signac, van Rysselberghe, et al.)	Paris, 20 rue Laffitte	
1895 Paris	February 22–March 14	Exposition de quelques peintures, aquarelles, dessins et eaux-fortes de Ch. Agard, Eug. Delâtre, J.-H. Lebasque, feu [the late] Georges Seurat	Paris, Galerie Laffitte (Léonce Moline), 20 rue Laffitte	4 paintings, 20 oil studies, 13 drawings
1900 Paris, Revue Blanche	March 19–April 5	Georges Seurat (1860 [sic]–1891): Œuvres peintes et dessinées	Paris, La Revue Blanche, 23 boulevard des Italiens	1–53; hors catalogue: 13 paintings, 71 drawings*
1900 Paris, Exposition Universelle	April 15–October 15	Exposition centennale de l'art français (1800–1889)	Paris, Exposition Internationale Universelle de 1900, Grand Palais	610
1904 Brussels	February 25–March 29	Exposition des peintres impressionnistes	Brussels, La Libre Esthétique	144–50*
1905 Paris	March 24–April 30	Société des artistes indépendants, 21me exposition, rétrospective Georges Seurat	Paris, Grandes Serres de la Ville de Paris (Cours-la-Reine), Serre B	1–44*
1908–09 Paris	December 14–January 9	Exposition Georges Seurat (1859–1891)	Paris, Bernheim-Jeune et Cie., 15 rue Richepance	1–72, 72bis, 73–78, 78bis, 79–205, supplement: 206–210*
1910–11 London	November 8–January 15	Manet and the Post-Impressionists	London, Grafton Galleries, Grafton Street, Bond Street	54 and 55
1913 New York	February 15–March 15	International Exhibition of Modern Art [Armory Show]	New York, Armory of the Sixty-ninth Infantry, Lexington Avenue	454 and 455
1919–20 Paris	December 18–January 20	Indépendants: Œuvres d'artistes ayant exposé à la Société des Artistes Indépendants de 1884 à 1904	Paris, Galerie d'Art des Éditions G. Crès et Cie., 21 rue Hautefeuille	50–53
1920 Paris	January 15–31	Exposition Georges Seurat (1859–1891). Preface by Paul Signac	Paris, Galeries Bernheim-Jeune, 15 rue Richepance and 25 boulevard de la Madeleine	1–62*

1922 Brussels	July 25–August	Les Maîtres de l'Impressionnisme et leur Temps: Exposition d'Art français. Preface by Fierens-Gevaert; notices by Marguerite Devigne and Arthur Laes	Brussels, Musée Royal des Beaux-Arts de Belgique	31–33
1922 Paris	October	Vingt Dessins de Seurat	Paris, Galerie Devambez	
1924 New York	December 4–27	Paintings and Drawings by Georges Seurat. Preface by Walter Pach	New York, Galleries of Joseph Brummer, 27 East 57th Street	1–31
1926 Paris, Grand Palais	February 20–March 21	Société des Artistes Indépendants: Trente ans d'art indépendant, 1884–1914	Paris, Grand Palais	3216, 3216bis, 3217–27
1926 London	April–May	Pictures and Drawings by Georges Seurat	London, Lefèvre Galleries (Alex. Reid and Lefèvre, Ltd.), 1a King Street, St. James's	1–16
1926 Paris, Bernheim-Jeune	November 29–December 24	Les dessins de Georges Seurat (1859–1891). Including extracts from an essay by Lucie Cousturier	Paris, Bernheim-Jeune, Éditeurs d'Art, 83 rue du Faubourg-Saint-Honoré	1–140; *hors catalogue*: 141–50 (no. 26: 4 drawings; no. 27: 4 drawings)*
1927 Lyons		Rétrospective de l'Époque Néo-Impressionniste au Salon du Sud-Est	Lyons, Palace of Arts	
1928 Berlin		Seurat	Berlin, Galerie Flechtheim	
1929 Lucerne	February	L'École Impressionniste et Néo-Impressionniste		
1929 New York	November 7–December 7	First Loan Exhibition. Foreword by Alfred H. Barr, Jr.	New York, Museum of Modern Art	55–71
1932 London	January 4–March 5	Exhibition of French Art, 1200–1900. Introduction by W. G. Constable; catalogue edited by Constable, in collaboration with Trenchard Cox; entries of nineteenth-century pictures and drawings by Mlle Delaroche-Vernet	London, Royal Academy of Arts	503, 519, 523, 535, 541, 552–56, 559, 981, 984, 991, 1003

1932 Paris	February 25–March 17	Le néo-impressionnisme. Partial reprint of an essay by Paul Signac	Paris, Galerie d'art Braun et Cie., 18 rue Louis-le-Grand	20–24
1933 Chicago	June 1–November 1	A Century of Progress: Exhibition of Paintings and Sculpture Lent from American Collections. Edited by Daniel Catton Rich	Chicago, Art Institute of Chicago	370, 946
1933–34 Paris	December–January	Seurat et ses amis: La Suite de l'impressionnisme. Preface by Paul Signac; notices on painters and their works by Raymond Cogniat	Paris, La Gazette des Beaux-Arts, 140 rue du Faubourg-Saint-Honoré	59–78, 78bis, 79–87; printed supplement: 153, 156–75
1934 Paris	February 25–March 17	Le néo-impressionnisme	Paris, Galerie d'art Braun	
1935 Chicago	February 5–25	24 Paintings and Drawings by Georges-Pierre Seurat. Foreword by E. W. S. [Eve Watson Schütze]	Chicago, Renaissance Society of the University of Chicago	1–24
1936 Paris	February 3–29	Exposition Seurat (1859–1891)	Paris, Paul Rosenberg, 21 rue de la Boëtie	1, 1bis, 2–96, 96bis, 97–129; *hors catalogue*: 51bis, 130*
1936 New York	March 2–April 19	Cubism and Abstract Art. Preface and essay by Alfred H. Barr, Jr.; catalogue by Ernestine M. Fantl and Dorothy C. Miller; bibliography by Beaumont Newhall	New York, Museum of Modern Art	257–60
1936–37 Rotterdam	December 23–January 25	Catalogus van Schilderijen uit de Divisionistische School van Georges Seurat tot Jan Toorop. Foreword by D. Hannema	Rotterdam, Museum Boymans	39, 40, 42–48
1937 London	January 20–February 27	Seurat and His Contemporaries. Reprint of essay by Paul Signac; biographical notices by Raymond Cogniat	London, Wildenstein and Co. Ltd., 147 New Bond Street, in collaboration with the *Gazette des beaux-arts*	30–79; printed supplement: 88–89
1937 New York	March 22–April 17	Exhibition of French Masters from Courbet to Seurat	New York, Jacques Seligmann and Co., Inc., 3 East 51st Street	22–25
1937 Paris		Chefs-d'oeuvre de l'art français à l'exposition internationale de 1937. Preface by Léon Blum; forewords by Georges Huisman and Jean Zay; introduction by Henri Focillon	Paris, Exposition Universelle, Palais National des Arts, Avenue de Tokio	410–16, 730

1940 New York	May–October	Masterpieces of Art: European and American Paintings, 1500–1900. Introduction and descriptions by Walter Pach; biographies and notes by Christopher Lazare	New York, World's Fair	366–70
1942–43 Paris	December 12–January 15	Les néo-impressionnistes. Partial reprint of an essay by Paul Signac	Paris, Galerie de France, 3 rue du Faubourg-Saint-Honoré	1–15
1946 London		Reproductions of the Drawings of Seurat. Introduction by Gabriel White	London, Arts Council of Great Britain	
1947 New York	March 4–29	Seurat: His Drawings	New York, Buchholz Gallery, 32 East 57th Street	1–17, 19–29; printed addendum: 21a
1948 New York	April 8–May 8	A Loan Exhibition of Six Masters of Post-Impressionism. Introduction by Alfred M. Frankfurter	New York, Wildenstein, 19 East 64th Street	45–63
1949 New York	April 19–May 7	Seurat, 1859–1891: Paintings and Drawings	New York, Knoedler Galleries, 14 East 57th Street	1–61*
1949–50 London	December 10–March 5	Landscape in French Art, 1550–1900. Introduction by Bernard Dorival	London, Royal Academy of Arts	291–99, 301, 302, 316a, 538, 571, 575
1950 Venice	June 8–October 15	XXV Biennale di Venezia	Venice, Palazzo Centrale	Room XLI: 1–18
1950 Rome	From October 23	Georges Seurat. Preface by Umbro Apollonio	Rome, Galleria dell'Obelisco, 146 via Sistina	1–11
1950 London	November 2–December 2	Pointillists and Their Period. Foreword by H. E. Bates; foreword note by Paul Signac	London, Redfern Gallery Ltd., 20 Cork Street	78–83
1952 Venice	June 14–October 19	XXVI Biennale di Venezia. Preface by Raymond Cogniat	Venice, pianta dell' esposizione	Il Divisionismo: 14–19
1953 New York	November 18–December 26	A Loan Exhibition of Seurat and his friends. Essay by John Rewald	New York, Wildenstein, 19 East 64th Street	1–38; printed addendum: 15a
1954 Paris	June	Autour de Seurat	Paris, Galerie Baugin	

1957 Paris	November–December	Seurat. Introduction by Jean-Gabriel Domergue	Paris, Musée Jacquemart-André	1–66
1958 Chicago and New York	Chicago: January 16–March 7; New York: March 24–May 11	Seurat: Paintings and Drawings. Edited by Daniel Catton Rich; essays by Daniel Catton Rich and Robert L. Herbert	Chicago: Art Institute of Chicago; New York: Museum of Modern Art	1–41, 44–152*
1960 Paris	June 15–July 23	Les néo-impressionnistes belges. Galerie announcement by René Gas	Paris, Galerie André Maurice, 140 boulevard Haussmann	
1961 Paris	June 6–July 7	Les néo-impressionnistes	Paris, Jean-Claude et Jacques Bellier, 32 avenue Pierre-I^{er}-de-Serbie	32–34
1962 New York	October 30–November 17	Seurat and His Friends. Foreword by Victor J. Hammer	New York, Hammer Galleries, 51 East 57th Street	1–8
1963 Paris	May	Néo-impressionnistes étrangers et influences néo-impressionnistes. Catalogue by Guy Pogu	Paris, Galerie André Maurice	
1963 Hamburg	May 4–July 14	Wegbereiter der modernen Malerei: Cézanne, Gauguin, van Gogh, Seurat. Foreword by Hans Platte	Hamburg, Kunstverein in Hamburg	97–119
1963 New York	November 19–December 14	Exhibition of Pointillist Paintings	New York, Hirschl and Adler Galleries, Inc., 21 East 67th Street	44 and 45
1965 New Haven	January 20–March 14	Neo-Impressionists and Nabis in the Collection of Arthur G. Altschul. Robert L. Herbert, editor; William E. Mitchell, associate editor; contributions from Aimée B. Brown, Eric G. Carlson, Klaus D. Kertess, John T. Paoletti, and Paul F. Watson	New Haven, Yale University Art Gallery	no works by Seurat
1965 Paris	April 23–May 16	1884–1894, Les Premiers Indépendants. Preface by Jacques Fouquet	Paris, Grand Palais	197
1966 London	June 7–25	Pointillisme	London, Arthur Tooth and Sons Ltd., 31 Bruton Street	5

1967 Paris	May 24–June 27	Quelques tableaux de maîtres néo-impressionnistes. Preface by Guy Pogu	Paris, Hervé, 18 avenue Matignon	47, 47bis, 53
1968 New York	February 9–April 7	Neo-Impressionism. Introduction by Thomas M. Messer; preface and catalogue by Robert L. Herbert	New York, Solomon R. Guggenheim Museum	62–89
1977 Düsseldorf	May 27–July 10	Vom Licht zur Farbe: Nachimpressionistische Malerei zwischen 1886 und 1912. Foreword by Jürgen Harten; essay by Robert L. Herbert; artists' biographies by John Matheson	Düsseldorf, Städtische Kunsthalle Düsseldorf	104
1977 New York	September 29–November 27	Seurat: Drawings and Oil Sketches from New York Collections. Preface by Jacob Bean	New York, Metropolitan Museum of Art	1–49
1978 London	November 15–December 15	Seurat: Paintings and Drawings. Foreword by David Carritt; introduction by John Richardson; essay by Richard Wollheim	London, David Carritt, Limited, 15 Duke Street, St. James's	1–24
1979–80 London	November 17–March 16	Post-Impressionism: Cross-Currents in European Painting. Foreword by Hugh Casson; introduction by Alan Bowness; essays on French art by John House and MaryAnne Stevens	London, Royal Academy of Arts	194–205
1983 Indianapolis	January 26–March 20	The Aura of Neo-Impressionism: The W. J. Holliday Collection. Preface by Robert A. Yassin; catalogue by Ellen Wardwell Lee; artists' biographies by Tracy E. Smith	Indianapolis, Indianapolis Museum of Art	1 drawing, 1 painting
1983–84 Bielefeld, Baden-Baden, Zurich	Bielefeld: October 30–December 25; Baden-Baden: January 15–March 11; Zurich: closed May 15	Georges Seurat Zeichnungen. Foreword by Ulrich Weisner; catalogue by Erich Franz and Bernd Growe	Bielefeld: Kunsthalle Bielefeld; Baden-Baden: Staatliche Kunsthalle Baden-Baden; Zurich: Kunsthaus Zurich	1–86; printed addenda

1984–85 Los Angeles, Chicago, Paris	Los Angeles: June 28–September 16; Chicago: October 23–January 6; Paris: February 8–April 22	A Day in the Country: Impressionism and the French Landscape. Essays by Richard Brettell, Sylvie Gache-Patin, Françoise Heilbrun, and Scott Schaefer; foreword by Earl A. Powell II, James N. Wood, and Michel Laclotte; preface by Robert J. Fitzpatrick	Los Angeles: Los Angeles County Museum of Art; Chicago: Art Institute of Chicago; Paris: Galeries Nationales d'Exposition du Grand Palais	101, 121–24
1985 Tokyo, Kyoto	Tokyo: April 6–May 26; Kyoto: June 4–July 14	Exposition du Pointillisme. Introduction by Haruki Yaegashi; essay by Françoise Cachin	Tokyo: Musée National d'Art Occidental; Kyoto: Musée Municipal d'Art	16–20, 95–97
1986 Washington, D.C., San Francisco	Washington, D.C.: January 17–April 6; San Francisco: April 19–July 6	The New Painting: Impressionism, 1874–1886. Introduction by Charles S. Moffett; essays by Richard R. Brettell, Hollis Clayson, Stephen F. Eisenman, Joel Isaacson, Charles S. Moffett, Ronald Pickvance, Richard Schiff, Paul Tucker, Martha Ward, and Fronia E. Wissman; reprints of essays by Louis-Émile-Edmond Duranty, and Stéphane Mallarmé	Washington D.C.: National Gallery of Art; San Francisco: Fine Arts Museums of San Francisco, M. H. de Young Memorial Museum	152–56
1987–88 Cleveland, New York, et al.	Cleveland: January 14–March 8; New York: April 4–June 21; Fort Worth: July 11–September 27; Chicago: October 17–January 3; Kansas City: January 30–April 3	Impressionist and Post-Impressionist Masterpieces: The Courtauld Collection. Foreword by Annemarie H. Pope; essays by Robert Bruce-Gardner, Dennis Farr, Gerry Hedley, John House, and Caroline Villers	Cleveland: Cleveland Museum of Art; New York: Metropolitan Museum of Art; Fort Worth: Kimbell Art Museum; Chicago: Art Institute of Chicago; Kansas City: Nelson-Atkins Museum of Art	30–37
1988 Amsterdam	May 28–August 7	Neo-Impressionisten: Seurat tot Struycken. Foreword by Ronald de Leeuw; catalogue by Ellen Wardwell Lee; contributions by Connie Homburg, Ronald de Leeuw, and Ronald Pickvance	Amsterdam, Rijksmuseum Vincent van Gogh	1–5

1988 Geneva	June 16–October 30	Berggruen Collection. Catalogue edited by Simon de Pury, compiled by Jean M. Marquis, with the collaboration of Marie-Laure Trystram-Baudin; texts by Gary Tinterow and John Rewald; entries by Jean Paul Barbier, Henry John Drewal, Louis Perrois, John Rewald, Sabine Rewald, and Gary Tinterow	Geneva, Musée d'Art et d'Histoire	13–26
1990 New York	March 10–May 13	Master Drawings from the Woodner Collection. Foreword by Philippe de Montebello; introduction by Nicholas Turner and Jane Shoaf Turner. Catalogue compiled by Ann Dumas, Christopher Lloyd, Jean-Michel Massing, MaryAnne Stevens, Jane Shoaf Turner, Nicholas Turner, and Ian Woodner; edited by MaryAnne Stevens, assisted by Luci Collings (based on the 1987 Royal Academy of Arts catalogue *Master Drawings from the Woodner Collection,* edited by Joan Shoaf Turner).	New York, Metropolitan Museum of Art	131–37
1990 Indianapolis	October 14–November 25	Seurat at Gravelines: The Last Landscapes. Catalogue by Ellen Wardwell Lee; foreword by Bret Waller; essay by Jonathan Crary; biography by William M. Butler	Indianapolis, Indianapolis Museum of Art	1–18

Compiled with the assistance of Rebecca A. Rabinow

Seurat in France

Françoise Cachin

Perhaps the true *maudit* of Post-Impressionism is not van Gogh or Gauguin but Seurat, especially given his posthumous neglect in France. Now, a hundred years after his death, his country has finally offered him a tribute—the exhibition that this catalogue documents. We may well wonder why this recognition is so belated; why he had not been accorded a place earlier by the French in their modern pantheon, as he has been by the rest of the world; why there has been this indifference toward an artist who is so important in the history of French art and is, in fact, so profoundly French, so in the tradition of Fouquet and Poussin.

Between 1886 and 1889, Georges Seurat enjoyed a brief period when he was acclaimed by the Parisian artistic and literary avant-garde. He was twenty-six years old in 1886 when he showed *La Grande Jatte* at the last Impressionist exhibition. Suddenly he was the man of the hour; van Gogh remarked that he was the "master of the Petit Boulevard" (that is, the haunts of the young avant-garde artists; the galleries of artists who had arrived were on the Grand Boulevards). By 1890, however, his more radical stylistic departures perplexed even his friends. When he died the following year at thirty-one, he had no dealer and had sold only a few paintings (and those in Brussels). During the next thirty years a handful of friends, particularly Paul Signac and Félix Fénéon, attempted to bring him to broader attention through articles and exhibitions. But although the prestige of other Post-Impressionist heroes grew steadily after the turn of the century, no dealer or major collector was interested in Seurat; those who were given his works or bought them for next to nothing were the writers and artists who had known him. During the 1920s only one French collector—Jacques Doucet—purchased a Seurat, and significantly his purchase of *Sketch for "Cirque"* (cat. no. 226) was made on the recommendation of a writer, André Breton.

This situation was peculiar to France, for dealers, collectors, and museums in Germany, Belgium, the Netherlands, England, and the United States early recognized Seurat's singular genius. The entry of Seurat's works into museum collections speaks eloquently to this point. *Baignade, Asnières* belonged to the critic Félix Fénéon until the early twenties, when it left for London, to enter the Tate Gallery in 1924; *La Grande Jatte* stayed with the painter and writer Lucie Cousturier until 1924, when it left for Chicago, where it entered the Art Institute in 1926; *Poseuses*, which had once been owned by the poet and critic Gustave Kahn, went to the Barnes collection in the United States in 1926; and *Chahut*, which was offered in vain to the Louvre in 1914 by a German citizen, was bought in 1922 by Mme Kröller-Müller and is now in the museum of that name in the Netherlands.

Seurat was neglected by French collectors, but among artists the situation was different—he was always highly regarded by them. While the Neo-Impressionists remained faithful to his divided colors and his dotted technique, later generations of painters became interested in him for different reasons. The Fauves—among them Matisse and Derain—worked with Neo-Impressionist methods to present a lesson of pure color; the modulations of Signac and Cross moved toward broader brushstrokes and brighter tones than those of Seurat. Before 1914 the pioneers of abstraction—Mondrian, Kandinsky, the Italian Futurists —all practiced pointillism. Another Seurat, the master of composition rather than the theoretician of color, interested the Cubists: "In spite of his limited production, he is one of the beacons that guides the new generation, which is in search of an art that is lasting, both spiritually and materially" (André Lhote). During the 1920s essays and books about Seurat were published in France. Some critics—André Salmon (1921) and André Lhote (1922)— placed him in the modernist camp; others regarded him as a traditionalist—Robert Rey, for example, published a book with the revealing title *La renaissance du sentiment classique* (1931). This double identity was alluded to in 1926 by the Cubist Amédée Ozenfant: "We love in Seurat the austerity, so characteristic of the great French tradition, and that clarity, that civility of truly lofty things."

Yet, in 1924, when Seurat's *Cirque* was bequeathed to a French museum by the American John Quinn, Florent Fels wrote "Seurat is unknown to the public at large. But a reproduction of his *Cirque*, which is now entering the Louvre, is pinned to studio walls the world over." In fact for more than thirty years the walls of artists and writers were the only ones in France on which a Seurat, either real or in reproduction, could be seen.

The provenances given in this catalogue's entries are extremely illuminating: they document that almost all of the painter's work left France between 1900 and 1930. Some dealers—particularly Bernheim-Jeune, where Fénéon oversaw the modern section—did have an interest in Seurat: *Parade*, now at the Metropolitan Museum, was for sale at that gallery from 1908 until 1928. But only in 1947 did the French state buy its first Seurats: three panels for *Poseuses* from the Fénéon sale. In 1959 the hundredth anniversary of the artist's birth went unnoticed in France (it had already been celebrated by the Art Institute of Chicago and the Museum of Modern Art in New York).

Let us now put breast-beating aside and try to understand why Seurat enjoyed such short-lived renown in France and why he remained so remote, playing no part in the living memory of French modernism. It should be remembered that his early death took from him the years when he might have achieved an unassailable position. By the turn of the century he might have contended with Cézanne or Gauguin for the role of godfather to modernism, but by then he had been dead for nearly a decade. And collectors of Cézanne such as Pellerin showed no interest in Seurat. The important French collectors, with the exception of Baron Napoléon Gourgaud, skipped Seurat's generation, moving directly from Impressionism to Fauvism and Cubism, which were more immediately "modern." Some collectors and critics were interested in the speculative element in Seurat's art, in his tendency toward pure formal harmonies and what they saw as his abstraction. But even for them he was too naturalistic and too marked by his era—old-fashioned despite his irony. In 1928 Gustave Kahn remarked that Seurat was unlucky to have lived during the fashion for bustles, whose profiles he exaggerated in *La Grande Jatte*. And those who wanted

to accept him as the apostle of pure color were disappointed by his lack of flamboyance. Finally, when he might have been accepted and loved, his principal works were already abroad. For more than half a century *Baignade* in London and *La Grande Jatte* in Chicago have been more a part of the English and American artistic patrimonies than of that of France.

Ultimately, however, some essential traits in Seurat may have always chilled the enthusiasm of the French public and art lovers. His austerity, rigor, and underlying morality are characteristics that Nordic and Anglo-Saxon countries, with their Protestant sensibilities, could readily accept. Perhaps Fénéon was going beyond physical appearance when he described the artist's "sixteenth-century Huguenot mask." For Seurat was certainly a modern manifestation of a Reformation or Jansenist spirit. His unaccommodating stance toward the world was expressed through a method designed to keep a tight rein on a rare sensibility, a goal that it happily did not achieve.

Seurat's temperament seems to have been melancholic, with a trace of sarcasm, and it follows that his works do not always have an easy charm. In his slightly ferocious humor, some recent critics have tried to detect a social message, an expression of anarchist thought. A critic of the bourgeoisie, that he certainly was—but as an artist (a role fostered by Romanticism) rather than as a social rebel. His mockery is directed at appearances, at pretext, at artificial pleasures: he presents an indictment of vanity. His major paintings cause many viewers to feel uneasiness or even irritation. These emotions may somehow be stirred by the severity, the sadness that emanates from his calmest landscapes and his most graceful figures in conté crayon. Seurat's oeuvre may be seen as one grand memento mori, modulating the countless forms of isolation and absence. His scenes of contemporary life express the absurdity of existence; his drawings are poignant images of solitude; and his landscapes present a luminous vision of the void.

Never, however, did Seurat moralize. He became angered by facile interpretations of his paintings and considered himself a reformer solely in the domain of forms: "They see poetry in what I do. But I just apply my method." Yet his preoccupation with "harmony" reveals a Neoplatonic spiritualism. Seurat was probably closer than he realized to his bourgeois father, to a tentative religious sense, even if his own faith was completely up-to-date, since he believed in progress and science. And pursuing his "dream of art-science," in André Chastel's phrase, he was determined to direct his art toward transcendence, toward the eternal. Breaking up the world into discontinuous fragments so as to put them back in better order (Apollinaire called Seurat the "microbiologist of painting"), eliminating all sentimentality, and imposing a greater "harmony"—these are often-resisted characteristics of all utopian systems.

Seurat's scientific ambitions, his movement away from the simple earthly pleasures described by Impressionism, his wish to raise art above mediocrity not only through his technique but also through an underlying puritanism, the restrained but implacable sadness of his works—all these elements may explain why the French public has not easily entered Seurat's world.

Thus were we long deprived of an artist whose grandeur and rigor, far from stifling his exceptional sensibility, in fact served his art extraordinarily well; we were deprived too of one of the most enigmatic, abundant, and moving oeuvres of the nineteenth century. Let us hope that this exhibition, while incomplete, may lift the spell that has cast a pall over Georges Seurat in France.

Bibliography

The following comments are offered as a guide to the Seurat literature. Citations from the last three decades are the most frequent; the years since 1960 have seen the most extensive and serious work on Seurat. Except for those in the first paragraph, references in this introduction are ordered chronologically, to give an idea of the development of Seurat criticism.

Biography, catalogues, and general studies: All serious Seurat studies can be traced to the work of John Rewald: Rewald 1943, Rewald 1948, and Rewald 1956. The last has been especially useful and influential; it is the source, often unacknowledged, of many books and articles about Seurat. Fundamental are the two catalogues raisonnés by César M. de Hauke (H) and Henri Dorra and Rewald (DR). De Hauke's is the more complete since it catalogues drawings as well as paintings, and it incorporates the work of Félix Fénéon. The volume by Dorra and Rewald catalogues only those drawings that are studies for paintings, but it has the advantage of giving excerpts from contemporary and later criticism with the major pictures. Some unpublished documents and drawings appear in Herbert 1962 and in Franz and Growe 1983. The researches of the late Dr. Jean Sutter added most to Seurat's biography (Sutter 1964, some of which is assimilated in Sutter 1970). The exhibition I organized for the Solomon R. Guggenheim Museum, New York, in 1968 (Herbert 1968) remains the most inclusive study of Seurat in the context of Neo-Impressionism. John Russell's monograph (Russell 1965) is a general appreciation that was the standard monograph until the publication of Thomson 1985, an eclectic study rich in observations, not all of them convincing. The new book by Michael Zimmermann is the most satisfactory study of Seurat in terms of intellectual history (Zimmermann 1991).

Drawings: Long recognized as worthy of study in their own right, Seurat's drawings were singled out in numerous articles from the turn of the century onward. The two volumes of facsimile reproductions introduced by Gustave Kahn (Kahn 1928) remain indispensable. Seligman 1947 is a connoisseur's appreciation; Herbert 1962 is the first scholarly study of the body of drawings; Franz and Growe 1983 is a sensitive reevaluation.

Style and interpretation: The terms for consideration of Seurat as a Post-Impressionist were set by Rey 1931, but Schapiro 1935 was the first essay of lasting critical power. Goldwater 1941 gave a convincing account of Seurat's stylistic development, and his classicism (attuned to modern formalism) was put forth in Venturi 1944, Longhi 1950, and Venturi 1953. In the wake of the exhibition 1958 Chicago and New York, Meyer Schapiro wrote the most brilliant interpretive essay devoted to Seurat (Schapiro 1958), and Leslie Katz offered a subtle analysis of Seurat's late paintings (Katz 1958). Since then, interpretation of Seurat's work can be grouped in the following three categories.

Seurat's "science" and technique: Webster 1944 did some essential debunking while carefully describing Seurat's technique; Maret 1944 put it in the context of pigments actually used in the later nineteenth century. Homer 1964 made the first close analysis of Seurat's readings in science and aesthetics, at times overstating the case for his dependence upon them. In Herbert 1968 I summarized Neo-Impressionist color theory and practice, in Herbert 1970 Seurat's readings and theory, and in Herbert 1980 his interest in the work of Charles Henry, which I somewhat overstated. Semin 1980 published an excellent account of Seurat's painted borders and frames. Herz-Fischler 1983 showed that Seurat did not, in fact, use the golden section, a necessary job of debunking that has been followed up by Neveux 1990. Lee 1987 helpfully separated Seurat's theory and practice from science but condemned him for failing to join them; Gage 1987 rebuts Lee in a well-considered but slightly tendentious analysis. Fiedler 1989 found the culprit among Seurat's pigments that caused serious discoloration in *La Grande Jatte*.

Literature and criticism: Loevgren 1959 (looking back to Rey 1931) showed why literary Symbolism and the aesthetic ideas of Seurat's generation were essential components of an exegesis of his work, but he relied too much on secondary information, often now discredited. Since Félix Fénéon was Seurat's most important critic, Joan Halperin's anthology of his writings (Halperin 1970) is invaluable, and her biography of him is indispensable (Halperin 1988). Norma Broude's repertoire of writings about Seurat (Broude 1978) is very

useful, but only recently have younger scholars undertaken detailed studies of Seurat's relationships with the Symbolists: Smith 1988 and Smith 1990, and Zimmermann 1989 and Zimmermann 1991.

Social meanings: Meyer Schapiro's interpretations (Schapiro 1935, Schapiro 1958) underlie the recent surge of interest in the social content of Seurat's art (largely limited to his major paintings). Herbert and Herbert 1960 document and discuss anarchism in Neo-Impressionist circles, an analysis given broad extension in E. Herbert 1961. Herbert 1962 discusses the social meanings in Seurat's drawings. His possible endorsement of anarchism is studied with considerable exaggeration in Medlyn 1976. Social iconography enters importantly, but not always persuasively, in House 1980. T. J. Clark's interpretation (Clark 1985) of *La Grande Jatte* has proved especially influential, but the most thorough and circumspect study of Seurat and anarchism is the dissertation by John Hutton (Hutton 1987). The special issue of the Art Institute of Chicago's Museum Studies included three articles dealing with Seurat's views of society: Clayson 1989, Eisenman 1989, and Nochlin 1989. Nochlin's view is countered by Albert Boime (Boime 1990) who, however, overstates the role of the utopian and anarchist traditions.

In the following citations Paris is understood to be the city of publication unless otherwise noted. DR refers to the Dorra-Rewald catalogue when its bibliography is the source of a reference that has not otherwise been consulted. The Seurat argus (de Hauke archives) and the Signac album (Signac archives) are collections of press clippings and reviews made by the artists (see also Note to the Reader). Seurat and Signac rarely recorded page and volume numbers and sometimes cut off an article's title, hence the incompleteness of some entries for which their copies are the source.

Adam, Paul. "Les artistes indépendants," *La vogue* 2, 8 (September 6–13, 1886): 260–67.

———. "Peintres impressionnistes," *Revue contemporaine* 5 (April–May 1886): 541–51.

————. "Les artistes indépendants," *Revue rose* 3 (May 1887): 139–45.

————. "Les impressionnistes à l'exposition des indépendants," *La vie moderne* 10 (April 15, 1888): 228–29.

Ajalbert, Jean. "Le salon des impressionnistes," *Revue moderne* 3 (June 20, 1886): 385–93; reprinted in *Gazette de Neuilly et de Courbevoie* (July 10, 1886). Signac album.

Alexandre, Arsène. "Les peintres indépendants," *L'événement* (August 23, 1886). DR, p. 292.

————. "La semaine artistique," *Paris* (March 26, 1888). Signac album.

————. "Le mouvement artistique," *Paris* (August 13, 1888). Signac album.

————. [review article], *Paris* (March 21, 1890). Seurat argus.

————. "Un vaillant," *Paris* (April 1, 1891); reprinted in Valton et al. 1895.

Alexandrian, Sarane. *Seurat.* 1980.

Alexis, Paul [Trublot]. "À minuit" [column of miscellany], *Le cri du peuple* (March 12, 1886); (April 18, 1886); (May 2, 1886); (August 22 and 24, 1886); (March 26, 1887); (September 15, 1887). Signac album.

————. "Revue de fin d'année," *Le cri du peuple* (undated clipping, probably 1886). Signac album.

————. "L'exposition des artistes indépendants," *Le cri du peuple* (March 26, 1887). Signac album.

————. "La fin de Lucie Pellegrin," *La vie moderne* 10 (June 27, 1888): 372ff.

Angrand, Pierre. *Naissance des artistes indépendants 1884.* 1965.

Antoine, Jules. "Les peintres néo-impressionnistes," *Art et critique* 2 (August 9, 1890): 509–10; (August 16, 1890): 524–26.

————. "Georges Seurat," *La revue indépendante* 19 (April 1891): 89–93.

————. "Critique d'art: exposition des artistes indépendants," *La plume* 3 (May 1, 1891): 156–57.

Apollinaire, Guillaume. *Chroniques d'art.* Ed. L. C. Breunig. 1960. Articles mentioning Seurat, 1910–14.

Apollonio, Umbro. *Disegni di Seurat.* Venice, 1947.

Arnay, Albert. "Chronique artistique: l'annuel des XX," *Floréal* 1 (March 1892): 84–87.

Barr, Alfred H. *Georges Pierre Seurat: Fishing Fleet at Port-en-Bessin.* New York, 1945.

Barthelmess, Wieland. "Das Café-concert als Thema der franzosischen malerei und graphic des ausgehenden 19 Jahrhunderts." Berlin (Ph.D. diss.), 1987.

Bernier, Robert. "Salon de la Société des Indépendants, 2ᵐᵉ exposition," *Revue moderne* 3 (September 20, 1886): 616–19.

————. "Chronique d'art, les indépendants," *Revue moderne* 4 (April 20, 1887): 236–39.

————. "Les artistes indépendants," *Annales artistiques et littéraires* 4 (April 15, 1890): 58–59.

————. "Le socialisme et l'art," *Revue socialiste* 13 (May 1891): 599–604.

Bertram, Hilge. *Georges Seurat—Tegninger.* Copenhagen, 1946.

Bissière, Georges. "Notes sur l'art de Seurat," *L'esprit nouveau* 1 (October 15, 1920): 13–28.

Bock, Catherine C. *Henri Matisse and Neo-Impressionism, 1898–1908.* Ann Arbor, 1981.

Boime, Albert. "Seurat and Piero della Francesca," *Art Bulletin* 47 (June 1965): 265–71.

————. "Studies of the monkey by Seurat and Pisanello," *Burlington Magazine* 111, 791 (February 1969): 79–80.

————. "The Teaching of fine arts and the avant-garde in France during the second half of the nineteenth century," *Arts Magazine* 60 (December 1985): 46–57.

————. "Georges Seurat's *Un dimanche à la Grande-Jatte* and the scientific approach to history painting," in *Historienmalerei in Europa*, ed. Ekkehard Mai and Anke Repp-Eckert. Mainz, 1990, pp. 303–33.

Broude, Norma. "New light on Seurat's 'Dot': Its relation to photo-mechanical color printing in France in the 1880s," *Art Bulletin* 56, 4 (December 1974): 581–89.

————. "The influence of Rembrandt reproductions on Seurat's drawing style: A methodological note," *Gazette des beaux-arts* 88, 1293 (October 1976): 155–60.

————, ed. *Seurat in Perspective.* Englewood Cliffs, 1978.

Cachin, Françoise. *Paul Signac.* 1971.

————. *Seurat: Le rêve de l'art-science.* 1991.

————. "Les néo-impressionnistes et le japonisme, 1885–1893," in *Japonism in Art: An International Symposium*, ed. Yamada Chisaburo. Tokyo, 1980, pp. 225–37.

Cachin-Signac, Ginette. "Documenti inediti sul neo-impressionismo," *La Biennale di Venezia* 6 (October 1951): 20–23.

Chastel, André. "Le mutisme de Seurat et la psychologie de l'art," *Cahiers du sud* 3 (1948): 530–36.

————. "Une source oubliée de Seurat," *Études et documents sur l'art français* 22 (1950–57; i.e., 1959): 400–407.

————. "Seurat et Gauguin," *Art de France* 2 (1962): 297–305.

————. See Minervino, Fiorella.

Christophe, Jules. "Chronique: rue Laffitte, no. 1," *Le journal des artistes* (June 13, 1886): 193–94.

————. "Les évolutionnistes du pavillon de la ville de Paris," *Le journal des artistes* (April 24, 1887): 122–23. Signac album.

————. "Le néo-impressionnisme au pavillon de la ville de Paris," *Le journal des artistes* (May 6, 1888). Signac album.

————. "Symbolisme," *La cravache* 8 (June 16, 1888): n.p.

————. "Notices sur Georges Seurat (le peintre)," *Les hommes d'aujourd'hui* 8, 368 (April 1890).

————. "Causerie, l'impressionnisme à l'exposition des artistes indépendants," *Le journal des artistes* (April 6, 1890): 101–2.

————. "Georges Seurat," *La plume* 3 (September 1, 1891): 292.

————. "Salon des artistes indépendants," *La plume* 4 (April 1, 1892): 156–58.

Clark, Kenneth. *Landscape Painting.* New York, 1950.

Clark, Timothy J. *The Painting of Modern Life: Paris in the Art of Manet and His Followers.* New York, 1984.

Clayson, S. Hollis. "The family and the father: The *Grande Jatte* and its absences," *Museum Studies* (Chicago) 14, 2 (1989): 155–64.

Cogniat, Raymond. *Seurat.* 1951.

Cooper, Douglas. *Georges Seurat: Une baignade, Asnières.* London, 1946. Pamphlet.

Coquiot, Gustave. *Seurat.* 1924.

————. *Les indépendants 1884–1920.* 1924.

Courthion, Pierre. *Georges Seurat.* New York, 1968; rev. ed., 1988.

Coustier, Lucie. "Georges Seurat (1859–1891)," *L'art décoratif* 27 (June 20, 1912): 357–72; ibid. 31 (1914): 97–106. Incorporated in 1922 book.

———. *Seurat*. 1921.

———. *Georges Seurat*. 1926.

Darragon, Eric. "Seurat, Honfleur et La 'Maria' en 1886," *Bulletin de la société de l'histoire de l'art français* (1984): 263–80.

———. "Pégase à Fernando: À propos de *Cirque* et du réalisme de Seurat en 1891," *Revue de l'art* 86 (1989): 44–57.

———, ed. *Seurat*. 1991.

Darzens, Rodolphe. "Exposition des impressionnistes," *La pléiade* 1 (May 1886): 88–91.

DeLorme, Eleanor Pearson. See Pearson, Eleanor.

Demolder, Eugène. "Chronique artistique: Le salon des XX," *La société nouvelle* 5, 1 (1889): 225–31.

———. "Chronique artistique: Le salon des XX," *La société nouvelle* 6, 1 (1890): 108–11.

———. "Chronique artistique: l'exposition des XX à Bruxelles," *La société nouvelle* 8, 1 (1892): 347–56. Reprinted in Valton et al. 1895.

Denis, Maurice [Pierre Louis]. "Notes sur l'exposition des indépendants," *La revue blanche* 2 (April 1892): 232–34.

———. *Théories 1890–1910*. 1912 et seq.

Desclozeaux, Jules. "Chronique: les impressionnistes," *L'opinion* (May 27, 1886). Signac album.

———. "L'exposition des artistes indépendants," *L'estafette* (April 11, 1887). Signac album.

———. "Les artistes indépendants," *La cravache* 8 (June 9, 1888): n.p.

Distel, Anne. *Seurat*. 1991.

Dittmann, Lorenz. "Seurats Ort in der Geschichte des Helldunkel," in *Baukunst des Mittelalters in Europa; Hans Erich Kubach zum 75. Geburtstag*. Stuttgart, 1988: 739–56.

Dorra, Henri. "Renaming a seascape by Seurat," *Gazette des beaux-arts* 51, 1068 (January 1958): 41–48.

———. "Charles Henry's 'scientific' aesthetic," *Gazette des beaux-arts* 74, 1121 (December 1969): 345–56.

———. "Seurat's dot and the Japanese stippling technique," *Art Quarterly* 33 (summer 1970): 108–13.

———. "Japanese sources for two paintings by Seurat." *Gazette des beaux-arts* 114, 1448 (September 1989): 95–99.

Dorra, Henri, and Sheila C. Askin. "Seurat's japonisme," *Gazette des beaux-arts* 73, 1201 (February 1969): 81–94.

Dorra, Henri, and John Rewald. *Seurat: L'oeuvre peint, biographie et catalogue critique*. 1959.

Eglington, Guy. "The theory of Seurat," *International Studio* 81 (May 1925): 113–17; ibid. (July 1925): 289–92. Reprinted in Eglington's *Reaching for Art*, 1931.

Eisenman, Stephen F. "Seeing Seurat politically," *Museum Studies* (Chicago) 14, 2 (1989): 211–21.

Ernst, Alfred. "Exposition des artistes indépendants," *La paix* (March 27, 1891).

Faunce, Sarah. "Seurat and 'the soul of things,'" in Brooklyn Museum, *Belgian Art, 1880–1914*, April–June 1980, pp. 41–56. Exhibition catalogue.

Fels, Florent. "La peinture française aux XIXe et XXe siècles, Seurat," *ABC, magazine d'art* 3, 35 (November 1927): 282–87.

———. "Les dessins de Seurat," *Amour de l'art* 8 (1927): 43–46.

Fénéon, Félix. "VIIIe exposition impressionniste," *La vogue* 1 (June 13, 1886): 261–75.

———. "L'impressionnisme aux Tuileries," *L'art moderne* 6 (September 19, 1886): 300–302. Extracts reprinted in *La vogue* (September 20, 1886).

———. *Les impressionnistes en 1886*. October 1886. Edited version of articles published in June, July, and September.

———. "La Grande-Jatte," *L'art moderne* 1 (February 6, 1887): 43f.

———. "L'impressionnisme," *L'émancipation sociale* (April 3, 1887). Signac album.

———. "Le néo-impressionnisme," *L'art moderne* 7 (May 1, 1887): 138–40.

———. "Les poèmes de Jules Laforgue," *L'art moderne* (October 9, 1887).

———. "Exposition de la Revue indépendante," *La revue indépendante* 6 (January 1888): 171–74.

———. "Expositions: À la Revue indépendante," *La revue indépendante* 6 (March 1888): 481–82.

———. "Le néo-impressionnisme," *L'art moderne* 8, 16 (April 15, 1888): 121–23.

———. "Les arts: Quelques impressionnistes," *La cravache* 8 (June 2, 1888): n.p.

———. "Calendrier de septembre," *La revue indépendante* 9 (October 1888): 134–37.

———. "Calendrier d'octobre," *La revue indépendante* 9 (November 1888): 320.

———. "Autre groupe impressionniste," *La cravache* 6 (July 1889): n.p.

———. "Cinquième exposition de la Société des artistes indépendants," *La vogue* 4 (September 1889): 252–62.

———. "Exposition des artistes indépendants à Paris," *L'art moderne* 9 (October 27, 1889): 339–41.

———, [falsely, as "Willy"]. "Artistes indépendants," *Le chat noir* 10 (March 21, 1891): 1717 [*sic*].

———. "Notes et notules [Seurat obituary]," *Entretiens politiques et littéraires* (April 1891): 141.

———. "Quelques peintures idéistes," *Le chat noir* 10 (September 19, 1891): 1820–22 [*sic*].

———. "Au pavillon de la ville de Paris: Société des artistes indépendants," *Le chat noir* 11 (April 2, 1892): 1932 [*sic*].

———, ed. "Textes, extrait du *Livre des métiers*, de l'Hindou Wehli Zunbul Zadé," *Bulletin* (Bernheim-Jeune) 4 (March 14, 1914).

———, ed. "Paroles de Corot," *Bulletin* (Bernheim-Jeune) 6 (April 29, 1914).

———. "Georges Seurat," *Bulletin* (Bernheim-Jeune) 7 (May 14, 1914).

———. "De Seurat," *Bulletin* (Bernheim-Jeune) 9 (June 17, 1914).

———, ed. *L'art moderne et quelques aspects de l'art d'autrefois*. 2 vols. 1919. vol. 1, pp. 55–60.

———. "Influences; à propos de la révélation de Seurat par A. Salmon," *Bulletin de la vie artistique* 3, 1 (January 1, 1922): 11–12.

———. "Anachronismes, les cadres," *Bulletin de la vie artistique* 3, 3 (February 1, 1922): 60–62.

———. "Notes inédites de Seurat sur Delacroix," *Bulletin de la vie artistique* 3, 7 (April 1, 1922): 154–58.

———. "Sur Georges Seurat," *Bulletin de la vie artistique* 3, 12 (June 15, 1922): 278–79.

———. "Inédits d'Henri-Edmond Cross, V," *Bulletin de la vie artistique* 3, 18 (September 15, 1922): 425–27.

———. "Précisions concernant Seurat," *Bulletin de la vie artistique* 5, 16 (August 15, 1924): 358–60.

————. "Seurat au Louvre," *Bulletin de la vie artistique* 5, 20 (October 15, 1924): 451.

————. "Le 'Cirque' de Seurat," *Bulletin de la vie artistique* 7, 6 (March 15, 1926): 85–86.

————. "Charles Angrand," *Bulletin de la vie artistique* 7 (April 15, 1926): 117–18. Signac album.

————. "Les disparus, Charles Henry," *Bulletin de la vie artistique* 7 (November 15, 1926): 350. Signac album.

————. "Sur Georges Seurat," *Bulletin de la vie artistique* 7 (November 15, 1926): 347–48.

————. *Oeuvres*. Ed. Jean Paulhan. 1948.

————. *Félix Fénéon: Au-delà de l'impressionnisme*. Ed. Françoise Cachin. 1966.

————. *Oeuvres plus que complètes*. Ed. Joan U. Halperin. 2 vols. Geneva, 1970. (N.B.: All writings by Fénéon are reprinted in Halperin's anthology, but many are listed above to facilitate references in this catalogue and to document his role in Seurat's historiography.)

Fiedler, Inge. "A technical evaluation of the *Grande Jatte*," *Museum Studies* (Chicago) 14, 2 (1989): 173–79.

Flagg, Peter J. "The Neo-Impressionist Landscape." Princeton (Ph.D. diss.), 1988.

Fouquier, Marcel. "Les impressionnistes," *Le XIXe siècle* 17 (May 16, 1886): n.p.

————. [review article], *Le XIXe siècle* 18 (January 20, 1887): n.p. Signac album.

————. "L'exposition des artistes indépendants," *Le XIXe siècle* 18 (March 28, 1887): n.p.

Francastel, Pierre. *L'impressionnisme: Les origines de la peinture moderne de Monet à Gauguin*. 1937.

Franz, Erich, and Bernd Growe. *Seurat Drawings*. Boston, 1984. Exhibition catalogue; Bielefeld and Baden-Baden, 1983.

Fry, Roger. "Seurat," in *Transformations*, New York, 1926, pp. 188–96; reprinted in *The Dial* 81 (September 1926): 224–32; partly reprinted in *Seurat*, ed. Anthony Blunt. London, 1965, pp. 9–22.

————. "Seurat's 'La Parade,'" *Burlington Magazine* 55 (December 1929): 289–93.

Gage, John. "Colour in history: relative and absolute," *Art History* 1 (March 1978): 104–30.

————. "The technique of Seurat: A reappraisal," *Art Bulletin* 69, 3 (September 1987): 448–54.

Geffroy, Gustave. "Chronique, pointillé-cloisonisme," *La justice* (April 2, 1888). Signac album.

————. "Chronique d'art: Indépendants," *Revue d'aujourd'hui* 1 (April 5, 1890): 267–70.

————. "Les indépendants" (March 29, 1892), in *La vie artistique* 2 (1893), p. 367.

————. "L'art d'aujourd'hui: Néo-impressionnistes," *Le journal* (January 28, 1894): 3. DR, p. 294.

George, Waldemar. *Seurat*. 1928.

Germain, Alphonse. "L'exposition des indépendants," *Art et critique*, 1 (September 15, 1889): 250–52.

————. "Théorie des néo-luminaristes," *Moniteur des arts* (March 20, 1891): 534; "À l'exposition des indépendants," ibid. (March 27, 1891); reprinted in *L'art moderne* 11, 28 (July 12, 1891): 221–22; ibid. 30 (July 26, 1891): 239–40.

————. "Théorie chromo-luminariste, exposé et critique," *La plume* 3, 57 (September 1, 1891): 285–87.

———— [Kalophile l'Ermite]. "Exposition des indépendants," *L'ermitage* 4 (April 15, 1892): 243–45.

Goldwater, Robert J. "Some aspects of the development of Seurat's style," *Art Bulletin* 23 (June 1941): 117–30.

————. "Symbolic form: Symbolic content," in *Problems of the 19th and 20th Centuries; Acts of the XX International Congress of the History of Art* 4 (Princeton, 1963): 111–21.

————. *Symbolism*. New York, 1979.

Gould, C. "Seurat's 'Bathers, Asnières' and the crisis of Impressionism," National Gallery, London, *Painting in Focus*, 6, 1976.

Grenier, Catherine. *Seurat, catalogo completo*. Florence, 1990.

Growe, Bernd. See Franz, Erich.

Haacke, Hans. *Framing and Being Framed: Seven Works 1970–75*. Halifax and New York, 1975. Exhibition catalogue.

Halperin, Joan U. *Félix Fénéon and the Language of Art Criticism*. Ann Arbor, 1980 [dissertation 1967].

————. *Félix Fénéon, Aesthete and Anarchist in Fin-de-siècle Paris*. New Haven and London, 1988.

————. See Fénéon 1970.

Hauke, César M. de. *Seurat et son oeuvre*. 2 vols. 1961.

Hautecoeur, Louis. *Georges Seurat*. Milan, 1972.

Hélion, Jean. "Seurat as a predecessor," *Burlington Magazine* 69 (July 1936): 4, 8–14.

————. "Poussin, Seurat and double rhythm," in *The Painter's Object*, ed. Myfanwy Evans. London, 1937, pp. 94–107.

Hennequin, Émile. "Notes d'art: les impressionnistes," *La vie moderne* 8 (June 19, 1886): 389–90.

————. "Notes d'art: exposition des artistes indépendants," *La vie moderne* 8 (September 11, 1886): 581–82.

Herbert, Eugenia W. *The Artist and Social Reform: France and Belgium 1885–1898*. New Haven, 1961.

Herbert, Robert L. "Seurat in Chicago and New York," *Burlington Magazine* 100, 662 (May 1958): 146–55.

————. "Seurat and Jules Chéret," *Art Bulletin* 40, 2 (June 1958): 156–58.

————. "Seurat and Puvis de Chavannes," *Yale University Art Gallery Bulletin* 25 (October 1959): 22–29.

————. "Seurat and Émile Verhaeren: unpublished letters," *Gazette des beaux-arts* 54, 1091 (December 1959): 315–28.

————. *Seurat's Drawings*. New York, 1962.

————. "A newly discovered drawing for Seurat's 'Baignade,'" *Yale University Art Gallery Bulletin* 27, 1–2 (April 1962): 36–42.

————. *Neo-Impressionism*. New York, Guggenheim Museum, 1968. Exhibition catalogue.

————. "Seurat's theories," in *The Neo-Impressionists*, ed. Jean Sutter. Greenwich, Conn., 1970, pp. 23–46.

————. "'Parade de cirque' de Seurat et l'esthétique scientifique de Charles Henry," *Revue de l'art* 50 (1980): 9–23.

Herbert, Robert L., and Eugenia W. Herbert "Artists and anarchism: unpublished letters of Pissaro, Signac and others," *Burlington Magazine* 102, 692 (November 1960): 473–82; ibid. (December 1960): 517–22; in French: *Le mouvement social* 36 (July– September 1961): 2–19.

Hermel, Maurice. "L'exposition de peinture de la rue Laffitte," *La France libre* (May 27, 1886). Signac album.

Herz-Fischler, Roger. "An examination of claims concerning Seurat and 'The Golden Number,'" *Gazette des beaux-arts* 101, 1370 (March 1983): 109–12.

Homer, William Innes. "Seurat's Port-en-Bessin," *Minneapolis Institute of Arts Bulletin* 46, 2 (summer 1957): 17–41.

———. "Seurat's formative period: 1880–1884," *Connoisseur* 142, 571 (September 1958): 58–62.

———. "Notes on Seurat's palette," *Burlington Magazine* 101, 674 (May 1959): 192–93.

———. Review of de Hauke. *Art Bulletin* 42 (September 1960): 228–33.

———. "Seurat's paintings and drawings" [review of de Hauke], *Burlington Magazine* 105, 723 (June 1963): 282–84. Appendix by R. Ross Holloway.

———. *Seurat and the Science of Painting*. Cambridge, Mass., 1964.

Hoschedé, Ernest. "Exposition des artistes indépendants," *L'événement* (March 27, 1887). Signac album.

House, John. "Meaning in Seurat's figure paintings," *Art History* 3, 3 (September 1980): 345–56.

———. "Reading the *Grande Jatte*," *Museum Studies* (Chicago) 14, 2 (1989): 115–31.

Hutton, John. "A blow of the pick: science, anarchism, and the Neo-Impressionist movement." Northwestern University (Ph.D. diss.), 1987.

Huyghe, René. "Trois poseuses de Seurat," *Bulletin des musées de France* 12, 7 (August 1947): 7–14.

Huysmans, Joris Karl. "Chronique d'art: Les indépendants," *La revue indépendante* 3 (April 1887): 51–57.

Jamot, Paul. "Artistes contemporains, Ernest Laurent," *Gazette des beaux-arts* 4, 5 (March 1911): 173–203.

Javel, Firmin. "Les impressionnistes," *L'événement* (May 16, 1886). Signac album.

———. "Les artistes indépendants," *L'art français* (March 31, 1888). DR, p. 293.

Jedding, Hermann. *Seurat*. Milan, n.d. (1957?).

Joze, Victor. "Sztuki plastyczne," *Przeglad-tygosmowy* (May 8, 1887). Signac album.

———. "Sztuki plastyczne," *Przeglad-tygosmowy* (May or June 1888). Signac album.

Kahn, Gustave. "La vie artistique," *La vie moderne* 9, 15 (April 9, 1887): 229–32.

———. "Exposition Puvis de Chavannes," *La revue indépendante* 6 (February 1888): 142f.

———. "Peinture: expositions des indépendants," *La revue indépendante* 6 (April 1888): 160–64.

———. "Seurat," *L'art moderne* 11, 14 (April 5, 1891): 107–10. Reprinted in Valton et al. 1895.

———. "Au temps du pointillisme," *Mercure de France* 171 (May 1924): 5–22.

———. "Paul Gauguin," *L'art et les artistes* 12, 61 (November 1925): 37.

———. *Silhouettes littéraires*. 1925.

———. *Les dessins de Georges Seurat 1859–1891*. 2 vols. 1928; reprinted New York, 1971 (trans. S. Appelbaum).

———. "Les origines de la société des indépendants," *ABC* 87 (March 1932): 65–68.

Kahnweiler, Daniel Henry. "La place de Georges Seurat," *Critique* 2 (January–February 1947): 54–59; reprinted in *Confessions esthétiques* (1963), pp. 180–90.

Katz, Leslie. "Seurat: Allegory and image," *Arts* 32, 7 (April 1958): 40–47.

Kemp, Martin. *The Science of Art: Optical Themes in Western Art from Brunelleschi to Seurat*. New Haven and London, 1990.

Kinney, Leila. "An artificial paradise: painting, fashion, and consumption in the early Third Republic." New York, American Historical Association (unpublished lecture), 1983.

Labruyère. "Les impressionnistes," *Le cri du peuple* (May 28, 1886). Signac album.

Laprade, Jacques de. *Georges Seurat*. Monaco, 1945.

———. *Georges Seurat*. 1951.

"La recherche de la lumière dans la peinture," *L'art moderne* 7 (1887): 201–2.

Lebensztejn, Jean-Claude. "Chahut: le lieu, la danse," *Critique* 490 (March 1988): 236–51.

———. *Chahut*. 1989.

Lecomte, Georges. "'La ménagerie sociale' de M. Victor Joze—Une couverture de M. Seurat," *Art et critique* 2 (February 8, 1890): 87.

———. "L'exposition des néo-impressionnistes," *Art et critique* 2 (March 29, 1890): 203–5.

———. "Société des artistes indépendants," *L'art moderne* 10 (March 30, 1890): 100–101.

———. "Le salon des indépendants," *L'art dans les deux mondes* 19 (March 28, 1891): 225.

———. "L'art contemporain," *La revue indépendante* 23 (April 1892): 1–29.

———. "La renaissance idéaliste," *Revue de l'évolution* 2 (March 15, 1892): 169–72.

Lee, Alan. "Seurat and science," *Art History* 10 (June 1987): 203–26.

Lee, Ellen Wardwell. *The Aura of Neo-Impressionism: The W. J. Holliday Collection*. Indianapolis, 1983. Exhibition catalogue.

———. *Seurat at Gravelines: The Last Landscapes*. Indianapolis, 1990.

Le Fustec, J. "Exposition de la société des artistes indépendants," *Le journal des artistes* (August 22, 1886). DR, p. 292.

———. "Exposition des artistes indépendants," *Le journal des artistes* (April 10, 1887): 229–32. Signac album.

———. "Inauguration de l'exposition des indépendants," *Silhouette* (March 25, 1888). Signac album.

"Le salon de 1888," *La revue indépendante* 7 (June 1888): 407–42.

"Le salon des XX: L'ancien et le nouvel impressionnisme," *L'art moderne* 7 (1887): 253ff.

Lhote, André. *Georges Seurat*. Rome, 1922.

———. "Composition du tableau," *Encyclopédie française* 16 (1935): 16.30–36ff.

———. *Seurat*. 1948.

Loevgren, Sven. *The Genesis of Modernism: Seurat, Gauguin, van Gogh and French Symbolism in the 1880s*. Stockholm, 1959; reprinted Indiana, 1971.

Longhi, Roberto. "Un disegno per la Grande-Jatte e la cultura formale di Seurat," *Paragone* 1 (January 1950): 40–43.

Mabille, Pierre. "Dessins inédits de Seurat," *Minotaure* 3, 11 (spring 1938): 2–9.

Malivert, Octave. "La genèse du symbolisme," *La vie moderne* 8 (November 20, 1886): 742.

Maret, François [Franz von Ermengem]. *Les peintres luministes*. Brussels, 1944.

Marlais, Michael. "Seurat et ses amis de l'École des beaux-arts," *Gazette des beaux-arts* 114, 1449 (October 1989): 153–68.

Marx, Roger. "Le salon, VI (fin)," *Le progrès artistique* (June 15, 1883). Seurat argus.

———. "L'exposition des indépendants," *Le Voltaire* (December 10, 1884). Signac album.

———. "L'exposition des artistes indépendants," *Le Voltaire* (May 16, 1884). Signac album.

———. "Les impressionnistes," *Le Voltaire* (May 16, 1886). Signac album.

———. "Les indépendants," *Le Voltaire* (March 28, 1893). Signac album.

Maus, Madeleine Octave. *Trente années de lutte pour l'art 1884–1914.* Brussels, 1926.

Maus, Octave. "Les vingtistes parisiens," *L'art moderne* 6 (June 27, 1886): 201–4.

———. "La recherche de la lumière dans la peinture," in *Cinquième exposition des XX,* Brussels, 1888: preface.

———. "Le salon des XX, à Bruxelles," *La cravache* 9 (February 16, 1889): n.p.; ibid. (March 2, 1889): n.p.

Medlyn, Sally. "The development of Georges Seurat's art with special reference to the development of contemporary anarchist philosophy." University of Manchester (M.A. diss.), 1976.

Meier-Graefe, Julius. *Entwicklungsgeschichte des modernen Kunst.* 3 vols. Stuttgart, 1904; rev. ed., *Modern Art* (London, 1908), 2 vols., vol. 1, pp. 309–25.

Michaud, Eric. "La fin de l'iconographie," in *Cahiers du Musée national d'art moderne* 5 (1980): 446–55; also in *Méthodologie iconographique,* ed. Gérard Siebert, Strasbourg, 1981, pp. 125–36.

Michel, Albert. "Le néo-impressionnisme," *La Flandre libérale* (February–March 1888); reprinted in "Le néo-impressionnisme," *L'art moderne* 8 (March 10, 1888): 83–85.

Michel, J. M. "Exposition des impressionnistes," *Petite gazette* (May 18, 1886). Signac album.

Minervino, Fiorella, and André Chastel. *Tout l'oeuvre peint de Seurat.* 1973 (Milan, 1972).

Mirbeau, Octave. "Exposition de peinture, 1, rue Laffitte," *La France* (May 20, 1886). Signac album.

———. "Exposition des néo-impressionnistes, rue Laffitte," *Écho de Paris* (January 23, 1895); reprinted in Valton et al. 1895.

Moréas, Jean. "Peinture," *Le symboliste* 1 (October 22–29, 1886): n.p.

Muller, Joseph-Émile. *Seurat dessins.* 1960.

———. *Seurat.* 1960.

Natanson, Thadée. "Un primitif d'aujourd'hui, Georges Seurat," *La revue blanche* 21, 165 (April 15, 1900): 609–14.

Neveux, Marguerite. "Construction et proportion: apports germaniques dans une théorie de la peinture française de 1850 à 1950." Université de Paris (Ph.D. diss.), 1990.

Nicolson, Benedict. "Seurat's 'La Baignade,'" *Burlington Magazine* 79, 464 (November 1941): 139–46.

———. "Le doux pays," *Burlington Magazine* 95 (December 1953): supplement, n.p.

———. "Reflections on Seurat" (review of DR), *Burlington Magazine* 104, 710 (May 1962): 213–15.

Nochlin, Linda. "Seurat's *Grande Jatte*: An Anti-Utopian Allegory," *Museum Studies* (Chicago) 14, 2 (1989): 133–53.

Olin, Pierre M. "Les XX," *Mercure de France* 4 (April 1892): 341–45.

Ozenfant, Amédée. "Seurat," *Cahiers d'art* 1 (September 1926): 171–73.

Ozenfant, Amédée, and Charles Édouard Jeanneret (Le Corbusier). *La peinture moderne.* 1925. Incorporates articles from *L'esprit nouveau,* 1920–24.

Pach, Walter. "Georges Seurat (1859–1891)," *The Arts* 3, 5 (March 1923): 161–74; separately published as *Georges Seurat.* New York, 1923.

Paulet, Alfred. "Les impressionnistes," *Paris* (June 5, 1886). DR, p. 292.

———. "La vie artistique," *Le national* (March 27, 1888). DR, p. 293.

Pearson, Eleanor. "Seurat's *Le cirque,*" *Marsyas* 19 (1977–78): 45–51.

Perruchot, Henri. *La vie de Seurat.* 1966 (2 editions, one without illustrations).

Pica, Vittorio. *Gli' impressionisti francesi.* Bergamo, 1908.

Pissarro, Camille. *Camille Pissarro: Letters to His Son, Lucien.* Ed. John Rewald. New York, 1943; rev. ed., 1950.

———. *Correspondance de Camille Pissarro.* Ed. Janine Bailly-Herzberg. 1: 1865–1885 (1980); 2: 1886–1890 (1986); 3: 1891–1894 (1988); 4: 1895–1898 (1989).

Prak, Niels Luning. "Seurat's surface pattern and subject matter," *Art Bulletin* 53 (September 1971): 367–78.

Rall, Georges. "Indépendants," *Lutèce* 5 (August 29–September 5, 1886): n.p.

Ratliff, Floyd, ed. *Paul Signac and Color in Neo-Impressionism.* Berkeley, 1990 (with English translation of *D'Eugène Delacroix au néo-impressionnisme*).

Rearick, Charles. *Pleasures of the Belle Époque: Entertainment and Festivity in Turn-of-the-Century France.* New Haven and London, 1985.

Retté, Adolph. "Septième exposition des artistes indépendants," *L'ermitage* 2 (May 1891): 293–301.

Rewald, John. "Camille Pissarro and some of his friends," *Gazette des beaux-arts* 23, 965–66 (June 1943): 363–76.

———. *Georges Seurat.* New York, 1943; 2nd ed. 1946.

———. *The History of Impressionism.* New York, 1946 et seq.

———. "Félix Fénéon," *Gazette des beaux-arts* 32, 965–66 (July–August 1947): 45–62; 34, 972 (February 1948): 107–26.

———. *Seurat.* 1948 (rev. and enlarged from 1943 ed.).

———. "Seurat, the meaning of the dots," *Art News* 48 (April 1949): 24–27, 61–63. Reprinted in *Studies in Post-Impressionism.* New York, 1986.

———. *Seurat* [Collection des maîtres]. 1949.

———. *Post-Impressionism: From van Gogh to Gauguin.* New York, 1956 et seq.

———. *Seurat.* New York, 1991.

———. See Dorra, Henri.

Rey, Robert. "À propos du Cirque de Seurat au musée du Louvre," *Beaux-arts* 4, 6 (March 15, 1926): 87–88.

———. *La renaissance du sentiment classique dans la peinture française à la fin du XIXè siècle.* 1931.

Rich, Daniel Catton. *Seurat and the Evolution of "La Grande Jatte."* Chicago, 1935; reprinted 1969.

Roger-Marx, Claude. *Seurat.* 1931.

Rosenblum, Robert. "Fernand Pelez, or the other side of the Post-Impressionist coin," in *Art the Ape of Nature: Studies in Honor of H. W. Janson,* ed. M. Barasch and L. F. Sandler. New York, 1981, pp. 707–18.

Rosenthal, Léon. "Ernest Laurent," *Art et décoration* 29 (1911): 65–76.

Roskill, Mark. *Van Gogh, Gauguin, and the Impressionist Circle.* London, 1970.

Roslak, Robyn Sue. "Scientific aesthetics and the aestheticized earth: The parallel vision of the Neo-Impressionist landscape and anarcho-communist social theory." University of California, Los Angeles (Ph.D. diss.), 1987.

Rubin, James H. "Seurat and theory: The near-identical drawings of the café-concert," *Gazette des beaux-arts* 76, 1221 (October 1970): 237–46.

Russell, John. *Seurat.* London and New York, 1965.

Sakagami, Keiho. "L'évolution de la touche de Seurat à travers ses marines," *Bulletin de la société franco-japonaise d'art et d'archéologie* 5 (1985): 18–33.

Salmon, André. "Georges Seurat," *Burlington Magazine* 37, 210 (September 1920): 114–22; essentially the same as the next citation.

———. *La révélation de Seurat.* Brussels, 1921; incorporated in *Propos d'atelier.* 1922.

———. "Seurat," *L'art vivant* 37 (1926): 525–27.

Saunier, Charles. "L'art nouveau," *La revue indépendante* 23 (April–June 1892): 30–48.

———. "Expositions des peintres néo-impressionnistes à Paris," *L'art moderne* 12 (December 25, 1892): 412–13.

Schapiro, Meyer. "Seurat and 'La Grande Jatte,'" *Columbia Review* 17 (1935): 9–16.

———. "New light on Seurat," *Art News* 57, 2 (April 1958): 22–24ff; reprinted in Schapiro 1978.

———. "Seurat: Reflections," *Art News Annual* 29 (1964): 18–41, 162.

———. *Modern Art, 19th and 20th Centuries: Selected Papers.* New York, 1978.

Scharf, Aaron. "Painting, photography and the image of movement," *Burlington Magazine* 104, 710 (May 1962): 186–95; see W. Homer and Scharf letters, ibid. (September 1962): 391–92.

Seligman, Germain. *The Drawings of Georges Seurat.* New York, 1947.

Semin, Didier. "Note sur Seurat et le cadre," *Avant-guerre* 2 (1981): 53–59.

Sertat, Raoul. "Artistes indépendants," *Revue encyclopédique* 1 (January 1, 1891): 109.

———. "Société des artistes indépendants," *Revue encyclopédique* 2 (August 1, 1892): 1100–04 [*sic*].

Signac, Paul. "Quatrième exposition des artistes indépendants" (Signac letter to Alexis), *Le cri du peuple* (March 29, 1888). Signac album.

———. (letter to ed.), *La cravache* 8 (September 22, 1888): n.p.

——— [S. P.]. "Catalogue de l'exposition des XX, Bruxelles," *Art et critique* (February 1, 1890): 76–78.

——— [Un camarade impressionniste]. "Impressionnistes et révolutionnaires," *La révolte* 4, 40 (June 13–19, 1891): 3–4.

———. "Neoimpressionismus," *Pan* 4, 1 (1898): 55–62.

———. *D'Eugène Delacroix au néo-impressionnisme.* 1899. Incorporates articles published in 1898. Reprinted 1911, 1921, 1929, 1964 (ed. Françoise Cachin), 1978. See also Ratliff.

———. "Tableaux de chevalet, ou peinture décorative?" (letter to ed.), *Bulletin de la vie artistique* 3, 4 (February 15, 1922): 77.

———. "Fondation de la société des artistes indépendants," *Partisans* 3 (January 1927): 3–7.

———. "Charles Henry," *Hommage à Charles Henry*, special issue, *Cahiers de l'étoile* 13 (January–February 1930): 72.

———. "L'art des néo-impressionnistes," introduction to *Le néo-impressionnisme*, exhibition catalogue, Galerie d'art Braun, February–March 1932.

———. "Le néo-impressionnisme, documents," *Gazette des beaux-arts* 11, 76 (January 1934): 49–59. Introduction to *Seurat et ses amis*, exhibition catalogue, Gazette des beaux-arts, December 1933–January 1934.

———. "Les besoins individuels et la peinture," *Encyclopédie française* 16, II (1935): 84–87ff.

———. "What Neo-Impressionism Means," *Art News* 52, 8 (December 1953): 28ff. (Translation of his preface to 1933–34 exhibition).

———, ed. George Besson, "Fragments du journal de Paul Signac," *Arts de France* 11–12 (1947): 97–102; 17–18 (1947): 75–82.

———, ed. John Rewald, "Extraits du journal inédit de Paul Signac," *Gazette des beaux-arts* 36, 989–91 (July–September 1949): 97–128; ibid. 39, 1001 (April 1952): 265–84; ibid. 42, 1014–15 (July–August 1953): 27–57.

Sluyts, Charles. "L'association pour l'art," *Entretiens politiques et littéraires* 7 (July 10, 1893): 7–15.

Smith, Paul. "Seurat and the Port of Honfleur," *Burlington Magazine* 126, 978 (September 1984): 562–69.

———. "Paul Adam, *Soi* et les 'peintres impressionnistes': La genèse d'un discours moderniste," *Revue de l'art* 82 (1988): 39–50.

———. "Seurat, the language of idealism, and the concrete conditions of avant-garde practice." University of London (Ph.D. diss.), 1990.

———. "Seurat, the natural scientist?," *Apollo* (December 1990): 381–85.

———. "Seurat et le paysage," *L'estampille* 1 (April–May 1991): 30–35.

Stuckey, Charles F. *Seurat.* Mount Vernon, N.Y., 1984.

Stumpel, Jeroen. "'The Grande-Jatte,' that patient tapestry," *Simiolus* 14, 3/4 (1984): 209–24.

Sutter, Jean. "Recherches sur la vie de Georges Seurat." Unpublished manuscript, 1964.

Sutter, Jean, ed. *The Neo-Impressionists.* Greenwich, Conn., 1970.

Sweeney, James Johnson. *Plastic Redirections in 20th Century Painting.* Chicago, 1934: 7–11.

Thomas, David. *Manet/Monet/Seurat.* New York, 1970.

Thomson, Richard. "'Les quat' pattes': the image of the dog in late nineteenth-century French art," *Art History* 5, 3 (September 1982): 323–37.

———. *Seurat.* Oxford, 1985.

———. "The *Grande Jatte*: notes on drawing and meaning," *Museum Studies* (Chicago) 14, 2 (1989): 181–97.

Valin, Pierre. "L'art par le symbole," *L'ermitage* 2 (July 1891): 385–90.

Valton, E., et al. *Georges Seurat.* Brussels, n.d. [1895]. Published anonymously in Brussels (probably Veuve Monnom press), this pamphlet opens with "Paroles prononcées sur la tombe de Georges Seurat au nom de la Société des Artistes Indépendants, par le Président E. Valton." It then reprints the following articles: Alexandre 1891; Kahn 1891; Wyzewa 1891; "Ouverture du salon des XX, L'instaurateur du néo-impressionnisme," from the exhibition catalogue of Les XX, Brussels, 1892; Demolder 1892; and Mirbeau 1895. It concludes with letters of thanks to Mme Seurat, the artist's mother, for gifts of works by Seurat; these letters were written by Valton, Jean Ajalbert, Armand Guillaumin, E. G. Cavallo-Peduzzi, Henri de Régnier, Camille Pissarro, Henri Gaudin, Paul Adam, and Ernesta Urban.

Van de Velde, Henry. "Notes d'art," *La wallonie* 5 (1890): 90–92.

———. "Notes sur l'art: Chahut," *La wallonie* 5 (1890): 122–25.

———. "Georges Seurat," *La wallonie* 6, 3/4 (April 1891): 167–71.

Venturi, Lionello. "The art of Seurat," *Gazette des beaux-arts* 26, 929–34 (July–December 1944): 421–30.

———. *Impressionists and Symbolists*. New York, 1950; published in French as *De Manet à Lautrec*. 1953.

———. "Piero della Francesca—Seurat—Gris," *Diogenes* 2 (spring 1953): 19–23.

———, ed. *Les archives de l'impressionnisme*. 2 vols. 1939.

Verhaeren, Émile. "Le salon des vingt à Bruxelles," *La vie moderne* 9 (February 26, 1887): 135–39.

———. "Chronique d'art: Les XX," *La revue indépendante* 3 (March 1887): 367–70.

——— [attributed to]. "Types d'artistes," *L'art moderne* 10 (March 2, 1890): 65–67.

———. "Chronique artistique: Les XX," *La société nouvelle* 7 (1891): 248–54.

———. "Georges Seurat," *La société nouvelle* 7, 1 (1891): 429–38. Reprinted, with alterations, in *Sensations*, 1927.

———. "Le salon des indépendants," *L'art moderne* 11 (April 5, 1891): 111–12, reprinted from *La nation*.

———. "Exposition des XX," *Art et critique* 4 (February 13, 1892): 75.

———. "La libre esthétique," *La revue blanche* 15 (April 1, 1898): 540–42.

———. "Georges Seurat," *L'art moderne* 20, 13 (April 1, 1900): 104.

———. "Notes sur l'exposition Georges Seurat," *Nouvelle revue française* 1 (February 1, 1909): 92.

Vidal, Jules. [review article], *Lutèce* 5 (May 29–June 5, 1886): n.p. Signac album.

Vielé-Griffin, Francis. "Le banquet d'hier," *Entretiens politiques et littéraires* 2 (1891): 57–62.

Vincent, Madeleine. *La danse dans la peinture française contemporaine (de Degas à Matisse)*. Lyons, 1944.

Walter, François. "Du paysage classique au Surréalisme—Seurat," *Revue de l'art* 63 (1933): 165–76.

Ward, Martha. "The rhetoric of independence and innovation," in *The New Painting, Impressionism 1874–1886*. Exhibition catalogue. San Francisco and Washington, 1986: 421–42.

Watanabe, Yasuko. *Seurat*. Tokyo, 1978.

Wauters, A. J. "Aux XX, Seurat, la Grande Jatte," *La gazette* (Brussels) (February 28, 1887). Signac album.

Webster, J. Carson. "The technique of Impressionism: a reappraisal," *College Art Journal* 4, 1 (November 1944): 3–22.

Wilenski, Reginald Howard. *Seurat*. London, 1949; New York, 1951.

Wotte, Herbert. *Georges Seurat*. Dresden, 1988.

Wyzewa, Teodor de. "Georges Seurat," *L'art dans les deux mondes* 22 (April 18, 1891): 263–64. Reprinted in Valton et al. 1895.

Zahn, Leopold. *Seurat*. Cologne, 1965.

Zervos, Christian. "Un dimanche à la Grande Jatte et la technique de Seurat," *Cahiers d'art* 3, 9 (1928): 361–75.

Zilcken, Phillip. "En Hollande, notes," *La revue indépendante* 8 (August 1888): 317–21.

Zimmermann, Michael. "Seurat, eine theoretische Monographie." Cologne (Ph.D. diss.), 1985.

———. "Seurat, Charles Blanc, and Naturalist Art Criticism," *Museum Studies* (Chicago) 14, 2 (1989): 199–209.

———. *Seurat et le débat artistique de son temps; Seurat, das Werk und die kunsttheoretische Debatte seiner Zeit*. Antwerp, 1991.

Concordance

H. no. catalogue number from César M. de Hauke, Seurat et son oevure, 2 vols., 1961
Cat. no. catalogue number in the present publication

H no.	Cat. no.	H no.	Cat. no.	H no.	Cat no.	H no.	Cat. no.	H no.	Cat. no.	H no.	Cat. no.
2	74	109	129	188	209	473	62	578	34	651	69
3	75	110	121	189	208	475	176	582	32	653	172
6	77	112	118	190	205	478	55	583	31	654	61
7	76	117	119	192	207	481	180	585	177	655	158
10	86	120	128	193	206	484	39	586	71	656	169
14	79	121	130	194	212	485	43	587	28	661	189
16	80	122	126	195	211	487	22	588	30	663	190
18	81	125	122	196	210	488	26	589	115	664	184
20	87	126	120	197	217	494	29	590	116	665	192
28	83	128	127	198	218	496	27	591	114	667	201
36	84	129	131	200	213	501	40	595	112	668	45
39	88	130	132	205	220	503	157	596	111	669	203
46	149	131	139	208	219	508	37	597	117	671	44
51	91	133	154	209	222	511	36	598	113	672	198
53	90	134	153	210	221	519	66	600	33	674	199
55	92	137	133	212	226	525	54	601	181	675	178
58	78	138	137	213	225	526	60	602	47	680	202
59	98	142	141	221	1	527	57	603	38	681	204
60	93	145	152	255	2	530	68	607	175	683	195
65	151	146	159	260	6	531	67	608	64	685	196
67	99	156	163	265	7	536	63	612	156	687	197
71	85	158	162	278	10	539	52	619	123	688	193
75	82	159	161	285	3	540	56	620	124	689	194
77	95	160	160	300	9	543	70	624	148	694	216
78	97	164	170	309	4	545	53	628	143	695	215
79	103	167	166	315	8	546	11	629	144	696	224
81	108	168	165	366	16	550	58	630	146	702	223
84	107	169	164	380	15	553	73	631	145	707	230
86	105	172	168	403	18	554	72	632	142	709	228
88	106	173	167	438	17	556	20	633	147	710	227
89	104	177	173	442	19	558	24	635	125	712	229
91	109	178	171	446	23	560	182	636	135		
93	110	179	183	447	155	562	25	639	136	Not in H	5
96	102	180	188	450	21	564	65	640	134	Not in H	96
98	101	181	187	455	50	565	46	641	140	Not in H	179
100	89	182	186	459	14	567	174	644	138	Not in H	214
101	94	183	185	463	13	568	42	645	49		
104	100	184	191	471	51	571	48	646	59		
106	150	187	200	472	12	573	41	649	35		

Acknowledgments for the American Edition

With an eye to the centenary of Seurat's death in 1991, the Metropolitan Museum began to lay plans for a great retrospective. When we learned that Françoise Cachin, newly named director of the Musée d'Orsay and longtime scholar of Neo-Impressionism, had herself begun to organize an ambitious retrospective in Paris, and that she had already secured the services of Robert L. Herbert, we suggested a joint venture. This idea was graciously received by our colleagues at the Réunion des Musées Nationaux and the Musée d'Orsay. Robert L. Herbert, professor of art history at Mount Holyoke College and distinguished Seurat scholar, was the guiding intellect behind the selection of works and the shaping of the catalogue. The organizers of the exhibition at the Metropolitan and the Musée d'Orsay owe an enormous debt to his intimate knowledge of the artist and his oeuvre.

At the Metropolitan the exhibition was organized by Gary Tinterow, Engelhard Associate Curator, and Susan Alyson Stein, Special Exhibitions Associate, Department of European Paintings. They worked closely with Professor Herbert and with Françoise Cachin and Anne Distel, their French colleagues, to shape the exhibition and catalogue. In particular, Mr. Tinterow secured many of the loans with his adroit diplomacy, and to him we owe the handsome and intelligent installation of the exhibition in New York. Susan Stein coordinated the exhibition with her capable hand and meticulous care. To her we owe the fascinating results of her research into the early ownership of Seurat's works, much of which is published here for the first time.

The American edition of the catalogue has been sensitively and skillfully edited by Kathleen Howard, Senior Editor, who made this complicated endeavor a success. She worked closely with designer Bruce Campbell and Gwen Roginsky, Production Manager, who was ably assisted by Peter Antony. Robert Parker, working in Paris, diligently compiled information and uncovered new findings pertinent to the histories of exhibition and ownership. Rebecca A. Rabinow devoted her enthusiasm and intelligence to research problems and to the preparation of the catalogue and exhibition in general. The keen research skills of Anne M. P. Norton were an asset to this project, as was the assistance provided by Gretchen Wold and Alastair Wright.

For their generous cooperation in this project, the organizers would like to thank their Metropolitan colleagues: Jacob Bean, Helen Mules, and Calvin Brown, Drawings Department; Laurence Kanter, Robert Lehman Collection; Everett Fahy, European Paintings Department; Hubert von Sonnenberg, Gisela Helmkampf, George Bisacca, Charlotte Hale, and Maryan Ainsworth, Paintings Conservation; Marjorie Shelley, Paper Conservation; John O'Neill, Editorial; John Buchanan and Herbert Moskowitz, Registrar's Office; Linda Sylling, Operations; Deanna Cross and Diana Kaplan, Photograph and Slide Library. Valuable assistance in the preparation of the exhibition was provided by other members of the Metropolitan's staff, in particular, Mahrukh Tarapor, Assistant Director, and Emily Rafferty, Vice President for Development. The handsome design of the exhibition and its graphics is owed to Dan Kershaw and Barbara Weiss, both of the Design Department.

The exhibition was a bilateral, collaborative effort, and equal thanks are due to those colleagues in Paris who assisted Françoise Cachin, Director, and Anne Distel, Curator, at the Musée d'Orsay. Among those individuals at the Réunion des Musées Nationaux, the Musée d'Orsay, and Musée du Louvre who contributed significantly to the realization of this show, we should like to acknowledge Irène Bizot, Uté Collinet, Jean-Pierre Cuzin, Lola Faillant-Dumas, Claire Filhos-Petit, Jacques Foucart, Frédérique Kartouby, Caroline Larroche, Monique Nonne, Rodolphe Rapetti, Arlette Sérullaz, Françoise Viatte, and Pierrette Turlais.

Many individuals generously gave their time and expertise to this project, beyond professional courtesy. In particular, we should like to thank heartily Melissa De Medeiros of M. Knoedler and Co. and Ay-Whang Hsia of Wildenstein and Co. Other research questions were graciously answered by Vivian Barnett, Karen Breuer, Jacqueline Cartwright, Claudia Daivda Defendi, Lisa Dennison, Marianne Feilchenfeldt, Michael Findlay, Starr Figura, Beatrice Kernan, Pascale Kraus, Guy Loudmer, Fieke Pabst, John Rewald, Elaine Rosenberg, Esperanza Sobrino, Patricia Tang, and Judy Throm. We should also like to record our gratitude for the support and assistance offered by other friends and colleagues, especially Arthur Altschul, Madame Aubrun, Janine Bailly-Herzberg, Annick and Pierre Berès, Marc Blondeau, Sir Adam Butler, Marie-Thérèse Caille, A.-L. Combe, Henri Claude Cousseau, Dr. Guy Dulon, Anne-Gabrielle Durand, Alain Fischer, Denise Gazier, Martine Gosse, Philippe Grunchec, Roseline Hurel, Françoise Leboulenger, Ronald de Leeuw, Carmen Gimenez, Peter Nathan, Bruno Pfäffli, and Michel Sutter.

Needless to say, this exhibition would not have been possible without the generosity of its lenders. *Seurat, 1859–1891* is a reality because of the willingness of owners, private and public—on an international scale—to part, for a time, with their works by Seurat. In acknowledging their sacrifice, we mark their great contribution to our documentation of Seurat's oeuvre. For making special allowances for loans from their collections we are particularly grateful to Thomas Krens and his staff at the Solomon R. Guggenheim Museum, Dennis Farr and the trustees of the Courtauld Institute, London, and James Woods and Douglas Druick of the Art Institute of Chicago. Heinz Berggruen deserves special recognition; he embraced this project from the beginning, and his support, typical of his largesse to this institution, guaranteed the success of the exhibition.

We are most fortunate that the ambition of this undertaking was matched by the generous financial support it has received in the United States from its sponsor, Fondation Elf, a non-profit organization established by Elf Aquitaine. We hope that with *Seurat*, the first exhibition at the Metropolitan to be funded by Fondation Elf, we have established a new tradition further uniting French and American cultural interests. The exhibition was supported in part by the National Endowment for the Arts. Transportation assistance has been provided by Air France. An indemnity has been granted by the Federal Council on the Arts and the Humanities.

Philippe de Montebello
Director
The Metropolitan Museum of Art

I am grateful to my collaborators in Paris and New York for their many professional courtesies, with a special thanks to Marina Ferretti Bocquillon and Susan Stein. For information and courteous reception, I wish to acknowledge Jean-Claude Bellier; Huguette Berès; Heinz Berggruen; Marc Blondeau; Philippe Brame; André Bromberg; Cheryl A. Brutvan; Ruth C. Cross; Suzanne, Georges, Annick, and Christian Dufour; Judith Eurich; Marianne Feilchenfeldt; Erich Franz; Christian Geelhaar; Bernd Growe; Ay-Whang Hsia; Jennifer E. Jones; E. W. Kornfeld; Duncan MacGuigan; Peter Nathan; Ursula Perucchi; Thierry Picard; Louis-Antoine Prat; Katharina Schmidt; Robert Schmit; George Shackelford; Alain Tarica; Serge Le Bailly de Tilleghem; and Rolf and Margit Weinberg.

For many kindnesses, professional and personal, I am thankful to Arthur Altschul, Yves Astier, Helen Chillman, Patricia H. Cody, Anne and Bertrand Dorny, Douglas Druick, Jennifer Gough-Cooper and Jacques Caumont, Gloria Groom, Kathleen Howard, Yuzo Iida, Yoichiro Idée, Hans Luthy, Akiko Mabuchi, and Shinichi Segi.

I wish to dedicate my contribution to this catalogue to three people no longer alive: Pierre Angrand, Ginette Signac, and Jean Sutter, who managed in their different realms to rediscover and conserve the history of Seurat and the Neo-Impressionists.

Robert L. Herbert

Index

(Compiled by Susan Bradford)

Aberconway, Lady (Christobel Mary Melville McLaren), as former owner, 154, 380

Acquavella Galleries, New York, as former owner, 119, 153, 227, 304

Adam, Paul, 7, 54, 66, 177, 179, 244, 278, 279, 293, 306, 384, 402, 403; as former owner, 380, 405

Adams Bros., London, as former owner, 32

Ader Picard Tajan sales, 37, 71, 119, 136, 228, 263

Aghion, Mme, as former owner, 239

Ajalbert, Jean, 7, 66, 75, 150, 198, 344, 402, 403, 405, 406; as former owner, 169, 196, 198, 380; poetry by, 75, 344, 360; work by: *Paysages de femmes*, 345

Alcazar d'Été, Paris, 299

Alexandre, Arsène, 126, 273, 340, 364, 377, 378, 386, 403, 408; as former owner, 126, 256, 258, 380, 406

Alexis, Paul, 148, 402, 403; as champion: of Seurat, 7, 66, 147, 148, 150, 322, 339; of Signac, 339; as disciple of Zola, 147; as former owner, 128, 320, 322, 380, 403; friendships: with Seurat, 147, 360; with Zola, 7; literary evenings attended by, 66; naturalism and, 7, 150, 322; plays by: *Frères Zemganno* (with Métérier; after E. de Goncourt), 360–61; *Monsieur Betsy* (with Métérier), 361; portrait of, 322, 339, 340; *339*; as writer (Trublot), 66, 151, 339, 360–61, 406

Alinari, Florence, 15

Allerton, Robert, 229

Aman-Jean, *see* Jean, Amand-Edmond

Ambassadeurs, Paris, 299

American Art Association, New York, 45, 48, 270, 333

American Art Galleries, New York, 93, 214, 403

Ancien-Monde, L', Paris, 345

Anderson, A. E., as former owner, 41

Anderson, Julia Quinn, as former owner, 261, 295

Anderson, Mary, as former owner, 295; *see also* Conroy, Mary Anderson

Anderson Galleries, New York, 48, 86–88, 93, 270

Angrand, Charles, 3, 7, 44, 147, 170, 280, 306, 344, 362, 401, 404, 406, 408, 410, 411; work by: *Accident, Un*, 306; *306*

Anquetin, Louis, 407, 408, 409, 410, 411

Antoine, Jules, 361

Apollinaire, Guillaume, 279, 280, 361, 424

Appert, Léon, 6, 11, 378, 380, 399; as former owner, 37, 57, 71, 107, 108, 115, 138, 139, 204, 208, 228, 229, 262, 265, 285, 286, 312, 322, 350, 353, 363, 380, 403; works by: *Note sur les verres des vitraux anciens*, 13; *Verrerie depuis vingt ans, La* (with Henriaux), 13

Appert, Léopold, as former owner, 57, 107, 204, 350

Appert, Mme Léopold, as former owner, 20, 23, 37, 57, 185, 186, 265, 368

Appert, Marie-Berthe Seurat, 6, 11, 399; as former owner, 265, 363

Appert, Maurice, as former owner, 138

Appert family, Paris, as former owner, 46, 180, 318

Arden Gallery, New York, 88

Argüelles, José, 392

Ariosto, writing by: *Orlando furioso*, 20

Aristotle, 387, 388

Aristoxenus, 393

Arnay, 179

Art, L', 387, 400

Art Amateur, The, 151

Artemis S. A., as former owner, 25, 165, 295, 328

Art Institute of Chicago, 161, 178, 423, 424

Art moderne, L', 397, 406

Art Nouveau style, 318, 320

Astier, Mme, as former owner, 20

Augier, Paul, as former owner, 143

Aumale, duc d', 276

Auriol, 179

Aviat, Mme Jules, 394

Baffier, Jean, 411

Baillet, Charles, 397

Baker, Walter C., as former owner, 73, 291

Ball, A. and R., New York, as former owner, 65, 282

Balzac, Honoré de, 39

Barbazanges, Galerie, Paris, 68; as former owner, 154, 196, 255, 327

Barbier, André, as former owner, 101

Barbizon painting, 104, 105, 112, 113, 114, 128, 132, 136, 298

Barnes Foundation, Merion, Pennsylvania, 279, 280, 295, 423

Barr, Alfred H., Jr., 322; and wife, as former owners, 15

Barrès, Maurice, 411

Bat, The (London), 179

Baudelaire, Charles, 34, 39, 249; writing by: *Fleurs du mal, Les*, 229

Bauer, Maurits, 411

Bazille, Frédéric, work by: *Scène d'été*, 151

Beatty, Alfred Chester, as former owner, 124, 204, 239, 247, 327

Beatty, Mrs. Chester, as former owner, 124, 204, 239, 247, 327

Beaubourg, Maurice, 8, 279, 280, 363, 372, 381–83, 411

Bellanger, Camille-Félix, 22; work by: *Study from antique sculpture* (Satyr and Goat), 22; *22*

Bellier, Alphonse, as former owner, 88; *see also* Bellier, Galerie

Bellier, Galerie, Paris, as former owner, 97

Bellier, Jean-Claude, as former owner, 143; *see also* Bellier, Galerie

Bellini, Giovanni, 12, 15

Béranger, Pierre-Jean de, 344

Bérès, Huguette, Paris, as former owner, 109, 122

Bernard, Émile, 3, 54, 150, 175, 297, 298, 407, 411; photograph of, 150; *149*; portrait of van Gogh by, *410*

Bernard, 364

Bernheim, Georges, Paris, as former owner, 27, 77, 119, 157, 222, 325; *see also* Bernheim-Jeune, Paris

Bernheim de Villers, Gaston, as former owner, 196; *see also* Bernheim-Jeune, Josse and Gaston; *see also* Bernheim-Jeune, Paris

Bernheim-Jeune, Josse and Gaston, as former owners, 239, 312; *see also* Bernheim-Jeune, Paris

Bernheim-Jeune, Paris, 29; exhibitions of Seurat's work at, 28, 29, 31, 107, 136, 216, 240, 279, 295; Fénéon's affiliation with, 216, 292, 295, 423; as former owner, 25, 40, 86, 113, 119, 131, 135, 154, 167, 181, 183, 190, 193, 202, 224, 228, 240, 242, 246, 247, 264, 286, 295, 314, 328, 331

Berthellemy, André, as former owner, 206

Besnard, Albert, 409

Bignou, Étienne, Paris, as former owner, 62, 107, 108, 119, 124, 152, 153, 156, 165, 180, 196, 223, 239, 246, 256, 327, 350, 353

Bignou Gallery, New York, 240; as former owner, 108, 127, 153, 222, 240, 350

Billard, Mme, as former owner, 101

Bing, Alexander, as former owner, 302

Biondi, Anna Maria, as former owner, 109

Birnbaum, Martin, New York, as former owner, 27, 77

Birren, Faber, 391

Blanc, Charles, 58, 151, 384, 393; antinaturalism of, 340, 385; artistic philosophy of, 6, 7, 36, 148, 150, 151, 164, 340, 384–85, 385; artists admired by, 384, 385; classicism of, 175, 385; compared to David Sutter, 387; criticism of, 387; Egyptian art extolled by, 305, 340, 385; essay on Delacroix by, 384; ideas of, as parallel to the Symbolists, 385; influenced by: Chevreul, 384; Humbert de Superville, 340, 345, 361, 384, 386, 393; influence of, 384, 385; on Seurat, 5, 6, 7, 104, 173, 174, 181, 246, 293, 305, 340, 345, 361, 378, 382, 383, 384–86, 387, 390, 392, 394;

painting and color theories of, 6, 103, 106, 148, 173, 384–86, 389, 395; Seurat's readings on, 384–86; as Seurat's source: for Chevreul's theories, 103, 388; for Humbert de Superville's theories, 6, 340, 345, 386; as spokesman of the Beaux-Arts tradition, 148; writings by: 103, 340, 384, 385, 395; *Grammaire des arts du dessin* (*Grammar of Painting and Engraving*), 6, 13, 103, 148, 151, 340, 345, 377, 378, 384–86, 394, 397; illustration in, *341*, *384*, *385*; *Histoire des peintres de toutes les écoles*, 384

Bliss, Lillie P., as former owner, 27, 51, 77, 188, 298, 322

Bliss, Mr. and Mrs. Robert Woods, as former owners, 107

Bloch, Ernst, 179

Block, Mr. and Mrs. Leigh B., as former owners, 190, 304, 336

Blot, Eugène, as former owner, 116, 119

Blot, Jacques, as former owner, 63

Boch, Anna, 409, 410, 411

Boggs, Frank, work by: *Harbor at Honfleur, The*, 235; *234*

Boime, Albert, 13, 179, 387, 397

Bonheur, Rosa, 104

Bonington, Richard, 233

Bonnard, Pierre, 292, 337, 411; as former owner, 291, 292

Bossuat, Marguerite, as former owner, 85

Bossuat, Victor, as former owner, 85, 132, 143, 144

Bouchot-Saupique, J., 291

Boudin, Eugène, 104, 233, 249

Bouglé, Louis, as former owner, 206

Bouillon, Jean-Paul, 385

Boulanger, Georges, 7

Bourgeat, 403

Bourgeois, Stephan, as former owner, 208

Bourgeois Galleries, New York, as former owner, 45, 48

Bourget, Paul, 403

Boussod et Valadon, Paris, 298, 395

Bracquemond, Félix, 400, 403, 409

Bracquemond, Marie, 400

Brame, Hector, as former owner, 75; *see also* Brame et Lorenceau

Brame et Lorenceau, Paris, as former owner, 58, 186, 230, 368

Brancusi, Constantin, 51

Brandt, Mortimer, Gallery, New York, as former owner, 141

Bauer, Maurits, 411

Breton, André, 366, 423

Brewster, David, 390

Brû, Casimir, as former owner, 412

Brû, Lucie, photograph of, *412*; *see also* Cousturier, Lucie

Bruce, Ailsa Mellon, as former owner, 185

Bruck, Zdenko, as former owner, 100

Brugère, General, 411

Bruneau, as former owner, 141

Buchholz Gallery, New York, as former owner, 302

Burden, Mr. and Mrs. William A. M., as former owners, 354

Burlington Magazine, 151

Burty, Philippe, 394, 396

Butler, the Honorable and Mrs. R. A., as former owners, 353

Cachin, Françoise, 293

Caetani de Bassiano, Marguerite, as former owner, 99, 328

Cahen-Alexandre, Colette, 31

Cahn, Isabelle, 364

Caillebotte, Gustave, 170, 400, 401

Callawaert, Michel, as former owner, 162

Canning, Susan M., 298, 325

Canu, Mme, as former owner, 269

Caradec, François, 298

Caran d'Ache (Emmanuel Poiré), 228

Carcan, Le, 383, 384

Cargill, D. W. T., as former owner, 127, 153, 222, 350

Carlet, 406

Carnot, Sadi, 410, 411

Cartier, work by: *Coin de mon tableau du Salon, Un* (*A Part of My Salon Picture*), 273; *275*

Cassatt, Mary, 170, 400, 403

Caze, Robert, 66, 150, 232, 383, 402, 403; as former owner, 66, 161, 380

Caze, Mme Robert, as former owner, 66, 161, 232

Cazin, Marie, 406

Cézanne, 403

Céard, 403

Cézanne, Paul, 73, 124, 128, 233, 277, 423; photograph of, *402*; works by: *Grandes baigneuses, Les*, 279; *Trois baigneuses, Les* (*Three Bathers*), 277; *277*

Cham, 379

Champfleury (Jules Husson), 175

Chantron, work by: *Toilette du mannequin, La* (*Dressing the Dummy*), 273; *275*

Chapone, François, 366

Charlet, Frantz, 409

Charlier, Guillaume, 244

Charpentier, Galerie, Paris, 192, 291; as former owner, 109, 230

Chastel, André, 386, 424

Chateaubriand, François-René, 233

Chénot, 379

Chéret, Jules, 338, 342, 344, 345, 361, 362, 409, 411; posters by: *Amant des danseuses, L'*, 338, 362; *337*; *Folies-Bergère, les Girard*, 342; *342*; "Horloge: les frères Léopold, L'," 362; "Spectacle Promenade de l'Horloge," 362

Chevalot, Mme Gustave, as former owner, 136

Chevreul, Michel-Eugène, 5, 174, 258, 387, 388–90; Blanc, as source for Seurat's knowledge of, 103, 388; influence: on Blanc, 384; on Neo-Impressionists, 389; on Seurat, 6, 29, 103, 132, 322, 361, 376, 381, 383, 384, 389, 390, 392, 404; on Signac, 389, 390; on David Sutter, 387; theories of, 29, 103, 104, 376, 384, 389–90, 391; treatise by, 376; writings by: *On Abstraction Considered Relative to the Fine Arts and Literature*, 390; *Principles of Harmony and Contrast of Colors, The*, 388–89

Choate, Mabel, as former owner, 135

Christie's, London, 101, 165, 295, 328

Christie's, New York, 59

Christophe, Jules, 280, 295, 383, 384, 407; as former owner, 295; friendship with Seurat, 340, 343; reviews and writings by, 179, 283, 296, 306, 339, 340, 343, 345, 360, 363, 377, 382, 401, 403, 410, 411

Chronique des arts et de la curiosité, 402

Churchill, Ivor Spencer, as former owner, 131, 156

Cirque Corvi, Paris, 305, 309, 312, 315, 392, 393; illustration of (Garnier), 312; *312*; photograph of, *306*

Cirque Fernando (later Médrano), Paris, 360

Claessens, Armand, as former owner, 162, 247

Claessens, M. and Mme Victor, as former owners, 162, 247

Clark, Alan and Colin, as former owners, 81

Clark, Kenneth, as former owner, 81, 113, 240

Clark, Stephen C., as former owner, 49, 159, 312

Clark, T. J., 179

Claude Lorrain, 233, 379, 388

Clayson, S. Hollis, 179

Clozet, Paris, 383

Collection de 120 dessins, croquis et peintures de M. Ingres, classés et mis en ordre par son ami Édouard Gatteaux (album of reproductions), 16

Conroy, Mary Anderson, as former owner, 261; *see also* Anderson, Mary

Conroy, Thomas, as former owner, 261

Contet, 406

Coquiot, Gustave, 179, 280, 304, 345, 362, 377, 378; as former owner, 315

Cordova, O'Hanart de, as former owner, 48

Corneau, André, as former owner, 157

Corot, Camille, 81, 387; compared to Seurat, 215, 256, 258, 261; influence on Seurat, 104, 113, 215, 383, 394, 399; landscapes by, 104, 113, 119, 142; seascapes by, 233; style of, 142, 215; works by: *Pont de Mantes, Le* (*Bridge at Mantes*), 256, 258; *256*; *Rue Saint-Vincent, La*, 142; writing by, 394

Corot, Émile, 394

Corot, Fernand, 394

Correggio, 396

Corso, del, as former owner, 99

Corvi, Fernand, 305; *see also* Cirque Corvi

Couessin, Charles de, 364

Courbet, Gustave, 33, 81, 104, 175, 233, 244, 334, 401; work by: *Atelier, L'*, 276, 277

Courcelle, as former owner, 109

Cours de dessin, fac-simile des grands maîtres (album of lithographs), 15

Courtauld, Samuel, as former owner, 154, 256, 333, 346, 353

Courtauld Institute, London, 224

Courthion, Pierre, 280

Cousturier, Edmond, as former owner, 65, 119

Cousturier, François, as former owner, 65

Cousturier, Lucie, 54, 303, 361, 423; photograph of, *412*

Couture, Thomas, 33, 34, 103, 383, 389, 396–97, 400; writing by: *Méthode et entretiens d'atelier*, 396, 397

Crane, Walter, 411

Cravache, La, 409

Cri du peuple, Le, 66, 151, 339, 403

Cross, Henri-Edmond, 7, 344, 423; exhibitions of the work of, 3, 170, 401, 404, 406, 408, 409, 410, 411; as former owner, 84, 196; friendship with Seurat, 196; meeting with Seurat, 147; Neo-Impressionism and, 3; sale of the contents of the studio of, 196

Cross, Mme Henri-Edmond (née Irma Clar), as former owner, 84, 196

Cubism (Cubists), 279, 361

Cunningham, Ruth Paine, as former owner, 194, 196

Cutsem, Henri van, as former owner, 240, 244, 380, 381, 405, 406

Dale, Chester, as former owner, 258

Danforth, Mrs. Murray S., as former owner, 300

Dantan, work by: *Moulage sur nature, Un* (*A Cast from Life*), 273

Darragon, Eric, 255, 361, 362, 364

Darwin, Charles, 387; writing by: *Expression of the Emotions in Man and Animals, The*, 387

Darzens, Rodolphe, 66, 402, 403

Daubigny, Charles, 113, 119, 179; compared to Seurat, 224, 244, 256; influence on Monet, 233; on Seurat, 104, 233; landscapes by, 73, 104, 132, 224; seascapes by, 233, 244

Daudet, Alphonse, 403

Daumier, Honoré, 35; caricatures by, 40, 60; compared to Seurat, 60, 66, 128; influence on Seurat, 34, 35, 39, 60; lithographs by, 39; *39*; modernity and, 39; palette of, 128; political imagery and social criticism in the work of, 310; redefinition of fine arts initiated by, 342; sad clowns, as subject of, 66; works by: *Ce qui explique la vogue des cache-nez* (*In Explanation of the Fashion for Mufflers*), 39; *Nourrice, La* (*The Nursemaid*), 60; *59*; *Parade foraine, La* (*Parade: Traveling Circus*), 310

David, Émile, 390

David, Jacques-Louis, 8, 149

Davies, Arthur B., as former owner, 93, 214

Davies, as former owner, 88

Davis, Mrs. Dwight F., as former owner, 153

Davray, Jean, as former owner, 315

Debucourt, 380

Decamps, 385

Degas, Edgar, 397, 403, 405; café-concert, as subject of, 298–99, 342; circuses, as subject of, 310, 360, 362; color, in the work of, 106; compared to Seurat, 35, 50, 103, 298–99, 342; exhibitions of the work of, 170, 299, 400, 403; falling out with Neo-Impressionists, 405, 406; friendship with Duranty, 176; horses' motion portrayed by, 364; modernity and, 39; monotypes by, 35; naturalism and, 310; photograph by, *407*; prices for the work of, 409; reaction of, to Seurat's work, 174; reviews of the work of, 170; Seurat nicknamed by, 6; technique and style of, 299; works by: *Café-concert*, 342; *342*; *Mlle Bécat au café des Ambassadeurs*, 296; *Miss Lala au cirque Fernando*, 362; *Suite de nus de femmes*, 170

Delacroix, Eugène, 5, 387, 396; admired by Blanc, 384, 385; broken (divided) color, use and theories of, 103, 104, 105, 108, 113, 116, 119, 122, 132, 161, 173, 202, 220, 246, 258, 336, 384, 390, 394–95; compared to Seurat, 5; essay on (Blanc), 384; exhibition of the work of, 402; influence: on Camille Pissarro, 149; on Renoir, 149; on Seurat, 28, 103, 104, 105, 108, 113, 116, 119, 122, 132, 139, 161, 173, 181, 202, 220, 246, 258, 336, 362, 381, 383, 384, 390, 392, 394–96, 400, 401; on Signac, 394; photograph of (Nadar), 400; Seurat's copies after, 275; Seurat's notes on the paintings of, 5, 394–96; technique of, 103, 104; works by: *Christ on the Sea of Galilee*, 396; *Cortège de l'empereur du Maroc* (*Sultan of Morocco and His Entourage, The*), 395–96, 400; *Fanatics of Tangiers, The*, 395, 396; *Heliodorus Chased from the Temple*, 396; *Horses Coming out of the Water*, 395; *Jewish Merchant in Algiers*, 396; *Lion attaqué* (*Lion in the Mountains*), 400; *Noce juive* (*Jewish Wedding*), 395, 396; *Struggle of Jacob with the Angel, The*, 396; writings on, 106, 384, 386, 394

Delaunay, Robert, 4, 8, 279, 377

Demolder, Eugène, 179, 234–35

Denis, Maurice, 411

Desboutin, Marcellin, 409

Descaves, Lucien, as former owner, 230

Desgranges, Jeanne Selmersheim, 284

Dessins de Raphaël de la Galerie de Vienne, IIIe série (album of lithographs), 15

Devambez, Galerie, Paris, 29; as former owner, 167

Develly, C., 379

Deventer, Salomon van, as former owner, 327

Diable à Paris, Le, illustration for (Gavarni), 310

Diamand, Pamela, as former owner, 224

Diaz de la Peña, Narcisse, 104, 113, 136

Distel, Anne, 378

Divan Japonais, Paris, 302

Dorny, Thérèse, as former owner, 213

Dorra, Henri, 132, 136, 161, 247, 249, 316, 331, 363, 364, 392

Doucet, Jacques, as former owner, 364, 423; studio of, 366; *363*

Doucet, Jeanne, as former owner, 364, 366
Dreyfus, Émile, as former owner, 119
Drouot, Hôtel, Paris, sales at, 30, 37, 85, 86, 109, 119, 122, 131, 132, 136, 143, 144, 198, 203, 220, 228, 229, 247, 258, 263, 281, 297, 331, 400, 408; *see also* Fénéon, Félix, sales of the collection of (Drouot)
Druet, Eugène, 29; as former owner, 40, 158, 199
Druet, Mme, galerie, Paris, 29
Druick, Douglas, 161
Dubois, 411
Dubois-Pillet, Albert, 66, 170, 293, 298, 406–7; archaicism in the work of, 334; correspondence to Signac, 409; compared to Seurat, 334; death of, 383, 411; exhibitions of the work of, 3, 401, 404, 406, 408, 409, 410, 411; as founder of Société des Artistes Indépendants, 382; influenced by Seurat, 376, 405; meeting with Seurat, 147; Neo-Impressionism and, 3, 407; popular arts, interest in, 334; work by: *Portrait of Mlle M. D.*, 334
Dubourg, Jacques, as former owner, 64, 109, 141
Dubourg, Louis-Alexandre, 244; work by: *Bains de mer à Honfleur, Les* (*Seaside, Honfleur*), 149, 173, 179; *148*
Duchenne de Boulogne, Guillaume-Benjamin, 386–87; writing by: *Mécanisme de la physionomie humaine . . . appliquable à la pratique des arts plastiques*, 387
Dujardin, Édouard, 179, 406
Dumoulin, 403
Dupuis, Alexandre, 12, 13
Durand-Ruel, Paris, 45, 139, 277, 308, 383, 384, 402
Durand-Ruel, Paul, 151, 179, 380, 402, 403, 405
Duranty, Louis-Émile-Edmond, 176; novel by: *Peintre Louis Martin, Le*, 176; pamphlet by: *Nouvelle peinture, La*, 106; portrait of (Degas), 106
Durkheim, Émile, 177
Duval, Mathias, 13, 387; writing by: *Précis d'anatomie à l'usage des artistes*, 387

École des Beaux-Arts, Paris, 71, 97, 386; Aman-Jean, as student at, 13, 377, 378, 399, 400; curriculum at, 12, 20–21, 162; Duchenne's photographs bequeathed to, 387; exhibitions at, 272, 401, 402, 406; faculty at, 12, 22, 387, 400; Seurat, as student at, 6, 7, 12, 13, 18, 20, 22, 162, 273, 286, 377, 399, 400
École Municipale de Sculpture et de Dessin, Paris, 399
École Turgot, Paris, 378, 399
Eden Concert, Paris, 298
Edwards, Alfred, 395, 400
Edwards, as former owner, 119
Edynski, B. A., as former owner, 295
Eiffel Tower, Paris, 314, 328
Enne, Francis, 403

Fabre, Maurice, as former owner, 158
Faivre, Ernestine, *see* Seurat, Ernestine Faivre
Famenne, George, as former owner, 240
Fantin-Latour, Henri, 35

Faramond, Maurice de, 280
Fauves (Fauvism), 423
Faverol, J., 66; work by: *Traveling Circus*, 66; *67*
Feilchenfeldt, Marianne, as former owner, 20, 100, 101
Fels, Florent, 361
Fénéon, Fanny, 333, 336; as former owner, 252
Fénéon, Félix, 104, 273, 338, 397, 407, 409, 424; advice received from Camille Pissarro, 179; affiliation of, with Bernheim-Jeune, 107, 136, 216, 292, 295, 423; archives of, 280, 383, 384, 396; as champion of Seurat's work, 66, 178, 279, 423; contents of Cross's studio purchased by, 196; correspondence of, 109, 136; correspondence: from Émile Seurat, 379, 411; from Mme Émile Seurat, 379, 380; from Seurat, 170, 172, 210, 383–84, 386, 387, 390, 391, 392, 394, 396, 410; correspondence to van de Valde, 331; death of, 29, 31; as editor, 293, 384, 405; elegant clothes worn by, 339; exhibition organized by, 107, 136, 295; as former owner, 14, 15, 18, 29, 39, 41, 51, 54, 65, 81, 84, 88, 89, 93, 97, 100, 109, 112, 115, 119, 122, 127, 130, 132, 135, 139, 142, 152, 153, 165, 167, 181, 188, 196, 198, 199, 208, 214, 215, 216, 219, 220, 222, 223, 237, 249, 252, 266, 270, 272, 283, 284, 285, 286, 289, 291, 292, 300, 314, 318, 331, 333, 337, 346, 364, 366, 367, 372, 380, 383, 395, 406, 412, 423; friendships: with Charles Henry, 340, 392; with Seurat, 104, 279, 360, 405; information about Seurat gathered from the heirs of, 115, 116; leftist political views of, 7; literary evenings attended by, 66, 402; marriage of, 333; meeting with Seurat, 403; mistaken information on Seurat released by, 127, 128, 389; mistress of, 28, 29, 31; pamphlet written by: *Impressionistes en 1886, Les*, 170, 404, 405; photograph of, *405*; portraits of: (Luce), 283; *283*; (L. Pissarro), *407*; posthumous inventory of Seurat's studio by, 14, 15, 18, 29, 30, 37, 127–28, 152, 179, 203, 215, 280, 283, 367, 380, 411; reviews and writings by, 66, 170, 173, 174, 179, 265, 278, 279, 281, 283, 295, 296, 306, 327, 333, 338, 339, 363, 377, 382, 383, 394, 395, 410; sales of the collection of (Drouot), 29, 30, 31, 54, 81, 84, 88, 89, 109, 115, 119, 122, 130, 167, 198, 219, 249, 272, 283, 285, 286, 289, 367, 423; Seurat's work sold by, on behalf of the family, 239; Symbolism and, 340; term Neo-Impressionism coined by, 3, 170, 178, 404
Fesler, Caroline (Mrs. James W.), 350
Fèvre, Henry, 177, 179, 403
Fiedler, Inge, 178, 206
Figaro, Le, 383, 390, 400, 404
Filiger, Charles, 409, 410, 411
Finch, A. Willy, 406, 409, 410, 411
Fine Arts Associates, New York, as former owner, 222
Flax, Neil M., 385
Flechtheim, Alfred, Berlin and Düsseldorf, as former owner, 70, 113, 126, 240, 298, 354
Flornoy, John, 404
Forain, Jean-Louis, 400, 403, 404
Fouquet, Jean, 423

Fouquier, Henry, 403
Franz, Erich, 36, 51, 230
Fremiet, Emmanuel, 409
French Art Galleries, New York, as former owner, 222
French Gallery, London, as former owner, 333
Freud, Sigmund, 53
Frey, as former owner, 122
Fry, Roger, 279, 311; as former owner, 224
Futurists, 423

Gachet, Paul, 411
Gage, John, 8
Gaines, John R., as former owner, 316
Gallatin, A. E., as former owner, 70
Gampenrieder, Karl, chromolithograph by: *Au Cirque*, 362; *361*
Ganay, Comtesse de, as former owner, 122
Garibaldi, Marseilles, as former owner, 320
Garlot, Eugène, as former owner, 124
Garnier, Jules, illustration by: *Cirque Corvi*, 312; *312*
Gary, as former owner, 161
Gasnault, François, 345
Gatteaux, Édouard, 16, 380
Gauguin, Paul, 3, 405; compared to Seurat, 376, 423; correspondence of, 54; exhibitions of the work of, 170, 400, 401, 403, 409, 411; falling-out with Seurat, 397, 403–4; influenced: by article (Oriental text) on hues in Oriental rugs, 397–98; by Blanc, 384, 385; by Puvis de Chavannes, 148; by Seurat, 409; by Signac, 409; models used by, 336; primitive arts, interest in, 175, 263; rural subjects of, 220; works by: *Nature morte ripipoint*, 409; *Self-portrait: "Les Misérables,"* 404; writing by, 398; writing on, 398
Gausson, Léo, 3, 406, 408, 409, 410, 411; as former owner, 73, 139, 227
Gavarni, 39, 60, 310; illustration for *Diable à Paris, Le*, by, *310*
Gazette des beaux-arts, 336, 384
Gebhard-Gourgaud, Eva, as former owner, 39, 157, 264, 299
Geffroy, Gustave, 296, 306, 361, 403; as former owner, 101, 266, 279
Gerard Frères, as former owner, 127
Gerbier, Jeanne, as former owner, 136
Géricault, Théodore, 364
Germain, Alphonse, 360, 363
Gervaert, Gustave, as former owner, 298
Ghiberti, Lorenzo, 12, 13, 15
Giacometti, Alberto, 281
Gille, Philippe, 383, 390, 400
Gillet, Charles, as former owner, 58, 81
Gingerbread Fair, Paris, 305, 312
Ginisty, Paul, 403
Giotto, 174
Girardon, François, 277
Gleizes, Albert, 392
Gobelins tapestry manufactory, 389, 390

Goetz, Richard, as former owner, 247, 331
Goffman, Erving, 56
Gogh, Theo van, 54, 279, 293, 298, 312, 407–8, 409; as former owner, 297, 298, 408; photograph of, *408*
Gogh, Vincent van, 3, 298, 423; at Arles, 279, 293, 298, 407; Art Nouveau style anticipated in the work of, 320; at Asnières, 150; brushwork of, 320; compared to Seurat, 42, 320; correspondence from Theo van Gogh, 312; correspondence to Theo van Gogh, 279, 298, 408; death of, 382, 410–11; exhibitions of the work of, 298, 382, 383, 407, 408, 409, 410, 411; Goncourt brothers, admiration for, 150; influenced: by Blanc, 384; by Dutch art, 293; by Japanese art, 293; by Millet, 42, 112, 132; by Seurat, 279, 293, 298; influence of, 412; meeting with Seurat, 382, 407; Neo-Impressionism and, 407; pamphlet biography on, *410*; peasants and rural life, as subject matter of, 112, 132, 220; photograph of, 150; *149*; popular arts, interest in, 175; portraits of: (Bernard), *410*; (L. Pissarro), *407*; primitive arts, interest in, 175; Puvis de Chavannes, admiration for, 151; at Seurat's studio, 279, 298, 407–8; subject matter of, 42, 150
Gogh, V. W. van, as former owner, 297
Gogh-Bonger, Johanna van, as former owner, 297
Gold, Alfred, as former owner, 165, 190
Goldwater, Robert J., 345, 363, 364, 370, 377
Goncourt, Edmond de, 33, 378, 402, 403; novel by: *Frères Zemgganno, Les*, 81, 360–61
Goncourt brothers, 33, 34, 39, 106, 150, 261; novels by: *Manette Salomon*, 179; *Renée Mauperin*, 150
Goodyear, A. Conger, as former owner, 88, 185, 216
Goubaud, Gustave, as former owner, 84
Gould, Florence J., as former owner, 180
Goupil's, Paris, 395, 396, 401
Gourgaud, Napoléon, as former owner, 39, 157, 264, 299, 423
Gow, Leonard, as former owner, 127
Goya, Francisco de, 5, 34, 35, 45, 60; works by: *Bellos consejos* (*Good Advice*), 60; *60*; *Pobrecitas I*, etching from *Caprichos*, *45*
Gramont, 403
Grand Concert Parisien, Le, Paris, 302
Grand-Fort-Philippe, France, 349; photographs of, *350, 353*
Grand Palais, Paris, 350
Gravelines, 349; photograph of, *349*
Greef, Jean de, as former owner, 128, 152, 153, 159, 193, 242
Greenaway, Kate, 175, 179
Grévin, A., work by: *J'parie qu'ça ne lui coûte pas plus d'vingt-cinq sous l'mètre!* ("I bet that doesn't cost him more than twenty-five sous a meter!"), 177; *177*
Gris, Juan, 5
Groot, Adelaide Milton de, as former owner, 134, 200
Gros, Roger, as former owner, 249
Groupe des Artistes Indépendants, 147
Growe, Bernd, 36, 40, 106

Grunwald, as former owner, 247, 249
Guérinet, Armand, 16
Guggenheim, Solomon R., as former owner, 97, 132, 139, 215, 220
Guggenheim, Solomon R., Museum, New York, 97
Guilbert, Yvette, 300, 302
Guillain, Alix, as former owner, 86, 99
Guillaume, Eugène, 12, 13
Guillaumin, Armand, 6, 170, 383, 384, 400, 401, 402, 403, 404, 405, 407, 410, 411
Gutbier, L. W., as former owner, 256
Guyot, Yves, 387
Guys, Constantin, 269, 404

Hahnloser-Bühler, Hedy, as former owner, 101
Hale, Charlotte, 211
Halperin, Joan, 392
Halvorsen, Walter, as former owner, 261
Hammer, Armand, as former owner, 293
Hanley, T. Edward and Tullah, as former owners, 48
Harriman, the Honorable and Mrs. W. Averell, as former owners, 126, 318
Harriman, Marie, Gallery, New York, as former owner, 126
Hartmann, Frédéric, 395, 400
Haskell, Francis, 314
Hauke, César M. de, 49, 132, 377, 383; archives of, 116, 127, 128, 136, 336, 380, 381, 384, 389, 396; cataloguing of Seurat's work by, 8, 13, 28, 29, 30, 51, 85, 141, 151, 152, 179, 190, 239, 240, 266, 280, 284, 286, 292, 297, 303, 316, 350, 363, 364, 378, 380; as former owner, 58, 75, 203, 206, 230, 291, 302, 372, 383
Hauke, de, and Co., New York, 49; as former owner, 49, 51, 63, 68, 159, 165, 188, 190, 194, 196, 203, 247, 249, 298, 300, 313, 315
Hault, G. de la, as former owner, 325
Haumonté, Anaïs Faivre, 11, 47, 114, 269; portrait of, 11, 64, 232, 269, 407; cat. no. 179
Haumonté, Paul, 11
Haumonté family, as former owner, 269
Hauptmann, Gerhardt, as former owner, 25, 119
Hauptmann, Ivo, as former owner, 25, 119
Haussmann, Baron, 12, 101
Hayet, Louis, 3, 328, 403, 409
Hazlitt, Gooden and Fox, London, as former owner, 228, 230
H. D., as former owner, 85
Helmholtz, Hermann von, 381, 390, 392
Hennequin, E., 280, 403
Henner, J. J., 276; work by: Idylle (or La fontaine), 276, 280
Hennique, 403
Henriaux, J., work by: Verrerie depuis vingt ans, La (with Appert), 13
Henry, Charles, 195, 196, 338, 340, 343, 391–93, 403; as former owner, 195, 196; friendships of, 392;

influenced by Humbert de Superville, 361, 386; influence on Seurat, 6, 279, 309, 333, 338, 340, 343, 344, 345, 361, 376, 381, 383, 392–93, 402; Symbolism and, 7, 391, 392; theories of, 309, 340, 343, 381, 393; writings by, 362, 392; Cercle chromatique, 407; Introduction à une esthétique scientifique, 7, 309, 386, 392, 393, 402
Herbert, Robert, 8, 13, 280, 286, 295, 298, 303, 305, 310, 312, 315, 338, 361, 362, 385, 392, 397
Hermel, Maurice, 403
Herpin, Léon-Pierre, 249
Herz-Fischler, Roger, 8, 392
Hessel, Jos, Paris, as former owner, 56, 158, 185, 229–29, 302
Heydt, August Freiherr von der, as former owner, 298
Heydt, Eduard von der, as former owner, 70
Heymans, A. J., 376; work by: Mine, environs de Charleroi, La, 377
Hirsch, Albert, as former owner, 381
Hirsch, Robert von, as former owner, 229, 316, 337
Hochschiller, Max, as former owner, 295
Holbein, Hans, the Younger, 12, 15, 50, 339, 340; work by: Saint Thomas More, 339
Homer, William I., 309, 345, 385, 386, 387, 389, 391, 392, 394
Hommes d'aujourd'hui, Les, series, 339, 382, 383, 384, 410, 411; covers for, 410
Hodebert, Paris, 68; as former owner, 68, 203, 222
Hoschedé, Ernest, 406
Houdon, J.-A., 379
Houll, J. P., 379
House, John, 179
Hughes Le Roux, illustration for (Garnier), 312
Hugo, Victor, 349
Humbert de Superville, David-Pierre-Giottin, 386, 387, 393; diagrams by, used in Blanc's Grammaire, 386, 393; 385; influence: on Charles Blanc, 340, 345, 361, 384, 386, 393; on Charles Henry, 361, 386; on Seurat, 333, 338, 340, 344, 361, 363, 384, 386, 392; as known through Blanc's Grammaire, 6, 340, 345, 386; theories of, 333, 338, 386, 393; writing by: Essai sur les signes inconditionnels dans l'art, 386
Huyghe, René, 284
Huysmans, Joris-Karl, 34, 45, 150, 179, 249, 261, 362, 402; as former owner, 68, 230, 232, 380–81; writings by: Art moderne, L', 106; Certains, 362; Croquis parisiens (Parisian Sketches), 34; etching for Raffaëlli, 34; 35
Hyde, Charlotte, as former owner, 141

Ibels, H. G., 411; work by: Orchestre, L', 303; 303
Impressionism (Impressionists): break with traditional painting and color theories of, 104, 105; brushwork of, 105; color, in the work of, 105, 202, 203; controversy over the inclusion of Seurat and Signac as, 402, 403; exhibition poster, 403; exhibitions, 299, 380, 402, 403; (1879), 104, 400; (1880), 400;

(1881), 400; (1882), 139, 401; (1886), 66, 138, 139, 170, 172, 179, 232, 235, 255, 380, 382, 384, 392, 403; frames used for the work of, 376, 377, 389; Camille Pissarro and, 139, 402, 403; reactions of avant-garde artists to the weaknesses of, 277; reviews of, 104, 404–5; Seurat and, 3, 5, 6, 7, 20, 33, 104, 105, 106, 114, 124, 132, 134, 139, 144, 147–48, 149–50, 154, 170, 172, 174, 176, 178, 202, 220, 222, 232, 233, 239, 258, 261, 340, 389, 391, 394, 400, 402, 406; Signac and, 233, 394, 401, 402; style and technique of, 105, 113, 124, 132, 148; subject matter of, 112, 124, 148, 150, 178, 220, 233
Indépendants, see Société des Artistes Indépendants
Independent Gallery, London, as former owner, 159, 196
Ingres, Jean-Auguste-Dominique, 5, 35, 39, 380, 387; as art teacher, 286, 377; compared to Seurat, 103, 286; influenced by Holbein, 12; influence of, 16; on Lehmann, 12; on Lequien, 12; on Seurat, 16, 17, 275, 286, 287, 378; Seurat's copies after 12, 15–16, 17, 20, 24, 103, 106, 275, 286, 380; cat. nos. 3, 4, 8; technique and working methods of, 17; works by: Angélique au rocher, L', 16, 20, 106, 275; Apothéose d'Homère, 16; Baigneuse de Valpinçon, La (Valpinçon Bather), 275, 286; 287; Martyrdom of Saint Symphorian, 380; Oedipus and the Sphinx, 379; Roger Rescuing Angelica, 20; Self-portrait at the Age of 55, 380; Source, La, 275, 283, 286; Stratonice, La, 275; Tu Marcelluseris, 380
Intransigeant, L', 361
Isabey, Jean-Baptiste, 233, 244
Ittleson, Mr. and Mrs. Henry, Jr., as former owners, 227

Jacquart, G., as former owner, 313
Jacques, H., 272
Jaeggli-Hahnloser, Lisa, as former owner, 101
Jamot, Paul, as former owner, 40
Jarry, Alfred, 179
J. D., Mme, as former owner, 28, 29, 30, 64, 75, 86, 97, 99
Jean, Amand-Edmond (Aman-Jean), 13, 33, 399; as artist, 377, 401; as art student, 13, 377, 378, 399, 400; correspondence to Gustave Coquiot, 377–78; exhibitions of the work of, 147, 401; as former owner, 13, 30, 49; friendship with Seurat, 13, 30, 33, 49, 104, 109, 113, 136, 147, 377, 400, 401; Impressionism and, 104; meeting with Seurat, 13, 399; portrait of, 49–50, 51, 70, 147, 270, 339, 377, 378, 401, 402; cat. no. 30; recollections of Seurat by, 13, 50, 109, 377–78; studio of, shared with Seurat, 13, 50, 377, 378, 400; travels with Seurat: to Barbizon, 401; to Pontaubert, 136, 378, 401
Johnson, Chester H., as former owner, 62
Johnson, Lee, 395
Jongkind, Johann Barthold, 104, 233, 235, 244, 249, 255
Journal des Arts, 405

Joze, Victor, 337, 338; as former owner, 337; novel by: Homme à femmes, L', 337, 409; Seurat's cover for, 337–38; cat. no. 215

Kaganovitch, Max and Rosy, as former owners, 130
Kahn, Gustave, 174, 179, 261, 409, 411, 423; correspondence from Seurat, 397; as former owner, 162, 247, 279, 376, 381, 412; friendships: with Charles Henry, 392; with Seurat, 279, 340, 344; reviews and writings by, 6, 179, 261, 283, 296, 297–98, 305, 306, 311, 340, 344, 376, 377, 384, 386, 392, 403, 404
Kahn, Mme Gustave, 411; as former owner, 312, 411
Kandinsky, Wassily, 423
Kann, Alphonse, as former owner, 228, 295
Kélékian, Dikran Khan, as former owner, 45, 333
Kende Galleries, New York, 109
Kessler, Harry Graf, as former owner, 126, 279, 331, 412
Kettaneh, Mr. and Mrs. Francis, as former owners, 258
Keynes, John Maynard, as former owner, 202
Kinney, Leila, 179
Kline, Franz, 89
Klinger, Max, 409
Knoblock, Madeleine: annuity left to, by Seurat's mother, 412; child born to, 335, 409; correspondence of, 336; correspondence: to Mme Félix Fénéon (Fanny), 336; to Signac, 286, 362, 394, 409; death of, 412; as former owner, 56, 86, 99, 101, 116, 123, 127, 128, 152, 153, 156, 159, 183, 193, 223, 242, 247, 249, 255, 286, 313, 333, 354; as mistress of Seurat, 99, 275, 286, 333, 335, 409; as model for Seurat, 275, 286, 333, 335–36; pregnancy of, 331, 335; Seurat's works given to, after his death, 411, 412
Knoedler, M., and Co., New York, London, and Paris, as former owner, 62, 93, 107, 112, 153, 159, 180, 194, 196, 204, 222, 223, 239, 282, 312, 315, 322, 325, 331, 350
Kocherthaler, Julio, as former owner, 113, 240
Koehler, Bernhard, as former owner, 167
Koning, A. H., 407
Kraushaar, C. W., Art Galleries, New York, as former owner, 56, 93, 204, 214
Kröller-Müller, Mme, 136, 423
Krugier, Galerie, Geneva, 315
Kunsthaus Zurich, 130

Lady Tuya (Egyptian sculpture), 174; 174
Laforgue, Jules, 340, 392, 407, 412; poetry by: "Soir de carnaval," 310
Langaard, Johan H., 154, 295
Larsson, Carl, 411
Laurent, Camille, as former owner, 240
Laurent, Ernest, 33, 104, 147, 151, 400, 401; works by: Alphonse Osbert et Georges Seurat, 401; Georges Seurat, 401; Scène au bord d'un ruisseau (Beethoven, op. 68), 401

Lavieille, Adrien, engraving after Millet by, *113*
Lebasque, Henri, as former owner, 124
Lebensztejn, Jean-Claude, 314
Lebourg, Albert, 400, 406
Lèbre, G., 406
Lecomte, Georges, 7, 338, 340, 360, 364, 383, 384, 410; as former owner, 116, 165
Le Corbusier, 392
Lee, Alan, 8
Lefebvre, Jules-Joseph, 377, 378
Léger, Fernand, 4, 8
Lehman, Robert, as former owner, 84, 112, 181, 252, 264, 282
Lehmann, Henri, 12, 13, 39, 379, 400; dinners for the former pupils of, 407; exhibition of the work of, 401; as painter, 18, 149; as pupil of Ingres, 286, 377; as Seurat's art teacher, 12, 13, 18, 103, 149, 275, 286, 377, 378, 399, 400, 401; Seurat's drawing after, 13, 18; cat. no. 5; works by: *Homme combat les animaux féroces, L'*, 18; *18*; *Lutte de l'homme contre les éléments, La*, 18
Leicester Galleries, London, as former owner, 32
Leiris, Mme, 30–31
Lemercier, 379
Lemmen, Georges, 409, 410, 411; as former owner, 89, 266
Lépine, Stanislas, 249
Lequien, Justin, 12, 13, 14, 399; as Seurat's art teacher, 12, 13, 14, 20, 22, 103, 275, 378, 388, 399
Lequien, Justin Marie, 399
Leroy, Alphonse, 15, 379
Le Roy Frères, Galerie J. et A., Brussels, 331
Le Savoureux, Henri, 29; as former owner, 28, 31, 75, 97
Le Sueur, Eustache, 388
Levasseur, Paul, as former owner, 46
Lévêque, Charles, 393
Levert, Léopold, 400
Levy, David M. and Adele (Dr. and Mrs.), as former owners, 161, 247
Lévy, Gaston, 132
Lévy, Georges, as former owner, 127, 131–32, 143, 144, 237
Lévy, Pierre, 249; and wife, Denise, as former owners, 119, 138
Lewisohn, Adolph, as former owner, 208
Lewisohn, Mr. and Mrs. Samuel A., as former owners, 89, 208
Lhote, André, 361, 423
Lilienfeld Galleries, New York, as former owner, 302
Liston, Eugene O. M., as former owner, 333
Loewenstein, as former owner, 247, 249, 331
Lombard, Alfred, 320, 350
Lonquety, M. and Mme Maurice, as former owners, 181
Loudmer, Étude, Paris, 31, 249
Louvre, Paris, *see* Musée du Louvre, Paris
Luce, Maximilien: correspondence to Signac, 261; exhibitions of the work of, 3, 406, 408, 409, 410, 411; as former owner, 32, 38, 39, 119, 190, 202, 203, 212, 282, 283, 286, 397; leftist political views of, 7, 44, 344; as Neo-Impressionist, 3, 39, 44, 344; pamphlet biography on (Christophe), 382; portrait of Seurat by, 339, 410; *410*; posthumous inventory of Seurat's studio by, 14, 73, 136, 143, 144, 203, 215, 266, 282, 411; work by: *Félix Fénéon*, 283; *283*
Lutèce, 383, 384
Lutz, John H., 270

Macbeth, William, Inc., New York, as former owner, 188
McIlhenny, Henry P., as former owner, 295, 313
McInnes, William, as former owner, 152
McNay, Marion Koogler, as former owner, 62
Magritte, René, 350
Mainardi, Patricia, 385
Maitland, Mr. and Mrs. Alexander, as former owners, 156
Mallarmé, Stéphane, 311, 349, 411; photograph of (Degas), *407*
Manet, Édouard, 178, 273, 403; café-concert, as subject of, 299, 342; compared to Seurat, 177, 198, 239; exhibitions of the work of, 176, 177, 178, 198, 239, 401; influence: on Monet, 178; on Seurat, 149, 178, 239, 276–77; model used by, 336; modernity and, 39; political views of, 7; seascapes by, 233, 239; works by: *Argenteuil*, 151; *Déjeuner sur l'herbe, Le*, 176, 178, 276–77, 299, 336; *176*; *Enfant à l'épée*, 400; *Jeanne, ou le Printemps*, 177, 198; *177*; *Olympia*, 336, 409; *Pier at Boulogne*, 239; *Sur la plage de Boulogne*, 177
Mani, 397
Manzi, Joyant, Galerie, Paris, 328
Maré, Rolf de, as former owner, 354
Marey, Étienne-Jules, 364, 387, 390
Marlais, 8
Marlborough Fine Art Ltd., London, as former owner, 88, 240
Marquet, Albert, as former owner, 116
Marseille, Léon, as former owner, 86, 202, 237
Martel, Charles, 388
Martinet, Louis, 308, 405
Marville, Charles, 16, 380
Marx, Karl, 177
Marx, Roger, 49, 401; as former owner, 228, 328
Masson, Clémentine, as former owner, 136
Matisse, Henri, 5, 280, 376, 423
Matthiesen Gallery, London, as former owner, 29
Maufra, 411
Maus, Octave, 255, 280, 403, 405, 406, 409; as former owner, 89, 411
Maus, Mme Octave, as former owner, 298
Maxwell, Charles, 390
May, Saidie A., as former owner, 246
Meier-Graefe, Jules, 376, 377; as former owner, 376
Meisener, Galerie Kurt, Zurich, as former owner, 198
Mellon, Mr. and Mrs. Paul, as former owners, 59, 247
Memling, Hans, 177

Mercier, Alain, 392
Méténier, Oscar, 360–61; plays by: *Frères Zemganno* (with Alexis; after E. de Goncourt), 360–61; *Monsieur Betsy* (with Alexis), 361
Metropolitan Museum of Art, 423; technical examinations at, New York, 211, 306
Metthey, Jean, as former owner, 119
Metthey, P., as former owner, 249
Meunier, Constantin, 409
Meurent, Victorine, 336
Miais, 403
Michallet paper, 35, 269
Michelangelo, 12, 15
Michelet, Jules, 298; book by: *Mer, La*, 234
Michelson, Leo, as former owner, 212
Michoux, as former owner, 89
Mikhaël, Ephraïm, 402
Milès, L. Roger, 364
Millet, Aimé, 13
Millet, Jean François, 81; compared to Seurat, 5, 78, 128, 272; drawing technique of, 78; exhibition of the work of, 272, 406; influence: on van Gogh, 42, 112, 132; on Camille Pissarro, 112, 132; on Seurat, 34, 39, 42, 54, 104, 106, 112–13, 132, 139, 151, 272; landscapes by, 73, 104; palette of, 128; rural and peasant themes of, 33, 78, 112, 119, 128; seascapes by, 233, 240; works by: *Crépuscule (Twilight)*, 78; *78*; *Faucher, Le (The Reaper)*, 272 (engraving after, by Lavieille, *113*); *Gleaners*, 132; *Harvesters, The*, 379; *Travaux des champs*, 112
Milton, John, 81
Mirbeau, Octave, 390, 403; and wife, as former owners, 45
Mistinguett, 300
Modern Paintings, Inc., New York, 49
Modigliani, Amedeo, 249
Molière, 16
Moline, Léonce, 99; as former owner, 84, 99, 101, 123–24, 128, 381, 412
Molyneux, Edward, as former owner, 183, 185
Mondrian, Piet, 423
Monet, Claude, 81, 170; abstinence from final Impressionist exhibition, 139; brushwork of, 320, 349; compared to Seurat, 5, 102, 177, 178, 204, 222–23, 224, 233, 235, 239, 247, 261, 318, 320, 349; exhibitions of the work of, 139, 244, 400, 401, 403, 406, 409; friendship with Mirbeau, 45; industrial subjects by, 258; influenced: by Boudin, 233; by Daubigny, 233; by Jongkind, 233; by Manet, 178; influence on Seurat, 104, 139, 149, 204, 222, 233, 240, 249, 383, 391; landscapes by, 261; portrait of his dead wife by, 269; prices for the work of, 409; seascapes by, 233, 235, 239, 240, 244, 247, 249, 258, 318, 320, 349; style and technique of, 204, 244, 261; subject matter of, 149, 204, 222–23, 224; work of, criticized by Camille Pissarro, 5; works by: *Cabane du douanier, Pourville (Customhouse, Pourville)*, 318; *Déjeuner sur l'herbe*, 178; *Fishermen on the Seine at Poissy*, 139; *Parc Monceau*, 179; *Terrace at Sainte-Adresse*, 177

Monnom, Mme, as former owner, 354
Montagné, Maurice, as former owner, 192
Montrosier, Eugène, 379
Moore, Henry, 266; and wife, Irena, as former owners, 54, 265
Morat, Charlotte, as former owner, 101
Morat, Franz Armin, as former owner, 101
Morat Institut für Kunst und Kunstgeschichte, Freiburg im Breisgau, as former owner, 101
Moréas, Jean, 402, 404, 411; writing by: *Pèlerin passionné, Le*, 411
Moreau-Nélaton, Étienne, 394, 409
Moreux, M. and Mme Jean-Charles, as former owners, 293
Morin, Étienne Victor, as former owner, 269
Morisot, Berthe, 170, 233, 400, 401, 402, 403, 406
Morrison, S. A., London, as former owner, 165
Moss, Stanley, 89
Motte, Galerie, Geneva, as former owner, 86
Mouton, Mme, as former owner, 112
Murer, Eugène, 407
Musée d'Orsay, Paris, 64
Musée du Louvre, Paris: Goetz's art collection offered to, 247, 331, 423; Seurat's copies of works in, 12, 16, 275; works in the collection of, 16, 21, 51, 273, 275, 276, 280, 286, 287, 306, 395
Musée du Luxembourg, Paris, 20, 24, 106
Museum of Modern Art, New York, as former owner, 51, 77, 188
Museum of Non-Objective Art, New York, 97; *see also* Guggenheim, Solomon R., Museum
Musseleck, Auguste, 302
Mützenbecher, Curt von, as former owner, 247
Muybridge, Eadweard, 363, 364, 387

Nadar, photographs by, *400*, *401*
Natanson, Adam, as former owner, 122
Natanson, Alexandre, 293; as former owner, 113, 116, 122, 143, 144, 258, 293
Natanson, Bolette, as former owner, 293
Natanson, Thadée, 8; as former owner, 81, 93, 229
Natanson, Mme Thadée, as former owner, 93
National Academy of Design, New York, 403
National Gallery, London, 124, 240
Neo-Impressionism (Neo-Impressionists), 39, 385, 423; artists of, 3, 44, 71, 139, 147, 170, 196, 293, 328; Belgian periodical supporting, 397; in Belgium (Brussels), 3, 136, 244; Charles Pillet as champion of, 405; Chevreul's theories, interest in, 389; coining of the term, 3, 170, 178, 404; Degas's falling out with, 406; exhibitions of the work of, 170, 244, 412; leftist political views of, 44, 344; literary ties of the painters of, 66; nudes, as subject matter of, 286; Rood's theories, interest in, 389, 391; scientific and methodical aspect of, 3, 5, 174, 309; Seurat and, 3,

174, 286, 293, 328, 385, 390, 391, 394, 407; Seurat, as initiator of, 3, 7, 170, 383, 404, 405, 408; Signac and, 44, 293, 344, 390, 407; Société des Artistes Indépendants, as center of activities for, 3, 407; writings on, 338
Netcher, Mrs. Charles, 63
Neuville, Alphonse de, 13
Neveux, Marguerite, 8, 364, 392
Nichols, Edward L., 391
Nicolson, Benedict, 109, 151, 162
Noailles, Charles de, as former owner, 42
Nochlin, Linda, 179, 216
Nouvel Essor, Le, Paris, as former owner, 313
Nouvelle Athènes, La, Paris, 403, 405

Oberländer, Adolf, 411
O'Conor, 409, 410
Olin, Pierre, 411
Opéra-Comique, Paris, 300
Ørvig, Olaf, as former owner, 154
Osbert, Alphonse, 33, 147, 151, 400, 401, 407, 409, 410, 411
Ozenfant, Amédée, 8, 392

Pacquement, Charles, as former owner, 325
Paine, Robert Treat, II, as former owner, 194, 196
Palais des Beaux-Arts, Brussels, 64, 331
Palais Galliéra, Paris, 86
Palmié, Charles, 328
Pan, 412
Pangallos, Mme, as former owner, 130
Parade (ballet), 361
Parke-Bernet, New York, 237, 258, 293
Paulet, Alfred, 403
Paulhan, M. and Mme Frédéric, as former owners, 85
Paulus and Clovis, 302
Pausanias, 388
Pelez, Fernand, 312; Grimaces et misères (Circus Performers), 311; 310
Pellequer, Raoul, as former owner, 219
Pellerin, Auguste, 423
Perls, Kate, as former owner, 32
Perugino, Pietro, 12, 15; work by (formerly attributed to Raphael): Apollo and Marsyas, 276, 280; 276
Petit, Galerie Georges, Paris, 70, 403, 406; as former owner, 81, 198, 256
Petit, Georges, 256; as former owner, 256; see also Petit, Galerie Georges, Paris
Petit bottin des lettres et des arts, 383, 384
Petit-Fort-Philippe, France, 349
Pétridès, Paul, as former owner, 115
Phidias, 46, 57, 148, 174, 178, 385, 388, 392
Phillips, Lazarus, as former owner, 75
Picard, Edmond, 130, 406, 411; as former owner, 331
Picard, Robert, 406, 410, 411; as former owner, 130

Picasso, Pablo, 279, 361; as former owner, 30–31, 219; work by: Demoiselles d'Avignon, Les, 279, 366
Piero della Francesca, 5, 174
Pierre, Galerie, Paris, as former owner, 119
Pillet, Charles, 298, 405, 408
Pillet, Marguerite, 297, 298, 408
Pimienta, Gustave, as former owner, 195
Piron, E. A., 394, 395
Pissarro, Camille, 128, 174, 308, 380, 406; advice given: to Fénéon, 179; to Seurat, 406; to Signac, 406, 408; archaicism in the work of, 334; compared to Seurat, 35, 124, 139, 224; correspondence of, 179, 308; correspondence: from Guillaumin, 402; from Schuffenecker, 403; from Signac, 406; correspondence: to Lucien Pissarro, 179, 364, 402, 403, 404, 409; to Signac, 277, 280, 377, 408; development of, 383; Durand-Ruel's interest in, 402, 405; Eiffel Tower condemned by, 328; at Éragny, 408; exhibitions of the work of, 3, 139, 170, 175, 179, 400, 401, 403, 404, 406, 409, 411; as former owner, 24, 25, 43, 47, 69, 78, 84, 201, 219, 380; frames used for the work of, 376, 377; friendships: with Mirbeau, 45; with Seurat, 405, 408; Impressionism and, 139, 402, 403; influenced: by article on hues in Oriental rugs, 397; by Cézanne, 277; by Delacroix, 149; by Millet, 112, 132; by Rood, 391; by Seurat, 405, 406; influence on Seurat, 3, 104, 139, 149, 239, 383; landscapes by, 73, 132; leftist political views of, 7, 44, 175, 344; literary evenings attended by, 383, 384; meeting with Seurat, 139, 377, 383, 384, 402; modernity of the work of, 139; Monet's work criticized by, 5; monotypes by, 35; Neo-Impressionism and, 3, 5, 7, 44, 293, 344; painting by, commissioned by Seurat's mother, 47, 405; peasants and rural life, as subject matter of, 112, 119, 124, 132, 139, 220; philosophy of, 408; photograph of, 402; popular arts, interest in, 175, 334; reaction of, to Seurat's work, 308, 363, 364, 376, 377; Seurat's works bequeathed to the French nation by, 25, 43, 47, 69, 78, 84, 201; social consciousness of, 69; style of, 78, 124, 139, 149, 175, 179; subject matter of, 224; support for Seurat, 403, 404, 405, 407; unstable pigments recommended to Seurat by, 172, 179; views on "romantic" and "scientific" impressionism, 174, 179; works by: Cueillette des pommes, La (Gathering Apples), 175; Paysanne assise, 139; Père Melon en repos, 139; Soleil couchant, 405; Vue de ma fenêtre par temps gris, 179
Pissarro, Esther, as former owner, 51
Pissarro, Lucien, 44, 405, 406; archaicism in the work of, 334; correspondence from Camille Pissarro, 179, 364, 402, 403, 404, 409; Camille Pissarro's gift of Seurat's works to the French nation realized by, 25, 43, 47, 69, 78, 84, 201; exhibitions of the work of, 3, 51, 170, 403, 404, 406, 408, 409, 410, 411; as former owner, 24, 43, 47, 51, 181, 182; frames used for the work of, 376; friendship with Seurat, 51;

leftist political views of, 7, 175, 344; Neo-Impressionism and, 3, 7, 344; photograph of, 402; popular arts, interest in, 175, 334; reaction of, to Seurat's work, 376; work by: Van Gogh in Conversation with Félix Fénéon, 407
Platteel, Camille, 28, 29, 31; as former owner, 28, 29, 30, 31, 64, 75, 86, 97, 99, 167, 249
Ponge, Francis, as former owner, 86
Pontormo, 12, 15
Popova, Liubov, 5
Port-en-Bessin, France, 318; engraving of, 320; photograph of, 327
Portier, 406
Poussard, as former owner, 130
Poussin, Nicolas, 8, 12, 15, 16, 233, 388, 423
Poznanski, as former owner, 229
Pradier, 380
Prix de Rome, 400
Proust, A., 280
Proust, Marcel, 349
Puvis de Chavannes, Pierre, 148–49, 151, 360, 377, 378; admired by Gustave Kahn, 179; classicism of, 147, 148–49, 175; compared to Seurat, 6, 139, 147, 148, 149, 150, 151, 174, 179, 186, 277; exhibitions of the work of, 148, 277, 401; frames used for the work of, 376; influence: on Gauguin, 148; on Seurat, 148, 149, 151, 164, 277, 362; on Symbolists, 148; photograph of (Nadar), 401; reaction of, to Seurat's work, 364; Seurat's copy after, 109, 149, 401; cat. no. 77; style of, 6, 139, 147, 148–49, 174; works by: Automne, L' (Autumn), 277; 277; Doux pays, 148–49, 151; 148; Jeunes filles au bord de mer, 277; Pauvre pêcheur, Le (The Poor Fisherman), 109, 149, 401, 409; 109; writings on, 147, 148, 179
Pythagoras of Rhegium, 388

Quincy, Quatremère de, 385
Quinn, John, as former owner, 88, 93, 214, 216, 261, 295, 331, 333, 363, 364, 423
Quintilian, Aristide, 393

Raffaëlli, J. J., 34, 135, 344, 400, 406, 409; works by: Chestnut Seller, etching for Croquis parisiens (Huysmans), 34; 35; Quadrille naturaliste aux Ambassadeurs, Le (Naturalist Quadrille at the Ambassadeurs), 343
Rains Gallery, New York, 48
Ranft, Richard, work by: Paris l'été, aux Ambassadeurs (Summer in Paris at the Ambassadeurs), 296
Raphael, 35, 276, 379, 388; Seurat's copies after, 12, 14–15, 379; cat. no. 2; works by: Man with Extended Arms, 15; 15; Three Graces, The, 276; 276; work formerly attributed to: Apollo and Marsyas, 276; 276
Redon, Odilon, 35, 54, 64, 99, 102, 147, 270, 401, 403, 406; works by: Hommage à Goya, 35; Prisonnier, Le (The Prisoner), 54; 54

Régnier, Henri de, 402, 403, 409, 411; as former owner, 151, 169
Regoyos, Dario de, 189, 406, 409, 410, 411; as former owner, 189–90
Reid and Lefevre, London and Glasgow, 239; as former owner, 119, 124, 127, 142, 156, 158, 165, 180, 190, 194, 196, 204, 239, 242, 247, 249, 256, 298, 312, 322, 327, 350, 353
Reisman, David, 177
Rembrandt van Rijn, 5, 34, 35, 54, 232, 339, 340, 385, 388
Renan, Ary, 406
Renand, Georges, as former owner, 27, 180, 281
Renoir, Pierre Auguste, 8, 104, 170, 403, 407; circuses, as subject of, 310, 360, 362; classical period ("Ingres period") of, 148; compared to Seurat, 64, 154, 178, 223, 224, 279; exhibitions of the work of, 401, 403, 406; influenced by Delacroix, 104, 149; influence on Seurat, 149, 161, 391; naturalism and, 310; palette of, 161; photograph of (Degas), 407; prices for the work of, 409; seascapes by, 233; studio of, 142; style of, 149; subject matter of, 224, 277, 279; works by: Au cirque Fernando, 362; Canotiers à Chatou, 149, 151, 154; 154; Clown, Le, 362; Déjeuner des canotiers, 178; Grandes baigneuses, Les (Large Bathers), 277; 277; Loge, La, 404
Renoue et Poyet, Galerie, Paris, as former owner, 100
Retté, Adolphe, 360, 364
Revue Blanche, Paris, 47, 54, 69, 219, 363, 366, 412; as former owner, 84
Revue blanche, La, 293, 412
Revue contemporaine, 402
Revue indépendante, La, 298, 311, 404–5, 407
Rewald, John, 8, 128, 132, 136, 161, 247, 249, 280, 298, 316, 331, 363, 364, 377, 381, 392, 394; as former owner, 14, 15, 17, 51, 252, 383
Rey, Robert, 335, 387, 423
Rheims, Maurice, 192
Richard, 136
Richard, George N. and Bernice, as former owners, 109
Richard, Marguerite, as former owner, 136
Riley, Bridget, 4
Rimbaud, Arthur, 310; poem by: "Parade, La," 309–10
Rivière, Marguerite, Thérèse, and Georges-Henri, as former owners, 192
Roberts, Mme Henry (née Marie Gueydan), as former owner, 93
Roché, Henri Pierre, 214, 363
Roche, Juliette, 392
Rochefoucauld, Antoine de la, as former owner, 212
Rockefeller, Abby Aldrich, as former owner, 214
Rodin, Auguste, 406
Rodrigues-Henriques, Jacques, Paris, as former owner, 32, 42, 63, 101, 134, 199–200, 282, 315
Roger-Milès, L., 360
Rood, Ogden, 5, 381, 390–91; influence: on Neo-Impressionists, 389, 391; on Camille Pissarro, 391; on Seurat, 6, 104, 132, 134, 181, 258, 361, 381, 383,

390, 391, 392, 400; on Signac, 391; theories of, 104, 105, 124, 390–91; writing by: *Modern Chromatics, Students' Text-Book of Color* (*Théorie scientifique des couleurs*), 104, 390, 391, 400; writings on, 173, 383, 390

Rosenberg, Alexandre P., as former owner, 20

Rosenberg, Paul, Paris, as former owner, 333

Rosenberg, Paul, and Co., New York, as former owner, 204, 239, 252, 264, 320, 327, 331, 354

Rosenblum, Robert, 312

Rothbart, Alfred, as former owner, 45

Rotonchamp, Jean de, 398

Rouart, Henri, 400

Rousseau, Henri, 328, 404, 406, 408, 409, 410

Rousseau, Théodore, 73, 104, 113, 128, 233, 387

Roussel, François, as former owner, 37, 108

Roussel, Ker-Xavier, as former owner, 100

Roussel, Mme Léon, as former owner, 71, 108, 228, 262–63

Roussel, Louise Appert, as former owner, 37

Rubens, Peter Paul, 178; work by: *Garden of Love*, 178

Rubin, James H., 300–301

Rudenstine, Angelica, 139

Ruskin, John, 391

Russell, John, 280, 309–10, 311

Rysselberghe, Marie van, as former owner, 354

Rysselberghe, Théo van, 71, 130, 189, 266, 354, 406, 409, 410, 411; as former owner, 58, 70, 71, 298, 325, 354; work by: *Émile Verhaeren, 404*

Sachs, Mr. and Mrs. Howard J., as former owners, 190

Sainsbury, Sir Robert and Lady, as former owners, 32

Saint-Ange, Mme, 298

Saint-Pierre, Bernardin de, 233

Sair, Mr. and Mrs. Samuel, as former owners, 65

Salinger, Margaretta M., 136

Salmon, André, 361, 423

Salmon, Blandine, 364

Salomon, Antoine, as former owner, 122

Salomon collection, Nancy, as former owner, 336

Salon, Paris: (1879), 277; (1881), 109; (1882), 148, 177, 198; (1883), 49, 51, 147, 401; (1884), 147, 401; (1885), 277; (1886), 273; (1888), 273, 311

Salon des Indépendants, *see* Société des Artistes Indépendants, exhibitions of

Salon des Refusés (1863), 176

Salz, Sam, Inc., New York, as former owner, 59

Sandblom, Grace and Philip, as former owners, 222

Sardey, Jehan, 302

Sarrazin, Jehan, 302

Schapiro, Meyer, 5, 8, 175, 309, 314, 328, 344–45, 361

Schloback, 406

Schmit, Galerie, Paris, as former owner, 242

Schmit, Robert, as former owner, 115, 124

Schommer, T., 379, 400

Schuffenecker, Émile, 401, 403

Segonzac, M. and Mme André Dunoyer de, as former owners, 213

Seligman, Germain, 162, 316; as former owner, 63, 165, 315, 328; *see also* Seligmann, Jacques, and Co.

Seligman, Mrs. Germain, as former owner, 63, 165, 328; *and see* Seligmann, Jacques, and Co.

Seligmann, Jacques, and Co., New York, 49; as former owner, 49, 63, 68, 70, 159, 165, 188, 190, 194, 196, 203, 247, 249, 298, 300, 313, 315, 328

Semin, Didier, 377

Séon, Alexandre, 33, 147, 151, 400, 401, 408, 409; as former owner, 261

Seurat, Antoine Chrysostome, 6, 13, 377–78, 424; artificial arm of, 54, 377, 378; background of, 11; birth of, 399; death of, 411; as parent, 6, 11, 13, 53; personality of, 11; portrait of, 11, 53–54, 272; cat. no. 33; profession of, 6, 11, 399; villa of, in Le Raincy, 11, 27, 47, 119, 399

Seurat, Émile Augustin, 6, 11, 29, 379, 399, 411; as former owner, 14, 24, 25, 27, 29, 30, 41, 43, 47, 51, 53, 60, 69, 77, 78, 81, 93, 112, 113, 122, 132, 143, 144, 157, 165, 188, 201, 206, 219, 222, 237, 252, 272, 289, 293, 312, 314, 331, 363, 367, 380

Seurat, Mme Émile, 27, 379, 380; as former owner, 51, 77, 132, 252, 272, 331

Seurat, Ernestine Faivre, 6, 377, 400, 412; annuity left to Knoblock by, 412; background of, 11; birth of, 399; as collector, 47, 405, 409; death of, 412; as former owner, 51, 53, 154, 181, 206, 239, 265, 285, 312, 318, 320, 322, 331, 346, 347, 350, 353, 362, 363, 370; as parent, 6, 11, 11, 53; personality of, 11, 51, 53; portraits of, 11, 50, 51, 53, 54, 266, 272; cat. nos. 31, 32, 177; selflessness of, 11, 51, 53; Seurat's work given away by, to his friends, 51, 73, 139, 181, 182, 190, 196, 203, 347; sister of, 47, 269

Seurat, François-Gabriel, 11

Seurat, Georges
abstract quality of the work of, 32, 51, 97, 138, 279, 281, 349
académies (studio nudes) by, 20, 23; *see also* Seurat, nudes by
aesthetic philosophy of, 36, 75, 78, 88, 103, 139, 148, 177, 215, 244, 275, 308, 314, 336, 382, 384
allegory in the work of, 151, 178, 273, 277
ambiguity in the work of, 35, 60, 75, 77, 93, 101, 278, 303, 334
ambitions of, 5–7, 13, 36, 60, 70, 109, 147, 148, 169, 178, 271, 273, 340, 376, 385, 387
analogy with work by Richard Wagner, 376, 377
anthropomorphic aspect of the industrial sites drawn by, 89
antisocial behavior of, 13
apartment of the family of, 11–12, 362, 399, 401; *100*; as subject matter for, 47, 48, 100–101, 266
artistic concerns of, 103
artistic development of, 12, 13, 22, 25, 104, 105, 106, 136, 139, 147, 220, 247, 275, 305, 361, 363, 383, 391

artistic goals of, 66, 150, 151, 174, 177, 213, 279, 305, 306, 316, 318, 362
artistic sensibility of, 4–5, 275, 338, 423–24
artistic theories of, 203–4
Art Nouveau style anticipated in the work of, 318, 320
as art student, 6, 7, 12, 13, 16, 18, 20, 22, 33, 103, 104, 273, 275, 286, 377, 378, 387, 399, 400
art teachers of: Lehmann, 12, 13, 18, 103, 149, 275, 286, 377, 378, 399, 400, 401, 407; Lequien, 12, 13, 14, 20, 22, 103, 275, 378, 388, 399
at Asnières, 149, 150, 152, 154, 161, 224, 261, 405
baptism of, 399
at Barbizon, 401
Beaux-Arts tradition of the work of, 6, 39, 103, 105, 148–49, 151, 163, 164; break with, 33, 34
birth of, 11, 399
black-and-white work, importance to, 75, 103, 297
borders by, *see* Seurat, painted borders and frames by
Brest sketchbook, 28, 29, 30; cat. nos. 16–18
in Brittany, 30
broadsides collected by, 71, 124, 175, 334, 378
brushwork of, 5, 113, 114, 116, 119; arbitrary, 105, 154, 220; *balayé* style, 104, 105, 106, 220, 226, 244, 258; boldness of, 104; conventional, 308; crisscross, 258, 322; freshness of, 132; Impressionistic, 132, 149, 150, 153, 154, 178, 239; largeness of, 132, 134, 227; link of, to artist's actions and emotions, 320; looseness of, 360; minute dots used for treatment of flesh by, 278; modernity of, 220; regularity and control of, 318; smaller dots placed on larger ones by, 309, 322, 325; spatial illusion created by, 131, 224; spontaneity of, 132, 153, 154, 237, 283, 286; surfaces created by the, 105, 106; varied aspect of, 173, 226–27, 237, 239, 240, 244, 247, 286, 336; vitality of, 84, 102
caricature, as element in the work of, 4, 6, 71, 219, 277, 278, 292, 295, 338, 340, 342, 344, 361
champions of the work of, 7, 54, 66, 73, 75, 126, 136, 147, 150, 178, 198, 258, 279, 322, 339, 385, 423
child born to, 335, 409, 410
childhood of, 11–12, 13, 47, 101, 378
"chromo-luminarist" style of, 170, 305, 308, 396
classicism of, 6, 7, 103, 139, 147, 148, 164, 174, 186, 273, 286, 334
at Clichy, 85
as cofounder of Société des Artistes Indépendants, 35, 54, 147
as collector, 269, 273, 334, 338, 361, 362, 378–80, 404, 409; *see also* broadsides collected by
colored engravings, relationship to the work of, 175, 179
color (palette) in the work of, 113; arbitrariness of, 139; association of, with nature, 104; based on underpainting technique of, 202; broken (divided), 28, 108, 116, 119, 132, 161, 173–74, 202, 220, 336, 390; complexity of the use of, 181, 249, 336; contrasts and opposites of, systematically used,

29, 107, 108, 119, 122, 124, 132, 134, 139, 150, 181, 183, 203–4, 220, 246, 249, 258, 295, 336; earth tones used by, 109, 112, 113, 128; experimentations with, 104, 124, 193; gray weather depicted by, 261; Impressionist, 114, 134, 149, 154, 202, 391; influenced by Barbizon painters, 104; limited, 123; modernity of, 220; optical mixtures and, 173, 220, 320, 384; pre-Impressionist, 115; pursuit of color-light contrast and, 29, 132, 134, 144, 181, 196; saturated, 134, 136, 249; spatial illusion created by, 131, 224; subdued, 150; symbolic aspect of, 361; theories of, studied by, 3, 5, 6, 7, 29, 103, 104, 105, 108, 124, 132, 134, 173, 174, 181, 202, 258, 322, 340, 361, 376, 381, 382, 383, 384, 389, 390, 391, 394, 396; use of, in dating the work of, 220
communication, rare instance of, in the work of, 45
compared to: Brancusi, 51; Corot, 256, 258, 261; Courbet, 233, 244; Daubigny, 224, 244, 256; Daumier, 60, 66, 128; Degas, 35, 50, 103, 298–99, 342; Delacroix, 5; Diaz, 136; Dubois-Pillet, 334; Dubourg, 244; Dutch painting, 51; Egyptian art, 174, 179, 263, 266; Fantin-Latour, 35; Gauguin, 376, 423; van Gogh, 42, 320, 423; Goya, 45, 60; Greek sculpture, 46, 57; Kate Greenaway, 175, 179; Grévin, 177; J. J. Henner, 276, 280; Ingres, 5, 103, 286; Jongkind, 235, 244, 255; Franz Kline, 89; Manet, 177, 198, 239; Matisse, 5; Millet, 5, 78, 128, 272; Monet, 5, 102, 177, 178, 204, 222–23, 224, 233, 235, 239, 244, 247, 261, 318, 320, 349; Phidias, 46, 57, 174; Piero della Francesca, 174; Camille Pissarro, 35, 124, 139, 224; Puvis de Chavannes, 6, 139, 147, 148, 149, 150, 151, 174, 179, 186, 277; Raffaëlli, 34; Redon, 35, 54, 64, 99, 102, 270; Rembrandt, 232; Renoir, 154, 178, 223, 224, 279; Rimbaud, 310; Rubens, 178; Signac, 177, 255, 423; Sisley, 106, 222–23; tapestries, 175, 179; Toulouse-Lautrec, 311; Turner, 88; Watteau, 314; Adolphe Yvon, 22
compositions of the work of, 60, 69, 73, 151, 220, 270; ambitious, 27; axial symmetry of, 281; based on geometries, 147; centered, 46, 56, 58, 213; cropping, as device used in the studies of, 302; of lateral planes, 239; modernity of, 116; spatial considerations of, 305, 316, 333, 350, 353; symbolic aspects of, 128; symmetrical, 240, 263, 264, 322
concentration of, on the work of, 13, 273
conservatism in the work of, 6, 17, 50, 51, 149
contemporary elements of the work of, 174, 176, 177, 258, 273, 278, 279–80, 334, 396
continuity of the development of, 13
copies by: after antique sculpture, 14, 20, 22, 185, 275, 336; after Bellini, 12, 15; after contemporary artists, 12; after Delacroix, 275; after engravings, 14; after Ghiberti, 12, 13, 15; after Holbein, 12, 15, 50, 339; after Ingres, 12, 15–16, 17, 20, 24, 103, 106, 275, 286, 380; cat. nos. 3, 4, 8; after

Lehmann, 13, 18; cat. no. 5; after lithographs, 12, 14, 15; after Michelangelo, 12, 15, 29; from oil paintings, 16; after Perugino, 12, 15; after plaster casts, 12, 20, 378; after Pontormo, 12, 15; after Poussin, 12, 15, 29; after Puvis de Chavannes, 109, 149; cat. no. 77; after Raphael, 12, 14–15, 379; cat. no. 2; after reproductions, 29; after Titian, 12, 15

correspondence, 273, 345; to Maurice Beaubourg (never sent), 8, 279, 280, 372, 381–82, 411; 372–73; to Fénéon, 170, 172, 210, 383–84, 386, 387, 390, 391, 392, 394, 396, 410; to Kahn, 397; to Maus, 280, 405; to Signac, 233, 235, 244, 278, 280, 403, 404, 408, 411; to Verhaeren, 235

at Courbevoie, 85, 152, 170, 224, 256

cover for novel by Victor Joze drawn by, 337–38, 409; cat. no. 215

croquetons by, 105, 106, 278, 280, 316, 402

death of, 3, 8, 335, 360, 362, 411

as draftsman, 103

drawings by: continuum of light and dark in, 106; compared to the paintings of, 38, 44, 103, 107, 190, 286; in conté, closeness to lithography and etching, 376; conté crayon, preference for, 41; for cover of novel by Victor Joze, 337–38, 409; cat. no. 215; early, 12, 14, 399; gestural freedom of, 89, 97; as illustrations, 293, 407; as immediate responses to life, 34; large scale of, 27, 50; light and dark continuum in, 106, 165, 296; mature, 13, 17, 261, 270; in military service, 27, 400; movement conveyed in, 89; mysterious quality of, 45; after photographs, 14, 15, 16, 17; preference of critics for, over the paintings of, 5, 45; Signac's comments on, 103; small scale of, 31; as student, 12, 14, 18, 36, 57, 107, 185, 186, 273, 275, 336; unfinished, 27, 32, 41, 66; see also Seurat, croquetons by; figure drawings by; techniques

Durand-Ruel's interest in, 402, 403

early artistic influences on, 11

effect of time on the work of, 172, 178–79, 206, 210, 298, 299, 300, 316

Eiffel Tower, as subject of, 328, 408

entrance of, into the world of vanguard art and journalism, 147

"esthétique" of, 6, 305, 333, 340, 345, 348, 372, 376, 381–83, 387, 392, 393, 394, 397; 372–73

exhibitions of the work of, 33, 51, 227, 240, 301, 331, 407, 423; in Amsterdam, 298, 408; in Brussels (Les Vingt), 3, 128, 170, 240, 244, 247, 255, 261, 279, 286, 298, 300, 306, 325, 354, 376, 377, 382, 405, 409, 411; first work exhibited by, 49; Impressionist, 66, 138, 139, 170, 172, 232, 235, 239, 380, 382, 403, 423; in Kraków, Poland, 287; list of, in artist's lifetime, 66; in London, 279; in Nantes, 404; in New York (with Durand-Ruel), 151, 204, 380, 402, 403; posthumous, 47, 54, 69, 128, 144, 234, 240, 279, 286, 287, 350, 354, 412; posthumous, at Bernheim-Jeune, Paris, 28, 29,

31, 107, 136, 216, 240, 279, 295; at the Salon, Paris, 49, 51, 147, 401; with the Société des Artistes Indépendants, Paris, 89, 106, 128, 144, 170, 204, 239, 258, 265, 271, 272, 275, 278, 279, 280, 283, 289, 296, 297, 298, 300, 305, 306, 308, 311, 312, 333, 339, 340, 342, 360, 363, 364, 376, 377, 382, 401, 402, 403, 404, 406, 409, 410, 411; strategy for, 232

expressive power of line, theories of, 6, 309, 312, 333, 338, 340, 360, 363, 376, 381, 382, 384, 386

falling-out with Gauguin, 397, 403–4

family background of, 6, 11, 13, 377

family relationships of, 11, 51, 53, 377–78

fashion, as artistic concern of, 177, 179, 198, 230, 270

figure drawings by, 29, 34, 35, 36, 37–72, 188, 424; anonymity of, 40, 43, 75, 81, 229, 269, 299, 302; as archetypal images, 36; atmospheric, indefinite space in, 39, 44, 45, 51, 59, 60, 215, 218, 263, 339; close focus, as feature of, 169, 213; compared to the landscape drawings of, 75, 81; compositions of, 39, 46, 48, 51, 56, 169, 213, 216, 270; dignity of, 40, 51, 72, 232; elegance in, 57, 58, 70; flatness of, 36, 48, 66, 72, 214, 216; folds of clothing rendered in, 165; iconic, frontal quality of, 263, 264–65; illusion of three-dimensionality in, 50; in interiors, 13, 51, 53, 54, 232; isolation and gravity of, 36, 39; knowledge of the human body exhibited by, 17; lack of narrative surroundings for, 37, 46, 51, 56, 57, 62; light and dark contrasts handled in, 35, 36, 38, 40, 41, 43, 45, 51, 57–58, 60, 66, 163–64, 169, 212, 215; from the live model, 12, 17, 22, 23, 24, 214, 273, 275, 378; in profile, 39, 71, 229, 230; in public places, 32, 34; schematic environments given to, 59, 60; see also Seurat, portraits by; studies by, figures

frame by, designed and replaced by van de Velde, 376, 377

frames by, see Seurat, painted borders and frames by

friendships, 51, 66; with Ajalbert, 344, 360; with Alexandre, 126, 340; with Alexis, 147, 360; with Aman-Jean (Amand-Edmond Jean), 13, 30, 33, 49, 104, 109, 113, 147, 377, 400, 401; with Caze, 66; with Christophe, 340, 343; with Cross, 196; from the École des Beaux-Arts, 71, 147, 151; with Fénéon, 104, 360, 405; with Gustave Kahn, 340, 344; with Laurent, 33, 104, 147, 151, 400, 401; with Lecomte, 340; with leftist artists and writers, 34, 150; with Osbert, 33, 147, 151, 400, 401; with Camille Pissarro, 405, 408; with Lucien Pissarro, 51; with van Rysselberghe, 71; with Séon, 33, 147, 151, 400, 401; with Signac, 66, 393, 401, 402, 405, 408; with van de Velde, 340; with Verhaeren, 73, 340, 344; with de Wyzewa, 340

genre paintings by, 103, 109, 273

geometric aspect of the work of, 32, 66, 73, 77, 97, 105, 113, 116, 119, 124, 132, 147, 151, 159, 164, 173, 256, 261, 302, 305, 311, 328, 339, 349, 363, 393

golden section not used by, 4, 8, 301, 316, 392, 393

at Grandcamp, 170, 172, 224, 233, 235, 237, 239, 240, 242, 243, 318, 383, 384, 402

at Gravelines, 233, 349

homages to, 412

at Honfleur, 233, 235–36, 244, 246, 247, 249, 252, 255, 258, 318, 404

humanism and, 36

humor and wit in the work of, 6, 63, 71, 177, 178, 228, 230, 278, 279, 291, 327, 333, 334, 336, 340, 423

illustration by: for article by Paul Adam written on, 293; for La revue indépendante, 407

Impressionism and, 20, 33, 105, 106, 149, 153, 176, 178, 402; Barbizon painting supplanted by, 105, 106, 113, 114; challenge to, 3, 5; color and, 114, 134, 149, 154, 202, 391; controversy over inclusion with, 402, 403; criticism of, 406; impact of, on Une Baignade, 27, 148, 149–50, 154; influenced by, 222, 233, 389, 391, 394, 400; landscapes as, 222–23, 340; new "scientific" technique and organization applied to, 258; reviewers linking the work to, 147–48; reworking of the motifs of, 174, 340; shift toward, 7, 27, 104, 114, 132, 144, 220; subject matter of, in the work of, 149–50, 261; techniques of, approximated by, 124, 139; turning away from, 6, 7, 174; see also Seurat, brushwork of, Impressionistic

influenced: by antique (Hellenistic) sculpture, 273, 282, 286, 336, 387; by Barbizon painters, 104, 105, 106, 113, 114, 128, 136, 150; by Blanc, 5, 6, 7, 148, 151, 173, 174, 181, 246, 293, 305, 340, 345, 361, 377, 382, 383, 384–86, 387, 390, 392, 394; by Bonheur, 104; by Boudin, 104, 233, 249; by Chéret, 6, 338, 342, 344, 345, 361, 362; by Chevreul, 6, 29, 103, 132, 322, 361, 376, 381, 383, 384, 389, 390, 392, 404; by Corot, 104, 113, 215, 383, 394, 399; by Courbet, 104, 276, 277; by Couture, 33, 34, 383, 396–97, 400; by Daubigny, 104, 233; by Daumier, 34, 35, 39, 60, 230; by Delacroix, 28, 103, 104, 105, 108, 113, 116, 119, 122, 132, 139, 161, 173, 181, 202, 220, 246, 258, 336, 362, 381, 383, 384, 390, 392, 394–96, 400, 401; by Diaz, 104, 113; by Egyptian art, 6, 174, 305; by Gauguin's article (Oriental text) on hues in Oriental rugs, 397–98; by Goya, 34, 35; by Helmholtz, 381, 392; by Charles Henry, 6, 279, 309, 333, 338, 340, 344, 345, 361, 376, 381, 383, 392–93, 402; by Holbein, 339, 340; by Humbert de Superville, 6, 333, 338, 340, 344, 361, 363, 376, 384, 392; by Ingres, 16, 17, 275, 286, 287, 376, 384, 392; by Jongkind, 104, 233, 249; by Lépine, 249; by Manet, 149, 178, 239, 276–77; by Millet, 34, 39, 42, 54, 104, 106, 112–13, 132, 139, 151, 272; by Monet, 104, 139, 149, 204, 222, 233, 240, 249, 383, 391; by Oriental tradition in art, 381; by Camille Pissarro, 3, 104, 139, 149, 239, 383; by Puvis de Chavannes, 148, 149, 151, 164, 277, 362; by Raphael, 276; by Rembrandt, 34, 54, 339,

340; by Renaissance painting, 6, 164, 174, 276, 339; by Renoir, 104, 149, 161, 391; by Rood, 6, 104, 132, 134, 181, 258, 361, 381, 383, 390, 391, 392, 400; by Théodore Rousseau, 104, 113, 128; by Signac, 3; by Sisley, 222; by David Sutter, 383, 387; by Vermeer, 51

influence of, 5, 412, 423; on Cubists and post-Cubists, 279, 361, 423; on Dubois-Pillet, 376, 405; on Gauguin, 409; on Vincent van Gogh, 279, 293, 298; on Camille Pissarro, 405, 406; on Signac, 405

"instinct" as the source of art for, 13

interiors by, 34, 336

isolation of, 273

key point in the career of, 147

landscapes by, 25, 33, 34, 149, 424; absence of people in the, 25, 97; combination of geometric and amorphous shapes in, 77; compositions of: drawings, 75, 81, 84, 86, 88, 89, 93, 97; paintings, 75, 119, 132, 135, 142, 156, 224, 226, 256, 258; done at the site, 223, 224, 227, 258; drawings, 24–25, 29, 34, 36, 73–102; drawings, compared to the figure drawings of, 75, 81; earliest surviving, 109; figures in, 256; frames used for, 376; generalized and without pronounced edges, 75, 81, 84, 89, 93, 99, 101, 102; gray weather depicted in, 261; horizontal banding, as characteristic of, 130–31, 135, 137; Impressionist, 222–23, 340; light and dark contrasts as basis of, 24–25, 75, 88, 93, 97, 131, 132, 134, 154, 156, 226; nature, affected by and juxtaposed with industrial society in the, 75, 78, 88; nostalgia as aspect of, 73; paintings by, 103, 104, 109, 113, 136, 138–39, 141, 143–44, 232, 305; poetic quality of, 75, 77, 102; reworked in the studio, 113, 115, 116, 258; skies handled in, 88, 93, 97; spatial considerations in, 73, 81, 84, 85, 86, 89, 93, 102, 105, 131, 132; stagelike aspect of, 172, 176; synthesizing of, 174; temporal considerations of, 73, 81, 89, 97, 142; unmarked by modern change, 25; from urban areas, 142; see also Seurat, seascapes by; studies by, landscapes

at Le Crotoy, 233, 331, 335, 409

leftist political views of, 7, 13, 34, 344, 378

light in the work of: artificial (nocturnal) light, used by, 304; in outdoor scene, 275, 305, 306, 308, 336; daylight, in indoor scene, used by, 275, 336; gray weather depicted by, 261; importance to, 244, 255, 396; poetic force of, 54; studied, for the seascapes of, 237; used by, to establish spatial relationships, 305–6

light and dark contrasts in the work of, 20, 22, 37, 128, 149, 270; artists influential to the concept of, 35; balance of opposites created by, 167; as basis of landscapes by, 24–25, 75, 88, 93, 97, 131, 132, 134, 154, 156, 226; continuum of, in the drawings by, 106, 165, 296; as controlling phenomenon of the work of, 103, 150, 215; effects of simultaneous

contrast depicted by, 312; enigmatic space created by, 262; figure and ground welded together in, 263; in the figure drawings of, 35, 36, 38, 40, 41, 43, 45, 51, 57–58, 60, 66, 163–64, 169, 212, 215; hatching as means of evoking, 31, 32; "irradiation" technique used to achieve, 278; poetic aspect of, 75, 77, 97; in seascapes, 240, 242, 327; sunlight and, 255; surface pattern created by, 38, 40, 44, 60, 108, 119, 203, 269; uncanny moods created by, 54

linear expression and opposing directions, theory of, as element in the work of, 6, 333, 338, 340, 342, 348, 360, 363, 376, 392

list of owners of the works of, made by, 232, 258, 380–81

literary evenings attended by, 66, 383, 384, 402

literary influences on, 33, 150, 309–10, 378, 383; *see also* Seurat, naturalism and; Symbolism and

marine landscapes by, *see* Seurat, seascapes by

meetings: with Aman-Jean, 13, 399; with Fénéon, 403; with Vincent van Gogh, 382; with Charles Henry, 392; with future members of Neo-Impressionist group, 147; with Camille Pissarro, 139, 377, 383, 384, 402; with Redon, 35; with Signac, 147, 233

men and women portrayed in conventional roles by, 224

middle-class character of, 6, 7, 34, 233, 377

military service of, 13, 27, 30, 103, 114, 378, 400, 402, 407

mistress of (Knoblock), 99, 275, 286, 333, 335, 409

as model, for Laurent, 401

modernity of the work of, 6, 27, 39, 51, 73, 81, 97, 105, 116, 119, 132, 142, 164, 174, 220, 224, 236, 279, 322, 328, 340, 344

monograph on (Coquiot), 304, 377

in Montmartre, 340, 342

mural-scale canvases of, 7, 33, 139, 147, 148, 273, 275, 385

music, importance to, 314, 376

mythological connotations of the work of, 273, 279

naturalism and, 4, 7, 20, 33–34, 35, 36, 54, 132, 139, 148, 150–51, 174, 175–76, 261; literature of, relationship to the work of, 86, 150, 170, 176, 232, 234, 261, 269, 279

Neo-Impressionism and, 39, 174, 244, 286, 293, 328, 385, 390, 391, 394, 423; as the movement's initiator, 3, 7, 170, 383, 404, 405, 408

nickname of, from Degas, 6

nocturnal scene by, 305, 306, 308, 312

notebooks and sketchbooks of, 12, 13, 24, 27, 30, 31, 33, 36, 37, 40, 66, 85, 114, 115, 199, 261, 270, 380, 391, 392–93; pages from, *12, 308, 392*; Brest sketchbook, 28, 29, 30; cat. nos. 15–17

notes by, on paintings by Delacroix, 5, 394–96

nudes by, 20, 23, 103, 107, 185, 273, 275, 281, 282, 283, 286, 289

optimism of, 177, 178

painted borders and frames by, 5, 109, 204, 206, 210, 211, 240, 247, 255, 261, 286, 289, 295, 309, 320, 322, 327, 328, 331, 333, 336, 347, 348, 350, 353, 354, 363–64, 376–77, 389

paintings and drawings by, compared, 38, 44, 103, 107, 190, 286

pamphlet biography written on (Christophe), 339, 343, 345, 360, 361, 384, 410, 411; *410*

personality and temperament of, 6, 8, 13, 36, 177, 178, 235, 273, 280, 333, 335, 395, 408

perspective in the work of, 93, 228, 262, 269, 350, 363

photographs of, *4, 399*

physical appearance of, 3, 6, 377, 400

plein-air paintings by, *see* landscapes by

pointillism and, 3, 173, 295, 306, 308, 316, 363, 385–86

at Pontaubert, Burgundy, 113, 114, 115, 136, 378, 401

popular and journalistic arts, interest in, 3, 6, 39, 71, 124, 175, 198, 228, 269, 334, 338, 342, 344, 345, 361

at Port-en-Bessin, 233, 318, 349, 408

portraits by, 19, 103, 107, 115–16; cat. no. 6; of family, 11, 13, 50, 51, 53–54, 107, 262–64, 266, 269, 339, 407; cat. nos. 31–33, 74, 175, 177, 179; of friends, 49–50, 339, 340, 401, 410; *339, 410*; cat. nos. 30, 216

portraits of: (Laurent), 401; (Luce), 339, 410; *410*

posthumous inventory of the contents of the studio of, 14; by Fénéon, 14, 15, 18, 29, 30, 37, 127–28, 152, 179, 203, 215, 280, 283, 367, 380, 411; by Luce, 14, 73, 136, 143, 144, 203, 215, 266, 282, 411; by Signac, 14, 15, 18, 64, 203, 312, 347, 367, 411

presented to the president of France, 410

primitivism (neo-primitivism) of, 6, 124, 139, 174, 175, 177, 186, 210, 263, 266, 334

printmaking (lithography and etching), lack of interest in, 338, 376

productivity of, 3–4, 8

psychological implications in the work of, 64

reaction of, to Dubois-Pillet's death, 411

readings of, influence on artistic theories of, 5, 29, 36, 103, 104, 108, 124, 132, 134, 181, 361, 383, 384–93, 396–98, 400, 402; *see also* Seurat, influenced by, Blanc; Chevreul; Couture; Charles Henry; Humbert de Superville; Rood; David Sutter

relatedness and correspondence of the arts, as interest of, 7, 376, 377

reviews of the work of, 49, 54, 106, 138, 147–48, 151, 170, 173, 174, 175, 176, 177, 179, 232, 234–35, 239, 240, 244, 249, 258, 263, 265, 278, 279, 281, 283, 296, 297–98, 305, 306, 333, 340, 342, 343, 344, 360, 361, 363, 376, 377, 386, 401, 403

satire and irony in the work of, 177, 178, 198, 336, 343

scale of the work of, 113, 156, 273; *see also* Seurat, mural-scale canvases of

scientific theories and principles, applied to the work of, 3–8, 273, 308, 328, 333, 384, 393; of color, 3, 5, 6, 7, 29, 103, 104, 105, 108, 124, 132, 134, 173, 174, 181, 202, 246, 258, 322, 340, 361, 376, 381, 382, 383, 384, 389, 390, 391, 396; of direction of lines to indicate moods, 6, 309, 312, 333, 338, 340, 360, 363, 376, 381, 382, 384, 386; of expression, 278, 279, 333, 361, 362, 381, 382; of physiognomy, 361, 387

seascapes by, 206, 233–55, 318–27, 331, 349–59; absence of people in, 8, 233, 235–36, 240, 255, 349; brushwork in, 320, 353, 356; color in, 233, 237, 243, 244, 249, 320, 322, 325, 333, 353, 354, 356; completed in the studio, 235, 240, 318; compositions of, 236, 239, 240, 244, 247, 322, 327, 350, 353, 354; from Grandcamp, 233, 235, 237, 239, 240, 242, 243, 247, 318; from Grand-Fort-Philippe, 349, 353, 354; from Gravelines, 349, 350, 353, 354, 356, 357; from Honfleur, 235–36, 244, 246, 247, 249, 252, 255, 258, 297, 318, 328; at Le Crotoy, 331; light and, 244, 255; light and dark contrasts in, 240, 242, 327; luminous stillness of, 233–34; melancholy aspect of, 234–35, 236, 240; people appearing in, 318, 327, 331, 353; from Petit-Fort-Philippe, 349, 350; from Port-en-Bessin, 318, 320, 322, 325, 327, 328, 349; romanticism of, 234, 247, 320; strictly ordered compositions of, 236; temporal aspect of, 247, 252, 255, 318, 320, 327, 354, 356; time spent in the execution of, 249

secretiveness of, 333, 335

sensuality in the work of, 286, 334

sexuality in the work of, 230

social content and significance of the work of, 4, 6, 151, 176, 177, 178, 179, 219, 279, 310–11, 344, 362

solitude and reclusiveness of, 13

still lifes by, 103, 109, 289, 291–92

studies by, 27, 149, 150, 151; for *Une Baignade*, 136, 141, 149, 150, 151, 152–69, 286, 291, 302, 354, 361; for *Chahut*, 346–48; for *Cirque*, 362, 364, 366–70; figure drawings as, 161, 163, 165, 167, 169, 172–73, 182, 183, 185, 188–89, 212, 213, 214, 215, 216; for *La Grande Jatte*, 66, 170, 172, 173, 179, 180–219, 220, 223, 224, 227, 237, 312, 354, 361, 364; landscapes as, 105, 116, 132, 143–44, 153, 154, 156–57, 158, 159, 161, 172, 180, 182, 183, 185, 258; for *Parade de cirque*, 68, 272, 312–16, 392, 393; for *Poseuses*, 277–78, 281–95; seascapes as, 235, 242, 243–44, 246, 318, 354, 356, 357

studios and homes of, 11–12, 13, 50, 189, 273, 335, 340, 360, 362, 377, 378, 381, 399, 400, 401, 403, 404, 410

style of the work of, 5–7, 12, 32, 124, 174, 178, 220; artificial devices and, 57; austerity of, 63, 349; conservative and traditional aspect of, 6, 17, 50, 51, 149; contrast between figures and objects, as aspect of, 333; creative mark of, 105; decorative art, relationship to, 342, 345; decorative surface and line, as element of, 363, 370; dialogue between surface pattern and believable space, as element of, 84, 89; distinctive vision of, 114; emotional and expressive force of, 89, 97, 165; fashion and ironic interpretation as element of, 177, 179; flattened forms of, 6, 36, 48, 66, 72, 173, 174, 214, 216, 220, 224, 258, 262, 266, 270, 333, 340, 363; freedom of handling and, 223; frozen movement, as characteristic of, 304; harmony and, 279, 286; hieratic quality of, 6, 200, 296, 340; iconic quality of the imagery of, 46, 56, 263, 264–65, 281, 333–34, 336, 361; idealization as aspect of, 150–51; intersection of city, suburban, and country themes in the work of, 78; intimate quality of, 286, 295; isolation and lack of involvement in the figures of, 8, 36, 39, 173, 177, 179, 311; line and contour, as element of, 6, 19, 37, 339; lyrical quality of, 101; maturity of, 25, 33, 104, 113, 258; melancholy in, 234–35, 236, 240; monumentality and, 6, 161, 292, 305, 316; mystery of, 45, 54, 97, 99, 252, 261, 270, 275, 305, 311; opposites, as the essence of the art of, 64; organization of forms in a rational order, 178, 349; penchant for strong surface pattern by, 19, 27, 38; pervasive light and controlled composition, as essential elements of, 114; poetic mood of, 54, 75, 77, 97, 102, 265, 308; polygonal heads of the figures of, 116; rigidity of, 361; romanticism in, 174; sense of permanence in, 234; sensitivity of, 265, 286; severity of, 139; simplicity (simplification) of, 50, 64, 71, 139, 216, 266, 281, 286, 296, 311, 334; spontaneity of, 89, 132, 153, 154, 237, 281, 283, 286; static quality of, 316; stiffness and uniformity of the figures of, 177, 179, 226; tentativeness in the early work of, 25; toylike aspect of, 174, 175, 179, 226, 229, 256, 299, 327, 363

subject matter of: animals, 114; cafés-concerts, 270, 272, 296, 298, 300, 302, 303, 304, 342–44, 346; circuses and clowns, 30, 37, 66, 68, 266, 296, 309, 310, 314–16, 342, 360–64; coachmen, 85, 270; concierges, 60; contemporary life, merged with traditional elements, 177, 273, 278, 279–80, 396; drawbridges, 33, 34; entertainers, 27, 30, 33, 37, 68, 266, 338 (*see also* subject matter of, cafés-concerts); entertainments, 296, 305, 340; everyday life, 4, 33, 34; factories, 88, 89, 123, 150, 157, 176; factory workers, 34, 84–85; fairgrounds, 68, 296; funeral scene, 232; horse-drawn wagons, 85, 86, 93, 97, 220; horses, 84, 85; industrial subjects by, 11, 25, 33, 34, 81, 88, 89, 104, 328; laundresses, 34, 60; leisure scenes, 148, 157, 176, 178, 179, 220, 226, 258; leisure scenes, cohabiting with industry, 135–36, 150, 151, 175–76; locomotives, 33, 34; market porters, 34, 60; middle-class subjects of, 13, 34, 47, 57, 59, 64, 71, 101, 222; monkeys,

199, 200, 201; music halls, 30; musicians, 314; nurses, 60, 216; nurses with children, 34, 40, 45, 66; ordinary people, 39, 230; peasants, 25, 33, 34, 103, 104, 112, 114, 115, 149; peasants, shown actively at work, 119, 122, 126, 128, 132, 135; rural scenes and figures, 42–43, 44, 97, 104, 106, 112, 113–14, 119, 124, 126, 132, 220; saltimbanques and acrobats, 304; soldiers, 27, 29, 30; stone breakers, 27, 34, 38, 119; street scenes and figures by, 30, 35, 39, 56, 57, 58, 66; suburban scenes and figures by, 25, 27, 33, 34, 42, 84–85, 89, 93, 97, 104, 106, 119, 123, 128, 132, 135, 150, 258, 328; urban carriages, 269; urban scenes and figures, 25, 27, 33, 39, 40, 42, 45, 60, 72, 93, 97, 103, 104, 228, 229, 230, 261, 272; vendors, 33, 34, 39, 60; women in interiors, 47, 48, 51, 101, 265, 269, 270; women promenaders, 56, 57, 58, 62, 64, 175, 188, 196, 218, 219, 229, 230; working-class men and women, 60, 66, 69, 70, 72, 150, 151, 154, 175–76, 178, 216

summer holidays of, 13, 30, 113, 114, 115, 136, 170, 233, 318, 378, 401, 402, 404, 408, 409

symbolism in the work of, 88, 128, 249, 252, 266, 289, 333, 344, 360, 32

Symbolism and, 6, 7, 54, 174, 234, 279, 311, 314, 340, 344, 360, 376, 385, 394, 411

techniques of: charcoal, 14, 19, 20, 21, 41; charcoal stumping of, color application, 104; conté crayon, 19, 34, 35–36, 40, 41, 48, 60, 62–63, 64, 69, 75, 81, 84, 85, 88, 93, 165, 188, 204, 216, 232, 263, 265, 298, 299, 300, 316, 339; of copying, 17, 20; drawing, 73, 93, 199, 229, 293; drawings squared for transfer, 28, 316, 367, 368; exposed wood as the equivalent of orange, in panel paintings of, 105, 136, 139, 144, 150, 153, 154, 158, 180, 182, 185, 193, 196, 227, 237, 242–43, 244, 246, 281; graphite, 17; hatching, 21, 31, 32, 69, 265; impersonality of, 178; "irradiation" (dark stippling) used by, 278, 387; Michallet (textured) paper used for the drawings of, 22, 35, 39, 50, 75, 269; of modeling in light and dark, 20; painting, 108, 113–14, 119, 124, 134, 136, 185, 204, 210–11, 237, 239, 247, 286, 308–9; pastel, 28; pencil, 32; pencil lines as guidelines, for, 43; preoccupation with, 13; and subject matter, relationship to, 244, 255; texture suggested by, 81, 88; undercoating (underpainting) used by, 113, 124, 202, 210–11; on unprimed canvas, 261; unstable pigments used by, 172, 178–79, 206, 210, 406; white gouache used, to cover the mistakes of, 316; on white ground (gesso), 105, 124, 261, 278–79, 295, 308, 336

traditional printmaking, as source of inspiration for, 45

twelve panels shown in a single frame by, 152, 190, 380

unfinished works by, 27, 32, 41, 66, 109, 119, 144, 202, 235

vanitas, as theme of, 333–34, 336, 424

varnishing of canvases, opposition to, 405

withdrawal of, from the traditional art route, 13

wood engraving made, as illustration of the work of, 298

work attributed to(?): *Loge de l'artiste* (H 659), 280

work contributed to benefit sale by, 297, 298

working methods of, 41, 64, 85, 124; empirical aspect of, 172; existing drawings, used as compositional tools, 162, 188; grids on canvas used by, 360, 363, 364; lines scored into panel for transference of sketch, 161; methodical nature of, 172, 174; for painting, 190, 192, 322; reworking and repainting by, 220, 240, 247, 255, 278, 283, 360, 363; role of studies, 5, 258, 336; for *Une Baignade*, 149, 150, 154, 156, 161, 163; for *Chahut*, 346, 347, 348; for *Cirque*, 364, 367, 368, 369, 370; for *La Grande Jatte*, 185, 188–89, 190, 193, 194, 196, 199, 201, 202–3, 204, 206, 210, 212, 214, 215, 216, 218, 289; for *Parade de cirque*, 313–14, 315–16; for *Poseuses*, 277–78, 283, 286, 289, 291–92, 293, 295; speediness of, 66; spontaneity of, 89; on wood panels, 105, 106

work of, bequeathed to the French nation by Camille Pissarro, 25, 43, 47, 78, 84, 201

work of, given as gifts by, 7, 11, 97, 126, 198, 232, 261, 283, 284, 380, 406

work of, given as gifts by his family, 73, 84, 89, 130, 139, 189–90, 227, 266, 270, 337, 411

work of, given as gifts by his mother, 51, 73, 139, 181, 182, 190, 196, 203, 347

writings on, 6, 13, 136, 178, 179, 261, 273, 278, 279, 293, 295, 300–301, 311, 338, 345, 360, 361, 376, 377, 378, 384, 385, 386, 397, 404, 408, 409, 410

youthful inexperience of, 15

Seurat, Georges, works by (English titles)

Acrobat by the Ticket Booth (H 671), 34–35, 37, 66, 68, 170, 232, 403; cat. no. 44

Aman-Jean (H 588), 49–50, 51, 70, 147, 270, 339, 377, 378, 401, 402; cat. no. 30

Anaïs Faivre Haumonté on Her Deathbed, 11, 64, 232, 269, 339, 407; cat. no. 179

Anchorage at Grandcamp, The (H 146; DR 142), 237; cat. no. 159

Angelica, After Ingres (H 315; DR 1a), 20, 275; cat. no. 8

Antique Statue, Satyr with Goat (H 300), 20–22; cat. no. 9

Artist at Work (H 602), 70; cat. no. 47

Artist's Mother, The (H 583), 50, 51; cat. no. 31

At the Concert Européen (H 689), 296, 298–99, 300, 325, 408, 409; cat. no. 194

At the Concert Parisien (H 687), 270, 300, 302; cat. no. 197

At the Divan Japonais (H 690), 296, 345, 346, 408; *346*

At the Gaîté Rochechouart (H 685; Providence), 270, 272, 296, 300–301, 303, 408, 409; cat. no. 196

At the Gaîté Rochechouart (Cambridge), 300–301; *301*

Back View of a Male Nude, Leaning on a Staff (H 265), 19, 20; cat. no. 7

Balcony (H 586), 47, 100–101; cat. no. 71

Bandleader (H 672), 270, 303; cat. no. 198

Bareback Rider; Equestrienne (H 707; DR 210d), 361, 364, 369; cat. no. 230

Bathers in the Water (H 84; DR 91), 157–58; cat. no. 107

Bathing Place, Asnières, see Seurat, Georges, works by (French titles), *Baignade*

Bec du Hoc, The (H 159; DR 153), 170, 235, 239, 240, 403, 404, 405, 407; cat. no. 161; study for, 242–43; cat. no. 162

Bineau Bridge, The (H 106; DR 103), 222–23; cat. no. 150

Black Bow, The (H 511), 57–58, 59, 64, 278; cat. no. 36

Black Horse, The (H 88; DR 95), 156–57, 161, 163; cat. no. 106

Bootblack (H 447), 228; cat. no. 155

Bouquet (H 3; DR 7), 103, 108–9; cat. no. 75

Boy Viewed from Behind (H 596; DR 97c), 161–62, 286; cat. no. 111

Bridge, The; View of the Seine (H 77; DR 78), 85, 135–36, 139; cat. no. 95

Bridge at Courbevoie, The (H 178; DR 172), 126, 247, 256, 258, 261, 297, 380, 406; cat. no. 171

Bridge at Courbevoie, The (H 653; DR 172a), 258; cat. no. 172

Cadet from Saint-Cyr (H 130; DR 115), 196; cat. no. 132

Carriage and Dog (H 543), 99, 270; cat. no. 70

Chahut, see Seurat, Georges, works by (French titles), *Chahut*

Channel of Gravelines: Evening, The (H 210; DR 203), 349, 354, 360, 411; cat. no. 221; studies for, 356, 357; cat. nos. 222–24

Channel of Gravelines: Grand Fort Philippe, The (H 205; DR 206), 349, 353, 360, 411; cat. no. 220

Channel of Gravelines: Petit Fort Philippe, The (H 208; DR 205), 349, 350, 360, 411; cat. no. 219

Child in White (H 631; DR 138b), 215–16; cat. no. 145

Circus, see Seurat, Georges, works by (French titles), *Cirque*

Circus Sideshow (H 187; DR 181), *see* Seurat, Georges, works by (French titles), *Parade de Cirque*

Circus Sideshow (H 681; DR 181a), 312, 316, 393, 403; cat. no. 204

Clearing, The; Landscape with a Stake (H 28; DR 26), 104, 105, 119; cat. no. 83

Clothing on the Riverbank (H 81; DR 89), 158–59; cat. no. 108

Clown and Ringmaster (H 710; DR 210e), 361, 364, 367; cat. no. 227

Clown, Study for "Circus" (H 712; DR 210c), 361, 364, 369; cat. no. 229

Concierge (H 603), 59–60; cat. no. 38

Condolences; Family Gathering (H 655), 170, 230, 232, 269, 380–81, 403; cat. no. 158

Corner of Dock Basin, Honfleur (H 163), 235, 381, 404, 405; *234*

Corner of the Studio; The Stove (H 661; DR 178a), 271, 277, 289, 291; cat. no. 189

Couple, The (H 438), 30–31; cat. no. 17

Couple, The (H 138; DR 136), 202–3, 210; cat. no. 137

Couple, The (H 644; DR 135a), 31, 203–4; cat. no. 138

Courbevoie: Factories by Moonlight (H 536), 89; cat. no. 63

Courbevoie, Landscape with Turret (H 96; DR 106), 143, 144; cat. no. 102

Dancer with Cane (H 682), 316; *315*

Dozing Man (H 590; DR 97g), 167; cat. no. 116

Drawbridge (H 608), 34, 81, 89; cat. no. 64

Drummer at Montfermeil (H 442), 30, 33, 37; cat. no. 37

Echo, The (H 597; DR 97a), 169; cat. no. 117

Eden Concert (H 688), 272, 296, 297–98, 300, 406, 408; cat. no. 193

Edge of the Wood, Springtime (H 51; DR 54), 130–31; cat. no. 91

Eiffel Tower, The (H 196; DR 191), 11, 328, 377, 408; cat. no. 210

Embroidery; The Artist's Mother (H 582), 11, 51, 53, 54, 147, 401; cat. no. 32

End of the Jetty, Honfleur (H 170), 380

Evening, Honfleur (H 167; DR 171), 236, 247, 322, 376, 405, 406, 407; cat. no. 166

Evening, Study for "The Channel of Gravelines: Evening" (H 696; DR 202a), 354, 357; cat. no. 224

Farm Women at Work (H 60; DR 41), 104, 105, 132, 220; cat. no. 93

Field of Alfalfa, Saint-Denis (H 145; DR 159), 220, 224, 404; cat. no. 152

Final Study for "Une Baignade, Asnières" (H 93; DR 97), 151, 161, 380; *161*

Fisherman, 380

Fishermen (H 78; DR 80), 138–39, 170, 380, 403; cat. no. 97

Fisherwoman and Seated Figures (H 120; DR 128), 189, 190, 192; cat. no. 128

Five Heads, After Old Masters, 11

Foal (H 527), 84; cat. no. 57

Forest at Pontaubert, The (H 14; DR 8), 113–14, 115, 116, 136; cat. no. 79

Forest Path, Barbizon, 136–37; cat. no. 96

Fort Samson at Grandcamp (H 157), 239, 244; study for, 243–44; cat. no. 163

Gardener (H 562), 43–44; cat. no. 25

Gardener, The (H 101; DR 48), 44, 105–6, 134–35, 139; cat. no. 94

Gateway (H 651), 97; cat. no. 69

Girl in a Slouch Hat (H 573), 63–64; cat. no. 41

Gray Weather on the Grand Jatte (H 177; DR 190), 258, 261, 409, 410; cat. no. 173

Hackney Coach (H 481), 269–70; cat. no. 180

Hand of Poussin, After Ingres, The (H 285), 15–16; cat. no. 3

Hat, Slippers, Undergarments (H 593), 291; *289*

Haystacks (H 540), 81, 97; cat. no. 56

Head of a Clown (H 709; DR 210f), 361, 364, 367, 368; cat. no. 228

Head of a Man (H 260), 19; cat. no. 6

Head of a Young Woman (H 2; DR 2), 103, 107; cat. no. 74

High Collar, The; Lady in Black (H 508), 58, 59, 188, 230; cat. no. 37

Honfleur, Entrance to the Harbor (H 171), 252, 380

Horse and Cart (H 46; DR 31), 220; cat. no. 149

Horsecart (H 646), 85, 269; cat. no. 59

Horses in the Water (H 86; DR 88), 149, 150, 154, 156; cat. no. 105

House at Dusk (H 545), 77; cat. no. 53

Housepainter (H 565), 47, 69, 70, 261; cat. no. 46

House with the Red Roof (H 55; DR 73), 131–32; cat. no. 92

Lamp, The (H 578), 34, 54, 266; cat. no. 34

Landscape at Saint-Ouen (H 7; DR 3), 105, 109; cat. no. 76

Landscape, Island of the Grande Jatte (H 131; DR 116), 172, 204, 206; cat. no. 139

Landscape, Island of the Grande Jatte (H 641; DR 116c), 206; cat. no. 140

Landscape of the Île de France (H 18; DR 27), 116, 124; cat. no. 81

Landscape with Copy After "Le pauvre pêcheur" (H 6; DR 4), 109, 149, 401; cat. no. 77

Landscape with Figures (H 112; DR 110), 172, 180–81; cat. no. 118

Landscape with Houses (H 455), 73; cat. no. 50

Le Crotoy, Downstream (H 195; DR 192), 331, 409, 411; cat. no. 211

Le Crotoy, Upstream (H 194; DR 193), 331, 333, 409, 411; cat. no. 212

Lighthouse and Mariners' Home, Honfleur (H 173; DR 168), 73, 236, 244, 247, 249, 404, 405, 406; cat. no. 167; study for, 249, 252; cat. no. 168

Lighthouse at Honfleur (H 656; DR 163a), 252, 406; cat. no. 169

Locomotive (H 478), 34, 81, 89; cat. no. 55

Male Nude Combatting a Lion, After Lehmann, 18; cat. no. 5

Male Nude, Profile (H 278), 23–24; cat. no. 10

Man Dining; The Artist's Father (H 600), 11, 53–54, 272, 408; cat. no. 33

Man Hoeing with a Cultivator (H 558), 42–43; cat. no. 24

Man in a Bowler Hat (H 591; DR 97f), 165, 167; cat. no. 114

Man in a Top Hat (H 571), 71; cat. no. 48

Man in Shirt Sleeves Working the Soil, see *Gardener*

Man Leaning on a Parapet (H 459; DR 9b), 27–28; cat. no. 14

"Maria" at Honfleur, The (H 164; DR 169), 255, 406; cat. no. 170

Market Porter (H 484), 34–35, 60, 62, 63–64; cat. no. 39

Maurice Appert (H 607), 11, 45, 262–64; cat. no. 175

Men in Front of a Factory (H 550), 34, 47, 84–85, 136; cat. no. 58

Men Laying Stakes (H 39; DR 51), 126; cat. no. 88

Model Facing Front (H 179; DR 173), 271, 275, 277, 281, 282, 283; cat. no. 183

Model Facing Front (H 664; DR 174a), 271, 276, 281, 282–83, 287, 291, 293; cat. no. 184

Model Facing Front (H 183; DR 174), 271, 275, 276, 277, 278, 279, 281, 283–84, 286, 289, 297, 328, 406; cat. no. 185

Model from the Back (H 181; DR 176), 271, 275, 277, 278, 283, 284, 286–87, 289; cat. no. 187

Model in Profile (H 182; DR 175), 271, 277, 283, 284, 285–86, 289; cat. no. 186; infrared photograph of, *285*

Models (H 184; DR 179), 271, 289, 291, 295; cat. no. 191

Models, Small Sketch (H 180; DR 177), 271, 277, 278, 283, 286, 289, 291, 295; cat. no. 188

Model Standing (H 665; DR 179a), 271, 283, 293, 316, 385; cat. no. 192

Monkey (H 636; DR 134d), 199–200; cat. no. 135

Monkeys (H 640; DR 134a), 198–99, 200; cat. no. 134

Monsieur Loyal and Pony, Study for "Circus Sideshow" (H 669; DR 180c), 312, 314–16; cat. no. 203

Mower, The (H 58; DR 39), 44, 105, 112–13, 128, 135; cat. no. 78

Music Hall Scene (H 683), 270, 299–300; cat. no. 195

Nude, from "A Study of Three Warriors," 15

Nude Leaning Against a Table, 15

Nurse (H 488), 40, 45, 66, 230; cat. no. 26

Nurse (H 630; DR 138c), 216; cat. no. 146

Nurse and Child (H 487), 40–41, 66; cat. no. 22

Nurse with Carriage (H 485), 40, 45, 65–66; cat. no. 43; verso of, 66; *65*

On the Balcony (H 587), 47, 100, 266; cat. no. 28

Orange Vendor (H 450), 30, 33, 35, 39–40; cat. no. 21

Parthenon Ilissus, The (H 221), 14; cat. no. 1

Paul Alexis (H 691), 339, 340, 409, 410; *339*

Paul Signac (H 694), 339, 340, 410; cat. no. 216

Pierrot and Columbine (H 674), 270, 303, 304; cat. no. 199

Pink Landscape (H 98; DR 43), 143–44; cat. no. 101

Place de la Concorde, Winter (H 564), 34, 89, 93; cat. no. 65

Plowing (H 525), 34, 47, 78, 88, 97; cat. no. 54

Poplars (H 554), 101; cat. no. 72

Port-en-Bessin, Entrance to the Outer Harbor (H 192; DR 186), 322, 327, 410; cat. no. 207

Port-en-Bessin, the Bridge and the Quays (H 188; DR 187), 233, 318, 320, 327, 409; cat. no. 209

Port-en-Bessin, the Outer Port (High Tide) (H 193; DR 188), 320, 322, 325, 409, 410; cat. no. 206

Port-en-Bessin: the Outer Harbor (Low Tide) (H 189; DR 184), 325, 409, 410; cat. no. 208

Port-en-Bessin, the Semaphore and Cliffs (H 190; DR 185), 318, 320, 409, 410; cat. no. 205

Ragpicker, The (H 520), 34; *33*

Railroad Station (H 472), 25, 75, 89; cat. no. 12

Railway Tracks (H 471), 75; cat. no. 51

Rain (H 519), 93; cat. no. 66

Rainbow (H 89; DR 92), 153–54, 163; cat. no. 104

Reading (H 585), 47, 265–66, 271, 272, 408; cat. no. 177

Reaper, The (H 456), 43; *42*

Reclining Man (H 589; DR 97h), 167; cat. no. 115

Reclining Nude (H 660), 275; *276*

Riverbanks, The (H 79; DR 84), 152–53; cat. no. 103

Riverman; Fisherman (H 65; DR 99), 223–24; cat. no. 151

River's Edge (H 67), 106, 141; cat. no. 99

Riverside, The (H 10; DR 17), 106, 123–24; cat. no. 86

Roadstead at Grandcamp, The (H 160; DR 154), 170, 235, 239, 403, 404, 405, 407; cat. no. 160

Romulus, Conqueror of Acron, After Ingres (H 309), 17; cat. no. 4

Rose-Colored Skirt, The (H 121; DR 127), 173, 185, 190, 193–95, 202; cat. no. 130

Rue Saint-Vincent, The (H 104; DR 104), 142, 403; cat. no. 100

Rue Saint-Vincent, Winter, The (H 70), 380

Sailboat (H 110; DR 109), 183, 185; cat. no. 121

Sailboats, Study for "The Channel of Gravelines: Evening" (H 702; DR 202b), 354, 357; cat. no. 223

Scaffolding (H 567), 261–62; cat. no. 174

Sea at Grandcamp, The (H 152), 380

Seated and Standing Women (H 125; DR 124), 173, 185, 194, 206; cat. no. 122

Seated Bather (H 91; DR 96), 159, 161; cat. no. 109

Seated Boy, Nude (H 598; DR 97b), 165; cat. no. 113

Seated Boy with Straw Hat (H 595), 162–64; cat. no. 112

Seated Man, Reclining Woman (H 109; DR 126), 192–93; cat. no. 129

Seated Soldier, and Other Studies (H 366), 27, 29–30, 31, 400; cat. no. 16

Seated Woman (H 403), 32; cat. no. 18

Seine at Courbevoie, The (H 134; DR 161), 170, 220, 224, 226–27, 258, 261, 381, 403, 404; cat. no. 153; study for, 224, 227; cat. no. 154

Seven Monkeys (H 639; DR 134c), 47, 201; cat. no. 136

Shore at Bas-Butin, Honfleur, The (H 169; DR 165), 244, 247, 381, 404, 405, 406; cat. no. 164; study for, 246; cat. no. 165

Sibyl, After Raphael, A (H 255), 14–15; cat. no. 2

Sidewalk Show (H 668), 68, 170, 266, 312, 315, 316, 380–81; cat. no. 45

Sketch for "Circus" (H 212; DR 210), 363, 364, 366, 367, 370, 423; cat. no. 226

Sketch with Many Figures (H 128; DR 119), 188, 190; cat. no. 127

Skirt (H 624; DR 133c), 165, 219; cat. no. 148

Soldier Fencing, Another Reclining (H 380), 28–29, 31, 400; cat. no. 15

Soldier Seated, and Other Studies (H 366), 29–30; cat. no. 16

Standing Nude, Weight on Left Leg, 23

Steamboat (H 654), 86, 88; cat. no. 61

Still Life with Hat, Umbrella, and Clothes on a Chair (H 663; DR 178b), 271, 278, 291–92; cat. no. 190

Stone Breaker (H 556), 38–39; cat. no. 20

Stone Breaker (H 36; DR 28), 119, 122; cat. no. 84

Stone Breaker and Wheelbarrow, Le Raincy (H 100; DR 49), 38, 104, 119, 127–28, 135; cat. no. 89

Stone Breaker at Montfermeil, 381

Stone Breaker, Le Raincy (H 463), 27, 119; cat. no. 13

Stone Breakers, Le Raincy (H 38), 38; *38*

Street Sweeper (H 560), 261, 272, 408; cat. no. 182

Study for "A Sunday on La Grande Jatte" (H 142; DR 138), 173, 188, 208, 210–11, 312, 376; cat. no. 141; details of, *208, 210, 211*; X-ray photograph of, *208*

Study for "Chahut" (H 197; DR 197), 346–47; cat. no. 217

Study for "Chahut" (H 198; DR 198), 347–48; cat. no. 218

Study for "Fort Samson at Grandcamp" (H 156; DR 156), 243–44, 381; cat. no. 163

Study for "Lighthouse and Mariners' Home, Honfleur" (H 172; DR 167), 249, 252; cat. no. 168

Study for "The Bec du Hoc" (H 158; DR 152), 242–43; cat. no. 162

Study for "The Channel of Gravelines: Evening" (H 209; DR 202), 356; cat. no. 222

Study for "The Seine at Courbevoie" (H 133; DR 160), 224, 227; cat. no. 154

Study for "The Shore at Bas-Butin, Honfleur" (H 168; DR 164), 246; cat. no. 165

Study for "Young Woman Powdering Herself" (DR 194), 336; cat. no. 214

Study with Figures (H 117; DR 114), 51, 172, 181–82; cat. no. 119

Suburb (H 75; DR 13), 27, 119, 123, 124; cat. no. 82

Sunday Afternoon on the Grande Jatte, see Seurat, Georges, works by (French titles), *Dimanche à la Grande Jatte, Un*

Three Boats and a Sailor (H 153), 380

Three Men Seated (H 122; DR 121), 183, 189–90; cat. no. 126

Three Young Women (H 633; DR 138d), 216, 218; cat. no. 147

Tipcart (H 531), 93; cat. no. 67

Tree (H 619; DR 116a), 185; cat. no. 123

Tree by a Road (H 539), 75; cat. no. 52

Trees Against the Sky (H 530), 31, 34, 97; cat. no. 68

Trees by the Riverside (H 553), 101–2; cat. no. 73

Tree, Study for "Circus Sideshow" (H 667; DR 180a), 312; cat. no. 201

Tree Trunk (H 546), 24–25; cat. no. 11

Tree Trunks (H 620), 186; cat. no. 124

Trombonist, Study for "Circus Sideshow" (H 680; DR 180b), 312, 313–14; cat. no. 202

Truth Emerging from the Well (H 4), 106

Turrets (H 473), 88–89; cat. no. 62

Two Clowns (H 675), 68, 232, 266; cat. no. 178

Under the Bridge; The Tramp (H 645), 72; cat. no. 49

Veil, The (H 568), 64, 269, 270, cat. no. 42

Village Road (H 53; DR 68), 75, 128; cat. no. 90

White Houses, Ville d'Avray (H 20; DR 34), 116, 124, 132; cat. no. 87

White Smock (H 475), 264–65; cat. no. 176

Wine Tumbril (H 526), 86; cat. no. 60

Wintry Suburb (H 71; DR 61), 122–23; cat. no. 85

Woman Fishing, A (H 635; DR 131a), 188–89; cat. no. 125

Woman Raising Her Parasol (H 503), 229–30; cat. no. 157

Woman Reading (H 584), *54*

Woman Reading in the Studio (H 601), 270–71, 272, 280, 408; cat. no. 181

Woman Seated in the Grass (H 59; DR 29), 139; cat. no. 98

Woman Seen from the Back, Bending Forward (H 494), 47, 48, 100; cat. no. 29

Woman Sewing (H 126; DR 125), 182–83, 204; cat. no. 120

Woman Sewing, Unfinished (H 446), 41; cat. no. 23

Woman Standing (485), 66; *65*

Woman with a Dog (H 649), 56; cat. no. 35

Woman with a Monkey (H 137; DR 134), 177, 196, 198, 380; cat. no. 133

Woman with a Muff (H 612), 228–29, 230; cat. no. 156

Woman with a Parasol (H 628; DR 138g), 213, 214; cat. no. 143

Woman with Basket (H 464), 27; *27*

Woman with Bouquet, Seen from Behind (H 496), 46, 57; cat. no. 27

Women Seated and Baby Carriage (H 129; DR 129), 195–96, 202, 216; cat. no. 131

Young Girl (H 236), 275; *276*

Young Girl (H 501), 62; cat. no. 40

Young Peasant in Blue (H 16; DR 44), 115–16; cat. no. 80

Young Peasant Sitting in a Meadow (H 15), 116; *115*

Young Woman Powdering Herself (H 200; DR 195), 286, 292, 333–36, 340, 343, 376, 410; cat. no. 213; study for, 336; cat. no. 214

Young Woman Seated (H 632; DR 138i), 212; cat. no. 142

Young Woman with Parasol (H 629; DR 138f), 214; cat. no. 144

Seurat, Georges, works by (French titles)

Abords du village (H 53; DR 68), 75, 128; cat. no. 90

Académie, de profil, tête baissée (H 278), 23–24; cat. no. 10

À deux chevaux (H 526), 86; cat. no. 60

À la Gaîté Rochechouart (H 685; Providence), 270, 272, 296, 300–301, 303, 408, 409; cat. no. 196

À la Gaîté Rochechouart (Cambridge), 300–301; *301*

Allée en forêt, Barbizon, 136–37; cat. no. 96

Aman-Jean (H 588), 49–50, 51, 70, 147, 270, 339, 377, 378, 401, 402; cat. no. 30

Anaïs Faivre Haumonté sur son lit de mort, 11, 64, 232, 269, 339, 407; cat. no. 179

Angélique, d'après Ingres (H 315; DR 1a), 20, 275; cat. no. 8

Arbre, L' (H 619; DR 116a), 185; cat. no. 123

Arbre et route (H 539), 75; cat. no. 52

Arbre, étude pour "Parade de cirque," L' (H 667; DR 180a), 312; cat. no. 201

Arbres grêles (H 530), 31, 34, 97; cat. no. 68

Arc-en-ciel, L' (H 89; DR 92), 153–54, 163; cat. no. 104

Attelage à deux chevaux (H 646), 85, 269; cat. no. 59

Au Concert Européen (H 689), 296, 298–99, 300, 408, 409; cat. no. 194

Au Concert Parisien (H 687), 270, 300, 302; cat. no. 197

Au Divan Japonais (H 690), 296, 345, 346, 408, *346*

Badigeonneur, Le (H 565), 47, 69, 70, 261; cat. no. 46

Baignade, Asnières, Une (H 92; DR 98), 3, 13, 33, 70, 113, 147–51, 220, 280, 381, 382, 401, 412, 423, 424; *146–47*; allegorical aspect of, 151; brushwork in, 104; classicism of, 385; compared to *Doux pays* (Puvis de Chavannes), 148, 149, 151; compared to *La Grande Jatte*, 175–76, 179, 181, 182, 190; compared to *Poseuses*, 291; composition of, 151, 158, 159; as culmination of schoolboy training, 148; currents forming influence on, 148; exhibitions of, 33, 106, 147, 342, 401; handling of figures in, 148, 149, 157, 161, 162, 163–64, 165, 167, 169, 275; handling of landscape in, 150, 154, 156, 158, 161; idealization of, 150–51; Impressionism and, 27, 148, 149–50, 154; leisure cohabiting with industry, as theme of, 27, 136, 148; monumentality of, 305; naturalism and, 148, 150–51, 175–76, 336; palette of, 150; as plein-air painting, 305; preoccupation with, 149; reviews of, 147–48, 151; reworking of, 179; studies for, 136, 141, 149, 150, 151, 152–69, 286, 291, 302, 354, 361; *289*; cat. nos. 103–17; style of, 6, 139, 148, 149, 150, 151; subject matter of, 150, 151, 154; transitional aspect of, 27, 114, 139

Baigneur nu (H 91; DR 96), 159, 161; cat. no. 109

Balayeur (H 560), 261, 272, 408; cat. no. 182

Balcon, Le (H 586), 47, 100–101; cat. no. 71

Ballerine au chapeau blanc, La (H 677), 30

Banlieue (H 75; DR 13), 27, 119, 123, 124; cat. no. 82

Banlieue sous la neige (H 72), 123

Banquiste, La (H 671), 34–35, 37, 66, 68, 170, 232, 403; cat. no. 44

Banquistes (H 384), 30

Bateau à vapeur, Le (H 654), 86, 88; cat. no. 61

Bateaux (H 155), 404

Bec du Hoc, Grandcamp, Le (H 159; DR 153), 170, 235, 239, 240, 403, 404, 405, 407; cat. no. 161; study for, 242–43; cat. no. 162

Blouse blanche (H 475), 264–65; cat. no. 176

Bonnet à rubans, Le (H 485), 40, 45, 65–66; cat. no. 43; verso of, 66; *65*

Bords de la Seine (Croqueton) (H 132), 404

Bords de la Seine (Île de la Grande-Jatte) (H 176), 409

Bords de rivière (H 553), 101–2; cat. no. 73

Bords de rivière (H 67), 106, 141; cat. no. 99

Bouquet dans un vase (H 3; DR 7), 103, 108–9; cat. no. 75

Bout de la jetée d'Honfleur, 406

Broderie; La mère de l'artiste (H 582), 11, 51, 53, 54, 147, 401; cat. no. 32

Carriole et le chien (H 543), 99, 270; cat. no. 70

Casseur de pierres (H 556), 38–39, 44; cat. no. 20

Casseur de pierres (H 36; DR 28), 119, 122; cat. no. 84

Casseur de pierres à la brouette, Le Raincy (H 100; DR 49), 38, 104, 119, 127–28, 135; cat. no. 89

Casseur de pierres à Montfermeil, 381

Casseur de pierres, Le Raincy (H 463), 27, 119; cat. no. 13

Casseurs de pierres, Le Raincy (H 38), *38*

Chahut (H 199; DR 199), 3, 280, 303, 340–45, 360, 376, 412, 423; *341*; caricature, as element in, 338, 340, 342, 344, 361; composition of, 297; exhibitions of, 309, 312, 333, 340, 343, 376, 377, 410, 411; frame used for, 376, 377; as interior (indoor scene), 305, 336; musical element of, 376; painted border of, 336, 376; popular arts, as element of, 342, 343; reviews and writings on, 333, 340, 342, 343, 344, 345, 386; schematic quality of the linear structure of, 340; social content of, 344; studies for, 346–48; cat. nos. 217, 218; style of, 309, 311, 340, 342

Chapeau et ombrelle (H 663; DR 178b), 271, 278, 291–92; cat. no. 190

Chapeau, souliers, linge (H 593), 291; *289*

Charrette attelée, La (H 46; DR 31), 220; cat. no. 149

Chef d'orchestre (H 672), 270, 303; cat. no. 198

Chenal de Gravelines: direction de la mer (H 206), 411

Chenal de Gravelines: Grand-Fort-Philippe, Le (H 205; DR 206), 349, 353, 360, 411; cat. no. 220

Chenal de Gravelines: Petit-Fort-Philippe, Le (H 208; DR 205), 349, 350, 360, 411; cat. no. 219

Chenal de Gravelines: un soir, Le (H 210; DR 203), 349, 354, 360, 411; cat. no. 221; studies for, 356, 357; cat. nos. 222–24

Cheval au tombereau, Le (H 531), 93; cat. no. 67

Cheval blanc, Le (H 87), 149

Cheval noir, Le (H 88; DR 95), 156–57, 161, 163; cat. no. 106

Chevaux dans l'eau (H 86; DR 88), 149, 150, 154, 156; cat. no. 105

Chiffonnier, Le (H 520), 34, 123; *33*

Cireur de bottes, Le (H 447), 228; cat. no. 155

Cirque (H 213; DR 211), 3, 360–64, 412, 423; cat. no. 225; caricature, as element in, 338, 361; composition of, 360, 363, 364, 368, 370; exhibitions of, 306, 360, 411; frame used for, 376; grid drawn on, before painting, 360, 363, 364; rendering of, *365*; as interior (indoor scene), 305, 336; infrared photograph of, 363; *365*; interpretations of, 361–62; musical element of, 376; painted border and frame of, 363–64; popular arts, as element of, 342, 361; reviews and writings on, 306, 345, 360, 361, 363; studies for, 361, 364, 366–70; cat. nos. 226–30; style of, 309, 311, 361, 363

Cité, La (H 545), 77; cat. no. 53

Clochetons (H 473), 88–89; cat. no. 62

Clown, dessin pour "Cirque" (H 712; DR 210c), 361, 364, 369; cat. no. 229

Clown et M. Loyal, Le (H 710; DR 210e), 361, 364, 367; cat. no. 227

Clown rouge, Le (H 385), 30

Cocher de fiacre (H 481), 269–70; cat. no. 180

Coin de l'atelier; Le fourneau (H 661; DR 178a), 271, 277, 289, 291; cat. no. 189

Coin d'un bassin, Honfleur (H 163), 235, 249, 381, 404, 405; *234*

Concierge, La (H 603), 59–60; cat. no. 38

Condoléances; Réunion de famille (H 655), 170, 230, 232, 269, 380–81, *403*; cat. no. 158

Convulsionnaires de Tanger, Les (H 386), 275

Couple, Le (H 438), 30–31, 37, 40; cat. no. 17

Couple, Le (H 138; DR 136), 202–3, 210; cat. no. 137

Couple, Le (H 644; DR 135a), 31, 203–4; cat. no. 138

Courbevoie, paysage à la tourelle (H 96; DR 106), 143, 144; cat. no. 102

Couseuse (H 446), 41; cat. no. 23

Couseuse (H 126; DR 125), 182–83, 204; cat. no. 120

Croqueton (Courbevoie) (H 116), 404

Croquis de la rue Saint-Vincent, effet de neige, Montmartre (H 70), 380

Dame au bouquet, de dos (H 496), 46, 57; cat. no. 27

Dame en noir, La (H 508), 58, 59, 188, 230; cat. no. 37

Danseur à la canne (H 682), 316; *315*

Danseuse de Corvi (H 381), 316; *315*

Deux rives, Les (H 79; DR 84), 152–53; cat. no. 103
Devant le balcon (H 587), 47, 48, 100, 266; cat. no. 28
Dimanche, Un (H 191), 318
Dimanche à la Grande Jatte, Un, 3, 7, 13, 70, 106,
 170–79, 220, 226, 229, 277, 280, 296, 361, 381, 382,
 383, 384, 402, 412, 423, 424; *170–71*; detail of,
 172; color handling in, 173–74, 196, 206, 210,
 336; compared to *Une Baignade*, 175–76, 179,
 181, 182, 190; composition of, 173, 183, 185,
 190, 204, 206, 210, 212, 215; controversy over,
 239, 275, 281; dates and method worked on, 170,
 172, 173, 204, 206, 210; Degas's reaction to, 174;
 drawing compared to, 71; Egyptian art evoked
 by, 263; exhibitions of, 3, 170, 172, 232, 239, 249,
 286, 403, 404, 405, 406; fame of, 3, 170, 178;
 figures handled in, 172–73, 175, 176–77, 178,
 185, 189, 190, 193, 194, 196, 206, 258;
 formula for dark shadow used in, 128; geometric
 elements of, 173; goals for, 174, 305, 392; humor
 and wit in, 228; Impressionism and, 176, 178,
 258; interpretations of, 177, 178, 179, 216; as
 landmark of early modern art, 170, 178; landscape
 handled in, 172, 182, 183, 185, 186, 190, 206;
 light and dark in, 203, 206, 212, 215; naturalism
 and, 176, 336; painted border and frame on, 204,
 206, 376, 377; as plein-air painting, 305; popular
 arts, relationship to, 175, 176, 342; primitivism
 of, 175; proportions of, 175, 189, 206; reviews,
 writings, and critical reaction to, 138, 170, 173,
 174, 175, 176, 177, 178, 179, 232, 239, 249, 263,
 273, 281, 345, 360; reworking of, 172, 173, 179,
 189, 204, 210, 219, 235; satire and irony in, 177,
 178; section of, painted into composition of
 Poseuses, 273, 275, 277, 278, 283, 286, 287, 289,
 291, 292, 376; social meaning of, 176, 177, 178,
 179; studies for, 66, 170, 172, 173, 179, 180–219,
 220, 223, 224, 227, 237, 312, 354, 361, 364; cat.
 nos. 118–48; style of, 3, 6, 174, 175, 176, 247,
 305, 334; unstable pigments used in, 172, 178–79,
 206, 210; varied brushstrokes used in, 173, 178
Dîneur, Le (H 600), 11, 53–54, 272, 408; cat. no. 33
Dormeur, Le (H 590; DR 97g), 161–62; cat. no. 116
Échafaudage, L' (H 567), 161–62; cat. no. 174
Écho, L' (H 597; DR 97a), 169; cat. no. 117
Écuyère, L' (H 707; DR 210d), 361, 364, 369; cat. no.
 230
Eden Concert (H 688), 272, 296, 297–98, 300, 406,
 408; cat. no. 193
Effet de neige; Hiver en banlieu (H 71; DR 61),
 122–23; cat. no. 85
Embouchure de la Seine, soir, Honfleur (H 167; DR
 171), 235, 236, 247, 322, 376, 405, 406, 407; cat.
 no. 166
Enfant blanc, L' (H 631; DR 138b), 215–16; cat. no.
 145
Entrée du port de Honfleur, L' (H 171), 252, 380, 406
Esquisse pour "Cirque" (H 212; DR 210), 363, 364,
 366, 367, 370, 423; cat. no. 226

Étude complète (H 93; DR 97), 151, 161, 380; *161*;
 cat. no. 110
Étude d'ensemble (H 142; DR 138), 173, 188, 208,
 210–11, 312, 376; cat. no. 141; details of, *208*,
 210, *211*; X-ray photograph of, *208*
Étude pour "Chahut" (H 197; DR 197), 346–47; cat.
 no. 217
Étude pour "Chahut" (H 198; DR 198), 347–48; cat.
 no. 218
Étude pour "Gravelines: un soir" (H 209; DR 202),
 356; cat. no. 222
Étude pour "Jeune femme se poudrant" (DR 194), 336;
 cat. no. 214
Étude pour "La grève du Bas-Butin, Honfleur" (H 168;
 DR 164), 246; cat. no. 165
Étude pour "La Seine à Courbevoie" (H 133; DR 160),
 224, 227; cat. no. 154
Étude pour "Le Bec du Hoc Grandcamp" (H 158; DR
 152), 242–43; cat. no. 162
Étude pour "Le Fort Samson à Grandcamp" (H 156;
 DR 156), 243–44, 381; cat. no. 163
Étude pour "L'hospice et le phare de Honfleur" (H 172;
 DR 167), 249, 252; cat. no. 168
Faucheur, Le (H 58; DR 39), 44, 105, 112–13, 128,
 135; cat. no. 78
Femme à l'ombrelle (H 628; DR 138g), 213, 214; cat.
 no. 143
Femme à l'ombrelle (H 503), 229–30; cat. no. 157
Femme au chien (H 649), 56; cat. no. 35
Femme au panier (H 464), 27; *27*
Femme au singe, La (H 137; DR 134), 177, 196, 198,
 380; cat. no. 133
Femme debout (H 485), 66; *65*
Femme de dos, penchée (H 494), 47, 48, 100; cat. no. 29
Femme lisant (H 584), 51; *54*
Femme nue étendue (H 660), 286
Femmes assises et voiture d'enfant (H 129; DR 129),
 195–96, 202, 216; cat. no. 131
Femme sur un banc (H 403), 32, 37, 40; cat. no. 18
Fort de la halle (H 484), 34–35, 60, 62, 63–64; cat.
 no. 39
Forte chanteuse (H 684), 296, 408
Fort Samson à Grandcamp, Le (H 157), 244, 403;
 study for, 243–44; cat. no. 163
Frileuse (H 612), 228–29, 230; cat. no. 156
Garçon assis portant un chapeau de paille (H 595),
 162–64; cat. no. 112
Garçon de dos (H 596; DR 97c), 161–62, 286; cat. no.
 111
Garçon nu assis (H 598; DR 97b), 165; cat. no. 113
Grandcamp (soir) (H 161), 404
Grève du Bas-Butin, Honfleur, La (H 169; DR 165),
 244, 247, 381, 404, 405, 406; cat. no. 164; study
 for, 246; cat. no. 165
Grande Jatte, La, see *Dimanche à la Grande-Jatte, Un*
Grille, La (H 651), 97; cat. no. 69
Groupe de gens (H 550), 34, 47, 84–85, 136; cat. no.
 58

Groupe de personnages (H 117; DR 114), 51, 172,
 181–82; cat. no. 119
Haut de forme, Le (H 571), 71; cat. no. 48
Homme à femmes, L' (H 695; DR 196a), 337–38,
 409; cat. no. 215
Homme assis, femme étendue (H 109; DR 126), 192–93;
 cat. no. 129
Homme au chapeau melon, L' (H 591; DR 97f), 165,
 167; cat. no. 114
Homme combat les animaux, d'après Lehmann, L', 18;
 cat. no. 5
Homme couché, L' (H 589; DR 97h), 167; cat. no. 115
Homme en bras de chemise travaillant la terre, see
 Jardinier, Le, cat. no. 25
Homme peignant son bateau (H 66), 106, 223
Hommes enfonçant des pieux; Bûcherons (H 39; DR 51),
 126; cat. no. 88
Hospice et le phare de Honfleur, L' (H 173; DR 168),
 73, 236, 244, 247, 249, 404, 405, 406; cat. no.
 167; study for, 249, 252; cat. no. 168
Ilissus du Parthénon, L' (H 221), 14; cat. no. 1
Invalide, L' (H 459; DR 9b), 27–28; cat. no. 14
Jardinier, Le (H 562), 43–44, 47; cat. no. 25
Jardinier, Le (H 101; DR 48), 44, 105–6, 134–35,
 139; cat. no. 94
Jetée d'Honfleur, La (H 170), 380, 405
Jeune femme à l'ombrelle (H 629; DR 138f), 214; cat.
 no. 144
Jeune femme assise (H 632; DR 138i), 212; cat. no.
 142
Jeune femme se poudrant (H 200; DR 195), 286, 292,
 333–36, 340, 343, 376, 410; cat. no. 213; study
 for, 336; cat. no. 214
Jeune fille (H 236), 275; *276*
Jeune fille au chevalet; Lecture (H 601), 270–71, 272,
 280, 408; cat. no. 181
Joueur de trombone, étude pour "Parade de cirque"
 (H 680; DR 180b), 312, 313–14; cat. no. 202
Jupe (H 624; DR 133c), 165, 219; cat. no. 148
Jupe rose, La (H 121; DR 127), 173, 185, 190,
 193–95, 202; cat. no. 130
Jupiter et Thétis (H 5), 106
Labourage, Le (H 525), 34, 47, 78, 88, 97; cat. no. 54
Laboureur, Le (H 558), 42–43; cat. no. 24
Lampe, La (H 578), 34, 54, 266; cat. no. 34
Le Crotoy, amont (H 194; DR 193), 331, 333, 409,
 411; cat. no. 212
Le Crotoy, aval (H 195; DR 192), 331, 409, 411; cat.
 no. 211
Lecture (H 585), 47, 265–66, 271, 272, 408; cat. no.
 177
Lisière du bois au printemps (H 51; DR 54), 130–31;
 cat. no. 91
Locomotive (H 478), 34, 81, 89; cat. no. 55
Lune à Courbevoie: Usines sous la lune, La (H 536), 89;
 cat. no. 63
Luzerne, Saint-Denis, La (H 145; DR 159), 220, 224,
 404; cat. no. 152

Mme Seurat, mère (H 583), 50, 51; cat. no. 31
Main de Poussin, d'après Ingres, La (H 285), 15–16;
 cat. no. 3
Maison au toit rouge, La (H 55; DR 73), 131–32; cat.
 no. 92
Maisons (H 455), 73; cat. no. 50
Marchand d'oranges, Le (H 450), 30, 33, 35, 39–40,
 41, 43, 46; cat. no. 21
"Maria" à Honfleur, La (H 164; DR 169), 235, 255,
 406; cat. no. 170
Maurice Appert assis (H 607), 11, 45, 262–64; cat. no.
 175
Mer à Grandcamp, La (H 152), 380
Meules, Les (H 540), 81, 97; cat. no. 56
Moissonneur, Le (H 456), 43; *42*
Monsieur Loyal et poney, étude pour "Parade de cirque"
 (H 669; DR 180c), 312, 314–16; cat. no. 203
Mouillage à Grandcamp, Le (H 146; DR 142), 237;
 cat. no. 159
Noeud noir, Le (H 511), 57–58, 59, 64, 278; cat. no.
 36
Nourrice, La (H 488), 40, 45, 46, 66, 230; cat. no. 26
Nourrice, La (H 630; DR 138c), 216; cat. no. 146
Nourrice et enfant (H 487), 40–41, 45, 66; cat. no. 22
Nu couché (H 660), 275; *276*
Nu debout, hanchant à gauche, 23
Nu de dos, appuyé sur un bâton (H 265), 19, 20, 22;
 cat. no. 7
Parade, Une (H 675), 68, 232, 266; cat. no. 178
Parade, Une; Clowns et poney (H 668), 68, 170, 266,
 312, 315, 316, 380–81; cat. no. 45
Parade de cirque (H 187; DR 181), 3, 233, 261, 266,
 280, 305–12, 360, 392, 393; *306–7*; cat. no. 200;
 brushwork in, 308–9; central role, in oeuvre of,
 305; compared to *Poseuses*, 275, 278, 314;
 composition of, 305, 312, 314, 315–16; details
 from, *308–11*; Egyptian art evoked by, 263;
 exhibitions of, 272, 305, 306, 308, 309, 311, 312,
 392, 408; goals for, 305, 316; interpretation of,
 314; light, as key feature of, 305–6, 308; literary
 source for, 309–10; musical element of, 376;
 mysteriousness of, 305, 311; as outdoor scene, by
 artificial light, 275; painted border for, 309;
 pointillist technique perfected in, 308; popular
 arts, as element of, 342; possible studies for, 303,
 304; problems with the exhibition of, 308; reviews
 and writings on, 305, 306, 327; studies for, 68,
 272, 312–16, 392, 393; *317*; cat. nos. 201–4; style
 of, 305, 311, 316; underappreciated, 305–6
Parade de cirque (H 681; DR 181a), 312, 316, 393,
 403; cat. no. 204
Parade de danseuses (H 678), 30
Paul Alexis (H 691), 339, 340, 409, 410; *339*
Paul Signac (H 694), 339, 340, 410; cat. no. 216
Paysage au piquet (H 28; DR 26), 104, 105, 119; cat.
 no. 83
Paysage au tas de bois (H 7; DR 3), 105, 109; cat. no.
 76

Paysage avec "Le pauvre pêcheur (H 6; DR 4), 109, 149, 401; cat. no. 77

Paysage dans l'Île de France (H 18; DR 27), 116, 124; cat. no. 81

Paysage d'eau (H 10; DR 17), 106, 123–24; cat. no. 86

Paysage et personnages (H 112; DR 110), 172, 180–81; cat. no. 118

Paysage et personnages (H 125; DR 124), 173, 185, 194, 206; cat. no. 122

Paysage, l'Île de la Grande Jatte (H 131; DR 116), 172, 204, 206; cat. no. 139

Paysage, l'Île de la Grande Jatte (H 641; DR 116c), 206; cat. no. 140

Paysage rose (H 98; DR 43), 143–44; cat. no. 101

Paysanne assise dans l'herbe (H 59; DR 29), 139; cat. no. 98

Paysannes à Montfermeil (H 34), 106

Paysannes au travail (H 60; DR 41), 104, 105, 132, 220; cat. no. 93

Paysans enfonçant des pieux (H 38), 126

Pêcheur, Le (H 65; DR 99), 223–24; cat. no. 151

Pêcheur à la ligne, 380

Pêcheurs à la ligne, Les (H 78; DR 80), 138–39, 170, 380, 403; cat. no. 97

Pêcheuse à la ligne, La (H 635; DR 131a), 188–89; cat. no. 125

Peintre au travail, Le (H 602), 70; cat. no. 47

Personnages dans l'eau (H 84; DR 91), 157–58; cat. no. 107

Petite esquisse (H 128; DR 119), 188, 190; cat. no. 127

Petite fille au chapeau niniche (H 573), 63–64; cat. no. 41

Petit paysan assis dans un pré (H 15), 116, 139; *115*

Petit paysan en bleu, Le (H 16; DR 44), 115–16; cat. no. 80

Peupliers, Les (H 554), 101; cat. no. 72

Phare de Honfleur, Le (H 656; DR 163a), 252, 406; cat. no. 169

Pied droit, Un (H 289), 15

Pierrot (H 95), 350, 380

Pierrot et Colombine (H 674), 270, 303, 304; cat. no. 199

Place de la Concorde, hiver (H 564), 34, 89, 93; cat. no. 65

Pluie, La (H 519), 93; cat. no. 66

Plusieurs personnages assis; Petite esquisse (H 120; DR 128), 189, 190, 192; cat. no. 128

Pont, Le (H 77; DR 78), 85, 135–36, 139; cat. no. 95

Pont Bineau, Le (H 106; DR 103), 222–23; cat. no. 150

Pont de Courbevoie, Le (H 178; DR 172), 126, 247, 256, 258, 261, 297, 380, 406; cat. no. 171

Pont de Courbevoie, Le (H 653; DR 172a), 258; cat. no. 172

Pont-levis, Le (H 608), 34, 81, 89; cat. no. 64

Port-en-Bessin, entrée de l'avant-port (H 192; DR 186), 322, 327, 410; cat. no. 207

Port-en-Bessin, l'avant-port (marée basse) (H 189; DR 184), 325, 409, 410; cat. no. 208

Port-en-Bessin, l'avant-port (marée haute) (H 193; DR 188), 320, 322, 325, 409, 410; cat. no. 206

Port-en-Bessin, le pont et les quais (H 188; DR 187), 233, 318, 320, 327, 409; cat. no. 209

Port-en-Bessin, les grues et la percée (H 190; DR 185), 318, 320, 409, 410; cat. no. 205

Port-en-Bessin—Les jetées, 409

Port-en-Bessin—Un dimanche (H 191), 409, 410

Poseuse debout (H 665; DR 179a), 271, 283, 293, 316, 385; cat. no. 192

Poseuse de dos (H 181; DR 176), 271, 275, 277, 278, 283, 284, 286–87, 289; cat. no. 187

Poseuse de face (H 179; DR 173), 271, 275, 277, 281, 282, 283; cat. no. 183

Poseuse de face (H 664; DR 174a), 271, 276, 281, 282–83, 287, 291, 293; cat. no. 184

Poseuse de face (H 183; DR 174), 271, 275, 276, 277, 278, 279, 281, 283–84, 286, 289, 297, 328, 406; cat. no. 185

Poseuse de profil (H 182; DR 175), 271, 277, 283, 284, 285–86, 289; cat. no. 186; infrared photograph of, *285*

Poseuses, 3, 233, 273–80, 381, 406, 407, 408; *274*; caricature, as element of, 277, 278, 292, 295; compared to *Une Baignade*, 291; compared to *Parade de cirque*, 275, 278, 314; composition of, 277, 278, 279, 283, 286, 289, 291–92, 293, 295; exhibitions of, 272, 279, 289, 305, 376, 408, 409; frame used for, 376, 377; as interior (indoor scene), by daylight, 275; influenced by Renaissance painting, 276; isolation of, at the Barnes Foundation, 280, 295; models for, 278, 286, 287; painted frame for, 364; painting tradition of the subject matter of, 273, 276–77, 279–80, pointillist technique perfected in, 308; price for, 409; psychological isolation of the figures in, 273; reviews and writings on, 278, 279, 306; section of *La Grande Jatte* painted into, 273, 275, 277, 278, 283, 286, 287, 289, 291, 292, 376; studies for, 277–78, 281–95; cat. nos. 183–92; techniques and style used for, 278–79, 286, 289, 295

Poseuses, ensemble (H 184; DR 179), 271, 289, 291, 295; cat. no. 191

Poseuses, petite esquisse (H 180; DR 177), 271, 277, 278, 283, 286, 289, 291, 295; cat. no. 188

Poulain, Le (H 527), 84; cat. no. 57

Printemps à la Grande Jatte (H 176), 261, 410

Promeneuse à l'ombrelle (H 625), 219

Rade de Grandcamp, La (H 160; DR 154), 170, 235, 239, 403, 404, 405, 407; cat. no. 160

Répétition, La (H 676), 30

Romulus vainqueur d'Acron, d'après Ingres (H 309), 17; cat. no. 4

Roses dans un vase (H 572), 109

Route de la gare (H 472), 25, 75, 89; cat. no. 12

Rue Saint-Vincent, La (H 104; DR 104), 142, 403; cat. no. 100

Rue Saint-Vincent, hiver, La (H 70), 142

Saint-Cyrien, Le (H 130; DR 115), 196; cat. no. 132

Satyr et chèvre, d'après l'antique (H 300), 20–22; cat. no. 9

Scène de théâtre (H 683), 270, 299–300; cat. no. 195

Seine à Courbevoie, La (H 134; DR 161), 170, 220, 224, 226–27, 258, 261, 381, 403, 404; cat. no. 153; study for, 224, 227; cat. no. 154

Sept singes (H 639; DR 134c), 47, 201; cat. no. 136

Sibylle, d'après Raphaël, Une (H 255), 14; cat. no. 2

Silhouette de femme; La dame jouffue (H 501), 62–63; cat. no. 40

Singe, Le (H 636; DR 134d), 199–200; cat. no. 135

Singes (H 640; DR 134a), 198–99, 200; cat. no. 134

Soir, dessin pour "Gravelines: un soir," Un H 696; DR 202a), 354, 357; cat. no. 224

Soldat assis... (H 366), 27, 29–30, 31, 400; cat. no. 16

Sous-bois à Pontaubert (H 14; DR 8), 113–14, 115, 116, 136; cat. no. 79

Sous la voûte; Le clochard (H 645), 72; cat. no. 49

Tabouret et soulier (H 658), 380

Tambour à Montfermeil (H 442), 30, 33, 37, 39; cat. no. 19

Temps gris à la Grande Jatte (H 177; DR 190), 258, 261, 409, 410; cat. no. 173

Terrassiers, Les (H 18), 126

Tête de clown (H 709; DR 210f), 361, 364, 367, 368; cat. no. 228

Tête de jeune fille (H 2; DR 2), 103, 107; cat. no. 74

Tête d'homme (H 260), 19; cat. no. 6

Torse d'après l'antique (H 238), 399

Tour Eiffel, La (H 196; DR 191), 11, 328, 377, 408; cat. no. 210

Trois bateaux et un marin (H 153), 380

Trois dos (H 122; DR 121), 183, 189–90; cat. no. 126

Trois jeunes femmes (H 633; DR 138d), 216, 218; cat. no. 147

Tronc d'arbre, Le (H 546), 24–25, 27, 47; cat. no. 11

Troncs d'arbres (H 620), 186; cat. no. 124

Troupier à l'escrime (H 380), 28–29, 31, 400; cat. no. 15

Vêtements sur l'herbe (H 81; DR 89), 158–59; cat. no. 108

Ville d'Avray, maisons blanches (H 20; DR 34), 116, 124, 132; cat. no. 87

Voie ferrée, La (H 471), 75; cat. no. 51

Voile sur l'eau, Une (H 110; DR 109), 183, 185; cat. no. 121

Voilette, La (H 568), 64, 269, 270; cat. no. 42

Voiliers, dessin pour "Gravelines: un soir" (H 702; DR 202b), 354, 357; cat. no. 223

Zone, La (H 521), 123

Seurat, Marie-Berthe, *see* Appert, Marie-Berthe Seurat (Mme Léon)

Seurat, Pierre-Georges, 335, 409, 410, 411

Severini, Gino, 376

Signac, Berthe, as former owner, 27, 53, 59, 66, 72, 128, 161, 189, 192, 213, 243, 303, 304, 347, 357

Signac, Ginette, 397; as former owner, 19, 27, 42, 53,

59, 66, 72, 128, 161, 182, 189, 226, 243, 261, 289, 303, 132, 339, 357, 369, 370

Signac, Paul, 361, 362, 380, 382, 423; advice on pigments from Camille Pissarro, 406; archaicism in the work of, 334; archives of, 66, 89, 235, 244, 261, 336, 381, 384, 397; at Asnières, 150; Paul Alexis as champion of the work of, 339; compared to Seurat, 177, 255; correspondence: from Angrand, 362; from Émile David, 390; from Dubois-Pillet, 409; from Madeleine Knoblock, 286, 361, 394, 409; from Luce, 261; from Camille Pissarro, 277, 280, 377, 408; from van Rysselberghe, 354; from Seurat, 233, 235, 244, 278, 280, 403, 404, 408, 411; to Coquiot, 378; to Maus, 255; to Mirbeau, 390; to Camille Pissarro, 406; development of, 383; diary of, 106, 279, 295, 362, 394, 397, 412; Durand-Ruel's interest in, 402, 403; elegant clothes worn by, 339; exhibitions of the work of, 3, 170, 175, 255, 298, 401, 402, 403, 404, 406, 407, 408, 409, 410, 411; as former owner, 19, 27, 53, 54, 59, 60, 66, 72, 128, 161, 169, 182, 183, 189, 213, 226, 243, 261, 269, 281, 289, 303, 304, 312, 339, 347, 357, 362, 363, 369, 370, 381, 395, 412; frames used for the work of, 364, 376; friendships: with Caze, 66; with Lucie Cousturier, 54; with Guillaumin, 383; with Charles Henry, 392; with Seurat, 66, 393, 401, 402, 405, 408; Impressionism and, 233, 394, 401, 402, 403; influence: on Gauguin, 409; on Seurat, 3; influenced: by Blanc, 384, 386; by Cézanne, 277; by Chevreul, 389, 390; by Delacroix, 394; by Rood, 391; by Seurat, 405; leftist political views of, 7, 44, 344; literary evenings attended by, 66, 384; meeting with Seurat, 147, 233; Neo-Impressionism and, 3, 7, 44, 293, 344, 390, 407; pamphlet biography written on (Fénéon), 339, 382, 383, 410; *410*; popular arts, interest in, 334; at Port-en-Bessin, 233; portrait of (Seurat), 339, 340, 410; *410*; poster and illustrations designed by, for Charles Henry, 407; posthumous inventory of Seurat's studio by, 14, 15, 18, 64, 203, 312, 347, 367, 411; presented to the president of France, 410; reaction to Seurat's work, 103, 376; sales of Seurat's work arranged by, 279, 320; second wife of, 284; student of, 361; studio of, 404; style of, 174, 298; subject matter of, 89, 150; technique and subject, analogies of, with industrial organization, 255; unstable pigments used by, 179; Les Vingt exhibition in Paris suggested by, 406; works by, 382, 383; *Apprêteuse et Garnisseuse (modes), rue du Caire (Milliners, rue du Caire)*, 175, 177; *174*; *Bouée rouge, La*, 364; *Gazomètres à Clichy, Les*, 89, 255; *Passage du Puits Bertin, Clichy*, 89; *Petit-Andely, Le*, 179; writings by, 179, 296, 344, 378, 381, 392; *D'Eugène Delacroix au néo-impressionnisme*, 386, 394, 412

Silberberg, Max, as former owner, 70

Simler, Rudolph, 391

Simmel, Georg, 177

Simon, Norton, as former owner, 293

Simon, Mr. and Mrs. Sidney, as former owners, 89

Sisley, Alfred, 106, 149, 170, 222–23, 401, 406, 411;
 work by: *Neige à Louveciennes*, 106
Smith, Paul, 255, 377
Smits, Eugène, 411
Société des Artistes, Indépendants, 3, 179, 401, 407,
 409, 411; exhibitions of: (1884), 106, 204, 342, 362,
 383, 401, 402; (1886), 89, 170, 175, 239, 382, 401,
 404; (1887), 258, 278, 283, 296, 297, 298, 306, 382,
 406; (1888), 265, 271, 272, 275, 279, 280, 289, 296,
 300, 305, 306, 308, 311, 382, 408; (1889), 333, 382,
 409; (1890), 333, 339, 340, 376, 377, 382, 410;
 (1891), 360, 363, 364, 411; (1892), 128, 144; founding
 of, 3, 35, 54, 147, 382, 401
Song Misook, 385
Sotheby's, London, 86, 88, 119, 156, 229, 252, 316, 337
Sotheby's, New York, 180, 316
Sounboul-Zadé, Mohammed, 397
Spencer, Herbert, 390
Sprenger, as former owner, 161
Stafford, Barbara M., 386
Stang, Jorgen B., as former owner, 159, 190
Stappen, Charles van der, 411
Steer, P. Wilson, 409, 411
Sterling, Charles, 136
Stern, Louis E., as former owner, 212
Sterner, Leonie Knoedler, as former owner, 48
Sterner, Marie, and Galleries, as former owners, 48
Stott, W., 409
Stransky, Josef, as former owner, 112
Suarès, André, 366
Sullivan, Mr. and Mrs. Cornelius Joseph, as former
 owners, 196, 216, 270
Sutherland, Helen C., as former owner, 156
Sutter, David, 5, 103, 383, 387–88, 400; writing by:
 "Phenomena of Vision, The," 387
Sutter, Jean, 8, 114, 179, 315, 335, 336, 377, 397
Sykes, Henry, as former owner, 48
Sykes, S. W., as former owner, 142
Symbolism (Symbolists), 234, 411; antinaturalist and
 anti-Impressionist tenets of, 385; cafés-concerts and
 circuses embraced by, 342; Chéret admired by, 342;
 critics, writers, and journals involved with, 7, 54,
 174, 175, 270, 279, 309, 340, 360, 385, 391, 392,
 394; Charles Henry and, 7, 391, 392; hieratism and
 ritual, as preferred qualities of, 343; leftist political
 views of, 344; modern science, as strong interest of,
 7; Puvis de Chavannes, as major figure for, 148;
 Seurat and, 6, 7, 54, 174, 234, 279, 311, 314, 340,
 344, 360, 376, 385, 394, 411
Symboliste, Le, 75

Tannahill, Robert, as former owner, 331
Tanner, G., as former owner, 202
Tardif, M. and Mme Georges, as former owners, 73, 227
Tarnopol, Alexander and Grégoire, as former owners, 89
Tate Gallery, London, 423
Tavernier, 403

Teisset, Germaine, as former owner, 93
Tessa, New York, 49
Thaw, E. V., and Co., New York, as former owner,
 113, 119, 165, 230, 328
Théâtre d'Application, Paris, 361
Thérésa, 299, 343
Tholen, W. B., 409
Thomson, Richard, 316, 337, 338
Thorndike, Charles Hall, as former owner, 124, 242
Three Graces, The (Roman copy of Greek original),
 273, 280; 275
Tillin, work by: *Sieste, La* (*The Siesta*), 273
Tillot, Charles, 400, 403
Tissot, James, 360; work by: *Cirque amateur*, 362;
 Dames des chars, Les, 362
Titian, 12, 15
Tobler, Alfred, as former owner, 242
Toorop, Jan, 409
Tooth, Arthur, 156
Toulouse-Lautrec, Henri de, 3, 311, 337, 342, 360,
 407, 409, 410, 411; work by: *Au cirque Fernando*, 362;
 Reine de joie, 337
Tours, Constant de, engraving from *Du Havre à Cherbourg*
 by, 320
Trublot, *see* Alexis, Paul
Turner, Joseph Mallord William, 88, 233, 235
Turner, Percy Moore, London, as former owner, 41,
 131, 152, 154, 183, 196, 220, 333, 346

Universal Exposition, Paris (1889), 11, 343

Valentine Gallery, New York and Paris, as former
 owner, 135
Valéry, Paul, 392
Vallotton, Alfred, as former owner, 89, 237
Valton, Edmond, 411
Vautheret, Étienne, as former owner, 222
Vauxcelles, Louis, as former owner, 134
Velde, Henry van de, 136, 331, 340, 376, 377, 409,
 410, 411; as former owner, 97, 135, 136, 411
Veraccho Gallery, as former owner, 93
Vergé, Mme, as former owner, 88
Verger, Suzanne Léo, as former owner, 64
Verhaeren, Émile, 235, 244; as former owner, 73, 247,
 249, 255, 380, 381, 405, 406, 411; friendship with
 Seurat, 13, 73, 340, 344; leftist political views of, 7,
 344; poetry by, 13, 344; "Au café-concert," 345;
 portrait of (van Rysselberghe), *404*; reviews and
 writings by, 6, 8, 13, 340, 345, 361, 377, 386, 403
Vermeer, Jan, 51; works by: *Lacemaker, The*, 51; *52*
Vernet, Carle, 380
Vernet, Claude-Joseph, 233
Veronese, Paolo, 396
Verster, Floris, 411
Vetzel's (Taverne de l'Opéra), Paris, 403
Viardot, Léon, 379

Vidal, Eugène, 400, 403, 406
Vielé-Griffin, Francis, 270, 402; as former owner, 270
Vie moderne, La, 293, 339, 406
Vigne, Paul de, 409
Vignier, Charles, 66, 402; as former owner, 58, 70,
 193–94, 298
Vignon, Victor, 400, 401, 403
Villon, Jacques, 32
Vingt, Les, Brussels, 3, 130, 189; exhibition of, in
 Paris, 406; exhibitions of, in Brussels, 3, 128, 244,
 247, 298, 300, 325, 354, 405, 408, 409, 411; homage
 to Seurat organized by, 412; impact of Seurat and
 Neo-Impressionism on, 244; *see also* Seurat,
 exhibitions, in Brussels (Les Vingt)
Vogels, Guillaume, 409
Vogue, La, 309, 404
Vollard, Ambroise, Paris, as former owner, 128, 158, 412
Vuaflart, Albert, as former owner, 86

Waetjen, Otto von, as former owner, 113
Wagner, Richard, 7, 376, 377
Wagner, work by: *Cirque*, 362
Wagstaff, Samuel, 397
Walpole, Hugh, as former owner, 32
Ward, Martha, 179
Warrain, François, 392
Watson Art Galleries, Montreal, as former owner, 141
Watteau, Antoine, work by: *Gilles*, 314
Webster, J. Carson, 8
Weill, Alain, 298
Werckmeister, O. K., 179
Werner, C., 379
Wertheim, Maurice, as former owner, 108, 270
Wetmore, Edith, as former owner, 169, 223–24
Whistler, James Abbott MacNeill, 106, 311, 376
Wichmandel, A., 379
Wildenstein and Co., New York, London, and Paris,
 181; as former owner, 112, 161, 169, 180, 181, 183,
 185, 190, 227, 247, 261, 266, 293, 316, 331, 336, 347
Williams, Henry S., as former owner, 29
World's Fair, Paris, *see* Universal Exposition, Paris
Wyzewa, Teodor de, 340, 403

XX, Les, Brussels, *see* Vingt, Les, Brussels

Young, Thomas, 381
Yvon, Adolphe, 22, 400

Zandomeneghi, Federico, 400, 403, 405
Zapolska, Gabriela, 287; as former owner, 286
Zayas, Marius de, 88; as former owner, 86, 88, 93, 295
Zborowski collection, as former owner, 131
Zebrowski, Bronislas, 361
Zilcken, Phillip, 298

Zilczer, Judith, 331, 364
Zimmermann, Michael, 385, 392
Zola, Émile, 7, 34, 39, 147, 176, 261, 349; work by:
 Ventre de Paris, Le, 86
Zürcher Kunsthaus, Zurich, 328